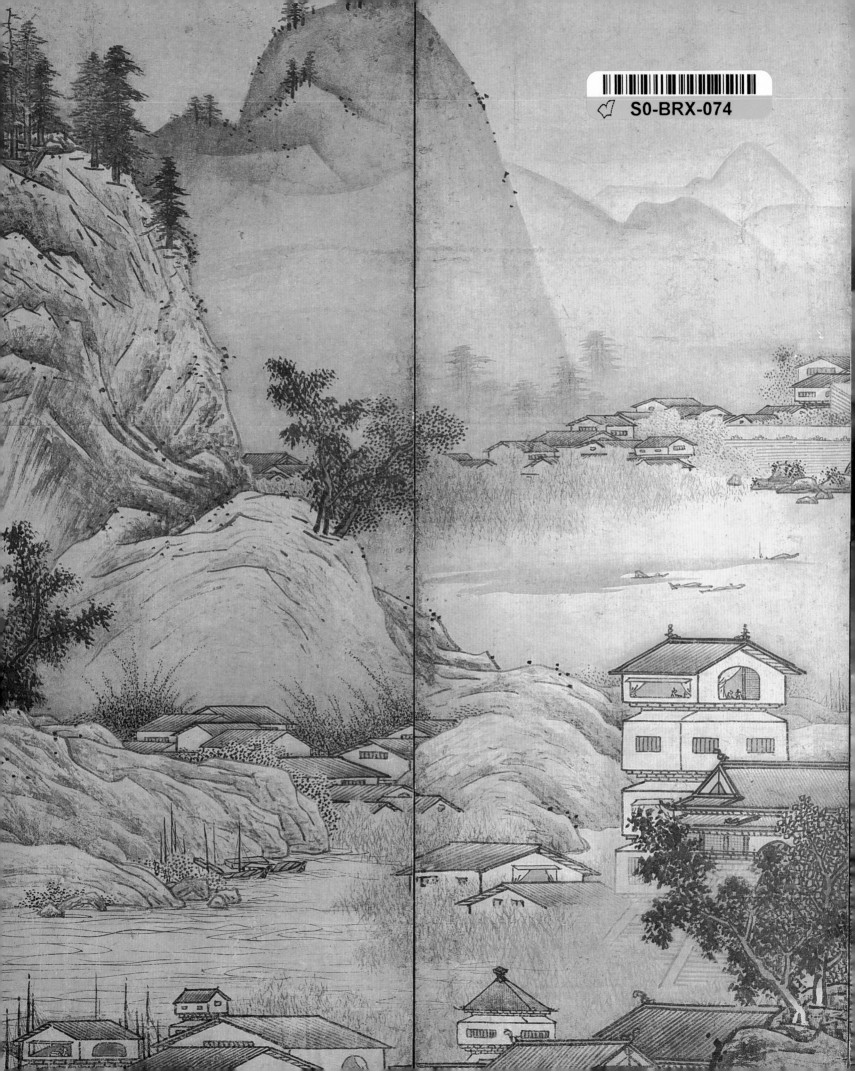

JAPAN'S GOLDEN AGE
Momoyama

YALE UNIVERSITY PRESS
NEW HAVEN AND LONDON

IN ASSOCIATION WITH
SUN & STAR 1996 AND
DALLAS MUSEUM OF ART

JAPAN'S GOLDEN AGE
Momoyama

MONEY L. HICKMAN

JOHN T. CARPENTER
BRUCE A. COATS
CHRISTINE GUTH
ANDREW J. PEKARIK
JOHN M. ROSENFIELD
NICOLE C. ROUSMANIERE

Published on the occasion of the exhibition *Japan's Golden Age: Momoyama*, held at the Dallas Museum of Art from 8 September to 1 December 1996.

Japan's Golden Age: Momoyama was organized by the Agency for Cultural Affairs, The Japan Foundation, Sun & Star 1996, and the Dallas Museum of Art. The founding sponsors for Sun & Star 1996 are EDS and Hitachi, Ltd. Texas Instruments is the major sponsor of the exhibition. Additional funding was provided by Occidental Chemical Corporation, the National Endowment for the Humanities and the National Endowment for the Arts, federal agencies, the Japan-United States Friendship Commission, and an indemnity from the Federal Council on the Arts and Humanities.

Published and Distributed by Yale University Press, New Haven and London

Library of Congress Cataloging-in-Publication Data
Japan's golden age : Momoyama / Money L. Hickman . . . [et al.].
 p. cm.
 Catalog of an exhibition held at the Dallas Museum of Art, Sept. 8–Dec. 1, 1996
 Includes bibliographical references and index.
 ISBN 0-300-06897-2. – ISBN 0-300-06900-6 (acid free paper)
 1. Art, Japanese – Kamakura-Momoyama periods, 1185–1600 – Exhibitions.
 I. Hickman, Money L. II. Dallas Museum of Art.
 N7353.4.J39 1996
 709'.52'0747642812–dc20 96-17758
 CIP

ACKNOWLEDGMENTS
Money Hickman would like to express his gratitude to the following individuals for their guidance, kind advice, and generous cooperation: Watanabe Akiyoshi, Miyajima Shin'ichi and Kobayashi Tatsurō of the Agency for Cultural Affairs, Tokyo; Sen Sōsa, Hisada Sōya and Yoshimizu Tadakiyo of the Omote-Senke, Kyoto; Koga Kyoko of the Japanese Embassy in Madrid; Beatriz Martin Arias of the Ministry of Culture, Madrid; Tokugawa Yoshinobu of the Tokugawa Reimeikai Foundation, Tokyo; Kumakura Isao of the Osaka National Museum of History and Ethnology; Itō Yoshiaki of the Tokyo National Museum; Kanzawa Hiroshi of the Kyoto National Museum; Harada Heisaku of Osaka University; Naitō Akira of the Aichi Prefectural Industrial University; Fujimura Izumi, Kido Masatoshi and Matsushita Hiroshi of the Shiga Prefectural Research Institute of Azuchi Castle; Tanaka Katsuhiro, Yoshida Hidenori, Takagi Nobuko and Numata Takehiro of the Shiga Prefectural Azuchi Castle Archeological Museum; Hinata Miyu, Tokyo; and Ikai Saburō, Okutani Tomohiko and Kimura Moriyasu of Kyoto.

The authors would also like to thank the following people who assisted in various ways in the preparation of the catalogue: Arakawa Masaaki, David Bialock, Barbara Burke, Constance A. Carpenter, Leon Long-yien Chang, Peggy and Richard Danziger, Julie Nelson Davis, Judith Day, Victor Harris, Sebastian Izzard, Kasashima Tadayuki, Kubota Kazuhiro, Kuroda Taizō, Matthew McKelway, Terry Milhaupt, Murakami Nobuyuki, Nagafuchi Tomoko, Nogami Takenori, Ōhashi Kōji, Suzuta Yukio, Henry D. Smith II, Takeuchi Jun'ichi, and Melinda Takeuchi.

ILLUSTRATIONS
FRONT COVER: detail from cat. no. 46. *Mythological "Chinese Lions,"* by Kanō Eitoku. Six-panel folding screen. Imperial Household Collection.
BACK COVER: cat. no. 118. Hand-drum Core with Design of Holly Leaves and Papers. Lacquer on wood base. Tokyo National Museum.
TITLEPAGE SPREAD: detail from cat. no. 74. *The Crane Scroll*, calligraphy by Hon'ami Kōetsu, painting attributed to Tawaraya Sōtatsu. Kyoto National Museum

Contents

Lenders

Agency for Cultural Affairs
Aichi Prefectural Ceramic Museum, Aichi
Chishakuin Temple, Kyoto
Chishōin Temple, Kyoto
Daigoji Temple, Kyoto
Daikakuji Temple, Kyoto
Daitokuji Temple, Kyoto
Daitōkyū Kinen Bunko Foundation, Tokyo
Daizenji Temple, Kyoto
Eisei Bunko Foundation, Tokyo
Equine Museum of Japan, Kanagawa
Fukuoka City Museum, Fukuoka
Fushin-an, Kyoto
Gifu City Museum of History, Gifu
Gokokuin Temple, Tokyo
The Gotoh Museum, Tokyo
Hayashibara Museum of Art, Okayama
Hikone Castle Museum, Shiga
Hōkiin Temple, Wakayama
Hōkongōin Temple, Kyoto
Idemitsu Museum of Arts, Tokyo
Imperial Household Agency, Tokyo
Jimyōin Temple, Wakayama
Jukōin Temple, Kyoto
Kaizu Tenjin Shrine, Shiga
Kamo Shrine, Shimane
Kanagawa Prefectural History Museum, Kanagawa
Kanazawa Nakamura Memorial Museum, Ishikawa
Kasuga Shrine, Gifu
Kenninji Temple, Kyoto
Kiyomizudera Temple, Shimane
Kobe City Museum, Hyogo
Kongōji Temple, Hyogo
Kōsetsu Museum, Hyogo
Kōzu Kobunka Kaikan Museum, Kyoto
Kunōzan Tōshōgū Shrine, Shizuoka

Kyoto National Museum, Kyoto
Kyūshōin Temple, Kyoto
Kyushu Ceramic Museum, Saga
Manno Art Museum, Osaka
Mishima Taisha Shrine, Shizuoka
Mitsui Bunko, Tokyo
Myōhōin Temple, Kyoto
Myōkakuji Temple, Okayama
Myōkōji Temple, Aichi
Myōshinji Temple, Kyoto
Nagoya City Museum, Aichi
Namban Bunkakan Museum, Osaka
National Museum of History and Ethnology, Chiba
Nezu Institute of Fine Arts, Tokyo
Okayama Prefectural Museum, Okayama
Osaka Aoyama Junior College, Osaka
Saikyōji Temple, Shiga
Sakai City Museum, Osaka
The Seikadō Bunko Art Museum, Tokyo
Seikeiin Temple, Wakayama
Sendai City Museum, Miyagi
Senkōji Temple, Kyoto
Sennyūji Temple, Kyoto
Shōgoin Temple, Kyoto
Shōunji Temple, Tokyo
Suntory Museum of Art, Tokyo
Taga Taisha Shrine, Shiga
Tenjuan Temple, Kyoto
Tokugawa Reimeikai Foundation, Tokyo
Tokyo National Museum
Umezawa Kinenkan Museum, Tokyo
Zenkyoan Temple, Kyoto

Private Collections

Sun & Star 1996 Support

Many in Japan and the United States recognize the need for opportunities to better understand each other's cultures. Generous financial support has been provided by Japanese and American corporations, governments, and philanthropists. We gratefully appreciate their commitment to Sun & Star 1996, without which this exhibition – and this festival – would not have been possible.

FOUNDING SPONSORS

EDS
Hitachi, Ltd.

FESTIVAL BENEFACTORS

Agency for Cultural Affairs
The Japan Foundation
Texas Instruments
Toyota Motor Corporation

PRESENTERS

Fuji Xerox Company Limited
National Endowment for the Humanities
NEC Corporation
Occidental Chemical Corporation
Sony Corporation
The Tokyo Electric Power Company
Toshiba Corporation

PARTNERS

American Airlines
The Imperial Hotel, Tokyo and Osaka

SUPPORTERS

A. H. Belo Corporation
Bank of Tokyo-Mitsubishi Ltd
Compaq Computer Corporation
The Dallas Morning News
Delta Air Lines, Inc.
Fujitsu Limited
Industrial Bank of Japan
Itochu Corporation
JCPenney
Kajima Corporation
Maxroy Corporation
Mitsubishi Corporation
Mitsui & Company Limited
NationsBank
Sanwa Bank Limited
Sprint
Sumitomo Corporation
TU Electric

DONORS

Alliance Development Corporation
American Express
Bank One, Texas
Dallas World Salute
Enron
Enserch
Fairmont Hotel at the Arts District
Halliburton Corporation
Hanabi America, Inc. (JFAA)
Marubeni Corporation
National Endowment for the Arts
SBC Foundation
Sewell Motor Company
Texas Commerce Bank
Thompson & Knight
WFAA-TV

FRIENDS

Arthur Andersen LLP
BMC Software, Inc.
Dallas Educational, Inc.
The Dallas Foundation
Dell Computers
FedEx
Fuji Bank
Gulf States Toyota
Haynes and Boone
Hitachi Construction Machinery Co., Ltd.
Hunt Oil Company
Japan – US Friendship Commission
Johnson & Higgins
KPMG Peat Marwick LLP
Mitsubishi Heavy Industries, Ltd.
Eugene McDermott Foundation
Nisho Iwai Corporation
Omron Corporation
Sid W. Richardson Foundation
Edward Rose III Family Fund
The Southland Corporation
Tandy
Tokyo Gas Co., Ltd.
Toyota Motor Sales
Wyndham Travel Partners, Inc.

ASSOCIATES

ADP
Austin Industries
Collmer Semiconductor
Columbus Realty Trust
Comerica Semiconductor
Comerica Bank-Texas
Coopers & Lybrand
The Dai-ichi Kangyo Bank, Limited
Daiwa Steel Tube Industries Co., Ltd.
Dallas Semiconductor
Donohoe, Jameson & Carrol, P.C.
Dresser Industries
Fuji Electric
Horiba, Ltd.
Jones, Day, Reavis & Pogue
Kaneka Corporation
Kirin Brewery Co., Ltd.
The M/A/R/C Group
Meehan & Co.
Mitchell Energy & Development
Mitsubishi Estate Company, Limited
Padgett Printing
Pier 1 Imports Inc.
Sanden Corporation

TEXAS AMBASSADORS

Caroline Rose Hunt, Chair

Forewords

Over the last thirty years, art museums in America have been transformed by the phenomenon of the special exhibition. New museums have been built and older ones rebuilt to accommodate the huge new audiences drawn by special exhibitions which have now come to define the new public profile of the art museum in America. On their grandest scale, such exhibitions rise to the level of discourse between nations, genuine examples of international diplomacy where governments, industry, and cultural institutions cooperate so that societies separated by time and geography may better understand each other's cultural patrimony. *Japan's Golden Age: Momoyama* constitutes a paradigm of that essential cooperation.

That generation in Japanese history known to us as Momoyama embraces an astonishing breadth of artistic achievement. It remains synonymous not only with Japanese decorative style at its lavish and sumptuous extreme, but also with that ultimate refinement which is the art of tea. The gathering of such treasures that constitutes this exhibition at the Dallas Museum of Art as part of Sun & Star 1996 is possible, first and foremost, because of the remarkable generosity of our Japanese partners. The list of exhibitions made possible over the years by the Agency of Cultural Affairs of Japan (Bunka Cho) and The Japan Foundation is legendary to those of us who labor in the arena of the art museum. Only their extraordinary selectivity and cooperative spirit could have brought from museums and temples and shrines across Japan such a priceless array of objects to grace the galleries of the Dallas Museum of Art.

The financial resources required to underwrite so vast and ambitious an undertaking far exceed those readily available to any but the largest and most well-endowed institutions. It is, therefore, only with the impressive support of the corporate community in Dallas and Japan, led by EDS and Hitachi Ltd, that *Japan's Golden Age* has become a reality.

Finally, it is with great personal pleasure that I acknowledge the central role played by the Board and staff of Sun & Star 1996 at every level and virtually every moment of the journey that has produced *Japan's Golden Age: Momoyama*. Particular credit is due to Sun & Star's very able director, Debra Skriba. The people of Dallas and the state of Texas have been offered a rare opportunity in the form of this exhibition. The age of the Momoyama constituted a moment of peace in otherwise turbulent times. Its art offers us the finest ideas of that age crystalized into objects of opulence and extraordinary refinement. Such a gesture of friendship can only bode well for a future that we must all learn to share.

Jay Gates
The Eugene McDermott Director
Dallas Museum of Art

International cultural exchange is one of the important missions of the Agency for Cultural Affairs. We organize exhibitions focused on traditional Japanese art all over the world. In the United States we have held such exhibitions since 1951, but *Japan's Golden Age: Momoyama* is our first in Dallas.

The splendid and widely varied arts of the Momoyama period are enormously important in the history of Japanese art, and they are very influential on the arts of the following centuries. This exhibition is very significant indeed, both in the quantity of works and in their quality. Nearly one third of them have been designated as National Treasures or Important Cultural Properties.

The Momoyama period was the most vital time in Japanese history, a pivotal era in which human activities of all kinds flourished again after a long period of war. Since it was characterized by an unusual amount of international contact, this is a particularly appropriate subject for Dallas, a world famous economic and cultural center, where business and arts institutions collaborate to create international exchanges. We are delighted to help bring the spectacular world of beauty of the Momoyama period to Dallas.

I would like to express my deepest appreciation to the lenders for their generosity in sharing these precious objects, and to the staff members of Sun & Star 1996 and of the Dallas Museum of Arts who planned and implemented this exhibition. I very much hope that *Japan's Golden Age: Momoyama* will further enhance friendship between the USA and Japan.

Yoshida Shigeru
Commissioner
Agency for Cultural Affairs
Government of Japan

It gives me great pleasure to be one of the co-organizers of the main event of Sun & Star 1996, *Japan's Golden Age: Momoyama*, an exhibition at the Dallas Museum of Art presenting the culture of Japan's Azuchi-Momoyama period (which lasted from the mid-sixteenth century through the beginning of the seventeenth century).

The Momoyama period was an age full of vitality, during which the powerful warlords Oda Nobunaga and Toyotomi Hideyoshi ruled over a land embroiled in fierce warfare as they attempted to unify the entire country. During this period the various daimyo, or feudal lords, vied in building splendid castles in order to assert their own power and influence. It was also an age in which the foundations of a commodity-based economy were laid, with a profusion of skilled artisans and the appearance of a class of wealthy townspeople. In addition, Japan carried on vigorous trade not only with the neighboring countries of Asia, but with Europe as well. This contact had a profound impact on the culture of the time.

The art of the Momoyama period was intimately linked with the realities of life in those days. Vigor and ostentatious splendor are its hallmarks. The castles were an excellent example of this. Their interiors were decorated with paintings, sculptures, and lavish ornamentation. Gold was used extensively in the opulent screen and wall paintings. The themes of these paintings were often taken from everyday life. In the applied fine arts, there was a noticeable European influence, and many of the works exhibit an exuberant extravagance and creativity.

This exhibition focuses on the Momoyama period, one of the great turning points in Japanese history. It brings together more than 160 masterpieces – paintings, sculptures, and numerous works of calligraphy and the applied fine arts – including some that have been designated National Treasures or Important Cultural Properties by the Japanese government.

Since its establishment in 1972, the Japan Foundation has organized a number of exhibitions in the United States, but this is our first major exhibition to be held in a southern state. As one of the co-organizers of this event, it is our fervent hope that this occasion will serve as an opportunity for the people of the United States to deepen their understanding of Japanese culture, and that it will thereby help to strengthen the friendship between our two countries.

In closing, I wish to extend my deepest gratitude to the collectors and museums who have generously agreed to lend their treasures for this exhibition. I would also like to express my sincere thanks to the co-organizers: on the American side, the Dallas Museum of Art and Sun & Star 1996, both of which generously agreed to host it, and on the Japanese side, the Agency for Cultural Affairs.

Asao Shinichirō
President
The Japan Foundation

One of the many exciting and innovative features of life in Japan during the Momoyama period was the active exchange with Western Europe. Japanese leaders sent emissaries abroad. They also received foreign visitors of many kinds – including merchants, priests, and adventurers. Accounts left by some of these reveal the curiosity and wonder with which they confronted Japanese monuments and customs. Already then, during their first encounters, it was clear that the venerable and distinguished civilization of Japan had much to teach the West.

The same is true today. Sun & Star 1996 is honored to bring to Texas and the American heartland many of the finest achievements of four hundred years of Japanese culture. Named for Japan's Rising Sun and the Lone Star of Texas, Sun & Star 1996 includes more than sixty events and exhibitions in the performing and visual arts; *Japan's Golden Age: Momoyama* is the centerpiece.

The festival showcases Japan's artistic legacy to the world. It recognizes the productive presence of Japan and the Japanese in present daily life and business in Texas. It encourages conversations between our two cultures that will strengthen our mutual understanding, now and for the promising future we share.

The ties that bind Japan and Texas are numerous, broad and well established. This festival, however, is a new kind of undertaking, one that attempts to coordinate for the first time the resources and programs of many of Texas' cultural institutions. Following the spirit of a distinguished Dallas citizen, Virginia Nick, Sun & Star 1996 was planned for the Dallas/Fort Worth metroplex. As the time drew near, some institutions in Houston and Austin whose schedules permitted chose to participate. The result is a 100-day banquet that will give millions of Texas residents and visitors the chance to savor the traditional and contemporary tastes of Japan. We hope that this will inspire many such cooperative ventures in the future.

Cross-cultural projects of this scale require support in equal magnitude. As the exhibition credits of *Japan's Golden Age: Momoyama* attest, Sun & Star 1996 received generous support from the agencies of both the Japanese and U. S. governments. Nevertheless, corporate leadership has been the keystone of Sun & Star 1996. Lester M. Alberthal, Jr., EDS Chairman, and CEO, was an early advocate for the project and chose to commit EDS to become the American Founding Sponsor of Sun & Star 1996. Leadership at EDS, especially by John Castle, Gary B. Moore, Vicki Yacovoni, and Jim Young, provided essential support for the project. The Japanese Founding Sponsor is Hitachi Ltd, led by Mita Katsushige, Chairman of the Board, and supported by Kuwata Yoshirō, Saitō Tetsuo, Kohama Masayuki, Makita Akira, and Matsumura Ryōkō.

The board of directors and staff of Sun & Star 1996 thank Texas Instruments, the major sponsor of *Japan's Golden Age: Momoyama*. We express great sadness at the untimely death of Jerry R. Junkins, the chairman of Texas Instruments. Jerry Junkins, a distinguished leader of the global business community, understood well the importance of cultural exchange and education. His vision of the world in the twentieth century enhanced cooperation among governments and corporations, thus strengthening the bonds of friendship among the peoples of many nations.

Sun & Star 1996 has benefited enormously from the commitment of a dedicated and effective board of directors led by Richard Freling. I would like to thank the board of trustees of the Dallas Museum of Art, led by Deedie Rose, who also serves as a vice president of the board of directors for Sun & Star 1996.

The outstanding arts professionals who created the remarkable exhibition, *Japan's Golden Age: Momoyama*, are listed in these pages. In thanking them, I must also give special gratitude to three distinguished leaders, past and present, in the Agency for Cultural Affairs: Watanabe Akiyoshi, Washizuka Hiromitsu, Miwa Karoku and Suzuki Norio.

Debra Skriba
Executive Director, Sun & Star 1996

Note to the Reader

The romanization of Japanese words is based on the Hepburn system; that of Chinese words on the Wade-Giles system. Words such as daimyo, shogun, and Shinto that now appear in Webster's dictionaries, as well as common place names, such as Kyoto, Kyushu, Osaka, and Tokyo are anglicized (with macrons over long vowels omitted); elsewhere diacriticals are used throughout. Names are given in Japanese order, surname first, followed by a personal or art name. After the first occurrence artists are often referred to solely by their art name, for example, Hasegawa Tōhaku is referred to simply as Tōhaku. Proper nouns formed of a root word and suffix are closed; hence, Daitokuji (Daitoku Temple), not Daitokuji, and Jukōin (Jukō Subtemple), not Jukō-in.

Ages are given according to traditional Japanese convention: a person is considered a year old at birth and turns a year older on New Year's Day. For instance, Hideyoshi's son Sutemaru died at age three according to Japanese methods of calculation, age two by Western reckoning.

In the data sections, dimensions are given in centimeters, height preceding width. Measurements for paintings and calligraphy exclude mounting. Unless otherwise indicated, dimensions for three-dimensional objects are given with height first, followed by width and then depth.

When pairs of screens are illustrated one on top of the other, the right screen is above the left.

Apart from the catalogue entries there are two sequences of illustration numbers in the text. Thus (fig. 27) refers to an illustration in the introduction or media essays. This sequence runs right through the book. (Cat. no. 39a) refers to a comparative illustration to catalogue number 39.

The Agency for Cultural Affairs (Bunkachō) supervises a registration system to identify works of art considered important to Japan's cultural heritage. The classifications are, in order of importance: National Treasure (*kokuhō*), Important Cultural Property *jūyō bunkazai*, and Important Art Object (*jūyō bijutsuhin*). The system of designating National Treasures and Important Cultural Properties is explained below in the essay "Japan's National Treasures." The category of Important Art Object, used between 1933 and 1950, is no longer assigned.

CHRONOLOGY

CHINA

T'ang dynasty: 618–906
Five Dynasties: 906–960
Northern Sung dynasty: 960–1127
Southern Sung dynasty: 1127–1279
Yüan dynasty: 1279–1368
Ming dynasty: 1368–1644
Ch'ing dynasty: 1644–1911

JAPAN

Nara period: 710–794
Heian period: 794–1185
Kamakura period: 1185–1333
Ashikaga (Muromachi) period: 1333–1573
Sengoku ("Country at War") period 1467–1573
Momoyama (Azuchi-Momoyama) period: 1573–1615
Edo (Tokugawa) period: 1615–1868

(for fuller information see the chronological tables on p. 302)

CONTRIBUTORS

The author of each catalogue entry is indicated by the following initials:

JTC	John T. Carpenter
BAC	Bruce A. Coats
CG	Christine Guth
MLH	Money L. Hickman
AJP	Andrew J. Pekarik
JMR	John M. Rosenfield
NCR	Nicole C. Rousmaniere

Japan's National Treasures

Japan has the world's most comprehensive legislation for protecting, preserving, and classifying its cultural patrimony. This legislation bestows official recognition, subsidies, and ranks to those monuments, artifacts, craftspeople, and performers that the government deems best exemplify traditional Japanese culture. Included in this official registry are painting, sculpture, decorative arts, writings, archeological artifacts, and architecture. Works of Japanese origin are in the majority, but some foreign works of great rarity or of historical or artistic importance are also registered. The designations Important Art Object, Important Cultural Property, and National Treasure noted in many of the entries in this catalogue are, in ascending order, the three highest categories in this classificatory system.

The genesis of this comprehensive registry dates to the Meiji era (1868–1912), when Japan launched a vigorous effort to modernize, industrialize, and colonialize so as to gain parity with the West. Keenly sensitive to the power of art to foster a sense of national pride and identity as well as to confer international prestige, the Meiji government made preserving the nation's cultural patrimony an important part of its modernization effort. In 1897, it enacted the Law for the Preservation of Ancient Shrines and Temples (*Koshaji hozon hō*) to protect religious institutions and their contents. Buddhist temples and Shinto shrines, like monasteries and churches in Europe, were the primary repositories of the nation's religious and secular art. Like their European counterparts also, many of these institutions were being destroyed or dismantled and their contents dispersed, a trend accelerated by the growing market for art both at home and abroad.

Growing awareness of the importance of historical preservation following the devastating Kantō earthquake of 1923, compounded by fears that Japanese treasures would be sold abroad following the financial crash of 1927, were the twin catalysts for the institution of an expanded registry. It extended official protection to articles of historical and artistic merit in private collections, and as a result led to the inclusion of a growing number of secular works, such as screen paintings and narrative handscrolls. Reflecting the nationalism of this era, the 1929 legislation was entitled Law for the Protection of National Treasures (*Kokuhō hozon hō*). A term of Chinese origins, National Treasure (*kokuhō*) had been used in Japan since early times to refer both to articles such as Buddhist paintings, statuary, and other ritual paraphernalia whose possession was believed to contribute symbolically to the protection and prestige of the nation. This honorific was also given to charismatic teachers, most notably, Buddhist priests whose religious activities were believed to benefit the nation. The early-twentieth-century usage of the term subsumed these traditional connotations.

In 1950, the government revised the legislation again, renaming it the Law for the Protection of Cultural Properties (*Bunkazai hogo hō*). This law dramatically expanded the scope of articles under government protection by instituting a new two-tier system with National Treasures at the top and a much larger body of objects and sites designated as Important Cultural Property below them. Since that time, the classificatory system has expanded still further, The Cultural Properties Commission, or Bunkazai hogo iinkai (Bunkachō for short), a division of the Ministry of Education, is empowered to make the selection and determine classification on all levels. As of 1989, Important Cultural Properties numbered 11,476 and National Treasures 1,034. While works are added yearly to the ranks of Important Cultural Properties (including the *Portrait of Sen no Rikyū,* cat. no. 5, which was registered in 1996), additions to the ranks of National Treasures are rare.

Revising the earlier registry in keeping with changing ideological concerns has been one of the Cultural Properties Commission's main tasks since 1950. Changes in art historical thinking and methodology played a major role in this process. Technical virtuosity and craftsmanship, and usefulness as models for practicing artists, for instance, were important artistic criteria in the selection of National Treasures in the late nineteenth and early twentieth centuries, but by 1950 this was no longer the case. New scientific techniques for study and dating also led to many revisions. Despite this updating in keeping with modern Western art historical categories, in many respects, the selection still reflects a traditional Sino-Japanese cultural outlook. For instance, painting and sculpture now comprise 20% of all National Treasures, but writings of various kinds, are equally well represented, a reflection of the high esteem in which calligraphy was traditionally held. Similarly swords, including the one presented by Tokugawa Ieyasu's son to a shrine in his father's memory (cat. no. 132), also figure prominently.

As a result of the Bunkachō's efforts in the postwar years, many works previously designated *kokuhō* were demoted to Important Cultural Properties. Kaihō Yūshō's *Plum Tree* and *Pine Tree with Mynah Birds* (cat. nos 59–60), Tawaraya Sōtatsu's *Screens Mounted with Fans* (cat. no. 64), and the armor made for Hideyoshi's son Sutemaru (cat. nos 139–40) are among the works reclassified in this way. Some works, such as Kanō Hideyori's *Maple Viewing at Mount Takao* (cat. no. 27), Kanō Naganobu's *Merrymaking under the Cherry Blossoms* (cat. no. 28), Hasegawa Tōhaku's *Maple Tree and Autumn Plants* (cat. no. 54), and Sōtatsu's *Wind and Thunder Gods* (cat. no. 65), all retained their earlier National Treasure ranking. Objects in the Imperial Household Collection are exempt from the designation, although some, including Kanō Eitoku's *Chinese Lions* (cat. no. 46), were previously recognized as National Treasures.

CG

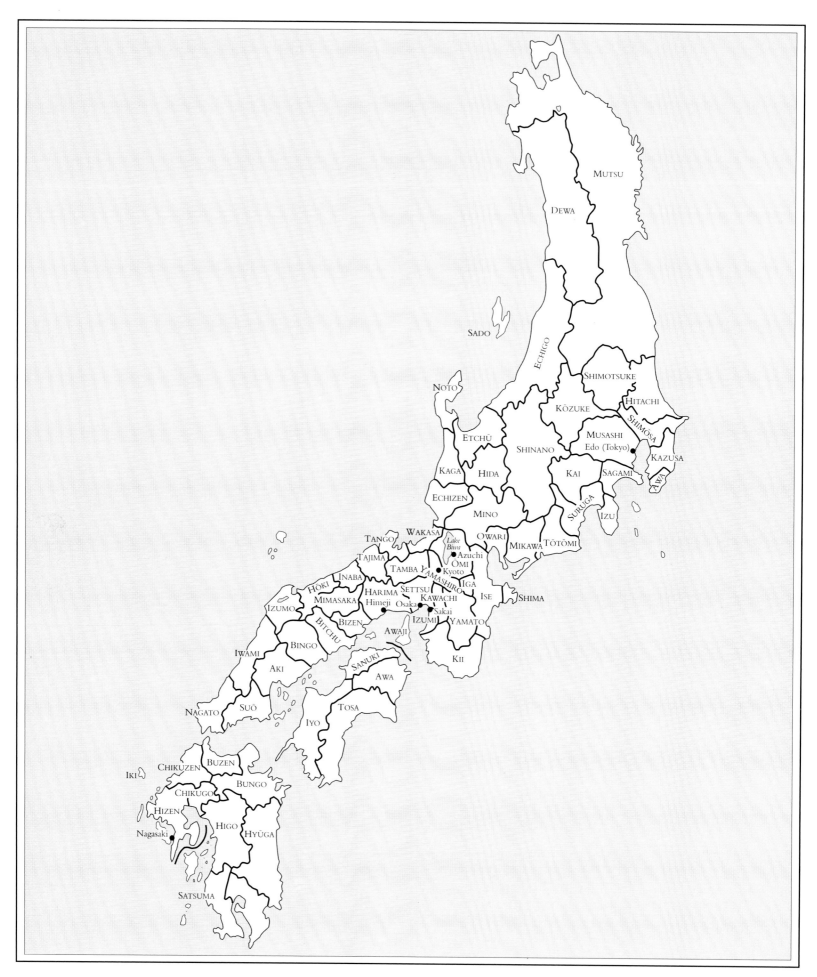

MUTSU

DEWA

ECHIGO

SADO

NOTO

SHIMOTSUKE

KŌZUKE

HITACHI

ETCHŪ

SHINANO

MUSASHI
Edo (Tokyo)

SHIMŌSA

KAZUSA

KAGA

HIDA

KAI

SAGAMI

AWA

ECHIZEN

MINO

SURUGA

IZU

WAKASA

OWARI

TANGO

Lake Biwa

Azuchi

MIKAWA

TŌTŌMI

TAJIMA

ŌMI

TAMBA YAMASHIRO

Kyoto

IGA

ISE

SHIMA

INABA

HOKI

SETTSU

HARIMA

Himeji

Osaka

KAWACHI

Sakai

IZUMO

MIMASAKA

BIZEN

IZUMI

YAMATO

BITCHŪ

AWAJI

IWAMI

BINGO

AKI

SANUKI

AWA

KII

NAGATO

SUŌ

TOSA

IYO

IKI

CHIKUZEN

BUZEN

CHIKUGO

BUNGO

HIZEN

Nagasaki

HIGO

HYŪGA

SATSUMA

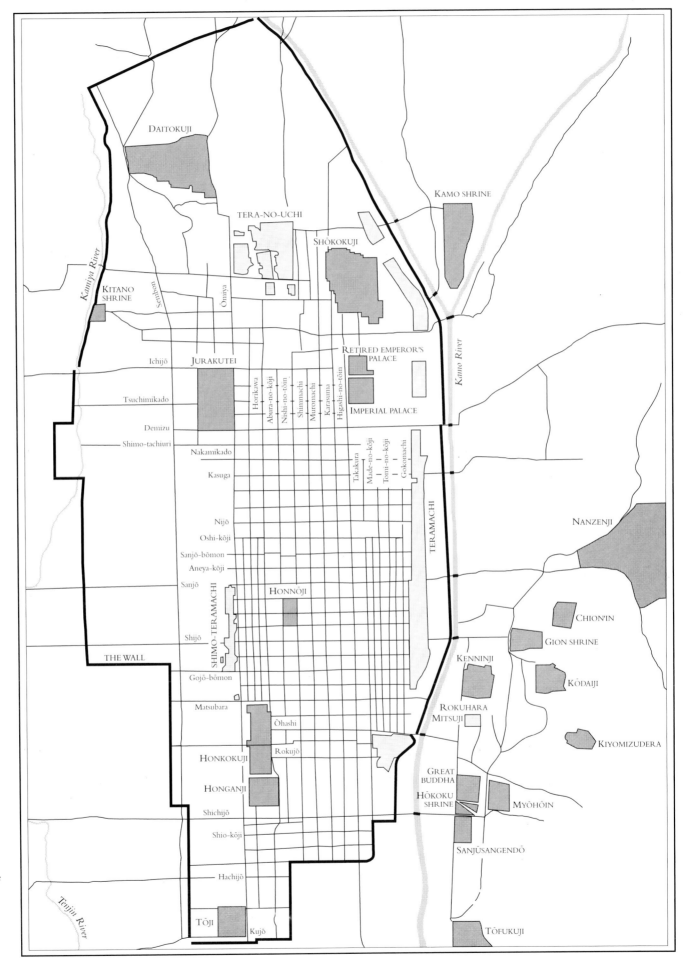

(left) The pre-modern provinces of Japan.

(right) Kyoto in the age of Hideyoshi.

Based on Mary Elizabeth Berry, *Hideyoshi* (Cambridge: Harvard University Press, 1982).

DAITOKUJI

KAMO SHRINE

TERA-NO-UCHI

SHŌKOKUJI

Kamiya River

KITANO SHRINE

Senbon

Ōmiya

RETIRED EMPEROR'S PALACE

Kamo River

Ichijō

JURAKUTEI

Tsuchimikado

Horikawa
Abura-no-kōji
Nishi-no-tōin
Shinmachi
Muromachi
Karasuma
Higashi-no-tōin
IMPERIAL PALACE

Demizu

Shimo-tachiuri

Nakamikado

Takakura
Made-no-kōji
Tomi-no-kōji
Gokomachi

Kasuga

NANZENJI

Nijō

TERAMACHI

Oshi-kōji

Sanjō-bōmon

Aneya-kōji

Sanjō

SHIMO-TERAMACHI

HONNŌJI

CHION'IN

GION SHRINE

Shijō

KENNINJI

THE WALL

KŌDAIJI

Gojō-bōmon

Matsubara

ROKUHARA MITSUJI

KIYOMIZUDERA

Ōhashi

HONKOKUJI

Rokujō

GREAT BUDDHA

HONGANJI

HŌKOKU SHRINE

MYŌHŌIN

Shichijō

Shio-kōji

SANJŪSANGENDŌ

Hachijō

Tenjin River

TŌJI

Kujō

TŌFUKUJI

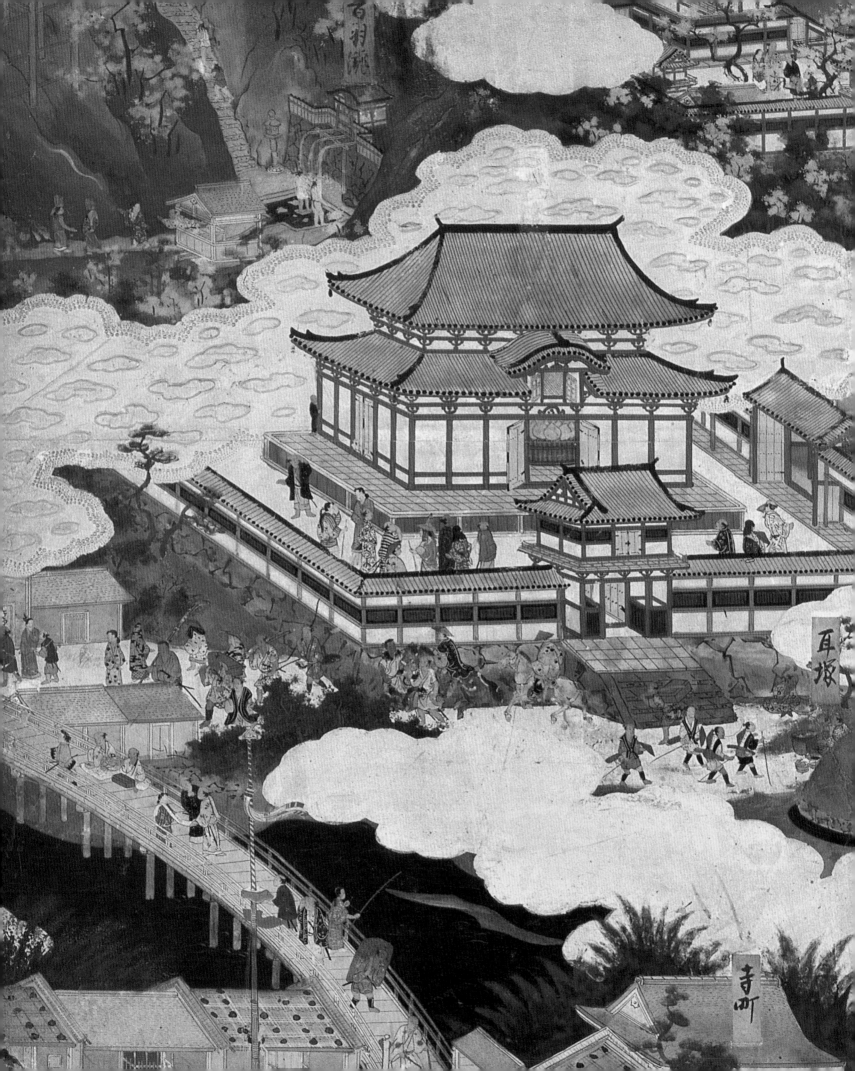

Introduction

MONEY L. HICKMAN

Toward the end of the sixteenth century the successive efforts of three powerful warlords, Oda Nobunaga, Toyotomi Hideyoshi, and Tokugawa Ieyasu, finally brought Japan under a single, unified authority after more than a century of warfare, civil disorder, and social fragmentation. Modern scholars, in search of an appropriate designation for that short but momentous period, selected "Momoyama" because of its topographical association with the last of Hideyoshi's great architectural projects, Fushimi Castle. The site where the castle had once stood, with its scenic prospects and historic associations, later become a favorite destination for excursions among the local populace. Drawn by the handsome stand of flowering peach trees that had grown up there, local inhabitants calledthe place *Momoyama* ("Peach Blossom Hill").

In an attempt to be more comprehensive, cultural historians have used the term "Azuchi-Momoyama," which includes reference to the site of Nobunaga's castle. But the name "Momoyama" has, through repeated usage, become the common and prevailing designation for the span of about four decades that includes the last quarter of the sixteenth century and the first decade and a half of the seventeenth century. Individual scholars, depending on their disciplinary inclinations, have drawn the chronological parameters of the period in various ways: 1573, the year Nobunaga deposed the last Ashikaga shogun, is one date frequently used to mark its beginning. The year 1615, when the Toyotomi forces were overwhelmed by the Tokugawa armies in the fall of Osaka Castle, is generally recognized as a convenient *terminus ad quem* for the period. But the seamless, evolutionary nature of cultural history seldom lends itself to easy chronological divisions, and the artistic

and architectural accomplishments of the "Momoyama" decades continued to exercise a powerful influence well into the following Edo period.

"Momoyama" also seems appropriate in another sense, for the vision of a brilliant cloud of evanescent peach blossoms serves well as an evocative visual metaphor for the period, a "golden age" of short duration but memorable accomplishments. Seen from a broader historical perspective, the late sixteenth century marks the watershed between the medieval and early modern periods in Japan. The latter, which begins with the four decades of the Momoyama period, continues until the fall of the Tokugawa shogunate in 1867.

The Momoyama period was an age of prodigious building and magnificent display. Castle complexes, which were constructed in impressive numbers during this time, epitomize both the dynamic spirit of the age in their great size, ostentatious splendor, and dominating presence, as well as the quality of brevity and impermanence that is associated with the period. Astonishing in their time, the great castles of Nobunaga and Hideyoshi exercised a strong hold on the popular imagination of successive generations. These monumental edifices reveal the grandiose, dynamic, and pragmatic temper of the age. Erected by parvenu warlords, they served as overwhelming symbols of the newly acquired authority and status of their owners, as well as ostentatious demonstrations of their worldly riches and luxury. Some, like Himeji, Osaka, and Edo, were conceived on an unprecedented scale, but only a few of those that have been preserved retain much of their original layout and appearance. Matsumoto (fig. 2) and the smaller Hikone (fig. 3) are two examples that appear to be largely original and not substantially changed by subsequent repair and rebuilding, but there are also many that were abandoned in later times and lie in ruin. Indeed, none of the four most renowned castle compounds of Momoyama times – Azuchi, Jurakutei, Osaka, and Fushimi ("Momoyama") – survived the period.

Fig. 1. Daibutsuden ("Great Buddha Hall") of the Hōkōji, detail of *Scenes In and Around the Capital*, cat. no. 23. Second quarter of seventeenth century. Pair of six-fold screens. Namban Bunkakan, Osaka

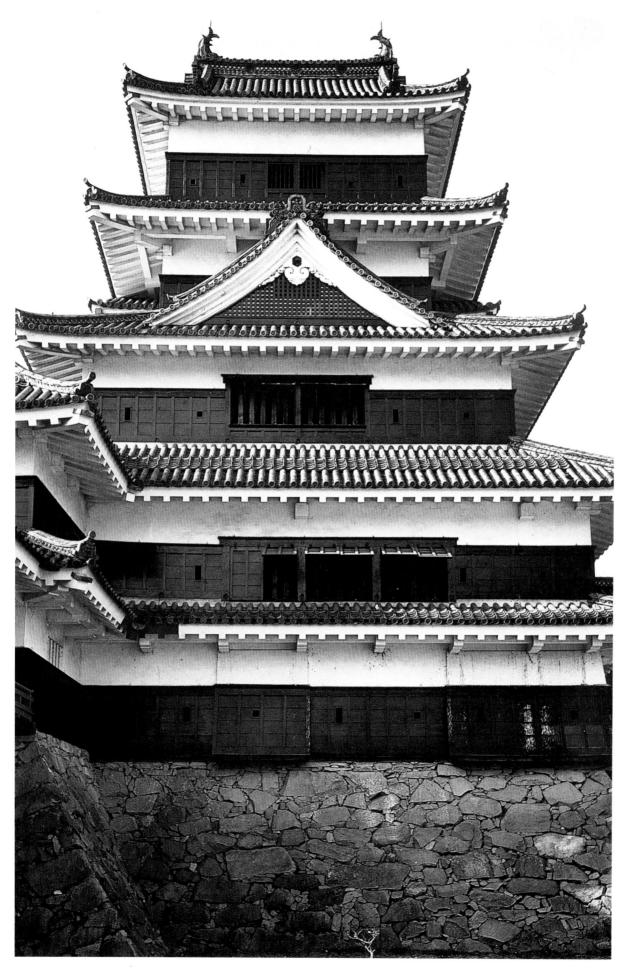

Fig. 2. Donjon of Matsumoto
Castle, ca 1597. Nagano
Prefecture.

Fig. 3. Donjon of Hikone Castle,
ca 1606. Shiga Prefecture

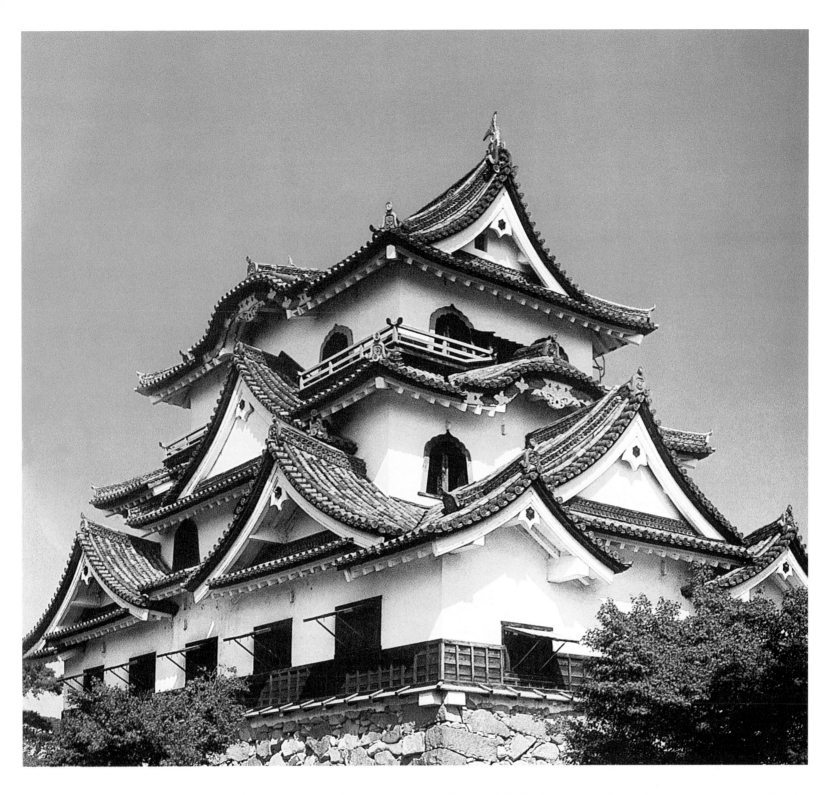

The aspirations that motivated these parvenu military auto- crats and those who attended them may be summarized in three words: power, wealth, and pleasure. The mesmeric material that held out promise of the realization of these ideals was gold, which took on a seminal symbolic role far beyond its pragmatic function as a medium of exchange. Both Nobunaga and Hideyoshi used the glittering metal freely and ostentatiously to impress the world with their majestic circumstances and extraordinary wealth. Gold had been known and used in small amounts for decorative purposes since ancient times, but chiefly in a religious context. Gold leaf was used to embellish elegant temples and retreats constructed by the nobility during the Heian period, and this tradition was revived in the Ashikaga period by the shogun Yoshimitsu (1358–1408), whose Kinkaku, or "Golden Pavilion" (fig. 4), was inspired by the visionary conception of a Buddhist paradise. At the same time, however, Yoshimitsu's extensive use of gold leaf on the Kinkaku also served as an unmistakable demonstration of his aristocratic sta- tus and worldly wealth, and it was these manifestations that inspired warlords like Nobunaga and Hideyoshi to emulate his precedents in behavior and taste.

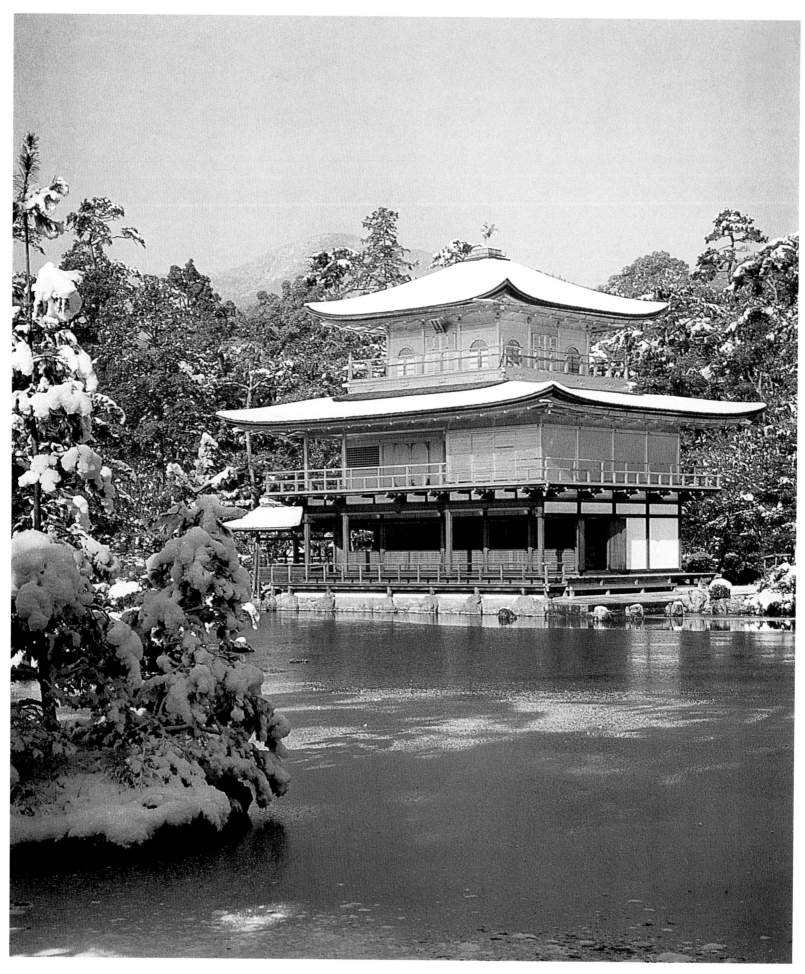

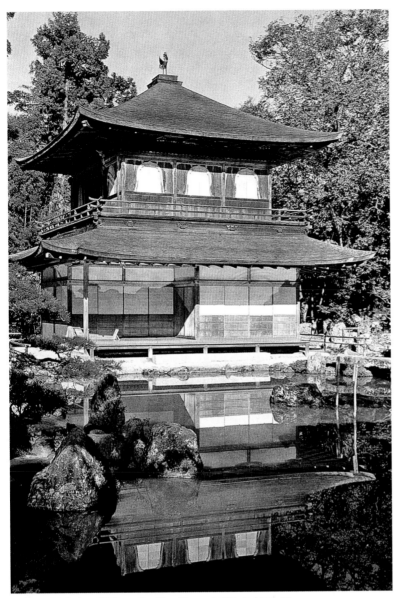

Fig. 5. Ginkaku ("Silver Pavilion"), ca 1489, Jishōji, Kyoto.

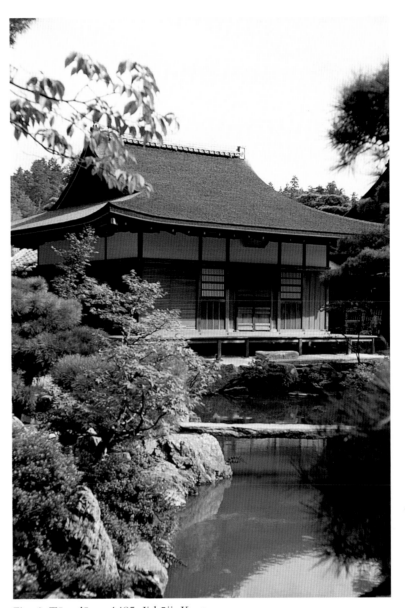

Fig. 6. Tōgudō, ca 1485. Jishōji, Kyoto.

The Ginkaku, or "Silver Pavilion" (fig. 5), and its companion structure, the Tōgudō (fig. 6), were erected almost a century later, by Ashikaga Yoshimasa (1436–1490). Although certain features of the Ginkaku were undoubtedly inspired by Yoshimitsu's Kinkaku, the two buildings express the marked differences between the aesthetic standards of the two periods and their builders. One is a parade of resplendent gold in an expansive, sumptuous setting, the other a delicate understatement in gray, black, and white, filled with an intimate atmosphere that evokes the discerning activities that took place there. These contrasting aesthetics are both fundamental to the Momoyama period.

In the Ginkaku compound Yoshimasa and his group of cognoscenti evaluated paintings, calligraphy, and tea utensils, shared discerning observations, and pursued the refined rituals and dis-

criminating pleasures of the tea ceremony in conjunction with Murata Shukō (d. 1502), the innovative pioneer of this evolving discipline. The small chamber in the Tōgudō, four and half mats in size, with its spare but companionable ambience, is called the Dōjinsai ("Equal Merit Study"), a name that implies that to the enlightened man, all men are the same, irrespective of social status. Diminutive in its scale, and arbitrarily plain in its "natural" surfaces and textures, this unprepossessing room is of particular importance in the history of Japanese aesthetics, for it represents the initial phase in the development of the distinctive tea ceremony room that will take its characteristic, independent sōan ("thatched hut") form under the guidance of Sen no Rikyū (1522–91) and other tea masters of the Momoyama period, almost a century later. It was under the insightful direction of Rikyū and his followers that the wabi aesthetic, with its emphasis on spareness, understatement and the awareness of beauty in the commonplace, becomes a central ideal of the tea ceremony.

Aside from their symbolic connotations, gold and silver also

Fig. 4. Kinkaku ("Golden Pavilion"), modern reconstruction of 1397 original. Rokuonji, Kyoto.

provided the most convenient means for paying for military campaigns and massive construction projects of the age. Mining technology had remained rudimentary until the discovery of a rich vein of silver in Iwami in about 1530, and authorities were prompted to import more efficient smelting techniques from China and Korea. A decade later, an even richer silver deposit was found further north at Ikuno in Tajima. Both Nobunaga and Hideyoshi promoted the development of mining in the provinces under their control and accumulated prodigious reserves of gold and silver in their great bastions. Most of the influential daimyo also acquired large stocks of gold and silver bullion and gold dust. Because of the astounding demand, gold was freely imported while silver was exported in great quantities in the sixteenth century.

After they had seized Macao in 1557, Portuguese traders became the main maritime carriers and brokers in the trade between Japan and China. The most profitable export was silver from Japanese mines, which was exchanged for Chinese commodities and gold. The export of silver was also of great advantage to the growing ranks of Japanese mercantile entrepreneurs since it brought not only Portuguese ships but also those from other parts of Asia to Japan, and this profitable commerce contributed to the unprecedented economic prosperity of Momoyama Japan and the evolution of an independent urban class of merchants and financiers.

The first Europeans reached Japan in the 1540s, Portuguese traders early in the decade, and Catholic prelates including the celebrated Jesuit Francis Xavier, later. The industrious efforts of Jesuit missionaries from the Portuguese bases at Goa and Macao furthered the propagation of Christianity in Japan. By the early 1580s it is estimated that the number of Japanese who had embraced the faith had grown to about 150,000. As these Europeans (and the Asians and Africans who accompanied them) had come to Japan from the south, they were referred to by the collective term *Nambanjin* ("Southern Barbarians"), a designation of ancient Chinese origin which had originally been used to refer to the non-indigenous peoples and cultures adjoining China to the south. The influence of Namban culture and the arts, crafts and technology that arrived with the Europeans is an important aspect of the late sixteenth and early seventeenth centuries in Japan (see cat. nos 40–1, 122–6). Converts to Christianity were concentrated in Kyushu, where a number of influential daimyo also joined the church. Churches and seminaries were also established in other regions, including the city of Kyoto (cat. no. 42).

The central stage of the Momoyama period was the enduring metropolis of Kyoto and the surrounding provinces. Founded in 794 as the seat of imperial government, the great city, known as Heiankyō, the "Capital of Peace and Tranquility," was laid out on a broad area of gently sloping, fertile plain, open to the south and surrounded to the north, east, and west by modest ranges of mountains. The city was blessed with abundant sources of natural water, easy land routes leading to the neighboring provinces, and convenient access to the maritime trade of the Inland Sea through the Yodo River and its tributaries that run south and west from the city (see Map).

Until the middle of the sixteenth century, Kyoto was virtually the only major urban center in Japan. Many important religious institutions were situated in and around the city, and these were meccas for pilgrims from the provinces, who patronized the inns and shops that grew up around them. Kyoto was also the chief center of trade and industry, and the home of skilled craftsmen who produced fine lacquers, pottery, elegant textiles, metalwares, and other luxury goods for affluent members of the aristocracy, clergy, warrior and merchant classes. Although the city had suffered repeatedly during the warfare, conflagrations, and instability of the late fifteenth and early sixteenth centuries, and many of its courtiers, skilled artisans, and merchants had taken up temporary residence in other areas, by the middle of the sixteenth century, the city had not only recovered but grown. The population had increased significantly, and the number of inhabitants in Kyoto was probably at least the equal of that of any contemporary city in Europe.

Foreign visitors to Kyoto wrote glowing accounts of the capital and its inhabitants. João Rodrigues (1561?–1633), a Jesuit who spent more than thirty years in Japan and served as an interpreter for both Hideyoshi and Ieyasu noted:

> The people of Miyako (Kyoto) and thereabouts are even tempered, courteous and very obliging; they are well dressed, prosperous and are much given to continual recreations, amusements and pastimes, such as going on picnics to enjoy the sight of flowers and gardens. They invite each other to banquets, comedies, plays, farces and their type of singing. They often go on pilgrimages and have much devotion to their temples; there are usually so many men and women going to pray and hear sermons at these temples that it looks as if there is a jubilee. Their speech is the best and most eloquent of all Japan because of the presence of the court and *kuge* (nobility), among whom the language is best preserved. . . . All over the city there is an enormous number of inns and taverns which provide food for people from outside, and there are also many public baths where a man blows a horn and invites people to the baths, for the Japanese are very fond of bathing.[1]

Many of the city's inhabitants belonged to the Hokke (Lotus) sect, a militant branch of Buddhism founded by the monk Nichiren (1222–82). As the sect became increasingly influential in Kyoto society during the fifteenth century, it attracted adherents from the ranks of the aristocracy and custodians of traditional courtly culture, such as the Konoe courtier family; and from the *machishū*, the elite strata of the city's merchants, brokers, artisans, and manufacturers. Among the fundamental teachings of the Lotus Sutra, the primary scripture of the Hokke sect, is the assurance that happiness can be realized in this world, and that salvation is possible for all, irrespective of social class, gender, occupation, or material wealth. These egalitarian doctrines held a particular appeal for the *machishū* of Kyoto, whose social status and mercantile traditions set them apart from the aristocrats and warriors. After the tragic carnage and destruction of the late fifteenth century, adherents of the Hokke sect had been among the first to begin the restoration of the city, and by the early decades of the sixteenth century, the *machishū* had formed their own militia to protect the city from random lawlessness within the city and organized insurrections by other religious groups. The cooperation of the *machishū* was essential to the finan-

cial and logistical well-being of Kyoto and other growing cities, and during the Momoyama period, members of the Suminokura, Chaya, and Hon'ami families played prominent roles not only in mercantile activities, but also as patrons of the arts.

The long, turbulent, and generally unstable epoch that preceded the Momoyama period is known by two designations: the "Ashikaga period," taken from the family name of the fifteen successive Ashikaga shoguns who headed the *bakufu* (military government) between 1338 and 1573; and the "Muromachi period," named for the area in Kyoto where the administrative headquarters and palace of the Ashikaga shoguns was located, beginning in the late fourteenth century. Although the first and third Ashikaga shoguns, Takauji (1305–58) and Yoshimitsu (1358–1408) exercised considerable power, the careers of their successors were generally weak and ineffective, and by the sixteenth century they had become little more than nominal rulers, political pawns, and figureheads. The contentious nature of the early Ashikaga period is reflected in the circumstances of the imperial house, which was divided into two rival courts for most of the fourteenth century. The Ashikaga *bakufu,* supported by several of the powerful military houses, reached the apex of its power and prestige under Yoshimitsu, shogun from 1367 to 1394, but its authority declined following his death. The general impotence of the Ashikaga shoguns and declining prestige of the imperial house during the fifteenth century made it difficult for the military and civil governments to exercise their influence beyond the capital, and in the provinces, powerful warrior families, constabulary chieftains, and local warlords had gained control over large domains where they exercised autonomous rule. The century is marked by feuds and armed conflicts between these contentious factions at one location or another, as well as uprisings by disaffected samurai and the bellicose activities of militant religious groups. During this period great military houses rose and fell, sometimes in combat against their peers, sometimes against aggressive vassals. These conflicts culminated in the Ōnin War of 1467–77, fought chiefly in and around the capital city of Kyoto and later in other regions. This destructive cataclysm devastated the ancient citadel of Japanese culture, and many of its great monasteries, palaces, and residential neighborhoods were set to the torch and leveled. Armies of prodigious size were involved in great carnage and the protracted battles hastened the downfall of a number of prestigious feudal families, who were defeated or reduced to insignificance in savage battles.

Throughout these hostile times the imperial house and the Ashikaga shogunate were free from attack, not because they were feared, but because they were impotent. The court had lost its estate incomes and was impoverished, so much so that in 1500, the body of the deceased emperor remained unburied for six weeks for lack of funds. With the Ashikaga *bakufu* incapable of asserting authority, *nariagarimono* (upstart or parvenu) leaders often assumed power in the outlying regions. Established warrior families were displaced through force or guile, either by their subordinates, opportunistic adventurers, or local military chieftains, who established independent principalities. Authority, rank, and lineage were ignored, lowly warriors challenged great warlords, and commoners took over estates where they had formerly labored. This phenomenon, one of the seminal characteristics of this fractious age, is known by a phrase borrowed from the ancient Chinese literary classic, the Book of Changes, *gekokujō,* "mastery of the high by the low."

The decades from the late fifteenth century to the close of the sixteenth are known as the *Sengoku jidai,* the "Age of the Country at War." Although armed conflicts had occurred more or less continuously in various regions before the Ōnin War, they afterwards became endemic, and no province was spared. Before the Ōnin War, there were about 260 feudal daimyo houses, but by 1600 only a dozen of these had survived and remained influential, mainly in the northeastern and western regions of Japan. This evolutionary change in the power structure involved the realignment of established alliances and family relationships. As weaker factions were absorbed, the conflict gradually resolved into a rivalry between half a dozen powerful families or coalitions by about 1560, a circumstance that would lead eventually to the restoration of governmental controls, social stability, and unification under a single, central authority.

In the realm of religion, the Zen sect of Buddhism was particularly influential during the Muromachi period, especially among the higher echelons of the warrior class. Zen had been introduced from China at the end of the twelfth century, and the military leaders of the Kamakura *bakufu* had not only become its chief converts and advocates, but also its chief benefactors, building a number of great monasteries in Kamakura and Kyoto. The Ashikaga shoguns continued this patronage, and Zen monks were familiar guests at their residences and palaces, where they were admired for their scholarly knowledge of Chinese literature and poetry, and their proficiency in calligraphy, painting, and the discipline of tea, which had its origins in Zen ritual. Because of their familiarity with Chinese culture and language, Zen prelates also served the *bakufu* as diplomatic envoys in official relations with Ming China.

The shoguns of the early sixteenth century were little more than figureheads, devoid of power and the puppets of powerful

Fig. 7. Chinese Chien (Temmoku) tea bowl on a black lacquer stand with inlaid mother-of-pearl designs, Southern Sung period. Ryūkōin, Daitokuji, Kyoto.

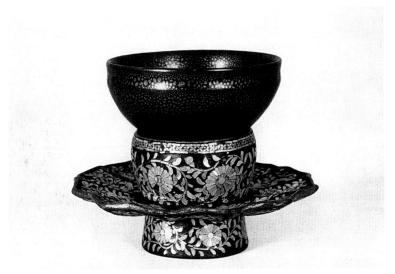

daimyo factions. Although their established governmental seat was in Kyoto, they were periodically forced to flee when opposing warlords threatened them. Indeed, only one shogun of the sixteenth century died in the capital, the thirteenth shogun, Yoshiteru (1535–65), who was forced to commit suicide in his palace as it went up in flames after an attack by rebellious warriors. The provinces around Kyoto came under the control of new military leaders, such as the Miyoshi family of Yamashiro, and their rebellious vassal Matsunaga Hisahide (1510–77), who was responsible in some degree for Yoshiteru's death and famed as a treacherous and violent *gekokujō* exemplar. Interestingly, members of the Miyoshi family and Hisahide were enthusiastic *chanoyu* practitioners, and both hosted and came as guests to tea gatherings with merchants in the entrepot city of Sakai, where Chinese imports occasionally included rare *karamono* ("Chinese treasures"), such as Sung tea bowls and other antique implements (e.g., fig. 7).

During this period, a number of ambitious warlords were competing for land and power in the outlying provinces, and some aspired to control whole regions. The most contentious struggle for power occurred in the provinces east of Kyoto, where four formidable families were opposed, the Uesugi of Echigo, the Takeda of Kai, the Imagawa of Suruga, and the Hōjō of Kantō. Among the smaller factions that played a peripheral role in these struggles were the Oda family of Owari, and the Matsudaira (Tokugawa) clan.

The Oda family had served as Shiba daimyo vassals and minor officials in Owari since the fifteenth century. After the decline of the Shiba, Oda Nobuhide (1510–51) had assumed control of one region of Owari. He gradually consolidated and enlarged his domain. About 1535 he made a substantial contribution to a fund to repair the imperial palace, evidence of his growing wealth and influence, and by the time of his death, he had become a prominent figure in Owari. His son Nobunaga (1534–82; cat. no. 1, fig. 8) was less than twenty when he fell heir to his father's estates. After considerable effort, he was able to assemble a modest force of fighting men, mainly mercenary warriors and untried foot-soldiers, and he was victorious in leading this small force against Kiyosu Castle, where he deposed a rival branch of his own family. After defeating a rebellious group of his father's former retainers in 1559, Nobunaga controlled all of Owari. He was a fearless warrior and daring tactician. In 1560, he learned that the Imagawa army, which may have numbered as many as 40,000 men, was moving into Owari on the way to Kyoto. Although the odds were overwhelmingly against him, he launched a surprise attack with 2,000 men against the Imagawa at Okehazama, routing the enemy troops and driving them in a panic through flooded rice fields, where many were slaughtered. Nobunaga himself led an attack on the enemy command post, and one of his captains took the head of the Imagawa general, Yoshimoto.

From his base in Owari, which was strategically situated between the eastern provinces and Kyoto, Nobunaga managed to extend his power by bold military tactics and politically beneficial alliances. Thus, he married his sister Oichi to Asai Nagamasa (see cat. no. 2), a warlord in Ōmi, just east of the capital; his adopted daughter to the son of Takeda Shingen (see cat. no. 3); and his daughter to the son of Tokugawa Ieyasu of Mikawa Province, with

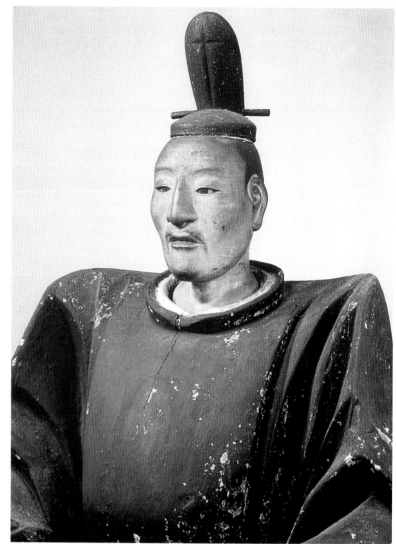

Fig. 8. Portrait of Oda Nobunaga, early seventeenth century. Amidaji, Kyoto.

whom he made a pact in 1561. With his eastern flank secure, Nobunaga prepared to extend his authority to the west. In 1567, he moved against the Saitō stronghold in Mino, Inabayama Castle. He studied the terrain and knew that the construction of a temporary stronghold at Sunomata opposite Inabayama would provide a commanding position for overthrowing the castle, and his troops were able to storm and take it without great difficulty. Here victory was achieved through the foresight and industry of one of Nobunaga's junior officers, Kinoshita Tōkichirō, known as Hideyoshi.

After taking Inabayama Castle in 1567, Nobunaga set up residence there, renaming the castle town Gifu. Nobunaga's growing power had come to the attention of Emperor Ōgimachi (r. 1557–86). Motivated by the hope that Nobunaga would help in the restoration of confiscated imperial estates, Ōgimachi sent him a confidential letter, commending him on his extraordinary military prowess. The emperor was, of course, aware that Nobunaga's father had come to the aid of the needy court during a previous reign. From his refuge in Echizen Yoshiaki, younger brother of Yoshiteru, the thirteenth shogun, also communicated with Nobunaga, requesting his support in restoring the Ashikaga *bakufu*. These two requests

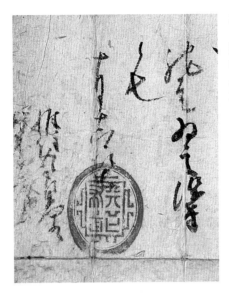

Fig. 9. Seal of Oda Nobunaga, *Tenka fubu* ("Rule the Empire by Force"), c. 1567 on. Courtesy of Shiga Prefectural Azuchi Castle Archaeological Museum.

provided the legitimacy and sanction for Nobunaga's future actions. His motive was evident in a seal he began to use on official documents that year, which bears the inscription *Tenka fubu*, "Rule the Empire by Force" (fig. 9).

It was now apparent that Nobunaga's intention was to bring the whole country under his control, and after several successful campaigns against the local warlords, the road to Kyoto was clear. On 9 November 1568, Nobunaga, accompanied by Yoshiaki, entered the capital at the head of his triumphant army, and on 28 December Yoshiaki became the fifteenth shogun. Although the residents of Kyoto and the court were apprehensive about the arrival of yet another potentially destructive army, Nobunaga maintained strict discipline among his troops, and he ordered that the safety of the citizens be insured. Moreover, his own position, though advantageous, was still tenuous, and his first concern was to improve his military strength. To demonstrate his gratitude to Nobunaga, the newly installed Yoshiaki staged a magnificent program of Noh, but the irritable Nobunaga left after viewing only five of the fifteen offerings, complaining that the time was not appropriate for protracted diversions, and he returned to his castle at Gifu.

In the following years Nobunaga fought a series of opponents in order to protect his holdings and extend his power and authority. In addition to truculent daimyo warlords who periodically threatened him, he was also opposed by militant religious factions who formed alliances with his enemies. In 1571, he launched a surprise attack on the great Tendai monastery of Enryakuji, on Mount Hiei northeast of Kyoto. Caught unprepared, the warrior-monks were easily subdued, and all the great buildings were set to the torch and their precious contents lost. Nobunaga's soldiers butchered all who could not flee, irrespective of rank, sex, or age. Perhaps no event in Nobunaga's career reveals more clearly his ruthless determination to crush any obstacle in his way, either religious or secular. A much more formidable opponent was the Ikkō ("Single-minded") branch of the Pure Land sect of Buddhism, which had an impressive history of intimidating civil authority. They had powerful enclaves in various localities, particularly in Kaga, Echizen, and Noto provinces in the north, and a seemingly impregnable defensive bastion in their headquarters, the Ishiyama Honganji in Osaka. Nobunaga's troops fought the Ikkō adherents

at several places, and his soldiers were frequently forced to retreat by the militant parishioners. In 1574, Nobunaga sent a large army against an Ikkō league stronghold at Nagashima. He met with fierce resistance, but after a long siege many of the defenders, close to death from hunger, offered to surrender. The vengeful Nobunaga would spare none, however, and he set the stronghold ablaze and some 20,000 defenders died. Opposition also came from the merchant-citizens of the city of Sakai, who had also intrigued with Nobunaga's enemies and refused to accede to his demands for contributions to his war chest. The apprehensive inhabitants moved their goods to neighboring towns and prepared to defend their city. But they avoided warfare by submitting to Nobunaga.

The Sakai merchant and tea master Imai Sōkyū (1520–93) went to conciliate Nobunaga. Like Matsunaga Hisahide who also had connections with Sakai, and was forced to present Nobunaga with his famed tea caddy *Tsukumogami* when he submitted in 1568, Sōkyū presented Nobunaga with two famous tea implements, the water jar known as *Matsushima*, and the *nasu* caddy *Jōō*, two events that reflect Nobunaga's inordinate interest in rare tea ceremony pieces, and reveal the motivation that drove him to become a compulsive collector of *meibutsu* (famous art objects), particularly prestigious tea implements, in the following years.

Having been instrumental in installing Yoshiaki as shogun, Nobunaga was willing to show outward signs of respect for the office as long as Yoshiaki confined his activities to traditional ceremonial observances, but he would tolerate no attempts at political intrigue. Yoshiaki, however, could not keep clear of politics and conspired with Nobunaga's foes, and this insubordinate behavior infuriated Nobunaga, who deposed him in 1573. Nobunaga labored diligently to consolidate his extended power, for he had by no means subdued all his enemies. Several daimyo warlords, each with military strength at least as great as his own, were prepared to move against him if their territories were threatened or he showed any sign of weakness. He was fortunate in that two of his most formidable opponents died in their prime, Takeda Shingen of Kai, aged fifty-three, in 1573, and Uesugi Kenshin of Echigo, at forty-nine, in 1578. Early in 1575 Nobunaga organized his forces for a campaign against the powerful Ikkō settlements in Echizen. But Takeda Katsuyori, Shingen's son, had meanwhile moved to attack Nobunaga's ally, Tokugawa Ieyasu, and Nobunaga had to move east to aid him. The ensuing conflict fought at Nagashino in Mikawa, marks the advent of a new chapter in Japanese warfare (see cat. no. 21).

After their introduction by Portuguese merchants in 1543, native artisans soon began to produce muskets, and they were used in the battles fought at Kawanakajima in 1555 and 1564 between the Uesugi and Takeda armies. But the weapon was not put to effective use in warfare until Nagashino, where Nobunaga used a force of 3,000 foot soldiers with muskets to annihilate Katsuyori's forces. Members of the Ikkō sect recognized the potential value of muskets early on, and they set up workshops to manufacture their own in enclaves at Saiga, Negoro, and at their great bastion and arsenal, the Ishiyama Honganji, in Osaka. Merchants in the commercial city of Sakai, aware of the growing demand, established their own factories and profited from a brisk trade in firearms, ammunition and gunpowder as well as other military necessities

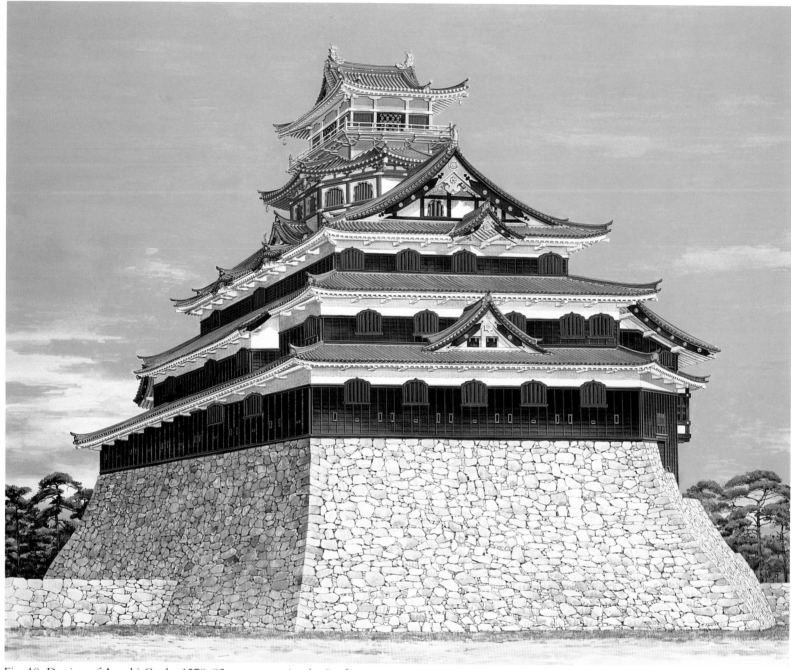

Fig. 10. Donjon of Azuchi Castle, 1579–82, reconstruction by Professor
Naitō Akira. Shiga Prefectural Azuchi Castle Archaeological Museum.

such as armor and iron helmets.

The defeat of the Takeda at Nagashino greatly improved Nobunaga's strength and authority, and in the following year he felt secure enough to begin work on a great castle on the shore of Lake Biwa. Strategic concerns were foremost in Nobunaga's mind when he decided on this location, which lies in Ōmi Province just over twenty miles northeast of Kyoto, along the main road that connects the capital with the regions to the east and north. Moreover, the traditional water route for transporting goods on Lake Biwa, Japan's largest body of fresh water, was along the south shore, close by, and this also made the site advantageous. The area was, therefore, convenient for controlling the movement of men

and merchandise. The surrounding terrain, with water to the north and broad expanses of rice fields, made it well suited for defensive purposes. The immediate site chosen by Nobunaga for his extraordinary architectural undertaking was a precipitous promontory known as *Azuchiyama* (Azuchi Hill) that rose about 350 feet above the flat surrounding rice fields, and projected out to the north, to the edge of the shoreline.

The colossal engineering feat of constructing the massive stone walls, battlements, and foundations was begun in the first month of 1576. Laid out on a grand scale, the sprawling castle complex, which extended along the summit and down the slopes of the hill, consisted of six stone wall enclosures, which protected

the donjon (central tower), the palatial residential buildings constructed for Nobunaga's relatives and vassals, with their gardens, and assorted warehouses and arsenals. These, in turn, were protected by a series of massive stone fortifications and moats designed to ensure the security of the castle against the most determined foe. The enormous donjon, the first of its sort in Japan, set a new standard for size and splendor (fig. 10). Shaped like a truncated pyramid, this mighty building was erected above high walls, and had seven levels – a subterranean chamber and six above-ground stories. The lower four stories, roughly square in floor plan, had a massive wooden superstructure, while the fifth was octagonal in shape, and the topmost square, with a continuous balcony. The top chamber served as an observation post, and commanded an inspiring, panoramic view of the entire surrounding countryside. Seen from below, the giant tower was a dazzling mass of dramatic color: black timbers and white stucco on the lower stories, crimson lacquer on the octagonal level, and resplendent gold leaf covering the highest level. The bold roofs, accented with gabled forms embellished in gold, were protected from the weather and enemy attack by heavy gray tiles. Construction on all the buildings seems to have been completed about four years later, at the end of 1579, when Nobunaga took up residence in the donjon. But the splendid interior furnishings were not finished until the ninth month of 1581. Specialists from fourteen provinces are said to have been employed.

Azuchi Castle was designed to perform two functions, one pragmatic, the other symbolic and authoritative. It was intended not only as a formidable defensive bastion, but also as an awesome display of the wealth, prestige, and commanding status of Japan's most powerful warlord. The soaring donjon was the most prominent landmark in the region, visible from all sides and from considerable distance, especially the fabulous gold chamber at its summit which glowed luminously in the sun's rays. Nobunaga encouraged merchants and artisans to settle in the town he had constructed at the foot of the castle, and trade and commerce flourished there, free from traditional restrictions and controls. This "castle town" served as a model for similar communities that grew up around later castles of the Momoyama period.

Both native chroniclers, such as Ōta Gyūichi (1527–1610+), author of the *Shinchō kōki* (1610), and Europeans, such as the Jesuit priests who traveled to Azuchi, wrote admiringly of the great castle compound, its edifices, and their interiors. The Portuguese Jesuit historian Luis Frois (1532–97) noted: "On top of the hill in the middle of the city Nobunaga built his palace and castle, which as regards architecture, strength, wealth and grandeur may well be compared with the greatest buildings in Europe."[2] Given the celebrated nature of the castle and its remarkable appearance, it is surprising that no pictorial representation of it has been preserved. We know that Kanō Eitoku produced a pair of screens with depictions of the castle. Oda Nobunaga gave these paintings to the Jesuit priest Allesandro Valignano, who in turn sent them as a present to Pope Gregory XIII with a Japanese delegation that departed in 1582. The paintings are known to have reached Rome, for a Flemish artist, Philips van Winghe, studied them there sometime between 1585 and 1592, but it is thought that the screens are no longer extant. Two small and inept illustrations inspired by van Winghe's studies were published in the sixteenth century, but these

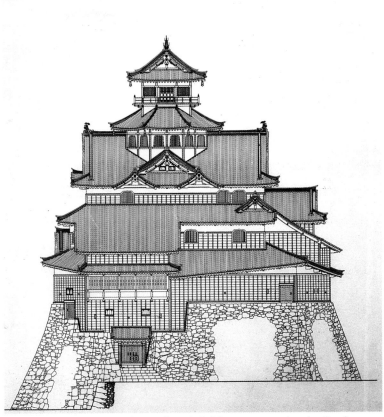

Fig. 11. Donjon of Azuchi Castle, 1579-82, reconstruction by Professor Naitō Akira. Shiga Prefectural Azuchi Castle Archaeological Museum.

are of little help in reconstructing more than a few particulars. An extensive account of the rooms of the donjon and the subjects of the screens created there by Eitoku and his team appears in Ōta Gyūichi's *Shinchō kōki*, but this information is only of secondary value for the purposes of recreating the structure. As a consequence, architects have proposed a variety of shapes and details for the donjon, based on the location of pillar foundation stones and comparative studies of later towers. Although some controversy still exists, the careful reconstruction proposed by Professor Naitō Akira in 1976, which is based on his study of builders' plans, is convincing in its reasoning (figs 10 and 11).[3] His calculations indicate a massive structure, 138 feet in height, which rises from the walls surrounding the foundation. The interior incorporated a novel feature, a central shaft that extended up to the fifth story, almost 62 feet from ground level. A stage for Noh and other dramatic performances extended out into the shaft from the third level, and a bridge was built across on the fourth level. Nobunaga's enthusiasm for Noh is well documented, and the projecting stage would have provided spectators with a variety of vantage points for viewing the performances. Among the profusion of elegant rooms, was an intimate seven-mat tea ceremony chamber, evidence of Nobunaga's second passion, *chanoyu*, where he proudly utilized and displayed his *meibutsu* objects to select groups of visitors.

Archaeologists have worked at the site of Azuchi Castle over the decades, and careful, scientific excavations by the Shiga

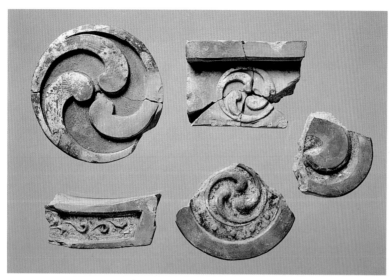

Fig. 12. Roof-end tiles from Azuchi Castle, c. 1577–9. Shiga Prefectural Azuchi Castle Research Institute.

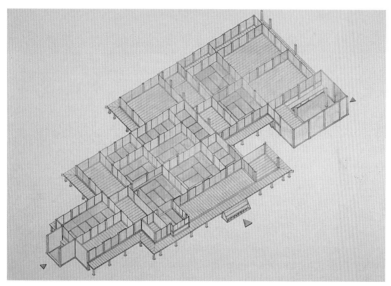

Fig. 13. Reconstruction of residential complex, Azuchi Castle. Shiga Prefectural Azuchi Castle Research Institute.

Fig. 14. Reconstruction of main gate of Azuchi Castle, 1578–82. Shiga Prefectural Azuchi Castle Research Institute.

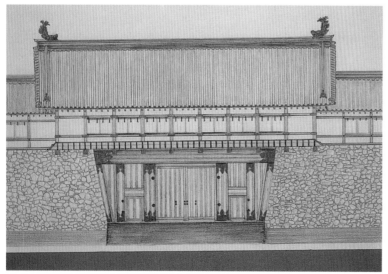

Prefectural Research Institute of Azuchi Castle in recent years have brought much to light. Among the physical remains of the great donjon are a substantial number of roof tiles. Among these are many roof-end decorative tiles with *tomoe* ("whorl") designs that are embellished with gold leaf (fig. 12), a feature that sets the precedent for employing this lavish adornment on similar tiles on subsequent castles, such as Hideyoshi's Jurakutei, Osaka, and Fushimi castles. Excavation at other Azuchi locations, such as the main gate to the castle complex, and residential complexes, such as the one traditionally thought to have been used by Hideyoshi, have produced reliable information that helps to reconstruct these structures (figs 13 and 14). Investigations on the slope above the gate have unearthed a grand ceremonial stairway (fig. 15). This feature is unique, and unlike the approaches to other castles, which have turns and cutbacks to discourage attackers, is thought to have been constructed in anticipation of a visit by the emperor and his entourage, where the direct ascent would provide a proper setting for a stately procession. Documentary sources mention a palatial structure, resplendently decorated in gold, which is presumed to have been built to accommodate an imperial visit, one perhaps inspired by the precedent of Emperor Go-Komatsu's state visit to shogun Yoshimitsu's Kitayama villa, with its Golden Pavilion, in 1408.

Nobunaga had provided substantial support for the Emperor Ōgimachi, including rebuilding his palace compound, and it is likely that his intention in having the sovereign and his entourage travel from Kyoto to Azuchi was that the visit would serve as a symbolic demonstration of his own undisputed authority to rule. But Nobunaga was dead before this grandiose plan could be realized.

The top two stories of the Azuchi donjon combine two traditional architectural forms, the octagonal shape occasionally used in Buddhist devotional halls, and the intimate, airy chamber on the top, which traditionally (as at the Kinkaku) commands an inspiring view of a landscape or garden complex with a lake. The use of rich red lacquer on the sixth level is consistent with traditional Buddhist practice, where vermilion is commonly used on temple edifices. The ostentatious use of gold on both the inside and the exterior of the topmost chamber can only have been inspired by the comparable treatment of the third story of Yoshimitsu's celebrated Kinkaku in Kyoto. Nobunaga may well have regarded Yoshimitsu as a paragon worthy of emulation, a man whose power, high status, and aesthetic sophistication had guaranteed him a revered place in Japanese history. Yet Nobunaga's aspirations were even grander than Yoshimitsu's, and while the view from the top story of the Kinkaku out over the spacious lake and elegant garden was superb, Nobunaga's panoramic view from his vantage point was much grander, for he had the blue expanse of Lake Biwa before him and the natural scenery of two mountains, Hira and Hiei, in the misty distance. Nobunaga's golden chamber served as a metaphorical beacon, a potent display of his commanding authority. On at least one occasion, however, it appeared in a more romantic, fanciful light. This memorable circumstance was admired by Luis Frois, the insightful Jesuit observer, who noted how Nobunaga illuminated the castle during the annual Bon Festival by having many colored lanterns and candles set out on the balconies of the top story: ". . . it was truly a wonderful sight to see such a multitude of

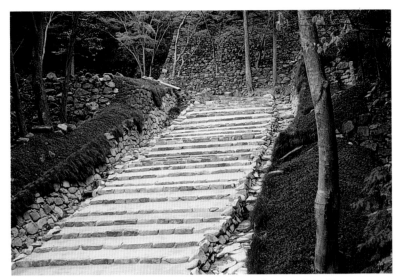

Fig. 15. Excavated grand stairway of Azuchi Castle, ca 1578–82. Shiga Prefectural Azuchi Castle Research Institute.

lanterns burning so high up."[4]

Nobunaga commissioned the leading painter of the day, Kanō Eitoku (see cat. nos 44–6) to outfit the elaborate castle chambers with paintings that reflected the lord's authority and filled his visitors with awe.[5] Eitoku and his atelier worked with the greatest industry to complete this challenging task, and the extensive list of subject titles for the compositions preserved in documentary sources gives us some idea of the daunting scale of the project. The largest chambers were of great size, and it is said that single, continuous screen compositions may have extended over as many as twenty-four *fusuma* (sliding screen) panels, each perhaps as large as six by four feet in dimension. Such a project thus entailed covering a prodigious amount of surface space, and Eitoku had to put aside the time-consuming practices of the past and develop a new, labor-intensive production-line method of painting that involved a team of specialized painters who brought the screens to completion after Eitoku had created the basic composition and essential details, and subsequently supervised their efforts. This collaborative system was successfully utilized in subsequent years at Hideyoshi's vast castle at Osaka and his splendid castle-residence and pleasure dome in Kyoto, the Jurakutei.

Among the quantities of screens that Eitoku and his painters executed at Azuchi a few examples were done in the ink monochrome style that had been popular in an earlier age, but the neoteric taste for rich decorative displays of polychrome that became the hallmark of Momoyama painting was already apparent and predominated here. The prospect of producing so many paintings seems to have encouraged interest in innovative subject matter, such as depictions of Chinese mythological and anecdotal themes of the sort that subsequently became part of the established inventory of the Kanō school.

On 20 June 1582, Nobunaga hosted a great tea gathering in the Honnōji, a fortified monastery-residence in Kyoto. He had brought a selection of his *meibutsu* tea objects from Azuchi to show an assembly of discerning nobles and warriors. But before daybreak on the following day, his vassal Akechi Mitsuhide (1526–82) had surrounded the Honnōji and launched a treacherous attack against him. Nobunaga and his attendants were caught by surprise and fought desperately, but when it appeared all was lost Nobunaga committed suicide rather than fall victim to his enemy. In the ensuing conflagration, Nobunaga's body was destroyed, together with his treasured tea ceremony objects. He was forty-eight. Later in the day Akechi led his troops to Azuchi, where he remained several days, distributing gifts from Nobunaga's treasures. Akechi appears to have left the great castle undamaged, but a week or so later it went up in a fiery holocaust, probably as a result of the frenzied actions of looters. Although a few of the outlying buildings may have survived, the monumental donjon and palatial residences were completely destroyed. On 30 June Akechi's troops were attacked at Yamazaki, southwest of the capital by an army led by Hideyoshi. They were completely routed and Akechi fled north, where he was soon ignominiously cut down by a band of peasants. His head was taken to the charred ruins of the Honnōji and put on public display.

Nobunaga's death at the Honnōji brought an end to a remarkable career. Within the space of two decades, Nobunaga had gained control of twenty-nine of Japan's sixty-six provinces, a third of the realm in area, and this included the most important region, Kyoto and the neighboring provinces. But he had ruthlessly and methodically eliminated his enemies, and his cold, autocratic behavior and ferocity were such that few seem to have lamented his death. Indeed, the prevailing antipathy for Nobunaga prompted some to defend Mitsuhide's actions and suggest that they were justified. The popular perception of Nobunaga's brutal character continued into later times, and in the dramatic *Jōruri* puppet plays of the eighteenth century Mitsuhide is a sympathetic character who bravely justifies the necessity for bringing an end to the miscreant's life. Nevertheless, Nobunaga was the first warrior of the period to recognize that aggressive conquest and the extension of authority could lead to national unification. Although it is easy enough to see Nobunaga simply as a cold-blooded opportunist, it should also be recognized that his behavior was not unusual for the period. Violence was commonplace, and patricide, callous marriage alliances, the treacherous murder of allies, and the relentless suppression of religious groups are all aspects of the period. Premature death in violent conflict was common for warriors. Nobunaga himself witnessed the deaths of seven of his ten brothers in battle.

Akechi Mitsuhide was only one of a dozen of Nobunaga's allies and vassals, and the attack on the Honnōji and death of Nobunaga caught the others off-guard. Concerned for their own safety, most vacillated and gathered their forces in preparation for a realignment of power. Hideyoshi (known as Hashiba Hideyoshi at this time) was away campaigning against the powerful daimyo Mōri Terumoto (1553–1625) in Bitchū Province, but he intercepted an emissary sent by Akechi to Mōri, asking for his support, on the day after Nobunaga's death. He promptly concluded an advantageous truce and set out on a forced march to Kyoto. Joined by friendly forces along the way, he arrived at Yamazaki nine days later, where he routed Mitsuhide's army in a battle of only two hours duration.

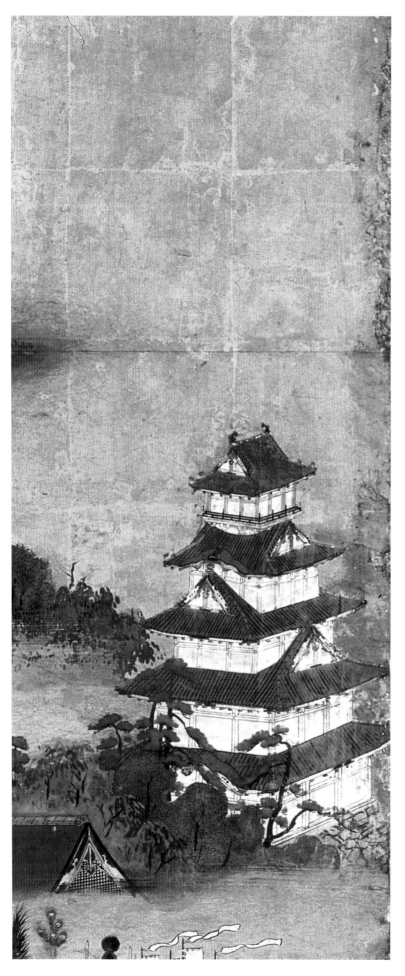

Less than a month after Nobunaga's death, a conference was held at Kiyosu Castle, where the deceased warlord's vassals met to discuss the crucial matter of who should succeed Nobunaga and how the domains should be divided. Hideyoshi was forced to relinquish his lands in Ōmi to his rival Shibata Katsuie, but in compensation received the three adjoining provinces of Yamashiro (which surrounds Kyoto), Kawachi, and Tamba, giving him an important strategic base. After Hideyoshi returned from Kiyosu, he began work on a castle at Yamazaki, a short distance south of Kyoto, and assigned his deputies to administrative positions in the capital. Hideyoshi's chief contenders for power in the region were Nobukata (Nobunaga's son) and Shibata Katsuie. Nobukata, seeking support, wed his aunt, Oichi, to Katsuie (see cat. no. 2). Relations between Hideyoshi and Shibata worsened, and when Hideyoshi learned that Shibata had attacked his troops in Ōmi, he launched a campaign against him. He caught Shibata's army unprepared at Shizugatake and entirely routed it. Pursued to Kitanoshō Castle in Echizen, and, with his bastion about to be overwhelmed, Shibata committed suicide together with his vassals and his family.

In the following years, Hideyoshi extended his authority through combat, alliance, and enfeoffment. He conquered Shikoku in 1585, and fought in Etchū and Kii, where he destroyed the last stronghold of the militant Ikkō parishioners at Negoro. In 1586 he set out on an ambitious expedition to pacify Kyushu. Because of its remoteness from Kyoto, Kyushu had remained more or less autonomous and peripheral, but it was the center of maritime intercourse with the outside world. Ports in Kyushu – at Hakata, Nagasaki, and Hirado – were entrepôts for foreign trade, not only for the products of other Asian countries, but also for the great black Portuguese carracks that arrived with luxury goods from Europe and monopolized the silk trade with China.

Hideyoshi's great military campaign against the daimyo of Kyushu was by far the largest he had undertaken, and he may have had as many as 250,000 men in his coalition of armies. By the fifth month of 1587 he and his generals had finally gained control of the whole island after subjugating its strongest military faction, the Shimazu clan. With Kyushu now under his authority, Hideyoshi began to think of other conquests, and he seems already to have considered an invasion of Korea, an ill-fated and tragic campaign he embarked upon in 1592.

During the 1580s, the imperial court, cognizant of Hideyoshi's increased power and anxious for his continued support and generosity, had bestowed a sequence of prestigious ranks on him, culminating in his designation as Kampaku (Regent) in 1585 by the newly enthroned Emperor Go-Yōzei, who joined him in watching a celebratory performance of Noh at the palace in Hideyoshi's honor. Hideyoshi was the first military leader to receive this high civil title. Some months later Hideyoshi took the surname Toyotomi (composed of two characters which read propitiously "bountiful minister"), intended as an expression of filial indebtedness to the throne. One consequence of Hideyoshi's elevation to Kampaku was that his wife and mother were given the courtly titles Kita no Mandokoro and Ōmandokoro (see cat. no. 8).

Fig. 16. Donjon of Osaka Castle. Detail from *The Summer Siege at Osaka Castle*, cat. no. 22.

After Nobunaga's bloodthirsty campaigns against the militant Ikkō sectarians in the 1570s he had turned, finally, in 1580, to assault their heavily fortified headquarters, the Ishiyama Honganji, in Osaka. This mighty bastion had resisted attacks for a decade, but Nobunaga's seven-month long blockade was effective in cutting off supplies and supporters, and the abbot finally agreed to a negotiated peace. Nobunaga was conciliatory in his terms, but he achieved his objective, and the Ikkō forces gave up their bastion and left Osaka.

Three years later Hideyoshi began construction on a huge castle at this site, which commanded the strategic approaches to Kyoto from the west, and was convenient to river traffic as well as maritime connections with other regions of Japan through ports such as Sakai. This enormous undertaking was carried out with huge armies of laborers and the finest artists and artisans available. Its monumental scale, with its multiple moats, prodigious stone defensive embankments, elaborate residential facilities, and castle compound with its huge donjon was unprecedented in its time (fig. 16). When it was completed in 1590 it was the greatest and strongest castle in Japan. Hideyoshi and his family took up residence in the castle as soon as adequate quarters could be erected for them, and Osaka Castle remained the chief bastion of the Toyotomi family until its fall in 1615 (see cat. no. 22).

In 1586, in the midst of the construction, a delegation of Jesuit priests was welcomed to the castle and Hideyoshi personally guided them through the donjon. The account, by Luis Frois, relates:

> He acted as a guide just as if he were a private individual, opening doors and windows with his own hands. And so in this way he led us up to the seventh storey, describing on the way all the riches that were on each floor. Thus he would say, "This room which you see here is full of gold, this one of silver; this other compartment is full of bales of silk and damask, that one with robes, while these rooms contain mostly *katana* (swords) and weapons." In one of the chambers through which we passed, there were ten or twelve new cloaks, dyed a scarlet hue and hanging on silken cords – a most unusual sight in Japan. He showed us so many different things and so many large chests that we were astonished to see it all. And although it is not customary to sleep either in beds or on couches in Japan, we saw two furnished beds decorated with gold and all the rich trappings which are to be found on luxurious beds in Europe. . . . Now there is a balcony running around the top story and he desired us to go out to it in order to see the whole castle as well as the view of the four or five kingdoms situated in the flat country round about. He stood standing with us on the balcony for quite some time. Below us were toiling some five or six thousand men, and when they raised their eyes and saw high above them so many priests and catechists with Hideyoshi in their midst, they were greatly astonished. He told us that he had brought people from thirty kingdoms to work in these constructions and in those at Miyako (Kyoto), and he pointed out with his finger the people working on the defences and the exceedingly large warehouses, full of provisions for the use of the castle.[6]

Although Osaka Castle cannot be compared with one of the great Christian cathedrals of the Middle Ages as an architectural monument, it probably rivaled any European edifice in the sheer size, the labors required to transport and assemble its amazing amounts

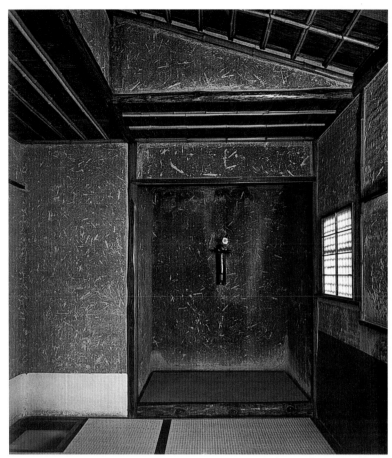

Fig. 17. Interior of Taian tea chamber, design traditionally attributed to Sen no Rikyū, 1580s, Myōkian, Yamazaki.

of lumber and stone, and the speed with which it was erected. Another Western visitor, the Englishman John Saris (1579–1643), who visited Osaka in 1613, observed:

> We found Osaka to be a very great Towne, as great as London within the walls, with many faire Timber bridges of great height, serving to passe over a river there as wide as the Thames in London. Some faire houses we found there, but not many. It is one of the chiefe Sea-ports of all Japan; having a castle in it, marvelous large and strong, with very deep trenches about it, and many draw bridges, with gates plated with yron. The castle is built all of Free-stone, with Bulwarks and Battlements, with loope holes for smal shot and arrowes, and divers passages for to cast stones upon the assaylants. The walls are at the least six or seven yards thicke, all (as I said) of Free-stone, without any filling in the inward part with trumpery, as they reported unto me. The stones are great, of an excellent quarry, and are cut so exactly to fit the place where they are laid, that no mortar is used, but only earth cast between to fill up voyde crevises if any be.[7]

In emulation of Azuchi, the apartments and residential palaces of Osaka Castle were sumptuously decorated with screen paintings by Kanō Eitoku and his team. The grounds had beautiful gardens, and a Yamazato ("Mountain Village") compound with natural features, exotic flora, and facilities for tea ceremony gatherings, including a rustic hut-like room, built in accordance with Sen no Rikyū's *wabi* aesthetic ideals (see cat. no. 5 and p. 205). Rikyū had apparently only served Nobunaga in a minor capacity, but he became

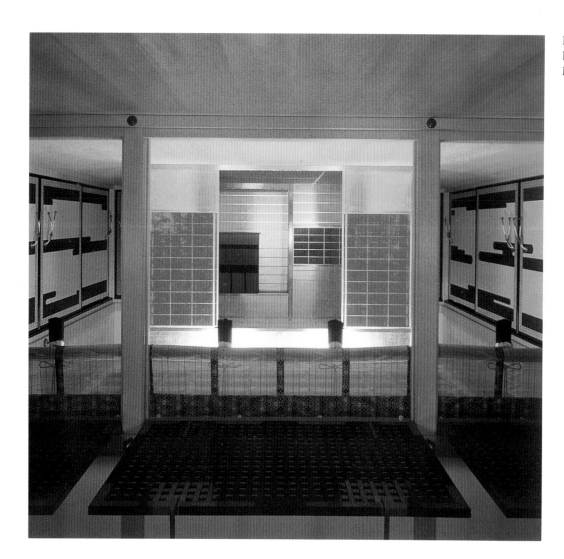

Hideyoshi's most influential advisor in matters of tea decorum, procedure and connoisseurship. The Taian, a two-mat *chashitsu* (tea-ceremony room) attributed to Rikyū (fig. 17) is preserved in the Myōkian, a temple in Yamazaki. The *chashitsu* in Hideyoshi's Yamazato compound was probably similar in its layout and appearance. The Taian was erected in 1582, and is traditionally thought to have been the site where Rikyū hosted Hideyoshi in a *wabicha* ceremony in which the tea room and all the implements utilized expressed Rikyū's ideas of spareness, understatement, rusticity, and humility. The Yamazato tea house (which was designed to be portable) was utilized by Hideyoshi as an intimate location where guests could be secluded, interrogated, entertained, and Hideyoshi's interests furthered. Hideyoshi's guests in this diminutive, austere tea room included Kamiya Sōtan, Ijūin Tadamune (emissary of the defeated Kyushu daimyo Shimazu Yoshihisa), and Oda Nobukatsu (Nobunaga's son), who came to Osaka in 1585 in order to establish amicable relations after his forces had suffered a defeat at the hands of Hideyoshi's army.

A contrasting aspect of Hideyoshi's taste may be seen in another *chashitsu,* usually kept in Osaka Castle, but which was portable and accompanied Hideyoshi on his travels. This amazing miniature edifice, only three mats in area, was constructed by a goldsmith from Sakai, and was known as *kigane no zashiki* ("golden chamber"), for it was completely embellished in gold and dazzled

all who saw it. In addition to the unrelieved gold that covered all its interior and exterior surfaces, the *shōji* (sliding screens) were covered with red gossamer, and the tatami mats were covered with woolen fabric dyed scarlet, and had edging of gold brocade. Further, all the tea ceremony objects and utensils, with the exception of the bamboo tea whisk, were fashioned of gold. This extraordinary chamber and its contents moved with Hideyoshi. He took it to Kyoto in 1586 for the grand performance of Noh and tea held at the imperial palace for the emperor, and displayed it ostentatiously at the grand Kitano tea gathering in the following year. In 1588, it was installed in the Jurakutei when the emperor and his entourage were entertained there, and in 1592 it was transported to Nagoya Castle in Kyushu, where Hideyoshi had set up his headquarters for the invasion of Korea. There can be little doubt that Hideyoshi's pleasure in this miniature golden chamber was inspired by the golden chambers at Azuchi and Yoshimitsu's Kinkaku. But Hideyoshi went one better. Unlike his predecessors, he did not have to remain in one location to enjoy his tea room. Two modern reconstructions based on literary sources, have been completed in recent years, one in Osaka Castle Museum, and the other in the MOA Museum in Atami (fig. 18).

After the capitulation of the Shimazu in Kyushu, Hideyoshi returned to Chikuzen Province, where he set up his temporary headquarters at the Hakozaki Shrine. There he rested and devoted

himself to *chanoyu* with his tea masters for several weeks. On two occasions the rich merchant from Hakata, Kamiya Sōtan (1551–1635), was invited to partake of tea. Hideyoshi seems to have been particularly cordial towards Sōtan, and he is said to have personally welcomed him by opening the sliding entrance screen and guiding him to his place of honor in the tea room. Hideyoshi's behavior may well have been motivated not only by the ideals of tea ceremony decorum, but also by his grand plan for the future conquest of Korea, in which the logistical support of Hakata merchants would be of crucial importance. Hideyoshi was already familiar with Sōtan, who had been a guest at an opulent daimyo tea gathering held at Osaka Castle at the beginning of the year, where many of Hideyoshi's celebrated tea objects had been proudly displayed and several tea masters had prepared tea for important guests.

After the Kyushu campaign, Hideyoshi returned to Osaka, where he conceived a grandiose plan to hold a huge public tea extravaganza in the spacious grounds of the Kitano Shrine in Kyoto. Toward the end of summer in 1587, he had notices posted in Kyoto, Osaka, Nara, and the other neighboring cities proclaiming that he would host a tea gathering, starting on the first day of the tenth month. Representative segments of society, irrespective of status or rank, were invited to participate in this grand event, and the announcement noted that Hideyoshi himself would prepare and serve tea. The only implements participants needed to bring were a kettle, water container, tea bowl, and a portion of tea or *kogashi*, (an inferior category of tea made of burned rice or barley), together with two mats to sit upon. The proclamation noted further that all of Hideyoshi's tea treasures would be on view to visitors and for the benefit of those who would be coming from distant locations, the pieces would continue to be on exhibit for ten days. A final cautionary paragraph stated that the *kampaku* had made these arrangements for the benefit of *wabi* practitioners, and that those who failed to attend would subsequently be prohibited from preparing tea of any sort. The protocol and logistics of this great event must have kept Rikyū and the other organizers busy, and when it was decided in the ninth month to include members of the aristocracy in the proceedings, hundreds of special stalls had to be hastily constructed.

Lots were drawn on the day of the gathering, and the participants divided into four groups. Those fortunate enough to join the first group were privileged to drink tea at the *kampaku*'s location, while the others were assigned to other locations under the supervision of Sen no Rikyū, Tsuda Sōgyū, and Imai Sōkyū. Something of the scale of the event may be judged by the fact that more than eight hundred tea enthusiasts were served at these four locations alone. One can only imagine the colorful atmosphere that must have pervaded the grounds of the Kitano Shrine. Tea was served according to a diverse range of aesthetics and tastes. The throngs of visitors were also treated to performances of plays, music and dancing. The most compelling attractions, however, were Hideyoshi's rare *meibutsu* tea treasures, which were displayed in a special enclosure inside the shrine together with that singular possession that exemplified his persona and power, the glittering portable golden teahouse. Although scheduled to last ten days, the event did not continue beyond the first, despite good weather. Hideyoshi himself

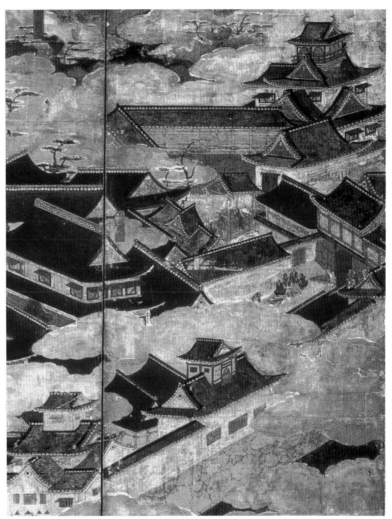

Fig. 19. Tower of Jurakutei. Detail from *The Jurakutei*, cat. no. 25, ca early 1590s. Six-panel folding screen. Mitsui Bunko, Tokyo.

must have been responsible for this abrupt curtailment, but the reasons are unclear. One suggestion is that the great man was simply exhausted by the long day's activities of supervising and serving tea to so many enthusiasts during the morning, and then walking about to visit many of the tea stalls, estimated at over fifteen hundred, that were set up here and there in the extensive shrine grounds. Other theories are that he was simply surfeited with the scale and human activity of the crowds and tired of communing with the common populace; or, alternately, that his fabled assemblage of tea treasures had not received the accolades he expected, and he was ill-humored by the end of the day. At any rate, it seems likely that his motivation in organizing the Kitano tea gathering had less to do with any egalitarian desire to interact with the general population and spread the gospel of tea to larger segments of society than with his compulsive inclination to demonstrate his power, position, and material riches in a dramatic manner.

Among his many grandiose activities and projects, the massive compound known as the Jurakutei ("Mansion of Assembled Pleasures") stands out as the most dramatic demonstration of Hideyoshi's extravagance and the quintessential spirit of opulence and grandeur that is characteristic of the Momoyama period (see cat. no. 25 and detail in fig. 19). This complex of fortifications and

buildings, which combined castle architecture with luxurious residential quarters, was begun early in 1586, and in the autumn of the following year, soon after his return from subjugating the Shimazu in Kyushu, Hideyoshi brought his family and entourage from Osaka Castle and they took up residence in the newly-completed compound. Huge crowds are said to have lined the streets to admire the regal procession, led by the Kampaku, his mother Ōmandokoro, and his wife Kita no Mandokoro (Onene), riding in their sumptuous palanquins, and followed by hundreds of guards and attendants, who supervised the transport of their possessions.

The Jurakutei was laid out in a huge area (said to have measured 700 square meters) in the Uchino neighborhood of Kyoto – occupying a portion of the plot of the Heian-period imperial compound. It consisted of water-filled moats and high stone wall fortifications, which surrounded the castle structures, and several lavish residential complexes, as well as gardens, facilities for tea gatherings, a stage for Noh and other traditional dance performances, and all the other buildings necessary to house guards, servants, and the storage of food and arms that were essential for the logistical operations of the compound. The interiors of the palatial residences must have been luxurious in the extreme, for the finest painters of the age, among them Kanō Eitoku, Kanō Sanraku, and the members of their atelier, are known to have worked there. Hideyoshi's vassals are said to have provided one hundred thousand workers and artisans for the construction and additional thousands of craftsmen and artists would have been necessary to create the furnishings and decorative adornments of the buildings. Construction materials were apparently brought from distant provinces; locally, Buddhist temples were prevailed upon for the decorative stones used in the gardens; and the Yoshida Shrine provided hundreds of pines that were carefully transplanted and set up among the buildings and belvederes.

A fundamental dynamic of the Momoyama period was the remarkable progress in organizational efficiency and logistical coordination that was necessary to supply large armies in the field. A similar evolution may be seen in the execution of public works and huge projects, particularly the construction of enormous castles and residential and religious buildings of unprecedented size, which were often erected with amazing speed. Perhaps no example is more instructive in this regard than the Jurakutei, which was pushed to completion in about a year and a half. Pressure from Hideyoshi to finish the project quickly must have been unrelenting, for the Jurakutei was intended to serve not only as the official residence and seat of government, but also as a dramatic, monumental symbol of his martial power, unrivaled material wealth, and autocratic domination of the capital.

Hideyoshi, following the time-honored precedents of many aspirants to political power before him, was well aware that the legitimacy of any pretender to rule was ultimately dependent on the symbolic sanction of the court and the awarding of high civil rank. Although he had been awarded a series of lower ranks earlier, his appointments as Kampaku (Regent) in 1585, and Daijō Daijin (Great Minister of State) early in 1587, were explicit court affirmations of his power and status. But he repeatedly sought more direct, personal relations with the court, and the esteem and recognition this intimacy with the throne would bring him. Late in

1585, following his appointment as Kampaku, Hideyoshi sponsored a performance of five Noh plays at the imperial palace and, assisted by Sen no Rikyū, he served tea to the Emperor Ōgimachi (1517–93). This was the first occasion on which an emperor had participated in a formal *chanoyu* ceremony. This unprecedented event, moreover, demonstrates Hideyoshi's enthusiastic advocacy of tea, as well as his feeling that it was an appropriate expression of gratitude for receiving the office of Kampaku. As a result of his role in this event, Rikyū's position was firmly established as the foremost practitioner of *chanoyu*. Hideyoshi visited the imperial palace once again early in 1586, where he proudly exhibited his portable gold teahouse to the emperor.

The most celebrated event staged by Hideyoshi involving the court took place in the spring of 1588. This was the sumptuous imperial procession and visit to the Jurakutei, an extravaganza of pomp and display, where the Emperor Go-Yōzei, the Retired Emperor Ōgimachi, and a large delegation from the court were hosted by Hideyoshi in a variety of lavish ceremonies and entertainments that lasted for five days. Although Hideyoshi may have been inspired by earlier precedents in staging such events, such as the Emperor Go-Komatsu's imperial procession and reception at the Ashikaga shogun Yoshimitsu's palatial Kitayama estate in the spring of 1408, where the festivities lasted twenty days, there was clearly no comparison in regard to scale and opulence.

Preparations for the regal outing started well in advance, when Hideyoshi assigned his comrade-in-arms Maeda Gen'i (1539–1602), who held an official post as administrator for Kyoto and the neighboring provinces, to investigate the precedents and protocol for entertaining royalty on such occasions. As a consequence, in accordance with court etiquette, on the morning of 9 May 1588, Hideyoshi went to the palace in person to conduct the imperial cortege to the Jurakutei. To guarantee security and proper decorum, six thousand soldiers were stationed along the route, which was about a mile in length. The colorful procession consisted of the imperial retinue, the emperor and ex-emperor, the empress and dowager, great court nobles and ladies and their attendants, escorted by a host of guards of honor and mounted warriors, with companies of men-at-arms. The emperor, riding in his ornate ox-drawn court vehicle, led a contingent of courtiers; and Hideyoshi followed, attended by his generals and their officers. Although the total number of participants is unclear, the length of the procession was such that when the first mounted escorts reached the entrance to the Jurakutei, the rear guard had not yet departed from the palace compound. After the emperor's welcome at the sumptuous gate reserved for great dignitaries, he was ceremoniously installed in his palatial quarters according to court ritual. Following this, a sumptuous banquet was held, with a recital of *kangen*, an ancient musical mode in which courtiers performed on strings and woodwinds, together with other entertainments.

More tangible demonstrations of the Kampaku's enthusiasm and support of the court occurred on the second day. During the fifteenth and early sixteenth centuries, the court's income had decreased markedly as a result of the widespread loss of its estates, and the influence and prestige of the imperial house had declined to an unprecedented low. Nobunaga had restored it to respectability by aiding it financially, allocating incoming producing properties

to it, and rebuilding Emperor Ōgimachi's palace compound. Hideyoshi was notably more generous toward the court, however, and on the second day of the imperial visit to the Jurakutei he magnanimously directed that the annual taxes on rented properties in the city of Kyoto, a yearly sum of 5,530 *ryō* in silver, be assigned to the court. In addition, other gifts were given to his guests, among them several extensive properties that provided substantial annual incomes to the recipients: 300 *koku* to the emperor; 600 *koku* to the emperor's courtiers; and rich ricelands in Ōmi Province that provided 8,000 *koku* in annual income for the emperor and other noble families. Another demonstration of Hideyoshi's support for the court and its future stability took place during the afternoon, a carefully orchestrated ceremony in which the Kampaku's most powerful warrior-vassals swore an oath to protect the estates of the emperor and noble families.

The following day, the sixteenth, was devoted to more elegant pursuits, and the participants, led by the Kampaku himself, turned to the composition of *waka*, the traditional aristocratic form of poetry that had flourished in court circles for many centuries. Go-Yōzei and the Retired Emperor Ōgimachi both contributed to the competition, as did many of Hideyoshi's great vassals. The dramatic highlight of the seventeenth day was a program of Bugaku, an ancient form of court music and dance; and on the eighteenth, Go-Yōzei and his splendid entourage were escorted back to the palace. Clearly the most significant ceremonial occasion in Hideyoshi's career, the grand extravaganza seems to have been an unqualified success, and the memorable events and charismatic presence and interaction of so many high court dignitaries and powerful warriors in the festivities have guaranteed its place in history and legend.

Hideyoshi's period of residence in the Jurakutei was short — only about four years. Hideyoshi's first son Tsurumatsu (also known as Sutemaru) was born in 1589, but he died in the eighth month of 1591, leaving Hideyoshi without an heir (fig. 20). Four months later Hideyoshi, apparently with some reluctance, chose his twenty-three-year-old nephew and adopted son Hidetsugu (1568–95) as his successor. Hidetsugu was appointed Kampaku in February 1592, while Hideyoshi took the title of Taikō, which was reserved for the father of the Kampaku. Hidetsugu and his retinue were installed in the Jurakutei, and at the beginning of the following year the new Kampaku welcomed the emperor there, an event intended to replicate the unforgettable imperial procession and its colorful events staged by Hideyoshi almost four years before. With the passing months, however, doubts seem to have grown in Hideyoshi's mind as to the choice of his successor, and Hidetsugu's position became more tenuous when Hideyoshi's consort Yodogimi (Ochacha) gave birth to a second son, Hideyori, in the autumn of 1593. Although Hidetsugu accompanied Hideyoshi in a great pilgrimage to the Buddhist monastery on Mount Kōya in 1594, when an impressive mortuary monument was dedicated in memory of Hideyoshi's mother, and Hideyoshi also visited Hidetsugu at the Jurakutei later in the year (December 1594) in what appears to have been a show of good faith, Hideyoshi's antipathy for Hidetsugu came to a head in the middle of the following year, and he was sent into exile at Mount Kōya and commanded to take his own life. Hidetsugu had acquired a reputation

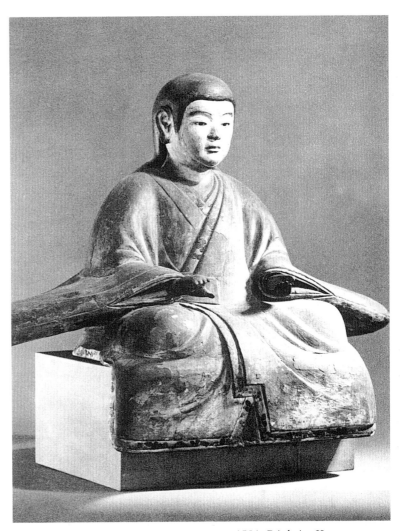

Fig. 20. Portrait of Toyotomi Sutemaru, ca 1591, Rinkain, Kyoto.

for being immoral, dissipated and bloodthirsty, which was no doubt a factor in Hideyoshi's turning against him. The decisive factor in Hideyoshi's decision, however, was undoubtedly the presence of his young son Hideyori, and Hideyoshi's determination that he would be the future leader of the Toyotomi family. Nevertheless, Hideyoshi's cruel treatment of Hidetsugu's family and retainers reveals a dark, vindictive, fanatical side to his nature. Some of Hidetsugu's immediate followers had followed him in suicide at Mount Kōya, but his great vassals were also summarily put to death. Hidetsugu's wife, his two children, and more than thirty women in his service were paraded through the city and brutally decapitated before a stake on which Hidetsugu's head was displayed, and the corpses were thrown in a common grave on the west bank of the Kamo River below the Sanjō Bridge, the traditional location for executing criminals. This barbarous treatment of Hidetsugu's household is a deplorable episode in Hideyoshi's career. So intense was his desire to eradicate the memory of Hidetsugu that he had the incomparable Jurakutei compound, with all its glorious buildings and battlements, completely dismantled and demolished.

But the strength of the Jurakutei's hold on the popular imagination remained constant over the centuries, an evanescent bench-

mark for opulence and grandeur. Some of the structures may have been re-erected in the great castle retreat that Hideyoshi was constructing southeast of Kyoto at Fushimi, while others may have been given to temples or shrines in the area. In fact, the beguiling reputation of the Jurakutei has exercised such a powerful influence on later generations that a fabric of pious attributions evolved, in which many fine structures of the late Momoyama or early Edo periods were supposed to have had their origins in the fabulous compound. But the castle at Fushimi, where certain of the buildings might well have been transferred, was so seriously damaged in an earthquake in 1596 that it was abandoned. Its successor was built close by, on the same high hill that became known in later times as Momoyama, "Peach Blossom Hill." The castle seems to have been burned down during a battle early in 1600, and all of its main buildings appear to have been leveled. It is, of course, possible that certain outlying structures, such as corner towers, small villas, or teahouses that might have stood at isolated locations, such as in the broad garden, might have survived, but few contemporary scholars support such a thesis.

In 1586, the same year in which construction on the Jurakutei was begun, Hideyoshi was also planning another monumental project, a Buddhist temple complex with a Daibutsuden ("Great Buddha Hall") in which a colossal seated image of the Buddha Vairocana was to be enshrined (fig. 1). This was an immense undertaking, and its scale and complexity were such that it would require huge numbers of workers to bring it to eventual completion. It involved the transport of large quantities of timber from almost all of the forested areas of central and western Japan. Hideyoshi's vassals competed to find and unearth the mammoth slabs of rock that were to buttress the elevated rubble foundation on which the buildings were to stand. These were laboriously moved to Kyoto by gangs of coolies in giant rafts on rivers or by the even more onerous method of wooden skids, pulled by men and animals.

Hideyoshi is said to have instructed the daimyo that no boulders that were cracked, damaged, or inferior in any way would be accepted for the project. As is the case with all of Hideyoshi's great undertakings, no reliable figures on the number of workers involved are to be had; however, a proclamation issued by Hideyoshi in 1591, noting that over sixty thousand men had been sent by twenty-eight separate daimyo to labor on the construction has the ring of credibility about it. It is quite likely that skilled craftsmen from all the provinces surrounding Kyoto were involved. The site chosen was a gentle slope at the foot of the eastern hills, to the southeast of the city. Maeda Gen'i, right-hand man to Hideyoshi in many of his great ventures, who held the office of magistrate for shrine and temple affairs in Kyoto, was directed to oversee the planning. A broad new bridge was constructed over the Kamo River, as well as an approach way that would display the Great Buddha Hall to best advantage.

A Chinese specialist in the manufacture of Buddhist images, Wang T'ui, was employed in Bungo Province at the time, and Hideyoshi's general Ishida Mitsunari consulted with him about the feasibility of building the huge image. It was agreed that an inordinate expenditure of time and labor would be necessary to cast the image in bronze, so it was decided to construct it of wood and coat it with lacquer, with embellishments of color. One of Hideyoshi's tea masters, Imai Sōkyū, the rich merchant from Sakai, is said to have been assigned the task of providing the prodigious amounts of raw lacquer required for the multiple layers that were to be applied to the image. Wang T'ui, and the Buddhist sculptor Kōshō (1534–1621) were given responsibility for creating the huge image. The Daibutsuden, the central structure in which the Buddha was installed, is generally agreed to have been the largest wooden building ever constructed in Japan. It stood on a foundation of about 330 by 220 feet, and soared 160 feet into the sky. As seen in figure 1, it is represented as a two-storied, tile-roofed structure in *Rakuchū rakugai* paintings as well as in screen depictions of the festivities that were held to mark the seventh anniversary of Hideyoshi's death, held at the Hōkoku Shrine, a spacious compound built to enshrine Hōkoku Daimyōjin ("Great Luminous Deity of Our Bountiful Land"), Hideyoshi's deified spirit. This spectacular architectural manifestation of Hideyoshi's obsessive passion for enormous undertakings had its inspiration in the greatest architectural wonder of earlier times, the great Daibutsuden erected by the Emperor Shōmu in Nara in the eighth century, and the fact that Hideyoshi's structure was even larger exemplifies his preoccupation with greater scale, splendor, and magnitude in all his ventures.

Little is known and nothing apparently preserved of the colossal wood and lacquer image of the Buddha Vairocana. Construction on the temple started in 1588, and three years later, the pillar-erecting ceremony was held. In 1593 the main crossbeam at the ridge of the roof was installed, and work continued on until 1595. The final months of the year were taken up with elaborate Buddhist ceremonies celebrating the completion of the Hōkōji and commemorating the spirits of the deceased members of the Toyotomi clan. A thousand monks were assembled for these rituals. Hideyoshi's own religious inclinations are unclear, and it seems that he had no preference in assigning any particular sect to administer the great temple, for members of eight sects were pressed into service in these solemn observances. In the following year, however, a tremendous earthquake devastated the region, and the building and its outsized icon were destroyed. Plans for reconstruction were soon initiated, and Hideyoshi prevailed on the monks of the Zenkōji, in faraway Shinano, to bring the revered main image from their monastery to serve temporarily as the main object of worship. The subsequent history of the Hōkōji is a melancholy one. Reconstruction was begun under Hideyori and the casting of a metal image begun in 1599, but in 1603 a fire broke out in the foundry, and the new building burned to the ground. Reconstruction began again in 1609, but progress seems to have been erratic, and must have been suspended after the fall of Osaka Castle in 1615. Another reconstruction took place later in the century, but this was destroyed in 1662.

In 1588 when the Emperor Go-Yōzei and his entourage visited the Jurakutei and work on the massive foundation of the Great Buddha Hall was underway, Hideyoshi also began a concerted campaign to disarm the non-military segments of society. Known as "the Taikō's Sword Hunt," this measure was intended to solve the recurrent problem of agrarian uprisings; confiscate weapons from the troublesome militant clergy of monasteries; and generally separate the peasants, merchants, and other members of

the populace in order to distinguish civilians from the warrior class. Hideyoshi's proclamation noted that weapons of all sorts were to be turned in to the local authorities, and that these were to be melted down and the metal used to manufacture the nails, bolts, and other fastenings necessary for assembling the great wooden image that was to be erected in the Daibutsuden. Those who were obliged to give up their arms were sanctimoniously assured that their donations would guarantee their salvation both in this world and the next.

Reconstructing architectural monuments was an essential aspect of Hideyoshi's grand plan to restore stability, decorum, prosperity and grandeur to Kyoto. Nobunaga had supported the court and rebuilt the Emperor Ōgimachi's palace, but Hideyoshi's relationship with the throne was more congenial and generous, and in addition to allocating substantial income-producing properties to the court on several occasions, his largesse is also apparent in his expenditures to restore the imperial palace compound in the years from 1589 to 1591, when eleven structures, ranging from the *shishinden* (official ceremonial hall) to the imperial bathing facilities, were built. A number of ancient Zen monasteries in Kyoto, such as the Shōkokuji, Nanzenji, Kenninji, and Tōfukuji, which had suffered greatly in the destructive wars that had devastated the capital, received substantial aid from Toyotomi sources, and the restoration carried out in these compounds included not only monumental structures such as worship halls and administrative buildings that had been absent for many decades but also the construction of new sub-temples in these and other Zen monasteries that were endowed by Hideyoshi and other powerful military figures of the period. Monasteries of the Esoteric Shingon and Tendai sects located in and around the capital were also the beneficiaries of substantial largesse that made possible the rebuilding of missing buildings and the renovation of temple grounds. The prodigious architectural accomplishments that took place in Buddhist monasteries in Kyoto and other regions during the Momoyama periods were, in their scale and variety, no less impressive than the dramatic palaces and castles that appeared at this time.

The indefatigable Hideyoshi was also directing other ambitious projects in Kyoto in these years. In 1591 a conscripted army of laborers was put to work, and in less than half a year, they had raised a high, continuous rampart around the city. The wall, known as the odoi, was constructed of piled earth and rubble, and enclosed a huge, irregular north-south rectangle that included not only the central, populated section of the capital, but also extensive open, rural sections to the north and west (see Map 2.). The average dimensions of the *odoi* are thought to have been about forty feet thick at the base, about fifteen across the top, and roughly fourteen to eighteen feet in height. The total length amounted to almost fifteen miles, and one can only marvel how laborers and animals could have moved and piled the necessary earth and rubble in such a short time. Existing waterways were utilized and channeled into deep trenches excavated along the western and southern boundaries of the *odoi*, creating a continuous moat, and stands of bamboo were planted on the top of the rampart to prevent erosion. Ironically, the rationale for erecting the *odoi* remains something of a mystery. There were ten gates, and these were certainly intended to control the passage of undesirables of various sorts, but the *odoi*

was not a true fortification and could have been easily scaled by any determined adversary. Like the Daibutsuden, it may have been inspired in part by ancient precedent, for a section of earthen wall had been built at the southern entrance to the capital in the eighth century, and Hideyoshi is said to have consulted with Hosokawa Yūsai (see cat. no. 17), a scholar and student of history, about the function of this wall before he began the project. Hideyoshi's intention in such undertakings seems to have been to improve and enhance the city not only in a physical but also in a symbolic sense, and to resurrect something of its ancient grandeur as the center of governmental power and high culture.

Another interesting example of Hideyoshi's various efforts to shape the plan and physical layout of Kyoto took place during the decade prior to 1592. This involved the massive relocation of a great number of Buddhist temples that stood in the heavily populated neighborhoods of the city to three peripheral areas (see Map). One, named Teranouchi, was a substantial area in the northern outskirts, where a temple complex had stood in former times. The second was a smaller compound, Shimo-Teramachi, well to the south, that flanked Ōmiya Avenue. The third, Teramachi, was the largest in area and most distinctive in plan, with a long, narrow conformation, which paralleled the western bank of the Kamo River, stretching from Kuramaguchi in the north all the way to Rokujō in the south. As many as one hundred and twenty temples are thought to have been relocated in the Teramachi area, and this distinctive concentration of Buddhist buildings and cemeteries remains a salient feature of Kyoto to the present day. Temples from at least five Buddhist sects were resituated in Teramachi, many of them Nichiren sanctuaries, such as the Honnōji, site of Nobunaga's death at its earlier location in the center of the city. Sixteen temples are thought to have been relocated in the Teranouchi enclave, and about forty to Shimo-Teramachi. If these numbers are to be believed, the total number of temples affected by this mammoth undertaking may have approached one hundred and eighty, and the labor of dismantling, transporting, and reconstructing these buildings at their new locations reveals once again how one prodigious undertaking followed another during the decade and a half Hideyoshi dominated the city. Organized opposition from militant elements of the Buddhist church had been a recurrent problem for both Nobunaga and Hideyoshi, and removing this large number of temples from their original locations in local neighborhoods and situating them in designated compounds away from their congregations would have weakened the traditional ties of the followers with their places of worship and reduced the potential for any organized opposition to official policy. At the same time, concentrating temples into specific outlying areas was a characteristic feature in the evolution of castle towns, and at both Osaka and Fushimi, these areas were situated at peripheral locations at the outskirts of the towns.

Hideyoshi also had new roads laid out through parts of the city, and this stimulated commercial activity and building development. Among his most admired contributions to the local inhabitants were three broad bridges with permanent stone foundations that were constructed across the Kamo River, engineering marvels in their day. The Sanjō Bridge, which was built at Hideyoshi's order in 1590 by Masuda Nagamori (1545–1615), still retains some

Fig. 21. Roof-end tiles from Fushimi Castle, 1590s.

Kyushu, wrote to Maeda Gen'i, stating that he wanted to consult with him on the details of the castle plan. He also expressed his concern about recent earthquakes in the Kyoto area and the necessity for protecting the castle against potential damage in the future. Hideyoshi returned to Kyoto in the following year, where he took a personal hand in directing the work on the castle. Ironically, four years after the letter, in 1596, a disastrous earthquake devastated the region and destroyed two of Hideyoshi's most memorable undertakings: Fushimi Castle and the colossal Daibutsuden. Among the many structures destroyed at Fushimi were the splendid five-storied donjon, the palatial ceremonial hall, and various residential halls (the largest of which had a floor area of one hundred *tatami* mats). Fragments of gold-embellished roof tiles from the donjon which were excavated in modern times hint at the extravagance of the entire castle project (fig. 21). Undeterred by this calamity, Hideyoshi ordered the rebuilding of the castle. But the damage had been so extensive that a new site was chosen at Kohata, just to the north. Here again, work was carried out at breakneck speed, and the compound was completed even more quickly, in less than a year.

In addition to the elaborate ceremonial and residential buildings at Fushimi, the compound included a number of other structures that throw light on Hideyoshi's interests and preoccupations in the last decade of his life. The grounds included a rambling garden enclave of the same sort that had been built at Osaka Castle, known as Yamazato ("Mountain Village"), which had two rustic teahouses, Noh stages, a pavilion for moon-viewing, and colorful stands of flowering trees and other exotic flora. A channel that led south to the Uji River made boating excursions and parties on the miniature islands in the river possible. Hideyoshi's enduring devotion to the practice and aesthetics of tea is apparent here, as is his continued zeal for the drama, color, and spectacle of Noh performances, in which he frequently appeared. But the facilities for more relaxing, dilatory pursuits are also present, for banqueting under the moon and pleasure partying afloat, activities that may reflect the Taikō's advancing age.

Before the decisive battle at Sekigahara in the ninth month of 1600, the castle was taken by Torii Mototada (1539–1600), a follower of Tokugawa Ieyasu. There is a tragic irony in the fact that the great castle was reduced to ashes in an attempt to retake it by the Toyotomi general Ishida Mitsunari in a ten-day siege. In 1603 Ieyasu came to Kyoto to be invested with the rank of shogun. Fushimi Castle was reconstructed and many buildings were erected, but later the Tokugawa *bakufu* abandoned the castle and in 1619, the authorities had it dismantled.

By the end of 1590, much of the task of national unification, achieved in part by Nobunaga, had been completed by Hideyoshi. He had subdued all of his former rivals, who now recognized his supreme authority and their own status as vassals. Ieyasu, however, had remained a powerful independent force, and Hideyoshi had sought to strengthen their alliance by adopting his son and having Ieyasu marry his sister. In the spring of 1590, Hideyoshi had set off on a campaign against the Hōjō clan, the last truculent opponents of his authority, who controlled a large region in eastern Japan from their heavily fortified castle as Odawara. The armies of Hideyoshi and his allies eventually overthrew Odawara Castle after a protracted siege. Ieyasu, in recognition of his help, was awarded a

appearance of the original structure and is said to have been the first instance where stone pillars were used in bridge construction in Japan.

The last of Hideyoshi's great architectural achievements was Fushimi Castle. Built on a steep hill at a site known as Shigetsu, above and to the east of the town of Fushimi, the location commanded fine views of the surrounding countryside: the broad expanse of Kyoto to the northwest, and the fertile Uji and Yodo River deltas that stretched out to the south and southwest, in the direction of Osaka. At the time of its conception in the eighth month of 1592, Fushimi seems to have been intended as a modest suburban retreat, but a year later this scheme was radically altered, and replaced by a much grander plan for a palatial castle compound along the lines of Jurakutei. This change in size and design came from Hideyoshi's decision to establish his headquarters and permanent residence at the site, and his desire for a compound whose scale and grandeur not only reflected his status, but was also appropriate for his extravagant ceremonial and recreational gatherings. Amazingly, Fushimi appears to have been completed in less than two years, and one can only marvel once again at the logistical coordination and productive efficiency of the work force. Like Jurakutei, Fushimi had the outward appearance of a castle, with defensive walls and an imposing five-storied donjon, but it consisted essentially of sumptuous residential complexes, their subsidiary buildings for storage and recreation, and colorful gardens. Unfortunately, no contemporary plans or details of this fabulous compound seem to have been preserved, but architectural historians are of the opinion that it rivaled the Jurakutei in the grandeur of its conception and sumptuous buildings. Kanō Eitoku, the most revered painter of the period, had died in 1590, but the leading men of his atelier, his brother Sōshū, his sons, Mitsunobu and Takanobu, and his brilliant adopted son Sanraku, were all employed in producing the multitude of luminous polychrome screens that were installed there, but have not survived.

In the twelfth month of 1592 Hideyoshi, who was directing the campaign of his army against Korea from Nagoya Castle in

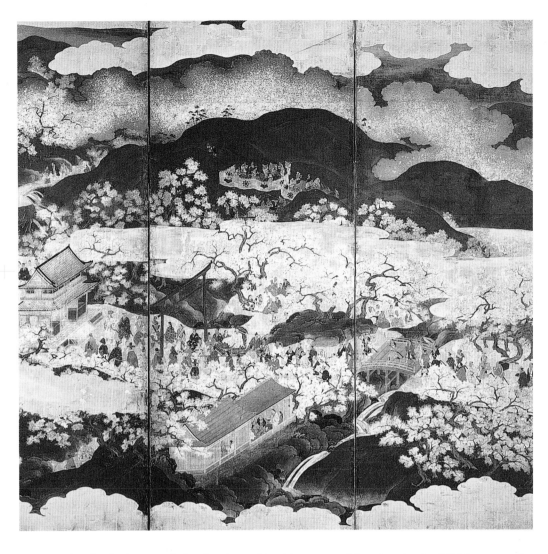

Fig. 22. *Pilgrimage to Yoshino*, early seventeenth century. Detail from a pair of six-panel folding screens. Hosomi Collection.

huge domain, the eight Kantō provinces, and by September he had moved his headquarters to the town of Edo (now Tokyo), and settled into the castle there. This arrangement was a pragmatic one for both Hideyoshi and Ieyasu. Hideyoshi, for his part, was glad to have Ieyasu at a distance, in Edo, some three hundred and fifty miles from Kyoto; and Ieyasu, who governed an area famed for its fighting men, now controlled the Kantō plain, the most extensive alluvial plain in Japan. By the last decade of the sixteenth century Hideyoshi had established a new feudal hierarchy, more stable and effective than any of earlier centuries; and in the early decades of the seventeenth century, Ieyasu and the shoguns who followed him continued this evolutionary process, strengthening governmental controls and imposing a rigid, stratified social hierarchy on society.

During the last decade of his life, Hideyoshi was, as we have observed, much given to entertainments on a grand scale. One of these was a splendid excursion to the hills of Yoshino to view the celebrated stands of blossoming cherries in the spring of 1594. Hideyoshi's large entourage included Hidetsugu, a throng of vassals and attendants. Also in attendance were several *renga* (linked verse) poets, among them Satomura Jōha (1524–1602), so that the occasion could be properly memorialized. A pair of screens in the Hosomi Collection shows the long procession of colorful dignitaries and followers, moving ceremoniously up the path to the Yoshino Shrines (fig. 22). The bright, vivid colors of the painting

and the floating white blossoms of the cherries in full bloom evoke a pervasive air of grand pageantry and sensuous enjoyment. The memorable excursion was commemorated not only in the contributions of the *renga* masters, but also in one of the Noh plays written early in 1594 by Hideyoshi's secretary Ōmura Yukō (d. 1596), dealing with the great events in the Taikō's life. Hideyoshi himself performed this selection, *Yoshino mōde* (Pilgrimage to Yoshino) before Hidetsugu at Osaka Castle only a month after the grand excursion. The fact that the role performed by Hideyoshi was a personification of the revered chief deity of the Yoshino Shrines, Zaō Gongen, reveals his inordinate self-esteem and his perennial interest in being the dominant, central figure wherever he was present. Hideyoshi is thought to have planned to perform the same role in a three-day gala at the imperial palace later in the same month.

Another festive outing to view cherries in full bloom took place four years later, on a fine, bright day in the spring of 1598. The grounds of the ancient Daigoji monastery, and its subtemple, the Sambōin, were the locale for this gathering, only a short distance from Fushimi Castle. Hideyoshi had visited the temple a month before, and instructed the authorities to begin preparations, ordering the construction of residential and recreational facilities, including teahouses and a stand for cherry blossom viewing. Although the entourage consisted of hundreds of his vassals and

their retinues, Hideyoshi's own party was smaller and more intimate, and consisted mainly of family members, concubines, and their servants. Yodogimi and the boy Hideyori were of course present. A broad, picturesque area was curtained off and guarded by soldiers so that the party would not be disturbed by imprudent spectators.

The Daigoji, which traced its aristocratic origins back to the early tenth century, had been badly damaged in the Ōnin War, like many of the monasteries in and around Kyoto, and it was one of the Buddhist temples that Hideyoshi helped to rebuild. In addition, extensive stands of cherries were brought from various regions, and planted in the temple grounds. Hideyoshi seems to have taken a liking to Gien, the abbot of the Sambōin, and he ordered the compound rebuilt together with a spacious garden (fig. 23). There is a possibility that certain of the structures still preserved there, such as the *Karamon* ("Chinese Gate" fig. 24), with its dramatic Toyotomi paulownia and chrysanthemum crests, may have been brought from other Toyotomi locations, and certain of the distinctive boulders in the garden are reputed to have come from the Jurakutei. Hideyoshi himself had visited the Sambōin on more than one occasion before the cherry-blossom viewing excursion, and had

taken a particular interest in the layout of the garden, planning the design, with its elaborate arrangement of meandering waterways, miniature islands and stone waterfalls and bridges. He is also credited with the arrangement of the hundreds of extraordinary rocks that give the garden its particular atmosphere and charm. Although the work at the Sambōin had only started, Hideyoshi, his family, and his closest vassals gathered there, and participated in the composition of *waka* and linked verse under the guidance of Jōha, who had been present at the Yoshino excursion four years earlier.

A screen painting in the National Museum of History and Ethnology shows Hideyoshi at the Daigoji, accompanied by ladies in colorful attire (fig. 25). The figure to his left, wearing an *uchikake*, is undoubtedly Yodogimi. Hideyoshi wears a stylish *dōbuku* decorated with large peony designs. The Taikō's coterie of women are said to have had individual teahouses put up for the occasion, and he is described as leading Hideyori to each of them in turn to enjoy hospitable tea drinking. Tradition has it that the ladies of his party put on a show of fashion, each changing her sumptuous robes three times. Hideyoshi appears here less an audacious warlord than an elderly pleasure seeker.

Daigoji was to be the Taikō's last great festive affair. In early

Fig. 23. The garden of Sambōin, ca 1598. Daigoji, Kyoto.

Fig. 24. Karamon ("Chinese Gate"), ca 1598. Sambōin, Daigoji, Kyoto.

Fig. 25. Detail of *Toyotomi Hideyoshi at the Daigoji*, ca 1598–1615. Six-panel folding screen. National Museum of History and Ethnology, Chiba.

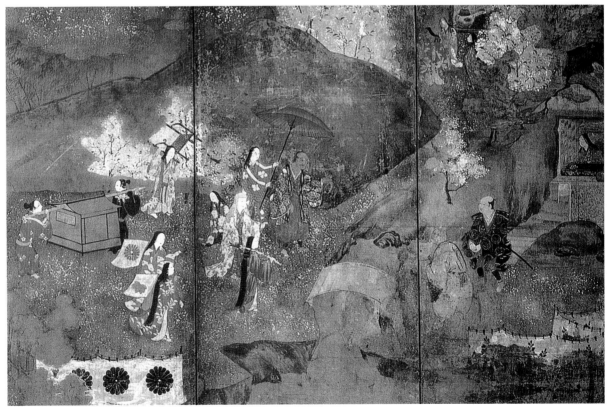

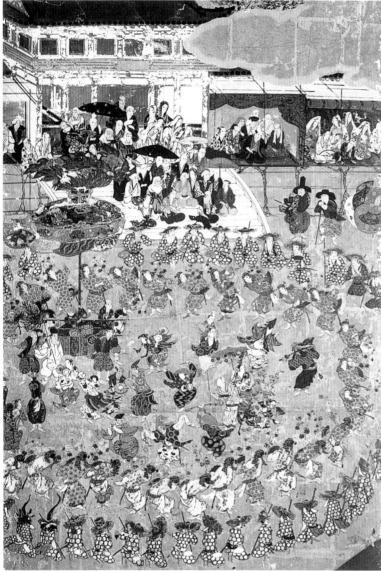

Fig. 26. Detail of *Hōkoku Shrine Festival*, 1604, by Kanō Naizen. Pair of six-panel folding screens. Hōkoku Shrine, Kyoto.

while others, keen to sense the growing momentum behind Ieyasu, threw in their lot with him, further increasing his already formidable forces. The armies of these two factions finally joined battle in 1600 at Sekigahara, where the Toyotomi "Western" armies were decisively defeated, and Ieyasu's role as the leader in the final stages of unification was foreshadowed. In 1603, Ieyasu was appointed shogun by the emperor, legitimizing his position of authority. After this Ieyasu's influence grew rapidly, while Hideyori's began to decline as some of his father's faithful supporters died. Ieyasu, never one to take rash action, waited and planned carefully. In December 1614, a huge, well coordinated army led by Ieyasu's son Hidetada laid siege to the great Toyotomi bastion, Osaka Castle. Although the attacking forces were far stronger, they attacked cautiously, for Ieyasu wished to avoid excessive losses in assaulting the almost impregnable fortress. Although this first phase of the siege – the "Winter Siege" – ended six weeks later in a truce, Hidetada's soldiers continued to fill the moats and demolish the outer defenses, and in May, the second phase of the assault, the "Summer Siege" began (see cat. no. 22). After a month of desperate, bloody struggles, Hidetada's warriors forced their way into the inner ring of the defenses. Although Hideyori's wife, who was Hidetada's daughter, implored her father and grandfather to spare her husband and his mother Yodogimi, there was no response. Hideyori committed suicide and a retainer killed Yodogimi to keep her from falling into enemy hands. Unlike the short-lived authority of Nobunaga and Hideyoshi, Ieyasu and his successors were to govern the country for the next two and a half centuries.

The Emperor Go-Yōzei apotheosized Hideyoshi in the year after his death, declaring his spirit a divinity of the first rank, with the title Hōkoku Daimyōjin, "Great Luminous Deity of Our Bountiful Country". In the same year construction of a splendid mortuary complex to enshrine Hideyoshi's spirit was begun to the southeast of the Hōkōji Daibutsuden, which was reconstructed after being destroyed in the disastrous earthquake of 1596. The Daibutsuden and the Hōkoku ("Bountiful Country") Shrine were among the architectural marvels of the capital, and are therefore invariably included among the subject matter of screens on the theme of "Scenes In and Around the Capital" (cat. nos 23–4). Popular religious observances and festivals seem to have been held periodically at the Hōkoku Shrine, but an extravaganza of great size and activity was staged in the eighth month of 1604, in observance of the seventh anniversary of Hideyoshi's death. This spectacular event continued for a week, and included not only religious rites but also musical and dramatic performances. On the third day, a magnificent procession of colorfully attired warriors on horseback and high prelates from temples and shrines came to the shrine, and there were command performances of Noh by four troupes. The climax of the festival took place on the following day, when five hundred townspeople from the Kyoto neighborhoods performed dances in the shrine grounds, and also at the imperial palace, before Go-Yōzei and his entourage of court ladies and nobles. Five days later, this grand spectacle was staged again, for Tokugawa Ieyasu in the garden of Fushimi Castle.

A pair of screens painted by Kanō Naizen (1570-1616) shows the exuberant public dances of the fourth day (fig. 26). Here, in front of the entrance to the Hōkōji, the groups of dancers, each

summer he became ill. Lying in his bed at Fushimi, he became weaker and suffered occasional fits of delirium. The court, responding to his wife's request, sponsored sacred Kagura dances to entreat the help of the gods in his recovery, and invocations were offered up at most of the shrines and temples in Kyoto. Then Hideyoshi, ever the generous benefactor, sent off his last gifts of gold, silver, swords, and robes to the emperor, members of the nobility, and his most important vassals. His greatest concern was for the safety and welfare of his young son, Hideyori, and he had all his senior daimyo assemble at Fushimi Castle and pledge their loyalty to him. Hideyoshi rallied briefly, but died on the eighteenth day of the eighth month of 1598, in his sixty-third year, six months after his final divertissement under the brilliant but evanescent blossoms.

Predictably enough, Hideyoshi's death in 1598 was followed by instability and competition between the great daimyo to consolidate their power and domains, and ensure their security through alliances. The traditional vassals of Hideyoshi closed ranks behind the Toyotomi family and its nominal head the young Hideyori;

Fig. 27. Karamon ("Chinese Gate"), late sixteenth–early seventeenth century. Hōkoku Shrine, Kyoto.

distinctively dressed, move rhythmically in rotating circles around a central float with a large brocaded parasol, topped by a large, artificial peony in bloom. The dancer and musicians in the center, with their various drums and flutes, are each dressed in individual costumes, and move in improvised, elated movements; while behind, seated on the steps to the temple and in temporarily erected boxes on each side, spectators enjoy the activities. In carnival-like events of this sort, participants often dressed in special outfits, such as the Namban clothing with Portuguese hats and pantaloons worn by two men standing to the right of the stairs. This memorable festival may have been the last great demonstration of public pageantry in Kyoto of the Momoyama period. For in the previous year, Tokugawa Ieyasu had been appointed shogun, and the future of

the Toyotomi family was already a matter of skeptical conjecture. The festival demonstrated the dedication of the Kyoto populace for Hideyoshi's memory. But after the Hōkoku Shrine burned in about 1610, the Tokugawa authorities would not allow it to be rebuilt, for they wished to discourage any public reverence for Hideyoshi's greatness. Indeed, even popular songs with any reference to him were subsequently banned. Although Hideyoshi's exploits and accomplishments were preserved in the popular lore and mythology of the inhabitants of Kyoto and the neighboring provinces, it was not until the Meiji Restoration that official recognition of his support for the imperial house and his court ranks were reaffirmed, and the Hōkoku Shrine was rebuilt in 1880 at the site of the Hōkōji. All of its original buildings had long since disap-

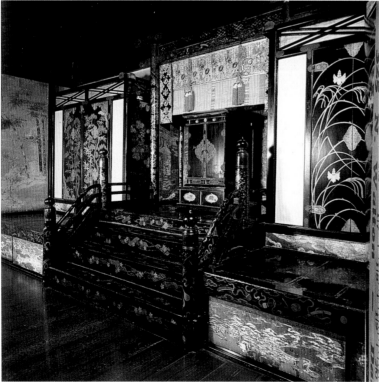

Fig. 28. Shiguretei ("Pavilion of the Autumn Rain"), late sixteenth–early seventeenth century. Kōdaiji, Kyoto.

Fig. 29. Interior of the Tamaya ("Sanctuary"), ca 1605. Kōdaiji, Kyoto.

peared, but a monumental Karamon (Chinese gate) was moved from the Nanzenji (fig. 27). This impressive structure, with its bold yet graceful front roof contour and exuberant decorative details, exemplifies the large scale, grandeur, and preoccupation with sculptural embellishments that are typical of Momoyama architecture. Tradition has it that the gate was originally part of Fushimi Castle, was moved to the Tokugawa Nijō Castle, and was subsequently utilized at the Nanzenji.

Hideyoshi's widow Kita no Mandokoro (Onene; 1548–1624) was fifty-one at the time of her husband's death in 1598, and several years later she moved from Osaka Castle and took up residence in Kyoto. She was much respected by Hideyoshi's allies and vassals, and in 1603 the Emperor Go-Yōzei conferred on her the Buddhist name Kōdaiin, indicating that she was a woman of high status who had taken religious vows and become a nun. When she turned to building a monastery for her retirement, Tokugawa Ieyasu gave her land in Kyoto and certain of Hideyoshi's generals, such as Katō Kiyomasa (see cat. no. 10) and Asano Nagamasa also supported her

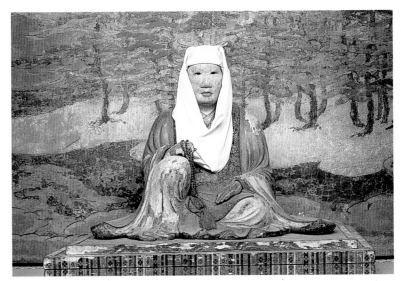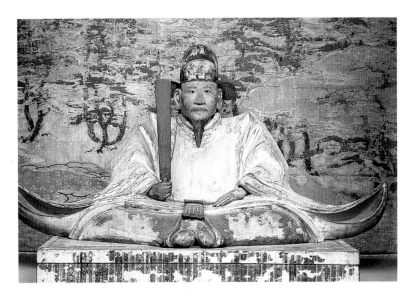

Fig. 30. Portraits of Kōdaiin and Hideyoshi, early seventeenth century. Tamaya ("Sanctuary"), Kōdaiji, Kyoto.

generously. The temple, known as Kōdaiji, was erected on the slope of the hills that overlook the capital to the west. It incorporated several structures that are said to have come from Fushimi Castle, such as the Omotemon ("Main Gate") and two rustic teahouses, the Shiguretei ("Pavilion of the Autumn Rain"; fig. 28) and the Karakasatei ("Chinese Umbrella Pavilion"), so named because of the shape of its roof. The most impressive structure in the complex is the Tamaya ("Sanctuary"), built in 1605 to enshrine Hideyoshi's spirit. The details of the interior are particularly elegant in their decor (fig. 29). Flanking the main altar are two miniature shrines that house wooden images of Kōdaiin and Hideyoshi (fig. 30). The two shrines and the central altar are completely covered with black lacquer with a variety of *maki-e* designs in gold (fig. 31). The doors on the front of Hideyoshi's shrine (fig. 70), are decorated with the elegant pampas grass designs that are often used in lacquer objects of the Momoyama period (e.g., cat. nos 111, 116, 117). The paulownia crest used by the Toyotomi family appears interspersed with the designs on both shrines. The doors of Kōdaiin's shrine are similarly decorated with pines and bamboo, while the pillars and the banisters of the altar have elegant representations of flutes, drums, lutes, and other musical instruments of the sort used to produce celestial music in a Buddhist paradise. An inscription found in Hideyoshi's shrine, "Kōami Matazaemon, twelfth month, 1596," indicates that this lacquer master of the famous Kōami line had created the shrine ten years earlier than construction on the Kōdaiji was begun – adding credence to the suggestion that it may have originally been installed in Fushimi Castle.

So renowned is the extensive collection of elegant Momoyama lacquer in the Kōdaiji, beginning with the shrines and interior of the sanctuary, and extending to other objects of considerable variety and function, that this has given rise to the use of "Kōdaiji *maki-e*" as a generic and stylistic term for the finest lacquerwares of the period (see pp. 237–8). Two superb pieces that exemplify this tradition are a Zen prelate's folding chair (fig. 32),

Fig. 31. Back doors of Hideyoshi's miniature shrine, ca 1596. Tamaya ("Sanctuary"), Kōdaiji, Kyoto.

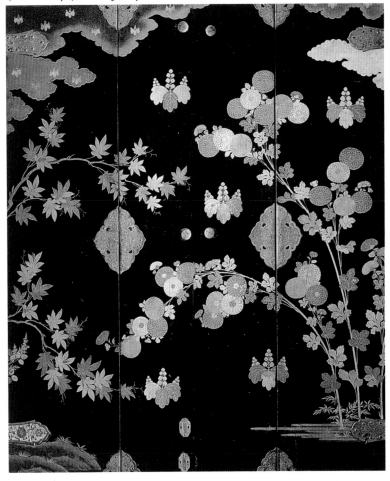

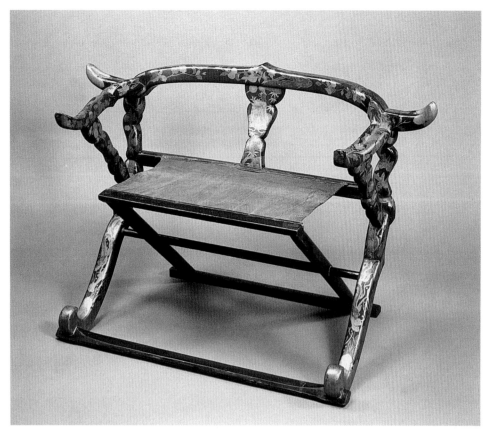

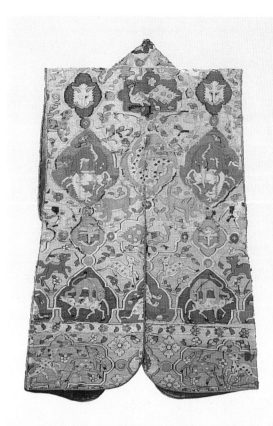

(above) Fig. 32. Zen prelate's folding chair, ca 1590–1598. Kōdaiji, Kyoto.

(right) Fig. 34. *Jimbaori* made of Persian fabric, ca 1590–1598. Kōdaiji, Kyoto.

Fig. 33. Collapsible lantern, ca 1590–1598. Kōdaiji, Kyoto.

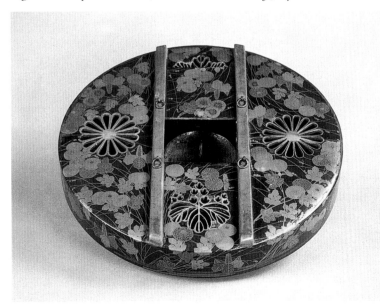

embellished in elegant gold designs that would have appealed to Hideyoshi's taste for rich, elaborate decor; and a unique collapsible lantern (fig. 33), the earliest extant example of this ingenious hanging device, which could be closed, accordion-like, when not in use. Two crest motifs used by the Toyotomi family, the paulownia and the chrysanthemum, have been utilized for the hot air outlets in the lid of the lantern, and the appearance of these two crests together here is good reason to believe that the lantern was used somewhere in Hideyoshi's own chambers, perhaps in Fushimi Castle.

Among the varied memorabilia reputedly used by Hideyoshi and still preserved in the Kōdaiji is a sleeveless *jimbaori* (fig. 34), made from a rare Persian textile which has woven into the fabric traditional Persian pictorial motifs – stylized flowers, peacocks, lions, and animal combat scenes – that would have been appropriate for a garment worn by a high military figure. It is likely that the garment (or the original textile) was brought to Japan by Portuguese traders, and it serves as an instructive example of the kind of exotic objects associated with the Namban trade.

Two of the finest examples of Momoyama-period architecture stand on the south slope of Chikubushima, a small island close to the northern end of Lake Biwa. Both structures are thought to have been moved to the island from the Hōkoku Shrine in Kyoto, and combined there with newly erected buildings. The first is the entranceway to the Hōgonji, a small Buddhist temple that overlooks the lake (fig. 35). Documentary sources mention that the Gokurakumon ("Paradise Gate") from the Hōkoku Shrine was transported to the island in 1602, and architectural historians are convinced this is the Hōgonji entranceway. The structure, which stands in front of and leads to the main hall of the temple, is notable for its imposing appearance and complex decorative orna-

Fig. 35. Karamon ("Chinese Gate") ca 1600. Hōgonji, Chikubushima, Shiga Prefecture.

Fig. 36. Karamon ("Chinese Gate"), early seventeenth century. Nishi Honganji, Kyoto.

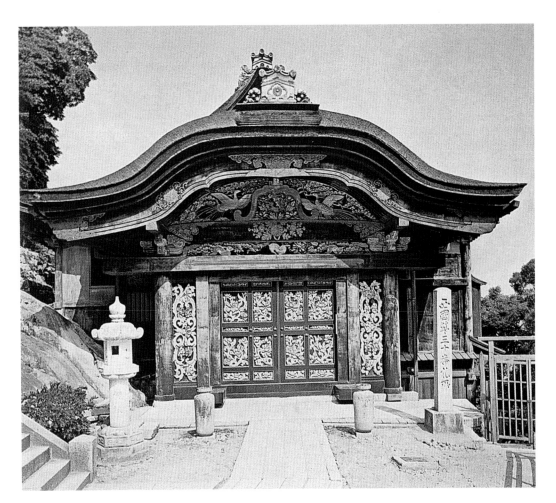

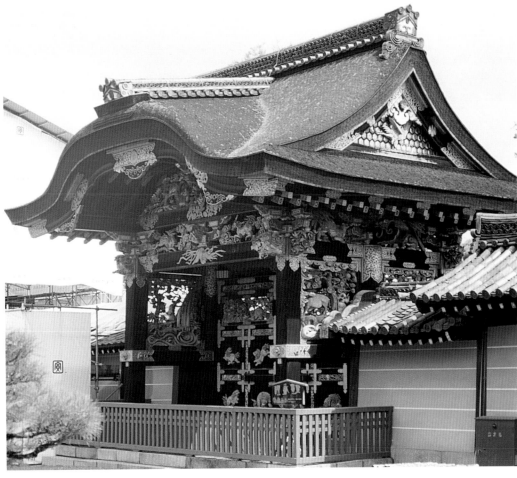

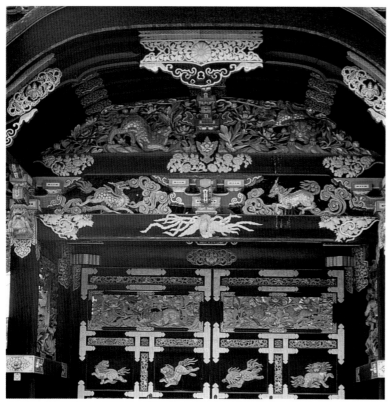

Fig. 37. Detail of fig. 36.

Fig. 38. Detail of interior of Tsukubusuma Shrine, ca 1600. Chikubushima, Shiga Prefecture.

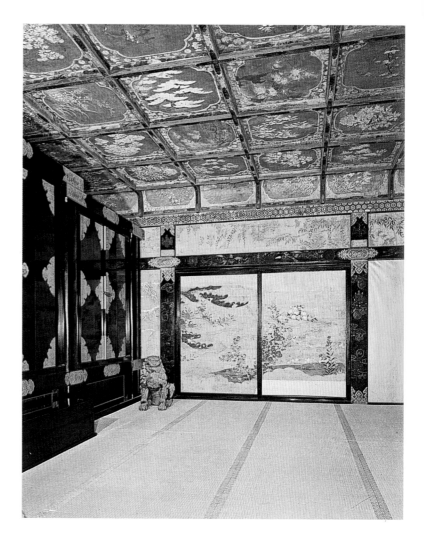

mentation. The stately *karahafu* ("Chinese gable") roof, with its graceful flowing curves, shows the same noble proportions present in the celebrated "Chinese Gate" that now serves as an entrance-way to the Hōkoku Shrine (fig. 27). But where the decor of the latter is relatively restrained, the facade of the Hōgonji structure is richly embellished with intricate sculptural forms and fanciful embossed metal ornaments. Moreover, the original appearance of the structure was even more striking, for it was painted with a bright spectrum of contrasting colors. These exuberant, rococo features are emblematic of the decorative ideals of the Momoyama period, in which painting and sculpture share a mutual preoccupation with extravagant, ornate visual display.

The second structure on Chikubushima that is thought to have been brought from the great Hōkoku compound is the main hall of the Tsukubusuma Shrine, now installed within a larger structure that was erected in 1602, and adjoins the Hōgonji. Shrine documents indicate that about twenty of Hideyoshi's vassals from the Ōmi region were associated with this shrine, and this supports the supposition that Hideyori would have been predisposed to donate buildings from the Hōkoku Shrine to religious sites on the island. The decorative details and interior embellishments, which include extensive use on pillars and beams of black lacquer with *maki-e* designs (similar to those in the Tamaya of the Kōdaiji, fig. 31), and colorful paintings of flora attributed to Kanō Mitsunobu

on the coffered ceiling and sliding screens, are striking in their intricacy and flamboyance (fig. 38).

Although smaller structures from the Jurakutei and Fushimi Castle may still exist, none of the grand audience halls where vassals were assembled on important occasions have been preserved. But the fame of these chambers was such that they were faithfully emulated in the monumental structures of the following decades. The great audience hall of the Nishi Honganji in Kyoto (fig. 39) was once thought to have been brought from Fushimi Castle, but it is now clear that it was constructed in its present location in the 1630s, when the temple was rebuilt after a devastating fire in 1617. This vast chamber, which has two hundred *tatami* mats (about 395 square yards) in floor space, has three horizontal levels within the room and elaborate relief carvings of storks on the transoms below the ornate coffered ceiling. Because of its immense size, little natural light reaches the interior, but the resplendent gold surfaces do provide sufficient reflected light to illuminate the colorful screen paintings of Chinese anecdotal themes by artists of the Kanō school. Among extant structures, it is this spacious chamber, with its impressive proportions and ornate, gold embellished decor that

Fig. 39. Interior of audience hall, ca 1630. Nishi Honganji, Kyoto.

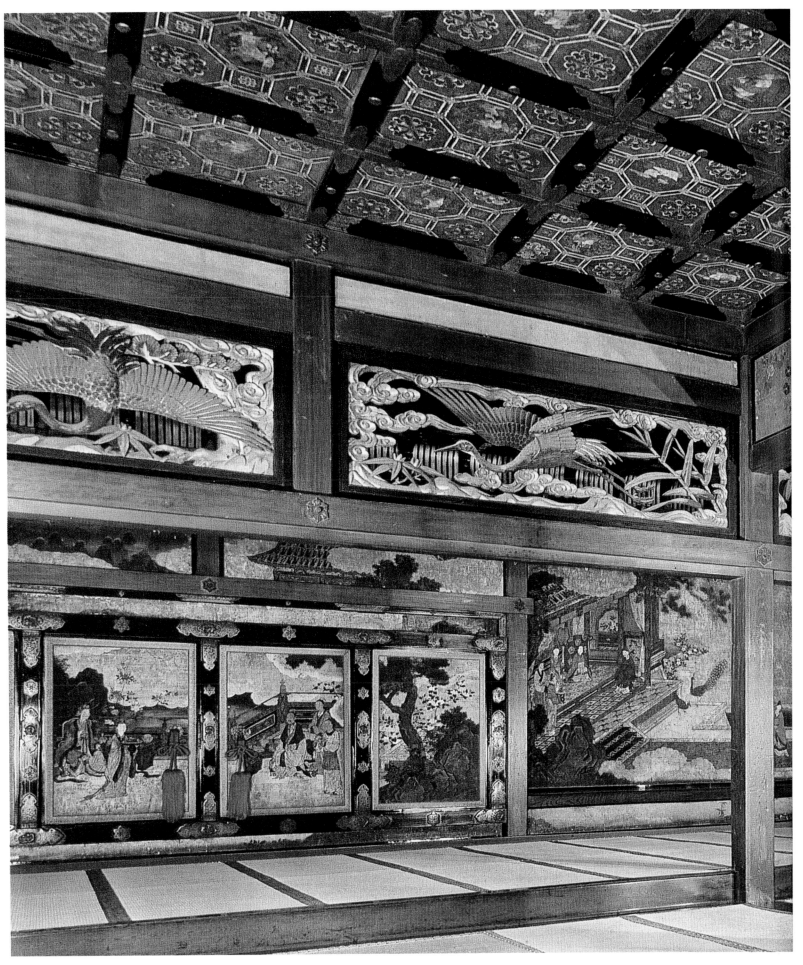

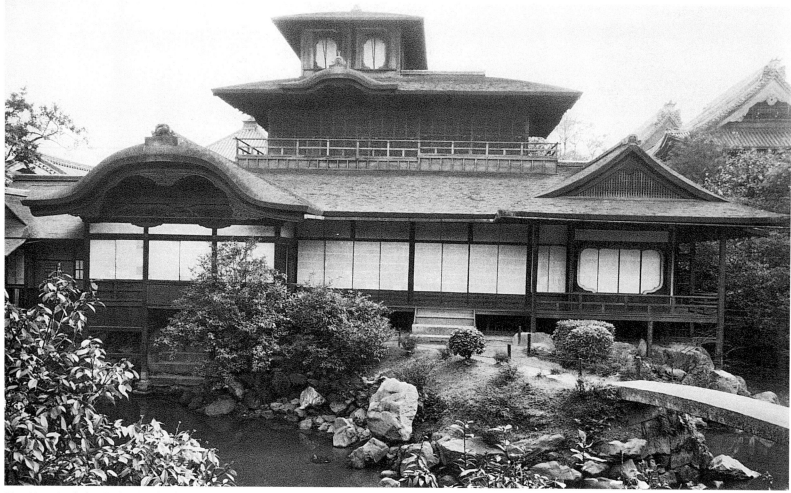

Fig. 40. Hiunkaku ("Flying Cloud Pavilion"), Momoyama-early Edo
period. Nishi Honganji, Kyoto.

comes closest to replicating the great audience chambers of
Hideyoshi's castles.

The architectural traditions of the Momoyama period are
reflected in several other structures in the Nishi Honganji com-
pound. Perhaps the most celebrated is the Hiunkaku ("Flying
Cloud Pavilion"), a three-story building surrounded by a garden
and pond (fig. 40). Like the audience hall, the Hiunkaku has tradi-
tionally been associated with Hideyoshi, for it was thought to have
originally stood in the Jurakutei. Its general appearance, with its
light, elegant construction, and its setting, adjacent to a graceful
body of water and overlooking a picturesque garden, attests to its
indebtedness to the "pavilion" tradition of Yoshimitsu's Kinkaku
(fig. 4) and Yoshimasa's Ginkaku (fig. 5). Some modern Japanese
architectural historians have been inclined to assign the Hiunkaku
to a post-Momoyama dating, or to suggest that only portions of the
structure, such as the second and third stories, may go back to the
time of Hideyoshi. A thorough study and restoration of the build-
ing is currently underway, and the results of these efforts in the
coming years may well clarify the history of the structure.

Among the several other structures in the Nishi Honganji
that have traditionally been associated with Fushimi Castle is the
Karamon ("Chinese Gate"), popularly know as the Higurashimon

("Spending-the-Day Gate"), a name that suggests to the spectators
that an entire day is required to take in all its beauties (figs 36–7).
This circumstance becomes apparent when the conscientious
observer turns to its complex decorative details and colorful orna-
mentation. Here the impulse to multiply sculptured components in
the diverse forms of human figures, birds and animals, and fanciful
floral themes reaches a new standard of rococo complexity. Little
opportunity for elaboration or embellishment is overlooked, not
even the ends of beams and brackets, which take three-dimensional
animal forms. A recent restoration makes it possible for visitors to
admire the ornate elegance of the gate as it appeared when it was
first erected.

The "Northern" Noh stage at Nishi Honganji is of particular
importance in the history of the Noh drama, for it is the oldest
extant structure of its sort, dating to 1581 (fig. 41). Where it was
originally erected is unknown, but temple tradition has it that it
was given to an influential parishioner by Tokugawa Ieyasu in
1611, and installed in its present location some years later. The
stage itself, and the connecting ramp, are relatively restrained in
construction, features that attest to its early date.

The Hōkoku Shrine, built as a splendid sanctuary for
Hideyoshi's deified spirit, served as a general model for the later

Fig. 41. Northern Noh Stage, 1581. Nishi Honganji, Kyoto.

compounds built for deceased Tokugawa shoguns. Several shrine compounds named Tōshōgū ("Shrine of Eastern Brightness") were erected as commemorative mausolea for Ieyasu, Tōshō being the deified name for Ieyasu, chosen because of his Kantō, or Eastern associations. The most celebrated is the grandiose Tōshōgū erected at Nikkō, in the mountains some distance north of Edo, by Ieyasu's grandson Iemitsu, in the 1630s. The Tōshōgū and the other Tokugawa mausolea at Nikkō are crowded, indeed encrusted, with carved and painted embellishments. The Karamon ("Chinese Gate") of Ieyasu's Tōshōgū carries ornamental elaboration to a new level. This singular structure makes an instructive comparison with the two Momoyama karamon from the Hōgonji (fig. 35) and the Nishi Hōnganji (fig. 36). The former, with its horror vacuii of compressed, miniature forms, has carried the rich Momoyama decorative tradition to its ultimate excess. Where the latter examples are dramatic and ebullient in their decorative complexity, the lavish decor of the former has lost its sculptural integrity and become nothing more than a series of convoluted pictorial patterns.

The most dynamic manifestations of the Momoyama preoccupation with power, authority and affluence were the monumental castles of the period. In the course of four decades, more than twenty castles were built in various provinces – a demonstration of the amazing coordination of labor, expertise, and logistics that is characteristic of the grand undertakings of the period. Hideyoshi encouraged his most powerful vassals not only to utilize their manpower and resources to erect monumental castles, but also to dismantle those of lords who might challenge his authority. Although castle building continued during the early Edo period under the

supervision of the Tokugawa bakufu – occasionally on a grand scale, as at Edo and Nagoya – much of the work took place on Momoyama foundations, as at Osaka, and shows little innovative advance over the great structures of the late sixteenth century. Of extant edifices, the sprawling castle complex at Himeji (fig. 42), begun in Hideyoshi's time and completed in the following decades, provides the most evocative impression of the stupendous scale of the greatest Momoyama castle structure, Hideyoshi's Osaka castle.

After the death of Hideyoshi and the Toyotomi defeat at Sekigahara, the power of military and political authority in Kyoto declined. The Tokugawa bakufu built the splendid Nijō Castle as its local administrative headquarters, but the constabulary was small and its functions primarily ceremonial. Relieved of the imperious presence of domineering warriors, the citizens of Kyoto, inspired by the models of their affluent machishū leaders, pursued their time-honored trades and occupations, and found new diversions in the elegant artistic precedents of their past and the evolving aesthetics of the present.

Hon'ami Kōetsu (1558–1637), grandson of the machishū Hon'ami Kiyonobu, had been trained in the family specialty, sword connoisseurship, but he had many creative interests and became accomplished in a diverse range of arts and crafts: tea ceremony ceramics (cat. no. 83), lacquer design and inlay (cat. nos 119–21), painting, and particularly calligraphy (cat. no. 74); he became renowned as one of the three calligraphic exemplars of the period, together with the monk Shōkadō Shōjō (cat. no. 77) and Konoe Nobutada, a member of the nobility. Specialists in various creative media admired Kōetsu because of his originality and vision, and he eventually became the leader of a group of about fifty men who were drawn together by their common interest in courtly artistic traditions, the discriminating taste of the tea ceremony, and innovative conceptual ideas. Although Kōetsu's group was only recently founded and lacked the prestige of an established lineage, it derived its inspiration from traditional Japanese pictorial and literary themes and the aesthetics of the tea ceremony, that had a strong appeal to various segments of Kyoto society, to the aristocrats of the court, the cultured members of the machishū, and even some of the more refined and discerning warriors. The Suminokura family, with their tradition of learning and cultural aspiration, were not only patrons and students of Kōetsu, but also collaborators. Sōan, the son of Ryōi (cat. no. 19), studied calligraphy under Kōetsu, and sponsored the publishing of fine woodblock printed books known as Sagabon (cat. nos 75–6) because the printing was done at the Suminokura home in the Saga district, west of Kyoto.

It was in 1615 that Kōetsu moved his family, friends, and his group of fellow artists from Kyoto to a location at Takagamine, northwest of the city, which had been given him by Tokugawa Ieyasu. Although this coterie of creative enthusiasts has been described as an artistic commune centered around the versatile genius of Kōetsu, it appears that it was also established as a Hokke sectarian retreat, where Hokke rituals were integral components of daily life. In this collaborative atmosphere, Kōetsu and his friends were motivated to share their creative ideas freely and produce a variety of works of art that demonstrated their common aesthetic interests. The use of traditional pictorial motifs in combination with

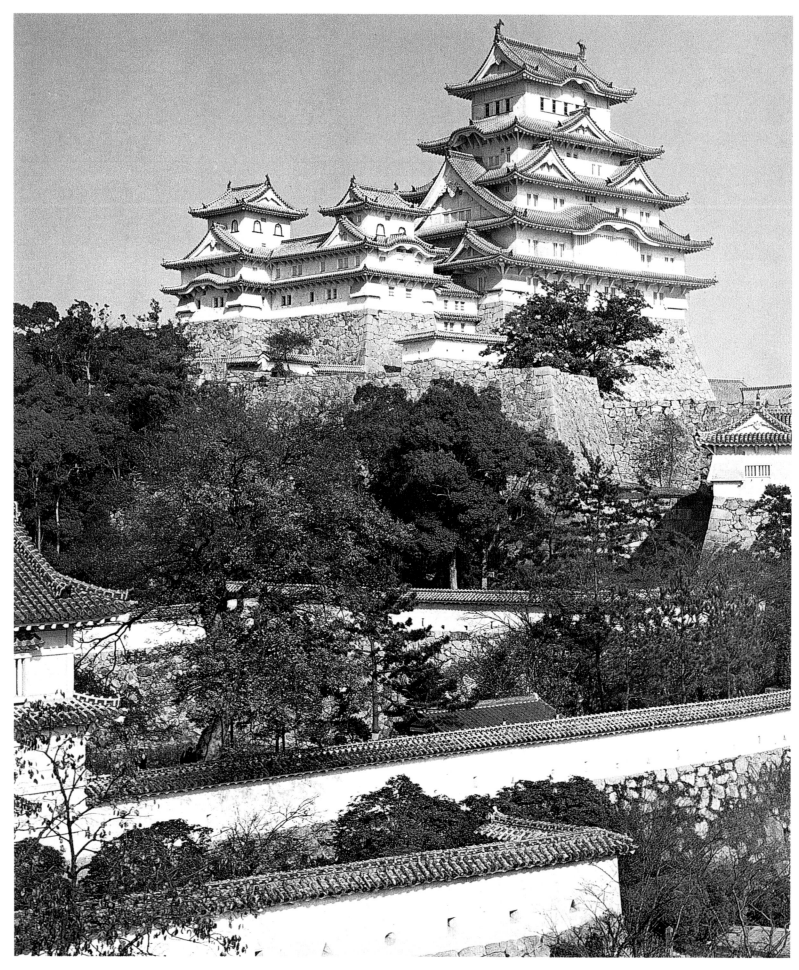

Fig. 42. Himeji Castle, ca 1609. Hyōgo Prefecture.

Fig. 43. End-flute, ca 1620–30, attributed to Hon'ami Kōetsu. Yamato Bunkakan, Nara Prefecture.

various artistic techniques is characteristic of the pieces produced by this group of artists. An instructive example of this approach is the elegant end-flute attributed to Kōetsu (fig. 43). This piece incorporates images of the sacred deer of the Kasuga Shrine in Nara, executed in raised *maki-e* technique and mother-of-pearl inlay on a gold lacquer ground. It was reputedly made by Kōetsu for his Noh teacher, a member of the Komparu School from Nara.

If Kōetsu's background had been one of specialized craftsmanship, it is likely that he would not have been able to experiment as he did with differing media and techniques, but his early training in evaluating swords and his genius for design and form allowed him to move from one creative challenge to the next with equal success and originality. Kōetsu's aesthetic was enduring, for it involved infusing elements of classical Japanese taste into simple, everyday circumstances. It served as an aesthetic counterpoint to the grandiose, gold-embellished arts and monuments of the military heroes of the day. At the same time, it surpassed them in innovative elegance and inspired design. The descendants of the Takagamine colony passed Kōetsu's ideas on to later generations, and they have remained influential to the present day, especially in the works of craftsmen working in the Kyoto area.

The most celebrated painter of Kōetsu's circle was Nonomura Sōtatsu (d. ca. 1643), an enigmatic figure who may have been related to Kōetsu by marriage. Like Kōetsu, he came from plebeian origins, and seems to have been a painter of fans before he came under Kōetsu's influence. Sōtatsu worked in two manners, monochrome ink line and washes, and bright, ebullient conceptions, generally inspired by classical native themes. In both styles his paintings are inventive and playful, and may be viewed as a kind of counterpoint to the mannered works produced in Kanō academic workshops in the early seventeenth century. Sōtatsu's paintings, such as *Wind and Thunder Gods* (cat. no. 65), serve as a splendid epilogue in the history of Momoyama painting, and their themes, drawn for the most part from Japanese antiquity, are unmistakable

evidence that the pendulum of artistic taste in Kyoto had swung away from the Chinese-derived themes popular with warlords and back to indigenous, familiar Japanese subjects that reveal the enduring sentiments and preoccupations of the populace of Kyoto.

The grand warlords' taste for opulent decor and exuberant use of gold in their possessions and surroundings, though overwhelming in its visual impact, did not represent the only influential aesthetic of the Momoyama period. Indeed, one might generalize that the arts and architecture of the era reveal not only a rich diversity of creative approaches but also a certain vacillation between two aesthetic poles that have their genesis in earlier centuries. The Momoyama period marks a watershed between the medieval centuries, when religious traditions and motivations predominated in the arts, and a new era, more secular and materialistic in its concerns, that foreshadows and fundamentally influences the subsequent course of history and culture.

The dynamic nature of the Momoyama period generated profound changes in the evolution of Japanese culture that occurred during the brief span of four decades. The most instructive manifestations of these changes are the innovative achievements in the arts and architecture of the era, which reveal, in turn, the differing tastes and interests of the various segments of society who patronized them. It is in the realm of secular architecture that the contrasting interests of the period are most apparent, in the massive grandiose castles and luxurious residences of the great warlords on the one hand, and in the diminutive tea houses, with their sense of reticence, disciplined simplicity, and rustic understatement on the other. Both aesthetics remained influential in the following centuries; the former in the authoritative context of the great castles and official chambers of the Tokugawa shoguns which were labored but uninspired imitations of the models of the Momoyama period, and the latter which had a broader more significant influence, and may be seen to the present day in traditional Japanese domestic architecture, with its sense of restraint, order, and discriminating taste.

Oda Nobunaga had envisioned the idea of unifying Japan under a single martial authority, and Toyotomi Hideyoshi had come close to achieving this objective by the time of his death. but it was Tokugawa Ieyasu who brought this profound change to fruition, and laid the foundation for a military dynasty and rigid, hieratic social system that was to last for two and a half centuries. Ieyasu established his *bakufu* government in Edo, and this city, parent of present day Tokyo, grew with astounding speed: by the end of seventeenth century the population was larger than that of any city in Europe. Edo, with its large number of warrior-bureaucrats, and the merchants and artisans who were the lifeblood of the metropolis, became not only the primary seat of administrative power but also the center of a vibrant new plebeian culture that inspired its own distinctive forms of popular art and entertainment.

But Kyoto continued as the steadfast wellspring of traditional creative inspiration, for the imperial court remained there, along with the artists and artisans who had served it for centuries. The city remained the focus for arbiters of refined taste and deportment, the descendants of Sen no Rikyū and other discerning tea masters of the Momoyama period, whose influence on Japanese thought, aesthetics, and the arts remains pervasive, even in contemporary life.

1. Copper 1965, 278–9.
2. Cooper 1965, 134.
3. See Naitō 1976. See also Miyagami 1977, which disputes some of Naitō's theories. For an English-language review of Naitō's writings on the subject, see Takayanagi 1977.
4. Cooper 1965, 368.
5. For a discussion of contemporary accounts of Eitoku's lost paintings for Azuchi Castle, see Wheelwright 1981c.
6. Cooper 1965, 136–37.
7. Cooper 1965, 288

Azuchi-Momoyama jidai, volume 8 of *Nihon bunkashi taikei* series (Tokyo: Shogakukan, 1958).

Mary Elizabeth Berry, *Hideyoshi* (Cambridge, Mass.: Harvard University Press, 1982).

C.R. Boxer *The Christian Century in Japan*, 1549–1650 (Berkeley: University of California Press, 1951).

Michael Cooper, S.J., *They Came to Japan: An Anthology of European Reports on Japan, 1543–1640* (London: Thames and Hudson, 1965).

George Elison and Bardwell L. Smith, *Warlords, Artists and Commoners* (University of Hawaii Press, Honolulu, 1981). Includes Smith's extremely informative bibliographic essay on Japanese society and culture in the Momoyama era.

Yamane Yūzō, ed., *Momoyama*, volume 8 of *Sekai bijutsu zenshū* (Tokyo: Kadokawa Shoten, 1965).

Robert Treat Paine and Alexander Soper, *The Art and Architecture of Japan* (Penquin Books, 1955).

George B. Sansom, *A History of Japan 1334-1615* (Stanford: Stanford University Press, 1961).

George B. Sansom, *Japan: A Short Cultural History* (New York: Appleton-Century-Crofts, New York, 1943).

Ryūsaku Tsunoda, Wm. Theodore de Bary, and Donald Keene, *Sources of Japanese Tradition* (New York: Columbia University Press, 1958).

H. Paul Varley, *Japanese Culture* (Honolulu: University of Hawaii Press, 3rd ed., 1984).

THE CATALOGUE

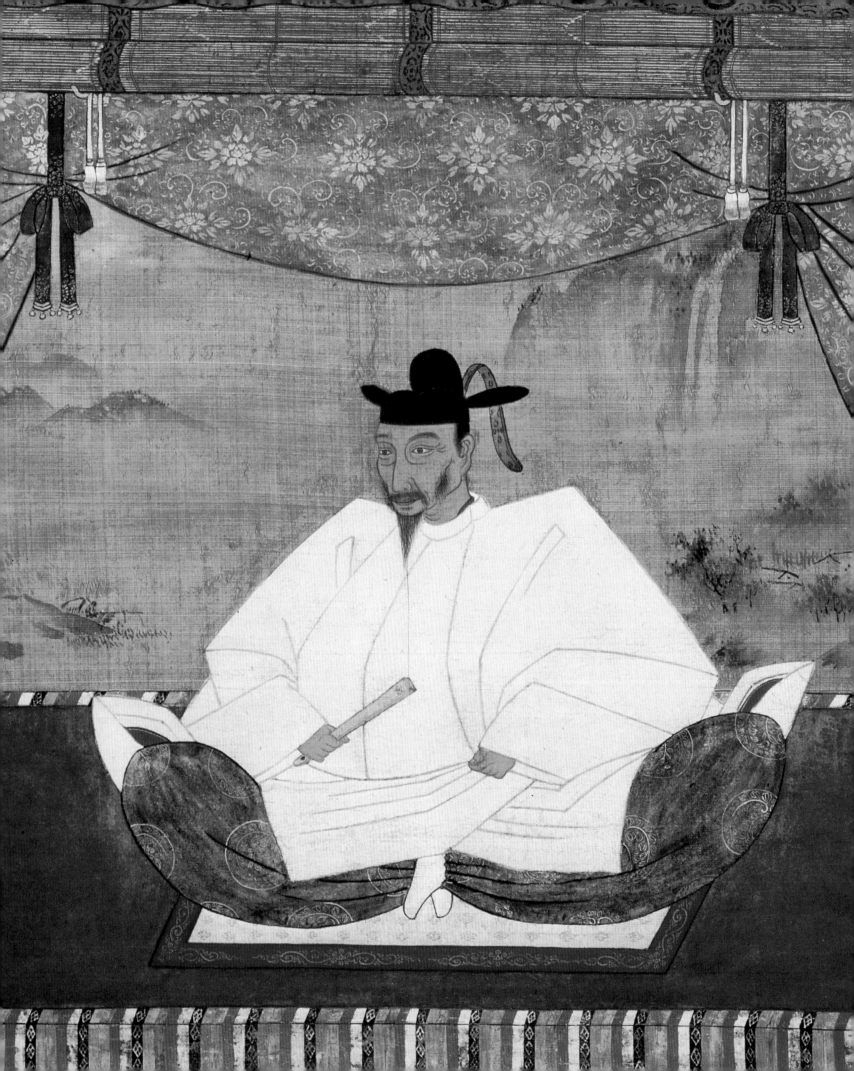

Portraiture

CHRISTINE GUTH

Painted and sculpted portraits of contemporary figures occupy a prominent place among the arts of the Momoyama era. Their subjects include emperors and warlords, prominent cultural personalities and merchants, monks and nuns, as well as lay women and children. Although there is a marked tendency towards conventionalization, the expressive range of Momoyama portraiture is broad, with many works of compelling physical and psychological insight.

Like portraiture in the West, the constellation of styles and meanings of Momoyama portraiture is based on the human likeness, but it does not necessarily follow that the same concept of individuality or of the means of giving it expression underlie both traditions. The sense of individuality that informs Japanese portraiture of the Momoyama period operates within the context of the group — family, lord-vassal, or master-disciple. Moreover, artists of this era, despite their apparent commitment to realism, were less concerned with superficial resemblance to the specifics of the observable world than with infusing their work with the essential spirit of the subject. If the proliferation of likenesses of contemporary figures such as the three hegemons Nobunaga, Hideyoshi, and Ieyasu raises provocative questions about changing perceptions of self-identity, it is important to recognize that the vast majority of portraits painted during this era served less as vehicles of self-propaganda than of family public relations. While the rise of portraiture would seem testify to a growing desire for self-aggrandizement, most paintings and statues were created to provide a tangible link between the living and the dead by serving in mortuary and memorial rites observed at Buddhist temples and Shinto shrines. Although these observances differed from one institution to another, Shinto, Buddhist, and even Neo-Confucianist elements were inextricably entwined in the beliefs underlying them. In an era when religion increasingly served to achieve temporal goals, spon-

sorship and veneration of portraits could be charged with political significance as well.

Both records as well as the number and variety of surviving works testify that the practice of recording an individual's appearance in pictorial or sculptural form became increasingly widespread from the fifteenth century on.[1] There is a paucity of information about the forces that precipitated this development, but the influence of ancestral portraiture, which first developed in China during the Ming dynasty (1368-1644), and the spread of Confucian values beyond the confines of Zen monasteries and academies in Japan must be considered among the contributing factors. Confucianism, intermingled with Buddhism and Shinto, fostered a growing emphasis on loyalty to the ruler and piety towards one's ancestors. During the fifteenth and sixteenth centuries, Confucian moral and ethical teachings were promoted by daimyos through books imported from China as well as through paintings, such as those illustrating the "Twenty-four Paragons of Filial Piety." The sponsorship and veneration of portraits of real or fictive ancestors was a further expression of these ideals.

The forms and styles of Momoyama portraiture do not differ significantly from those of preceding periods. And it is partly owing to this conservatism in an era of great artistic innovation, that portraits have been subjected to far less rigorous scrutiny than other aspects of Momoyama art. Portrayals of the deified Nobunaga, Hideyoshi, and Ieyasu, draw on the idioms traditionally employed for the representation of Buddhist and Shinto divinities, especially deified humans, to create images of considerable iconic power. A genre of realistic portrait painting and statuary known as *chinsō* first promoted by the Zen sect for the representation of eminent ecclesiastics continued to be practiced. The tradition of *nise-e,* "likeness pictures," a native style of painting that grew out of idealized portrayals of poets, may inform the representation of laymen and women. Within these disparate traditions, the weight accorded observable reality varies widely.

Fig. 44. *Portrait of Toyotomi Hideyoshi*, detail of cat. no. 6.

Fig. 45. *Portrait of Nisshin*, 1596. Kyoto National Museum.

portraits" and those made posthumously, known as *izō*, "portraits left behind." Although their creation was prompted by different ritual needs, whose precise nature is not fully understood, both may be based on sketches made from life and may employ the same idioms to create an image distinguished by a high degree of visual specificity. The production and practices associated with both types of images originated in China and were disseminated in Japan through Buddhist, especially Zen, influence. Initially eminent monks were the primary subjects of both types of portraits, but by the Kamakura period secular figures were honored in this form as well.

The arresting portrait of Takeda Shingen (cat. no. 3), which vividly conveys the daimyo's protean strength, earthy sensuality, and martial persona exemplifies the descriptive power characteristic of the finest *juzō*. Because of their especially close relationship to the person portrayed, many life portraits were later regarded as sacred relics and donated to temples to be displayed during mortuary rituals. Such works were generally created when a person reached a certain age or status, and may have been displayed in connection with ceremonies for the prolongation of life. If fear of death is never made explicit in *juzō*, there is no question but that their symbolic force derived from its potential. Longevity ceremonies had figured prominently among the rituals of most Buddhist sects since ancient times, but their precise relationship to the creation and use of portraiture remains unclear. However, a connection may be inferred from the portrait of the Nichiren sect monk Nisshin (1561–1617) now in Kyoto National Museum (fig. 45). Painted in 1596, when the monk retired after eighteen years as abbot of Honkokuji, it portrays him reading the "Nyorai juryōhon," the sixteenth chapter of the *Lotus Sutra* in which the Buddha Sakyamuni declares himself to be eternal. Recitation and copying of this scripture were central to many longevity rites (see cat. no. 73).[2]

Formal portraits painted or sculpted during the subject's lifetime, as well as those executed posthumously, often relied on sketches made on the basis of direct observation. The initial sketches, *kamigata*, generally showed only the face. Using these, the artist then prepared full body preliminary drawings, often with colors added, to be presented to the subject for his approval. The Itsuo Museum in Osaka has in its collection just such a drawing of Hideyoshi, with an approving notation by an intermediary that it closely resembles the subject. The tension between the veristic impulses seen in the face and the artifice and abstraction of the garment, characteristic of many secular portraits of the period, may be attributed to the fact that only the face was rendered from life.

Because they "captured" the spirit of the subject, sketches and preliminary drawings often became objects of veneration in their own right. A drawing of Myōhō, a nun of the Nichiren sect, executed in 1598, when she was seventy-three, is a case in point (fig. 46). The artist Hasegawa Tōhaku has rendered Myōhō's age-worn face with downcast eyes carefully and with great sensitivity, but the multiple lines delineating her garment show the artist searching for the perfect contours. Myōhō herself wrote the inscriptions on two large pieces of paper in the upper left and right, just prior to her death. Her son, the monk Nittsu, probably attached these to the sketch when he added his own inscriptions, including the invocation *Namu myōhō renge kyō*, "Hail to the Sutra of the Lotus of the

Physiognomy is the most important element in the construction of identity in all forms of Momoyama portraiture, but posture, dress, setting, and the absence thereof, are also employed to varying degrees towards this end. While observed data and illusionistic techniques including shading of the garments and sharp modeling of the face may create a tangible physical presence with a discrete identity, the relationship of image to person is often problematic since the "reality" recorded may not be empirical but based on the artist's concept of how the individual should be represented. This is especially clear in portraits of women, which, despite their apparent individuality, often use the authority of the idioms associated with the representation of esteemed poetesses to ennoble and dramatize their identity. Behavioral codes pertaining to facial expressions and gestures, cultural norms of dress, as well as artistic conventions may also play a role in fashioning the persona presented in a portrait painting or statue. For instance, strict frontality is rare in painted portraits, the legacy of a pictorial tradition in which only the Buddha is shown in full face. Finally, just as specific temporal settings and attributes may serve to inform the viewer about the subject's status and character, so to the stripping away of visual referents to the mundane world may strengthen the aura of divinity by removing the figure from the contingencies of time.

Portrait statues and paintings fall into two broad categories: those made during the subject's lifetime, known as *juzō*, "longevity

Fig. 46. *Portrait of Myōhō*, attributed to Hasegawa Tōhaku, 1598.

Fig. 47. *Portrait of Fujiwara no Kamatari*, fourteenth century. The Metropolitan Museum of Art, New York.
Purchase, Bequests of Edward C. Moore and Bruce Webster, by exchange, and Gifts of Mrs. George A. Crocker and David Murray, by exchange (1985.16).

True Law," inscribed directly above her head. These inscriptions make tangible the relationship between mother and son as well as adding to the portrait's aura of sanctity.

Signatures as well as documentary evidence indicate that artists of all the major schools, as well as the occasional amateur, painted portraits. Examples by or attributed to Kanō, Hasegawa, and Tosa painters are in the majority. In the increasingly competitive artistic environment of the late sixteenth and early seventeenth centuries, artistic survival depended on the ability successfully to fulfill the multifarious demands made on them by their patrons – whether a design for a saddle, the decor for an entire room, or a lifelike portrait. While talent was a major criterion in selecting a painter, political or religious affiliations could also play a role. Because they were adherents of the Nichiren sect, both Kanō and Hasegawa school painters were often commissioned to paint portraits of its prelates. A large body of documentary evidence as well as numerous preparatory drawings by Genji and Kyōgoku, two Tosa school artists living in the port city of Sakai during the 1570s, reveals that members of this school were unusually active in the realm of portraiture.

The personal vanity, ambition, and desire for immortality so pronounced in the lives of the three rulers, are given visible expression in the numerous portrait paintings and statues which they or their followers commissioned. At least eighteen portraits of Hideyoshi alone are known, a surprisingly large number in view of

the fact that production ceased after 1615, when Ieyasu wiped out the last of Hideyoshi's allies and sought to destroy all traces of his rule (cat. nos. 6, 7).[3] Borrowing the iconographic conventions traditionally employed for the representation of deified emperors and aristocrats, such as Fujiwara no Kamatari (fig. 47), they depict the subject seated on a raised ceremonial mat, often framed by richly figured brocade curtains, as if within a shrine. Their status as deified spirits helps to explain why any sign of their ruthlessness or violent personalities has been exorcised. It also helps to explain why, in an era when much painting pushes forward towards the spectator, portraiture is so often characterized by a sense of distance, with their subjects seemingly occupying a closed and clearly delineated space beyond our own.

The creation of portraits of Nobunaga, Hideyoshi, and Ieyasu, was closely tied to efforts to legitimate their rule by cloaking themselves in the mantle of religious authority. Since the Nara period (710-94), many historical personages had been honored posthumously for their personal qualities and achievements, a few becoming the objects of widespread cults. Prince Shōtoku's piety and contributions to Buddhist causes in the seventh century had led to his being revered as the founder of Japanese Buddhism. This process of mythologization included his portrayal as a divine ruler, through identification with various Buddhist deities including the historical Buddha Sakyamuni (J: Shaka) and the Bodhisattva Avalokitesvara (J: Kannon Bosatsu). Similarly, the descendants of Fujiwara no

Kamatari, sought to enhance the religious aura of the founder of their noble family by identifying him with the charismatic Buddhist layman Vimalakirti (J: Yuima). Unlike these eminent personalities, however, Nobunaga, Hideyoshi, and Ieyasu were not seen primarily as avatars of Buddhist deities of Indian or Chinese origin, but rather as Japanese deities in their own right.

Nobunaga was the first of the three hegemons to adopt the strategy of self-deification to advance his legitimacy. When Father Frois visited Azuchi castle, which Nobunaga designed as the ritual center for his worship as divine ruler, he declared himself to be "the very *shintai* and living *kami* and *hotoke* [god and Buddha] and that there was no other lord of the universe and author of nature above him."[4] Hideyoshi and Ieyasu, patterning their efforts after Nobunaga, also co-opted the symbolic language of Buddhism and Shinto to bolster their quest for national supremacy. The construction of the Great Buddha of Hōkōji, through which Hideyoshi sought to create a rival to the fifty-four-foot gilt bronze statue at Tōdaiji in Nara, built in the eighth century, was an early demonstration of his manipulation of religious symbolism for political ends. Hideyoshi also demanded that a shrine dedicated to himself be constructed adjacent to Hōkōji so he could be worshipped as the deity Toyokuni Daimyōjin (also read as Hōkoku Daimyōjin), the divine protector of Japan. Like Nobunaga before him, Hideyoshi even claimed the power to bestow divine blessings and salvation to all who worshipped him.

Ieyasu himself also sought to enhance his status and power through symbolic means, but his transformation into a divine ruler was carried out largely by his grandson Iemitsu, who oversaw the construction of the shrine dedicated to him at Nikkō, where he was worshipped as Tōshō Daigongen, "Great Incarnation Shining Over the East." Like the honorific (Dai)myōjin adopted earlier by Hideyoshi, (Dai)gongen and its variants were titles employed for deities worshipped at shrines whose cult combined both Shinto and Buddhist elements. The establishment of branches of Nikkō Shrine throughout the provinces promoted the worship of Tōshō Daigongen as the divine founder of the Tokugawa dynasty and as an exemplary ruler among both Tokugawa family members and vassals.

Inspired by these models, other daimyo were also promoted to *kami* status either during their lifetime or after death. Katō Kiyomasa was among those who made provisions for himself to be venerated as a Daigongen, while at the same time promoting the worship of Toyokuni Daimyōjin in shrines within his domain (see cat. no. 10).[5] In most instances, however, the apotheosis of an eminent personality was carried out by family members after his death. They in turn commissioned statues of them to serve as *shintai*, the material embodiment of the divine spirit, for installation in shrines, as well as paintings. Whereas statues functioning as *shintai* were generally not visible to the devotee, paintings were probably displayed on the occasion of commemorative festivals. However, most shrines were purged of such imagery as part of the official separation of Buddhism and Shinto carried out in the Meiji period, and few if any examples remain in situ.

The vast majority of surviving Momoyama-era portrait statues and paintings are in the possession of Buddhist temples, especially but not exclusively, *bodaiji,* those which assumed primary responsibility for conducting memorial rites on behalf of the members of

the families associated with them. The portrait of Emperor Go-Yōzei, for instance, has been preserved in Sennyūji, one of several *bodaiji* where prayers were offered to deceased members of the imperial family (see cat. no. 18). As the dwelling place for the spirit, these images were functionally equivalent to the tablet (*ihai*) bearing the name of the deceased that is placed in a mortuary temple.[6] Although the daimyo elite belonged to many sects, Kyoto's five leading Zen temples, Daitokuji, Kenninji, Myōshinji, Nanzenji, and Tōfukuji, as well as their regional affiliates, are especially rich repositories of portrait painting. Many of the lavishly decorated subtemples in the grounds of these complexes were constructed to honor the memory of eminent personalities, and their portraits were displayed there during special commemorative observances.

Inscriptions testify that family members or other associates sponsored the creation of commemorative portraits as an expression of filial piety to a real or fictive ancestor. The first anniversary of the subject's death was most often, although by no means the only, occasion for such a commission. Eminent monks associated in some way with the subject or family members were often asked to add to the portrait the subject's name and an eulogy, thus enhancing its talismanic value and sanctity. As a close family associate, the priest who inscribed the painting was often the officiant in such annual prayers and offerings. Portraits serving as the focal point of services held on the anniversaries of the day of death were often copied for distribution to disciples and family members.

Many of the monks who inscribed portraits of the three unifiers or other great personalities of the era were themselves commemorated in sculptural and pictorial form. Just as secular portraits confirmed real or fictive family ties, so too, religious portraits confirmed a spiritual genealogy. They were generally installed in portrait halls (*eidō*), founder's halls (*kaizandō*), or patriarch's halls (*soshidō*), where they were the focus of ritual offerings and other devotional activities by their spiritual descendants.

The portrait statue of Ishin Sūden (1569-1632), the Nanzenji abbot who inscribed the painting of Hosokawa Yūsai (cat. no. 17), is typical of the genre of *chinsō* sculpture created for temples of the Zen sect (fig. 48). Although the abbot's pose, sumptuous attire and props, such as the high-backed chair and staff, follow the conventions of traditional *chinsō*, this work exhibits a technical virtuosity and flamboyant coloring characteristic of sculpture of the Momoyama period. Its unusually small scale was no doubt motivated by its intended placement in the second story of the entry gate (Sammon) of Nanzenji, to commemorate Sūden's contributions to the reconstruction of this structure in 1628.

Although Sūden's statue was installed without incident, Sen no Rikyū's suicide, one of the most celebrated and enigmatic events of this era, has been attributed to the installation in 1589 of his portrait statue in the upper story of Daitokuji's entry gate. This now lost wooden statue of Rikyū, dressed in monastic garb and straw sandals, was enshrined after he had provided funds for the construction of a two-story gate at Daitokuji as a memorial to his father, who had died fifty years earlier, and as a tribute to his teacher Kokei Sōchin (see cat. no. 1). There is some question about whether the statue was commissioned at Daitokuji or at Rikyū's personal request, but its creation was no doubt intended as a tribute to him. Why such a statue could have so aroused Hideyoshi's anger

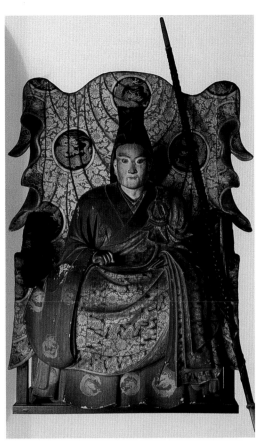

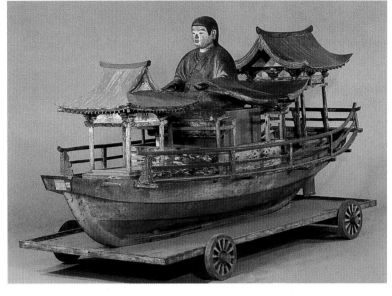

is not clear, but it is possible that he took umbrage because it was put in place during Rikyū's lifetime. While enshrining a statue of a donor on temple grounds was not uncommon, it was usually done posthumously. The role of portraiture in self-sacralization may also help to explain why Hideyoshi later had Rikyū's statue crucified.[7]

The proliferation of female portraiture can be explained by reference to the same dynastic concerns that underlay the growth of other forms of portraiture. Surviving works represent only members of the social, political, and cultural elite, with individuals singled out for representation not because of their character or achievements but rather for the position they occupy within a family lineage. They invariably present the subject in the most favorable light, as a model of those virtues most esteemed in a woman of the day. While a few women, such as Oichi no Kata (cat. no. 2) were noted for their exceptional beauty, for the most part, they are remembered for their piety and devotion to their family. The pictorial idioms employed – most notably the relatively stylized facial features and extreme attention to details of garment pattern – follow traditions that originated in courtly painting of the Heian period. In the Heian period, taste in dress was a sign of character and refinement, and this outlook continued to prevail to some extent in the sixteenth century. Because of this conventionalization, in the absence of poetic inscriptions or eulogies added by family members or respected monks, the subjects of such portraits are not always easy to identify today. It is possible, however, that some contain informative details, such as the special garment worn by Seitokuin (cat. no. 13), that would have ensured their identification by family members. Generally commissioned as expressions of filial piety, the portrayals of women today subject to public gaze were originally intended solely for family viewing.

The exceptionally large number of female portraits raises questions about the growing prominence of women in the culture of the period. If women indeed did enjoy greater standing, it was primarily as wives and mothers, sisters and daughters, and not, as in the Heian period, for their literary accomplishments. This emphasis is not hard to understand given the extraordinary importance of marriage politics and the authority resting in maternal hands in this era of uncertain succession. Although the desired results were not always achieved, strategic marriages were widely employed by daimyo of the period to expand their power base and secure loyalty among their allies. When Okudaira Nobumasa's first wife was assassinated by a rival for power, Tokugawa Ieyasu offered his daughter Kamehime (Seitokuin) in marriage in exchange for a pledge of allegiance (see cat. no. 13). When Hideyori came of age, however, Ieyasu's relationship through marriage to Hideyoshi's younger sister, did not prevent him from annihilating his nephew as a potential rival for power. Rendered powerless, Hideyori's mother Yodogimi, who had managed to protect her son from just such a fate during the years since Hideyoshi's death by surrounding herself with Toyotomi family supporters, committed suicide along with her son. Although suicides among women who had lost their value as pawns in political alliances were not uncommon, some chose instead to take refuge in Buddhist temples, and are represented in religious attire in their posthumous portraits.

Exceptional among portraits of the era, those of children are affectionate rather than merely respectful. In the touching portrayal of Maeda Kikuhime, the adopted daughter of Hideyoshi who died at age seven, her favorite toys – dolls, and a papier-mâché dog – are shown by her side. The statue of the baby-faced Sutemaru, Hideyoshi's beloved first son, who died at the tender age of three, though stylized, also exerts a strong emotional appeal (fig. 49). The statue, originally enshrined in Shōunji, Sutemaru's memorial temple, is now preserved at Myōshinji with a toy boat and miniature armor and helmet (cat. nos 139-40). Both the statue and the boat were presented to their respective temples by the grieving father, Hideyoshi.

Funerals and memorial services for the spirits of the dead were an integral part of the Momoyama ritual universe. The extra-

ordinary number of casualties on the battlefield or deaths under tragic circumstances occurring during this bellicose era no doubt intensified the preoccupation with pacifying and insuring the auspicious rebirth of the spirit of the deceased. By their sponsorship of portrait paintings and statues, men and women could honor their ancestors and secure for them a measure of immortality.

NOTES:

1. See Tani 1937, 129-33.
2. For a brief discussion of longevity celebrations and their association with this scripture, see Tanabe 1988, 42.
3. Tani 1939, 2.
4. Cited in Ooms 1985, 36.
5. Ooms 1985, 61.
6. Foulke and Sharf 1993-4, 193.
7. Varley and Kumakura 1989, 44–6, 220-2.

FURTHER READING:

Maribeth Graybill, "Portrait Painting," *Kodansha Encyclopedia of Japan* (Tokyo/New York: Kodansha, 1983), 6:226-8.

Jan Fontein and Money L. Hickman, *Zen Painting and Calligraphy,* (Boston: Museum of Fine Arts, 1970).

Sherman Lee, et. al., *Reflections of Reality in Japanese Art* (Cleveland: Cleveland Museum of Art/Indiana University Press, 1983).

Jared Lubarsky, *Noble Heritage: Five Centuries of Portraits from the Hosokawa Family* (Washington: Smithsonian Institution, 1992).

Mori Hisashi, *Japanese Portrait Sculpture*, trans. W. Chie Ishibashi (Tokyo/New York: Kodansha International, 1977).

Yoshiaki Shimizu, *Japan the Shaping of Daimyo Culture 1185-1868* (Washington, D.C.: National Gallery of Art, 1988).

Shirahata Yoshi, *Shōzōga*, vol. 8 of *Nihon no bijutsu* (Tokyo: Shibundō, 1966).

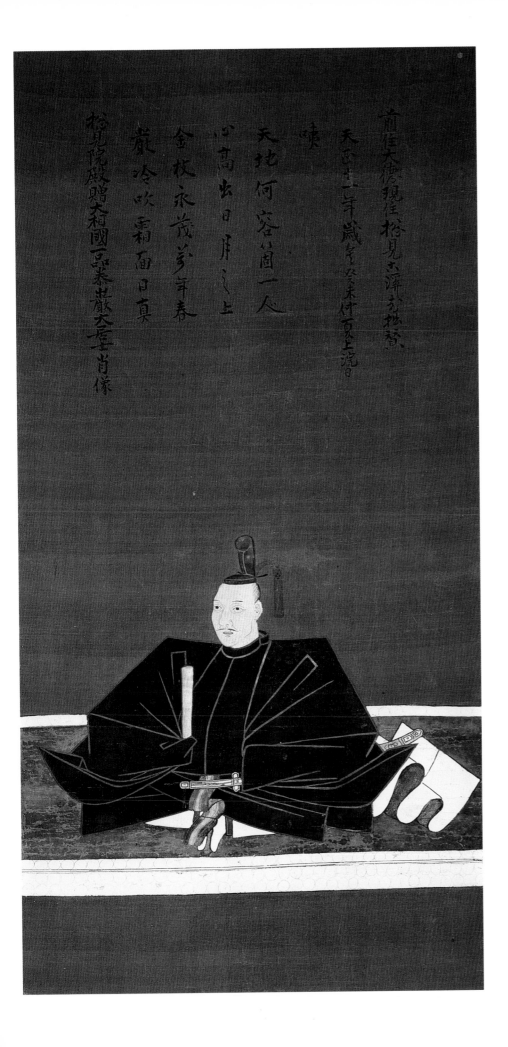

1. PORTRAIT OF ODA NOBUNAGA

Colophon by Kokei Sōchin, dated 1583
Hanging scroll; ink and colors on silk
73.3 x 36.8 cm
Kobe City Museum
Important Cultural Property

Alert and youthful in appearance, the powerful warlord Oda Nobunaga (1534–82) is depicted in stiff formal court dress with highly stylized robes engulfing his body. His facial expression in this portrait hardly reveals his ruthless, violent and determined nature. Ironically, the robes suggest his role as *udaijin* (minister of the right), the imperial court's third highest rank, which was awarded in 1577 by Emperor Ōgimachi, but which Nobunaga held only for a few months before he resigned of his own accord.

The inscription praising Nobunaga's virtues is by the Zen prelate Kokei Sōchin (1532–97), former abbot of the important Kyoto monastery Daitokuji. In 1583, the date given in the colophon, Sōchin was serving as founding abbot of the Sōken'in, a subtemple of Daitokuji newly established in memory of Nobunaga by Toyotomi Hideyoshi. Thus this idealized image is thought to have been commissioned for use in memorial ceremonies at the Sōken'in on the first anniversary of Nobunaga's death.

Nobunaga was the son of Oda Nobuhide (1510–51), daimyo of Nagoya Castle in Owari Province. At fourteen Nobunaga was married to the daughter of Saitō Dōsan (1494–1556), the daimyo of nearby Mino Province. At seventeen he succeeded his father, and spent the next decade consolidating and expanding his holdings. In 1557 Nobunaga killed his younger brother Nobuyuki for plotting against him, and during the 1560s fought the Saitō clan for lands to the west. At twenty-four Nobunaga defeated the powerful Imagawa Yoshimoto (1519–60) of Suruga Province and released the young Tokugawa Ieyasu who had been held hostage there. Ieyasu would become one of Nobunaga's most valued allies.

By 1568 Nobunaga's military prowess was recognized by Ashikaga Yoshiaki (1537–97), who sought support for his claims to be shogun and was desperately needing protection. Nobunaga marched into Kyoto in 1568 and installed Yoshiaki as shogun. He then embarked on a series of campaigns in the Kyoto area, taking in 1569 the influential port city of Sakai, where European-style firearms were being manufactured (see cat. no. 133). Nobunaga quickly trained his troops to use matchlocks, and guns were an important factor in his 1570 victory at the Battle of Anegawa over Asakura Yoshikaga (1533–73) of Echizen Province and his own brother-in-law Asai Nagamasa (1545–73). Nobunaga's sister Oichi no Kata was betrothed to Nagamasa as part of the treaty-making process, as discussed in the following entry. Some of the defeated armies of Asakura and Asai sought refuge in Buddhist monasteries

on Mount Hiei, northeast of Kyoto, and the following year Nobunaga attacked, torching temples and killing thousands of monks. The destruction of Mount Hiei was Nobunaga's way of demonstrating his determination to control central Japan and to dominate the various Buddhist strongholds, which had vast landholdings defended by troops of warrior-monks. It was also one of the greatest losses in Japanese cultural history, for Enryakuji and its numerous subtemples and associated facilities had been important repositories for Buddhist art since the ninth century.

As Nobunaga consolidated power in the early 1570s, his troops were challenged on all fronts. During this time Takeda Shingen (1521–73) began attacks in the east (see cat. no. 3). Religious uprisings (*Ikkō ikki*) to the north and southeast resulted in the slaughter of tens of thousands of Pure Land Buddhist adherents. To finance such military efforts Nobunaga began a systematic burning of Kyoto in 1573, until its residents agreed to higher taxes and stricter controls. In the late 1570s, the daimyo Mōri Terumoto (1553–1625) of Aki Province to the west and Uesugi Kenshin (1530–78) of Echigo Province to the north tried but failed to break Nobunaga's tightening grip on central Japan. Ultimately defections, defeats, and deaths among Nobunaga's adversaries resulted in his eventual control of the main part of Honshū. The surrender in 1580 of Kennyo Kōsa (1543–92), the powerful prelate of the Ishiyama Honganji fortified temple compound in Osaka, marked the beginning of the end of resistance to Nobunaga's unification policy.

To provide himself a safe residence outside but near Kyoto, Nobunaga began building Azuchi Castle in 1576 on the eastern shore of Lake Biwa (see pp. 28–30). His efforts to decorate the castle and to assert his cultural hegemony resulted in an extraordinary flourishing of the arts in Kyoto. He embarked on a rebuilding of the imperial palace, too, as a way of thanking and controlling the imperial court. Nobunaga's personal interest in Noh theater and the tea ceremony brought renewed attention, and money, to these arts. He was an ardent collector of tea utensils, sometimes at the expense of their owners who were forced to give up their prized possessions to satisfy his demands. While hosting a tea ceremony at the Nichiren Buddhist temple of Honnōji in Kyoto on 21 June 1582, a former ally Akechi Mitsuhide (1528–82) attacked Nobunaga. Wounded and seeing no escape, Oda Nobunaga committed suicide amid the burning temple halls.

Hideyoshi heard of Nobunaga's death while campaigning against Mōri Terumoto in the west and immediately returned to attack and kill Mitsuhide. Azuchi Castle was burned in the turmoil over succession, and Hideyoshi chose to build his own palace in Kyoto. To honor

Nobunaga, Hideyoshi ordered that a new subtemple be erected at Daitokuji in 1582, and the Sōken'in was elaborately outfitted, with Kokei Sōchin serving as its founding abbot. As suggested above, it was here that this portrait was probably inscribed and first displayed.

BAC

References: Fujiki and Elison 1981, 149–83; Tani 1973, 74.

Cat. no. 2a. Portrait of Oinu no Kata, Ryōanji, Kyoto.

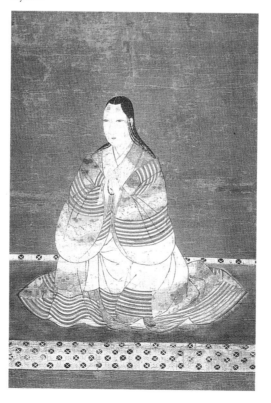

2. PORTRAIT OF OICHI NO KATA

1589
Hanging scroll; ink and colors on silk
96.0 x 40.9 cm
Jimyōin, Kōyasan, Wakayama
Important Cultural Property

Oda Nobunaga extended his sphere of political influence and consolidated his territorial gains not only by military campaigns, but also by forming alliances with other powerful warlords (see cat. no. 1). Agreements, intended to guarantee the safety of Nobunaga's eastern flank, were reached with Tokugawa Ieyasu in 1562 and the truculent Takeda Shingen of Kai Province three years later (see cat. no. 3). A treaty with Asai Nagamasa (1545–73) of Ōmi in 1564 served to buttress his security in a crucial area to the west, in strategic proximity to the capital. In keeping with common practice of the period, a marriage contract was concluded in connection with each of these alliances. Thus, one of Nobunaga's daughters was affianced to Ieyasu's eldest son, Nobuyasu (1559–79), while an adopted daughter was given to the son of Shingen. Nobunaga's younger sister Oichi no Kata ("Lady Oichi"), the subject of this portrait, was eventually married to Nagamasa in 1565. She was seventeen at the time.

Nagamasa's career demonstrates the insecurities and shifting allegiances that characterized the times. He had become Nobunaga's ally through treaty and marriage, but in 1570 he sided with Asakura Yoshikage (1533-73), one of Nobunaga's archrivals. In 1573 Nobunaga's forces were sent to attack his stronghold, the castle of Odani in Ōmi Province. When the castle fell, Nagamasa – who was only twenty-eight at the time – and his father took their own lives rather than fall into the hands on the attackers. The cruelties of the age are also revealed by the treatment of Nagamasa's mother, who was only put to death after her fingers were methodically removed. Some days later, Nobunaga had the heads of Nagamasa and Yoshikage publicly displayed to the inhabitants of Kyoto. These grisly trophies are said to have been subsequently lacquered and gilded, and exhibited at a banquet. Nagamasa's wife, Oichi, and her three young daughters escaped death, having been taken to Nobunaga's headquarters at Kiyosu in Owari before the battle.

Oichi's value in concluding alliances was demonstrated once again when she was married to the powerful warlord Shibata Katsuie (1522-83) in 1582. The marriage had been arranged by Oda Nobutaka (1558-83), after the death of his father, Nobunaga. But Hideyoshi, alarmed by Katsuie's opposition, attacked him at Kitanoshō Castle in Echizen in 1583. When the overthrow of the castle seemed imminent, Katsuie addressed his followers and urged his wife to escape. Oichi refused and, having made prior arrangements for the safety of her children,

resigned herself to death at her husband's side. Katsuie then set fire to the castle, stabbed his wife and other members of the family, and then cut open his abdomen in full view of his fellow combatants Many of his followers emulated his example, accompanying him in *seppuku* (ritual suicide). Oichi was only thirty-six years of age at her death.

Nagamasa's three adolescent daughters had been taken to Osaka where they were placed under the guardianship of Hideyoshi. The eldest of the daughters, Chacha, became Hideyoshi's principal concubine and the mother of his two sons, Tsurumatsu (Sutemaru) and Hideyori. Better known as Yodogimi or Yododono (names derived from the castle given her on the Yodo River south of Kyoto), she remained a powerful force after Hideyoshi's death. She and Hideyori directed the fortunes of the Toyotomi coalition from Osaka Castle, where she died in 1615, at age forty-six, in the final siege and conflagration of the great castle. Hideyoshi arranged marriages for Chacha's sisters to Kyōgoku Takatsugu (1560–1609) and Tokugawa Ieyasu's heir, Hidetada (1579–1632), who became the second Tokugawa shogun.

Oichi, along with her sister, Oinu (who is represented in a similar portrait in the Ryōanji; fig. 2a) were said to be great beauties, a tradition supported by this portrait, which presents Oichi in the manner typical of a woman of high status in a military household. Her hair is parted precisely, and allowed to fall naturally down her back, without decoration or embellishment, in the time-honored court style. She is shown with *tsukuri-mayu*, "made-up eyebrows," which were created by shaving off the actual eyebrows and redrawing them high on the forehead with cosmetic pigment (a custom that had its origins in fashions of the Heian court). She wears a white, patterned *kosode* garment over an elaborately woven, multi-colored *koshimaki*, or "waist wrap." Underneath, and apparent only at the collar folds and lower hem, is a *kosode* decorated in the *katasuso* ("shoulders and hem") manner, also seen in cat. no. 14. Sitting sedately on a *tatami* mat, she holds a Buddhist sutra handscroll in her right hand, indicating that the painting was intended to be used in ceremonies commemorating her death.

The Jimyōin, a mortuary temple affiliated with the great Shingon monastery at Kōyasan in the mountains of Wakayama Prefecture, also has memorial portraits of Oichi's husband, Nagamasa, and his father, Hisamatsu. It has been suggested that the representations of Nagamasa and Oichi were painted in 1589 to commemorate the seventeenth and seventh anniversaries of the deaths of the subjects. The pair of portraits were donated at some later date to Jimyōin, where they are now preserved together with the portrait of Hisamatsu, which was painted in 1569.

MLH

References: Shimizu 1988, no. 22.

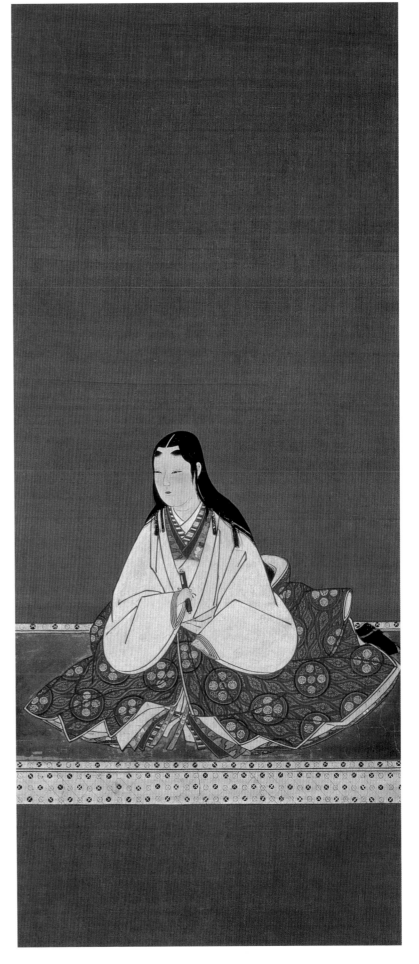

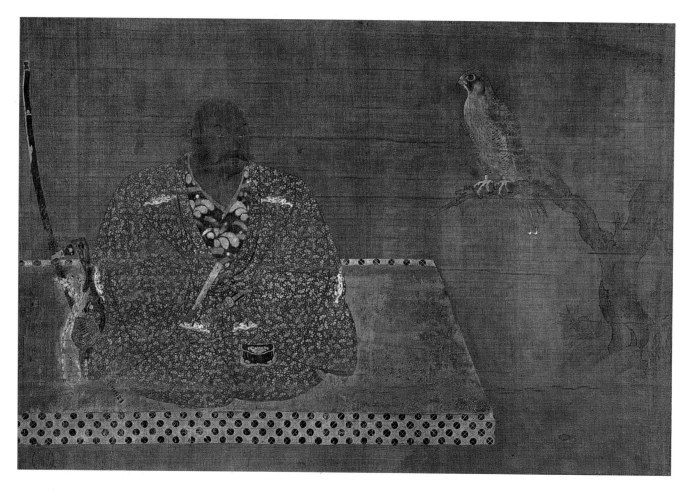

3. PORTRAIT OF TAKEDA SHINGEN

Hasegawa Tōhaku (1539–1610)
Circa 1570s
Hanging scroll; ink and colors on silk
42 x 63 cm
Seikeiin, Kōyasan, Wakayama
Important Cultural Property

This portrait of the famous warrior Takeda Shingen (1521–73), although small, is impressive for both its presentation of the daimyo's powerful appearance and for the exquisite detail of the garments and hunting hawk. Shingen's massive body seems taut, his expression stern, and his eyes piercing. While many warrior portraits show a seated figure with legs crossed in a relaxed pose, Shingen seems ready to spring into action. The symbolic juxtaposition of the warrior and the hawk (with its martial associations) is obvious; the visual connection is reinforced by having the warrior's patterned robe nearly matching the hawks chest feathers. The loosely brushed tree, rocks and grasses suggest an outdoor setting, again in contrast to conventional memorial portraits.

Shingen was a scion of the Takeda clan – descendants of the once-powerful Minamoto family – who served as military governors of Kai Province. He was the oldest son of Takeda Nobutora (1498–1574), but usurped his father's position in 1541 and drove him into exile. Later Shingen, in turn, arrested his own son for

political conspiracy and ordered him to commit suicide. In 1542 Shingen began a series of violent incursions into nearby territories, seizing Shinano Province and frequently battling with Uesugi Kenshin (1530–78) of Echigo Province at Kawanakajima for hegemony in this area of central Japan. The fourth battle of Kawanakajima in 1561 reportedly involved more than 30,000 troops, with heavy casualties on both sides, making it one of the bloodiest in sixteenth-century Japan.

Shrewdly Shingen, whose motto was "Fast as the wind; quiet as the forest; aggressive as fire; and immovable as a mountain" (Varley 1970, 108), was quick to see the advantage of European-style guns and in 1555 ordered three-hundred matchlocks for his troops. His experiments with firearms and his innovative techniques in troop deployment would greatly influence other daimyo. In 1568 Shingen turned south and occupied Suruga Province in preparation for an advance on Kyoto in 1572. He wanted to challenge Oda Nobunaga for control of the capital and the central government. Shingen's seasoned soldiers ravaged the armies of Tokugawa Ieyasu at the 1572 Battle of Mikatagahara in Totomi Province, but then Shingen decided on a tactical withdrawal for a later offensive. In 1573 Shingen again attacked Ieyasu, laying siege to Ieyasu's castle at Noda in Mikawa Province, but Shingen was

shot in the head by one of the Tokugawa gunners. Shingen's son Takeda Katsuyori (1546–82) attempted to carry out his father's plans, but the momentum was lost. The history of Shingen's rise and fall was featured in the film *Kagemusha* (The Shadow Warrior) by the noted Japanese director Kurosawa Akira .

The artist's seal reads "Nobuharu," and the work is considered to be an early painting by Hasegawa Tōhaku (see cat. nos 53–4). If Tōhaku painted this portrait from life, then it may have been done in the early 1570s, about the time when the artist moved from the provinces to Kyoto. The image has an unconventional freshness which suggests it was done before Tōhaku was greatly influenced by the Kanō artists. This portrait, according to a letter from Takeda's son Katsuyori (1546–82), was painted during Shingen's lifetime and later presented to Seikeiin, the Takeda family mortuary temple (*bodaiji*) on Mount Kōya, which still cares for it. Although this painting over the centuries has been revered as a portrait of Shingen, recent research by Katō Hideyuki has raised the possibility that it may not be portrait of the famous warrior, but may in fact represent the features of a Noto daimyo named Hatakeyama Yoshitsugu.

BAC

References: Katō 1993; Lee 1983, no. 78; Turnbull 1987, 41–56, 67–78 (on Shingen's military achievements).

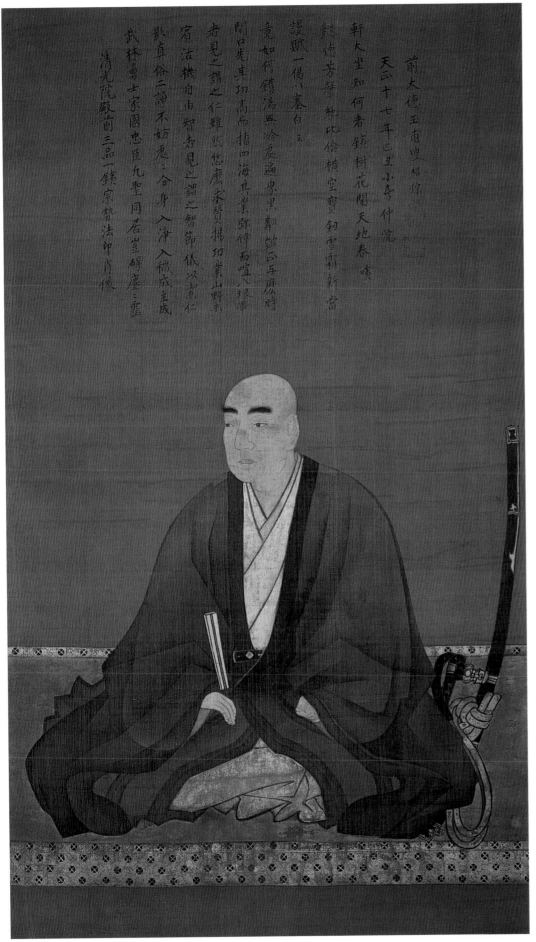

Attributed to Hasegawa Tōhaku (1539–1610)
Colophon by Gyokuho Shōsō, dated 1589
Hanging scroll; ink and colors on silk
94.0 x 54.6 cm
Chishōin, Myōshinji, Kyoto
Important Cultural Property

This portrait captures the essence of a man who was raised to be a priest, but was forced to live by the sword. Inaba Ittetsu (1516– 88) from his childhood lived in Sūfukuji Temple in Mino Province. After his father and five brothers died in battle against the Asai clan, Ittetsu renounced religious life to take over as head of his family. He later served as a retainer to the most powerful clans, including the Toki, Saitō, Oda, and Toyotomi.

This commemorative painting follows the conventions of ancient priestly portraiture. Ittetsu is depicted with shaven pate and clerical robes. The dagger tucked into his robes and a long sword by his side, however, are reminders of how Ittetsu earned his lasting reputation.

According to records kept by Ittetsu's son Sadamichi, an artist from Kyoto had been commissioned to do this portrait. It has been suggested that the artist may have been Hasegawa Tōhaku, an artist best known for his large-format paintings of scenes from nature (see cat. nos 53, 54), but in his own day highly regarded as a portraitist. Several examples of portraits with firm attributions to Tōhaku survive, among them the works described in the previous and following entries. Tōhaku is also known to have created a portrait of the author of the colophon to this painting, the Daitokuji priest Gyokuho Sōshō (1543–1613), which supports an attribution to Tōhaku.

Priest Sōshō's inscription, dated the tenth month of 1589, reinforces the picture we have of a man whose life embraced the contradictory vocations of priest and samurai. It opens by stating, "He was a stalwart warrior among fighting men and served as loyal retainer for his home province. He lived as layman and religious, not separating the two, just as dust mixes with dew." After praising his great wisdom, spirituality, and benevolence, the inscription concludes with a quatrain of Chinese verse:

> In moral virtue and sterling reputation
> he had no peers.
> His precious sword, as it swept across the sky,
> glistened like snow or frost.
> Posed so serenely in the temple hall,
> how might we describe him?
> A rare blossom on an "ironwood" tree,
> bringing spring to heaven and earth!

The last line likens a blossom on the "ironwood" tree, which is said to bloom only once in a hundred years, to Ittetsu, whose name literally means "Single Iron."

JTC

Reference: Shimizu 1988, no. 34.

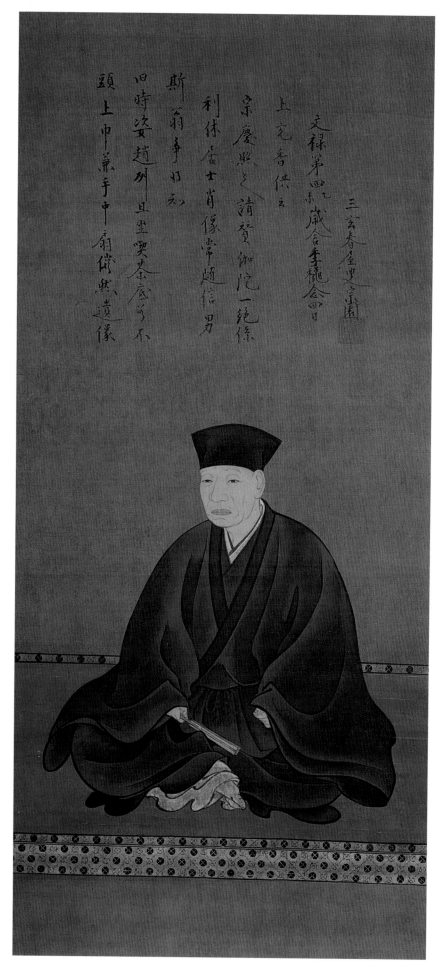

5. PORTRAIT OF SEN NO RIKYŪ

Attributed to Hasegawa Tōhaku (1539–1610)
Colophon by Shun'oku Sōen, dated 1595
Circa 1595
Hanging Scroll; ink and colors on silk
80.6 x 36.7 cm
Fushin-an, Kyoto
Important Cultural Property

The famous tea master Sen no Rikyū (1522–91) is shown wearing the black robes of a Buddhist layman in this posthumous portrait commissioned by the noted Raku potter Tanaka Sōkei (act. late sixteenth century) and inscribed by the Zen master Shun'oku Sōen (1529–1611), both close friends of the tea master. The Chinese quatrain praises Rikyū's extraordinary character and likens his wisdom to that of Chao Chou, a noted Chinese Zen priest:

> Hat on his head
> and fan in his hand
> The solemn image he left behind
> captures what he always was
> Like Chao Chou he sits awhile
> and drinks tea
> This old man seems to gain knowledge
> without struggle.
> Sōkei showed me Layman Rikyū's portrait and asked me to write an inscription, so I have written a four-line verse and offer this with incense.
> Fourteenth day, ninth month, fourth year of Bunroku (1595) Sangen, Old Shun'oku Sōen (trans. Shimizu 1988, no. 38)

While the painting is unsigned, it has long been attributed to Hasegawa Tōhaku (1539–1610), who was an intimate of both Rikyū and Sōen.

Rikyū was born into a prosperous trading family and grew up in the port city of Sakai, where his father owned warehouses and was involved in the wholesaling of fish to the military. Rikyū's grandfather reportedly was Tanaka Sen'ami who as personal attendant (*dōbōshū*) served tea to the shogun Ashikaga Yoshimasa (1436–90). The newly wealthy Sakai merchants also practied the tea ceremony, and Rikyū studied under tea masters Kitamuki Dōchin (1504–62) and Takeno Jōō (1502–55) who emphasized the poetic and spiritual aspects of the tea ceremony. Rikyū learned Zen teaching from the Daitokuji monks Dairin Sōto (1480–1568) and Shorei Sōkin (1505–83), and began a life-long relationship with that important Kyoto Zen monastery.

When Rikyū was in his early fifties, he became one of several tea masters who assisted Nobunaga at elaborate tea ceremonies. Following Nobunaga's death, Rikyū became more closely connected with Hideyoshi whom he frequently served as tea master, political advisor, and personal secretary. In 1585 Rikyū noted in a letter that he was in charge of Osaka Castle when Hideyoshi was absent. Under Rikyū's guidance in 1584, Hideyoshi built a tearoom at Osaka Castle named Yamazato

("Mountain Village") that represented the refined rusticity of *wabicha*, an aesthetic ideal that Rikyū promoted. The tiny room, less than two meters square, was designed to recall a humble farmer's cottage with roughly plastered walls, irregularly shaped posts and a thatched roof. This was in sharp contrast to the grandeur and opulence of Osaka Castle, and represented Rikyū's idea that even commonplace things can have great beauty.

As Rikyū further developed the aesthetics of *wabicha* he increasingly stressed simplicity and humility, using plain utensils and natural materials to enhance the serving and drinking of tea. Rikyū's tea ceremony became more introspective and inspired by Zen teachings than the outwardly ostentatious style Hideyoshi seemed to favor. By 1590 Rikyū's relationship with Hideyoshi was strained, and finally resulted in the dictator ordering the tea master to commit suicide in 1591. The reasons for this are still uncertain, but Rikyū is thought to have become involved in the political rivalries among Hideyoshi's military advisers.

A more specific cause was possibly Rikyū's involvement in rebuilding the main gatehouse at Daitokuji. To mark the fiftieth anniversary of his father's death, Rikyū contributed funds to complete the two-story structure. In gratitude, Daitokuji had a life-size wooden statue of Rikyū installed in the second floor chapel. Hideyoshi evidently objected to walking under the feet of this statue and had it removed and decapitated. Following Rikyū's suicide, his family members and followers dispersed, but by 1594 his adopted son Sen Shōan (1546–1614) had returned to Kyoto and begun the process of rehabilitating Rikyū's teachings. This portrait may have been commissioned about this time, when memorial services for Rikyū could be held more openly.

BAC

References: Shimizu 1988, 86–8; Nakajima 1979, 136–7.

6. PORTRAIT OF TOYOTOMI HIDEYOSHI

Colophons by Gempo Reisan and Ikyō Eitetsu dated 1600
Circa 1600
Hanging scroll; ink and colors on silk
109 x 51 cm
Saikyōji, Ōtsu, Shiga
Important Cultural Property

7. PORTRAIT OF TOYOTOMI HIDEYOSHI

Colophon by Nanke Genkō dated 1600
Circa 1600
Hanging scroll
Ink and colors on paper
101.8 x 54.5 cm
Myōkōji, Ichinomiya, Aichi

Both of these portraits present Toyotomi Hideyoshi (1536–98) as the Shinto deity Hōkoku Daimyōjin ("Great Luminous Deity of Our Bountiful Land"). Elegantly dressed in court robes and wearing the formal headgear of a senior minister of state, Hideyoshi is seated on a thin pad placed atop a raised ceremonial mat (*agedatami*) with elaborate silk edging. Rolled-up bamboo blinds and silk brocade curtains tied with elaborate tassels frame his image. In his right hand he holds a fan, while his left hand is tightly clenched. Hideyoshi was small in stature, and the elaborate starched robes and bulky trousers make his head and hands seem even smaller. He hardly appears god-like, but the pose and costume are based on a long tradition of court portraiture that depicts the emperors and nobles, such as Sugawara no Michizane (845–903), as Shinto deities or *kami* (see pp. 61–2).

In his will Hideyoshi indicated that his remains were to be interred on a hilltop east of Kyoto, Amidagamine, and that a shrine was to be built at the base of the hill, adjacent to the Buddhist temple complex he had constructed, Hōkōji (see p. 38). Emperor Go-Yōzei declared Hideyoshi a *kami* and entitled him Hōkoku Daimyōjin, also pronounced Toyokuni Daimyōjin. This title was derived from the abbreviation for Japan listed in the eighth-century history *Kojiki*: "*Toyo* ashihara no naka tsu *kuni*" (Central *land* of the *plentiful* reed plains). Thus, as a deity Hideyoshi would continue to watch over and protect his beloved country. In fact, both inscriptions on the first portrait suggest that Hideyoshi's benevolent gaze extends over Korea, China and India as well.

Portraits of Hideyoshi such as these were commissioned in the years immediately following his deification. Although the various paintings are not identical, they follow a format similar to these examples. Some works are attributed to the foremost artists of the era, such as members of the Kanō workshop in Kyoto who had been richly patronized by Hideyoshi in the preceding decades.

The first portrait has inscriptions by the Zen

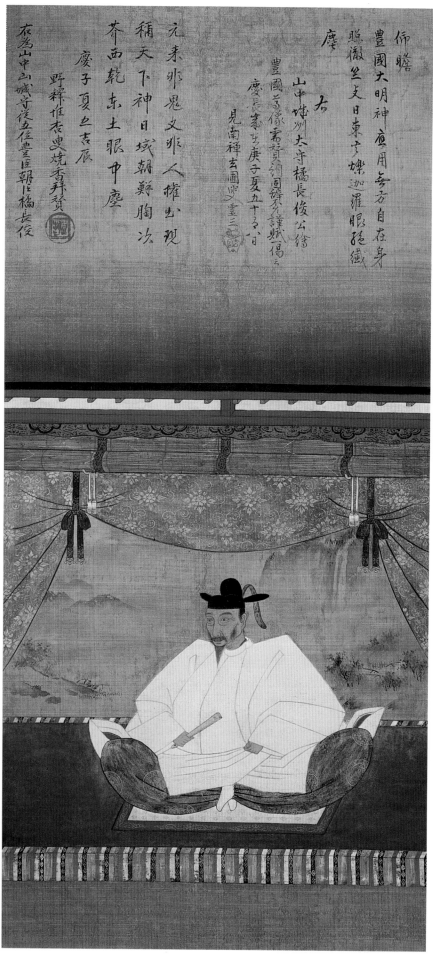

priests Gempo Reisan and Ikyō Eitetsu, about whom little is known, but the painting was commissioned by the daimyo Yamanaka Nagatoshi (1547–1607) who was a loyal supporter of the Toyotomi family. Nagatoshi did not switch his allegiances to Hideyoshi's successor Ieyasu, and was therefore reduced in rank. After 1600 Ieyasu began a systematic dismantling of the Hōkoku Daimyōjin cult, which he saw as a threat to his own plans for political hegemony, and after the defeat of the Toyotomi faction in 1615, such portraits as these were no longer produced.

The inscription above the second portrait is by the noted Zen master Nanke Genkō (1538–1604), who was a close friend of Hideyoshi and founded the Buddhist temple of Shōunji in Kyoto to commemorate the death of Hideyoshi's son Sutemaru (1589-91). Genkō played an important role as well in the celebration of Hideyoshi as the Shinto deity Hōkoku Daimyōjin, as depicted here. The inscription is dated to 1600, when shrines dedicated to Hideyoshi's spirit were being erected by daimyo in various provinces of Japan and the cult of Hōkoku Daimyōjin was flourishing. Although the artist of this particular posthumous portrait is not known, it follows a stylistic pattern established by the Kanō artists of Kyoto. As a patron of the arts, Nange Genkō had commissioned works from Kyoto's top painters, including Hasegawa Tōhaku (1539–1610) who did screen paintings for both the Shōunji in 1591 and the Myōshinji subtemple of the Rinkain for which Genkō was founding abbot in 1599 (see cat. nos 53–4).

From foot-soldier to military dictator of Japan, the life of Toyotomi Hideyoshi (1536–98) is a remarkably exciting story – one hardly suggested by these small reserved portraits. He developed an extraordinary interest in the visual and performing arts, both for personal pleasure and as propaganda to publicize his newly acquired wealth and power. Hideyoshi's accomplishments in the cultural realm and his large-scale architectural projects are described in greater detail in the Introduction.

As the son of a low-ranking foot-soldier (*ashigaru*), his childhood is undocumented, and later legends (many promoted by Hideyoshi himself) confuse the matter. For instance, Hideyoshi wrote his mother had a dream that sunlight filled the room the night he was conceived, and that a diviner predicted his glory would shine in ten thousand directions. His social class usually did not have family surnames, and he did not actually take the formal name of Toyotomi Hideyoshi until 1585, when he arranged his own adoption into an aristocratic Kyoto family.

By 1558 Hideyoshi had joined the ranks of Oda Nobunaga and gradually distinguished himself in battles to secure and extend Nobunaga's domain. Small in stature and

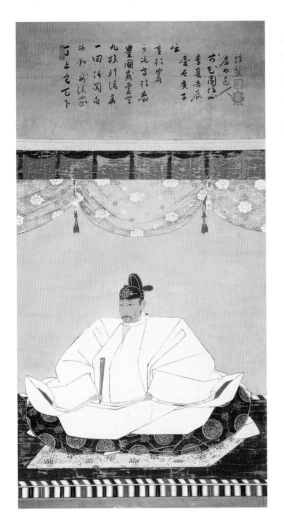

He was a vigorous and innovative commander, developing new tactics to take advantage of the recently introduced European-style firearms and using deceit as well as diplomacy to attain his goals. In 1567 Hideyoshi reportedly constructed a fortress overnight at Inabayama that helped defeat Saitō clan forces; in 1577 he captured Himeyama by encouraging defections; and in 1582 he forced a truce by flooding the besieged castle at Takamatsu. Hideyoshi's swift destruction in 1582 of Akechi Mistuhide (1528–82), who had forced Nobunaga's suicide, resulted in his taking over the Oda armies and domains in the name of Nobunaga's grandson Hidenobu (1580–1605). Within the next decade Hideyoshi pacified the country and consolidated power, so that in 1585 he was named *kampaku* (regent) by Emperor Ōgimachi and in 1592 *taikō* (retired regent) by Emperor Go-Yōzei.

Although of humble origins and narrowly educated as a youth, Hideyoshi radically changed his life, and Kyoto, in the 1580s and 1590s. Following Nobunaga's death, Hideyoshi was granted a court rank which allowed him access to the imperial palace and which began his systematic accumulation of aristocratic titles and privileges, culminating in his arranged adoption into the Fujiwara family in 1585. To have housing appropriate to his rank, Hideyoshi began construction in 1586 of an extraordinary palace complex, the Jurakutei (also pronounced Jurakudai), on the former site of the original Kyoto imperial palace built in the eighth century (see cat. no. 25). He went on to reshape the city of Kyoto completely, moving temples and whole neighborhoods to suit his plans. Over the next decade, Hideyoshi would employ the finest artists to decorate palaces, temples, shrines and castles in the Kyoto-Osaka area.

During this same period Hideyoshi developed deep interests in the tea ceremony, Noh theater, and in courtly entertainments such as flower-viewing and poetry contests. He was extremely close to the tea master Sen no Rikyū, and together they greatly changed the practice and aesthetics of the tea ceremony (see cat. no. 5). Hideyoshi also enjoyed theatrical productions, even acting the lead in Noh plays performed for the imperial court. Hideyoshi's enthusiasm and patronage spurred others of the newly empowered military elite to follow suit and as a consequence the arts of Japan flourished in extraordinary ways in the late sixteenth century.

A darker side to this brilliant display is revealed by the disastrous invasions of Korea and the ruthless murders or enforced suicides of individuals who Hideyoshi suspected of treason. Scheming to conquer Ming China, Hideyoshi began an invasion of Korea in 1592. He never himself left Japan, but supervised the armies from the western island of Kyushu, where he had Katō Kiyomasa (1562–1611) construct the elaborate Nagoya Castle complex in less than six months (see cat. no. 10). Hideyoshi's troops in Korea practiced a policy of wide-scale destruction, burning towns and temples and slaughtering thousands of civilians. The Japanese forces were finally repulsed in 1593, but Hideyoshi ordered another invasion in 1597, again with disastrous results for the Koreans and no real gains for the Japanese. The second invasion ended with Hideyoshi's death in 1598. As trophies, thousands of cut-off Korean ears and noses were brought to Kyoto and buried in a mound adjacent to the Shinto shrine established in honor of Hideyoshi (seen in the lower right corner of fig. 1).

Having himself struggled to the top through skill, luck and intrigue, Hideyoshi knew that his grip on power could always be challenged. Having no male heirs by his first wife, whom he had married about 1561, he made various political arrangements by adopting sons from both the Kyoto aristocracy and the daimyo ranks. In 1586 he adopted a grandson of Emperor Ōgimachi, Prince Kosamaru (1579–1629) who was later released from the obligation and became Prince Hachijō Toshihito, famed for building the Katsura Detached Palace complex. He also adopted sons from the Oda, Maeda, Ukita, and Kobayakawa clans. Most of these arrangements were dissolved when his concubine Yodogimi gave birth to Sutemaru in 1589, but unfortunately the child died in 1591 (see cat. nos 139–40). At that time Hideyoshi adopted his nephew Hidetsugu (1568–95), but when Yodogimi bore a second son, Hiroi (Hideyori 1593-1615), Hideyoshi became suspicious of Hidetsugu and ordered him to commit suicide. Other political figures and personal friends also suffered when Hideyoshi doubted their allegiance, having them exiled, killed or forced to commit suicide, among the latter being his advisor Sen no Rikyū.

The five daimyo Hideyoshi selected to guard the life and inheritance of his son Hideyori soon disagreed after Hideyoshi's death in 1598. The Battle of Sekigahara in 1600 decided the ultimate fate of Hideyori and gave political powers to Ieyasu. Yet, in the decade following his death, Hideyoshi's deification as Hōkoku Daimyōjin allowed his admirers to continue celebrating the changes that had occurred and were still taking place in the Kyoto and throughout Japan. Elaborate festivals in honor of Hideyoshi were staged. Shrines to Hōkoku Daimyōjin were erected by daimyo in various provinces. The ebullient world of visual and performing arts which he had patronized and promoted continued to reshape Kyoto and to redefine Japanese aesthetics for the next century.

BAC

References: Berry 1982; Elison 1981, 223–44; Herbert 1967, 450–1; Ooms 1985, 50, 178–81; Shimizu 1988, no. 21.

evidently not good-looking (as these portraits clearly attest), Nobunaga called the young soldier *Saru*, or "Monkey," a nickname that continued over the years. In 1560 both Hideyoshi and Ieyasu, who later would sequentially succeed Nobunaga, fought in the Battle of Okehazama where Nobunaga's army of 2,000 men defeated 40,000 troops of daimyo Imagawa Yoshimoto (1519–60). For the next thirty years Hideyoshi embarked on numerous military campaigns, initially to support Nobunaga and after Nobunaga's death in 1582 to capture the country for himself.

8. PORTRAIT OF TENZUIIN, HIDEYOSHI'S MOTHER

Colophon by Hōshuku Sōchin, dated 1615
Hanging scroll
Ink and colors on silk
123.7 x 54.8 cm
Daitokuji, Kyoto

Once we learn that this portrait is supposed to represent Hideyoshi's mother (1513–92), we may read into the simple outlines of her face the world-weary gaze of a devoted mother, born of peasant stock, who watched her son go off to war around age fifteen and eventually rise through the ranks to become the most powerful warlord of the era. She is portrayed by convention in the garb of a woman who has taken lay Buddhist vows. As befits her status as a woman of high court rank, she sits on a raised *tatami* mat.

Hideyoshi's mother, known by the familiar name Naka, grew up in Owari Province. She married a farmer known as Kinoshita Yaemon, who on occasion served as a footsoldier for the local warlord Oda Nobuhide – the father of Nobunaga. Yaemon died in 1543, when Hideyoshi was still only about seven years old; his mother soon married a man named Chikuami, who helped her bring up her child. Throughout his entire career Hideyoshi remained devoted to his mother and ever solicitous of her health, as is suggested by the letters he dispatched to her when away on military campaigns.

After 1585, when Hideyoshi was appointed *kampaku* (regent), his mother was respectfully referred to as Ōmandokoro, a court title bestowed by the emperor. Although this title was traditionally reserved for the mother of an acting regent, she retained the title even after her son officially "retired" as regent (and even posthumously, in the chronicles of later historians). She also came to be known by her posthumous Buddhist name Tenzuiin after the name of the Tenzuiji ("Temple of Divine Happiness"), which her son constructed as her mortuary temple, and where this portrait was originally displayed. The author of the inscription, Hōshuku Sōchin (1554–1617), an abbot of Daitokuji, also served as Tenzuiji's founding priest.

Construction of Tenzuiji began while Ōmandokoro was still alive, and in its day was one of the grandest of the Daitokuji subtemples. Hideyoshi, in a conspicuous display of filial piety, spared no expense on the decoration of its chambers. Records show that Kanō Eitoku was commissioned to create its interior. Three rooms of the temple were decorated with paintings of landscapes, bamboo, pines in color and gold. Two other rooms had ink paintings, one of a landscape with Mount Fuji, the other of the "Three Laughers" (a popular Chinese painting theme).

Sōchin's inscription refers to Hideyoshi's

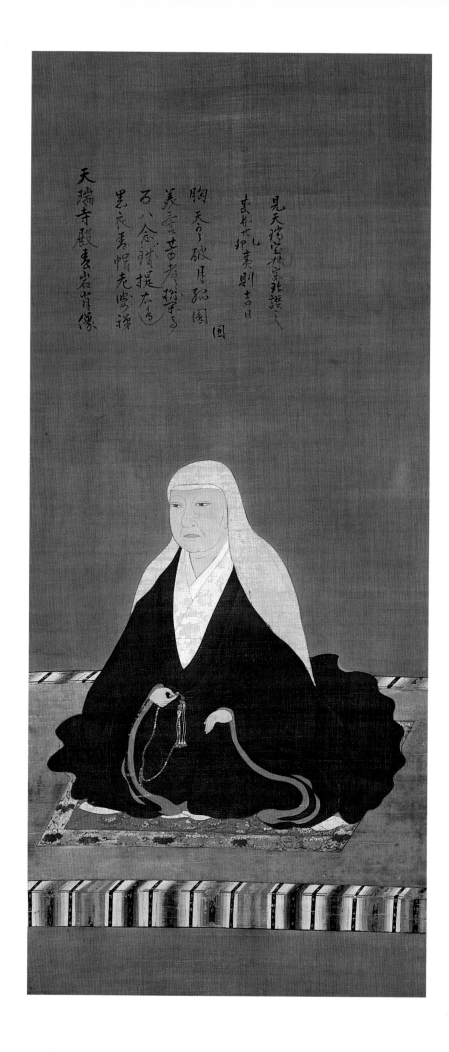

mother by another of her posthumous names, Shungan, and praises her with a quatrain of Chinese verse written in seven-syllable lines:

As an elderly woman she practiced Zen
 in black robes and blue headcloth,
Holding one hundred and eight prayer beads,
 in her right hand.
All the great honor and worldly fame
 were of little concern to her,
Like the solitary round moon, her intuition
 pierced through clouds in the sky.

As is customary in memorial portraits, the eulogy suggests the subject's piety or religious enlightenment. Reciting the Buddha's name as one counts the one hundred and eight beads of the Buddhist rosary was said to help dispel the equal number of human moral weaknesses. The moon is a metaphor for Zen enlightenment.

The inscription is dated "an auspicious day in the seventh month of Keichō 20 (1615)," some twenty-three years after the subject's death. This date becomes significant, however, when we recall that just two months earlier the final siege of Osaka Castle by Tokugawa troops had taken place (see cat. no. 22). This battle resulted in the death of Toyotomi Hideyori, Hideyoshi's son, and brought an end to the Hideyoshi legacy. Although the Tokugawa had taken steps to eradicate any public displays of reverence for Hideyoshi and his heirs, we may assume that this portrait was commissioned for memorial services held at Tenzuiji by close relatives of the deceased clan members.

JTC

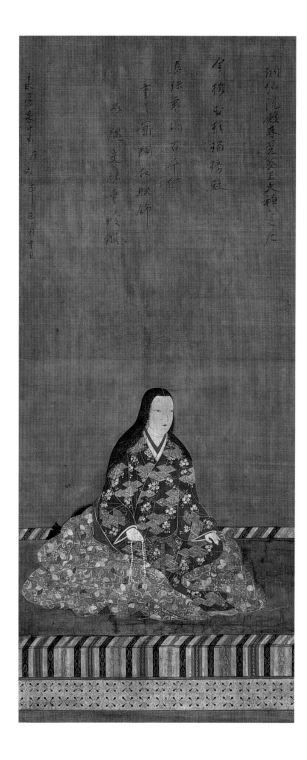

References: Berry 1982, 8–9, 179–80; Boscaro 1975, viii, et passim; Covell and Yamada 1974, 44–5 (on the Tenzuiji paintings); Haga 1993, 724.

9. PORTRAIT OF TŌSENIN

Colophon dated 1610
Hanging scroll; ink and colors on silk
81.7 x 34.8 cm
Daizenji, Kyoto

Little is recorded of Tōsenin's life, and her conventionalized representation with long oval face, white skin, and long hair provides few additional clues to her personality. In keeping with the norms of female portraiture of the era, she is depicted kneeling on a tatami mat with her face slightly turned away from the viewer. She wears a *kosode* patterned with overlapping lozenges and flowers and over it, tied at the

waist and enveloping only the lower half of the body, a *koshimaki* ("waist wrap") embellished with scrolling vines embroidered in gold and colored threads. The dark colors and small, complex patterns of her garments exemplify the luxurious textiles styles current in the Keichō era (1596–1615). Their sumptuous elegance suggests a sensitivity to fashion that conflicts with the image of piety conveyed by the string of beads in her hand. Whether this reflects Tōsenin's personal tastes or the artist's determination of the attire appropriate for a woman of her status is not clear.

A portrait of Hideyoshi's concubine Matsu no Marudono in Seiganji, a Kyoto temple with

which Daizenji was affiliated, offers clues to the identity of the subject of this work. Since Matsu no Marudono adopted the religious name Gekkō (Clear Moon), which includes the same character *kō* appearing in Tōsenin's religious name Shunkō (Clear Spring), it has been surmised that the woman represented here is one of Matsu no Marudono's younger sisters, possibly the wife of Ujie no Naizen Yukihiro, who fought against Ieyasu in the Battle of Sekigahara and was forced force to commit suicide after the Battle of Osaka.

CG

Reference: *Yamato bunka* 1972.

10. PORTRAIT OF KATŌ KIYOMASA

Early seventeenth century
Hanging scroll; ink and colors on silk
63 x 37.7 cm
Daitōkyū Kinen Bunko Foundation, Tokyo

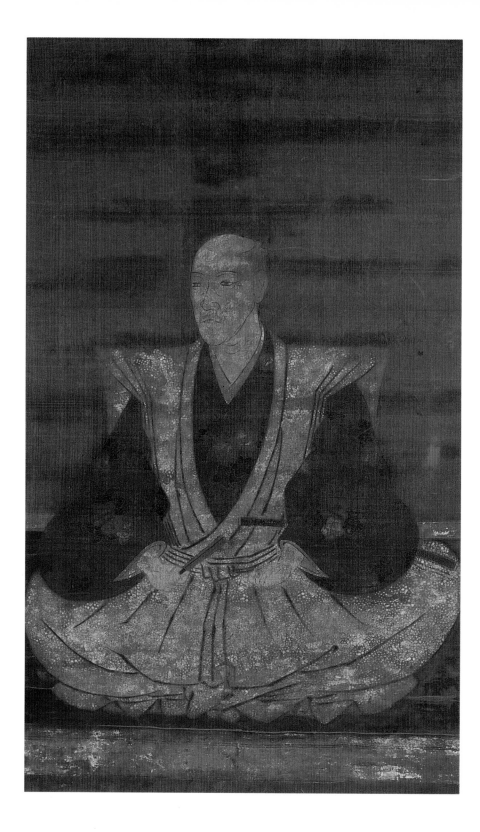

The steadfast gaze of Katō Kiyomasa (1562–1611) in this posthumous portrait captures the sense of loyalty he had for Hideyoshi and his heirs. Painted according to conventions of memorial portraits, the image shows the warrior in formal garb seated upon a *tatami* mat. Here Kiyomasa has only a short mustache, though in other early depictions he is shown with a full beard and wearing an exceedingly tall helmet which was lacquered and silver ornamented with red-painted suns. Kiyomasa's personal history, from his battle valor at Shizugatake to his tiger-hunting exploits during the Korean Invasion, has been frequently illustrated over the centuries, especially in woodblock prints of the nineteenth century. This more serious depiction is appropriate for Buddhist memorial services.

Kiyomasa's origins are obscure, but he is thought to have been born the son of a blacksmith in the village of Nakamura, Owari Province, the same birthplace as Hideyoshi. When his father died, the three-year old was placed in Hideyoshi's custody, since they were maternal second cousins. Kiyomasa joined Hideyoshi's campaigns, winning honor in 1583 at the Battle of Shizugatake as one of the "Seven Spear-bearers" (*Shichi hon'yari*) who fought bravely. Kiyomasa reportedly killed an enemy general with his bare hands. By the age of twenty-six Kiyomasa was an important daimyo with land holdings in Higo Province and a castle in Kumamoto, the important port city on the southern coast of Kyushu.

Kiyomasa was required to divide authority in Higo with Konishi Yukinaga (1556?–1600), another low-ranking soldier who had gained status through serving Hideyoshi. Their relationship was contentious. In addition to jockeying for power in Kyushu, they differed in religion, Kiyomasa being an ardent Nichiren Buddhist and Yukinaga being a Christian convert. When Hideyoshi assigned each to lead an army during the 1592-3 invasion of Korea, they frequently tried to upstage each other rather than coordinate their actions. After Hideyoshi's death, Kiyomasa and Yukinaga again became rivals, with Yukinaga backing Ishida Mitsunari (1560–1600) and Kiyomasa supporting Tokugawa Ieyasu (1542–1616), who had vowed to protect the political interests of Hideyoshi's heir. In 1600 Yukinari was captured and executed after the Battle of Sekigahara, while Kiyomasa remained in Kyushu securing the island for Ieyasu.

Kiyomasa was awarded Yukinaga's lands and became one Japan's richest daimyo. He immediately began a vigorous persecution of Christians in Higo, a policy supported by Ieyasu as a means of unifying the country. Kiyomasa also set about improving his domain, dredging rivers and harbors to make them navigable for ships and beginning trade missions to southeast Asia. In recognition of such management skills, Ieyasu asked Kiyomasa to help in the construction of the new Nagoya Castle in Owari Province. In his later years, Kiyomasa practiced the tea ceremony and studied classical literature. In 1611 when Katō Kiyomasa tried to loyally intervene on behalf of Hideyoshi's heir in a meeting with Ieyasu at Nijō Castle in Kyoto, Kiyomasa fell ill in suspicious circumstances and died soon after his return to Kumamoto.

BAC

Reference: Turnbull 1977, 204–12.

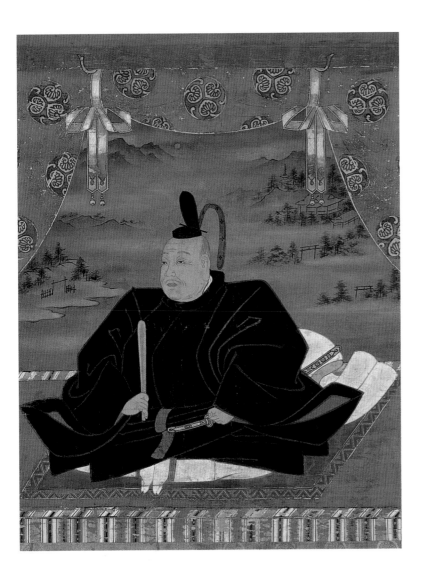

11. PORTRAIT OF TOKUGAWA IEYASU

Early seventeenth century
Hanging scroll; ink and colors on silk
57 x 48 cm
Sakai City Museum

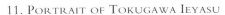

12. PORTRAIT OF TOKUGAWA IEYASU

Colophon by Tenkai
Early seventeenth century
Hanging scroll; ink and colors on silk
99.2 x 44.2 cm
Gokokuin, Tokyo

Tokugawa Ieyasu (1542–1616), the founder of the military government that controlled Japan for over 250 years, appears stiff and regal in these two portraits, which represent his form as the Shinto deity Tōshō Daigongen ("Great Incarnation Illuminating the East"), a title awarded by Emperor Go-Mizunoo. The title clearly associates Ieyasu with both the Shinto sun goddess Amaterasu and with Buddhist *gongen* (avatars) who help sentient beings. The laudatory inscription on the second portrait is by Tenkai (1536–1643), the venerable Tendai

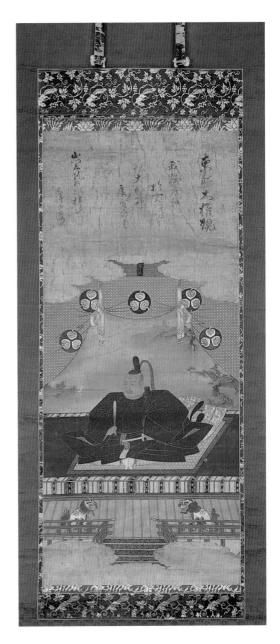

Buddhist priest who had vigorously promoted the deification process. Both portraits depict Ieyasu wearing court robes, seated on a *tatami* that is backed by a landscape painting. The various shrine buildings and *torii* gates depicted may symbolically represent an early version of the Shinto complex at Nikkō. Above Ieyasu are curtains with the Tokugawa crest of three paulownia leaves, and in front is a verandah and stairs guarded by two statues of *karashishi* ("Chinese lions"). This pose, with the figure looking to one side, is reminiscent of the Shinto deities of the Sannō cult depicted as guardians of the Lotus Sutra in Tendai *mandara*, or cosmic diagrams.

Numerous versions of this Ieyasu portrait were made in the early seventeenth century as the Tōshō Daigongen cult was spread by Tenkai and the Tokugawa government throughout the country. In each painting, the setting is nearly identical, but the costumes and faces vary slightly, and these must be considered imaginary portraits rather than true depictions. Some show Ieyasu in court dress, others in military garb or informal robes. The noted artist Kano Tan'yū (1602–74) painted several versions which show

Ieyasu as a kindly though corpulent grandfatherly figure. In the two versions displayed here, Ieyasu appears more distant and aloof.

Ieyasu was a brilliant military strategist and a consummate politician who actively participated in the tumultuous decades of the late sixteenth century and rose to the top through skill and intrigue. He was born Matsudaira Takechiyo, eldest son of Matsudaira Hirotada (1526–49), lord of Okazaki Castle in Mikawa Province. His mother, later called Odai no Kata (1528–1602), was daughter of Mizuno Tadamasa, lord of nearby Kariya Castle, also in Mikawa. To

guarantee a political alliance in the region, Ieyasu at age four was sent as a hostage to the daimyo Imagawa Yoshimoto (1519–60) of Suruga Province, but was captured in 1547 by the Oda family of Owari Province and spent two years at Atsuta, Owari. Returned to the Imagawa in 1549, Ieyasu was released from hostage status in 1560 when Nobunaga killed Yoshimoto in battle. The next year Ieyasu joined Nobunaga's ranks and helped this brash young daimyo consolidate and expand his power base in the region.

Ieyasu won fame quashing quasi-religious rebellions (*Ikkō ikki*) by farmers of the Pure Land Buddhist sect in Mikawa Province, and he won loyal adherents by taking lands from the defeated factions which he then awarded to his trusted followers. By 1565 he had firmly established control over Mikawa Province and by 1567 commanded an army of nearly ten thousand men. Relying on faithful service rather than kinship, Ieyasu maintained tight control over his domain and created civil and military hierarchies based on skill rather than family connections. With permission of the emperor, Ieyasu changed his family name in 1566 from Matsudaira to Tokugawa, to reflect his rising military status and personal independence.

Ieyasu's political career was closely tied to Nobunaga's, helping him triumph at the crucial battles of Anegawa in 1570 and of Nagashino in 1575. Ieyasu provided troops and tactics, and his strategic insights were invaluable. In both battles, gunfire helped decide the outcome; Nobunaga and Ieyasu had been quick to take advantage of these changing methods of warfare. Ieyasu was ever loyal to Nobunaga, even ordering his own wife and son killed in 1579 when Nobunaga suspected them of political plotting. After defeating Takeda Katsuyori (1546–82) in 1582, Ieyasu took over several large provinces in eastern Japan and began consolidating his holdings. Ieyasu was in the port city of Sakai when Nobunaga was killed in 1582, but rather than go immediately to Kyoto to avenge the death, he went east to prepare for a power struggle.

Toyotomi Hideyoshi, another of Nobunaga's generals, took control in Kyoto and began to assume Nobunaga's dictatorship. Hideyoshi and Ieyasu fought twice in 1584 but decided a truce was better. Ieyasu pledged loyalty to Hideyoshi in return for confirmation of his vast landholdings. In 1586 he married Hideyoshi's forty-three year old sister, who had been divorced for this purpose, to further bind the two families. Ieyasu now focused his efforts on the eastern provinces, and in 1590 joined with Hideyoshi to defeat Hōjō Ujimasa (1538-90) at Odawara Castle, after a five month siege. Ieyasu was awarded eight provinces in the rich Kantō plains, with land revenues even greater than Hideyoshi's. His new role was to maintain peace in the eastern and northern provinces, and to

provide loyal counsel to Hideyoshi's new government.

Ieyasu began building a new castle at Edo (modern Tokyo). He drained swamps, dug canals, erected warehouses, and laid out a complex system of road and bridges. This would eventually become one of the great cities of the world, and the seat of government for the Tokugawa shogunate. When Hideyoshi died, Ieyasu briefly took up residence at Fushimi Castle, south of Kyoto, to care for Hideyori (1593–1615), Hideyoshi's son and designated successor. Ieyasu was one of the five ministers (*tairō*) who were appointed to safeguard the five-year-old's inheritance, but Ieyasu soon disagreed with Ishida Mitsunari (1563–1600) on how the government should be run. In 1600 when Ieyasu returned to Edo to do battle against Uesugi Kagekatsu (1555–1623), another of the *tairō* whose land was north of the Tokugawa stronghold, Mitsunari took control of Osaka Castle in the name of Hideyori. Quickly the various daimyo chose sides, and followers of Ieyasu fought those of Mitsunari on the plains of Sekigahara in Mino Province. The Tokugawa forces and allies were victorious, and within ten days Ieyasu had taken possession of Osaka Castle and the young Hideyori. Over the next few years, Ieyasu would assert full control over the central government.

Following Sekigahara, Ieyasu confiscated domains from the defeated daimyo and redistributed land among the victors, so that he could carefully control property and power. In 1603 Emperor Go-Yōzei (r.1586–1611) officially recognized Ieyasu's role by naming him shogun. Realizing the need for an orderly transition of power, Ieyasu resigned the military title of shogun in 1605, yielding it to his son Hidetada (1579–1632), but he retained leadership of the Tokugawa clan, thereby maintaining his political authority. He continued to control the government from his retirement quarters at Sumpu Castle in Suruga.

Over the next decade Ieyasu issued various regulations which increasingly circumscribed the role of the aristocracy, and in 1611 he engineered the accession of Emperor Go-Mizunoo (r. 1611–29). Although the Tokugawa were still ostensibly holding power for Hideyori and the Toyotomi faction, Ieyasu demanded a pledge of loyalty from the regional daimyo to the Tokugawa shogun in 1611. Gradually Hideyori began to rebel under Ieyasu's controls, and in the Battle of Osaka Castle in 1615, Hideyori was killed. Tokugawa hegemony was nearly complete, and Ieyasu died in 1616 having firmly established his political dynasty.

In his later years, Ieyasu explored interests in philosophy, literature, and the arts. He recognized that the strict social and moral codes of Neo-Confucianism would be useful to his new government, and had Chinese classical texts printed and widely dispersed. The important

philosopher Hayashi Razan (1573–1657) began government service in 1605, eventually advising three generations of Tokugawa leaders. In order to resolve conflicts among various Buddhist sects, Ieyasu ordered the distribution of recent Ming-dynasty versions of Buddhist texts to serve as the officially sanctioned scriptures. As castles were built and temples restored around the country, the Tokugawa government commissioned the best artists and craftsmen available, and encouraged Kyoto artists to establish new studios in Edo. The momentum in the arts started in the Momoyama Period continued into the first decades of the Edo Period, and Ieyasu was an important patron of the visual and performing arts.

Shortly before his death Ieyasu met with the Tendai priest Tenkai, and the Zen prelate Ishin Sūden (1569–1633), and directed them that he wanted his remains to be interred first at Kunōzan, near his retirement quarters at Sumpu Castle in Suruga Province and then a year later reinterred at Nikkō, north of Edo, where his spirit could protect the country and his descendants. A shrine complex was built at Kunōzan, and he is still worshipped there as a deity (*kami*), along with guest deities (*aidono no kami*) Nobunaga and Hideyoshi. On the first anniversary of his death, Ieyasu's remains were transferred to Nikkō where they still remain.

Tenkai, the author of the inscription on the second portrait, was appointed founding abbot of Rinnōji, the Buddhist temple at Nikkō associated with the new Shinto shrine. Already in his eighties, Tenkai actively advocated the Tōshō Daigongen cult, and branch shrines were erected at a number of sites in central Japan. In 1625 Tenkai also established the temple of Kan'eiji in Edo, where Ieyasu's spirit was similarly enshrined. Tenkai's plan was to remove the Tendai-sect headquarters from Enryakuji, on Mount Hiei outside Kyoto, to Edo where it could better serve the new government and influence Buddhist institutional developments. Emperor Go-Mizunoo opposed such a move and refused to appoint an imperial prince to be an abbot at either Kan'eiji or Rinnōji. However, Tenkai's efforts to reinvigorate the Tendai sect and promote the Tōshō Daigongen cult eventually earned him the posthumous title of Jigen Daishi ("Compassionate Eye National Teacher"). The shrine building complex at Nikkō was greatly expanded in the 1630s under the patronage of Ieyasu's grandson Iemitsu (1604–51), the third Tokugawa shogun.

BAC

References: Kageyama 1973, 78; Kashiwahara and Sonoda 1994, 278–9 (on Priest Tenkai); Nakai 1988, 177–80; Ooms 1985, 173–86; Watson 1981, 4, 145; *Shogun Age Exhibition* 1983, 37–8 (for other portraits of Ieyasu); Totman 1967, 8–31.

13. PORTRAIT OF SEITOKUIN

Colophon by Sankō Yūrin
Probably circa 1625
Hanging scroll, ink and colors on silk
117.3 x 58.5 cm
Kyūshōin, Kyoto

In this solemn work, Seitokuin (1560–1625) is shown as a pious elderly woman, with prayer beads in her hands and a scarf covering her head. The painting is striking for its meticulous rendering of her costume and for its elaborate setting. Seitokuin is shown seated on a mat with an ornate rug over it within a recessed area framed by brocade curtains. This elaborate setting, while less common than the simple tatami mat characteristic of most female portraits, is shared by a small and stylistically similar group of paintings of women including Kōdaiin, and Matsu no Marudono. Since this pictorial convention is more commonly associated with representations of the deified Hideyoshi and Ieyasu, its adoption here may be an indication of Seitokuin's revered status as the eldest daughter of the first Tokugawa shogun.

Seitokuin was the second wife of Okudaira Nobumasa (1555–1615). In 1576 Ieyasu offered his daughter, then known as Kamehime, in marriage to Nobumasa after his first wife had been put to death by Takeda Katsuyori, a rival for power, in revenge for his pledging allegiance to Ieyasu. As a further token of favor, Ieyasu adopted their son Tadaaki (1583–1644), granting him and his heirs the family name Matsudaira. Kamehime took the tonsure and adopted the Buddhist name Seitokuin after her husband's death.

This memorial portrait was inscribed by Sankō Yūrin (also known as Shōeki; d.1650), the founding priest of Kyūshōin, the Okudaira family temple established by Nobumasa. After praising Seitokuin as a paragon of virtue, Yūrin's eulogy makes an allusion to the legendary Chinese Emperor Fu Hsi (J:Fukki) and his sister and successor, Empress Nü Wa (J:Joka), both of whom are ascribed important roles in Chinese cosmology. Fu Hsi invented writing; Nü Wa the institution of marriage. The suggestion here may be that Ieyasu and Seitokuin had the same elevated status in their own clan as these legendary figures have in the Chinese imperial lineage. The inscription ends with lines adapted from a poem composed on the theme of plum blossoms: "A pale shadow slants across the waters, shining like evening dew, in the clear, fragrant moonlight." In the Chinese poetic tradition, plum blossoms are associated with virtue.

Seitokuin's splendid white *kosode* with a random pattern of *aoi* (wild ginger) within medallions was a gift from her father. Ieyasu donated many personal garments to men who had performed meritorious service (see cat. nos 142, 143), as well as to family members. A wadded *kosode* similar to the one Seitokuin wears was handed down in the Owari branch of the Tokugawa family and is still preserved in the collection of the Tokugawa Reimeikai Foundation. Ownership of articles of clothing belonging to Ieyasu was both a source of pride and a tangible link to the past. Here it is emblematic of both Seitokuin and her son Tadaaki's close ties to Ieyasu.

A memorial portrait of Seitokuin's husband Nobumasa, also bearing an inscription by Yūrin, is also preserved at Kyūshōin. A nearly identical portrait of Seitokuin, kept at the Daihōin subtemple of Myōshinji in Kyoto, bears an inscription by the Myōshinji monk Ryōnan Sōtō dated 1625. It was apparently painted soon after Seitokuin's death at her son Tadaaki's request, for placement in the family mortuary temple.

CG

References: Itō 1985; *Yamato bunka* 1972, no. 44 (describes the Daihōin portrait).

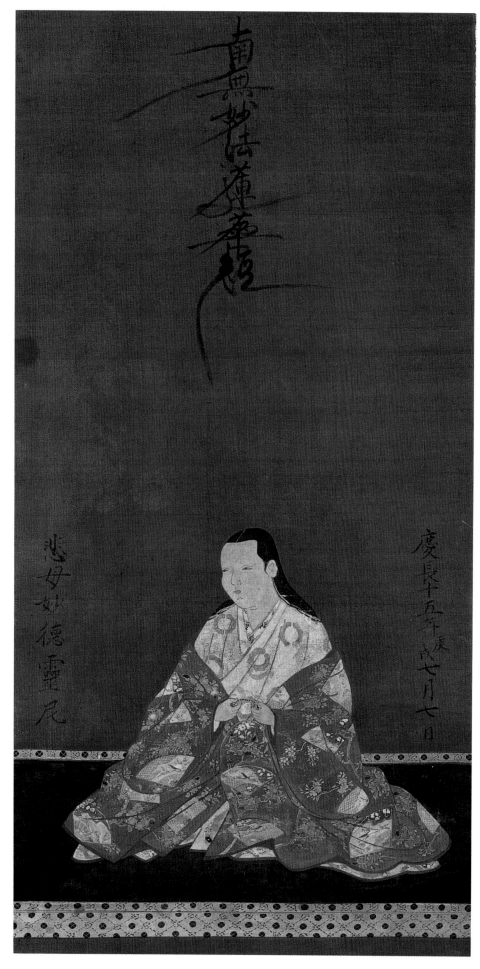

14. PORTRAIT OF THE WIFE OF GOTŌ TOKUJŌ

Early seventeenth century
Hanging scroll; ink and colors on silk
68 x 34.2 cm
Private Collection

Other than that she was the wife of Gotō Tokujō (1548–1631) little is known about the subject of this portrait. She is shown seated on a raised *tatami* mat edged with silk, an indication of the family's wealth and social status. The string of prayer beads she holds is a conventional feature of commemorative portraits. Her outer robe has fan designs appropriate to the summer season, perhaps an indication of the time of year that she died. The characters above reading *Namu myōhō renge kyō*, "Hail to the Sutra of the Lotus of the True Law," contribute to the pious aura of the portrait (see cat. no. 73). According to the inscription below, she died on the seventh day of the seventh month in Keichō 15 (1610), and was granted the Buddhist name of Myōtoku. The portrait is clearly the work of a professional artist, perhaps trained in the Kanō studio. Images such as this were usually commissioned for use in Buddhist memorial services.

Her husband was the fifth generation head of the Gotō family that had provided sword fittings and jewelry for the Ashikaga shoguns. Gotō Yūjo (1440–1512) came to Kyoto from Mino Province and won fame as goldsmith for the eighth shogun Ashikaga Yoshimasa (1435–90), making sword guards (*tsuba*) and hair ornaments with designs of Chinese lions, dragons, and floral patterns (Yasuda 1985, 217). The family also became important minters of coin for the government. Tokujō is credited with advancing the Gotō family fortunes by his service to Toyotomi Hideyoshi, providing him with traditional sword fittings but also minting the large gold coins known as *Tensho ōban*. The Gotō family would continue being involved in minting and in making fine quality gold items for the Tokugawa shoguns until the nineteenth century. A disciple of Tokujō was granted the name Gotō Mitsutsugu (1571–1625) and served Tokugawa Ieyasu, minting gold for him when he was the daimyo of Suruga Province and later establishing the new mint in Edo which would provide standardized coinage for the Tokugawa regime.

BAC

15. PORTRAIT OF HONDA TADAKATSU

Early seventeenth century
Hanging scroll; ink and colors on paper
124.0 x 64.0 cm
Private Collection
Important Cultural Property

Honda Tadakatsu (1548–1610) was counted
among Tokugawa Ieyasu's *Shitennō* (Four Deva
Kings), or four loyal retainers. Most notably he
was one of the central generals at the Battle of
Sekigahara in 1600 where Ieyasu's victory
allowed the Tokugawa clan to extend their
hegemony over all of Japan. Tadakatsu retired to
become a daimyo of a fief in Ise Province.

This portrait of Tadakatsu breaks from
convention in several ways. First of all, it is
unusual to find a memorial portrait of a warrior
that actually looks like one. Most warrior
portraits downplay the militaristic aspect of their
subjects by portraying them according to age-
old conventions as a courtier or cleric, as seen
for example in the following two entries. Nor is
Tadakatsu seated cross-legged on a mat, as we
see in most portraiture of this era, but rather
seated on a portable lacquer-frame stool of the
variety a general might have use while having
discussions with his vassals on the battlefield. A
long and a short sword are tucked into his sash.
He is portrayed as a man-of-action – his arms
akimbo, a commander's baton in his right hand
– ready to step into battle. Wisps of his wild hair
trailing in wind, a bulbous nose, and bulging
eyes give this posthumous portrait an almost
caricaturish aspect. His feet are splayed outward
in an impossible double-jointed contortion,
adding to the somewhat abstract, formalistic
aspect of the painting.

While the artist took liberties with the
depiction of the armor, the fanciful helmet is
not a figment of his imagination; it was clearly
based on a ceremonial helmet once used by
Tadakatsu, which still survives. The magnificent
helmet bears a set of antlers fashioned from
wood and layers of molded paper coated with
black lacquer – they are lighter than they appear.
The horned demon adorning the helmet was
carved from wood and coated with layers of
black lacquer. Also surviving is a set of gold-
leafed wooden prayer beads, which are shown
here draped across his breastplate – a sign of the
warrior's Buddhist faith.

JTC

References: Shimizu 1988, no. 31, no. 160 (Tadakatsu's
armor); *Shin shitei juūyō bunkazai* 1982, 6:68.

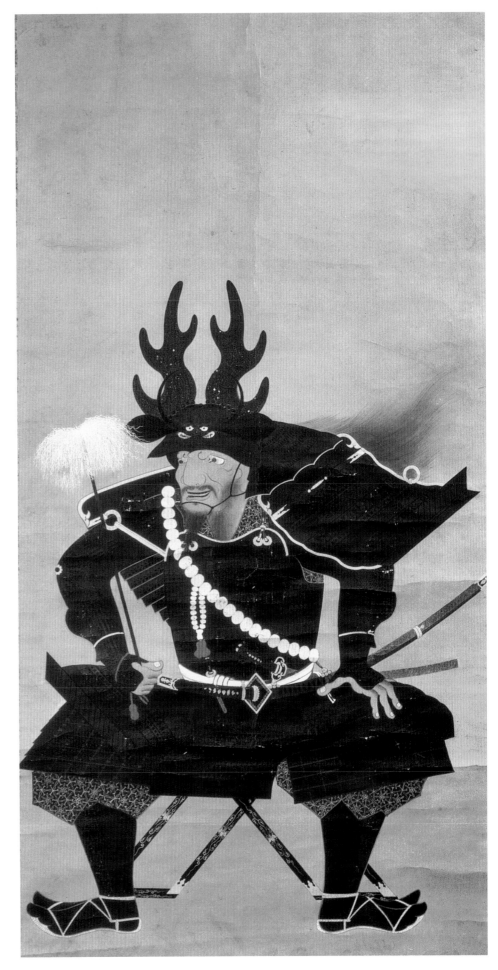

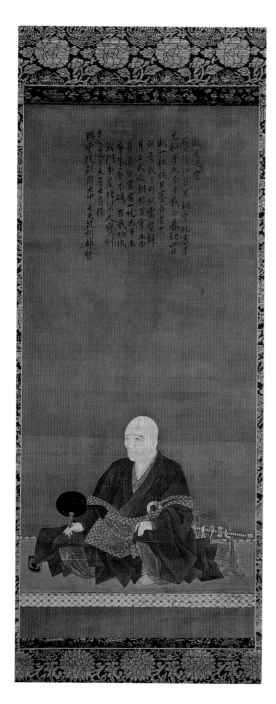

16. PORTRAIT OF KURODA NAGAMASA

Colophon by Kōgetsu Sōgan, dated 1623
Early seventeenth century
Hanging scroll; ink and colors on silk
98 x 44.4 cm
Shōunji, Tokyo

This sensitive portrayal of the elderly Kuroda Nagamasa (1568–1623), depicted with an intense and somewhat troubled expression, suggests something of his tumultuous past. Although he is dressed in Buddhist robes with a shaved head, he had an extraordinary career as a military man, evidenced by the sword mounted behind him. He was baptized a Christian but later became a major patron of Zen Buddhism, and was a ardent practitioner of the tea ceremony. The inscription is by his close friend Kōgetsu Sōgan (1574–1643), son of the tea master Tsuda Sōkyū (d. 1591) and the one-hundred fifty-sixth abbot of Daitokuji, a major Zen monastery in Kyoto. In 1606 Nagamasa built the subtemple of Ryōkōin at Daitokuji, in memory of his father, and Sōgan served as one of its abbots. This portrait belongs to the Zen temple of Shōunji, originally established at the Kuroda residence in Edo as a branch temple of Daitokuji (not to be confused with Shōunji in Kyoto), and moved in 1658 to its present location, where Nagamasa's remains are interred.

Nagamasa was the son of Kuroda Yoshitaka (1546–1604), lord of Gochaku Castle in Harima Province, a brilliant general and one of the famous Christian daimyo. When Yoshitaka allied with Nobunaga in 1577, the nine-year-old Nagamasa was sent as a "hostage" to serve Hideyoshi, who was fast becoming one of Nobunaga's foremost deputies. After valiantly fighting alongside Hideyoshi in central Japan at Shizugatake in 1583 and Komaki in 1584, Nagamasa was allowed to rejoin his father during the Kyushu Campaigns of 1586–87. For their efforts, Yoshitaka was awarded an important domain in northern Kyushu and the castle at Nakatsu. Yoshitaka had become a Christian in 1583 and took the name Dom Simeo; Nagamasa was baptized later and named Damiao (Jennes 1973, 55–8). In 1589 Yoshitaka retired to pursue his Christian faith, and the twenty-one year old Nagamasa inherited the important Nakatsu domain.

The next decade was a turbulent time for Nagamasa. During the 1592 invasion of Korea, Nagamasa commanded part of the Third Division, composed primarily of Christians from Kyushu. For the second Korean invasion in 1597 he joined with his father, who was requested to come out of retirement to advise Hideyoshi's twenty-year-old nephew Kobayakawa Hideaki (1577–1602), the overall commander of the Korean campaign (see cat. no. 141). As a result of friendships formed then, Nagamasa is credited with persuading Hideaki to defect secretly to the Tokugawa side at the Battle of Sekigahara in 1600, helping to decide that crucial conflict. Nagamasa's last battle was in 1615 to support the Tokugawa forces at Osaka Castle. He spent his final years managing an enormous and wealthy domain in northern Kyushu, and pursuing interests in literature and the tea ceremony.

Kōgetsu Sōgan, who inscribed this portrait, was the son of Tsuda Sōkyū, a rich Sakai merchant who served as Hideyoshi's tea master, along with Sen no Rikyū (1522–91). Sōgan studied Zen with the famed Daitokuji prelate Shun'oku Sōen (1529–1611). When Nagamasa established the Ryōkōin in 1606, Sōen was named founding abbot, but Sōgan is thought to have helped plan the compound. According to records, both Hasegawa Tōhaku (cat. nos 53, 54) and Unkoku Tōgan (cat. nos 57, 58), two of Kyoto's leading painters, were commissioned to decorate its interior. During Sōgan's abbacy, Ryōkōin became a major center for the tea ceremony, and still today, the subtemple has an extraordinary collection of utensils and ink paintings acquired by Sōgan.

BAC

17. Portrait of Hosokawa Yūsai

Colophon by Ishin Sūden, dated 1612
Hanging scroll; ink and colors on silk
104.0 x 51.0 cm
Tenjuan, Nanzenji, Kyoto
Important Cultural Property

Hosokawa Yūsai (1534–1610) was truly, as the inscription on this portrait suggests, a man for all seasons who had mastered both the arts of *bun* (literature) and the *bu* (military). Early in his military career Yūsai, then known as Fujitaka, served as a vassal for the fifteenth and last Ashikaga shogun, Yoshiaki. He then helped negotiate the rise of the warlord Nobunaga and fought beside him in a number of battles. Later he served as an advisor to Hideyoshi on various building projects, but was also his instructor in composition of *renga* (linked verse). He then switched allegiances to serve the Tokugawa clan; and ultimately was appointed official court antiquarian for Ieyasu.

In this portrait, however, the only hint of Yūsai's secular achievements is the sword tucked into his sash. In every other regard the artist has presented the subject according to age-old conventions of portraits of Buddhist clerics (*hottaizō*), with shaven pate, brown silk ceremonial robes, holding a fan – broadly resembling the portraits of Kuroda Nagamasa, described in the previous entry, or Inaba Ittetsu (cat. no. 4).

Though Yūsai never served as a temple priest, he had in fact taken Buddhist vows – on the very day that his vassal (and father-in-law of his daughter) Akechi Mitsuhide attack Honnōji, leading to the death of the warlord Nobunaga. We may assume that Yūsai sought religious solace (if not a place to hide) when he realized that he would have to cut all ties with his daughter's adopted family if he were to survive. The same year, 1582, he let his son take over as head of the clan, and expediently shifted his political allegiances to Hideyoshi.

The lengthy inscription – rendered in minute, precisely calligraphed Chinese characters occupying as much space as the portrait itself – is by Ishin Sūden (1569–1632), a prominent Rinzai Zen master who served as the abbot of Nanzenji. He came to be known as the "Black-robed Counselor" (*kokue no saishō*) because as well as his responsibilities as a Buddhist priest (who wore black robes) he also served as an influential advisor to Hideyoshi and later Ieyasu. Under the sponsorship of the latter Sūden drafted the influential *Buke shohatto* (Rules for the Military Houses) of 1615 that established guidelines for samurai conduct and which, among other things, officially outlawed Christianity.

Among various cultural accomplishments Sūden mentions in his eulogy of Yūsai is mastery of the secret teachings of the *Kokinshū*, an anthology of Japanese court verse compiled under imperial sponsorship around 905. Yūsai

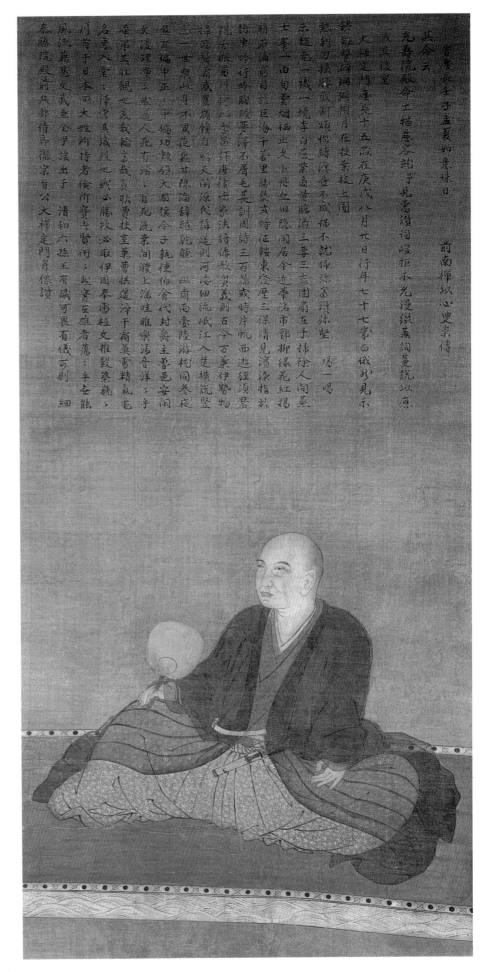

had in fact inherited from his poetry teacher a set of "secret commentaries" on the anthology, called the *Kokin denju*, and he was planning to transmit these teachings to the emperor's younger brother, Prince Hachijō Toshihito (1579–1629), as soon as he reached age thirty. In 1600, when Yūsai's residence, Tanabe Castle, was under siege, Emperor Go-Yōzei became worried that Yūsai might be killed and that Prince Toshihito would never have the opportunity to be initiated into the secret poetry teachings. Go-Yōzei sent an envoy to implore the attacking forces to desist from fighting until Yūsai was delivered to safety.

Yūsai was also an accomplished calligrapher and practitioner of the tea ceremony. He had close links with the Zen Buddhist community, as is suggested by Sūden's inscription, and was one of the primary patrons of the Zen temple Ryōanji. Yūsai, or perhaps his son Sansai, is thought to have commissioned the magnificent set of sliding-screen panels of Chinese Immortals painted around 1606 that were once installed in Ryōanji temple in Kyoto. Some of these paintings are now in the Metropolitan Museum of Art in New York. In the past these works were attributed to Kanō Takanobu, the artist of the portrait of Go-Yōzei discussed in the next entry. Recent scholarship, however, suggests that the artist may have in fact been Takanobu's younger brother Kotonobu, who records show carried out a number of commissions for the Hosokawa family (Onishi 1993).

Sūden's eulogy was written by request of Yūsai's wife, Kōjuin, who commissioned this portrait sometime after her husband's death in the eighth month of 1610. The portrait must have been completed by summer of 1612, the date on the inscription. A portrait of Yūsai's wife, Kōjuin, that forms a pair with this work, is kept at Tenjuan (Shimizu 1988, no. 27). Another, quite similar portrait of Yūsai attributed to Tashiro Tōho is now preserved in the Eisei Bunko (Lubarsky 1992, 50–1). The identical compositions and close stylistic correspondences suggest that Tōho may also have been the artist of the present portrait.

While most memorial portraits were used by family members at memorial services held on death anniversaries, in the case of literary or cultural figures it was also common for disciples to perform memorial services. In Yūsai's case, we know that his most famous disciple, the great haiku innovator Matsunaga Teitoku (1571–1653), never failed to conduct an annual memorial service for Yūsai, and instructed his own disciples to carry on the tradition.

JTC

References: Keene 1983, 71–8; Keene 1993, 1135–8; Lubarsky 1992, 22–6, 50–5; Shimizu 1988, no. 26 (includes a partial translation of the inscription), no. 66.

18. PORTRAIT OF EMPEROR GO-YŌZEI

Kanō Takanobu (1571–1618)
Circa 1617
Hanging scroll; ink and colors on silk
107.0 x 60.1 cm
Sennyuūji, Kyoto

Emperor Go-Yōzei (1571–1617) occupied the throne from 1586 to 1611, a crucial transition period during which Toyotomi Hideyoshi brought the entire country under his control, and Tokugawa Ieyasu laid the groundwork for the military government that was to rule for the next two and half centuries. Nothing in this subdued commemorative portrait suggests the grandeur or power that we might expect of an emperor – his exalted status seems to have been downplayed, especially if we compare it to the more elaborate images created to commemorate the great warlords Hideyoshi and Ieyasu, described earlier in this section.

Admittedly, we might be more impressed if we saw the painting in its proper setting, an alcove in the main worship hall of Sennyūji, which had served from the twelfth century as the mortuary temple for the imperial family (see cat. no. 20). The only overt suggestions of Go-Yōzei's court status are the raised *tatami* mat upon which he sits, and the *eboshi* (courtier's cap) balanced precariously atop his bald pate. Yet these were common conventions adopted in court portraiture, and co-opted in imaginary portraits of court poets, produced in great numbers by artists since ancient times. In contrast to the conscientious rendering of facial features, the stiff-shouldered robes give very little sense that they contain a body – also a characteristic of traditional poet portraiture.

With rare exceptions, Japanese emperors traditionally wielded little actual political might, and Go-Yōzei was no exception. The power of the emperor was symbolic and rested in his ability to confer an aura of legitimacy to those who acted with its blessings. Emperors usually relied on a *kampaku* (regent) or other high-ranking advisors to guide administrative policy. Thus it was of great significance when Hideyoshi, who was not born into the aristocracy, was appointed *kampaku,* following in the tradition of regents of the ancient Heian court.

Hideyoshi was particularly ambitious in his desire for recognition by the court. He lavished gifts of land and precious metals on high-ranking courtiers, and staged elaborate celebrations for the Emperor at his Jurakutei mansion, which not coincidentally was constructed on one of the former sites of the imperial palace precincts (cat. no. 25). Hideyoshi even adopted one of the Emperor's younger brothers, to further cement ties with the throne. The court reciprocated the favors by granting Hideyoshi and his relatives a distinguished array of court titles. After Hideyoshi's death in 1589, Emperor Go-Yōzei declared Hideyoshi was a divinity and granted him the sacred title Hōkoku Daimyōjin, "Great Luminous Deity of Our Bountiful Land."

While rarely emerging as figures of political reform, many Japanese emperors have served as protectors, sponsors, or performers of traditional court arts. In these capacities, Go-Yōzei achieved great distinction. He was an avid student of classical literature and poetry, and calligrapher of no small talent (see cat. nos 69–70). At the same time, Go-Yōzei was also one of the central figures in promoting the wider knowledge of the Japanese classics by promoting publishing projects.

The artist Kanō Takanobu, whose seals are impressed on the left of this painting, worked in the atelier his father, the noted Kanō studio head Eitoku. After the death of his elder brother, Mitsunobu, he took over as head of the Kanō school. He was also appointed the head of the *Edokoro* (Bureau of Painting), sponsored by the imperial palace, a post that customarily went to court painters of the Tosa School. In 1613, he received the ultimate commission – to oversee the screen and wall-paintings for the new palace. Some of the works produced for this prestigious commission were transferred to Ninnaji (a temple with close ties to the imperial family), where they are still preserved. In recognition of his various services on behalf of the court, he received the honorary title of *hōgen* ("eye of the law"), an honorary Buddhist rank conferred upon accomplished painters and artisans. He was father of the prominent Kanō painters Tan'yū, Naonobu, and Yasunobu. Among the works attributed to Takanobu is a set of sliding screens, once installed in the Danzan Shrine in Nara, which now belong to Seattle Art Museum (Murase 1990, no. 23).

JTC

References: Doi 1970; Shimizu 1988, no. 18.

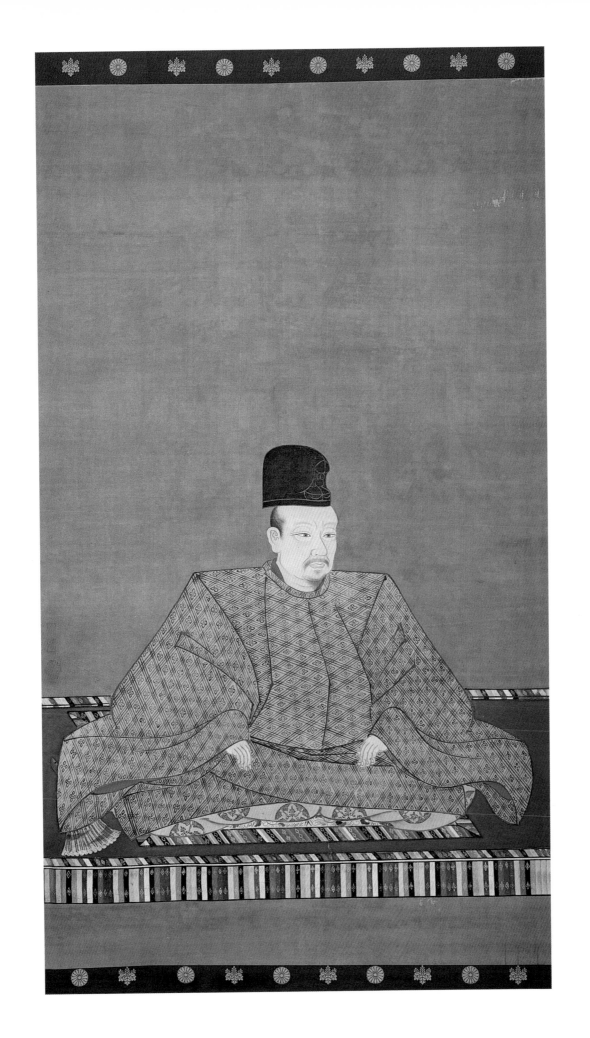

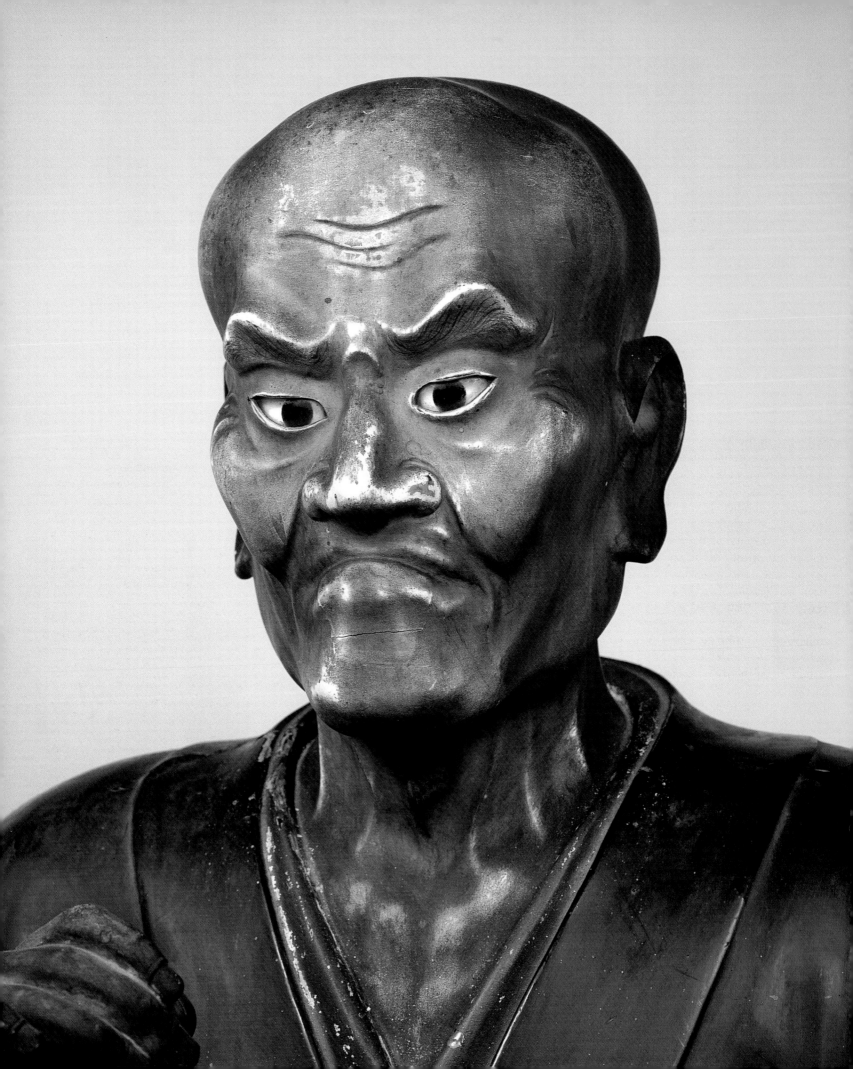

Sculpture

JOHN M. ROSENFIELD

Sculpture in the Momoyama era took on two separate and very different aspects: architectural decoration suited to the flamboyant taste of triumphant warlords; and statues of Buddhist and Shinto deities conservatively based on classical models. The former, innovative and colorful, embodied the vaunting ambitions of the new rulers; the latter, carefully crafted, sought to preserve the heritage of the past.

Ornamental sculpture on shrines, temples, and palaces was one of the most conspicuous, forceful statements of Momoyama-period taste. Its creators were not sculptors in the strict sense of the term but *horishi* ("decoration carvers"), artisans gathered in small teams who collaborated with others – stone masons, sawyers, plasterers, roofers, and painters – in construction projects. (On major buildings, the subcontractors were coordinated and supervised by government-licensed master carpenters, or *daiku*). Though the contributions of the *horishi* were, like a cosmetic, added only at the end of the construction process, their colorful handiwork was essential to the aesthetic identity and impact of the structures.

To imbue Momoyama buildings with rococo élan, the *horishi* prepared door panels with peony or lotus flowers rendered in low relief. They made rounded carvings of cranes, tigers, or phoenix birds to be inserted into gables. They carved columns and rafter-ends with twisting dragons. They sculpted lintels with scenes of Chinese sages, and made openwork transoms (ventilator panels between rooms) designed with elaborate flower-and-bird compositions. They lacquered the surfaces with bright colors and gold and added gilded metal fittings.

This ornamental vocabulary had long been established in Japan, for it was but one of the many cultural idioms that had come to medieval Japan from Sung and Yüan China – Zen Buddhist philosophy, for example, or ink painting, ceremonial tea, and strolling gardens. The oldest surviving Japanese examples of such decorative

motifs date from the thirteenth and fourteenth centuries and are found on bronze mirrors, embroidered silks, and wooden altar tables. Used to embellish shrine and temple structures as well, these motifs were replicated and elaborated by generations of *horishi* throughout the Muromachi period.[1] The idiom was further enriched by a steady stream of imported Ming Chinese craft goods – ceramics, textiles, and lacquerwares. By the end of the Civil War era, this old and highly developed decorative vocabulary was readily available to warlords like Oda Nobunaga, Toyotomi Hideyoshi, and Tokugawa Ieyasu, who demonstrated their authority by building ever more lavish castles, palaces, and religious structures.

Only a small percentage of the grandiose building projects of the Momoyama age have survived in good condition. The most often visited today are the Tokugawa family mortuary shrines at Nikkō, dating from the 1630s – the end of the era. Slightly less ornate is a site closely connected with the Toyotomi family, the Tsukubusuma Shrine on the tiny island of Chikubushima in Lake Biwa said to have been built in 1602 (see fig. 51). Local daimyo of the seventeenth century built small replicas of the Nikkō sanctuaries in their domains in order to demonstrate their fealty to the Tokugawas; their own mortuary monuments were constructed in the same ornate manner.

The names and biographies of Momoyama-era master carpenters (*daiku*) have been recorded: the Kōra and Heinouchi families, for example, hereditary craftsmen from western Japan who supervised the early Tokugawa family projects in Edo and Nikkō.[2] The decoration carvers (*horishi*), however, remain largely unknown; but where factual history has faltered, Japanese folklore has created an archetypical *horishi* – a left-handed prodigy named Hidari ("Lefty") Jingorō, whose life dates are traditionally given as 1594 to 1651.

A real person (or persons) must have inspired the entertaining Hidari Jingorō tales; indeed, several towns have claimed to be his birthplace, but a factual biography has thus far proven impossible.

Fig. 50. Portrait of Suminokura Ryōi, detail of cat. no. 19.

Fig. 51. Architectural decoration at the Tsukubusuma Shrine, Chikubushima, Lake Biwa, Shiga Prefecture, ca 1602.

He is said to have worked on virtually all of the most important building projects of the age: reconstruction of the Kyoto imperial palace and Hideyoshi's Hōkōji; the building of Edo castle, the Tokugawa family shrines at Nikkō, and the vast Edo temple of Kan'eiji in Ueno. So prodigious were his energies and so great were his skills that his sculptures, like those of Pygmalion, were said to come to life: a horse which grazed at night; dragons and lions which rescued a princess in distress; a beautiful woman whose image in a mirror he carved as a statue which then turned into living flesh. Tales of this wizard decoration carver were incorporated into Kabuki dramas and *manzai* (rapid-fire comic dialogues); they were also depicted in woodblock prints.

Far less energized or innovative were the workshops which produced votive statues of Buddhist and Shinto deities. Master sculptors (*busshi*), looking to the remote past for their models, tended to repeat classical formulas in a highly polished but mechanistic manner. This lack of creativity was not due to the lack of opportunity, however, for great quantities of statues were needed. Old temples and shrines, damaged or neglected in the Civil War era, were restored; new sanctuaries, reflecting the ambitions of the triumphant warlords, were commissioned.

The most spectacular of the new religious projects was the Buddhist monastery compound of Hōkōji in Kyoto, commissioned by Hideyoshi in 1586 (fig. 1). The *taikō* intended it to demonstrate that Kyoto under his rule had become the seat of Japanese state Buddhism, thereby replacing Tōdaiji in Nara, which had suffered grievous damage in 1567. The Main Hall (kondō) of Hōkōji, mea-

suring forty-five meters high and fifty wide, housed a giant wooden statue of Vairocana Buddha, intended to supersede the ruined bronze Great Buddha (Daibutsu) at Tōdaiji. The large compound – with a full complement of gateways, roofed colonnades, votive halls, and monks' quarters – was badly damaged by earthquake shortly after its dedication in 1596, and though soon rebuilt, it was subject to repeated vicissitudes and nothing remains today except the huge stone foundation.

Recipient of many commissions was Japan's foremost Buddhist workshop, the Seventh Avenue Atelier (*Shichijō bussho*) in Kyoto, which traced its long and complex history back to the Heian period and the renowned master sculptors, Kōshō (act. 990-1020) and his son Jōchō (d. 1057). Those two *busshi* were credited with perfecting the method of assembling statues from pieces of pre-carved wood and pegging and gluing them together (the so-called *yosegi tsukuri* technique); they were also said to have created an introspective, harmonious type of Buddhist statue deemed distinctly Japanese in spirit. The seated Amida statue at the Byōdōin (south of Kyoto), remains to this day the classic expression of Heian Buddhist aesthetics; it was carved in 1052 by Jōchō, whom the Seventh Avenue Atelier designated as its founder.

The Seventh Avenue Atelier occupied a central position among the many sculpture workshops of Kyoto and Nara, its status analogous to that of the main Kanō studios among the painting workshops. By the Momoyama period, a succession of twenty generations of sculptors had served as its heads; all had been trained there as apprentices to replicate the stylistic achievements of Jōchō or of the sixth-generation head, Unkei (d. 1223), leading master of the early Kamakura period. The twenty-first-generation head, Kōshō (1534-1621), was appointed by Hideyoshi to work on the gigantic *daibutusu* statue for Hōkōji – the most prestigious sculpture commission of the age. For this Kōshō was given the highest honor an artist could receive, the honorary Buddhist title of *hōin* ("Dharma Eye"), awarded by the throne. His Daibutsu statue has, of course, been lost, but other of Kōshō's works, notably a triad in the Image Hall (Kondō) of Tōji in Kyoto, are beautifully preserved.[3] His successor Kōyū was employed at the Tokugawa temple and shrine complex at Nikkō; and the next head, Kōon, worked for Kan'eiji in Edo. The Seventh Avenue lineage of master sculptors continued for five more generations and then died out; the atelier, too, has disappeared.

NOTES
1. For the early history of this decorative vocabulary, see *Daiku chōkoku, jisha sōshoku no fuōkuroa*, Inax booklet, vol. 6, no. 3 (Tokyo: Inax, 1986).
2. For English-language biographies of individual Momoyama sculptors and master carpenters, see Tazawa 1981.
3. *Tōji*, Hihō series, vol. 6 (Tokyo: Kōdansha, 1969), pls. 159, 178.

FURTHER READING

Okawa Naomi, *Edo Architecture: Katsura and Nikko*, Heibonsha Survey of Japanese Art, vol. 20 (Tokyo: Weatherhill/Heibonsha, 1975).

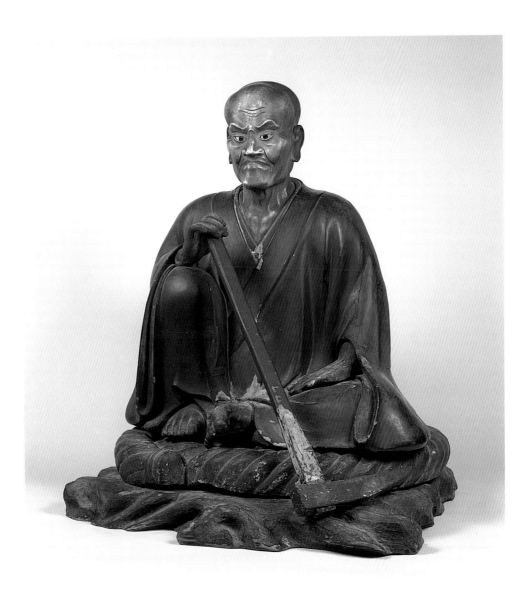

19. PORTRAIT OF SUMINOKURA RYŌI

Circa 1616
Assembled woodblock construction
Polychromed, inlaid glass eyes
Height 73.2 cm
Senkōji, Kyoto

This singular portrait statue commemorates a rich Kyoto shipping magnate and hydraulic engineer, Suminokura Ryōi (1554–1614). The face, animated by staring eyes of inlaid glass, conveys something of the energy and enterprise with which Ryōi conducted his worldly enterprises. To be sure, he is shown here dressed in the robes of a Zen Buddhist monk, but he is also provided with tokens of his engineering feats: a coil of thick rope on which he sits, and a giant adze which he holds in his left hand.

Though neither its date nor the name of the sculptor is recorded, the statue is thought to have been commissioned at the time of Ryōi's death by his eldest son, Suminokura Soan (1571–1632), a prominent figure in his own right in Kyoto culture of the Momoyama era. The portrait was installed in the Main Hall

(Daihikaku) of Senkōji, the small Zen temple which Ryōi built in the hills above Arashiyama in the western outskirts of Kyoto. The temple overlooks both the Saga district, where the Suminokura family homes were located, and the Hozu River, whose watercourse Ryōi had improved.

Ryōi belonged to a prosperous, long-established family of medical doctors who had also become *dosō* (literally, "warehouse keepers") – money lenders and merchants. Though the family were strong supporters of Hideyoshi during his lifetime, they transferred their allegiance to the victorious Tokugawa regime after the battle of Sekigahara. Ryōi, an eldest son, was trained in medicine by his father and in Confucianism by Fujiwara Seika (1561–1619), influential Kyoto poet and scholar. He was, however, far more interested in business, and, in close collaboration with his own eldest son, Suminokura Soan, he quickly amassed a great fortune lending money to domain lords.

Hideyoshi, seeking to expand Japanese commerce with Southeast Asia, issued the so-called Vermilion Seal (*shūin*) permits for trade

with Thailand, Luzon (Philippines), Taiwan, Cambodia, and Cochin China and Annam (present-day Vietnam); the licenses were continued by the Tokugawa regime until 1635. In 1603 the Suminokura were allowed to dispatch one vessel per year from Nagasaki – one of only four Kyoto-Osaka merchant families given that privilege.

The Suminokura ship was authorized to trade with Tonkin (the region around Hanoi-Haiphong in present-day northern Vietnam). Their vessel, nearly forty meters long and lavishly fitted out, carried some 390 crew members and passengers. Surviving manifests show that it took military equipment such as saddles, swords, and armor; raw materials such as sulphur and copper; and luxury goods such as crystal beads, fine paper, ink stones, and musical instruments. The ship returned to Nagasaki laden with such items as rolls of silk, elephant tusks, medicines, books, and jars filled with tea, aromatic wax, and incense.

After one of these voyages, the Prince of Annam sent a letter in Chinese complaining about the unruly behavior of the Suminokura

crew and the deplorable greed for profit on the part of the supercargos (merchants sent to negotiate the buying and selling of goods). To respond Ryōi and Soan induced their tutor, Fujiwara Seika, to write two documents (one addressed to the prince, and the other to the crew) that have become famous as early statements of internationalist and mercantile – and, indeed, capitalist – values (translated in Tsunoda 1958, 345–9). Seika promised the prince that the miscreants would be punished, and he stated that if parties in trade would only possess "good faith," national differences in clothing and speech could be overcome; he further insisted that merchants, despite their need for profit, have a legitimate role in a society based on Confucian principles. In his letter to the Suminokura employees Seika enjoined the supercargos not to seek excessive profit at the expense of others, and he told the crew to behave or else they would drown in their passion for liquor and women.

The peak of Suminokura trade with Tonkin lasted only from 1603 to 1611, and then the Tokugawa regime then began to question the benefits of the Vermilion Seal trade. The Suminokura managed to dispatch a few more ships before the trade was formally stopped in 1635. In the previous year the Suminokura – as was customary among shipowners – presented a lavish painting of their vessel to their tutelary temple, Kiyomizudera in Kyoto, to secure divine protection for both ship and profit (cat. no. 19a).

Ryōi was equally active as a hydraulic engineer. In 1604 he successfully petitioned the military regime in Edo to allow him to modify rivers to the west of Kyoto so that barges might carry grain, salt, ore, timber, and charcoal between the nearby Tamba district and the capital. Beginning in 1606 under Ryōi's direct supervision, gangs of laborers along the Ōi and Hozu rivers split and hauled away large boulders, flattened rapids, and – where necessary – built stone embankments in order to deepen

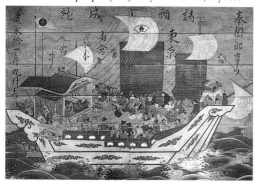

Cat. no. 19a. Suminokura Ship in Tonkin Trade. Painted votive plaque (ema). Kiyomizudera, Kyoto.

the draft. The vast project required but five months to complete. Bolstered by such success, Ryōi and son were authorized by the *bakufu* to improve other rivers in and around Kyoto. Ryōi and Soan added the stipends for river work and freight fees earned by their barges to the profits earned in the Tonkin trade.

Bolstered by their wealth Ryōi and Soan maintained a family tradition of erudition and cultural achievement. Soan became a calligraphy student and major patron of Hon'ami Kōetsu (see cat. no. 74) and secured Kōetsu's help in publishing fine woodblock printed books at a press in the family home in the Saga district (see cat. nos 75–6). Pioneering the use of movable blocks of type based on Kōetsu's writing style, the so-called Saga books printed Confucian texts, Japanese literary classics such as *Ise monogatari* (Tales of Ise) and *Tsurezuregusa* (Essays in Idleness), and the librettos of Noh plays – some of them lavishly printed on ornate papers.

Remarkably, a portrait statue of Ryōi similar in style to this one is preserved in Zuisenji, a small Kyoto temple built by Ryōi in 1611. Located along the bank of the Kamo River at the western foot of the Third Avenue Bridge (*Sanjō bashi*), the temple marks the site of one of the most gruesome episodes in Momoyama history and an enduring stain on the reputation of Hideyoshi.

When Hideyoshi's infant son died in 1591, he designated his nephew Toyotomi Hidetsugu (1568–95) as his successor and had him appointed regent (*kampaku*) in the imperial court. Immediately thereafter, however, a natural son was born to Hideyoshi. The strong-willed Hidetsugu continued as *kampaku*, but tensions between the him and the *taikō* increased until 1595, when Hideyoshi, enraged, sent his nephew into exile on Mount Kōya and then ordered him to commit suicide. Hideyoshi had Hidetsugu's wife and nearly thirty kinsmen and attendants paraded through the streets of Kyoto and then slaughtered near the western foot of the Sanjō Bridge. Hidetsugu's head was brought to the site and displayed to the public, and the victims' bodies were thrown into a rough pit and buried. Sixteen years later, as Ryōi was strengthening the embankment along the Kamo River, he constructed a proper grave for the victims and built Zuisenji to commemorate Hidetsugu and his wife. His own portrait was added there after his death.

Judging on the basis of style, the Zuisenji portrait and this one were done about the same time and in the same sculpture workshop, but the former is only half as tall and lacks the sense of energy conveyed by the Senkōji statue. Though Zuisenji burned in the great Kyoto fire of 1788, Ryōi's portrait and other memorabilia were spared.

JMR

References: Kawada 1974, figs 16, 92–9; *Kyōto no shōzō chōkoku* 1978, no.110; Nakano 1933, no. 150.

20. ANANDA, DISCIPLE OF SAKYAMUNI BUDDHA

Circa 1650
Assembled woodblock construction
Polychromed in lacquer; inlaid glass eyes
Height 65 cm
Tokyo National Museum

The colorful ornamentalism of Momoyama-period architectural decor adorns this figure of Ananda, a cousin and disciple of the historical Buddha. On his outer robe, for example, are roundels of peony flowers painted in a once brilliant array of malachite green, crimson, blue, and violet – enclosed in raised outlines of gold. The inner robe is divided by gold stripes into oblong panels which continue a tradition of piece-work monastic robes which began in ancient India. The skirt, visible at the ankles, is adorned with a fret pattern of gold on a black background. The massive shoes, Chinese in style, are painted in pale cinnabar, red, and blue, with a geometric pattern in gold.

As discussed in the introduction to this section of the catalogue, such lavish surface decor was characteristic of Momoyama taste in architectural monuments commissioned by ruling families. A prestigious pedigree may be assumed for this work as well, for Tokyo National Museum records state that it came from Sennyūji ("Temple of the Bubbling Spring") in Kyoto, a major sanctuary closely linked to the imperial family.

This statue was one of a triad of free-standing images depicting Sakyamuni Buddha flanked by his two leading disciples, Mahakasyapa and Ananda – a familiar Buddhist motif. The Ananda image stood to the left and, with its hands held in the gesture of prayer, tilted its head upward in reverence to the Buddha in the center. The Ananda and Sakyamuni statues were given to the Tokyo National Museum at a time before modern record-keeping standards had been established; the Mahakasyapa statue ended up in private hands. The statues are not inscribed nor, alas, is there documentation of the original patrons, sculptors, or place of installation. Dating must thus be determined solely on the basis of style. It is also not clear whether they had been installed in Sennyūji itself, or whether they belonged to a branch temple which was closed and its treasures transferred to Sennyūji and then dispersed.

Sennyūji, a large monastery compound located in the hills along the southeast edge of Kyoto, was for centuries one of several votive temples (*bodaiji*) where prayers were offered to deceased ancestors of the imperial family. Since its founding in the twelfth century many emperors and empresses came there here for religious instruction; graves of sixteen sovereigns and many family members are located in the forests immediately behind the temple. In one of its halls, the Reimeiden, are kept the name plaques of all deceased emperors and relatives

since the seventh century; also preserved there are memorabilia such as portrait statues and paintings (cat. no. 18), ceremonial robes and headdress, and samples of imperial calligraphy (cat. no 72).

Sennyūji, closely linked with the fortunes of the throne, was impoverished and gravely damaged during the Civil War era. Reconstruction began under Oda Nobunaga in 1574 and continued under both Hideyoshi and his Tokugawa successors. By the mid-seventeenth century – about the time when this statue was likely made – major reconstruction projects were well underway with the aid of Retired Emperor Go-Mizunoo (cat. nos 71-2), Empress Tōfukumon'in, and the shogunate in Edo. The Relic Hall was rebuilt by 1642; in 1668 the main Image Hall (Butsuden) and the Reimeiden were reconstructed.

In 1868, however, difficulties once again afflicted the temple; the newly established Meiji regime sought to loosen the throne's ties to Buddhism and to strengthen the role of Shinto in the ideology of the state. Sennyūji's official connection with the throne was severed; central government subsidy was cut off; and care of imperial graves was transferred to the government's imperial household agency in Tokyo. For nearly ten years the temple was almost destitute; many of its branch temples were closed, and their art works and ritual implements transferred to Sennyūji itself.

It was presumably during this time of hardship that the Ananda and the other two statues left the temple. Remaining behind, however, are sculptures adorned in a similarly florid, ornamental fashion. Closest in appearance to the Ananda statue are a pair of guardian figures carved in 1667 by the Kyoto sculptor Kōjō, member of the Seventh Avenue Buddhist Sculpture Atelier discussed in the introduction to this section. Given the high professional skill of the Ananda statue, it is highly likely that it too came from the same atelier at a slightly earlier date.

<div align="right">JMR</div>

Reference: *Ōshitsu no mitera Sennyūji ten* 1990, nos 19, 20 (for illustrations of the guardian figures by Kōjō).

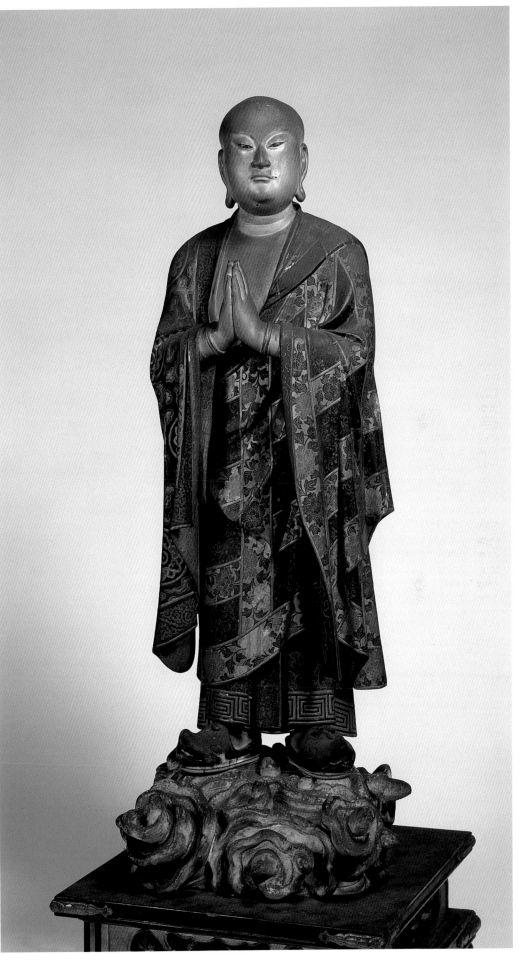

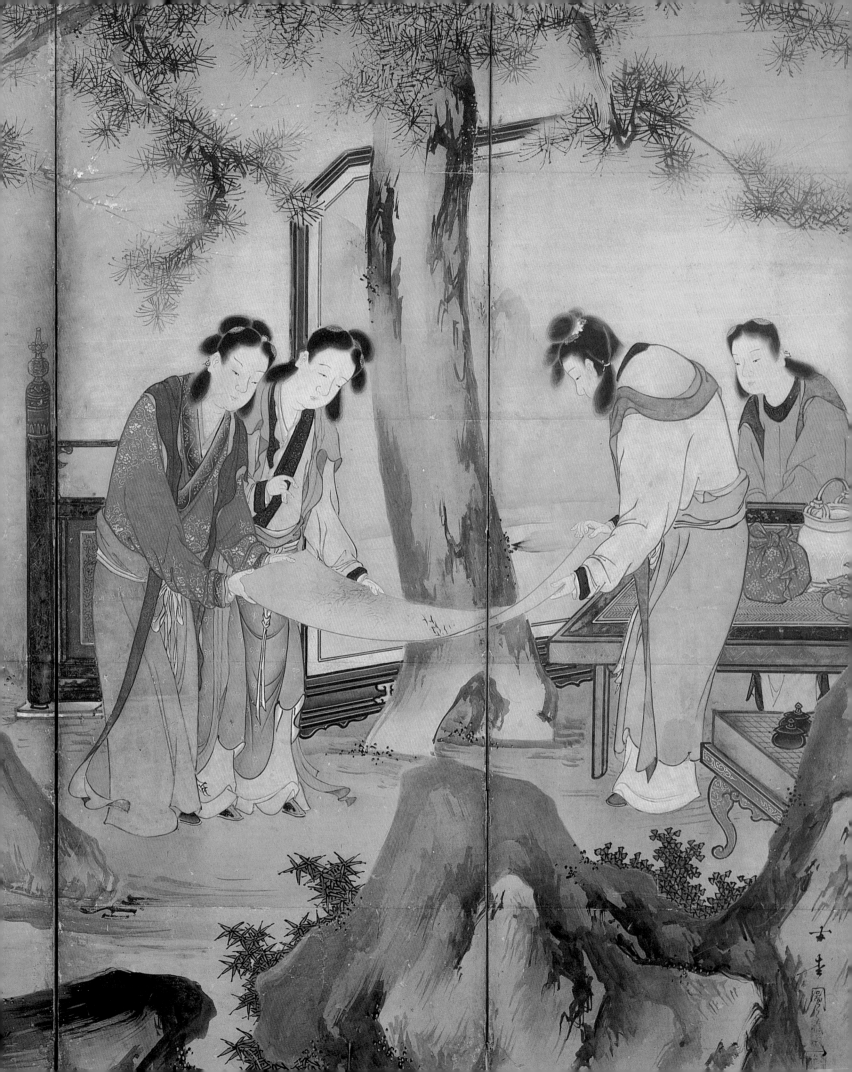

Painting

MONEY L. HICKMAN

The remarkable creative energies of Momoyama times, when the arts flourished with exceptional vigor, were fostered by the new circumstances of the age: relative political stability, economic opportunity, and newly-acquired affluence. Painting of this era, like other contemporary arts, is a dual reflection of the innovative attitudes of the artists who competed for commissions, and of the tastes of their patrons – the new military aristocracy and the affluent entrepreneurs who had been instrumental in their rise to power. The Momoyama period, under the single, unified authority of military autocrats, was pragmatic and mundane in its outlook, due in part to the priorities of its leaders, whose primary concern was to maintain their domination over the country and all segments of its populace. Buddhist prelates continued to perform their traditional ecclesiastical and funerary rites, but the church's influence had waned, and it no longer had the strength to challenge military power after it had been ruthlessly suppressed by Nobunaga and limited by Hideyoshi's restraints.

Momoyama painting reflects these changes in Japanese society in its content and its pictorial modes. It was essentially non-speculative and secular in spirit, concerned more with the forms of didactic or philosophical themes than their contents. It was worldly in the sense that human activities, the pleasures of festivals, grand events, and entertainments were a primary concern. It was also practical in the realization that most painting, particularly monumental screen compositions, had to communicate in a direct, informative manner, through assertive painterly techniques and graphic compositional schemes that were visually coherent from a distance. This concern with greater visual impact was necessitated, in large part, by the increased size and scale of the great audience and ceremonial chambers of the period. It was also prompted by another

Fig. 52. Women admiring a scroll painting. Detail of *The Four Accomplishments,* by Kaihō Yūshō, cat. no. 61.

rationale: these paintings were intended as dramatic statements of the power and importance of the warlords who commissioned them. This objective also underlies the bold brushwork, bright color schemes, and gold backgrounds. The elaborate use of gold in painting conspicuously demonstrates the pervasive preoccupation with this glittering metal, the ultimate symbol of wealth and power, that is a defining characteristic of the times. Beyond this symbolic, ostentatious function, however, gold in the form of broad areas of flat gold leaf, with its luminous qualities, was also important in bringing greater visual clarity to screen paintings through juxtapositional contrast of pictorial elements. Furthermore, gold-leafed screens also helped illuminate the dark, inner recesses of the large palatial chambers through the reflection of natural light during the day and the soft candlelight used when it became dark.

The painting of the Momoyama period represents the evolutionary flowering of centuries of pictorial tradition. In response to changing tastes and new sources of patronage, well-established artistic styles, conceptual approaches, and subject matter were adapted and modified. During the Kamakura and Muromachi periods, painting had served, more often than not, as the handmaiden of religion, whether in the production of traditional polychromatic Buddhist iconic works, colorful illustrated handscrolls depicting temple legends and tales of famous priests, or in paintings inspired by Zen ideas. Works in the latter category – landscapes, bird-and-flower paintings, and figure paintings based on Zen legends – were executed primarily in the subtle tones and evocative brush strokes of monochrome ink. Many of the techniques and subjects of early ink painting were inspired by the imported works of Chinese artists of the Southern Sung (1127-1279) and Yüan (1280-1368) dynasties. By the fifteenth century, however, Japanese Zen artist-monks such as Tenshō Shūbun (fl. 1423-60), Kenkō Shōkei (fl. c.1478-1506), and Tōyō Sesshū (1420-1506) had developed their own idiosyncratic monochrome techniques and compositional ideas, and their influential styles were widely emulated.

This painting tradition later came to be known as *Kanga* (Chinese painting) because of its general indebtedness to Chinese pictorial prototypes. The Zen (Ch'an) sect was introduced from China and firmly established in Japan during the Kamakura period, and it became the primary religious affiliation of the shogunate and many influential members of the military class. Great Zen monasteries were built, and it was in these institutions, with their pervasive atmosphere of Chinese learning and culture that *Kanga* evolved and flourished. Ashikaga shoguns, such as Yoshimitsu (1359-1408) and Yoshimasa (1439-90) were ardent admirers of Chinese works of art, and their collections of *karamono* (Chinese treasures) included superb examples of paintings, calligraphy, lacquer objects and tea bowls (fig. 7). In their elegant retreats and private temple-residences – such as the *Kinkaku* (Golden Pavilion; fig.4) and Ginkaku (Silver Pavilion; fig. 5) – these shoguns, with their congenial circles of discerning warriors, scholars, priests, and arbiters of taste, gathered to savor tea and reverently study these rare objects. The prestige of Chinese cultural traditions in high circles during the Muromachi period favored native painters whose works reflected Chinese ideas, therefore, *Kanga* artists were the chief beneficiaries of support and patronage. The prevalence of Chinese-inspired themes or painting styles may be observed in surviving hanging scrolls and portraits of the period, and is most clearly demonstrated by the screen compositions for shogunal buildings and the subtemples of Zen monasteries with family links to influential members of the military class.

From its inception in the late fifteenth century under Kanō Masanobu (1434-1530), the Kanō school of *Kanga* painters was the recipient of generous support from the military elite. Masanobu's son Motonobu (1467-1559), the most important pioneer in the early history of the Kanō lineage, synthesized earlier Chinese pictorial traditions into a distinctive and uniquely Japanese style. This new conceptual approach established the essential and enduring artistic precedents and painterly means of the Kanō school, the historic line of artists who flourished under official patronage, and were to be the chief beneficiaries of the largesse of the military class for the next three and a half centuries. Motonobu established his atelier in the north of Kyoto, close to important temple compounds and the buildings of the Ashikaga shogunate. He was followed, in succession, by industrious men who made the Kanō studio the main source of paintings for the feudal leaders during the Momoyama period. The accomplished painters who directed the school during this period were: Motonobu's son Shōei (1519-92); his grandson Eitoku (1543-1590); Eitoku's sons Mitsunobu (1565-c.1608) and Sadanobu (1597-1623); and Sanraku (1565-1635), who was adopted into the Kanō family. Paintings by Kanō masters, including Shōei, Eitoku, and Sanraku, are discussed in catalogue numbers 43 through 52.

Although often commissioned for Buddhist temples, Kanō screens were essentially secular in nature, produced by versatile, well-trained professional artists. Although these painters occasionally created commemorative portraits used for Buddhist memorial services such as the depiction of the emperor Go-Yōzei by Takanobu (cat. no. 18), or large traditional Buddhist iconic works, such commissions were relatively rare. The main subjects represented in their screen compositions were landscapes, birds and

Fig 53. Detail of *Landscapes with Sun and Moon*, mid-sixteenth century. Pair of six-panel folding screens. Kongōji, Osaka Prefecture.

flowers, and figural representations, generally of an anecdotal nature, and drawn primarily from traditional Chinese legends and didactic lore.

Motonobu's compositional ideas show some indebtedness to his great predecessors, Shūbun and Sesshū, but he was also influenced by paintings of the Che academic school, which flourished in China during the Ming dynasty. Che paintings, often of good size and most often devoted to bird and flower themes, reached Japan in substantial numbers during the Muromachi period, and Motonobu was clearly familiar with their subjects and painterly techniques. This is reflected in his choice and treatment of subject matter, particularly in natural features, such as rocks, trees and flowers, the kinds of birds depicted, and also in the selective use of opaque pigments, a characteristic feature in Che paintings. An idiosyncratic inventory of monochrome brush techniques appears in Motonobu's paintings, and primary importance was assigned to ink

outline and the consistency and linear strength of each distinctive stroke. The brush was held perpendicular to the paper surface, so that the ink flowed evenly as the tip of the brush was carefully manipulated by the artist to delineate the design. As a consequence of these explicit contours, natural forms are clear and unambiguous, and they are given substantiality through brush embellishments: hatching, inflected accents, and flat washes, together with the selective addition of appropriate colors. The artists's intention was to maximize visual clarity. Subject matter is brought forward, close to the picture-plane, and there are no implications of deep space or atmospheric ambiguity. Moreover, the viewer's sense of proximity is reinforced by the artist's inherent preoccupation with surface values and the decorative treatment of details. These basic features of style and subject matter, established by Motonobu in the early sixteenth century, are somewhat modified and augmented by successive Kanō artists, but they remained influential for a century or more.

In addition to the Kanō school artists and ateliers that worked primarily in the *Kanga* tradition, there were other artists who belonged to a separate artistic lineage, men who worked in the *Yamato-e* tradition. *Yamato* is an ancient name for Japan, and the suffix *-e* means "image" or "painting," so the term may be translated as "Japanese painting," with the connotation of being long-established. Tracing their origins back to the classical Japanese painting of earlier centuries, these artists had traditionally specialized in subjects that were indigenous to Japanese culture, its native literature, and the refined tastes and aesthetics of the court and noble aristocracy. During the fifteenth and sixteenth centuries, the artists who produced *Yamato-e* paintings were members of the Tosa school. Tosa Mitsunobu (1434-1525) was an official painter in the service of the court, the subject of high praise in documentary accounts, whose daughter married Kanō Motonobu. Traditional admirers of *Kanga* painting, who saw a moral quality, a certain strength of character in the steadfast Kanō brush line, contended that *Yamato-e* painting had been overwhelmed if not absorbed by the Kanō groundswell during the sixteenth century. But recent scholarship has shown that paintings in the *Yamato-e* tradition – not only smaller narrative handscrolls and hanging-scroll portraits, but also large screens – were produced in some numbers in the century preceding the Momoyama period. Moreover, it seems clear that their compositional ideas, graphic pictorial and decorative schemes, and bold use of color and gold embellishments were of basic importance in the evolution of the dramatic screens of the late sixteenth and early seventeenth centuries.

Landscapes with Sun and Moon, a pair of late Muromachi screens, is instructive in this regard (detail, fig. 53). The composition is notable for its rich stylized depictions of natural features, fantastic hills with high, curvaceous contours, luxuriant stands of pine, cryptomeria, and cherries, and the rhythmic action of rolling water and breaking waves. The dark green and brown pigments of the hills, together with the gold and silver embellishments, combine to create an image of graphic impact and high elegance. Small, irregular fragments of gold and silver leaf are used in conjunction with minute, dust-like gold particles, a technique similar to the *maki-e* process traditionally used in decorative lacquer.

Kanō Shōei (1519-92), Motonobu's son, was an accomplished but conservative artist whose works closely emulate those of his father (cat. no. 43). Shōei, in turn, trained his son Eitoku (1543-90), with whom he collaborated in producing the celebrated sliding screens in the Jukōin, a subtemple of the Daitokuji. Eitoku's compositions were completed in 1566, when he was in his early twenties (cat. nos 44-5). They demonstrate how he had absorbed and mastered the concepts and preceptive techniques of his grandfather. They also show that he had already developed an innovative new brush style, one that was more expeditious and animated than those of his predecessors. Recognition of Eitoku's talents brought him fame and prestigious commissions. In 1567 and 1568, he and three of his followers created screen compositions for the palace of the Konoe, a high-ranking noble family whose members traditionally served as ministers in the court. About this time, he was also turning to other kinds of subjects, including detailed topographical compositions showing celebrated locations, buildings, and seasonal activities in the great capital, a traditional genre known as *Rakuchū rakugai-zu*, or "Scenes In and Around Kyoto" (see cat. nos 23-4). A pair of Eitoku's folding screens with these subjects was sent to the great warlord Uesugi Kenshin by Nobunaga in 1574 as an official gift and expression of esteem, and they are still preserved in the Uesugi Shrine in Yamagata Prefecture. These complex compositions are done in bright polychrome against a splendid gold background. Impressive for their meticulous, realistic renditions of architecture, scenic locations, and human activities, they reveal another dimension of the artist's skill and versatility.

During the last decade and a half of his industrious life, Kanō Eitoku was the preeminent artist in Japan. The first of his celebrated painting commissions was the formidable assignment to produce the extensive series of screens for Nobunaga's Azuchi Castle, a project Eitoku and his painters took four years to finish. In 1583, Eitoku began work on an equally prestigious undertaking, the screens for Hideyoshi's huge Osaka Castle. These paintings finally completed, he and his Kanō atelier were engaged again by Hideyoshi in 1587, to produce screen paintings for the Jurakutei, his castle-residence in Kyoto, which seems to have surpassed in grandeur and magnificence all of the great architectural monuments of the Momoyama period. Eitoku undertook these vast projects with the help of a number of collaborators, among them his brothers Sōshū (1551-1601) and Naganobu (1577-1654), and his adopted son Sanraku (1559-1635). The vast expanses of sliding screens in the palatial buildings were painted according to an assigned plan, with responsibility for individual chambers divided among the various artists and their assistants. The choice of subjects and compositional schemes was undoubtedly Eitoku's and he himself worked on the most important screens, executing them in his bold, innovative signature style.

The fact that none of these great castles survived the Momoyama period is a reflection of the turbulent nature of the age, for they were either dismantled (Jurakutei in 1595) or destroyed in fires (Azuchi in 1582 and Osaka in 1615). As a consequence, only a handful of Eitoku's screens remain, and most of these have lost much of their original splendor. His *Rakuchū rakugai-zu* screens are still in good condition, but the finest example of the dramatic monumental screen style of his later years is the Imperial Household Collection's superb painting *Mythological Chinese Lions*

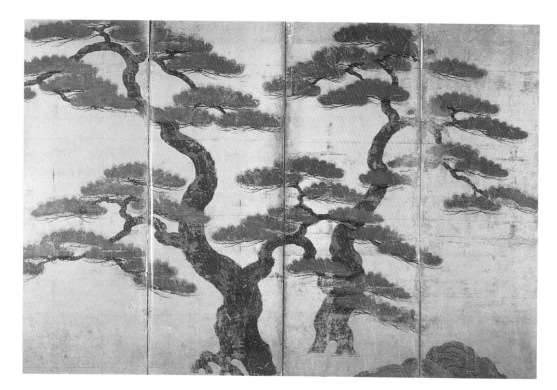

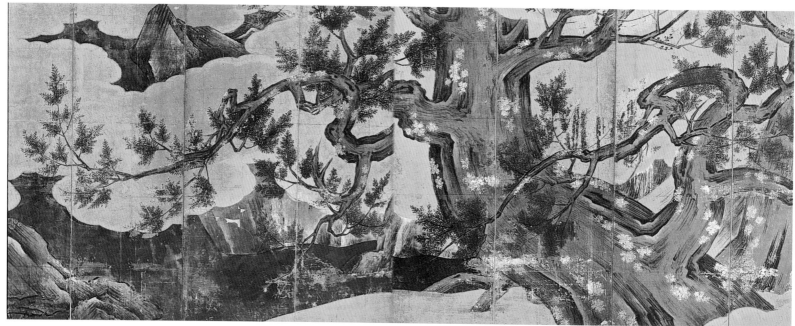

Fig 54. Detail of *Pine Trees*, attributed to Tosa Mitsunobu, early sixteenth century. Six-panel folding screen. Tokyo National Museum.

Fig 55. *Cypress*, traditionally attributed to Kanō Eitoku, 1580s. Eight-panel folding screen. Tokyo National Museum.

Fig 56. Detail of *Pines in Mist*, by Hasegawa Tōhaku. Pair of six-panel folding screens. Tokyo National Museum.

(cat. no. 46). This important monument in the history of Japanese painting – with its dynamic subjects, dramatic color scheme, and resplendent gold leaf background – epitomizes the pictorial ideals and accomplishments of the Momoyama period.

Another dynamic work, probably from the hand of a member of Eitoku's team rather than the master himself, also demonstrates all the salient features of Eitoku's late style. This is the powerful *Cypress* (fig. 55), originally a section of a sliding-screen composition but now mounted as an eight-panel folding screen. With its bold forms and massive scale, it gives us a substantial idea of how Eitoku conceived the great tree compositions, with broad-shouldered trunks and overarching limbs and foliage, for which he is renowned. In one prodigious example, he is reputed to have

extended a single tree over a continuous expanse of sliding screens for something approaching ninety feet. *Cypress* (fig. 55) and *Pine Trees* (fig. 54), the latter produced by a *Yamato-e* artist roughly half a century earlier, make an interesting comparison. Here the decorative ideas of the earlier artist, with their contrast of dark tree forms and reflective gold leaf, have been assimilated by Eitoku and become a part of his heroic, monumental style. Equally apparent is how Eitoku has transformed the lyrical mood of the earlier work into a dramatic demonstration of his own powerful imagery.

Eitoku died at age forty-seven in 1590, and it has been suggested that overwork may have been a factor in his relatively early demise. A number of accomplished Kanō artists who had worked with Eitoku were active, but it was Sanraku (1561-1635) who

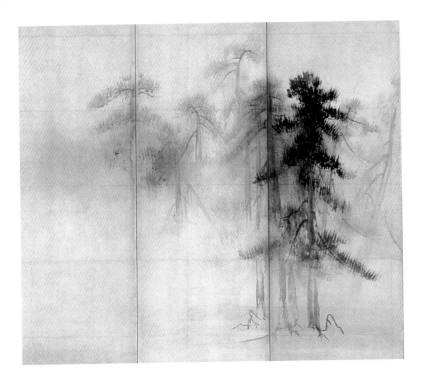

became the dominant Kanō artist of the second half of the Momoyama period and it was he who directed the painting of screens for Hideyoshi's Fushimi castle in 1592. Sanraku had a long and productive career and a significant number of his paintings have survived. A gifted, versatile artist who worked on occasion in the cursive monochrome manner, his most impressive conceptions are large screen compositions in vivid color on gold leaf, such as the pieces from the Daikakuji (cat. nos 50-1). With their sense of ebullient mannerism and arbitrary natural forms, densely grouped and precisely detailed, these screens are representative of Sanraku's mature years. There is a static, abstract character to these compositions, a calculated quality to the brushwork and decorative color treatment that is more closely indebted to *Yamato-e* traditions than to the dynamic pictorial schemes and vigorous brush strokes of Eitoku. Hideyoshi had earlier prevailed on Eitoku to accept Sanraku as an apprentice when he was a youth, and he was generously patronized by Hideyoshi until the great warlord died in 1598. After the Battle of Sekigahara in 1600, when the Toyotomi forces were defeated, a number of the Kanō artists recognized that the chief source of future patronage would be the Tokugawa, and seeking this support some moved to Edo, the center of Tokugawa power, and established ateliers there. Sanraku remained loyal to his local sources of patronage, however, and stayed on in Kyoto, where he and a succession of his followers maintained the Kyoto line of the Kanō school.

In light of the widespread prosperity and extraordinary amount of construction that took place in the Momoyama period, the prodigious artistic output of the painters of these years comes as no surprise. The new wellsprings of power and general affluence created more diverse sources of patronage. These propitious circumstances made it possible for independent artists to flourish and establish their own artistic lines, which led, in turn, not only to the increased production of paintings but also to a diversification into a rich variety of distinctive artistic styles and conceptual approaches.

Hasegawa Tōhaku (1539-1610) is one of the most impressive of these independent painters. He was already a skilled artist, with experience in depicting a variety of subject matter, when he came from Noto, his native province, to Kyoto, in about 1571. Whether or not he actually trained in the Kanō atelier remains unclear, but his screen painting *Birds and Flowers* (cat. no. 53) from this period demonstrates that he was familiar with Kanō techniques and compositional ideas. Working in Kyoto, Tōhaku became affiliated with the Hompōji, a Nichren-sect temple, for whom he painted traditional Buddhist iconic subjects in bright polychrome. He also became acquainted with high-ranking Zen prelates from various of the great Kyoto monasteries and influential tea masters, such as Sen no Rikyū (see cat. no. 5).

Tōhaku was an assiduous student of the artistic accomplishments of the past. He not only studied the works of native *Kanga* masters, such as Tōyō Sesshū, but he also gained access to many of the original Chinese monochrome ink paintings of the Southern Sung and Yüan dynasties preserved in Kyoto temples, such as the Daitokuji. These works strongly shaped the evolution of his own style. He particularly admired the evocative images of the thirteenth-century Chinese monk Mu Ch'i, with their soft blurred washes, dark and light brush accents, and imaginative use of broad areas of empty space. He incorporated these features into his own works, which were admired by influential Zen priests and warriors, more often than not men associated with the Daitokuji, where Tōhaku created monochrome paintings and screens in at least six of the subtemples in his later years. His most inventive and original monochrome work is *Pines in Mist* (fig. 56), where he used the monochrome ink techniques and distinctive open spatial schemes of Mu Ch'i, but applied them to a familiar native subject. Absent here are the mystic, religious implications of the Chinese artist, replaced by a more intimate sense of poetic sentiment and natural surroundings.

The fact that most of Tōhaku's monochrome paintings are preserved in the subtemples of Zen monasteries is not accidental, for the subjects are, in the main, landscapes, birds and flowers, or didactic themes of Chinese inspiration. Moreover, Tōhaku's monochrome ink conceptions, with their subtle, evocative effects, were particularly appropriate in the smaller, meditative ritual chambers of Zen subtemples. It is interesting to observe, however, that when Tōhaku was commissioned by Hideyoshi, an autocrat of grandiose taste, to produce an extensive set of sliding screens he turned to a different sort of expressive means. The extraordinary works Tōhaku created on this occasion were commissioned to be installed in the Shōunji, the grand funerary temple built to commemorate the spirit of Hideyoshi's son Sutemaru, who had tragically died before he reached his third birthday. Originally from the Shōunji, *Maple Tree and Autumn Plants* (cat. no. 54) is one of the great masterpieces of the Momoyama period. The composition is a superb blend of energy and elegance, with the power and sweep of the great tree and the rich colors of the leaves and the autumn flowers below, set against a resplendent surface of gold leaf. Although there is a pervasive sense of lively polychrome and decorative embellishment that is indebted to *Yamato-e* traditions, this is counterbalanced by the convincing quality of vibrant life and the precise rendering of natural details. The soft and unemphatic brush

Fig. 57. Detail of *Plum Tree*, by Kaihō Yūshō, cat. no. 59.

strokes that delineate the trunk and limbs are closely akin to those in *Pines in Mist*, and the two compositions share a grace of movement and serenity of mood.

Kaihō Yūshō (1533-1615) was another innovative independent who was also a devoted admirer and diligent student of Chinese painting, particularly the Southern Sung artists Liang K'ai and Yü-chien. He became a novice monk at the Tōfukuji Zen monastery when he was a boy, and there is a tradition that the abbot, realizing his latent talent for painting, arranged for him to study under Kanō Motonobu. Like Tōhaku, Yūshō produced screens in rich color suited to palatial castle chambers as well as monochrome works designed for smaller temple rooms. But his most original paintings are bold, idiosyncratic monochrome ink compositions, where the influence of Liang K'ai is apparent in the energetic, eccentric treatment of figures and natural forms (see fig. 57). During his later years Yūshō produced a large number of monochrome screens for Kenninji in Kyoto. These works, now mounted as large hanging scrolls, are a bravura display of his innovative ink style, combining a variety of soft, evocative washes, emphatic long lines, and contrasting accents. Yūshō's paintings in this manner stand in strong contrast to the carefully rendered subjects and predictable brushwork of the Kanō painters of the late Momoyama period.

Unkoku Tōgan (1547-1618) began his training in the Kanō atelier, probably under Shōei. In 1593, the formidable warlord Mōri Terumoto (1553-1625) invited Tōgan to come to paint in Suō Province in western Japan, where Tōyō Sesshū had worked at a studio called the Unkokuan. The Mōri family owned Sesshū's famed "long scroll" of 1486, which has depictions of Chinese landscapes during the four seasons, and Tōgan studied this inspiring work with great diligence, making a precise copy of it. Inspired by

Sesshū's venerable tradition, Tōgan adopted the name of his studio (Unkoku) and the "Tō" component from Tōyō, and proclaimed himself the third generation of Sesshū's line. Hasegawa Tōhaku, also a staunch admirer of Sesshū's painting, was equally interested in establishing his own genealogical association with the revered master, and thus Tōhaku also adopted the "Tō" component for his name, and designated himself the fifth generation head. Each man had access to a celebrated handscroll by Sesshū to buttress his claim: Tōgan to the Mōri scroll of 1486, and Tōhaku to a work done in 1474, executed in the soft, impressionistic "Southern" style of Chinese ink painting. This controversy apparently had to be settled in court, where Tōgan won out – a decision that appears justified because Tōgan's monochrome works do preserve more explicit, literal features of Sesshū's subjects and style than Tōhaku's. Although Tōgan was thus able to assert that he and his followers (who continued to work in Suō for several generations) were the exclusive artistic heirs of Sesshū, Tōhaku is generally recognized as the more innovative and original artist.

The prestige and exclusivity of the Kanō line, as well as the more general preoccupation with lineage in Japanese culture, explains why artists like Tōgan and Tōhaku wished to be part of an established artistic tradition. This was also the case with Soga Chokuan (fl. ca 1596-1610) who contended that he was a member of the Soga line of painters, a shadowy lineage of monk-artists associated with the Daitokuji was supposedly founded by Soga Dasoku in the fifteenth century. Chokuan, like several of the earlier Soga painters, such as Shōshō (fl. late 16th century) is thought to have worked for the Asakura daimyo family in Echizen Province. After the defeat of the Asakura by Nobunaga in 1573, Chokuan appears to have moved and set up a workshop in the entrepot city of Sakai. Chokuan's paintings are an eclectic pastiche, an ingenious mixture of the styles of Sesshū, the Kanō school, and the artist's own eccentric, mannered brushwork. Chokuan depicted various kinds of subject matter, from anecdotal figural representations to bird-and-flower works, and is admired for his distinctive renditions of fowl (see cat. no. 62).

The chief proponents of *Yamato-e* pictorial traditions during the sixteenth century were artists of the Tosa school, who traced their origins back to the enigmatic figures of Yukimitsu (fl. late 14th century) supposedly supervisor of the Edokoro (Painting Bureau), the official atelier in the service of the court, and his son Yukihiro of the early fifteenth century. Tosa Hirochika, head of the Edokoro from about 1439, was the father of Mitsunobu (1434-1525), who is much lauded in older documentary sources. Tosa Mitsuyoshi (1539-1613; see cat. no. 63), who also set up an atelier in Sakai, worked to rejuvenate the school after the civil wars of the sixteenth century. However, this was difficult because of the overwhelming prestige and popularity of *Kanga* painting, and the prevailing preference was for bold, monumental works with incisive brushwork, which ran counter to the static, miniaturist traditions in Tosa painting. Although Tosa artists had occasionally produced screens during the Muromachi period, their reputations were based primarily on their accomplishments in smaller formats, such as narrative handscrolls; and the refined, classical brush line of the school did not lend itself to larger compositions. In contrast, the firm bounding lines of Kanō artists, and the strong, inflected brushwork

of men like Tōhaku and Yūshō were instrumental in creating the powerful, dramatic images favored by Momoyama patrons. The Kanō and Tosa families had intermarried during the sixteenth century, and Kanō artists had adroitly appropriated certain of the decorative features of the Tosa tradition for their own works. But when Kanō Takanobu (see cat. no. 18) was appointed head of the Edokoro for the court, the event marked a low point in the school's prestige, for Tosa artists had traditionally held this post. It remained for Tosa Mitsuoki (1617-91) and Sumiyoshi Jokei (1599-1670) to reestablish the importance of the school in the early Edo period.

During the late Momoyama period, the chief beneficiaries of the colorful *Yamato-e* pictorial concepts were Hon'ami Kōetsu (1558-1637) and his artistic collaborators, including Nonomura Sōtatsu (fl. ca 1600-40). These talented artists, craftsmen, and arbiters of taste created a new aesthetic that combined the refined techniques and lively colors of native painting with an elegant sense of graphic design. This enabled them to depict venerable Japanese pictorial and literary themes that were characteristically imbued with an intimate admiration of nature. Kōetsu is celebrated for his originality, his unfailing sense of taste, his versatility, and the variety of his creative endeavors. His family were sword connoisseurs and this background undoubtedly contributed to his own discernment. He may have been a student under Kaihō Yūshō, but painting was only one aspect of Kōetsu's artistic activities, for he was a renowned calligrapher (see cat. no. 74), a potter whose *Raku* tea bowls are highly esteemed (see cat. no. 83), and an inspired designer of lacquerwares (see cat. nos 119-21), where his use of lead and pewter inlays is an important contribution to this traditional craft. He was also a garden designer and respected practitioner of the tea ceremony. Common to all these activities were his talent for pictorial organization, graphic design, and his sense of elegant form. He seems to have been congenial but independent by nature. Hideyoshi reputedly admired his abilities, but Kōetsu never served him in any capacity, and when he was invited to serve as a cultural advisor to the shogunal government in Edo, he politely declined. In 1615, Ieyasu gave him a large section of land at Takagamine, northwest of Kyoto, where he established a retreat and artists' colony. His creative roots, like those of the coterie of men who worked cooperatively at Takagamine, were in the ancient indigenous traditions of Kyoto and their associations with courtly sentiments.

Sōtatsu, the most accomplished artist of the school of decorative painting founded by Kōetsu, is an enigmatic figure and his family background is unclear. Like his mentor Kōetsu, who may have been related to him through marriage, Sōtatsu seems to have come from plebeian Kyoto origins, and it is thought that he may have worked as a painter of fans. Kaihō Yūshō seems to have known both Kōetsu and Sōtatsu, and may have instructed them in painting as he did the Emperor Go-Yōzei. Yūshō made a trip to visit the ancient Itsukushima Shrine in Aki Province in 1598, where he studied the famous set of illuminated Buddhist sutras that had been produced in the 1170s, and given to the shrine by Taira Kiyomori (1118-81), the most powerful warrior and court figure of the period. The painted frontispieces of these works reveal the sumptuous decorative taste of the nobility, with bright pigments,

gold and silver dusting, and artfully scattered fragments of gold leaf that are integrated into the stylized depictions of traditional aristocratic pictorial themes. These small-scale paintings with their mannered, graphic conceptual schemes and exuberant use of various gold and silver embellishing techniques not only anticipate the extravagant use of gold and silver in Momoyama screens designed for palatial chambers, but it is also clear that men such as Yūshō were influenced by their ebullient colors, and that Sōtatsu was directly inspired by the paintings. In 1602 he was given the job of repairing the Taira scrolls and painting several replacements for missing sections. This experience had a strong impact on him, and his subsequent works often replicate the subject matter and emulate the decorative concepts of the scrolls.

Creative collaboration seems to have been a fundamental priority at Kōetsu's enclave at Takagamine, and instructive evidence of its benefits may be seen in the various handscrolls where the talents of Kōetsu and Sōtatsu are combined to produce works of great elegance (cat. no. 74). But it is in the resplendent screens painted by Sōtatsu, such as the *Wind and Thunder Gods* (cat. no. 65), that the new aesthetic that evolved at the hands of Kōetsu and his group achieves its finest expression. It is important to observe that the school of painting founded by these men, and only much later given the name Rimpa, had its genesis in long-established native artistic traditions in Kyoto, and that the ancient citadel of the arts remained its center until late in the seventeenth century, when it was shifted to Edo, under the supervision of the artist Ogata Kōrin (1658–1716). The *rin* of Kōrin, combined with the *ha* (school or artistic line) combines to form *Rimpa*. In Kyoto, the primary source of support for Kōetsu and his fellow artists seems not to have been rich warriors, but rather influential arbiters of taste such as the Suminokura family (see cat. no. 19), who had become rich in commerce and the maritime trade. The paintings created by men like Sōtatsu combined a traditional sense of admiration for nature and gorgeous display with a vivid sense of color and decorative patterning in form. Their easy comprehensibility and ready appeal to the viewer's emotions are other manifestations of the extrospective spirit of the Momoyama period. These distinctive features of the school remained important in Japanese painting into modern times.

As we have observed, the creative wellsprings of Momoyama painting were primarily secular and temporal in inspiration. This circumstance, an expression of the optimism and prosperity of the times, provided the impetus for the evolution of a vigorous new pictorial tradition of genre painting. A variety of human activities and behavior may be observed in the *Yamato-e* handscroll paintings of earlier centuries, but these depictions are generally incidental to the essential content and narrative objective of the paintings, whether they be religious or secular in context. During the sixteenth century, however, one can observe a developing interest in the broader spectrum of human concerns – the depiction of various segments of society, their life-styles and distinctive vocations and, of particular interest, the pleasures and recreations of daily life and seasonal observances. Instructive representations of these animated subjects appear in *Rakuchū rakugai-zu* (Scenes In and Around the Capital; see cat. nos 23-4), where they are integrated into the topographical and architectural scheme of the city of Kyoto.

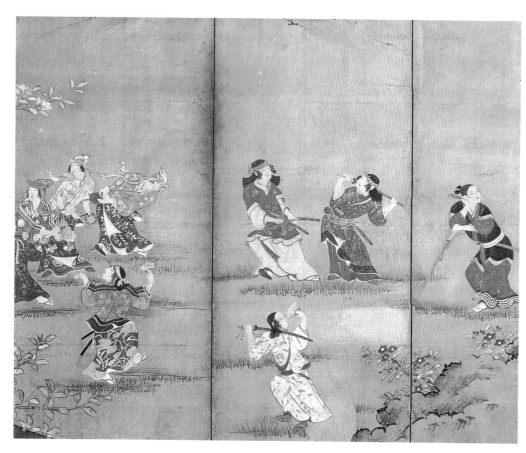

Fig. 58 Detail of *Merrymaking under the Cherry Blossoms*, by Kanō Naganobu, cat. no. 28.

Although such figural subjects had earlier been part of the repertory of the Tosa school, it appears that opportunistic Kanō painters, looking to expand their range beyond *Kanga* themes, eagerly took over these promising, lively subjects and utilized them in their own compositions. Kanō Eitoku's *Rakuchū rakugai-zu* screen compositions, painted sometime before 1574, show how skillfully an accomplished Kanō artist was able to incorporate these features into a pictorial genre that had already become a Kanō specialty. Eitoku's screens are made up of pictorial vignettes with many small figures engaged in the varied life and daily activities of the capital. Although the main emphasis in such paintings is on topography, it is also important to observe that the artist intended to enliven them with detailed depictions of actual life.

But Kanō artists were already turning to individual topographical sites, such as Mount Takao, and enlarging the scale of the figures, showing them enjoying themselves amidst the beauties of nature. Kanō Hideyori's *Maple Viewing at Mount Takao* (cat. no. 27) is a landmark in the history of Japanese genre painting. Traditional components in landscape and topographical painting, pictorial references to the four seasons (autumn and summer in this screen, and spring and summer in the lost right-hand counterpart) still play a dominant role in the composition, but the animated activities of the sightseers, enjoying *fête champêtre* pleasures, surrounded by the glorious background of red maple leaves, are what captures the viewer's attention. Significantly, the figures represented here are not aristocratic or otherwise famous, but rather typical members of the local Kyoto populace, out on a leisurely visit to the hills close to the capital. Kanō Naganobu's *Merrymaking under the Cherry Blossoms* (cat. no. 28), painted perhaps four decades after Hideyori's screen, shows a similar subject, human diversions and pleasurable activities in a seasonal setting. Here, however, the beauties of nature are relegated to a subservient background function, and the recreations and entertainments of the elegant participants, rendered in large scale and great detail, assume center stage (fig. 58). With its exuberant mood and worldly orientation, this is true genre painting, the progenitor of the rich Ukiyo-e school that evolved in the following decades.

Genre painting took a variety of forms during the late sixteenth and early seventeenth centuries. With its direct visual appeal and familiar subjects, it was often a vehicle for celebrating the various pleasures and events made possible by the greater stability and growth of leisure in Momoyama times. These included horse races, popular entertainments, and festivals. Among the most vivacious examples of festival depictions are the folding screens painted by Kanō Naizen (1570–1616) that commemorate the celebrations, at the splendid Hōkoku Shrine, dedicated to Hideyoshi held on the seventh anniversary of his death in 1604 . On this memorable occasion, huge crowds attended the festivities, and at the gate to the adjoining Hōkōji temple important dignitaries watched as gaily attired dancers from Kyoto neighborhood groups moved in great circles to the rhythmic accompaniment of drums (fig. 26). The festival continued for a week and featured a number of celebratory performances of traditional music and dance, as well as the elaborate dance pictured here. This presentation was widely emulated around Kyoto when fashionable "Hōkoku" dances were held at local festivals. These screens demonstrate how yet another Kanō master turned away from the fusty, stereotyped inventory of *Kanga* subject matter to depict dramatic scenes from real life.

Horses had played a significant role in Japanese culture since early times, and depictions of fine animals, their training, and vari-

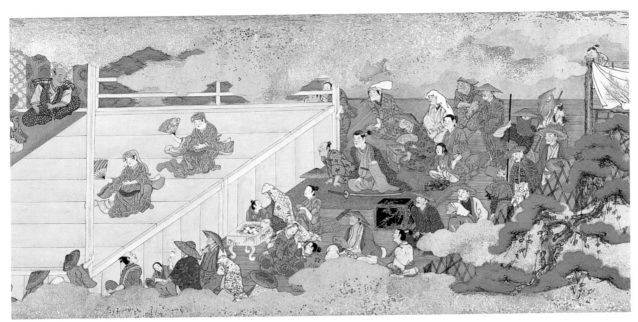

Fig. 59 Detail of *Women's Kabuki*, cat. no. 33.

ous competitions in which they were used make up another category of genre painting (see cat. nos 34-8). Seasonal events, such as the races held at the Kamo Shrine in Kyoto, were attended by crowds of onlookers from all segments of society, and demonstrate the enduring popularity of equestrian activities. Popular entertainments, ranging from traditional forms of ceremonial music and dance, such as Dengaku and Sarugaku, to Noh, which was generously supported by warriors such as Nobunaga and Hideyoshi during the Momoyama period (see cat. no. 26), and newly evolved theatrical forms, such as the Kabuki and puppet performances, with their theatres grouped together along Shijō Avenue east of the Kamo river (fig. 59) are also prominent genre subjects that remained favorites of the plebeian populations of the great cities during the Edo period.

Depictions of exotic foreigners, people from other parts of Asia as well as colorful European merchants and priests make up another category of genre. *Nambanjin* ("Southern Barbarian") subjects were painted mainly by enterprising Kanō artists and typically show European ships and their crews in port, together with their captains, merchants, and the Catholic priests who arrived in them (see cat. nos 40-2). Depictions such as these reflect the extensive Japanese intercourse with the outside world during Momoyama times. The direct artistic and religious impact of European ideas on Japanese culture in these decades may be seen in various art forms, such as lacquer pieces that were made for export under the direction of Europeans, either for commercial or religious purposes (e.g., cat. nos 122-6). There are also a significant number of painted screens in which the subjects are directly inspired by Western prototypes, which reflect the great age of European exploration and trade (e.g. cat. no. 39). With the persecution of Christianity and exclusion of European Catholics from Japan in the late sixteenth and early seventeenth centuries, this fascinating phase of painting came to an end in Japan.

The Momoyama period, with its competitive artistic environment, high creative standards, and affluent sources of patronage, is one of the most productive and important in the evolution of painting in Japan. Despite its relatively short duration, one might also argue that it is also the most innovative, dynamic, painterly,and splendid in that country's protracted history.

FURTHER READING

Michael R. Cunningham, et al., *The Triumph of Japanese Style: 16th-Century Art in Japan* (Cleveland: The Cleveland Museum of Art, 1991).

Doi Tsugiyoshi, *Momoyama Decorative Painting,* translated by Edna Crawford (New York/Tokyo: Weatherhill/Heibonsha, 1977).

Jan Fontein and Money L. Hickman, *Zen Painting & Calligraphy* (Boston: Museum of Fine Arts, 1970).

Elise Grilli, *The Art of the Japanese Screen* (New York: Walker/Weatherhill, 1970).

Mizuo Hiroshi, *Edo Painting: Sōtatsu and Kōrin,* translated by John Shields (New York/Tokyo: Weatherhill/Heibonsha, 1972).

Bettina Klein, *Japanese Kinbyōbu: The Gold-leafed Folding Screens of the Muromachi Period (1333-1573),* adapted and expanded by Carolyn Wheelwright (Ascona, Switzerland: Artibus Asiae, 1984).

Kondō Ichitarō, *Japanese Genre Painting: The Lively Art of Renaissance Japan,* translated by Roy Miller (Rutland and Tokyo: Charles E. Tuttle, 1961).

Taizō Kuroda, Melinda Takeuchi, and Yamane Yūzō, *Worlds Seen and Imagined: Japanese Screens from the Idemitsu Museum of Arts* (New York: Asia Society Galleries, 1995.

Sherman Lee, *Japanese Decorative Style* (Cleveland: The Cleveland Museum of Art, 1961).

Penelope Mason, *History of Japanese Art* (New York: Harry N. Abrams, 1993).

Miyeko Murase, *Masterpieces of Japanese Screen Painting: The American Collections* (New York: George Braziller, 1990).

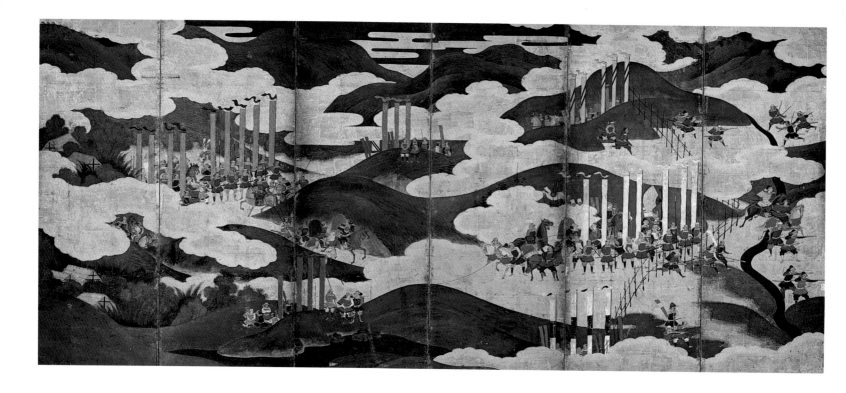

21. THE BATTLE OF NAGASHINO

Early seventeenth century
Six-panel folding screen
Ink, colors, and gold on paper
155.3 x 358 cm
Nagoya City Museum

The troops of Tokugawa Ieyasu are rallied at right beneath an enormous gold fan insignia while the main army of Oda Nobunaga enters the battlefield through the hills at left. This six-panel folding screen formed the left half of a pair, with the right screen (now lost) showing the castle at Nagashino and the attacking forces of Takeda Katsuyori (1546–82) in the summer of 1575. This battle would prove a resounding success for Nobunaga, and a decisive defeat for Katsuyori, who escaped with only a fraction of his forces. The Battle of Nagashino in Mikawa Province initially focused on a small castle situated at the intersection of two rivers. When Katsuyori's tunneling operations beneath the castle walls and water-borne attacks from the river failed to take the stronghold held by Okudaira Sadamasa (1555–1615), the Takeda armies, with about 6,000 men, began a siege. Ieyasu and Nobunaga soon arrived with 18,000 warriors, 3000 of whom were armed with guns and were entrenched behind wooden palisades in the marshy fields west of the castle. As Katsuyori led a charge of horsemen toward Ieyasu, the muddy streams and bamboo fences slowed their attack. Nobunaga's foot soldiers (*ashigaru*) were arrayed in three ranks and fired their matchlocks in sequence, each volley bringing down hundreds of Takeda troops. The slaughter was extraordinary, with estimates of nearly two-thirds of the Takeda forces killed or wounded. The film *Kagemusha* (The Shadow Warrior) by the noted

Japanese director Akira Kurosawa ends with this horrific battle.

Such a massacre hardly seems to be suggested by this screen, which shows troops assembling and just beginning their repulse of Katsuyori's attack. The artist has simplified the scene with only a few soldiers representing the massed thousands. Flags fixed vertically to poles (*nobori*) mark the troop positions, and Ieyasu's personal standard (*uma-jirushi*) of a large golden fan indicates his command post (see detail). According to records of the battle, Ieyasu's army was positioned behind the front lines near Rengo Creek, which can be seen running down the right side of this screen. When this screen is compared to others showing the Battle of Nagashino, this composition appears rather dispersed and the action subdued. Gold clouds

and rolling hills occupy much of the panorama. The samurai figures seem stiff, and their faces are relatively unexpressive. Scholars suggest, however, that this rendering of the battlefield may be closest to representing the actual site and that other compositions with flatter fields but more action are later in date, done by professional artists in Kyoto working from reports and their imaginations. This screen, with its repeated forms for both soldiers and horses, may be the earlier product of an amateur painter or regional artist.

BAC

References: Montreal 1989, 120–3, pls 75, 77; Osaka 1979, 6–7, pl. 5; Tokugawa 1983, 48–51, pls 8a, 9 (for other *Battle of Nagashino* screens); Turnbull 1977, 156–60.

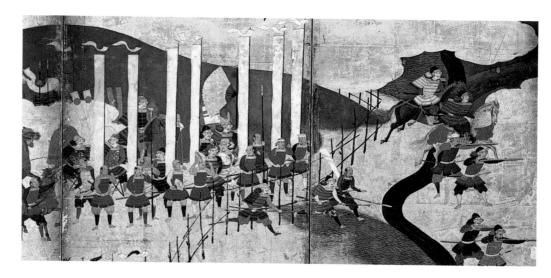

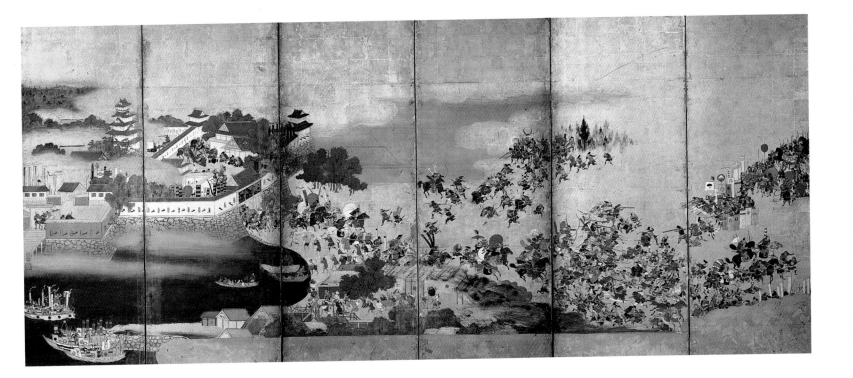

22. The Summer Siege at Osaka Castle

Hasegawa Tōi (act. late 16th–early 17th century)
Early seventeenth century
Six-panel folding screen
Ink, colors, and gold on paper
166 x 376 cm
Idemitsu Museum of Arts, Tokyo

With Osaka Castle depicted at upper left and the troops of Tokugawa Ieyasu at upper right, this screen shows the initial stages of the Summer Siege of 1615 that would result in the destruction of the castle, the Toyotomi family and many of their allies. In the winter of 1614 Ieyasu had suspected Toyotomi Hideyori (1593–1615) of stockpiling provisions and plotting rebellion, and so he ordered more than 180,000 troops to surround Osaka Castle. Hideyori's forces, numbering about 90,000, repulsed the initial attack and withstood the subsequent siege. In late January 1615 Ieyasu and Hideyori had reached a peace agreement, but the Tokugawa forces were already planning a second attack. On 3 June, 1615 the last major battle of the Momoyama period began, with the forces of Sanada Yukimura (1570–1615) and Mōri Katsunaga (d. 1615) launching an attack from the castle's south gate on the main body of the Tokugawa forces. This screen is thought to record an abbreviated view of those first moments, when the Toyotomi forces had the advantage of a surprise attack.

The battle took place on the swampy plains of Tennōji. Open rice fields can be seen at upper center, and various townspeople in the foreground are fleeing the imminent battle. Monks and merchants rush along the street while women and children are loaded into boats. At lower left are two ships, carrying the troops of Asano Nagaakira (1586–1632) whose loyalty to Ieyasu was momentarily doubted at the beginning of the battle. In the first clash of troops, the Mōri contingent burst through the front lines of Honda Tadatomo (1582–1615), and word was sent to Hideyori inside the castle that the attack had begun. To the right of the flaming houses, fierce fighting is shown in a chaotic way that truly captures the confusion of hand-to-hand combat (see detail). Some horsemen and footsoldiers carry colored banners (*sashimono*) and balloon-like capes (*horo*) attached to their armor to identify the different units. At right, beneath the banners and standards (*uma-jirushi*) marksmen shoot their guns from behind a wall of wooden shields (*tate*) that bear the insignias (*mon*) of the samurai families (detail in fig. 71). With just a few images of storming troops and bloody battle, the artist has successfully suggested here the first moments of a battle that would involve nearly a quarter million soldiers.

Very little is known about Hasegawa Tōi, whose seals are affixed at left. He is thought to have been a follower of Hasegawa Tōhaku (see cat. nos 53, 54). The meticulous detail and the animated expressions of the figures associate this work with other genre paintings popular in the early seventeenth century, such as views of the capital known as *Rakuchū rakugai-zu*, which are discussed in the following two entries. Such works might have been commissioned by participants in the summer siege of Osaka Castle or by Osaka merchants still harboring sentiments loyal to the Toyotomi family whose favor had helped create great fortunes.

BAC

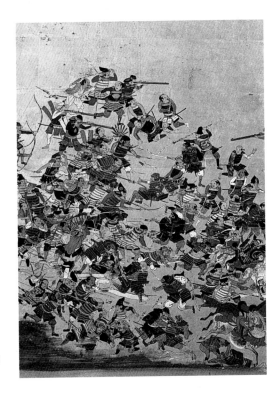

References: Osaka, 54–5, pl. 15; Turnbull 1977, 248–65.

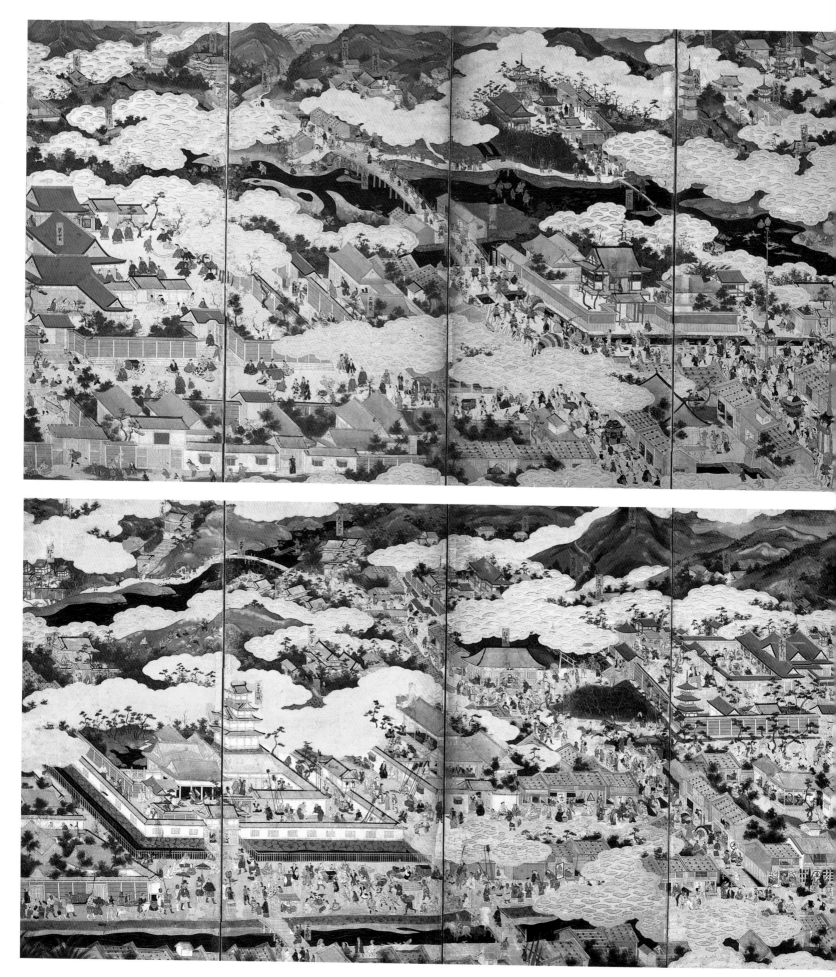

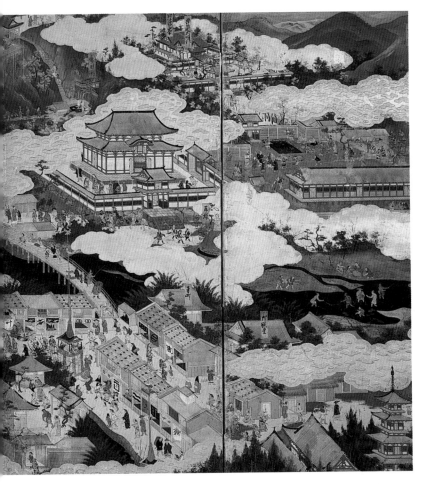

Right

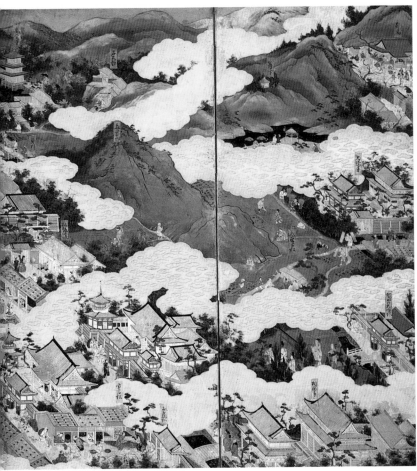

Left

Second quarter of seventeenth century
Pair of six-fold screens
Ink, colors, and gold leaf on paper
Each 94.1 x 272 cm
Namban Bunkakan Museum, Osaka

Artists of the Momoyama period responded to the transformation of the urban environment in many ways, but none is as all-encompassing or informative as the genre of screens known as *Rakuchū rakugai-zu* (Scenes In and Around the Capital). Panoramic views of Kyoto and its environs first emerged as an independent genre of screen painting by the beginning of the sixteenth century through the consolidation of scenes of famous sites, and ritual and seasonal activities. Artists of both the Tosa and Kanō schools painted them, but the latter seem to have been especially influential in their formalization and popularization. The earliest surviving example is a pair dating to the 1520s known after its former owners as the "Machida version." A second version dating to the 1570s, attributed to Kanō Eitoku, was formerly in the collection of the Uesugi family. Oda Nobunaga is believed to have presented these screens to their ancestor Uesugi Kenshin.

Many of the more than eighty surviving examples, including the present pair, follow a fixed format in which the eastern and southern part of Kyoto figures on the right and the western and northern on the left screen, but the selection of landmarks and activities may vary. These variations offer valuable clues that help to determine the authorship and date of a particular work. This pair of screens is thought to have been executed in the second quarter of the seventeenth century by a professionally-trained artist in the Kanō manner.

Kyoto and its environs are presented from a roving bird's-eye view through bands of gold clouds which serve both to separate and to draw attention to individual sites, thus imparting some coherence to the richly detailed panorama. While the distances and relationships between the various landmarks are not accurate, the gridlike structure of the composition reflects Kyoto's actual layout. Like the Chinese capital of Ch'ang-an after which it was modeled, Kyoto was laid out with named streets running north to south and numbered avenues running east to west. This axial orientation is echoed by the Kamo River, which flows in a southerly direction through the heart of the city.

The sites commemorated in these screens are roughly divided between the south and eastern part of Kyoto and its environs (on the right), and the north and western part (on the left). The dominant structures in the former are the double-roofed Great Buddha Hall of Hōkōji (detail in fig. 1), built by Hideyoshi, and the nearby Hōkoku Shrine dedicated to him after his death in 1598. The long structure to the right of Hōkoku Shrine is Sanjūsangendō, the

thirty-three bay hall dedicated to the Thousand-armed Kannon. To the left of Hideyoshi's shrine, projecting out over a hilly promontory are Kiyomizudera, a temple that offered a spectacular view of the city, and Yasaka (Gion) Shrine, and the distinctive Yasaka Pagoda. Partially visible on the far left is the spacious compound of the Imperial Palace, rebuilt first by Nobunaga and later again by Hideyoshi. Before its gates, a cock fight, a popular activity among aristocrats, is taking place.

Nijō Castle, situated at the southwest corner of Second Avenue dominates the left screen. Built in 1603, and renovated in 1626, it was intended to serve as Ieyasu and his heirs' temporary Kyoto residence, but no Tokugawa shogun visited Kyoto after 1634, when Iemitsu paraded through the city. To the right of Nijō Castle is Kitano Shrine (see detail). Dedicated to the patron deity of poetry and literature, this shrine was the setting for the grand tea ceremony hosted by Hideyoshi in 1587. The multi-storied Golden Pavilion, Kinkakuji, with its surrounding pond, as well as the compound of Daitokuji, one of the most influential Zen temples in Kyoto, also figure on the far right of this screen.

While prominent architectural landmarks are the most eye-catching features, human activities are equally important to these idealized visions of the flourishing city. Craftsmen make and sell the various objects – fans, lacquer, ceramics, and the like – for which Kyoto was renowned. Mendicant priests march purposefully through the alleyways soliciting funds from the citizenry. A procession of Portuguese merchants beneath colorful umbrellas promenades before Nijō Castle. The elaborate floats of the Gion Festival, held annually in mid-summer, can also be seen wending their way through the city center (see detail).

The representation of the surrounding hills dotted with flowering cherries, on the right, and maples in their autumn glory, on the left, completes the view of the city and its suburbs. These seasonal vistas testify to the importance these open spaces played in the lives of the Kyoto citizenry and by the same token convey a sense of the orderly progression of time and space.

CG

References: Berry 1994, 285–302; Takeda 1978a, figs 27–8; Tsuji 1976b, fig. 73; Yamane 1973, 29–35.

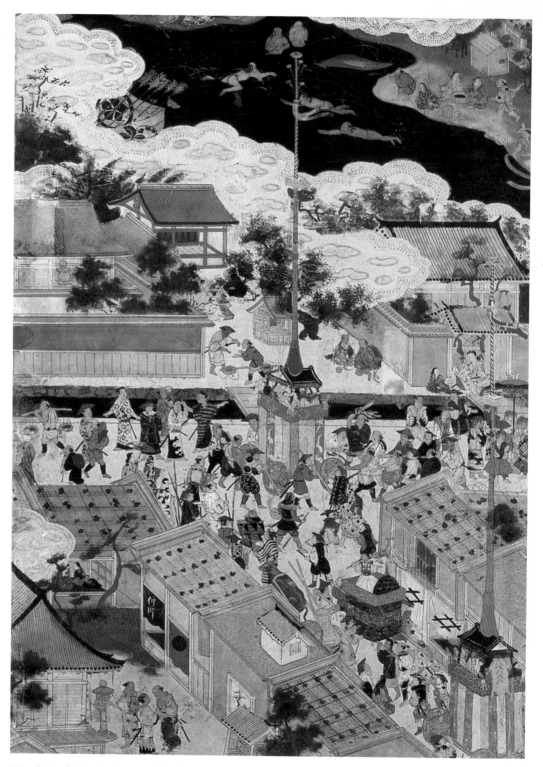

Gion Festival, detail of cat. no. 23, right screen.

Kitano Shrine, detail of cat. no. 23, left screen.

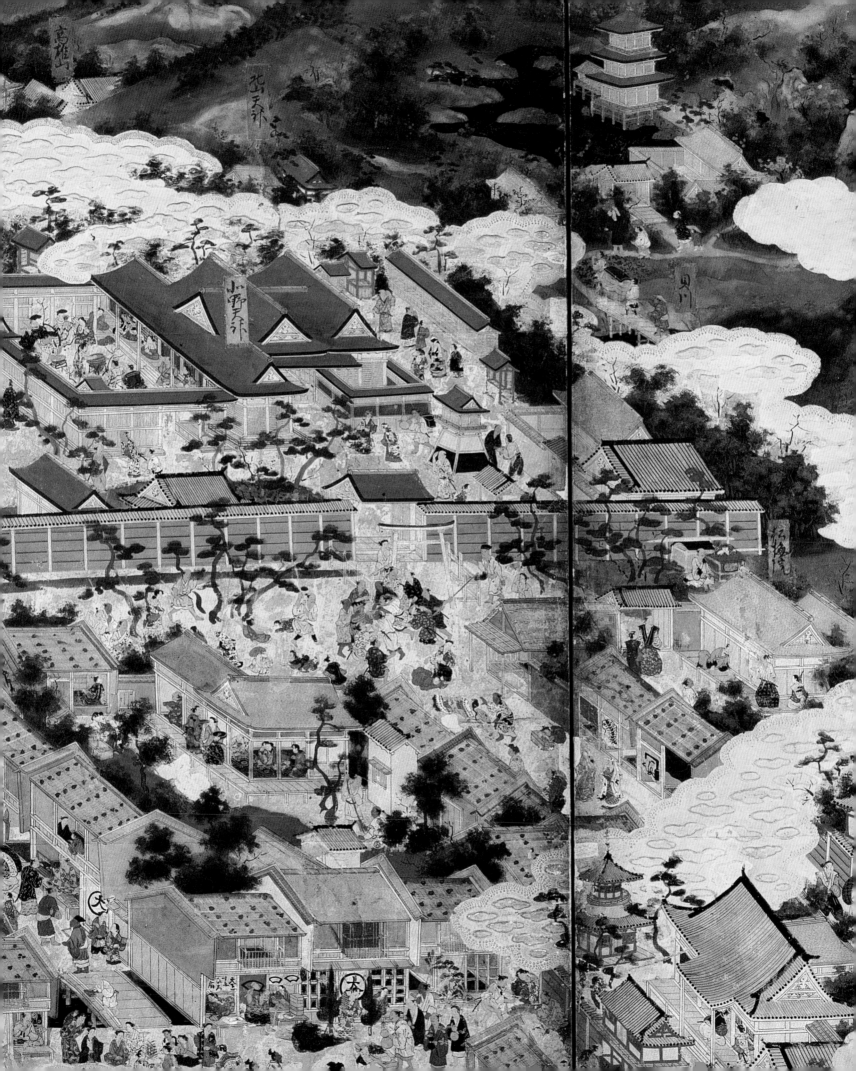

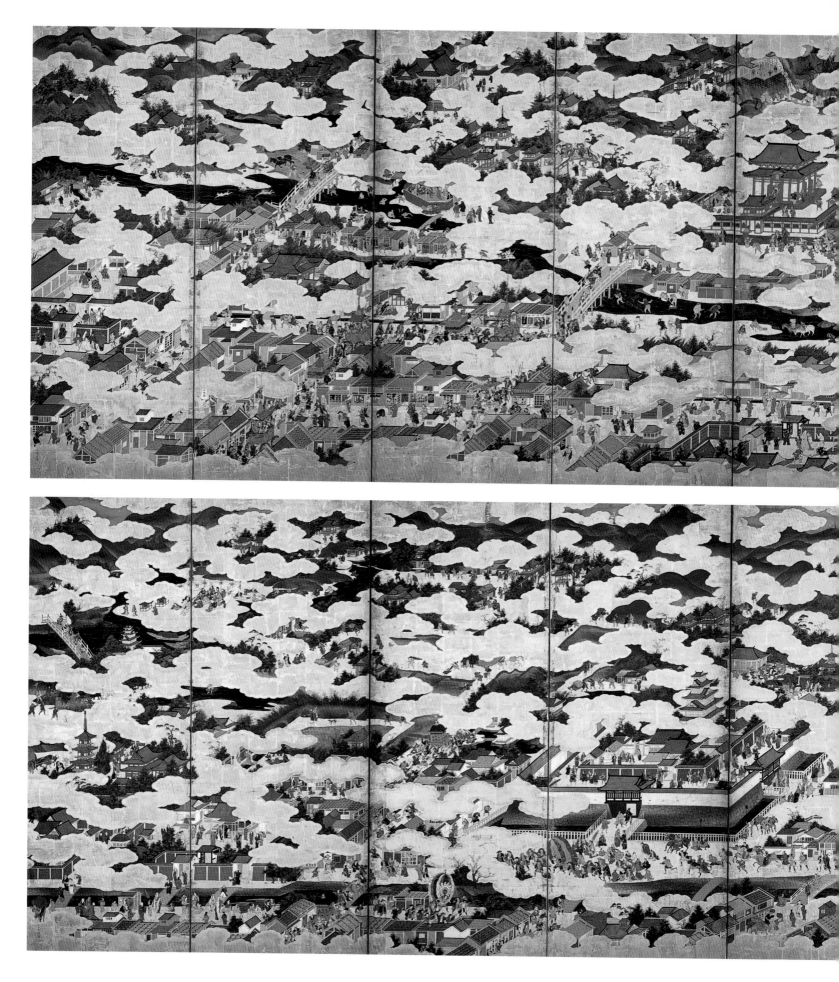

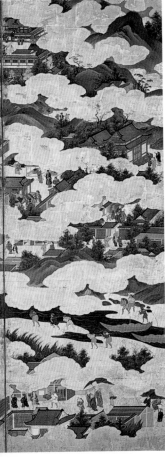

Right

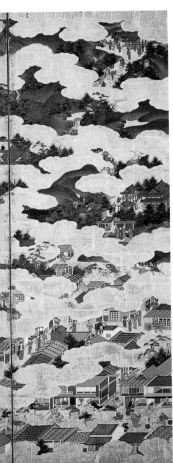

Left

Second quarter of seventeenth century
Pair of six-panel folding screens
Ink, colors, and gold leaf on paper
Each 156.5 x 366.8 cm
Manno Art Museum, Osaka

Although the scenes that unfold in this pair of screens for the most part match those in the previous one, the sharp diagonal slant of the architectural elements and the horizontal layering of buildings, streets, and figures gives the composition a more schematic quality. This strong lateral orientation is reinforced by the continuous bands of clouds that float over the surface of the screens, denying rather than enhancing the sense of pictorial depth. These characteristics suggest that the screens are the work of a *machi eshi*, or town painter, while the carefully delineated features of the figures are in the style associated with Iwasa Matabei (1578–1650). The signatures and seals of Tosa Mitsunobu are later additions.

Aerial, panoramic views of Kyoto and its environs encompass far more than can actually be seen by the human eye. This very comprehensiveness may have been one of the special attractions. By "taking in" the entire city in all its infinite variety, the viewer was in effect making it his own. This symbolic appropriation of Kyoto was reinforced by the manner in which *Rakuchū rakugai-zu* were customarily displayed. Rather than being displayed side by side, views of Kyoto were most likely arranged facing each other, with the viewer(s) occupying the three-dimensional space at their center.

Despite their schematic format, *Rakuchū rakugai-zu* are not simple maps but projections of the images and values, both real and imaginary, of their artists and patrons. As revealing for what they include as for what they ignore, they helped to articulate sixteenth- and early seventeenth-century perceptions of the symbolic sites of Kyoto and its surroundings. Through them, the modern viewer may gain some sense of the resonant past that has both defined and confined the city's inhabitants.

CG

References: Takeda 1978a, figs 66–7; Tsuji 1976b; Yamane 1973, 29–35.

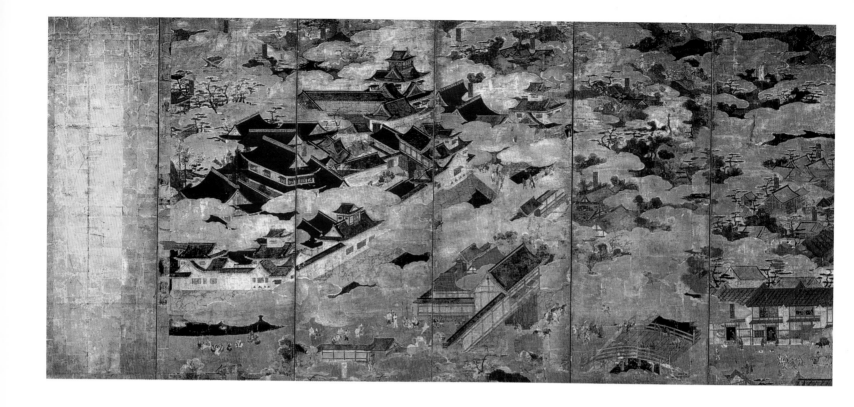

25. THE JURAKUTEI

Circa early 1590s
Six-panel folding screen
Ink, colors, and gold leaf on paper
156.1 x 355.2 cm
Mitsui Bunko, Tokyo

The most famous of Hideyoshi's amazing architectural projects – Osaka Castle, Jurakutei ("Mansion of Assembled Pleasures"), the Daibutsuden ("Great Buddha Hall"), and Fushimi Castle – were all short-lived. Their ephemeral histories serve as a metaphor for the Momoyama period itself: dynamic, prodigious, memorable, and transitory. It is ironic that, unlike the other sites, which were victims of either natural disaster, fire, or destructive warfare, the resplendent Jurakutei compound was intentionally dismantled and razed by the builder himself.

The Jurakutei (also pronounced "Juraku no tei" or "Jurakudai") was a sprawling complex of fortifications, luxurious residences, and elaborate attendant structures that was begun early in 1586, and miraculously brought to completion a year and a half later. It was laid out some distance west of the Imperial Palace Compound on a huge level area (said to have measured 700 meters square), occupying land that in ancient times had been part of the palace precincts. One-hundred thousand artisans, laborers, craftsmen, and artists were brought together for its construction, which must have surely established a new standard for logistical complexity and architectural splendor. Conceived as a dramatic expression of

Hideyoshi's power and status, it was intended to dominate the capital in a strategic as well as symbolic sense.

While colorful literary accounts provide us with descriptions of some of the splendid activities that took place within the precincts of the Jurakutei, there are no surviving records of the actual disposition of its buildings or their dimensions. The only exception is a ground plan, thought to be of a later date, that is said to represent the Great Reception Hall (Yamane 1966, 152). Because of this paucity of reliable information, the visual evidence provided by the Mitsui screen is of prime importance in any attempt to reconstruct the layout of the compound. There is a certain historical irony in the fact that it may very well be the only surviving contemporary depiction of this fantastic building complex – one of the most evocative and noteworthy in the history of Japanese architecture.

During its abbreviated history, Jurakutei was the scene of many elegant events and activities. The procession and five-day visit of Emperor Go-Yōzei and his entourage to the Jurakutei in the spring of 1588 – during which Hideyoshi and his greatest warlords feted the imperial party with ceremonies, entertainments, and expressions of admiration and fealty – was unparalleled in its grandeur and symbolic implications (described in greater detail in the Introduction, pp.36-7).

Hideyoshi and members of his family occupied the Jurakutei for several years. Hidetsugu, Hideyoshi's nephew and chosen

successor, was installed there in 1592. Three years later, Hideyoshi's growing antipathy for Hidetsugu, who had a reputation for cruelty and dissipation, finally reached a point of crisis, and Hidetsugu was ordered to commit suicide. So strong was Hideyoshi's aversion to Hidetsugu that the latter's vassals were all compelled to take their own lives. Soon after, Hidetsugu's wives, children, and more than thirty of his women attendants were paraded through the streets of Kyoto and decapitated on the bank of the Kamo River, where their corpses were interred in a common grave. To eradicate any further memory of his detested successor, Hideyoshi had the Jurakutei entirely dismantled and razed, bringing to an abrupt close the grandiose but ephemeral history of this fabulous architectural monument.

While it is possible that the Mitsui screen may originally have been created as a *haritsuke-e* (a composition on a continuous sheet of paper that was affixed to a flat surface), it seems more likely that it was conceived of as the left half of a pair of folding screens. The treatment of architectural detail, representations of varied human activities, and compositional scheme, all indicate that it is both artistically and conceptually related to the development of the distinctive genre known as *Rakuchū rakugai-zu* (Scenes In and Around the Capital), which evolved by the beginning of the sixteenth century and flourished in the Momoyama and early Edo periods (see cat. nos 23, 24). The renowned painter Kanō Eitoku (1543–90) produced screens of this sort. He and his atelier

are also known to have been active in the painting of screens for the Jurakutei. The compound of the Nijō Castle, a residential fortress like the Jurakutei, that became the headquarters of the Tokugawa *bakufu* early in the seventeenth century, is often depicted in a similar position in the left-hand screens of *Rakuchū rakugai-zu* compositions. One suggestion is that the Mitsui painting may have originally been balanced on the right by the Buddhist temple Hōkōji (fig. 1), another of Hideyoshi's prodigious architectural accomplishments. Hōkōji has as its central structure the Great Buddha Hall, a colossal building that rivaled if it did not surpass in size the original eighth-century structure of the same name in Nara.

The Mitsui screen is incomplete: its left-hand panel has been lost and the left-hand side of the adjoining panel has been damaged, but the rest of the panels are original and intact. It is generally assumed that the work was executed sometime in the years immediately following the completion of the Jurakutei in late 1587. If the Hōkōji was in fact the subject depicted in the missing right screen (as it is in some *Rakuchū rakugai-zu* compositions), this would suggest a dating to the middle 1590s. Work on the Daibutsuden and its mammoth wooden image of the seated Buddha (Skt: Vairocana), begun late in 1588, was not finished until 1595, when the Jurakutei was dismantled and razed during the later months of the year.

A section of an affluent mercantile neighborhood is depicted in the lower right-hand panel. The facades of the high, two-storied structures face the street, and to the rear are the tile-roofed fire-proof earthen warehouses (*dozō*) where commodities are stored. The individual firms are identified by distinctive motifs and names that appear on the blue curtains hung at the entrance. Pedestrians move along the street toward a broad bridge over the Horikawa Canal, and on to the main entrance gate to the Jurakutei. Having passed through this imposing tile-roofed portal, the visitor turned right, proceeding for some distance along the water-filled moat that surrounded the inner compound, and then turned left, passing over the stone bridge that led to the inner gate of the compound.

The Jurakutei complex consists of castle components, with their white battlements and protective towers and gates, built above high parapets constructed of huge, fitted boulders. The moat below encircles the luxurious residential quarters equipped with belvederes, sumptuous gardens, adjoining facilities for tea gatherings and banquets, and a stage for dramatic and musical performances such as Noh and Bugaku. The roofs of the castle towers and battlements (rendered in dark blue) are covered with tiles, while the brown-roofed structures are covered by layered cypress-bark shingles – the traditional choice for courtly architecture. In the center of the latter group is a multi-storied building that represents the palatial quarters occupied by Hideyoshi, his family, and close attendants. The highest edifice in the compound, the castle donjon (at the top of the composition) appears to have at least four levels. It seems to be similar in its complex architectural conformation, with its hipped roofs and gables and elaborate embellishments, to the extraordinary tower that rose above Nobunaga's Azuchi Castle, which undoubtedly provided the general source of inspiration for the Jurakutei. Here, following the precedent of Azuchi Castle (figs 10–11), the pervasive atmosphere of grandeur is heightened by the addition of gold leaf to the tiles along the rooflines and to the mythological animals atop the donjon. Several of Hideyoshi's high-ranking vassals, such as Maeda Toshiie (1538–99) and Gamō Ujisato (1557–96) are said to have built residences adjacent to the Jurakutei (these may be the buildings represented in the second panel from the right).

This unique screen was acquired by Mitsui family in 1875, when it was bought from a restaurant in Ōtsu, Shiga Prefecture. The earlier history of the screen is a mystery, but it is pleasant to imagine that because it came to light at a location close to Kyoto, its first owner may well have marvelled at the Jurakutei itself.

MLH

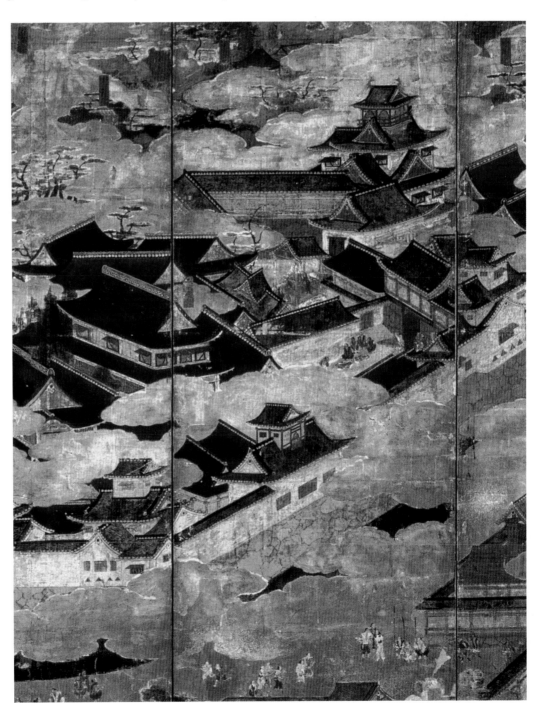

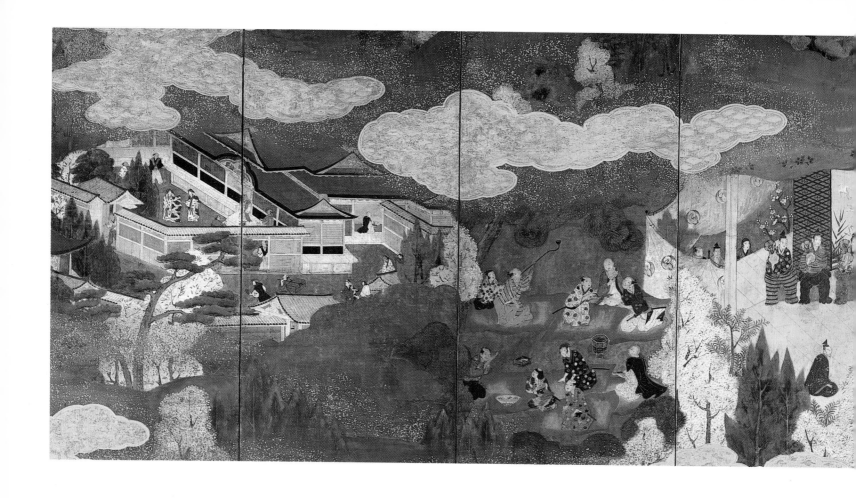

26. NOH PERFORMANCE

Early seventeenth century
Eight-panel folding screen
Ink, colors, gold leaf on paper
106.5 x 425.8 cm
Kobe City Museum

This screen is thought to describe an event during one of the visits of the Emperor Go-Yōzei to Hideyoshi's palatial mansion, the Jurakutei, either the visit in 1588 or the one in 1592. The emperor and his ladies are dimly and discreetly visible behind the bamboo blind at the top of the second panel from the right. Hideyoshi is presumed to be the gentleman with the fan in the first panel on the right. The ladies of his household occupy the verandah on the left. On a temporary stage set up in the garden a Noh actor, backed by musicians and a chorus, dances energetically. His role is traditionally identified as Okina, the deity whose invocation marks the beginning of a full program of Noh performances (detail in fig. 77).

The lower-level audience, seated on the ground or on portable mats, includes a number of foreigners and prominently features individuals smoking tobacco in long pipes. From the most exalted traditions of the past to the most up-to-date fashions of the present – here, the painting seems to suggest, we find the pinnacle of Momoyama life.

The emperor's visits to Hideyoshi served a very important political function. They publicly confirmed the important relationship between the figurehead of Japanese sovereignty and the military ruler. Hideyoshi was very sensitive to the legitimizing power of the court, and actively sought its favor. Both parties benefited. Hideyoshi single-handedly restored the financial health of the emperor through lavish donations of land and money. The emperor, in turn, awarded Hideyoshi the highest court titles (regent in 1585 and great minister of state in 1586), and allowed Hideyoshi to take a new family name (Toyotomi) and to adopt his younger brother.

This screen can be dated to the early seventeenth century, sometime after 1607, because of a gate included in the depiction of Kitano Shrine in the leftmost two panels.

AJP

References: Takada 1978b; Tani 1978, no. 14.

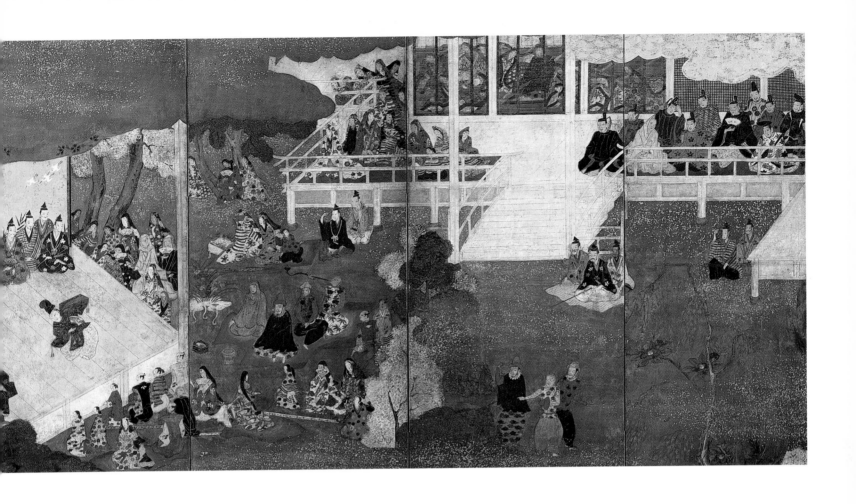

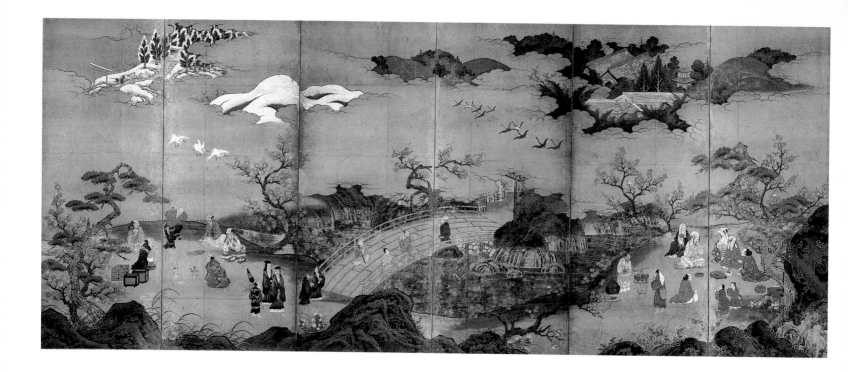

27. MAPLE VIEWING AT MOUNT TAKAO

Kanō Hideyori (died ca 1576/7)
Third quarter of sixteenth century
Six-panel folding screen
Ink and colors on paper
148.0 x 364.0 cm
Tokyo National Museum
National Treasure

This screen, once part of a pair, has long been considered a landmark in the development of Momoyama genre painting. Daily activities and seasonal rituals of all social classes had figured in *Yamato-e* screens and handscrolls since the Heian period (794–1185), but they became the focus of heightened artistic interest in the sixteenth century, giving rise to new pictorial subjects such as views of Kyoto and its environs and scenes of merrymaking. Although many of these works, now classified as genre painting (*fūzokuga*), appear to celebrate earthly pleasures, they often betray evidence of a medieval world view shaped by Buddhist cosmology.

The artist has taken as his subject three groups of festively clad merrymakers on an outing in the hilly northwestern suburbs of Kyoto, a scenic locale frequented by the city's inhabitants when the autumn foliage was at its finest. On the right, a convivial group of women sits near a vender of green tea, a product for which the region was famous (detail in fig. 65). A nun, seated on the far left of this group, holds a large bowl of tea she has just purchased while her companions chat, nurse an infant, and watch the antics of a pair of rambunctious children. Beyond them, in the central part of the composition, several soberly clad monks have paused at the foot of an arched bridge to listen to the commingled sounds of the flute and the swiftly flowing Kiyotaki river. To the left of the

bridge, a lively group of men dance and sing to the rhythmic beat of hand drums (see detail).

The piercingly bright fall colors and promising vistas of Mount Takao, with the roofs and pagoda of Jingoji rising above distant clouds on the right, and the snow covered pines of Mount Atago and its shrine on the left, serve to identify the locale and to create a sense of seasonal progression. (The now lost right-hand screen would have presented similar views of scenic spots in Kyoto and its environs against a spring and summer backdrop.) They also imbue the painting with religious overtones, since the region surrounding these two complexes was traditionally identified as a Buddhist paradise (*Jōdo*). Crossing the bridge spanning the Kiyotaki River signaled the entry into this sacred realm.

Attributed to Kanō Hideyori on the basis of the fact that the characters "Hideyori" figure in the jar-shaped seal impressed in the left side of the composition, this work vividly testifies to the Kanō school's appropriation of *Yamato-e* themes and styles previously monopolized by artists of the rival Tosa school. Although no comparable genre screens by Motonobu survive, the compositional balance and sense of pictorial depth achieved by the careful orchestration of figural and landscape elements betray Hideyori's Kanō training. So too do details such as the sturdy moss encrusted pines and faceted rocks. The stylized rendering of the ground, foliage and flowers in mineral pigments including malachite green, vermilion red, and azurite blue, however, derive from the *Yamato-e* tradition. With this syncretic pictorial vocabulary, Hideyori has fashioned a richly detailed and evocative celebration of activities that were inextricably bound up with the rhythms of life

in sixteenth-century Kyoto.

While Hideyori's idyllic vision is rich in symbolism, it is also grounded in reality. The styles of dress worn by the merrymakers, the lacquer boxes containing their picnic foods, and the ceramic bowls from which they sip green tea all accurately reflect prevailing tastes during the artist's lifetime. The *tsujigahana* style *kosode* patterned with flowering wisteria and camellia worn by the woman with her hair in a chignon and the nursing mother are astonishingly close in design to textile fragments collected and mounted on screens by Nomura Shōjirō. Extant textiles, as well as ceramics, lacquer, and printed books, also testify to the popularity of the motif of rabbits running over waves that decorates the sleeveless jacket worn by the man engaged in conversation with the monks standing at the foot of the bridge (see detail; see also fig. 75). Although attentiveness to costume is a characteristic of much Momoyama genre painting, this correspondence to surviving textiles is particularly noteworthy.

Hideyori was once thought to be the second son of Motonobu (1476–1559), a seminal figure in the fusion of pictorial styles, subjects, and materials of Chinese origin with those of Japanese origin. Recent scholarship, however, has identified him as Motonobu's grandson, who painted also under the name Nobumasa. Although this reidentification is not conclusive, it is supported by the discovery of a small corpus of paintings bearing the Hideyori seal, datable to the late 1560s, and showing some stylistic similarities with *Maple Viewing at Mount Takao*.

CG

References: Suzuki 1994; Takeda 1977a, fig. 1; Tsuji 1976a; Tsuji 1991, fig. 62; Yamane 1973, 40–51.

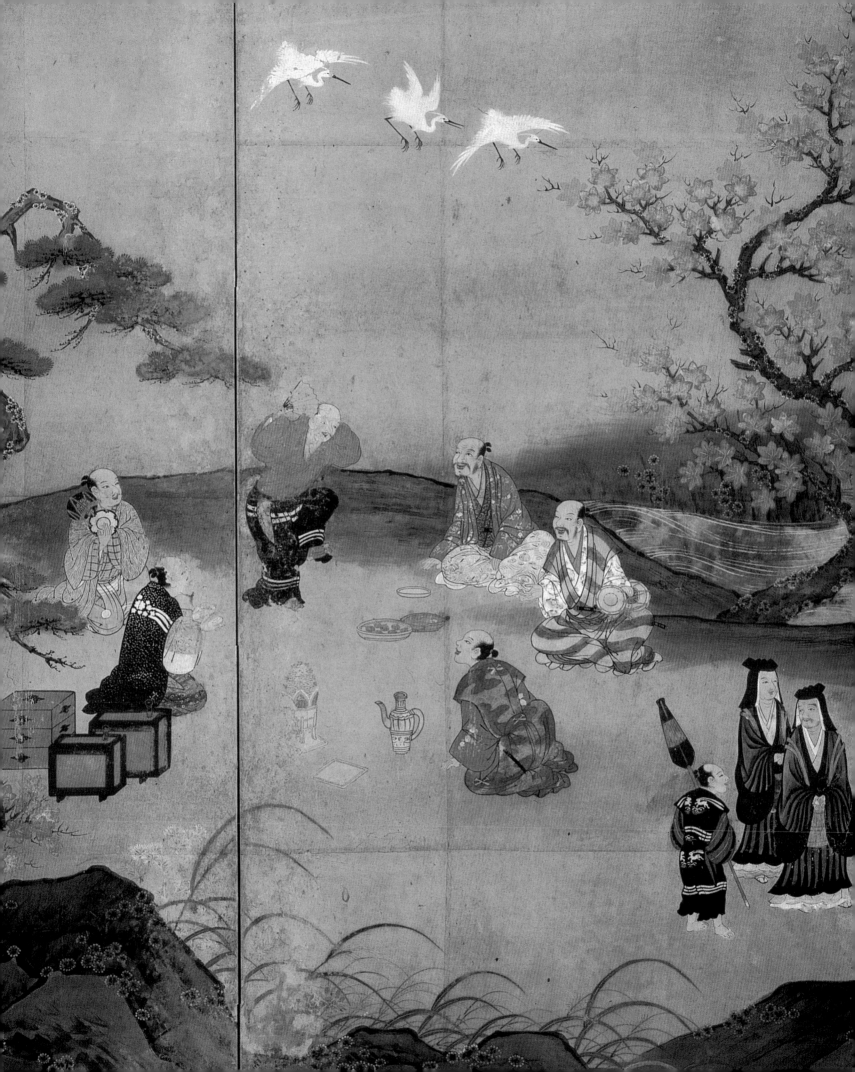

28. Merrymaking under the Cherry Blossoms

Kanō Naganobu (1577–1654)
Circa 1600–10
One of a pair of six-panel folding screens
Ink, colors, and light gold wash on paper
149.4 x 356.1 cm
Tokyo National Museum
National Treasure

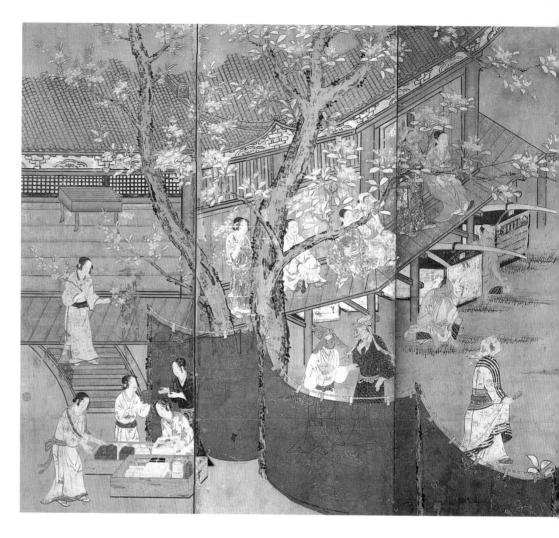

This screen is the left side of a pair, in which a continuous composition stretches across both halves. Although the two center panels of the right-hand screen were destroyed in the disastrous earthquake that ravaged Tokyo in 1923, the remaining panels and a photograph taken before the damage give a clear idea of its contents and details (cat. no. 28a). It shows two attractive women of high rank, dressed in sumptuous robes decorated with floral designs, sitting casually on what appear to be rugs, under a huge, ancient cherry tree, its outstretched branches heavy with white blossoms. The regal woman to the right is the center of attention, surrounded by a circle of followers who provide refreshments, singing and musical accompaniment. Set against the atmosphere of a warm, tranquil spring day, the scene is one of genteel, desultory pleasure.

The mood in the left screen is more exuberant, and focuses on a circle of fashionably attired dancers who sway and posture to the lively beat of a hand drum. Seated on the balcony of a hexagonal building to the left are a youth of aristocratic appearance and his companions, enjoying the movements of the animated performers before them. Some of the elegant participants in this spring outing have come by palanquins, which rest, together with their bearers, below the balcony. Preparing for a picnic repast, several servants to the lower left are unpacking food containers with an assortment of prepared delicacies. In the foreground, extending across the bottom of both screens, is a sheer textile curtain, decorated with floral designs and hung between poles, that encloses the festive activities and serves as a discreet reminder to outsiders that this is an exclusive, privileged gathering. For the people depicted here are not commoners but rather persons of high social status, probably members of the new warlord aristocracy.

The artist Kanō Naganobu was the fourth or fifth son of Shōei (cat. no. 43) and younger brother of Eitoku (cat. nos 44–6). Other than a few fragments of documentary information, little is known of his career. He was trained by his father, and known as Genshichirō and Saemon in early life, later taking the artist's name Kyūhaku. He seems to have gained favor with the Tokugawa *bakufu* by the early years of the seventeenth century, for he is reputed to have worked on sliding screens with depictions of Chinese court scenes in the *chūjōnoma* chambers of the Tokugawa headquarters, Nijō Castle in Kyoto. Furthermore, he is said to have been invited to paint at the castle at Suruga by the second shogun, Hidetada, after which he moved on to Edo where he established a Kanō atelier and was recognized for his artistic accomplishments with the honorific title Hokkyō ("Bridge of the Law"). *Merrymaking under the Cherry Blossoms*, which has the artist's jar-shaped Kanō seal, may well be the only work that can be confidently attributed to Naganobu's hand, but this single painting alone, which has been designated a National Treasure, suffices to demonstrate the artist's significant contribution to Momoyama painting.

Three, perhaps four decades separate Naganobu's screen from *Maple Viewing at Mount Takao*, discussed in the previous entry, done by his uncle Hideyori, and the later screen provides clear evidence of the evolution of genre painting in the interim. Naganobu lived in a time of greater stability and optimism than his uncle, when warfare was no longer common and increased commerce and affluence were reflected in a greater sense of self-assurance in society. Affluence brought leisure and the opportunity to spend more time enjoying entertainments and recreations. There are no religious overtones or philosophical implications in Naganobu's painting. Rather, it is concerned with human diversions and pleasures, and the natural settings that formerly dominated genre paintings are here relegated to a secondary role. The artist's efforts are concentrated on the sensuous spectacle of a spring outing, and the animated figures fill the screens with their actions and the vivid colors of their bright clothing, sublimating the lyrical hues of nature in the background.

MLH

References: Doi 1978a, vol. 9 (for color details of right panels of right screen, see pl. 24); Noma 1955 (for color details of left panels of right screen, see pls 11, 12, 13).

Cat. no. 28a. : *Merrymaking under the Cherry Blossoms*, by Kanō Naganobu, detail of right screen (destroyed in the Great Kantō Earthquake of 1923).

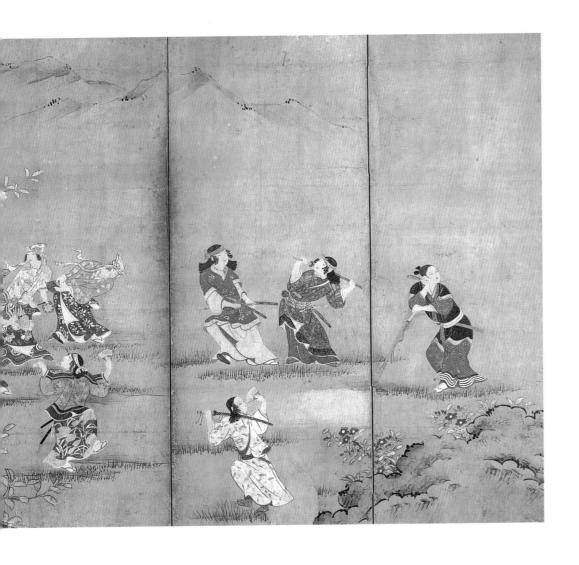

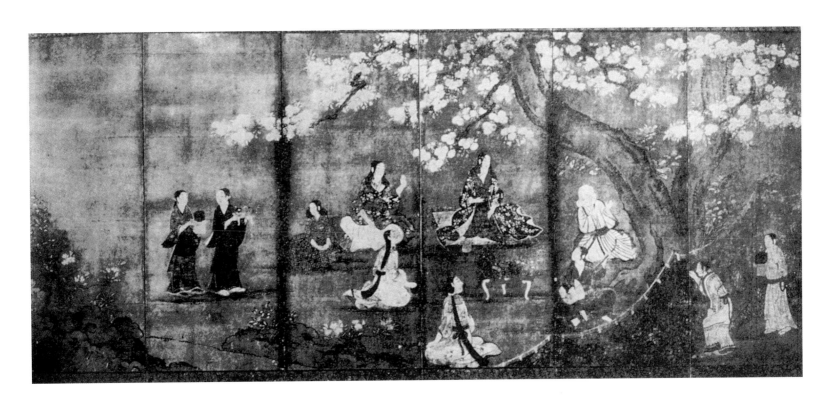

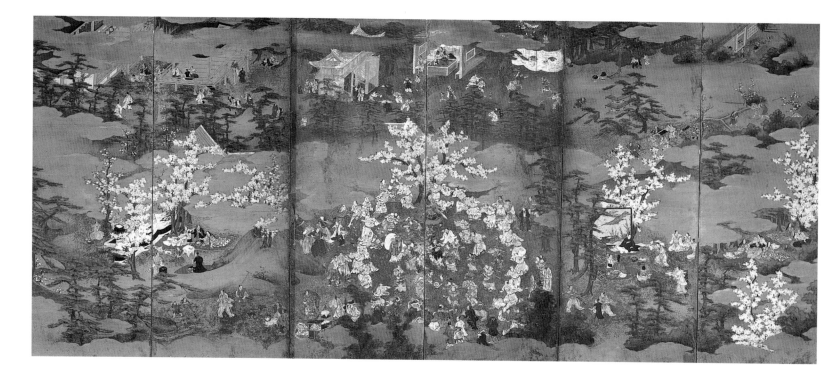

29. MERRYMAKING UNDER THE CHERRY BLOSSOMS

Kanō school
Early seventeenth century
Pair of six-panel folding screens
Ink and colors on paper
Each 149.3 x 352.7 cm
Kobe City Museum

Fūryū odori, literally "dances of the flowing wind," were a Momoyama phenomenon recorded in many screen paintings of the late sixteenth and early seventeenth centuries. Initially they were impromptu and often frenzied outbursts whose strong political overtones so unnerved Kyoto authorities that they made periodic, though largely unsuccessful, efforts to ban them. By the turn of the seventeenth century, as this carnivalesque atmosphere abated, *fūryū odori* became fashionable, and often competitive, spectacles performed at informal seasonal outings as well as shrine and temple festivals. One of the most celebrated performances took place in 1604 at the Hōkoku Shrine. As part of the observances honoring the deified Hideyoshi, more than five-hundred dancers divided into two groups, one from the Upper City (Kamigyō) and the other from the Lower City (Shimogyō), participated in an extraordinary *fūryū odori* that was later commemorated in painting by Kanō Naizen.

Two shrines, Yasaka (Gion), situated in the Lower City, and Kamigamo, situated in the Upper City, also serve as the setting for the *fūryū odori* represented in this pair of screens. Bending and swaying in perfect concert, the flamboyantly costumed dancers move in concentric circles. Some hold large umbrellas, others fans, and still others play small hand-held drums. Figures costumed in the baggy pants, jackets, and caps of Portuguese traders are at the center of the group at the Yasaka Shrine (on the right), while the dancers at Kamigamo Shrine (on the left) have encircled figures dressed as Daikoku and Ebisu, the gods of wealth and good luck (see detail). Although this spectacle does not commemorate an actual event, the artist's selection of shrines located in two distinct sectors of the city suggests a division of dancers comparable to that at Hōkoku Shrine.

Beyond the animated dancers, here and there among the cloud-draped groves of blossoming cherries and pines, men and women of various social classes engage in other pleasurable pastimes. A small group of noblemen, protected from the hoi polloi by a dazzling golden screen is entertained by a rowdy dancer (left screen, second panel from the right). Men arm-wrestle (right screen, fifth panel), women play *sugoroku*, a board game resembling backgammon (left screen, first panel), and still other merrymakers anticipate the tasty fish, fowl, and rice being prepared by busy cooks behind the cover of a large screen (right screen, sixth panel).

Although these festive screens are unsigned, the pictorial style adopted in the representation of the trees and figures point to an artist in the circle of Kanō Mitsunobu. These screens are almost identical in subject and style to a pair in the Suntory Museum bearing square seals reading "Amagi Sōchū," an artist who is otherwise unknown.

CG

References: Berry 1994, 244–59 (on *fūryū odori*); Okada 1978, no. 6; Takeda 1977c, figs 8–9; Yamane 1973.

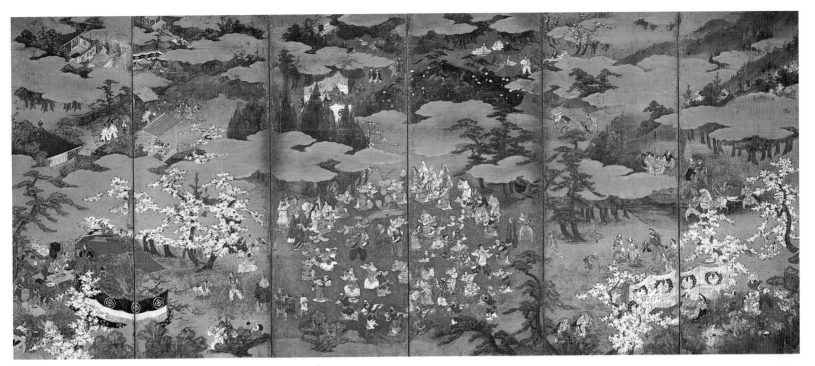

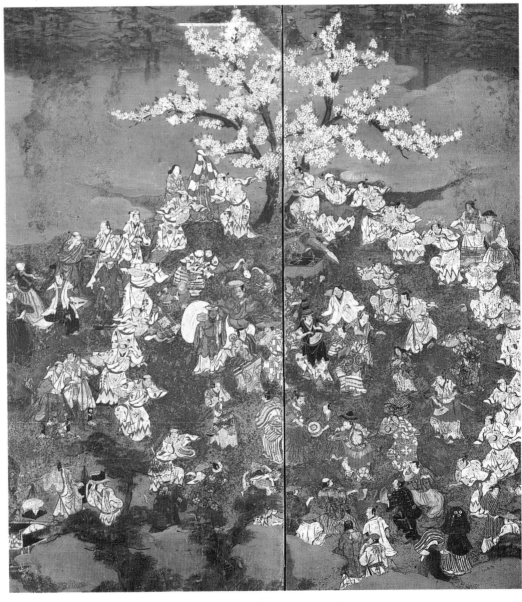

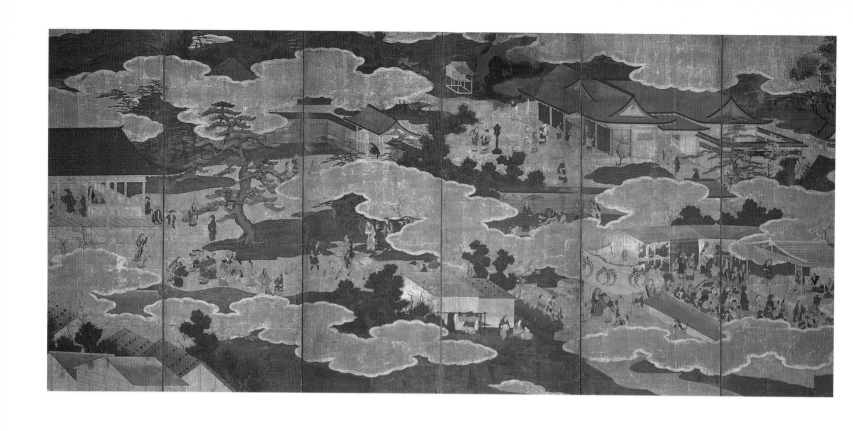

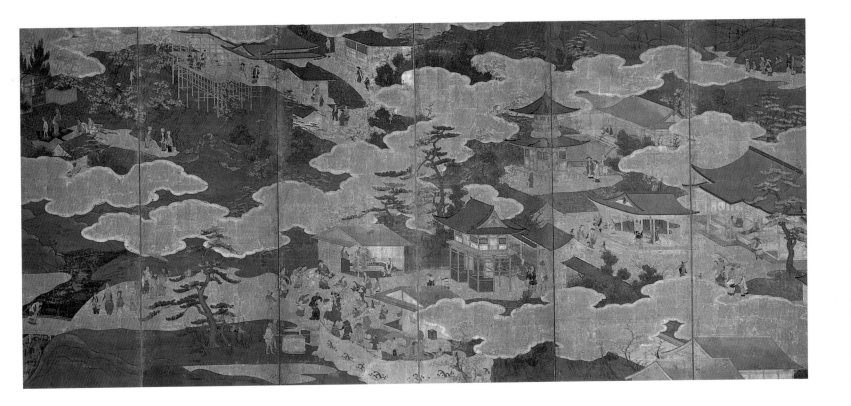

30. CELEBRATED PLACES IN KYOTO: HIGASHIYAMA AND KITANO

Kanō school
Circa 1610s
Pair of six-panel folding screens
Color and gold on paper
Each 168.5 x 349 cm
Suntory Museum of Art, Tokyo

In this pair of screens selected landmarks that figure in *Rakuchū rakugai-zu* have been singled out for more focused treatment. Each site is viewed from above and situated in a small pocket of space framed by bands of gold clouds, a compositional device also employed in more comprehensive cityscapes by artists of the Kanō school. Like *Rakuchū rakugai-zu* also, the views are divided between the eastern and western parts of the city.

The right screen features Kiyomizu Temple and Yasaka (Gion) Shrine, two famous religious institutions located in Kyoto's scenic Eastern Hills or Higashiyama District, and the left one, the vast compound of Kitano Shrine in the northwestern part of the city. At Kiyomizu, seen in the upper right, visitors have gathered on the stage-like veranda that juts out in front of the temple to admire the profusion of blossoming cherry trees in the valley below. In the foothills, dandies dressed in the height of fashion, with European pantaloons and tall red caps, admire the view near the bridge over the Kikutani River. Before the covered gateway marking the entrance to the Yasaka Shrine (lower left of the right screen), a crowd of gaily dressed visitors

has gathered to perform an impromptu dance, probably a variation of the *fūryū odori* in vogue during this era (see previous entry). At Kitano, a shrine devoted to a popular patron deity of poetry and literature, a performance of Okuni Kabuki is in progress. Since Okuni came from Izumo Shrine to Kyoto around 1603, and is said to have performed at Kitano Shrine several years later, this work probably dates from the end of the Keichō era (1598–1615).

Genre screens showing selected scenic spots and seasonal activities in and around the capital were exceedingly popular during the Momoyama period. A pair of screens also depicting Higashiyama and Kitano now in Chōenji, a temple in Nishio City, Nagano Prefecture, that is thought to have belonged to Itakura Katsushige (1542–1624), Ieyasu's representative (*shoshidai*) in Kyoto, suggests they were often made for the enjoyment of daimyo and their families. Not only for those living in the cultural heart of Momoyama Japan, but also for those remote from it, the scenes depicted were both souvenirs of past pleasures and promises of those to come.

CG

References: Okada 1978, no. 1; Sakakibara 1976; Suntory 1989; Takeda 1977c.

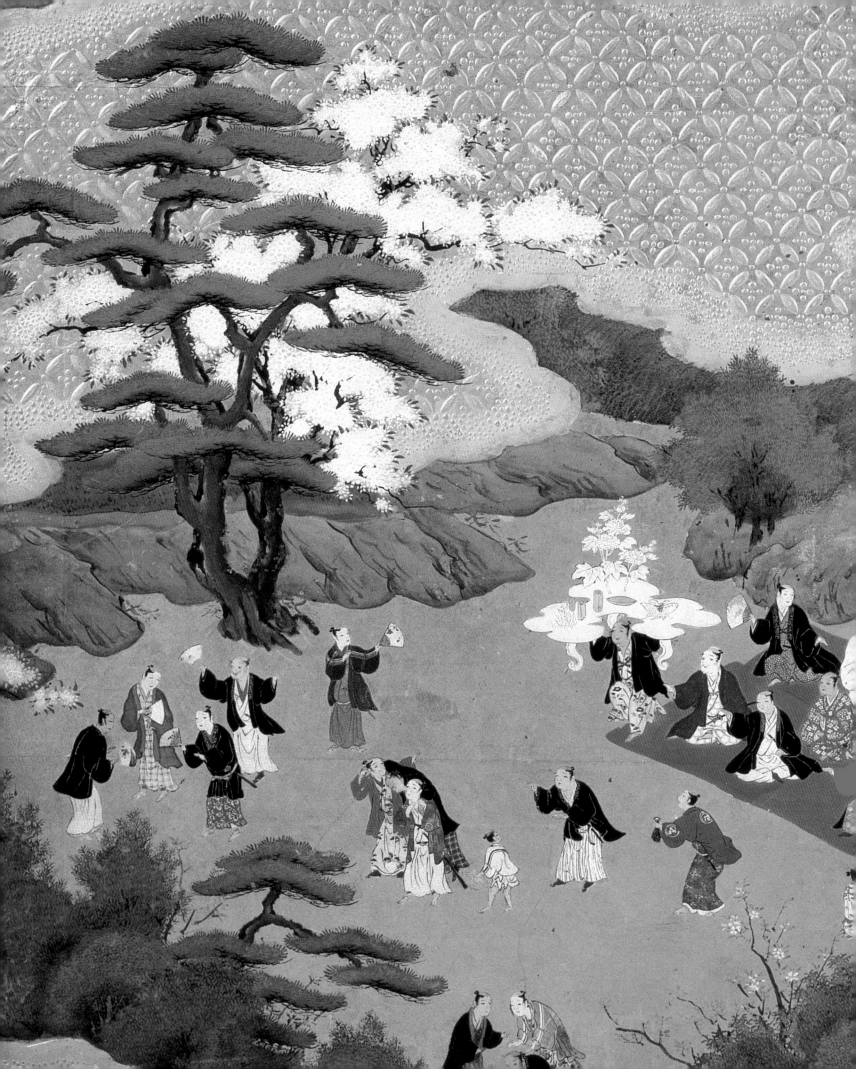

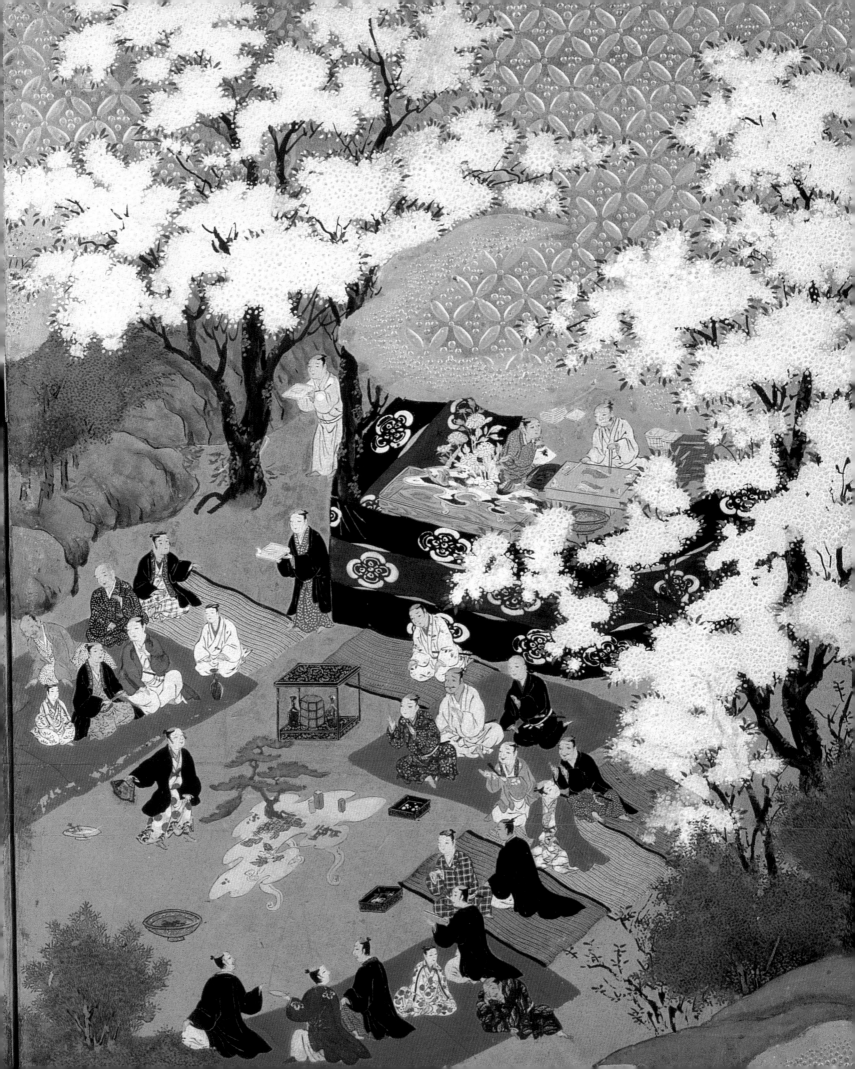

31. Amusements at Higashiyama

Kanō school
First quarter of seventeenth century
Pair of six-panel folding screens
Ink, colors, and gold on paper
Each 84 x 273 cm
Kōzu Kobunka Kaikan, Kyoto

On a beautiful spring day, at the peak of the
cherry blossoms, the upper levels of Kyoto society
stroll the eastern section of the city along the path
from Kiyomizu temple in the upper section of the
right screen, past the five-story Yasaka Pagoda of
Hōkanji, on into the Gion Shrine at the far left
end of the left screen. These two screens have a
narrow format and linear composition more
common to handscrolls than folding screens, and,
with the help of carefully positioned gold clouds,
they focus the viewer's attention on the parade of
well-dressed samurai and ladies.

Several picnic parties emphasize the
celebratory spirit of the occasion – one under
the cherry trees on the far right of the right-
hand screen, and one in the pine woods, in the
middle of the left-hand screen. The cherry
blossom picnic is easiest to see. At the far right,
behind a curtain, a samurai prepares fish for the
meal. In the middle of the group one man
dances with a fan, while the others clap time and
sing. The centerpiece is a large table with a
miniature pine tree, seashells, small rocks, and
other items. Tables of this kind, called *shimadai*
("island stand"), symbolize the fabled Mount
Hōrai, the island of immortality. Note that a
second table, this one with a chrysanthemum
theme, is waiting in the food preparation area,
while a third table, decorated with peonies,
grasses and a butterfly, is being removed from
the party. A seriously inebriated samurai is also
being helped from the picnic by two
companions as his friends wave farewell. The
party in the pine woods is less visible, but seems
to be more active. Most of the participants
dance in a circle around a *shimadai*.

On the right-hand side of the left screen we
encounter a group of upper-class ladies,
traveling with attendants and a palanquin, on
their way to the shrine. Several samurai turn to
watch them coming, peeking discreetly over
their fans. Along the side of the road, farmers,
street vendors, entertainers, and a few beggars
remind us of the other levels of society.

Just to the right of the main entrance to the
shrine a woman sells tea to the pilgrims and
sightseers in a simple shed. Her guests eat tea
cakes, drink tea, and chat amiably with one
another and passersby. A second tea-shop is
partially visible at the bottom of the screen on
the same panel. In these tea shops the tea is
prepared without ceremony, simply as a
refreshing beverage.

Since the screens are dominated by
depictions of samurai, it is assumed that they
were made for a member of the warrior class.

AJP

Reference: Shimizu 1988, no. 116.

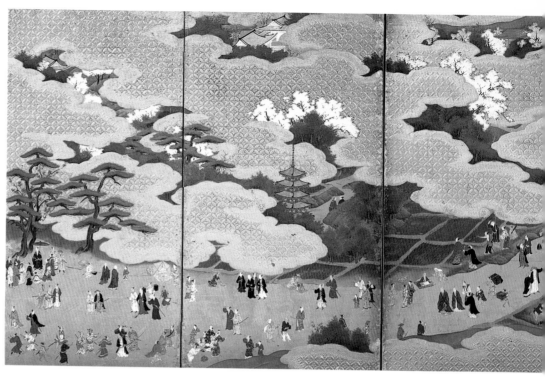

Right

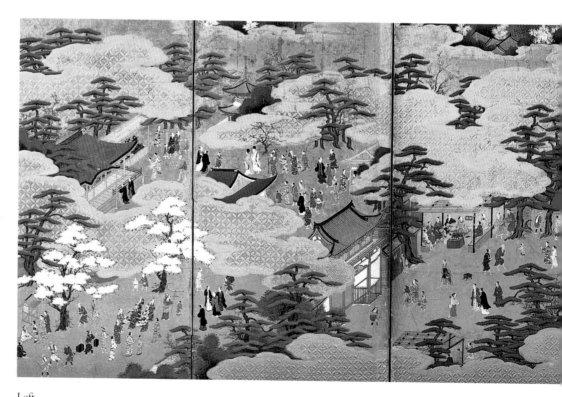

Left

124

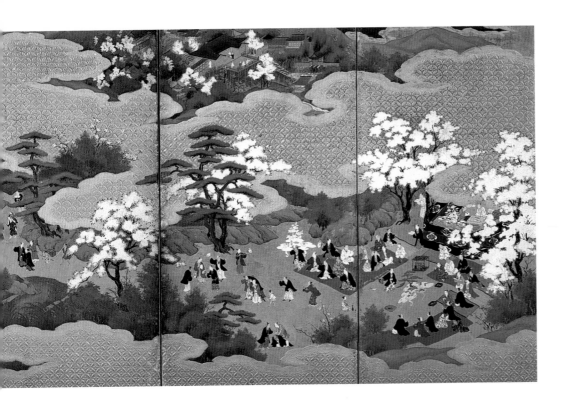

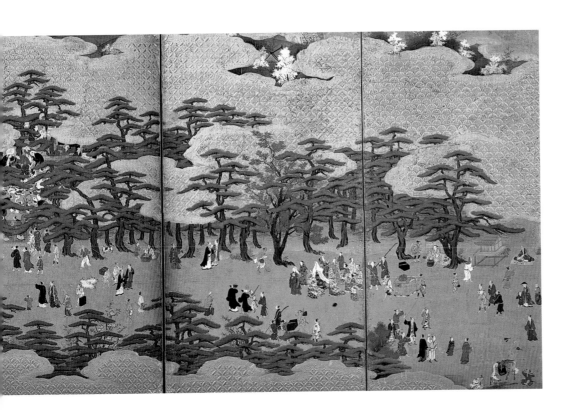

32. AMUSEMENTS OF SPRING AND AUTUMN

Circa 1620s–30s
Pair of six-panel folding screens
Ink, colors, gold, and silver on paper
Each 79.5 x 272.5 cm
Private Collection

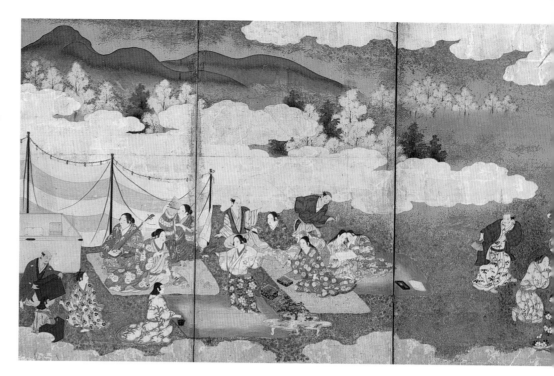

Samurai and their female companions indulge in leisurely pursuits as they enjoy two of the most popular Japanese seasonal pastimes, viewing cherry-blossoms in the spring, and maple trees in the autumn. Earlier genre screens often included similar scenes, but usually set in an identifiable locale, as in *Maple Viewing at Mount Takao* (cat. no. 27). Here the focus has shifted away from the landscape and architectural settings to the activities themselves, with the figures larger in proportion to the overall composition. Moreover, careful attention was given to the rendering of individualized facial features and distinctively patterned kimonos for each figure.

The lavish use of expensive metallic and mineral pigments contributes to the celebratory atmosphere of these screens. The viewer peers into the painting through gleaming gold-leaf clouds and bands of mist. In the background of the right screen, gentle waves of an abstract lake buffet a sinuous shoreline dusted with flakes of silver leaf; rounded contours of malachite-green mountains further enhance the lush vernal mood. To complement the blossoms of the cherry trees, the screens on the right are decorated with billows of golden scalloped-edged clouds. In the left screen, a single maple tree with leaves in various autumnal hues stretches its branches across the screen. To create visual contrast between the two screens the artist here used elongated bands of gold-leafed "trailing mist."

In the right screen, men and women in boldly patterned festival kimonos wave fans as they dance in a circle. In their midst a woman carries over her head a serving table decorated with flowers and grasses. In front of the blue-striped curtain, a woman dances beside a *shimadai* – a low table decorated with a miniature pine tree, small rocks, shells, and coral – meant to symbolize Mount Hōrai, the legendary abode of the gods of immortality (see also the previous entry). *Shimadai*, once commonly displayed at weddings, popular religious festivals, and other celebrations, are thought to have functioned as *yorishiro*, or places where gods could descend and bestow good fortune.

Musical accompaniment for the dancers is provided by a woman playing a *shamisen*, a three-stringed banjo-like instrument that has a sharp, twanging sound. Based on Chinese and Ryukyuan (Okinawan) prototypes, which were covered with snakeskin, imported into Japan as early as the fifteenth century, Japanese *shamisen* were made with dog or cat skin. During the Edo period, it became the favorite instrument of

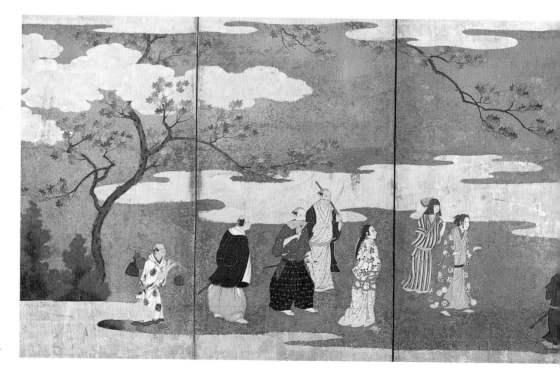

geisha performers, and provided the primary musical accompaniment for Jōruri (puppet) and Kabuki theater.

The left screen conveys the languid atmosphere of an autumn outing. A party of women, some of whom may be courtesans, loll about on brightly colored and decorated mats – waiting for the entertainment and samurai patrons to arrive. Some join in a game of *sugoroku*, a board game resembling backgammon. Two recumbent beauties, swathed in quilt-like robes, read and chat. Two others fill their long-stemmed pipes with tobacco, which Europeans introduced to Japan in the mid-sixteenth century. In premodern times, tobacco was consumed in pipes with extremely small bowls, which required constant refilling and relighting, and which could only be properly enjoyed in leisurely circumstances. Among the group of performers ambling towards the women is a blind man holding a thin cane, who is no doubt a professional chanter and *shamisen* performer (a common profession of blind people in premodern Japan).

While this screen may simply be viewed as a faithful depiction of outdoor entertainments, on another level it may also be interpreted as a playful reinterpretation of the traditional Chinese painting theme of the Four Accomplishments, which customarily showed elderly gentlemen indulging in the refined pursuits of *koto*, the game of *go*, calligraphy, and painting. Eitoku's masterwork *Four Accomplishments* (cat. no. 45) shows an orthodox treatment of this theme by a Kanō school painter. In Kaihō Yūshō's imaginative reinterpretation of the same theme, wizened Chinese sages are replaced with beautiful young Chinese women (cat. no. 61). The anonymous artist of the present screens, painted a decade or two after Yūshō's work, brings this process to the next stage by portraying Japanese women enjoying up-to-date versions of the Four Accomplishments. Young women in modern kimono are shown with *shamisen* instead of *koto*; playing *sugoroku* rather than the more challenging game of *go*. Painting is represented by the decorated fans held by the dancers; calligraphy is suitably represented by the box for writing implements and paper. By the mid-seventeenth century, such themes become so common in genre painting that the parodic aspect probably did not attract special notice.

JTC

References: Takeda 1977c, 14: nos 60–1.

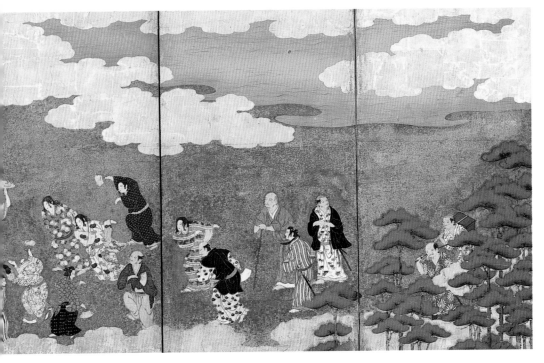

Right

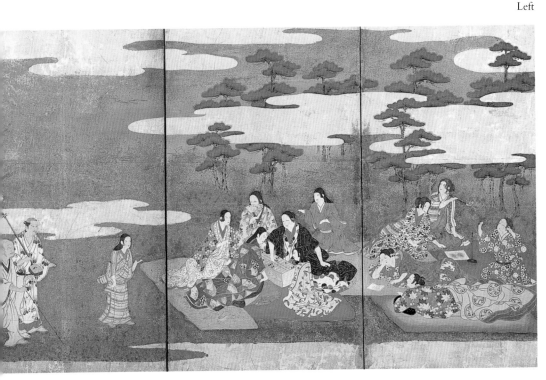

Left

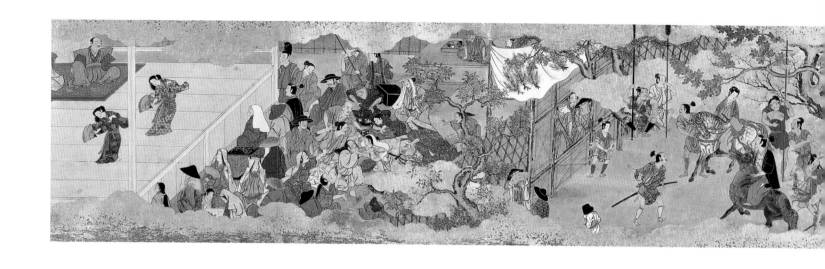

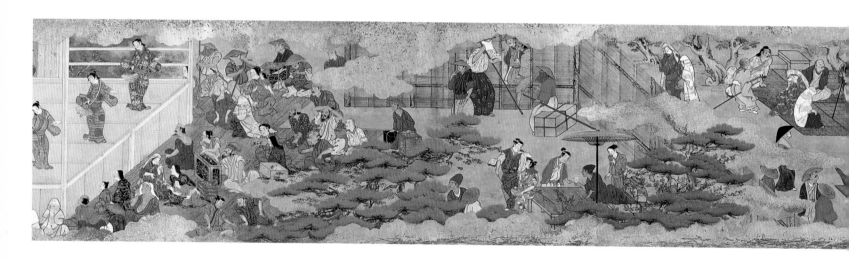

Cat. no. 33. *Women's Kabuki*, Scroll 1, section i.

Cat. no. 33. *Women's Kabuki*, Scroll 1, section ii.

Cat. no. 33. *Women's Kabuki*, Scroll 1, section iii.

33. WOMEN'S KABUKI

Circa 1620s–30s
Two handscrolls
Ink, colors, gold and silver leaf on paper
First scroll 36.7 x 836.1 cm
Second scroll 36.7 x 699.4 cm
Tokugawa Reimeikai, Tokyo
Important Art Object

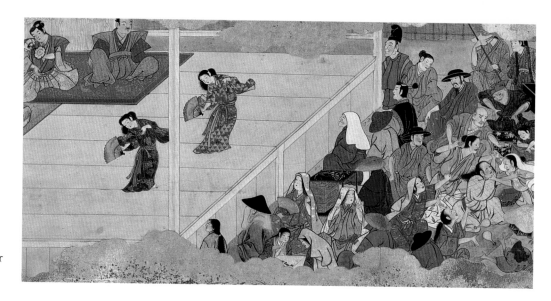

In contrast to the stately demeanor of Noh drama, which by the Momoyama period was already on its way to becoming the exclusive preserve of the military elite, the showy, sexually provocative dances and skits of early Kabuki appealed to warrior and commoner alike. In its earliest phase, during the first three decades of the seventeenth century, Kabuki was performed by young women, often as a front for prostitution. Kabuki as we know it today – a highly respectable "classical" theater performed by male actors playing established roles in plays with complex plots – did not begin to emerge until the late seventeenth century.

These colorful handscrolls, traditionally called *Uneme kabuki zōshi* (Illustrated Tale of Uneme Kabuki), capture a chapter in this early history of Kabuki. Uneme is thought to be the head of the troupe of performers shown here and one of several successors of Izumo no Okuni, the legendary founder of Kabuki. Okuni, who claimed to be a priestess from Izumo Shrine created quite a stir when she performed dances in Kyoto around 1603, at first along the banks of the Kamo River at Gojō and later on a stage in the precincts of Kitano Shrine. Audiences in the capital were long accustomed to the variety of folk dances and *nembutsu odori* (dances to accompany Buddhist chants) that she first performed, but had never seen them interpreted in such a provocative, sexually suggestive manner. She also began to improvise *kabuki odori* ("outlandish dances"), using movements and costumes associated with popular dances called *fūryū odori* (see cat. nos 29, 30). Within a few years, other female entertainers began to perform dances and skits in the style established by Okuni, stages were set up in the dry riverbed areas of the Kamo River in Kyoto's Shijō district, which is the setting of the scenes in these scrolls. The riverbed and banks of the river, though dry most of the year, were unclaimed, untaxed, and unregulated property where people of all classes and professions could freely mingle while enjoying entertainments of every ilk. Actors and dancers, despite their great popularity, were linked with prostitution and considered social outcasts.

The first handscroll opens with a preface introducing the dancer Uneme. In the flowery language of the barkers who announced the performers before a show, the text prepares readers for the excitement of the scenes that follow:

. . .while courtiers of the palace, in a realm beyond the clouds, are enjoying their refined poetry and music, here the common people bathe in the colors of autumn foliage. . . As crowds gather in the Shijō District, curtains flap in the wind, drummers shout as they pound a large drum. People ask what's going on. "It's the notorious Uneme," they are told, "performing her *kabuki* dance". . . .

Each of the six scenes is preceded by a professionally calligraphed text that provides the title of the dance and the related libretto. The paper used for the text sections is lavishly decorated: scattered bands of gold and silver leaf cut into thin strips are spread over a ground dusted with gold, silver, and mica powders. The painted sections, rendered in brilliant pigments with a liberal application of gold and silver flakes and powder, show not only illustrations of the delightful dances of dancer-courtesans and backstage scenes, but also the hustle and bustle of the surrounding Shijō entertainment district.

The opening scene of the first scroll shows two samurai mounted on horses making their way to the theater area, which is surrounded by a high fence constructed of bamboo palings covered with straw mats. Men wearing wicker hats and kerchief masks hold sticks while they guard the entrance, called a "mouse wicket" (*nezumi kido*) referring to its small size, designed to discourage gate-crashing. A small admission fee was collected. Inside we encounter a lively crowd of spectators of all social classes, ages, and walks of life. Some Japanese men are dressed in the latest European fashion (in other scenes, large-nosed Westerners can be seen). The audience is a bit restless, and spectators try to break up a scuffle between two apparently drunken women. On the stage, two young women, wearing fashionable "small-sleeved" *kosode* garments, do a graceful "Dance of Mount Fuji" (*Fuji odori*), gently waving fans.

Musical accompaniment is provided by a single flautist and a number of drummers. No string instruments were used in the earliest period of Kabuki. The three-stringed *shamisen*, which had been imported into Japan over a century before, did not become associated with Kabuki performances until the late 1610s. The stage and musical accompaniment, in fact, closely resembles that used for Noh performances of the day (see cat. no. 26).

In the right foreground of the next scene, sitting on the mat is a *nembutsu hijiri*, a holy man who incessantly recites the *nembutsu*, "Homage to Amida Buddha," the mantra of Buddhist salvation. Men and women fight back tears as they listen to the plaintive recitations of the *sekkyō bushi* (Buddhist sermon chanters), standing beneath an umbrella, tapping out a rhythm with bamboo clappers. Such vignettes are a reminder of a current of religious pessimism underlying the playful surface of things. Standing nearby is a blind chanter, holding his *shamisen* and cane. While the shamisen was not used early on in Kabuki, by this time it already rivalled the *biwa* (lute) as the most popular instrument of itinerant chanters. Inside the fenced-off area, three dancers perform the "Dance of Covert Love" (*Shinobi odori*). The title of this dance seems particularly appropriate for dancers who sometimes doubled as prostitutes.

European merchants in fancy high hats and brocade capes, a wealthy samurai with his entourage seated on a red mat, and townspeople of all ages are among the members of the audience shown in the third scene of the first scroll. The two dancers perform a "Rice Planting Dance" (*Inaba odori*). Backstage, members of the troupe enjoy meals served on black lacquer stands. The presence of waiting palanquins suggest that the Uneme and her dancers have already earned the patronage of a wealthy clientele.

The text section that opens the second scroll is simply titled "Kabuki," so readers may be surprised when they unfurl the scroll a bit

further and discover a scene of ruffians – probably *rōnin*, masterless samurai – engaged in a battle of long spears. The age of civil war had come to an end but order had not been fully restored. This scene is a reminder that the word *kabuki* – which derives from *kabuku*, a verb meaning "to be twisted," "bent," or "outlandish" – once had various meanings. The artist has juxtaposed the rampage of *kabuki mono* ("non-conformists") – a term used during this time to refer to the roving gangs of *rōnin* who committed random acts of protest and violence – with the less threatening "outlandish" *kabuki* dances of beautiful young women: an unsettling reminder that at the fringe of pleasurable pursuits, chaos and danger still lurked. Bouncers at the "mouse wicket" entrance gate brandish rake-shaped poles with spikes to keep the rabble rousers at bay. Inside, an attentive audience enjoys the performance of a dance called "Listening to the Bell" (*Kane kiki*), oblivious to the fray outside.

In the next scene, delivery men approach the "mouse wicket" carrying layered lacquer picnic boxes. Spectators who did not bring their own refreshments could have simple lunches or cakes delivered from local shops. The dance here is identified in the preceding text simply as *Shite,* which usually refers to the protagonist of a Noh play, the one who wears a mask. In fact, there is a *Okina* ("Old Man") Noh mask on the floor of the dressing room area behind the stage, where male performers are relaxing. Perhaps one of them has just finished a performance of the auspicious Sambasō dance, an adaptation of the Noh play *Okina* (see cat. no. 26), which often was performed at the outset of the daily program of Kabuki dances and plays.

The final scene shows Uneme performing a skit called *Chaya asobi* (Teahouse Entertainments) that had brought notoriety to Izumo no Okuni before her. Uneme is dressed as a gallant samurai in flashy robes, posturing suggestively as she leans on a long sword. A short sword is tucked into her obi, from which a cluster of showy pouches and lacquer *inrō* cases dangles. The crucifix about her neck is not a sign of piety, but a daring fashion statement. Christianity, tolerated and sometimes even promoted by the authorities during the sixteenth century, was now forbidden. Cross and sword, emblems of ultimate authority, are playfully mocked in this Kabuki skit. Uneme is accompanied by her comic sidekick, the manservant Saruwaka ("Young Monkey") – also played by a woman. They engage in saucy dialogue with a female teahouse owner or courtesan (on the right) – a role sometimes played by a young man. Audiences apparently delighted in the erotic suggestiveness of cross-dressing. Similar scenes of Uneme's predecessor Okuni performing this popular skit at Kitano Shrine can be found in contemporary depictions, including screens in the Idemitsu and Suntory museums, as well as in

a vignette in the left screen of *Celebrated Places in the Capital* (cat. no. 30).

Women's Kabuki was completely outlawed by the authorities in 1629, because its link to prostitution was thought to be injurious to public morals, not to mention that samurai were becoming involved in unseemly fights over favorite performers. The young women were initially replaced by teenage male known as *wakashu* performers (who likewise pandered their bodies to a male clientele). Eventually the authorities clamped down on *wakashu* Kabuki as well, and by the 1660s, adult male performers had to rely on their acting skills rather than sexual innuendo to captivate their audiences.

The calligrapher of the scroll is traditionally identified as Karasumaru Mitsuhiro (1579–1638), but the handwriting style does not correspond to any of the styles Mitsuhiro was known to have practiced (see fig. 64). The painted sections were at one time attributed to Iwasa Matabei (1578–1650). While there is no early documentation to support such an attribution, this highly animated and brightly colored style of genre painting is commonly associated with artists of the Matabei studio. Although the scenes represent Kabuki dances as they were performed from about 1605 to 1615, on the basis of stylistic considerations the scrolls were probably painted a decade or two later.

JTC

References: Ortolani 1990, 162–78 (on the early history of Kabuki); *Kabuki zukan* 1964; Suntory 1978, no. 10 (Okuni Kabuki screen); Trubner and Mikami 1981, no. 82 (Okuni Kabuki screen from the Idemitsu Museum); Yoshida 1950.

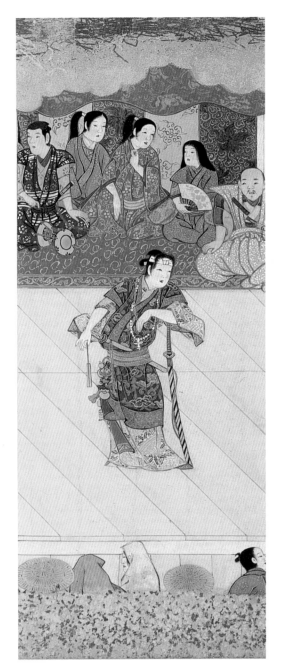

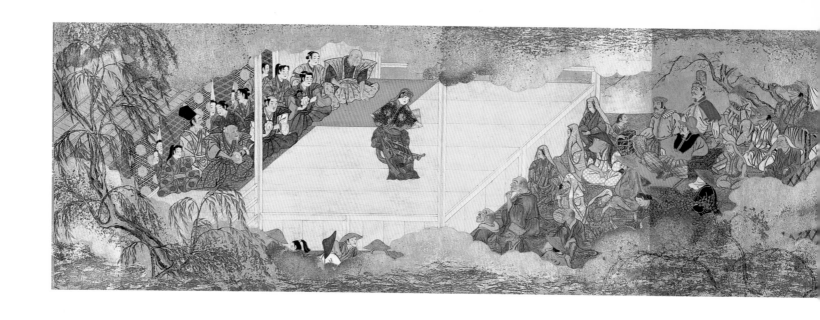

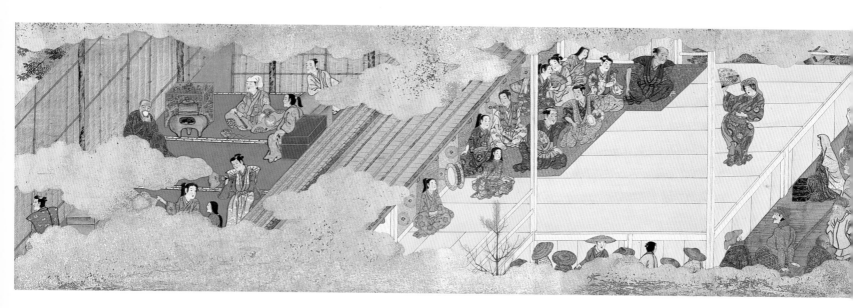

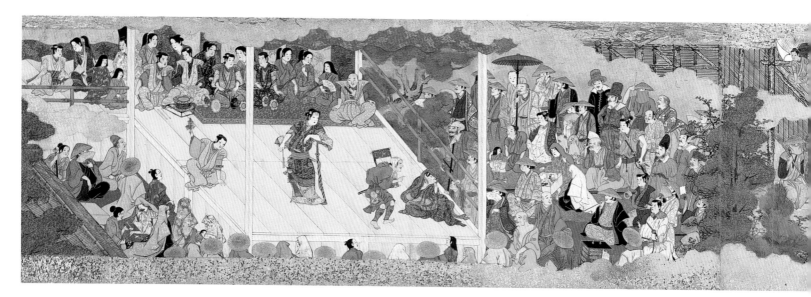

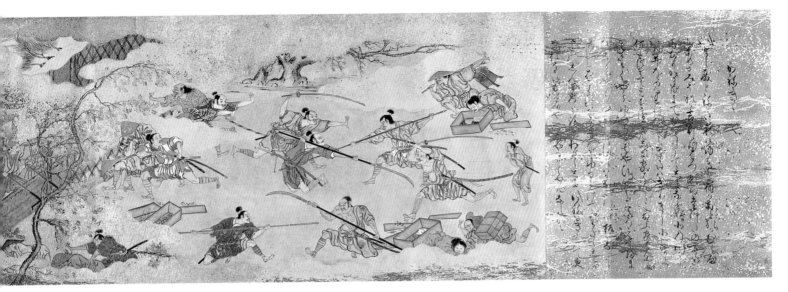

Cat. no. 33. *Women's Kabuki*, Scroll 2, section i.

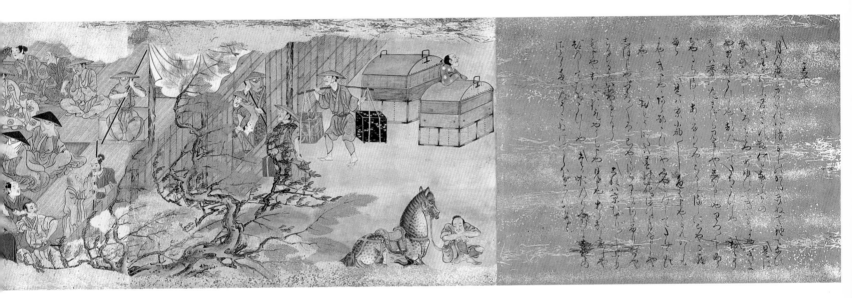

Cat. no. 33. *Women's Kabuki*, Scroll 2, section ii.

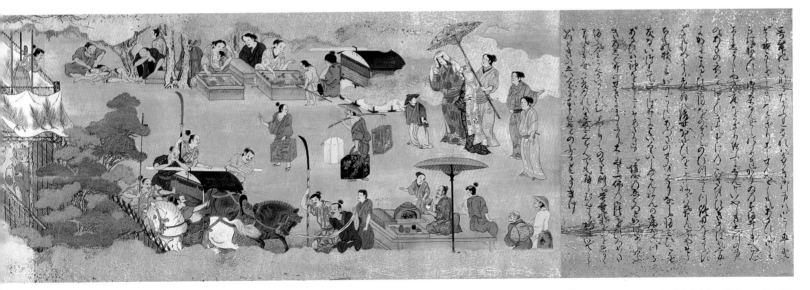

Cat. no. 33. *Women's Kabuki*, Scroll 2, section iii.

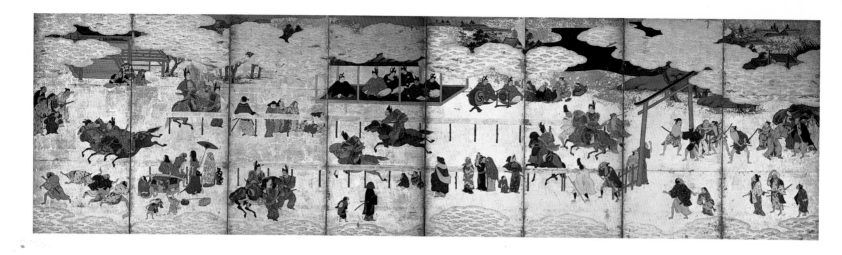

34. Amusements at a Picnic; Horse Racing at Kamo Shrine

Circa 1630s–40s
Pair of eight-panel folding screens
Ink, colors, and gold on paper
Each 104.4 x 375.6 cm
Kongōji, Miki, Hyōgo Prefecture

At first glance these screens seem mismatched. There is no direct correlation between the picnic and horse-racing scenes, and the discrepancy in the scale of figures is somewhat disconcerting visually. Yet the presence of a red *torii* gate in the upper left corner of the right screen, indicating the entrance to a Shinto shrine, provides a subtle thematic link with the activities depicted in the companion screen, which are set in the precincts of Kamigamo (Upper Kamo) Shrine in Kyoto.

In the right screen, samurai with their retainers and female companions are enjoying an elaborately appointed picnic. Folding screens (decorated with Rimpa-style flower motifs), garment racks, and an impressive array of lacquerware and ceramics demonstrate how wealthy samurai pursued leisure with a zeal they once reserved for military campaigns. On the right, a woman gently caresses the hand of her samurai escort as she engages in a friendly game of *sugoroku* (a game resembling backgammon). Behind them the rack for hanging swords and garments calls to mind the genre of screens called *Tagasode*, or "Whose Sleeves," in which garments rather than their wearers become the focus of attention (see detail, and cat. no. 145).

Three female entertainers in boldly patterned robes, one of them carrying a *shamisen*, approach the main gathering of samurai and their companions. In front of a bright red and green curtain, a young man performs an auspicious fan dance. Amid sake flasks, tea cups, and a lacquered picnic box is a *shimadai* decorated with a small pine tree (see also cat. nos 30, 31). Tea is being prepared by a *chabōzu*, literally "tea monk" or "tea boy," with a shaven pate. Originally an official post in samurai households, by this time *chabōzu* often served as amorous

companions for samurai, among whom homosexuality was accepted and widespread.

The isolating of individual female figures against plain backgrounds, with the focus on facial features and elegant kimono (as seen, for instance, in the second panel from the left), anticipates the genre of courtesan portraiture that emerges in the late seventeenth century – the predecessor of ukiyo-e woodblock prints of beautiful women. This screen has stylistic affinities with the famous Hikone screen, such as the gold-leaf background, the somewhat artificial posing of a small group of figures in a leisurely setting, and the rather stoical facial expressions.

In contrast to the languid mood of the picnic scenes, the left screen shows the frenetic activities surrounding the horse races that were held each year on the fifth day of the fifth month at Kamigamo Shrine. Though ritual horse races had been sponsored by the court since ancient times, during the late Momoyama and early Edo periods they became a popular public event, often depicted in genre screens. Usually spread across two screens, here the race track has been telescoped to accommodate the format of a single eight-panel screen. "Right" and "Left" teams, each made up of ten riders, competed while wearing traditional court costumes; the winners received bolts of silk as prizes.

In the present screen, and in earlier versions upon which it is based, one of the riders approaching the finishing line is engaged in what appears to be unsportsmanlike conduct. While his rival whips his horse forward, the rider on the left tries to slow him down by grabbing his collar with one hand and seizing the reins of his horse with the other. Similar scenes in other early horse-racing screens suggest such behavior was not prohibited. Looking on are the judges in traditional court garb and spectators of all classes.

The unrestrained use of gold-leaf ground and patterned clouds in these screens, which almost completely obliterates the landscape setting, is a

conspicuous legacy of Momoyama screen painting created for the castles of great warlords. Beginning in the late 1610s through the 1640s, decorative bird-and-flower paintings with solid gold-leaf backgrounds were created in great number. Painters of genre scenes followed suit.

JTC

References: Mason 1993, fig. 255 (for an illustration of the Hikone screen, owned by Ii Naoyoshi, Hikone, Shiga Prefecture); Takeda 1978b, pls 23–36 (for other versions of the Kamo Horse Race screens).

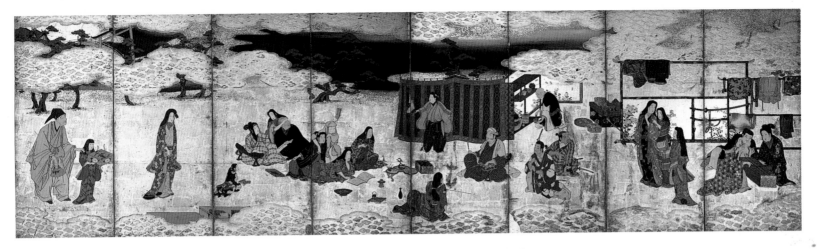

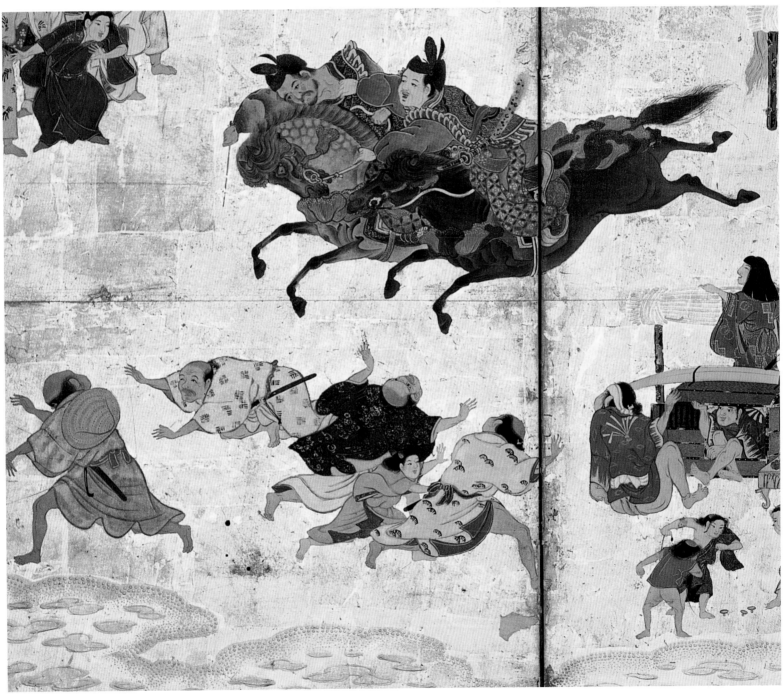

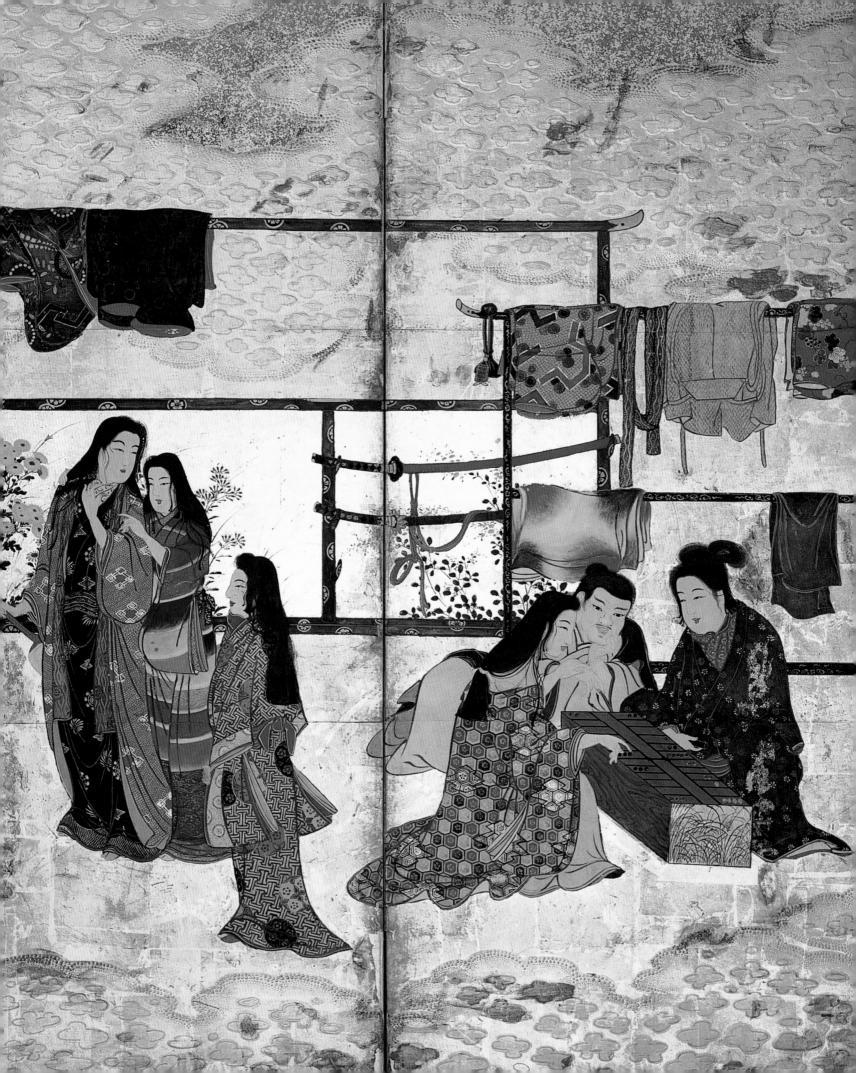

35. HORSES

Kanō Hideyori (d. ca 1576/7)
Dated 1569
Pair of *ema* (votive paintings)
Ink and colors on wood panels
Each 60 x 71.5 cm
Kamo Shrine, Hasumi, Shimane Prefecture
Important Cultural Property

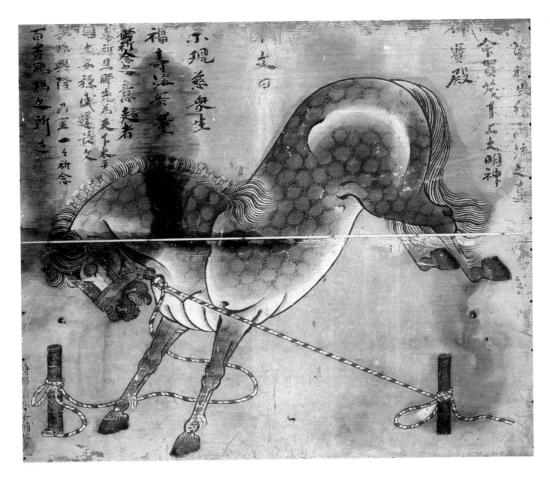

Admired for their strength and speed and venerated for their innate, resolute spirit, horses have played a conspicuous role in Japanese religious practices, ceremonial rites, and warfare since ancient times. Early accounts describe how horses were used in Shinto shrines, where their participation in solemn rituals was thought to be efficacious in precipitating rainfall or, conversely, in discouraging excessive rain and restoring good weather. To carry out these objectives, shrines were equipped with a pair of animals, one of a dark hue, to cause rain to fall, and a second, with a light coat, to bring back the sun. Essential for these and other equine ceremonial activities, the presence of a pair of fine horses became obligatory in large shrines in the following centuries. Substantial resources were required to acquire suitable animals, however, and they also had to be fed and maintained in appropriate stalls. As a consequence it appears that certain shrines, perhaps because of their smaller size and less affluent patronage, turned to substitute forms, such as wooden sculptures or, later, painted images of horses on wooden panels.

Horses, in addition to their function in rites intended to affect the weather, had a more basic role as messengers and intermediaries between the temporal world and the Shinto gods. They also served as vehicles for the deities when they moved from one location to another. Medieval handscrolls of the late twelfth and thirteenth centuries show scenes in which individuals from

Cat. no. 35a. *Horse Stable*, detail of cat. no. 37.

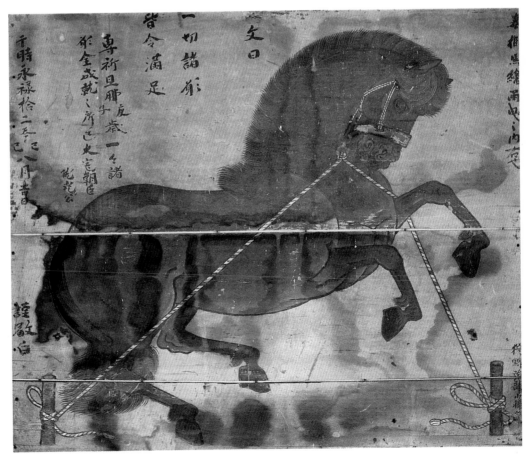

(left) *Horse Racing at Kamo Shrine*, detail of cat. no. 34, left screen.

137

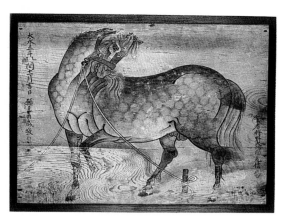

Cat. no. 35b *Ema*, by Kanō Motonobu. 1525. Wood panel; 61 x 85 cm. Komori Shrine, Tamba-chō, Kyoto.

Cat. no. 35c. *Watanabe no Tsuna fighting a demon*, by Kanō Shōei. Woodblock illustration from *Itsukushima ema no kagami* (Mirror of Ema paintings in the Itsukushima Shrine).

various classes have dedicated miniature painted images of horses at various locations in both Shinto shrines and in Buddhist temples. Similar practices took place at revered natural sites, such as great trees, where animistic deities were thought to be present (Kawada 1974, 28ff). These modest offerings served as supplicatory petitions from the donor to the gods, pictorial prayers for good health, success, spiritual support or other kinds of divine assistance. The lively image of the horse on the small wooden panels ensured that the donor's aspirations and hopes would be transmitted to the appropriate god. These abbreviated depictions of horses on flat wooden panels came to be known as *ema* ("picture horses"). While these small *ema* continued to serve popular, folk religion, other larger forms of *ema* gradually evolved, and these developed into a significant expressive means in which a variety of subject matter was represented (for example, cat. no. 19a shows an *ema* with a picture of a ship).

There is little evidence to indicate how *ema* evolved during the Kamakura and early Muromachi periods, but this is not surprising for we know from later examples that these familiar icons were usually installed in exposed locations, either on the outside of buildings under the

eaves, or inside, affixed to rafters above, where the elements caused them to gradually deteriorate. It is thought that sometime during the late fifteenth and sixteenth century, special shed-like, open structures (*emadō*) were developed for the display of large *ema*. These buildings were constructed in large numbers during the later sixteenth and seventeenth centuries, and the *ema* exhibited under their eaves and rafters provided the public with a permanent display of the talents, techniques, and artistic specialties of the artists of the present day and the past.

Among the examples preserved from the early decades of the sixteenth century is a large, relatively well-preserved example from the hand of Kanō Motonobu (1476–1559), which has recently come to light at the Komori Shrine in Tamba-chō, Kyoto (cat. no. 35b). Done in 1525, it shows a spirited steed, restrained by two lines leading from its bridle to stakes in the foreground. Age and exposure have darkened the surface of the panel, but it is apparent that the horse's coat was originally a dappled white. The animal appears essentially in profile, and it has the characteristic short legs and long torso of native Japanese horses. Its contours and general anatomical features are delineated with a slow, deliberate, slightly modulated line that is identical with that used by the artist in his hanging scroll depiction of the mounted warrior Hosokawa Sumimoto (1489–1520), in the Eisei Bunko collection (Doi 1978b, pl. 32).

The two *ema* illustrated here are from the hand of Kanō Hideyori and are dated 1569. The artist (who signs his full name and title here: Kanō Jibu Shōyū Hideyori) is traditionally thought to have been the second son of Motonobu and elder brother of Shōei, although in recent years scholars have suggested that he may rather have been Motonobu's grandson. He is thought to be the same artist who painted the celebrated genre screen *Maple Viewing at Mount Takao* (cat. no. 27). Recent scholarship has also suggested that Hideyori may be the artist of the *Horse Stable* screens illustrated in catalogue number 37. A comparison of the depictions of horse in the *ema* described here and those in the screens adds credence to the attribution, but may also simply be an indication that Kanō artists relied strongly on sketches and model books passed down from generation to generation (cf. detail cat. no. 35a).

Hideyori's horses preserve the archetypal pairing: the rearing, dark-hued animal to the left, and the light, dappled animal, vigorously bucking, to the right. Both examples show a direct indebtedness to Motonobu's *ema* in the Komori Shrine, produced more than four decades earlier, and demonstrate that the representation of horses by Kanō artists had already become a conservative, academic tradition, which was evolving slowly under the influence of existing prototypes. The Kanō

atelier had a prestigious history dating back almost a century. The training of its artists through emulative exercises, in which the works of earlier masters were assiduously copied, meant that Kanō artists were always aware of their indebtedness to the accomplishments of the past. Moreover, this atelier's substantial inventory of preliminary drawings, study sketches, and copies provided a rich, ready source of materials that could serve as a point of artistic departure for new works.

In this context it is interesting to note that a late Edo period woodblock-printed book, *Itsukushima ema no kagami* (Mirror of Ema Paintings in the Itsukushima Shrine), has an illustration of the legendary hero Watanabe no Tsuna mounted on a rearing horse and attacking a demon in which the horse is essentially a mirror-reversed version of Hideyori's left horse (cat. no. 35c).

In addition to the signatures and seals, which read "Hideyori" the Kamo shrine panels are inscribed with other data, such as the name of the donor, Ōyake Tomonori Ryūkō, and a series of short, conventional phrases that express his hope for peace, security, success in battle, and prosperity for his offspring, sentiments one might expect in a turbulent era of war and instability.

MLH

References: Iwai 1974; Kano 1991; Kawada 1974; Takeda 1979.

Cat. no. 36a. *Ema*, by Kanō Sanraku. 1614. Wood panel now mounted as a *tsuitate*; 88.7 x 125. Myōhōin, Kyoto.

36. HORSES

Kanō Sanraku (1559–1635)
Dated 1625
Pair of *ema* (votive paintings)
Ink and colors on gold leaf over wood panels
Each 64.7 x 75 cm
Kaizu Tenjin Shrine, Makino, Shiga Prefecture

This pair of *ema*, votive paintings of the variety described in the previous entry, were produced by Kanō Sanraku, one of the most gifted artists of the late Momoyama and early Edo periods (see also cat. nos 50, 51). During his middle fifties Sanraku, working then under the name Shūri, produced a pair of *ema* for the Hōkoku Shrine, which had been constructed to enshrine Hideyoshi's deified spirit following his death. A journal kept by one of the shrine priests notes that a pair of *ema* were dedicated to the shrine by a man named Anyōji Kibei, and installed there on the first day of the sixth month of 1614. One of these has been preserved, and is now in the Myōhōin in Kyoto (cat. no. 36a). Now mounted as a *tsuitate* (single-panel standing screen) measuring 88.7 x 125 cm, it has a superb representation of a rearing black horse, set off against a background of gold leaf. This is one of the most innovative and memorable horse representations by a Kanō painter, and it shows no sign of the growing mannerism or servile indebtedness to early pictorial models that is common in many Kanō *ema* by this time.

The pair of elegant *ema* illustrated here, produced by Sanraku a decade later, are among the most admired works of his later years. Painted when the artist was about sixty-six, they show his characteristic preoccupation with precisely executed detail and vivid pictorial effects set off against a solid expanse of gold leaf. Sanraku painted images of many kinds of animals, both real and fantastic, and there is a quality of animated life and energy in his horses that sets them apart from most *ema* representations of the subject. These paintings were commissioned by a man named Fukutomi Tōemon and dedicated to the shrine gods in the second month of 1625. The inscriptions are identical on each piece, and include the conventional phrase that entreats the gods to grant the donor's wishes and bring happiness. Dated works signed "Sanraku" are rare, so these *ema* are of particular importance in studying the late style of the painter.

MLH

References: Iwai 1974; Kawada 1974; Takeda 1979.

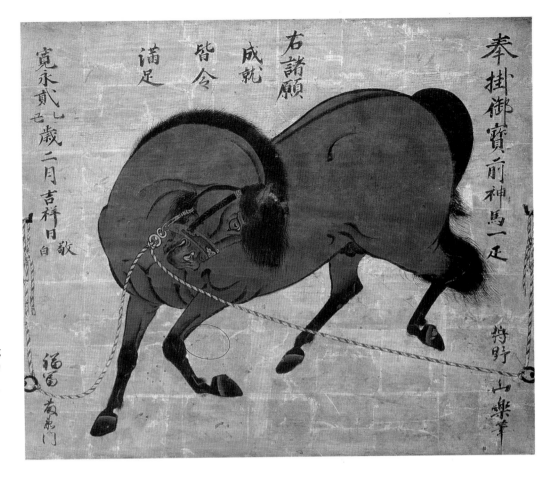

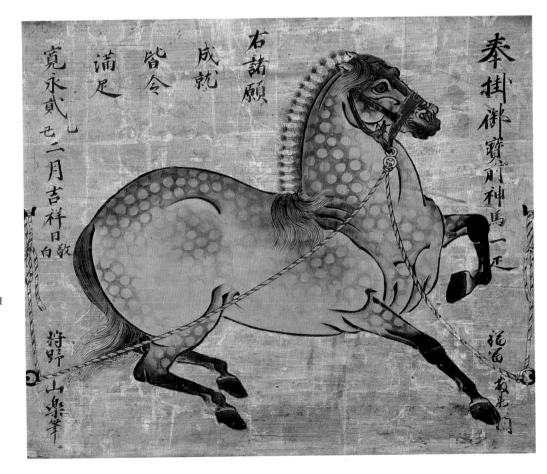

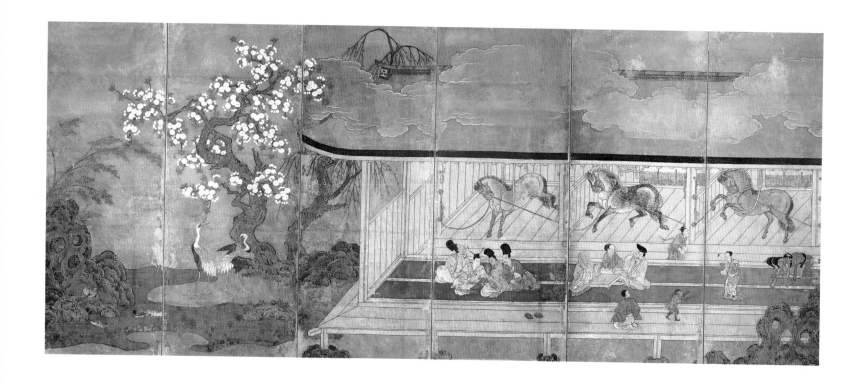

37. HORSE STABLE

Circa 1560s
Pair of six-panel folding screens
Ink, colors, and gold wash on paper
Each 149.5 x 355.5 cm
Tokyo National Museum
Important Cultural Property

Good horses were valued possessions in Japan, especially during the sixteenth century when military campaigns moved quickly. This pair of screens depicts a stable for six steeds, with grooms and visitors relaxing on *tatami* mats in a raised area adjoining the stalls. Each horse is tethered, and several have belly straps (*harakake*) to keep them standing upright. The artist has shown three of the horses kicking and jumping, in poses reminiscent of *ema,* "horse pictures," donated to Shinto shrines (cat. nos 35, 36).

Courtiers, monks and warriors, depicted with animated expressions, converse and play board games (*go, shōgi* and *sugoroku*). The apparent mix of people from different walks of life is a significant demonstration of how interest in horses and gaming resulted in interaction of various social classes. Two attendants kneel on the verandah, while another lad walking along the gallery brings tea in a bowl on a lacquered stand. Nearby is a monkey dressed in red;

according to folk traditions, monkeys were considered guardians of horses and could cure equine illnesses (Ohnuki-Tierney 1987, 48–50). The stable appears to be set in an elaborate garden, with ornamental rocks and meandering streams. In the roof gable at left is an heraldic device (*mon*) which might eventually help identify ownership of the stable or of the painting.

The blossoming cherry tree at left indicates springtime, but the wisteria vines hanging from the pine at right suggest early summer. While the change of seasons seems odd in this particular composition, the seasonal cycle was a common motif in bird-and-flower paintings, to which this work relates stylistically. Stable scenes (*umaya-zu*) were popular in the late sixteenth century, along with depictions of horse races, dog-chasing, archery tournaments, falconry, and hunting. The newly empowered military, who were building elaborate residences in Kyoto and in the provinces, celebrated their own traditions by choosing such genre themes for folding screens. Along with battle scenes and bird's-eye-views of Kyoto, the Kanō artists provided their customers with large-scale paintings of topics previously seen in small handscroll format. Such innovative changes in subject matter would

blend elements of the Kanō bird-and-flower and landscape painting traditions with aspects of Tosa school figural paintings in the *Yamato-e* style.

This pair of screens has traditionally been attributed to the Kanō studio, but no specific artists were identified. Recent scholarship, however, has proposed an attribution to Kanō Hideyori (Kano 1991, 28). Works with firm attributions to Hideyori include *Maple Viewing at Mount Takao* (cat. no. 27) and a signed pair of votive paintings depicting horses (cat. no. 35). A close comparison of details from these works in fact does much to substantiate an attribution to Hideyori for *Horse Stable*. For instance, a comparison of landscape elements in this work and *Maple Viewing* reveals remarkably similar brushwork. Stylistic correspondence can also be found in less-conspicuous thematic details, such as the rendering of pairs of turtles in each work: to the right of the bridge in *Maple Viewing* (third panel from the right) and in the right screen of *Horse Stable* (second panel from the right).

BAC

References: Cunningham 1991, no. 22; Shimizu 1988, no. 105; Tokyo 1989, 238.

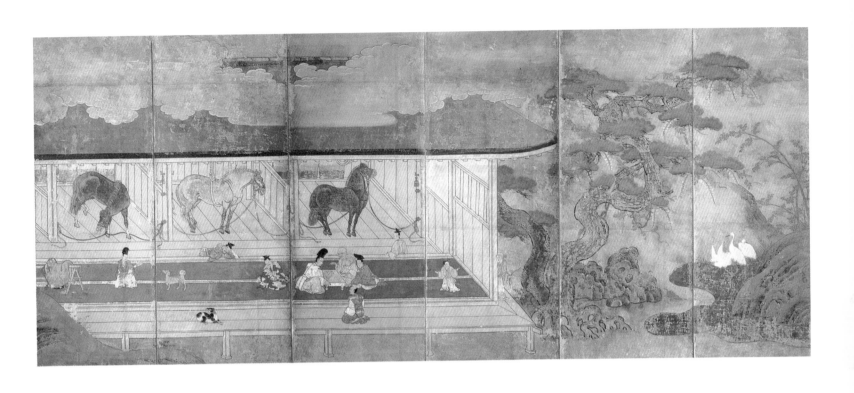

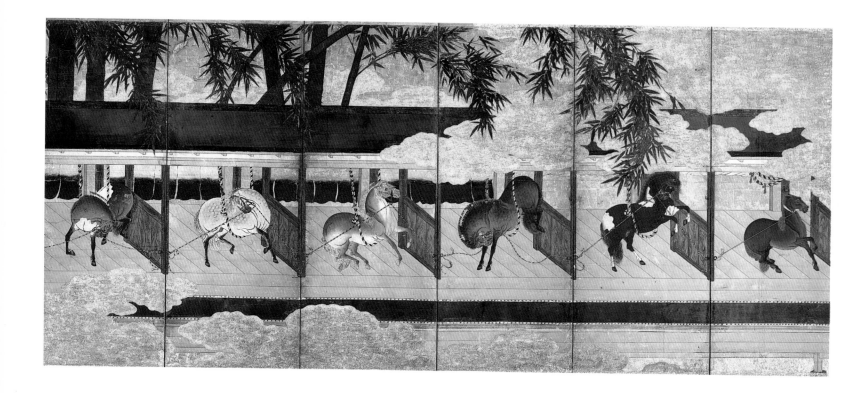

38. HORSE STABLE AND PADDOCK

First quarter of seventeenth century
Pair of six-panel folding screens
Ink, colors, and gold leaf on paper
Each 154 x 355 cm
Taga Taisha, Taga, Shiga
Important Cultural Property

While the left screen focuses attention on the six stabled horses, the right screen provides a more panoramic view into the residential compound of a military man. Gold clouds and gold ground visually link these screens, but they may be by different artists. The left screen closely relates to the votive paintings of horses (*ema*) given to Shinto shrines such as Taga Taisha, which owns these screens. The bird's-eye view and figural style of the right screen derives from traditional illustrated handscrolls in the *Yamato-e* style, with their emphasis on narrative and descriptive functions. Japanese scholars attribute both screens to early-seventeenth-century Kanō studio artists, with the distinctive style of Kanō Mitsunobu (1565–1608) seen in the pines and blossoming cherry trees. The repetitive aspects of the facial features and stylized forms of the horses, however, suggest that these screens are not from the master's hand but were produced in a workshop.

The right screen is extremely informative about *shoin*-style architecture, prevalent among the military class in the sixteenth and seventeenth centuries. The wooden post-and-beam residential structure is raised off the ground, to allow air to circulate under the *tatami* mat interior flooring, preventing dampness. Roofing is of layered cedar bark, and the curved roofline over the entryway (*genkan*) at right is a newly developed design called *karahafu* that proved quite popular for military houses in the *shoin* style. The *shoin* itself is the built-in writing desk seen near the corner of the building, with a sliding *shōji* screen window to provide light and a view into the garden. *Shoin*-style architecture is noted for its extensive use of removable sliding screen panels which allow for flexible room arrangements and for the close relationship between interior and exterior spaces. The room where the master sits with two young attendants has been opened to the paddock, and a wooden verandah beneath deep eaves makes the spatial transition. Sliding-screen paintings (*fusuma-e*) and a gold-leafed folding screen (*kinbyōbu-e*) can be seen inside the residence. A tea master prepares refreshments at a moveable stand (*daisu*), and his assistant brings a bowl of tea to viewers on the verandah. *Shoin*-style

architecture is remarkably free of furniture, with the room's decoration provided by the large-scale paintings and views to the garden.

BAC

References: Hashimoto 1981 (on *shoin*-style architecture); Shimizu 1988, no. 106.

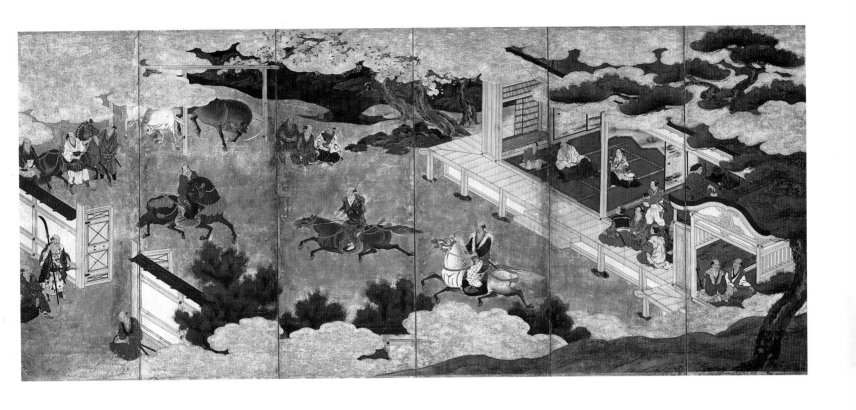

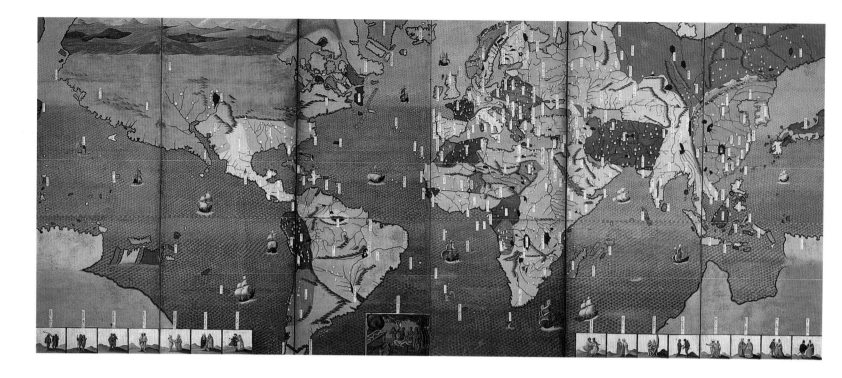

39. The Battle of Lepanto and Map of the World

Circa 1600–14
Pair of six-panel folding screens
Ink, colors, and gold on paper
Each 153.8 x 360.6 cm
Kōsetsu Museum, Kobe
Important Cultural Property

The adoration of religious icons is fundamental to Catholic ecclesiastical tradition, and the Jesuits are known to have sent significant numbers of religious paintings out from Europe to their Japanese missions. But as Christianity took hold in Japan, and the number of converts grew rapidly, the supply of religious icons, paintings and devotional prints from Europe fell short of the demand, and it became apparent that native artists would have to be trained. *Seminarios*, schools for educating future clergymen, were established by the Jesuits, and in addition to ecclesiastical studies, other aspects of Western learning were also taught to promising converts. Instruction in the techniques of Western illusionistic painting was intended to prepare capable native painters to produce the iconic representations necessary for devotional inspiration.

Father Alessandro Valignano (1539–1606) is credited with the idea of adding a training school to the seminary curriculum in order to meet the growing pictorial needs of the Japanese mission, which included both religious subjects, and secular representations intended to introduce European cultural traditions and topography to influential Japanese. During his first visit to Japan (1579–82), when he made Nobunaga's acquaintance, Valignano organized an embassy designed to secure papal

endorsement for the Jesuits' exclusive rights to missionary work in Japan and also to impress several young converts from prominent Kyushu daimyo families with the splendor of Catholic Europe. Departing in 1582, the entourage traveled to Portugal, Spain, and Italy, where they were received in audience by King Philip II of Spain and the Pope, Gregory XIII. In 1581 Oda Nobunaga had given Valignano a valuable set of screens painted by Kanō Eitoku and Valignano had, in turn, sent these on with the Japanese ambassadors as a present for the

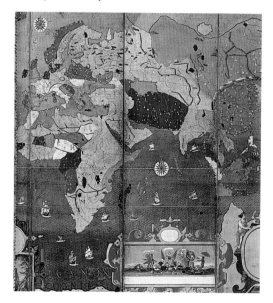

Cat. no. 39a. Detail of *Myriad Countries*. Eight-panel folding screen. Imperial Household Collection.

Pope.

Japanese artists were copying European paintings as early as 1565, but it was not until the summer of 1583 that a qualified teacher arrived in Japan. He was the Italian Jesuit Brother Giovanni Niccolo, who is said to have been an accomplished painter. Unfortunately Niccolo was frequently ill in the first years of his stay and this kept him from accompanying Father Gaspar Coelho (1531–90), the Jesuit Vice-Provincial in Japan, on a trip to Kyoto, the ancient center of culture and art, in 1586. Niccolo's poor health and his ecclesiastical duties apparently kept him from working regularly on his painting for several years.

In 1590, the Japanese envoys finally returned home to recount the marvels of the West and the glories of Christendom, bringing with them gifts from influential church figures and heads of state. These included several oil paintings, and a splendid selection of things European, such as religious and aristocratic clothing, jewelry, armor, maps, musical instruments, and a printing press and illustrated books, one of which may have been a volume with portraits of the Spanish royal family. In the same year, the painting school was finally established under Niccolo's direction. It went on to be an unqualified success, and the accomplished renderings of the students were such that their works were said to be in no way inferior to their European models. Father Niccolo's atelier is likely to have been the only place where aspiring painters had access to substantial European pictorial materials – the paintings, prints, maps and illustrated books that served as the basic source of subject matter for Western-style illusionistic painting. Located initially in Arima, but moved to Nagasaki in 1602, the

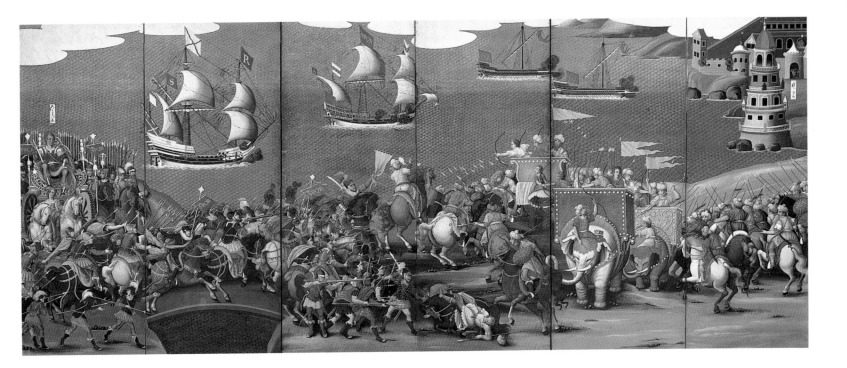

school trained a number of Japanese artists, the names of nine of whom have been preserved in documentary sources.In 1614 however,Tokugawa Ieyasu promulgated his Exclusion Edict, banishing from Japan all Catholic clergy, Japanese as well as European, and even some powerful Christian daimyo. This tragic, peremptory event brought an end to the painting school and its patronage. The school was transferred to Macao, undoubtedly with all its valuable Western pictorial archives, where Father Niccolo and several of the artists he had trained continued to work until his death in 1626.

The native artists who produced Western-style paintings in Japan worked with two general categories of subject matter, traditional Christian iconic and ecclesiastical themes intended for devotional worship (e.g., cat. no. 124), and eclectic secular compositions, inspired by a variety of pictorial prototypes in Western books and other source materials. Western secular themes were painted in several formats and sizes, but the most comprehensive are the small corpus of rare pieces in the form of large folding-screen compositions. These screens, with their exotic European themes and distinctive technical features, are thought to have been intended as Jesuit gifts for influential Japanese warlords, but it appears that some examples were also sent back to Europe.

This pair of rare screens from the Kosetsu Museum are superb examples of secular Namban painting. Rendered in precise detail using techniques and pigments intended to simulate European oil painting, they provide clear evidence of the sort of Western pictorial sources that were available in Japan in the late

sixteenth and early seventeenth centuries, and the manner in which these thematic materials were utilized by native Christian converts. *Map of the World* shows the closest correspondences in subject matter and cartographic detail with two other examples that are also halves of folding screen pairs, *Twenty-eight Cities and Myriad Countries* in the Imperial Household Collection (Shimizu 1988, no. 111; here cat. no 39a), and *Four Capital Cities and Map of the World* in the Kobe City Museum (Sakamoto 1970, no. 24).

The Kosetsu Museum screens are six-panel screens, while the two others are eight-panel screens, and somewhat larger in size. All three maps of the world utilize a comparable range of colors to differentiate countries, and share many details, such as the distinctive wave patterns in the oceans, types of ships and topographical particulars. But the Kosetsu map has fewer iconographic and pictorial embellishments, such as the heraldic cartouches in the Imperial Household piece, and does not have the navigational devices that appear in the other compositions. Scholars have suggested various Western pictorial sources for the compositions in the three sets of screens. The views of the *Four Capital Cities* are said to have been copied from Georg Braun and Franz Hogenberg's *Civitas Orbis Terrarum* (Cologne, 1572), while the three maps appear to have been inspired by illustrations in Abraham Ortelius's *Theatrum Orbis Terrarum* (Antwerp, 1570). It is possible that these books were among those brought back to Japan in 1590 by the Kyushu daimyos Otomo, Omura, and Arima. It has also been suggested, however, that the maps are likely to have been copied from a later source, a map of

the world published by Willem Blaeu (1571–1638) in Amsterdam around 1605. The depictions of fifteen pairs of men and women from different countries in their native dress along the bottom of the Kosetsu map, as well as the central panel showing cannibals in Brazil also appear to have come from Blaeu's illustrations.

The representations of a battle scene on this screen, traditionally identified as the Battle of Lepanto, is unique in its subject matter, essentially different from the second screen compositions in the two other collections, which are devoted to topographical depictions of cities and representations of regal mounted figures and courtiers and women. A stirring martial scene of one of the decisive battles of the late sixteenth century, when a combined fleet of Christian vessels defeated the Turks, denying the eastern invaders access by sea to Western Europe, would certainly have been of interest to a powerful member of the warrior class in Japan. But no pictorial prototype appears to have been available to the Japanese artist, and the composition is actually made up of an arbitrary pastiche of themes copied from various sources. The contending forces are the Turks, to the right, and the Christian battalions, tightly grouped to the left, with their logistical advantage, matchlock guns, clearly depicted (see detail). The front line of Turkish horsemen has turned to retreat from the determined advance of the Christian forces. Inspiration for the depiction of the Turkish leaders, riding in armored howdahs on elephants, has been traced to an engraving by Cornelis Cort, copied from a painting by Giulio Romano in the Vatican entitled *The Battle of Scipio Against Hannibal at Zama* (Sakamoto 1970, fig. 41).

The leader of the Christian forces, seated royally on a throne on a chariot to the left, and attired in the splendid but anachronistic Roman parade dress, is identified in the cartouche as the "King of Rome," apparently a reference to Philip II's descent from the Holy Roman Emperors (see detail), an identification confirmed by the red flags carried by the Christian soldiers and flown from the mast of the ship in the background, which bear the letters SPQR, an acronym for *Senatus Populusque Romanum*, a legend appropriate for Philip. This image was inspired directly from one of the engraved "Triumphs," from the series of Twelve Roman Emperors by Adriaen Collaert (1560–1618), which were published around 1590, and based on drawings by Jan van der Straet (Giovanni Stradano, also known as Stradanus; 1523–1605).

The spirited land battle which dominates the composition runs counter to history, for the Battle of Lepanto, fought on 7 October 1571 in the straits between the Gulf of Corinth and the Ionian Sea, in which the combined Christian naval forces of Spain, Rome, Venice and Genoa, defeated the fleet of the Ottoman Turks, was fought at sea. Four warships of the Christian fleet, two deep-water galleons and two smaller galleys, are firing their cannons at the Turkish fort at the far right, where the defenders return

the fire. But the fact that no Turkish ships are present is another indication of the artist's lack of fundamental knowledge about the great battle. Although Western ships are often represented in secular Namban Western-style paintings, this seems to be the only instance where cannon are actually depicted in action against an enemy. That there may well have been Japanese interest in such battle scenes is indicated in a letter written by Father Antonio Prenestino in Bungo, dated 11 November 1578, and sent to Antonio Possevino in Rome, requesting "pictures of knights in armor, and land and sea battles" (Vlam 1977, 242n62).

The persecution of Christianity after Ieyasu's Expulsion Edict resulted in the systematic and widespread destruction of Western-style paintings, not only the most obvious targets, religious icons, but also secular subjects, which could only have been saved by judicious concealment. *The Battle of Lepanto and Map of the World* are among the finest examples of Namban painting done by Japanese artists working in the Western, illusionistic style.

MLH

References: Boxer 1963; Boxer 1967; Cooper 1965; Cooper 1971; Tani 1973; Vlam 1977.

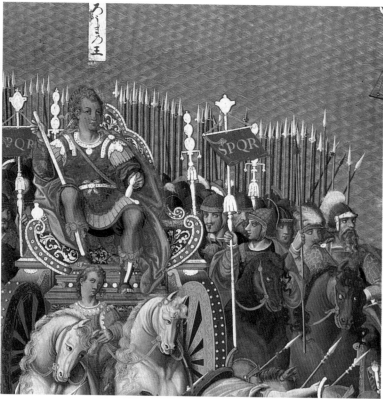

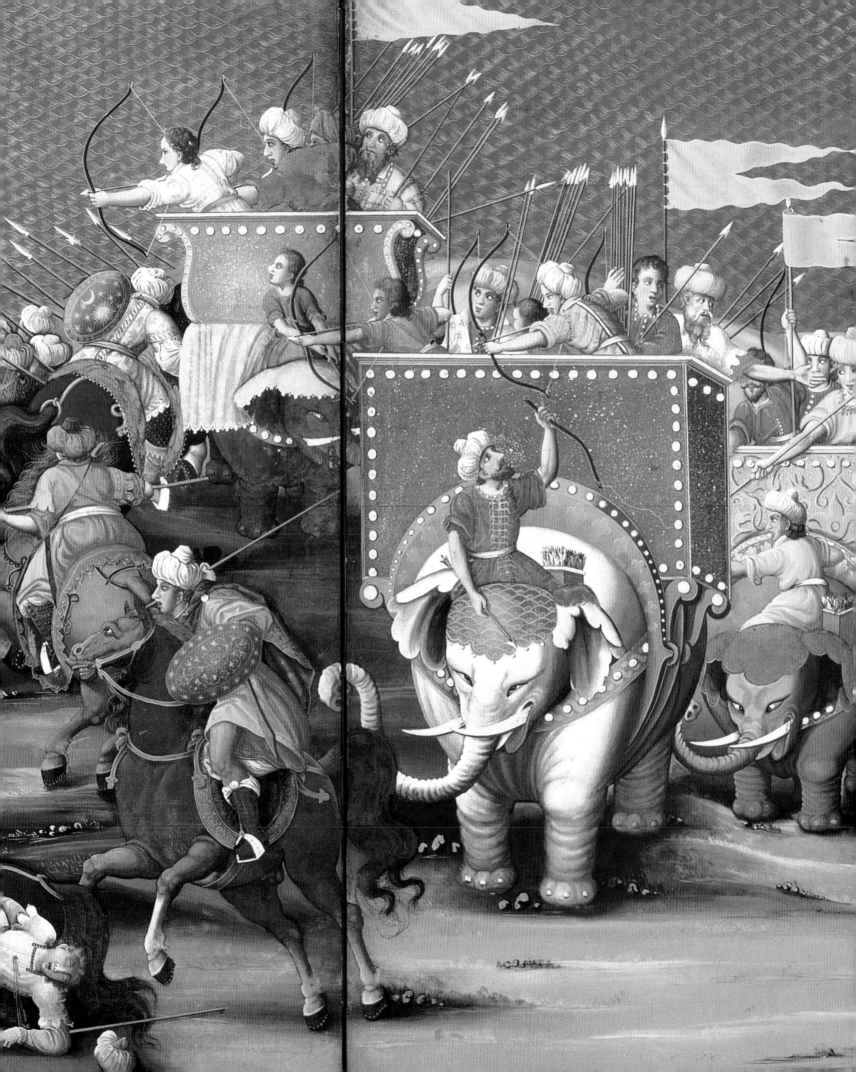

40. The Arrival of "Southern Barbarians"

Late sixteenth century
Pair of six-panel folding screens
Ink, colors, and gold leaf on paper
Each 154 x 354.4 cm
Kanagawa Prefectural History Museum

Portuguese ships first entered Japanese ports on the southern island of Kyushu in 1543, but it was not until about half a century later that artists began painting panoramic views of their comings and goings. Because Portuguese and other European traders and missionaries came to Japan from the south, they were called "Southern Barbarians," *Nambanjin*. Screens depicting the arrival of the Portuguese and procession through the streets of a Japanese port town are among the most characteristic expressions of what has come to be known as "Namban art."

An impressive Portuguese galleon dominates the right screen. Its decks are crowded with bearded figures dressed in baggy trousers and tall hats eating, drinking, and playing a board game. Men aboard a smaller boat poled by a dark-skinned man have begun unloading the ship's valuable cargo while three Catholic priests look on from the shore. Beyond them, on the left screen, a group of Portuguese, led by the captain, whose status is indicated by the umbrella held over him by an attendant, promenade through the town. Curious onlookers peep out from the windows of the

shops and residences flanking the street, but do not interact with the foreigners. Standing at the covered gateway at the end of the street is a priest, waiting to greet the visitors. Visible in the distance and separated from the mundane street scene by a band of gold clouds, is a Catholic church with a chapel, topped by a cross, and connected by covered walkway to a residence where a priest and laymen are engaged in a card game.

The directional orientation of these screens is unusual. Unlike most compositions of this type, the artist has represented the ship entering the harbor on the right screen and the street scene on the left. As a result, the compositional flow in each screen moves in opposing directions towards the center, rather than continuing in a single movement from right to left. This curious feature, as well as the relative paucity of figures and awkwardness of the ship's construction and rigging suggest that this work was painted by a town painter, *machi-eshi*, who had little understanding of his subject. Kanō Mitsunobu and members of his studio who participated in the decoration of Hideyoshi's Nagoya Castle in Kyushu between 1592 and 1593 may have had the opportunity to travel to Nagasaki to see for themselves the great Portuguese galleons, but most painters lacked such first-hand information and were forced to rely on pictorial models of various kinds.

Although the artist's identity cannot be determined, stylistically the screens can be

attributed to a painter trained in the Kanō workshops in the last decade of the sixteenth century. The screens were originally in the collection of a subtemple of the Higashi Honganji in the modern city of Ōtsu. According to temple tradition they were presented to Priest Kyōnyo (1558–1614), the founder of this Jōdo temple, sometime around 1602, thus providing a last possible date for their creation.

CG

References: Okamoto 1972, figs 21, 93; Sakamoto 1977, fig. 14; Sakamoto 1979, figs 49–50.

41. The Arrival of "Southern Barbarians"

Early seventeenth century
Pair of six-panel folding screens
Ink, color, and gold leaf on paper
Each 151 x 318 cm
Private Collection

Objective recording of the appearance and activities of the "Southern Barbarians" was not a major consideration in Namban screens. Artists strove rather to capitalize on the public's fascination with and fear of the world beyond Japanese shores by accentuating the exotic appearance and unfamiliar customs of these alien peoples.

The representations of a Portuguese ship's arrival in the port of Nagasaki on the right, and of a diplomatic reception in China on the left of this pair of screens are largely fanciful. The artist devised this composite scene by borrowing and recombining elements from other pictorial genres. The cluster of residences and shops flanking the street at harborside, for instance, derive from those commonly figuring in *Scenes In and Around the Capital* (cat. nos 23, 24). The Catholic church, the group of structures surrounding a rock garden in the background, resembles a Buddhist temple compound. Indeed, the elongated building with tiled, hipped and gabled roof on the right might even be mistaken for Kyoto's Thirty-three Bay Hall, or Sanjūsangendō.

Neither the geographic setting nor the precise nature of the activities depicted in the left screen is clear, but the pictorial conventions and the bridge which must be symbolically crossed before reaching the gathering of foreigners, leaves no doubt that the events take place in an alien country. The architectural style and vermilion color of the buildings, as well as the tiled walkway of the platform-like stage are all visual clues traditionally associated with depictions of China. However, the mustached and bearded figures, attired in pantaloons, brocade jackets and capes and tall hats, who stroll about, ride on horseback and converse with one another from their seats on the stage-like platform clearly represent Portuguese.

Of the more than sixty pairs of Namban screens, only a relatively small number combine a view of Portuguese galleons at anchor with a diplomatic reception on foreign shores. Views of a ship's arrival and of the procession of the Portuguese through Japanese streets, and of ships at anchor and leaving a Japanese port are far more common (cat. no. 40). The origins of this compositional type are not known, but Kanō Sanraku (1559–1635) may have contributed to its popularity. The landscape and figures in this composition suggest that it may have been produced in Sanraku's atelier somewhat later than the pair of screens of the same subject attributed to Sanraku now in the Suntory Museum.

CG

References: Sakamoto 1977, fig. 9; Sakamoto 1979, figs 64–5.

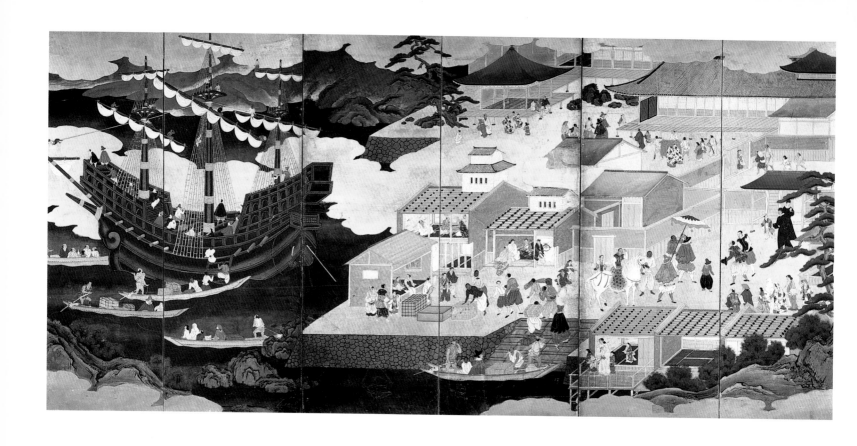

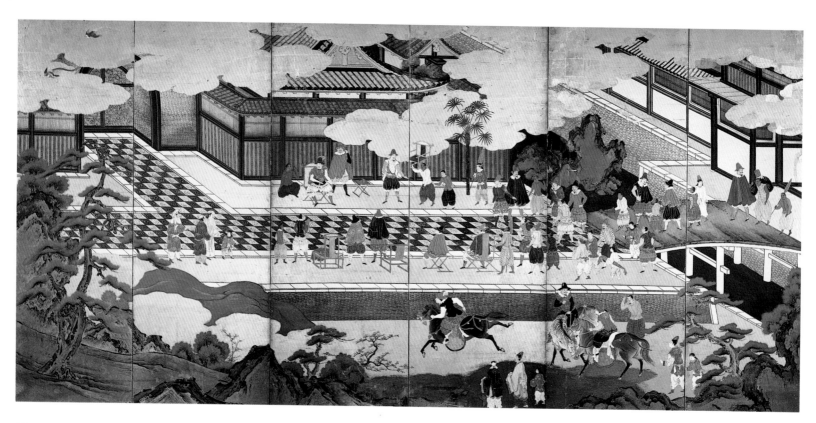

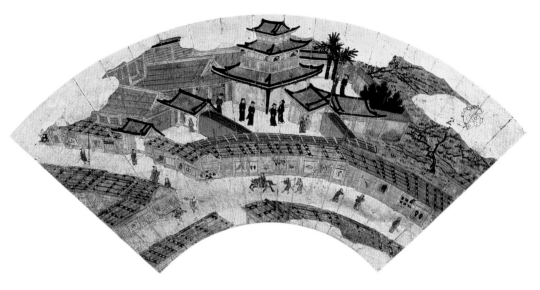

42. FAN PAINTING OF A JESUIT CHURCH

Kanō Sōshū (Motohide; 1551-1601)
Late sixteenth century
Fan painting; ink, colors, and gold leaf on paper
19.7 x 50.6 cm
Kobe City Museum

Popularly known as *Nambanji*, "Southern Barbarian temples," the churches built in Kyoto during the latter half of the sixteenth century by Jesuit missionaries so captivated the public imagination that they were incorporated into the repertory of the city landmarks memorialized in painting. Kyoto had a number of such churches: Nobunaga welcomed the Jesuits and permitted them to establish the first one soon after assuming control of the city, but it was lost to fire in 1573. At Christmas of 1576 a second church, built on the corner of Shijōbomon Street, was dedicated to the Assumption of Our Lady, but a decade later it was destroyed at the order of Hideyoshi. Still another was built under the auspices of Ieyasu on Ichijōmon Street during the Keichō era (1596–1614).

There is no consensus on which church is represented in this fan painting, but it is most likely the one on Shijōbomon. Its identity as a church is indicated by its unusual three-story construction, as well as by the cassocked figures standing nearby. Whether real or imaginary, the presence of a shop selling western hats on the street corner before the walled church compound enhances the exotic aura of the scene.

This painting was among a series of sixty-one fans painted by Kanō Sōshū, mounted in an album showing famous sites in and around Kyoto, of which only twenty-four paintings are thought to survive. The artist's identification is based on the seal reading "Motohide," appearing in the upper right corner. Although both Sōshū and his son Jinnōjō used this seal, the paintings are thought to be by Sōshū. Little is known of Sōshū beyond the fact that he was Kanō Shōei's second son, and was overshadowed by his elder brother Eitoku. The selection and arrangement of pictorial components in these fans suggest that he was a skilled painter of genre scenes and was especially familiar with the sites typically appearing in *Rakuchū rakugai-zu*, screens depicting views of Kyoto (see cat. nos 23, 24).

Paintings of *meisho*, poetic places named with imagistic associations, had figured prominently in *Yamato-e* since the Heian period. In the sixteenth century, however, the repertory of *meisho* expanded to include places without traditional sacred, literary, or historical associations that were of special interest to the Kyoto citizenry. Like the Nambanji pictured here, many of these sites were emblematic of the political, economic, and cultural renaissance following Nobunaga and Hideyoshi's consolidation of power in and around the capital.

CG

References: Okamoto 1972, fig. 68; Okudaira 1991, 166–9; Tani 1973.

43. BIRDS AND FLOWERS OF THE FOUR SEASONS

Kanō Shōei (1519–92)
Circa 1560s
Pair of six-panel folding screens
Ink and light colors on paper
Each 156.5 x 350.5 cm
Agency for Cultural Affairs

This imaginary landscape brings four seasons together in a single scene. The blossoming plum tree, dandelions and violets at right indicate early spring, the camellia bush at center suggests summer, the reeds and rose mallows at left are associated with autumn, and wintry snow covers the distant pines and mountains beyond. The turbulent waters at the base of the cascade at left are quickly quieted to a serene flow along gentle shores. The water motifs unify the composition and create a tranquil atmosphere overall.

The painter Kanō Shōei was the third-generation head of the Kanō studio, established in Kyoto by his grandfather Kanō Masanobu (1434–1530). In the sixteenth century this studio employed a number of artists, both Kanō family members and others, who painted folding screens, sliding-screen panels, fans, and scrolls for members of the military, merchant and aristocratic classes. Shōei inherited this occupation from his father Kanō Motonobu (1476–1559) and perpetuated the painting themes and brush styles popularized by him; Shōei's style was conservative rather than experimental. The informal brushwork (*gyōtai*) employed here gives a languid feeling to the whole scene and closely resembles Motonobu's *Birds and Flowers of the Four Seasons* painted in 1543, about twenty years earlier, at the Reiun'in, a subtemple of the Zen monastery of Myōshinji in northwest Kyoto. Shōei may have worked with his father on the Reiun'in project.

Thematically these screen paintings resemble the idyllic landscapes of fifteenth- and sixteenth-century *kinbyōbu* ("golden screens") that depicted brightly colored birds and flowers amidst gold-leafed clouds. The Kanō workshop was noted for their *kinbyōbu*. Shōei's father, Motonobu, was commissioned in 1541 by the daimyo Ouchi Yoshitaka (1507–51) to produce three pairs of *kinbyōbu*, along with a hundred fan paintings, to be taken on a trade mission to China by the Zen priest Sakugen Shūryō (1501–79). The commission took more than a year to complete, and the young Shōei was probably helping in the studio, learning to paint in Motonobu's distinctive styles (Klein 1984, 8–15).

Many *kinbyōbu* also featured four seasons in a similar layout, with the same flowers and birds that Shōei painted here. While *kinbyōbu* are delightfully decorative, diary entries from the fifteenth century indicate that such screens were occasionally used in funerals to surround the casket or to stand behind the memorial tablet. In such a context, the peaceful landscape might

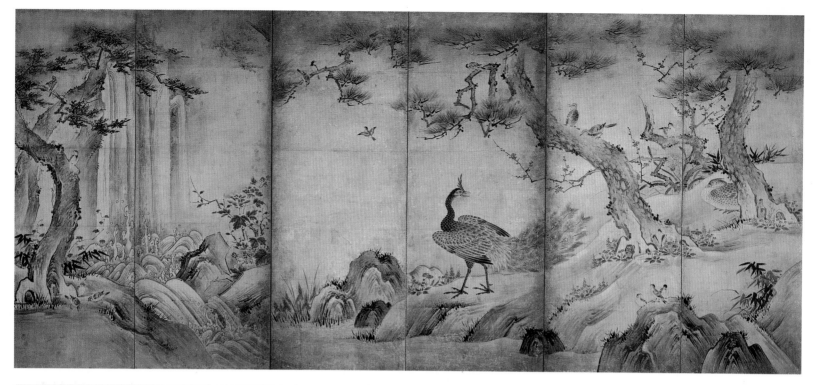

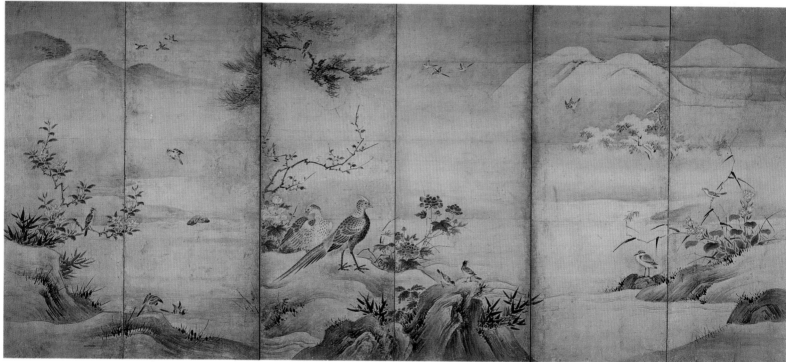

have alluded to the Pure Land (*Jōdo*) described in Buddhist texts, a paradise where recently deceased devotees were reborn to await final spiritual enlightenment. The specific patron and purpose of this pair of screens is not documented, however, so the iconographic relationship between this particular landscape scene and the *kinbyōbu* tradition is still tentative.

Each of these screens bears the artist's seal, which reads "Naonobu" – a name he used at mid-career. The Naonobu seal also appears on Shōei's monumental painting (633 x 381 cm)

showing the scene of the historical Buddha's death, *Nehan-zu*, done in 1563 for the Buddha Hall of Daitokuji, a Zen monastery in Kyoto. The artist's wall-panel ink paintings for the Jukōin, a subtemple at Daitokuji, executed in 1566 with similar brushwork, also help to date these folding screens to Shōei's middle years (see cat. nos 44–5). This was a busy time for Shōei, who signed the *Nehan-zu* with the official title *Mimbu no jō* (Assistant in the Ministry of Public Affairs), because the Kanō studio was being commissioned to provide a variety of large-scale

works for newly built castles, rebuilt palaces, and a number of temples in both Kyoto and the provinces.

BAC

References: Takeda 1977a, 81–103; Wheelwright 1981b; Yamaoka 1978, 116–20, 137 (on Motonobu's painting style).

44. BIRDS AND FLOWERS OF THE FOUR SEASONS

Kanō Eitoku (1543–90)
Circa 1566
Four sliding-screen panels
Ink and gold wash on paper
Each 175.5 x 142.5 cm
Jukōin, Daitokuji, Kyoto
National Treasure

A white crane grazes peacefully beneath the outstretched boughs of an old pine, while geese settle in among the reeds. These four panels are part of *Birds and Flowers of the Four Seasons*, a sixteen-panel panoramic composition, nearly sixty feet long, designed for three walls of the chapel at Jukōin, a subtemple of the Zen monastery of Daitokuji in Kyoto. The fourth wall on the chapel's south side has sliding doors that open to the garden, thus allowing exterior views of the landscaped space to visually unite with the interior wall paintings. Kanō Eitoku was just twenty-three when he executed these works, joining with his father Kanō Shōei (1519–92) in this commissioned work for one of Kyoto's foremost Zen monasteries.

The Jukōin paintings are Eitoku's earliest extant large-scale works. These four bird-and-flower *fusuma-e* make up the west wall of the subtemple's main hall and depict an autumn landscape. The seasonal cycle begins on the east wall with a massive old plum tree bursting into bloom and stretching its limbs nearly twenty feet across four panels. Various birds flitter through the misty spring sky, and three ducks glide along the cool waterway that extends from the east to north walls. In the northeast corner are snow-clad hills, but most of the north wall is decorated with depictions of a summer landscape. In the northwest corner are two enormous old pines that lean out and away from the room's corner post, their gnarled roots grasping the earth and their jagged limbs extending out across both the north and west walls. Beneath the pine boughs on the west wall, a graceful crane bends down to inspect some plants, while nearby on the north wall another crane stands upright, calling out with its beak open.

Eitoku depicted the pines and rocks here with broad bold brushstrokes that twist and turn to emphasize the rough surfaces. The feathers of the crane, in contrast, are delicately rendered to suggest their downy texture. To close the autumn imagery at left, a wild goose descends to the marshy shore where two others wait among the drying reeds and grasses. Eitoku has focused his attention on the foreground elements throughout this panorama, merely suggesting distant hills with pale washes of ink. The sweeps of gold dust that brighten the composition also lead the eye smoothly around the room, helping to further unify the entire composition. The vigorous brushwork and harmonious forms of this monumental painting mark the beginning of Eitoku's career as the leading artist of the

Momoyama period. During the next twenty-five years he would use such large-scale elements to decorate temples, palaces, and castles for Kyoto's most wealthy and powerful patrons.

The Jukōin subtemple was established in memory of Miyoshi Chōkei (1523–64), the ruthless military commander who controlled Kyoto for more fifteen years. Chōkei was the son of Miyoshi Motonaga who had seized the wealthy port city of Sakai from the Hosokawa family in the 1520s. Chōkei, in turn, took Kyoto from Hosokawa Harumoto (1519–63) in 1549 and forced the young shogun Ashikaga Yoshiteru (1536–64) into political exile for more than five years. On Chōkei's death, Daitokuji was selected by the Miyoshi family as the site for their memorial chapel. The Jukōin's founding abbot Shōrei Sōkin (1505–83) was a close friend of Chōkei, and served as the second abbot of Nanshūji in Sakai, a branch temple of Daitokuji built by Chōkei. Both Chōkei and Sōkin were patrons of the tea ceremony, and Sōkin was one of the Zen teachers of Sen no Rikyū (1522–91), whose grave site is now located within the Jukōin's walls. The Jukōin was intended to be one of Daitokuji's most prestigious subtemples, and Sōkin's choice of the Kanō artists Shōei and Eitoku reflects the extraordinary status of the Kanō studio in Kyoto during the 1560s.

BAC

References: Covell and Yamada 1974, 136–8; Morris 1981, 23–54; Takeda 1977a, 44–52; Wheelwright 1981c.

45. THE FOUR ACCOMPLISHMENTS

Kanō Eitoku (1543–90)
Circa 1566
Four sliding-screen panels
Ink and gold wash on paper
Each 175.5 x 142.5 cm
Jukōin, Daitokuji, Kyoto
National Treasure

In a languid landscape setting, several sages and their attendants are shown at leisure. Two of the four traditional Chinese gentlemanly accomplishments are depicted here: the ability to play a *koto* (zither) and the mastery of *go* (a board game); two other pastimes, calligraphy and painting, are depicted on an adjacent wall. Altogether eight sliding-screen paintings (*fusuma-e*) formed the east and north walls of the patron's room (*danna no ma*) of the Jukōin. Eitoku carefully rendered the figures of scholars and servants in precisely modulated lines which reflect his initial training in the Chinese painting styles of the Southern Sung artist Ma Yüan and of later Ming dynasty artists of the Che School. Eitoku learned such brush techniques from his grandfather Kanō Motonobu (1476–1559), whose paintings for the nearby Myōshinji

subtemple Reiunin includes a similar depiction of *The Four Accomplishments*. Although Eitoku's overall landscape composition differs from that of Motonobu, the use of exaggerated outlines for the rocks and trees, of "axe-cut" strokes for the faceting of cliffs and shorelines, and of wispy ink washes for the distant mountains clearly demonstrates the continuity of brushwork that would typify generations of Kanō studio artists. While Eitoku's later brush style became looser and more dynamic, this early example illustrates his debt to Motonobu and his awareness of various Chinese paintings in Kyoto, collected by the Ashikaga shoguns and by Zen temples such as Daitokuji.

As with Eitoku's *Birds and Flowers of the Four Seasons* (cat. no. 44), which decorated the adjoining room at the Jukōin (and part of which are on the reverse of these panels), a seasonal cycle is suggested in the landscape settings. Springtime is implied by the leafless plum tree at right and summer by the boating gentleman whose robes are opened to the cooling breezes. In the four panels not exhibited here, snowy peaks of winter close the left side of the composition. But the usual display of various birds and flowers to represent the seasons is not shown; instead Eitoku has focused his attention on the figure groupings. The *koto* musician and his listeners are framed by two twisted pines, while the *go* players seek refuge from the heat in a thatched waterside pavilion. In both scenes nearby tables are stocked with wine and food to sustain the spirits of the sages as they perfect their skills.

Such evocative depictions of elegant Chinese gentlemen were popular in Japan during the sixteenth century, and Motonobu's studio is credited with at least seven versions of *The Four Accomplishments*. These paintings thematically suggest that Japanese viewers shared the sophisticated tastes and subtle accomplishments of continental sages. Chinese connections are further reinforced by the stylized brushwork. Why would such secular subjects, rather than Buddhist imagery, be used to decorate the patron's room of a Zen subtemple? One possible answer is that the artists and patrons wanted to stress the cultural continuities between China and Japan, shared beliefs and practices that go beyond the Buddhist doctrine. These gentlemanly accomplishments, like Zen, may have their sources in China, but contemporary Japanese of the sixteenth century tried to maintain and promote such traditions as well. The Jukōin was built in memory of Miyoshi Chōkei (see previous entry), a powerful military man who may not have had the leisure to pursue such elegant pastimes, but his heirs could associate his name with such classic pursuits by selecting this theme for the patron's chamber.

BAC

References: Shimizu and Wheelwright 1976, 212–17; Takeda 1977a, 44–52; Wheelwright 1981c.

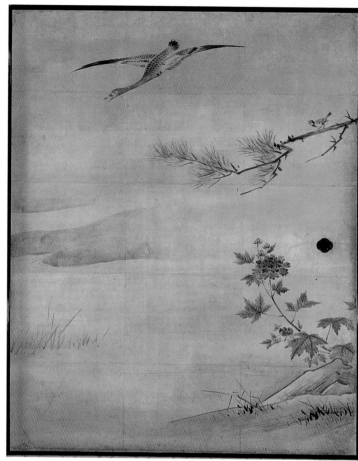

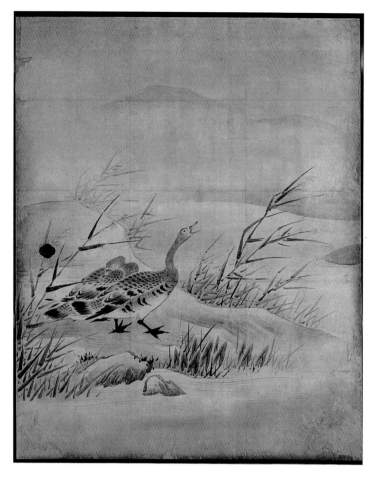

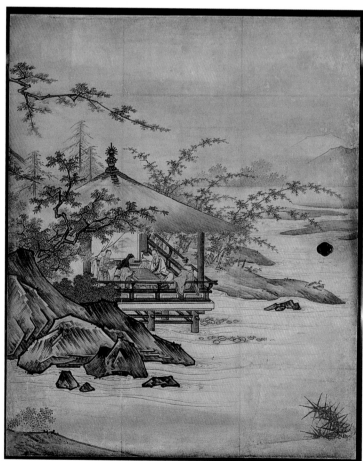

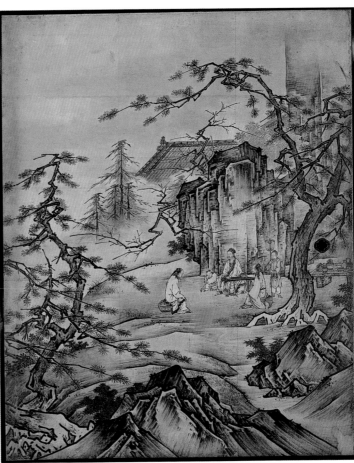

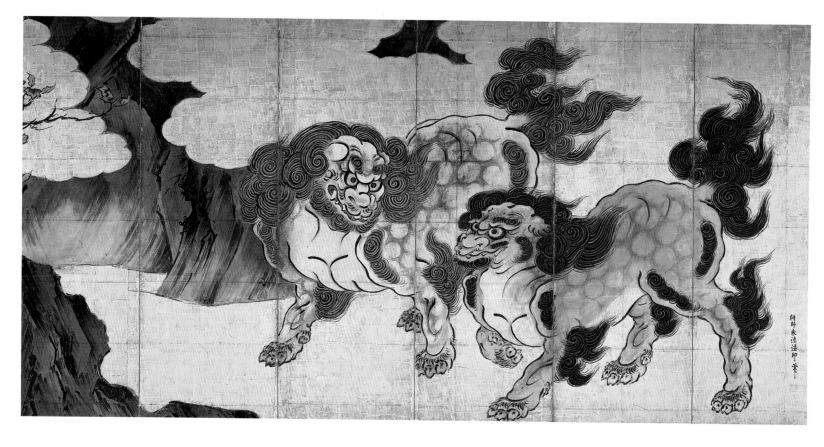

46. MYTHOLOGICAL "CHINESE LIONS"

Kanō Eitoku (1543–90)
Late 1580s
Six-panel folding screen
Colors and gold leaf on paper
222.8 x 452 cm
Imperial Household Collection

The *karashishi* (literally, "Chinese lion") is a mythological beast whose origins can be traced back to ancient Chinese legends. Widely utilized as an artistic motif during the T'ang dynasty (618–906), it is represented on a number of objects, either brought from the Asian mainland or inspired by continental prototypes, that have been preserved in the eighth-century imperial repository in Nara, the Shōsōin. Over the centuries, images of *karashishi* have appeared in both religious and secular contexts, acquiring a variety of potent symbolic associations – preeminence, power, bravery, and grandeur – that correspond, in a general way, to the characteristics that have traditionally been attributed to the lion in Western thought and legend. Given the martial, heroic tenor of the times, it is not surprising that the *karashishi* became an important emblematic motif during the Momoyama period, and was widely represented in painting, architectural decoration, metalwork, ceramics (see cat. no. 82), and even in roof ridge sculptures (cat. no. 46a).

Eitoku's celebrated folding-screen depiction of these two fabulous beasts is exemplary of the bold, monumental style developed by the artist in the later years of his career. No signature appears on the piece, but it bears the authentication of the artist's famous grandson, the prolific painter and connoisseur Kanō Tan'yū (1602–74) in the lower right-hand corner, and is universally recognized as one of Eitoku's masterpieces.

Painted on a screen that is unusual for its large dimensions, the two imperious *karashishi*, symbols of princely power, move majestically from the open space at the right, across the middle ground of the composition, and toward the left, where they approach a narrow passage with a sheer cliff behind and a rugged outcropping of rock in the foreground. The beasts seem to emerge, apparition-like, from the

Cat. no. 46a. *Karashishi* roof-ridge sculpture, by Raku Chōjirō. Late sixteenth century.

sea of resplendent gold space behind and around them. Represented on a grand scale, their dynamic forms not only fill the picture plane but seem to resonate visually beyond its boundaries.

The broad flat areas of gold leaf, which cover half of the entire surface of the screen, allow the viewer to focus on the fabulous beasts and the interplay of their movements and expressions. The fantastic, supernatural qualities of the beasts are also emphasized by superimposing them against the flat, translucent gold background, against which they seem to move easily, suspended in imaginary space, oblivious of gravity. This quality of spatial ambiguity is ingeniously carried further by the use of gold leaf, which serves not only to indicate clouds above, but continues on, unbroken, to serve as the foreground plane leading between the masses of rock. One's attention is also drawn to the differences in pose and detail, the subtle variations in their manes and the colors of their dappled bodies – the right animal with its warm tan coloring, and the light grey of its companion.

This screen was originally the right half of a pair. The movement of the animals, to the left, toward a cleft between rocks, would have had a comparable, balancing component on the left-hand screen. The composition seems to have been continuous across both screens, for the tips of a branch with leaves appear at the top of the left-hand panel. No seasonal context can be established, for the abbreviated treatment of the branch and leaves makes it impossible to

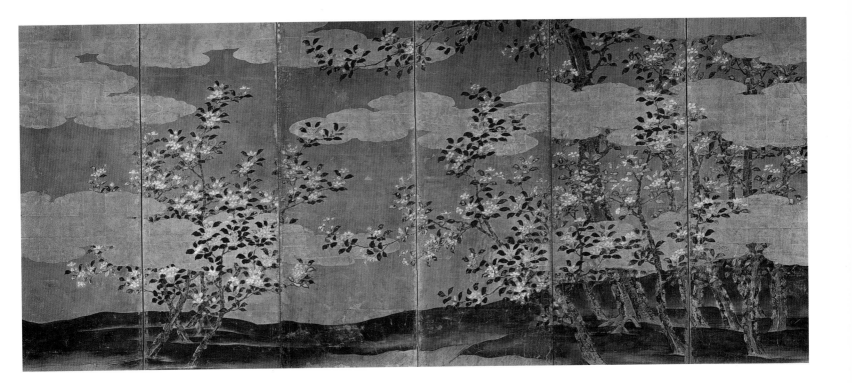

identify. One can only speculate on what subject matter appeared in the missing left screen; perhaps another *karashishi*, surrounded by the luxuriant peonies often associated with these beasts.

This screen was produced in the last years of Eitoku's life. We know that he was ill in 1588, and that Sanraku had to substitute for him in painting a large dragon on the ceiling of the Dharma Hall of the Tōfukuji. Eitoku was busy working on a painting commission for the palace of Prince Tomohito – together with his younger brother Sōshū (1551–1601) and his son Mitsunobu – at the time of his death at the age of forty-eight in 1590. He was outlived by his father Shōei, who died in 1592, at age seventy-four.

It is not surprising that various traditions have come to be associated with this impressive screen. One has it that it was displayed by Hideyoshi at his military headquarters, where it served as a dramatic, evocative backdrop for his activities. According to another tradition, the screen was supposedly presented by Hideyoshi to the warlord Mōri Terumoto (1553–1625) as a conciliatory offering at the time of the siege of Takamatsu Castle in 1582. Although the screen did belong to the Mōri family until it was presented to the Imperial Household Collection in 1888, careful consideration of the artist's stylistic evolution seems to cast doubt on this possibility, for scholars are inclined to date the screen several years later, to about 1587 or 1588.

MLH

47. CAMELLIAS IN BLOOM

Kanō school
Third quarter of sixteenth century
Six-panel folding screen
Ink, colors, and gold leaf on paper
154.5 x 355 cm
Kyoto National Museum

A grove of slender, gracefully swaying, flowering trees occupies the three right panels of this screen with a smaller, echoing arrangement on the left. All are concentrated in the foreground of the composition, firmly anchored in earthen banks devoid of rocks or other vegetation. While their arrangement suggests some spatial recession, this is offset by the stylized bands of gold clouds that waft in and out of the trees. Although the screen appears to be self-contained, it was no doubt designed as one half of a pair.

The blossoming trees have traditionally been identified as a species of camellia, but more recently, scholars have suggested that they may represent pears or crab apples instead. Trees with poetic and seasonal overtones – especially verdant pines, autumn maples, or blossoming cherries – were a time honored *Yamato-e* theme, but camellia, pear and crab apple figured only rarely in Japanese painting before the sixteenth century when there was a dramatic explosion in the pictorial repertory of flora and fauna due to the influx of Ming bird-and-flower painting. Although many of the new plant species that first appeared in Japanese painting of this era are represented with a considerable degree of

botanical accuracy, it is not always possible to be sure of their exact identity.

Mid-sixteenth-century screen paintings featuring groves of trees of the same type are most closely associated with painters of the Tosa school. Their treatment is generally distinguished by a flattening and conventionalization of form that results in a two-dimensional decorative effect. Although the influence of this pictorial approach is evident here, the more realistic physical setting as well as details, such as the moss-covered tree trunks, suggest that this is the work of a Kanō painter.

The conception and handling of the motifs in this composition are comparable to the panels in the *jōdan no ma* reception room of Kangakuin, Onjōji, painted in 1601 by Kanō Mitsunobu (1561–1608). An earlier date, however, is suggested by the fact that the screen is less fully articulated spatially and by the more restrained use of gold. Mitsunobu enjoyed the patronage of both Nobunaga and Hideyoshi and his pictorial style, distinguished by a more muted elegance than that of his father Eitoku, was extremely influential, especially after the latter's death in 1590.

CG

References: Suntory 1989, no. 21; Takeda 1982, fig. 146; Tsuji 1978, fig. 51.

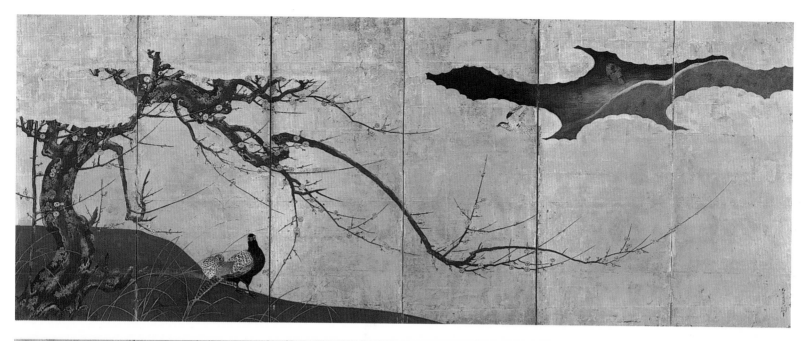

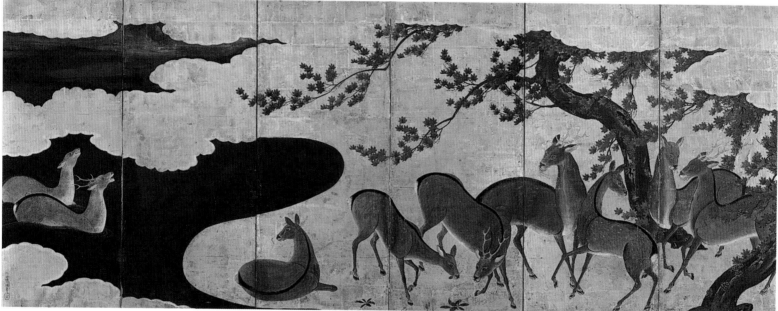

48. PLUM AND PHEASANT; MAPLE AND DEER

Kanō Naizen (1570–1616)
Early seventeenth century
Pair of six-panel folding screens
Ink, colors, and gold on paper
Each 137.7 x 355.4 cm
Private Collection

In these tranquil landscapes, characterized by the gently rhythmic curves of flora and fauna, illusionistic techniques are less important than the creation of a strong seasonal and emotional ambience. On the right screen, a blossoming plum tree with gracefully outstretched branches both shelters a pair of pheasants and points to the distant hills that emerge from between scalloped gold clouds. On the left screen, maple trees frame a herd of grazing deer. The pair of crying deer, wading in the water beyond them, adds a melancholy auditory quality to the scene. Further enhancing the poetic mood are the sun and moon that emerge from the distant, cloud-filled spring and autumn skies.

In subject matter, style and technique, these screens betray the influence of the indigenous *Yamato-e* tradition as it developed within the Kanō workshops. They are particularly indebted to the lyrical style popularized by Kanō Mitsunobu (1565–1608), the dominant figure in Kanō circles for fifteen years following the premature death of Eitoku in 1590. The Mitsunobu style became extremely influential both among his direct disciples and those of other Kanō masters during the first quarter of the seventeenth century.

These screens bear the signature and seals of Kanō Naizen, an artist trained in the atelier of Eitoku's father Shōei (1519–92). Naizen enjoyed Hideyoshi's patronage and collaborated in the decoration of various castles, but his best known surviving works are *Hōkoku Festival* (Hōkoku Shrine, Kyoto), and the *Arrival of Southern Barbarians* (Kobe City Museum). The striking contrast in style and mood between these genre screens and the poetic landscapes reproduced here are evidence of Naizen's talent and versatility.

CG

References: Suntory 1989, no. 12; Yamane 1973, 81–6.

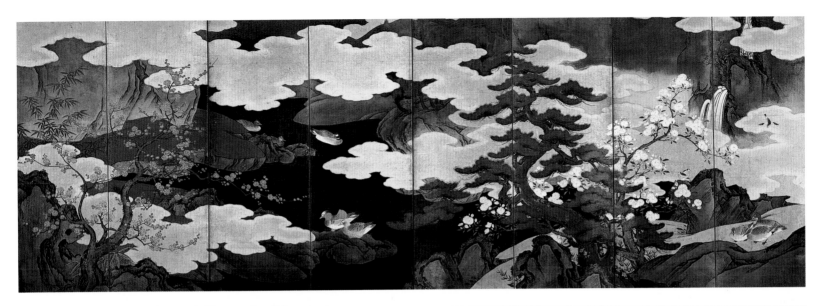

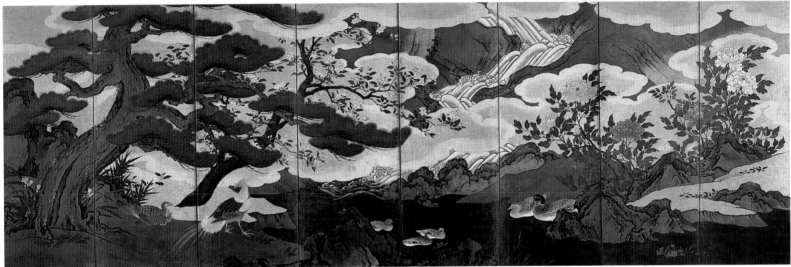

49. SPRING AND SUMMER LANDSCAPES

Kanō school artists
Last quarter of sixteenth century
Pair of eight-panel folding screens
Ink, colors, and gold on paper
Each 159 x 469 cm
Private Collection

This pair of screens features spring at right and summer at left, with appropriate flowers and trees in bloom. Thick colors and gold-leafed clouds help to join the two screens into a single composition. However, variations between the two screens, such as the brushwork in the rocks, the treatment of the pine boughs and tree trunks, and the shapes of the clouds, suggest that several different artists worked on these screens, and that perhaps these paintings were not produced as a matched pair. The Kanō painting studios were extremely busy during the late sixteenth century creating large-scale works for the newly rebuilt city of Kyoto, and folding screens such as these were extremely popular as room dividers for residential interiors.

The summer scene has a typical Kanō composition, with a large pine extending up and across several panels. Angular boulders help to define the foreground, and zigzag shorelines encourage the viewer's eye to travel back in space. A frothy waterfall cascades down a nearby hillside and returns the viewer's attention to the middle-ground area of birds and flowers. Everything seems carefully placed. The spring scene is less clearly structured, with a somewhat stunted pine emerging from near the center of the picture's lower edge and a small waterway awkwardly extending back and up. The distant falls seem unrelated to the pond, and the cliffs at left and center are of indeterminate size. Elements in the overall landscape composition appear less deliberately placed. Perhaps these screens were produced by apprentice artists at the Kanō studios or by regional artists working in the Kyoto style.

The thin sinuous curves of the pine and plum trees in the spring view are similar to those in paintings by Kanō Mitsunobu (1561–1608), who inherited the Kanō studio in Kyoto from his father Eitoku. As a youth Mitsunobu worked with Shōei and Eitoku, learning a conservative Kanō brush style from his grandfather and more innovative compositional techniques from his father. Mitsunobu worked with Eitoku at Azuchi Castle, receiving the gift of a *kosode* robe from Nobunaga (Takeda 1977, 118–33). Later, Mitsunobu painted wall-panels and folding screens for the rebuilt imperial palace, for Hideyoshi's Jurakutei, and for various temples and shrines in Kyoto and the provinces. As fifth-generation head of the Kanō studio, he oversaw production of their many commissioned works and helped train the numerous apprentices. However, only a few extant works can be securely identified as products of Mitsunobu's own hand. He appears to have moved away from the thick brushstrokes and monumental images of Eitoku's era to create more delicate and demure scenes. While these two screens are not by Mitsunobu, they reflect the changes taking place in the Kanō styles following the death of Eitoku in 1590.

BAC

50. Red Plum Blossoms

Kanō Sanraku (1559–1635)
Circa 1619
Four sliding-screen panels
Ink, colors, and gold on paper
Each 185 x 98.5 cm
Daikakuji, Kyoto
Important Cultural Property

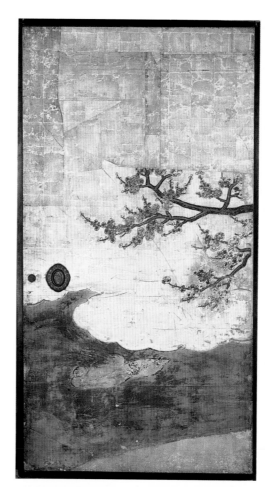
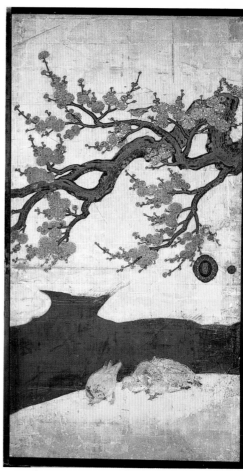

The excitement of spring as blossoms burst forth is truly captured in these brilliant sliding-screen paintings (*fusuma-e*) by Sanraku, the leading disciple and son-in-law of Kanō Eitoku. Sanraku's father was Kimura Nagamitsu, a military man who lived in Ōmi Province, east of Kyoto. As a boy, Sanraku reportedly studied the painting styles of Kanō Motonobu (1476–1559). In the early 1570s both Nagamitsu and his son (known then as Mitsuyori) served Toyotomi Hideyoshi, and in about 1574 Hideyoshi supposedly helped Sanraku enter Eitoku's studio. By 1588 Sanraku had mastered Eitoku's bold innovative style and was adopted as Eitoku's son. When his teacher became ill while painting an enormous dragon on the ceiling of the Dharma Hall at the Zen temple of Tōfukuji in Kyoto, Sanraku completed the commission in 1588.

In the 1590s Sanraku was frequently commissioned by Hideyoshi to provide paintings for temples, shrines and palaces, especially for the new Fushimi Castle south of Kyoto. When Hideyoshi's heirs were defeated at Osaka Castle in 1615, Sanraku feared retribution because of his close associations with the Toyotomi family. He initially sought refuge outside Kyoto with the artist Shōkadō Shōjō (1584–1639; see cat. no. 77) and then became a Buddhist priest, taking the name Sanraku. However, by 1619 the Tokugawa government had pardoned Sanraku, who then returned to head the flourishing Kyoto branch of the Kanō studio.

Sanraku's sliding-screen paintings for Daikakuji, of which these four panels are a segment, are considered his masterpieces in the gold-leafed "wall painting" (*kinpeki ga*) style. A branch of blossoming plum stretches several meters to the left; these four panels are balanced by another four (not illustrated) depicting the right side of the tree and another plum with pale blossoms. The power of the overall composition is reminiscent of Eitoku, but where Eitoku's thick outlines seem quickly and confidently brushed, Sanraku's more carefully modulated strokes appear painstakingly executed. The effect is more controlled and elegant. Sanraku's birds are not darting and dashing, but seem quiet, though alert. The blossoms in various shades of red, gold-leafed clouds, and gently curving shoreline make a splendid decorative display, most appropriate for a refined residential interior.

On the backs of these panels are depictions of pink and white peonies flowering amidst rock outcroppings, which are described in the following entry.

BAC

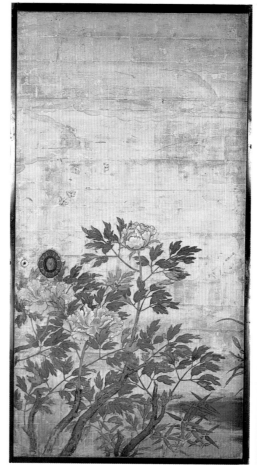
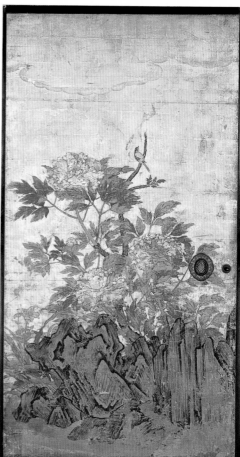

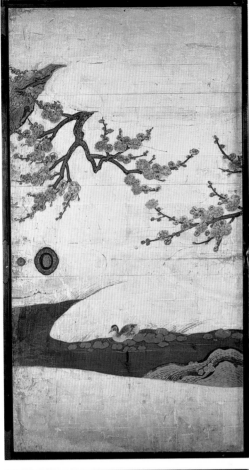
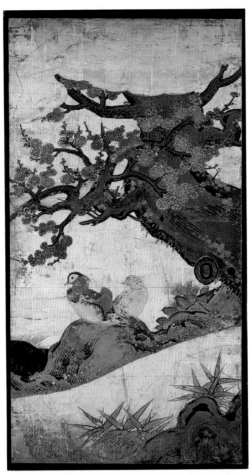
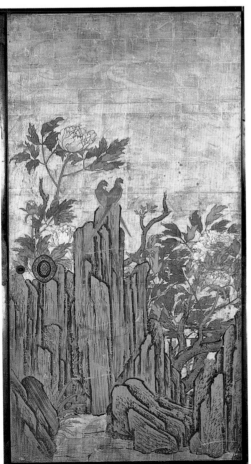
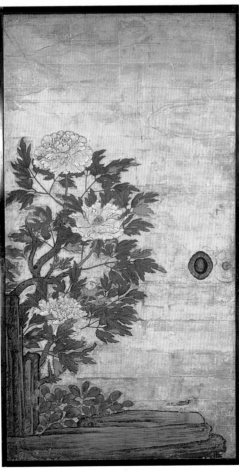

51. Peonies

Kanō Sanraku (1559–1635)
Circa 1619
Four sliding-screen panels
Ink, colors, and gold on paper
Each 185 x 98.5 cm
Daikakuji, Kyoto
Important Cultural Property

The rich royal appearance of peonies in full bloom has given these flowers imperial associations in both China and Japan. The four panels displayed here are among eighteen that now cover the east, north, and west walls of the "Peony Flower Room" (*Botan no ma*) in the Residential Hall at Daikakuji. When reinstalled at the temple in the late seventeenth century, some panels were altered to fit the new location, but these four maintain their original composition.

The striking rock arrangement, with its dramatically striated forms, suggests a garden setting where the pink and white peonies are blooming. The interplay of thick outlines and lightly brushed texture stokes on the rocks, with hints of shading to facet the surfaces, are distinctive to Sanraku's style, which is more relaxed than the twisting sweeping brushwork associated with his teacher Eitoku. While the stones seem stylized, the flowers and leaves are individually rendered with great sensitivity to the petal shapes and colors. As with *Red Plum Blossoms* on the reverse side of these panels (discussed in the previous entry), Sanraku has created an elegant and quiet scene, with birds at rest and clouds gently flowing above the bushes.

According to Daikakuji traditions, both sets of these sliding-screen panels were once installed in the ladies' quarters of the Imperial Palace, and were donated by the Retired Empress Tōfukumon'in (1607–78), daughter of Tokugawa Hidetada and wife of former Emperor Go-Mizunoo. Reportedly the paintings were done by Sanraku for her quarters in about 1619, when she was introduced to court. Sanraku was called out of retirement to help in this major commission, now numbered among his masterpieces. Daikakuji is an Esoteric (Shingon) Buddhist temple with close connections to the imperial family, and one of Go-Mizunoo's sons was serving as abbot when these panels were presented.

The paired parrots perched on the highest rock may allude to the imperial marriage, which evidently was highly successful. Both Go-Mizunoo and Tōfukumon'in were great patrons of the arts, and the Kyoto Kanō studio under Sanraku's direction was favored by their imperial commissions.

BAC

References: Doi 1967; Doi 1976; Doi 1980; Kyoto 1992, 23–6, 116–23.

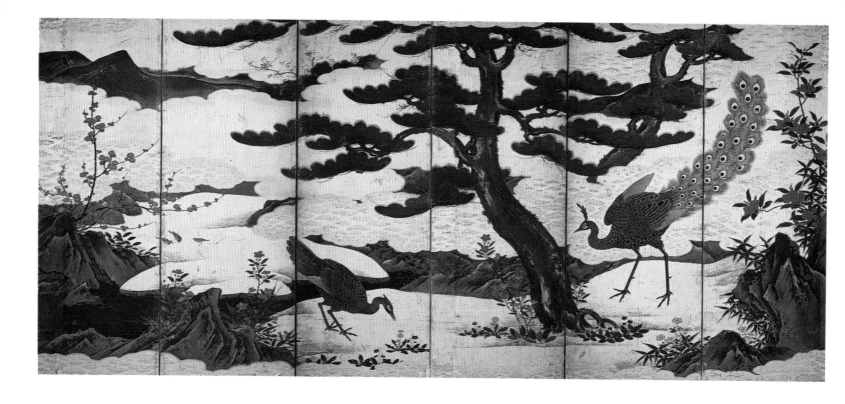

52. Peacocks under Pines

Kanō school
Last quarter of sixteenth century
Six-panel folding screen
Ink, colors, and gold on paper
162 x 365 cm
Private Collection

A strutting peacock accompanied by a peahen dominate this exuberant celebration of plant and animal life. Standing to either side of an elegant curving pine tree, they are surrounded by a profusion of colorful flowers, flowering shrubs and ornamental trees associated with spring and early summer. The tilted ground plane and careful staggering of landscape motifs creates a stagelike setting for this idealized vision of the natural world.

Like many bird-and-flower paintings (*kachōga*) of the late sixteenth and early seventeenth centuries, the primary emphasis is on the fore- and middleground. This restricted pictorial space is established by the jutting rocks along the lower edge of the composition and by the rolling banks occupied by the pine, peacock and peahen. Only the verdant mountains that emerge from gaps between the opaque gold clouds that stretch laterally beyond the pine tree hints at greater depth.

Models for polychrome paintings featuring peacocks in a paradisiacal garden originated in the studios of Kanō Motonobu and were creatively transformed by many of his followers. When this screen first came to light it was attributed to Eitoku, but in terms of spatial treatment and handling of individual motifs, it has more in common with Mitsunobu's works. A series of panels of the same subject by

Mitsunobu in the *ni no ma* reception room of the Kangakuin in the temple compound of Onjōji at Ōtsu feature the same elegantly curved pine tree and layered arrangement of space. Even closer in style is a pair of screens in a private collection in Japan, depicting birds and flowers of the four seasons bearing a seal reading "Shūshin" (also read Kuninobu). While the identity of this artist is unknown, he is believed to have belonged to the circle of Mitsunobu. Comparison with the Shūshin screens further suggests that this screen formed the right half of a pair.

CG

References: Suntory 1989, no. 10; Wakisaka 1982, fig. 22; Wheelwright 1981a.

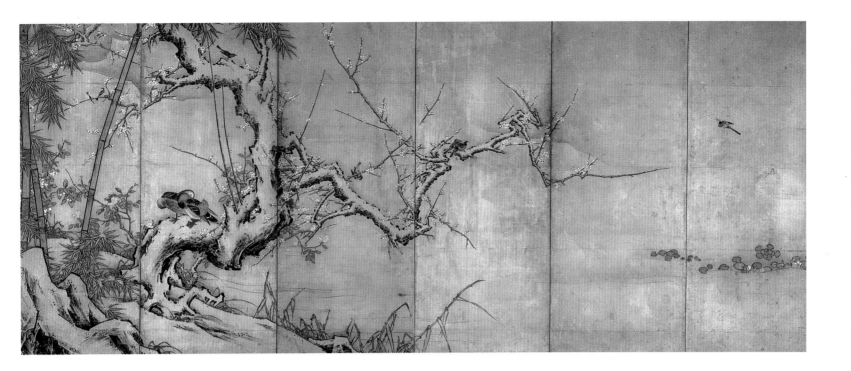

53. BIRDS AND FLOWERS

Hasegawa Tōhaku (1539–1610)
Circa 1570s
Six-panel folding screen
Ink and colors on paper
149.5 x 359.5 cm
Myōkakuji, Mitsu, Okayama Prefecture
Important Cultural Property

This folding screen, originally the left half of a pair, is considered an early work of the artist Tōhaku, who used the name "Nobuharu" found on the seals at the far left during the 1560s and 1570s. Tōhaku was born in Nanao, a small town on the Noto Peninsula north of Kyoto, and adopted into the Hasegawa family, who were fabric dyers. Little is known of his early life, but reportedly Tōhaku studied with Soga family painters, who worked for the daimyo of Noto Province.

Extant paintings with "Nobuharu" seals include bird-and-flower images, portraits (e.g. cat. no. 3), as well as traditional Buddhist figure paintings and several commemorative portraits of Nichiren (1222–82), the charismatic founder of the Nichiren sect of Buddhism which was widespread in the countryside during the sixteenth century. In 1568 Tōhaku painted a scene of the historical Buddha's death (Nehan-zu) for the important Nichiren temple of Myōjōji in Noto Province. Around 1570 Tōhaku is thought to have moved to Kyoto and worked at the Kanō studio, perhaps with Kanō Shōei (1519–92; see cat. no. 43).

Tōhaku's affiliations with the Nichiren sect provided an introduction to the abbot of Hompōji in Kyoto, where he was allowed to live in the subtemple of Kyōgōin. Through the abbot Nichigyō (1543–72), Tōhaku was evidently introduced to the tea master Sen no Rikyū (1522–91) and through Rikyū to the Zen-sect monks of Daitokuji, who gave him access to that monastery's extraordinary collections of Chinese and Japanese paintings, which influenced many of his own works. The close association of Tōhaku and Daitokuji tea and Zen circles adds credence to the Tōhaku attribution for the Portrait of Sen no Rikyū bearing an inscription by Daitokuji priest Shun'oku Sōen (see cat. no. 5).

Later Tōhaku painted several important sliding-screen paintings (fusuma-e) for the newly built or rebuilt subtemples of Daitokuji. He was also commissioned by Rikyū in 1589 to decorate the ceiling and pillars of Daitokuji's newly expanded main gatehouse. This screen was originally at the Myōkakuji, a Nichiren-sect temple in Kyoto, but later owned by the Gotō family who gave it to the Myōkakuji in Okayama.

Birds and Flowers demonstrates Tōhaku's debt to earlier Kanō artists and to the painting traditions established by Sesshū Tōyō (1420–1506). The twisted tree trunk that dramatically juts across the foreground space and the thickly brushed rocks and reeds recall Sesshū's famous screen painting Birds and Flowers. Tōhaku's articulated dotting and broken outlines, however, sharply contrast with the massiveness of Sesshū's more forceful forms. Tōhaku's shallow foreground and abbreviated mountain shapes seem closer to the spatial arrangements of Kanō Shōei, while the various birds and flowers follow the patterned style and coloring of Kanō Motonobu.

Tōhaku worked with Kanō Eitoku in 1587 on the decoration of Hideyoshi's Kyoto palace Jurakutei (see cat. no. 25), but by 1590 Tōhaku was at odds with the Kanō studio and struck out on his own. He changed his name from Nobuharu to Tōhaku, taking the character "Tō" from the names of Sesshū Tōyō and Sesshū school artist Tōshun (act. 16th c.), thereby emphasizing his artistic descent from Sesshū. Reportedly, this claim was successfully challenged in court by Unkoku Tōgan (1547-1618), who also declared himself heir to Sesshū's style and chose an artistic name with the same "Tō." During the 1590s and early seventeenth century, Tōhaku and Tōgan would be rivals with the Kanō artists and with each other for important commissions in Kyoto.

BAC

References: Doi 1973; Nakajima 1979.

54. Maple Tree and Autumn Plants

Hasegawa Tōhaku (1539–1610)
Circa 1593
Four sliding-screen panels
Ink, colors, and gold leaf on paper
Each 174.3 x 139.5 cm
Chishakuin, Kyoto
National Treasure

Tōhaku's reputation as one of the preeminent artists in Kyoto was clearly established in 1587 when he worked, together with Kanō Eitoku and his followers, on the screens for Hideyoshi's Kyoto palatial residence, the Jurakutei (see cat. no. 25). He may have had a falling out with Eitoku in 1590, for the head of the Kanō studio appears to have excluded him from a painting project for Prince Tomohito at the palace compound. But Eitoku died suddenly late in 1590, and when Hideyoshi began construction in the following year on a large mortuary temple (*bodaiji*) dedicated to the memory of his son Sutemaru (Tsurumatsu) – who had tragically died the previous year in his third year – Tōhaku and his atelier were given the commission to produce the large number of sliding screens necessary for the project.

The Zen priest Nange Genkō was appointed abbot of the new mortuary temple, a compound named the Shōunji, which was built on a spacious area to the southeast of the colossal Daibutsuden (Great Buddha Hall) of the Hōkōji. A portrait sculpture of Sutemaru (fig. 20) and various objects associated with him, such as his suits of armor (cat. nos 139, 140), were installed there. Tōhaku, his son Kyūzō, and the other artists of their group worked industriously until all the paintings were completed in 1593. After the demise of the Toyotomi family and their supporters at Osaka in 1615, Tokugawa Ieyasu delegated jurisdiction over the Shōunji to the Chishakuin, a neighboring monastery. Unfortunately, the Shōunji caught fire in 1682, and though many of the buildings were leveled, most of the screens seem to have survived, although they subsequently suffered damage when they were detached from the wooden frames on which they had been mounted. In 1727, the remaining screens were remounted and installed in the newly-erected Great Reception Hall and other buildings of the temple. In 1892 some of the screens disappeared, and in 1947 more were destroyed in another fire. Despite this unhappy history, some of the finest examples are still preserved.

The extant screens, which have no signatures or seals, appear to be from several hands, but the finest works – the scene of a majestic maple surrounded by autumn plants reproduced here, and another four-panel composition of a cherry tree in full bloom with other spring flora – are thought to be from the hand of Tōhaku himself, or, in the case of the cherry composition, perhaps by his son Kyūzō (1568–93). Originally the two compositions are said to have faced each other on opposite sides of the *hōjō* (abbot's quarters) of the Shōunji, an arrangement where the resonating interaction of their bright, evocative colors and luminous areas of gold leaf would have filled the chamber with exuberant splendor.

The cherry is shown at the most dramatic, brash moment of its spring display, with evanescent white clouds floating above the dark presence of its venerable trunk and outstretched branches. Each of the blossoms has been painstakingly executed in *moriage*, a raised appliqué technique which uses molded gesso to render the shapes of individual flowers (cat. no. 54a). The promise of warm, auspicious spring is heightened by the supporting cast of flora below, the dandelion, violet, azalea, yellow rose and iris.

The ambiance in the maple composition is quite different, elegantly theatrical with its

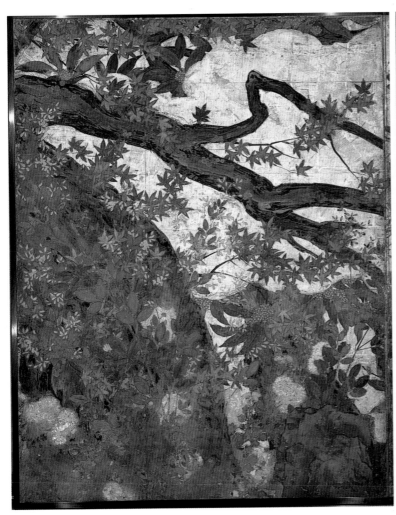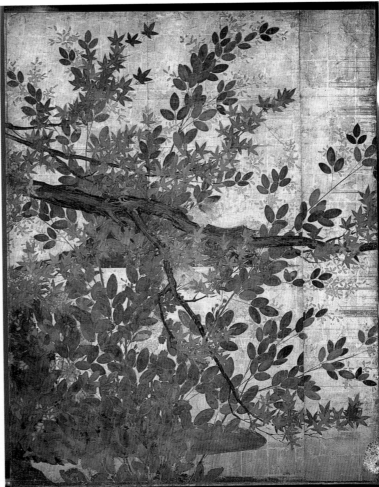

profusion of colors and diversity of flora, but with the distinctive admixture of exuberance and reflection evoked by autumn. The flowers below, fragrant olive, cockscomb, bush clover, and chrysanthemum, complement the coloristic array of high autumn created by the individual maple leaves, some still green, some already a rich crimson, and some a desiccated yellow. The rich multitude of flora in the maple composition provides an ideal inventory for this extraordinary tour-de-force demonstration of the artist's conceptual and painterly skills. The screen, with its massive trunk (85 cm across) and gnarled branches, set against a shimmering background of gold, clearly reveals Eitoku's influence in its preoccupation with dramatic visual impact and assertive brushwork, characteristics which at one time led scholars to attribute the work to either Eitoku or Sanraku. But Tōhaku's mastery of compositional balance is also apparent here in the harmonious mixture of strength and delicacy, the ingenious manner in which the bold, theatrical contours of the tree are so successfully combined with the elegant tapestry of precise detail and the luxuriant colors in the flowers and plants.

Another salient feature that distinguishes this work from that of any contemporary Kanō master is the realistic treatment of flora, and the pervasive sense of natural energy and life. Here, Tōhaku has drawn his inspiration from native Japanese Yamato-e and Tosa school pictorial traditions, such as the "autumn grasses" motif that was a favorite theme among craftsmen working in lacquer and metal work during the Momoyama period. On the other hand, the distinctive sense of abstract decorative design that becomes a hallmark of the school of Kōetsu and Sōtatsu (see cat. nos 64, 65, 74) in the following decades is already presaged here in Tōhaku's combination of natural motifs, set off against the rich, dynamic contrasts of gold leaf juxtaposed against the deep blue contours of the pond in the left-hand panels.

The Shōunji screens, done when Tōhaku was in his early fifties, are the representative works of his middle age. Kyūzō, his son who was instrumental in bringing the project to completion, died prematurely in the same year. Tōhaku lived for almost two more decades, creating one original expressive manner after another, primarily in inventive monochrome compositions rather than in the grand polychrome and gold style he had perfected at the Shōunji.

MLH

Cat. no. 54a. Detail of *Cherry Tree*, by Hasegawa Tōhaku or Hasegawa Kyūzō. Chishakuin, Kyoto.

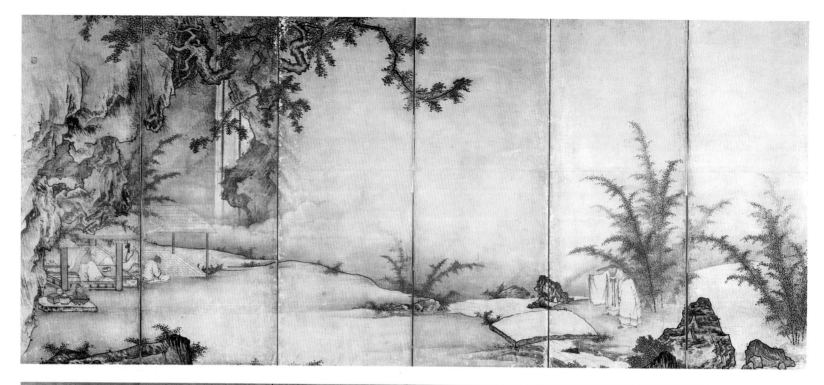

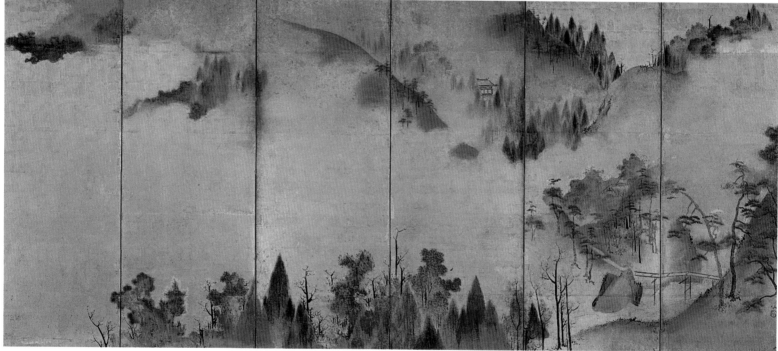

55. MOUNTAIN CHERRIES

Hasegawa Sōtaku (d.1611)
Early seventeenth century
Six-panel folding screen
Ink, colors, and gold on paper
153.1 x 347.2 cm
Private Collection

The soft pink and white blossoms of mountain cherries are barely visible now but once they enlivened this folding screen (*byōbu*), adding further brightness to the golden glow of the landscape. The second son of Hasegawa Tōhaku, Sōtaku studied painting under his father's direction and probably helped him on major commissions in the 1590s, such as the wall panel paintings for Shōunji and for the Zen subtemple Rinkain of Myōshinji, both projects in Kyoto. Few authenticated works by Sōtaku remain, of which figure paintings of the Chinese poets T'ao Yüan-ming and Li Po (Kitano Temmangū, Kyoto), *Autumn Grasses* (Nanzenji, Kyoto) and *Willows, Bridge and Waterwheels* (Gumma Prefectural Art Museum) are the best known examples (Wakizaka 1978, 165–76). These works indicate that Sōtaku closely followed the styles established by his father and older brother Kyūzō (1568–93), placing thick colors directly onto gold without bold ink outlines. Sōtaku may have contributed portions of the wall panel paintings now at the Sambōin,

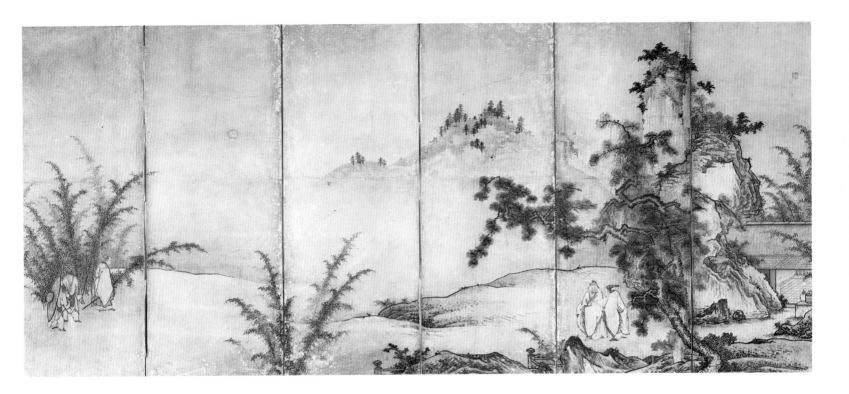

a subtemple of Daigoji south of Kyoto, for which Tōhaku and his workshop created a variety of landscape and bird-and-flower motifs. Although the Sambōin paintings are in poor condition now, aspects of the distant hills and towering trees seen in the *chūdan no ma* reception room resemble features in this screen, especially in the delicate brushwork on the trees.

This screen was originally the right half of a pair, with the trees at right serving to frame part of the composition. The expanses of gold-leaf between shapes is typical of early seventeenth-century spatial treatments, and resembles sections of the Rinkain landscape paintings completed by Tōhaku in 1599 or 1600 (Suntory 1982, 40–2). It also seems similar to the extensive use of flat gold areas in bird-and-flower paintings of the Sōtatsu school. Most of the pigment which colored the mountain cherry blossoms has flaked off, so that the brilliant color effects of the original composition are now rather subdued.

BAC

Reference: Doi 1977, 160–1; Mizuo 1972a, 22–3, 58–60 (on the Sambōin paintings).

56. SEVEN SAGES OF THE BAMBOO GROVE

Unkoku Tōgan (1547–1618)
Early seventeenth century
Pair of six-panel folding screens
Ink and light colors on paper
Each 156.1 x 365.4 cm
Eisei Bunko Foundation, Tokyo

The artist Tōgan depicts here a quintessentially Chinese theme using a strongly Chinese-style brushwork. *Seven Sages of the Bamboo Grove* recalls the many legends about scholar-bureaucrats in China retreating from their daily obligations of government service and the strict codes of Confucian conduct to relax and amuse themselves in the seclusion of a bamboo grove, seeking harmony with nature and discussing the ideas of Taoism. Such a generic topic is particularized here by imaginary portraits of seven friends who reportedly met regularly outside Lo-yang during the third century AD to escape the political conflicts of their time and to engage in conversations about philosophical issues. These gentlemen, and their loyal attendants, have sought solace in a garden setting, judging from the thatch-roofed pavilions and wooden balustrades that are tucked among the rocks and trees. The artist has created an idyllic landscape with fresh flowing water and dreamy distant views, and the sages seem quite comfortable discussing texts, playing chess, and debating the fine points of philosophy.

Tōgan's red seals are affixed to the outer edges of the two screens, and the panoramic quality of the composition suggests it is meant to be viewed as a whole, with gnarled trees and craggy rocks framing the outer edges of a unified scene. Dramatically articulated outlines

and strong tonal contrasts of ink are clearly derived from Tōgan's study of Sesshū's long handscroll of landscape views of China, which Tōgan copied about 1593. The painting style is deliberately Chinese to reinforce the refined continental origins of the painting's theme. Tōgan completed another work with the same subject in about 1595/6, a set of sliding-screen paintings (*fusuma-e*) for the Daitokuji subtemple Ōbaiin in Kyoto, but there the figures are nearly four feet tall and the settings are quite abbreviated. The exaggerated brushwork of the Ōbaiin panels also emphasizes the eccentric nature of the sages, whereas in these screens the quiet contemplative life seems to be celebrated.

BAC

Reference: Shimizu 1988, no. 119.

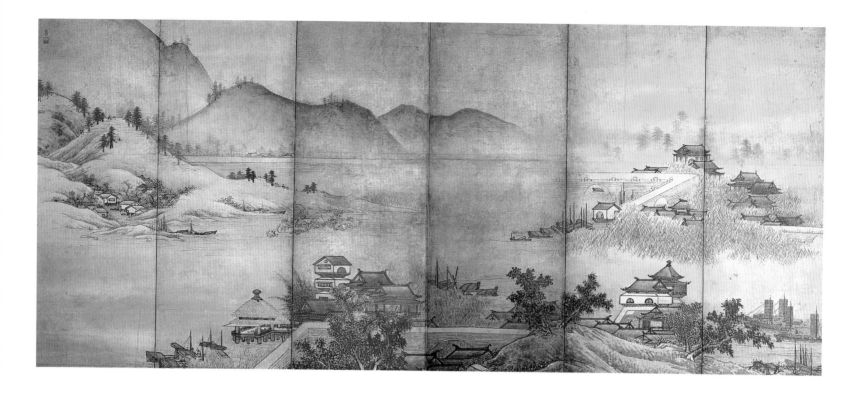

57. WEST LAKE

Attributed to Unkoku Tōgan (1547–1618)
Early seventeenth century
Pair of six-panel folding screens
Ink, light colors, and gold wash on paper
Each 152.7 x 349 cm
Kanazawa Nakamura Memorial Museum

These paintings imagine the mysterious landscape beauty of the famous West Lake at Hang-chou, in southeast China. While the West Lake's shores actually were edged with elaborate villas and extensive monastery compounds in the seventeenth century, the scenes shown here were entirely fabricated by the artist, who probably had not visited China. The arrangement of buildings seems quite fanciful, and the four-story pavilion at right defies structural logic. The hills surrounding the actual West Lake are low and rounded, like those in the left screen, but the towering island peaks in the right screen are wholly imaginary. The artist has created a peculiar pastiche that quotes and paraphrases sections of a handscroll painting by Sesshū Tōyō (1420–1506) who actually traveled to China in 1467/8. These screens also echo "West Lake" compositions by the noted Kanō Motonobu (1475–1559) and other Kanō artists, for the subject was extremely popular in Japan during the sixteenth and seventeenth centuries.

In these screens oversized pavilions are oddly juxtaposed with diminutive fishing boats, and reeds seem about to engulf the famous causeways that cross the West Lake. The layout of spatial relationships across the panels appears rather tentative and inconsistent, suggesting that these screens were not produced by Tōgan

himself but rather by members of his studio, using Tōgan's copy of the Sesshū handscroll. Because the brushwork seems to vary across the two screens, perhaps more than one painter was at work on this pair of screens. Some aspects of the brushwork seem similar to early works by Unkoku Tōeki (1591–1644), Tōgan's son who inherited his father's studio in 1618 and strove to create a distinctive Unkoku school style that would continue the Sesshū ink painting tradition into the seventeenth century and rival the Kanō school (Yamamoto 1993, 78–80).

BAC

58. PLUM TREES AND CROWS

Attributed to Unkoku Tōgan (1547–1618)
Early seventeenth century
Four sliding-screen panels
Ink and colors over gold on paper
Each 166.5 x 156.5 cm
Kyoto National Museum
Important Cultural Property

These spectacular sliding-screen paintings (*fusuma-e*), traditionally attributed to Tōgan, are thought to have been painted for the interior of Najima Castle in northern Kyushu (Najima is the former name of Fukuoka city). The castle

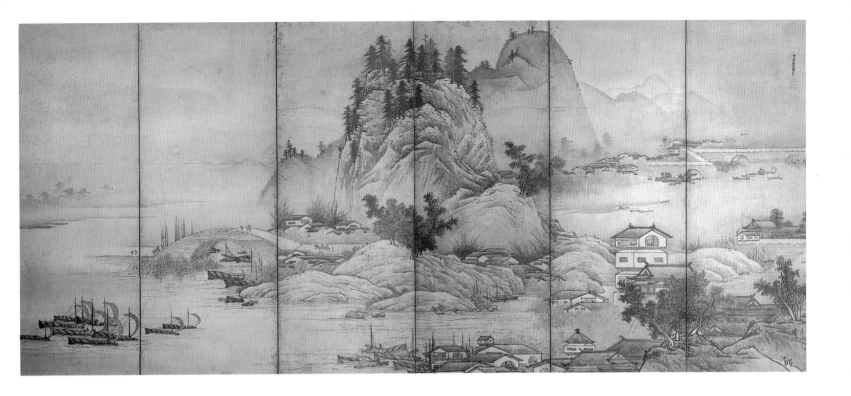

was erected in 1588/9 by Kobayakawa
Takakage (1533–97), a younger son of the
powerful daimyo Mōri Motonari (1497–1571),
who served as a close adviser to Hideyoshi and
led Mōri forces on several campaigns in support
of Toyotomi policies. In 1595 Takakage was
rewarded with appointment as one of the elders
(*tairō*) entrusted with the future of Hideyoshi's
two-year-old heir Hideyori. Takakage probably
was introduced to Tōgan by his nephew Mōri
Terumoto (1553–1625), the artist's primary
patron. Records indicate that before Takakage

died, he commissioned Tōgan to create *fusuma-e*
for the Ōbaiin, a subtemple of the Zen
monastery Daitokuji in Kyoto.

After Takakage's death in 1597, Najima
Castle was dismantled, and according to one
tradition, these gold-leafed panels which
decorated the grand hall (*ōhiroma*) of the
residential quarters were transferred to nearby
Fukuoka Castle by the Kuroda family.
However, no extant documents can prove that
Tōgan worked at Najima, or that any panel
paintings were removed to another site.

Recently-discovered sketches of Fukuoka Castle
suggest that perhaps *Plum Trees and Crows* may
have been initially commissioned for Fukuoka
Castle instead and might have been painted by
Tōgan's son Tōeki (Yamamoto 1993, 78–80).
This potential change in authorship does not,
however, alter the extraordinary visual splendor
of these panels.

Tōgan, who trained Tōeki, had studied
painting at the Kano workshop in Kyoto when
Eitoku was developing his monumental
brushwork style, using thick sweeping strokes to
define gnarled tree trunks and craggy rocks.
Tōgan's Ōbaiin *fusuma-e* were painted about
1588 and reflect this newly-developed style in
the bold outlines of *Seven Sages of the Bamboo
Grove* and the loose ink washes of *Geese and
Reeds*. Other large-scale bird-and-flower
paintings from this time period attributed to
Tōgan, such as the folding-screen painting
Mynah Birds in the Reeds (Ryūkōin, Daitokuji)
and panel paintings *Geese and Reeds* (Fumon'in,
Tōfukuji), have similar briskly brushed birds set
within abstract abbreviated settings, but none of
these have the forceful line quality of this work.

Tōgan's second son Tōeki, however, did
develop a more flamboyant brushstyle than his
father and some Japanese art historians credit
Tōeki with these extraordinary gold-leafed
panels. Tōeki was born in Hiroshima and raised
in Kyoto. His father carefully trained him in
Sesshū's style, and Tōfukuji has a faithful copy
by Tōeki of Sesshū's famous folding screens
Birds and Flowers of the Four Seasons.

BAC

References: Kawai 1978, 138–9; Takeda 1977, 160 ff.

59-60. Plum Tree; Pine Tree with Mynah Birds

Kaihō Yūshō (1533-1615)
Circa 1599
Four sliding-screen panels
(Two sets of panels remounted back to back)
Ink and gold wash on paper
Each panel 173.0 x 117.5 cm
Zenkyoan, Kenninji, Kyoto
Important Cultural Property

Painted around 1599, when he was sixty-six years of age, these panels are among Kaihō Yūshō's finest and most representative ink paintings. Originally they were part of a set of twelve sliding-screen panels representing bamboo, plum, and pine that covered three sides of the abbot's quarters in Zenkyōan, one of three subtemples of Kenninji for which Yūshō painted the interior decor. Bamboo, plum, and pine, a theme commonly known as "the three friends," was popular among Zen monks because of its association with the ideals of the Chinese scholar: the bamboo is flexible, the plum sends out fragrant blossoms, and the pine is strong. Like the scholar also, the three friends are all capable of withstanding the adversities of winter.

The original arrangement was conceived as a series of twelve panels read from right to left with the first four depicting bamboo and a small plum, the next four a larger plum, and the final four a venerable pine. When the panels were remounted, probably following damage due to a typhoon in 1934, "the three friends" were separated. Now, instead of reaching out to one another as if in conversation, the large plum and the pine stand back to back on the two sides of the same four panels (with the far left panel of the plum composition including the tip of a pine branch).

The composition is a study in contrasts: a slender plum with sharp sword-like shoots is juxtaposed with a massive pine with broad, feathery boughs. The plum is well rooted to the ground, while the lower trunk of the pine seems to float in mid air. Despite its massive bulk, it appears to be held in place only by the two mynah birds resting on its trunk. These oppositions extend also to the sweeping linear strokes used to delineate the plum and the coarser ones that suggest the contours of pine. The wide, largely unpainted area between the two trees, suggestive of mist or water, accentuates this expressive tension.

Yūshō's background and training are somewhat atypical of the Momoyama artist. The son of a retainer of the daimyo Asai Nagamasa (1545–73), as a child he was sent to study at Tōfukuji, a Kyoto Zen temple, where he later became a lay priest. According to the inscription on a portrait of Yūshō and his wife written by his grandson Yūchiku in 1724, Yūshō left the temple after his family had been annihilated in the fighting between the Asai and Nobunaga that culminated in Nagamasa's suicide in 1573. Most of his painting dates from this period onwards.

Yūshō was largely self-taught. His training seems to have consisted primarily in the personal study of Chinese paintings of the Sung and Yüan dynasties and of paintings by artists of the Kanō school, especially Eitoku. While Kanō influence is evident in Yūshō's compositional approach, his brush technique is more indebted to that of Chinese masters. The dramatic abbreviation of form and coarse brushwork of the pine are especially reminiscent of the style of Yü Chien, a thirteenth-century Ch'an priest-painter much admired in Japan, but the quick thrusting strokes of the plum are the hallmarks of Yūshō's personal style.

CG

References: Kawai 1978, fig. 1; Metropolitan 1975, no. 17; Takeda 1993, figs 4–5, 28.

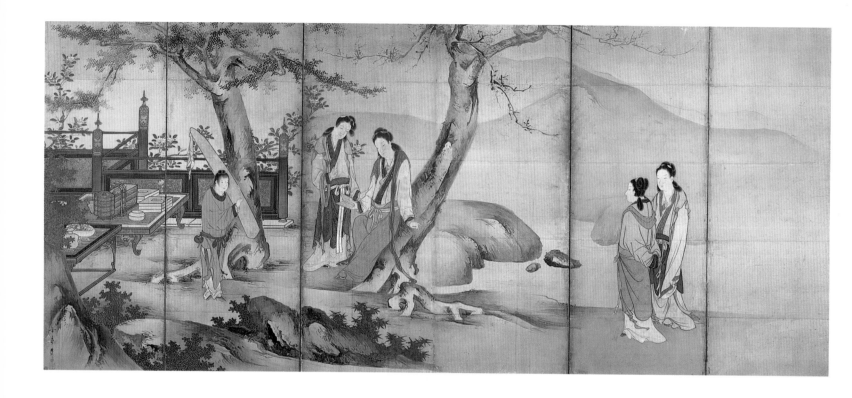

61. THE FOUR ACCOMPLISHMENTS

Kaihō Yūshō (1533–1615)
Early seventeenth century
Pair of six-panel folding screens
Ink, colors, and gold wash on paper
Each 153 x 355.4 cm
Tokyo National Museum
Important Cultural Property

One of the virtuoso ink painters of the
Momoyama era, Yūshō was also skilled in the
handling of mineral pigments and gold. This
pair of screens combines both techniques to
offer a novel interpretation of the four
accomplishments of calligraphy, painting, music,
and *go* (a board game). The prerequisites of the
Chinese scholar, whose appropriation conferred
their Japanese counterparts the mantle of cultural
legitimacy, the four accomplishments were a
popular motif in Momoyama painting.
Traditionally, such works featured dignified
scholar-gentlemen in an idyllic setting suggestive
of China. A set of sliding-screen paintings
Yūshō painted for Myōshinji typify the standard
interpretation of this theme. In this version,
however, the artist has playfully subverted the
tone of lofty erudition implicit in the *Four
Accomplishments* by substituting statuesque,
luxuriously attired Chinese court beauties. Their

appearance and movements give this
composition a languorous sensuality more
commonly associated with contemporary
paintings of Japanese courtesans.

Yūshō's pictorialization of the four
accomplishments is very loose. The art of
painting is represented by the trio viewing a
scroll on the right screen. The corner of a *go*
board on a red lacquer stand can be seen behind
the outcrop of rocks in the lower right corner.
Music is suggested by the brightly clad page
bearing a Chinese zither (*ch'in*) in its protective
covering on the left screen. Calligraphy is
implied by the voluptuous beauty leaning
against a tree, reading a folding book, as well as
by the books on the low table.

In keeping with a compositional approach
characteristic of many of Yūshō's screen
paintings, pictorial elements are concentrated in
the foreground of the two outside ends of the
screens, with the central panels left suggestively
open. This device not only gives the paired
screens stability but also imparts a sense of
atmospheric depth. The large-scale figures,
painted in bright mineral pigments, are skillfully
integrated into the landscape, which is rendered
in subtle tones of ink wash and line enhanced by
gold wash.

The subject and approach of Yūshō's *Four
Accomplishments* have much in common with a
recently discovered painting of *The Queen
Mother of the West and the Scholar Tung Fang-shuo*.
Attributed to Kanō Mitsunobu (1561–1608), it
also features a group of statuesque women in a
setting suggestive of a Chinese palace garden. As
Kuroda Taizō noted in a recent discussion of
this work, large scale figural compositions taking
Chinese women as their subject painted during
the Keichō era (1596–1615) may have provided
the impetus for the creation of paintings
featuring Japanese women of the pleasure
quarters such as became popular in the Kan'ei
era (1624–43). Yūshō's feminization of the four
accomplishments occupies an important place in
this development.

CG

References: Kawai 1978, fig. 10; Kuroda 1995; Takeda
1993, fig. 13; Tsuji 1991, fig. 57.

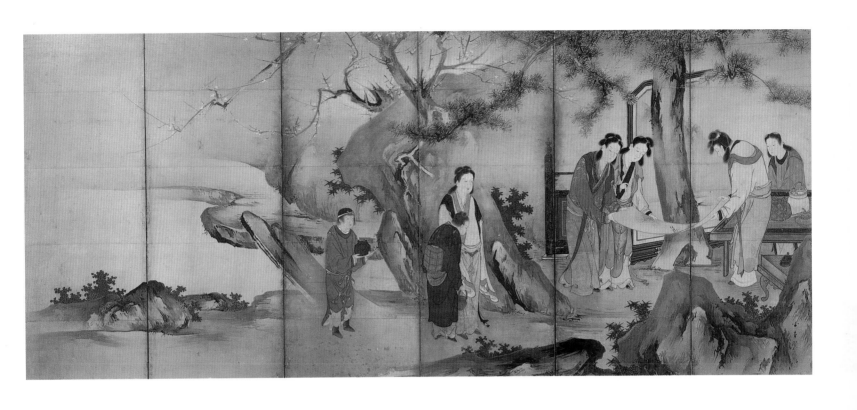

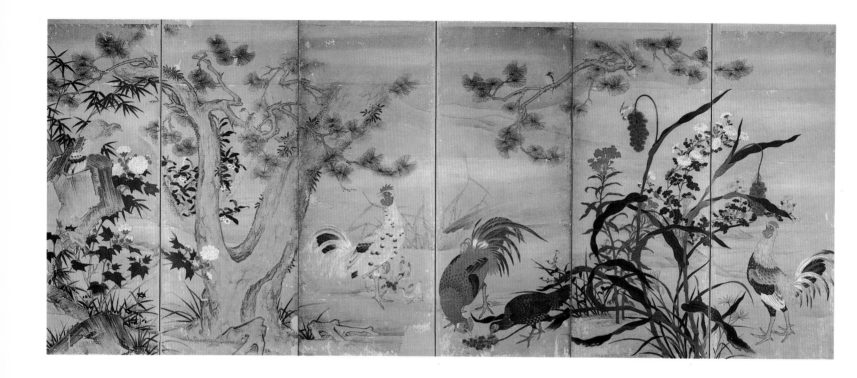

62. Birds and Flowers

Soga Chokuan (act. 1570–1610)
Late sixteenth century
Pair of six-panel folding screens
Ink and colors on paper
Each 160.1 x 389.2 cm
Hōkiin Temple Wakayama
Important Cultural Property

The depiction of roosters, hens and chicks has a long tradition in China and Japan. The thirteenth-century Ch'an (Zen) artist Lo Ch'uang, for example, painted *Rooster and Bamboo* in ink and pale colors, and inscribed the work with a brief verse alluding to the "Five Virtues" which are literary accomplishment, martial spirit, courage, virtue, and loyalty (Hickman and Satō 1989, 84). Such human qualities may be suggested here by the various birds. Seasonal changes are also represented, with the plum blossoms of spring, the irises of summer, the millet and chrysanthemums of autumn and the distant snowy peaks of winter.

This set of screens bears the red artist seals of Soga Chokuan, whose life is not well documented. He is known to have lived in Sakai (south of Osaka) and worked in the Kyoto-Nara-Osaka area from about 1596 through 1610. Reportedly his family were artists

for the Asakura clan in Echizen, north of Kyoto, and extant Chokuan works indicate he was familiar with various Kanō styles (Aichi 1979, 28–9, 111). He was noted for bird-and-flower paintings, particularly of roosters, hens, and hawks. Chokuan also produced votive tablets with horse paintings (*ema*), of which one at the Kitano Shrine is dated 1610. His son Nichokuan, who was active during the first half of the seventeenth century, is especially well-known as a painter of hawks. Among Chokuan's figural paintings are *Three Laughers of Tiger Ravine* and *Four Graybeards of Mount Shang*, a pair of screens belonging to the Henjōkōin, a subtemple on Mount Kōya near the Hōkiin where these painting are kept (Wakizaka 1980, 35–43).

While the overall subject and composition of these screens are clearly linked to Kanō paintings, like those of Kanō Shōei (see cat. no. 43), Chokuan has meticulously rendered these images in a very distinctive way. Feathers, in particular, are minutely drawn, with both attention to realistic depiction and concern for aesthetic patterns. Similarly the shapes and colors of the flowers and leaves suggest that, rather than relying on copy books, Chokuan carefully observed nature. The outlining and texturing of

trees and rocks appears fastidious when compared to Kanō Eitoku's bold brushstrokes (see cat. no. 44), but Chokuan's effect overall is one of delicate detail.

BAC

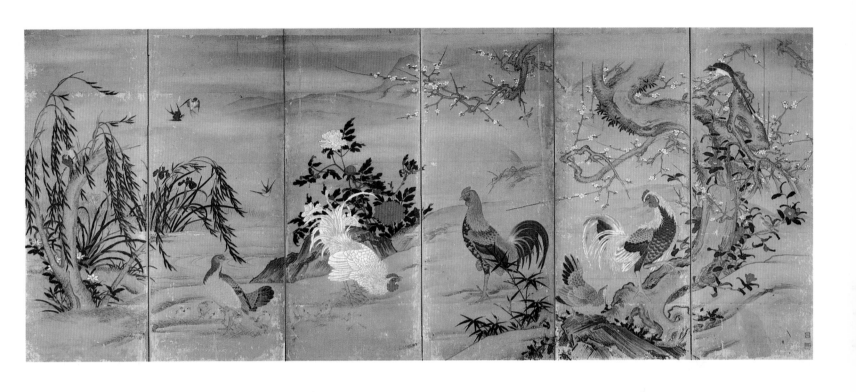

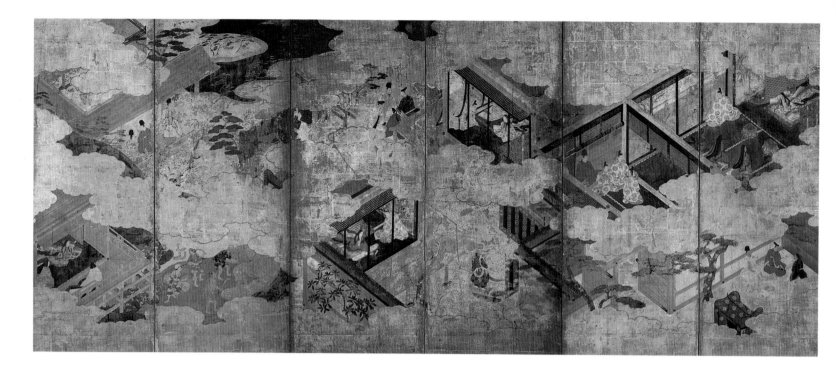

63. Scenes from *The Tale of Genji*

Attributed to Tosa Mitsuyoshi (1539–1613)
Late sixteenth century
Six-panel folding screen
Ink, colors, and gold leaf on paper
149.5 x 358.5 cm
Kyoto National Museum

Five memorable episodes from *The Tale of Genji* are randomly arranged across the six panels of this screen, once part of a set. Each is meticulously painted in bright mineral colors in the static, miniaturist style practiced by artists of the Tosa school. The composition is unified by the diagonal grids of the buildings, which are all viewed from an aerial perspective. Their interiors are visible because the roofs have been removed – a pictorial device developed by court painters of the Heian period widely employed by later artists. Also in keeping with time-honored technique are the bands of scalloped clouds, rendered in shimmering gold leaf. These frame individual vignettes and give the entire panorama a luxurious elegance consonant with its courtly subject.

The screen was painted at a time when there was renewed interest in *The Tale of Genji,* an eleventh-century literary classic written by Lady Murasaki that recounts the lives and loves of Prince Genji and his descendants. Familiarity with this work traditionally was limited to members of the aristocracy and military elite, but in the Momoyama period, newly printed editions of the text, often with illustrations by Tosa artists, were avidly read by wealthy and increasingly literate merchants as well. So popular was *The Tale of Genji* that it became a source of inspiration for textiles, ceramics, and lacquer (see cat. no. 120), as well as paintings.

Although the five episodes are not arranged in the order in which they occur in the story, all were probably immediately recognizable to the audience for whom the screen was painted. The earliest episode, in which Genji, while on an outing to a mountain temple, meets the young Murasaki, figures in the diagonally jutting structure in the lower left. Murasaki, identifiable by her short cropped hair and white singlet, is seated on the veranda with her back to the viewer. (Genji and his attendant, who spy on her through a wattled fence, are not shown.) The curving lines of a deserted beach and rustic dwelling above this evoke Suma, where Genji withdrew when his scandalous affairs forced him into exile from the capital. To the right of this is another rural scene. The angled *torii* (sacred gate), partially obscured by clouds, identifies it as the Nonomiya Shrine in the Saga district of Kyoto, where Genji visited his former lover, the jealous Lady Rokujō. A vast, multi-chambered palace occupying the four right-hand panels of the screen provides a continuous setting for two further episodes from Genji's life. In the lower center, Genji and the ailing Murasaki, now his wife, are seated before a garden where a ritual dance is being performed to bring about her recovery. On the far right court ladies are gathered for a picture competition organized by Genji to gain the favor of the impressionable young emperor for his young protégé Princess Akikonomu.

Although it bears neither signatures nor seals, the screen has been attributed on the basis of style to Tosa Mitsuyoshi, who helped to revive the fortunes of the Tosa school following the civil wars of the sixteenth century. The instability and chaos of this era reawakened Japan's sense of its own past – a past centered on the emperor and the court. Consequently, themes and styles long associated with the imperial painting atelier were eagerly embraced by many painters of the period. Painters of the Tosa school saw themselves as the legitimate heirs to this courtly tradition and took special pride in its faithful preservation.

CG

References: Metropolitan 1975, no. 24; Takeda 1976; Yamane 1979, fig. 99.

64. Screens Mounted with Fans

Attributed to Tawaraya Sōtatsu (act. 1600–40)
Early seventeenth century
Pair of two-panel folding screens
Gold foil on paper
Each 157 x 169 cm
Fans: ink and colors on paper (each 17.4 x 35.8 cm)
Sambōin, Daigoji, Kyoto
Important Cultural Property

Sōtatsu was exceptionally skilled in selecting striking pictorial motifs from traditional narrative handscrolls and adapting them in novel ways to suit a given format. The eleven fan paintings evenly arranged over the shimmering gold-leaf surface of this pair of screens exemplify the dramatic effects he achieved by cropping extraneous details, altering the scale and relationships of pictorial components, and rearranging motifs to echo the semi-circular shape of the fan. The vignettes here, ranging from figures and landscapes to farmhouses and animals, were adapted from unrelated narrative picture scrolls of the Kamakura and Muromachi periods. Each was chosen for its visual interest rather than narrative content. Five are from the *Tale of the Hōgen War,* a quasi-historic cycle of tales about the battles fought in the 1150s between the Taira and the Minamoto clans; three are from *The Tales of Ise,* a tenth-century

court classic about the poet Ariwara no Narihira; two from *The Miraculous Tales of Shikkongōjin*, a deity revered at Tōdaiji in Nara; and one from *The Poem on the Nine Stages*, also a work of Buddhist inspiration. This last work was the source of inspiration for the unusual scene of two dogs poised to attack depicted on the fan on the left panel of the right screen (above). In making what had been relatively minor scene in a larger composition the focal point of an independent design, the artist distorted and simplified the dogs, rocks, and wooden plank to echo the curvilinear contours of the fan.

Sōtatsu's inventive appropriation and transformation of the past operated on many levels. In addition to exploring classical themes, he also experimented in novel ways with the expressive possibilities of ink and color. The puddling effect, called *tarashikomi*, used to great effect in many of these fans, became a hallmark of the Sōtatsu style. The softly contoured figures and evocatively mottled landscapes created by using water-saturated ink and pigments, and wet on wet brushwork, were widely admired and emulated by artists of the Rimpa and other schools both during his lifetime and after.

The practice of mounting fans singly or in groups on hanging scrolls and screens developed in the Muromachi period, probably as an outgrowth of that of mounting *shikishigata* (squarish poem sheets) in that fashion. However, Sōtatsu's studio, the Tawaraya, which was celebrated in Kyoto for its fan paintings, may have furthered its popularity. In some instances, fans were pasted on screens in the atelier where they were painted, in others, the selection and arrangement was carried out by collectors and dealers at a later date. Small traces of gold leaf adhering to the seven fans with painted ribs here indicates that they were removed from another screen and subsequently remounted with four additional fans.

Little is known of Sōtatsu's life or background. One of the rare surviving documents by his hand, a letter of thanks to an acquaintance named Kaian for a gift of steamed bamboo shoots from Daigoji, has been taken as evidence that he had a special relationship with the temple, which is located in the eastern suburbs of Kyoto. This may account for Daigoji's ownership of three major works by Sōtatsu. In addition to the present screens, the temple owns a pair of screens depicting Bugaku dancers. Another pair representing the "Miotsukushi" and "Sekiya" episodes from *The Tale of Genji*, now in the Seikadō collection, was also formerly in Daigoji.

CG

References: Minamoto 1976, figs 12–16; Murase 1973; Yamane 1977, vols 1 and 2.

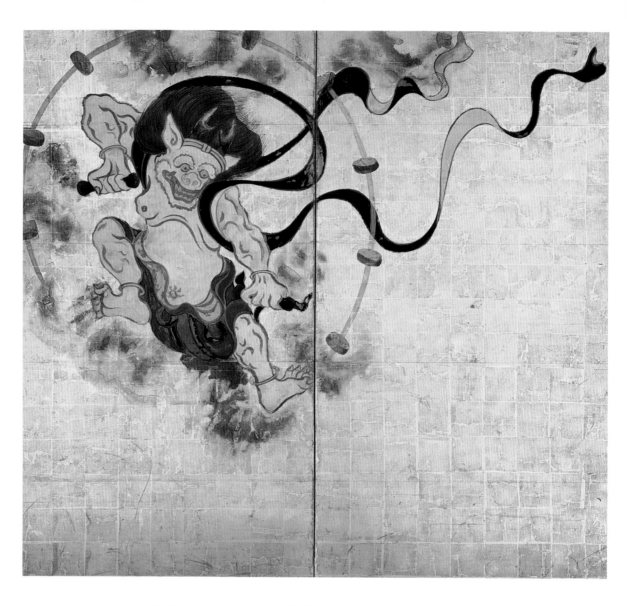

65. WIND AND THUNDER GODS

Tawaraya Sōtatsu (act. 1600–40)
Second quarter of the seventeenth century
Pair of two-panel folding screens
Ink and colors on gold foil
Each screen 169.8 x 154.5 cm
Kenninji, Kyoto
National Treasure

Few works compare with Sōtatsu's *Wind and Thunder Gods* in terms of drama, inventiveness, and expressive power. The Wind God (*Fūjin*), with his wind-filled sack ballooning over his head, his hair standing on end, and scarves flying, bursts into view on the right. Confronting him across a vast golden sky is the Thunder God (*Raijin*), framed by the ring of drums he uses to create the cacophonous thunderclaps that are his trademark. Balanced on his left foot, with his raised right and lowered left arms clasping thunderbolts, he casts his gaze downward, poised to strike at the unseen target of his fury.

The two gods are painted using thick mineral pigments, giving them a powerful sense of physical presence that is in sharp contrast to the translucent clouds that support them, which are rendered in thin washes of black ink. The solid curtain of gold foil provides the backdrop for this dynamic play of the gods, creating an aura that is both numinous and expansive. The confrontational placement of the deities on the outside panels of the paired screens enhances the illusion of spaciousness and by the same token invests the image with great dramatic tension.

The screens' precise source of inspiration is unknown, but the subject probably derives from the selection and creative recombination of motifs figuring in works of an earlier period. As the manifestation of the angry deified form of Sugawara no Michizane, the Thunder God is a key protagonist in the *Kitano Tenjin engi*, a narrative handscroll from which Sōtatsu drew inspiration for many fan paintings. Sōtatsu may have been familiar with the thirteenth century version of this scroll in Kyoto's Kitano Shrine or one of its many later copies, but works in which the two deities appear together are more likely sources. The Wind and Thunder Gods were occasionally represented in Buddhist paintings and in architectural ornaments as a kind of framing device, but the most celebrated, and no doubt familiar, example of their joint representation is a pair of thirteenth-century statues in Kyoto's Sanjūsangendō. So well-known was this temple's extraordinary array of more than one thousand statues of Kannon, among whose twenty-eight attendants the Wind and Thunder Gods figure, that even Jesuit missionaries commented on them. Theatrically poised as if ready to leap down from the billowing clouds that support them, these deities convey a sense of exhilarating, unfettered movement with few parallels among statuary of that period.

Like the Sanjūsangendō statues, Sōtatsu's *Wind and Thunder Gods* engage the spectator both psychologically and spatially. While they appear to be striding across the skies towards one another, they also acknowledge the presence of the viewer by their oblique downward movement. The scholar Mizuo Hiroshi has attributed Sōtatsu's use of diagonals radiating from a central point as the organizing compositional principle for this and other screen designs to his training as a fan painter. The

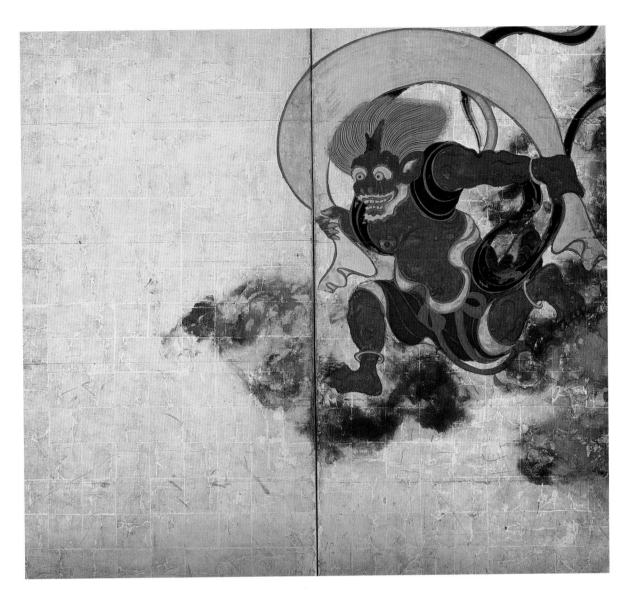

approach adopted here, however, also suggests the influence of religious paintings known as *raigō* in which the Buddha Amida and his host of attendant deities descend from the heavens to greet the deceased and transport him or her back to paradise. Like Amida *raigō*, the Wind and Thunder Gods are presented from an elevated point of view, and the narrative action bursts the boundaries of the picture surface, making the viewer the object of its action.

Sōtatsu's adoption of a two-panel folding screen is integral to the successful spatial manipulation of the two figures. Although this format was not unknown before the seventeenth century, Sōtatsu, who was exceptionally sensitive to the visual effects of various formats, seems to have found it particularly congenial. *Bugaku Dancers*, another of his representative works, was also painted on two-panel screens. Sōtatsu's innovative use of this format contributed to its popularity among later artists of the Rimpa school.

These screens are thought to have been painted during Sōtatsu's artistic maturity, when he was closely allied to the courtier Karasumaru Mitsuhiro (1579–1638). A disciple of Hosokawa Yūsai (see cat. no. 17) and well versed in art and literature, Mitsuhiro enabled Sōtatsu to study and copy many works of art from earlier periods thus expanding the artist's visual repertory. A copy of the *Saigyō monogatari emaki* (Picture Scroll of the Life of Saigyō) with illustrations by Sōtatsu and calligraphy by Mitsuhiro, dated 1630, testifies to the close relationship between the two men. Although the identity of the person who commissioned this work is unknown, patronage by such cultural sophisticates, meant that the artist could count on recognition of his subtle, multi-layered, and often witty allusions to the past.

CG

References: Grilli 1971, 82–92; Minamoto 1976, fig. 6; Mizuo 1972; Yamane 1977, vols 1 and 2.

Calligraphy

John T. Carpenter

In the hierarchy of East Asian cultural pursuits, calligraphy has always ranked high. Along with adopting Chinese as the written language for official and religious documents, the ancient Japanese court inherited the Chinese civilization's high regard for the art of brush writing. Calligraphy practice became an essential component of the upbringing of every young gentleman or lady of the court, and a practiced hand was considered a mark of culture and refinement. During the Heian period (794–1185), a distinctive Japanese writing system, *kana*, used to render the phonetic syllabary, gradually evolved along with its own set of aesthetic priorities. Members of the cultural elite transferred to *kana* calligraphy the same enthusiasm for stylistic experimentation and refinement that they had earlier reserved for Chinese characters. The diaries of aristocrats of the Heian period indicate the remarkable enthusiasm they had for exchanging poems and letters rendered in elegant calligraphy, prompting Arthur Waley to note that "it would scarcely be an exaggeration to say that the real religion of Heian was the cult of calligraphy."[1] Thus when one of the most innovative artists of the Momoyama period, Hon'ami Kōetsu, (1588–1637) the calligrapher of the *Crane Scroll* (cat. no. 74), sought inspiration for a new style of writing he looked back five hundred years to the masterpieces of Heian *kana* calligraphy.

Calligraphy in East Asian cultures is thought to have the potential to transcend mere attractiveness or legibility (though these remained the primary goals of an official scribe's work). From early on calligraphy acquired status as a means of artistic expression, as suggested by the eighth-century Chinese emperor who referred to calligraphy, along with poetry and painting, as one of the Three Perfections, the three supreme arts. Its important role in East Asian culture can in part be attributed to calligraphy's close relationship with the other arts. It shares with poetry a reliance on words as its

material – though the meaning or sound of words is of secondary importance to the calligrapher. With painting, calligraphy shares artistic tools, media, and formats; both are created with the same ink and brush, executed on paper or silk, and are commonly displayed on scrolls, screens, or in albums. Linear expression, a primary concern of the calligrapher's art, is similarly important to the ink painter, whose mastery of outline technique is an essential skill – a reminder that many painters study calligraphy as part of their artistic training. Painting and calligraphy sometimes appear together in the same composition, exhibiting varying degrees of literal correspondence or visual harmony. In the *Crane Scroll*, background image and energetic calligraphy effectively complement each other; in a screen with calligraphy by Konoe Nobutada (1565–1614), the painting of cypress trees is essential to the overall composition of the work as well as to the understanding of the poem (fig. 63).

Calligraphy, along with painting, flourished during the Momoyama period. Traditional styles of court calligraphy, elegant and highly conventionalized scripts that had evolved during the medieval period, gained wider acceptance not only among courtiers, but among samurai, merchants, and artisans as well. Zen priests continued to write bold, idiosyncratic calligraphy influenced by Chinese predecessors. The most important legacy of the era, however, was the revival and reinterpretation of early court styles by members of the cultural elite. This trend is reflected primarily by the highly refined and dynamic scripts of Nobutada and Kōetsu, who found inspiration in the flowing scripts of the Heian period. Yet it is also represented, on the other extreme, by the enthusiastic reception of the plain, ingenuous, and markedly brusque calligraphy style of Fujiwara no Teika (1162–1241) preferred by many tea adepts – reflected here in a scroll of poems by Shōkadō Shōjō, which includes two poems in the Teika style (cat. no. 77).

A full appreciation of the art of Japanese calligraphy requires at least a rudimentary ability to distinguish between the forms of different characters, and is further aided by a familiarity with the

Fig. 60 Tiger, calligraphy by Emperor Go-Yōzei, detail from cat. no. 69.

standard corpus of masterpieces of Chinese and Japanese calligraphy. Oftentimes the beauty or the significance of a work of calligraphy lies in the way that it evokes the spirit of a great calligrapher of the past, in much the same way that Japanese court poetry frequently makes subtle allusion to works of a long-established poetic canon. Still, many examples of calligraphy have much to offer even to the untutored eye. An immediately accessible expression of energy or excitement can be seen in the boldly splashed strokes of Go-Yōzei's "Dragon and Tiger" (detail, fig. 60) for example. A sense of understated but graceful movement or stately procession is conveyed by the examples of imperial calligraphy (cat. nos 68, 70, 71). A meticulously executed sutra text, lacking any suggestion of personal interpretation, projects a feeling of an orderly universe – solace during troubled times (cat. no. 73). Other works do not immediately betray their aesthetic virtues, but once their authorship or provenance has been determined, pique our curiosity for their links to famous political, cultural, or religious figures of the past – serving as mandalas of sorts into which one can read various historical and spiritual associations.

For the interested novice, knowledge of a few rudiments of East Asian writing will enhance one's appreciation of calligraphy. First, calligraphy is usually read in columns from top to bottom and from right to left, but this is not an inviolable rule. It is not unusual to find inscriptions on portraits written in columns that have to be read left to right (e.g., cat. nos 1, 4, 5, 17); the native reader of the time would have been able to make the shift instantaneously. Still the lay reader should remember that East Asian readers were once so accustomed to reading texts from right to left, that paintings too, whether in scroll or screen format, were customarily read in the same direction: the progression of the four seasons will always move from the right; the action in a illustrated handscroll may not make sense if "read" in the reverse direction, as seen for instance in the *Crane Scroll*.

Next, Japanese calligraphers had the option of using either *kanji* (Chinese characters) or *kana* (Japanese phonetic syllabary), or a combination of both, depending on the nature of the text. Even after the Japanese phonetic syllabary became standardized around the tenth century, Chinese remained the preferred language for business, administrative, and scholarly writing. Documents by military scribes (cat. nos 66, 67), court scribes (cat. no. 72), and religious texts (cat. no. 73) were invariably written in Chinese. Also, all of the inscriptions on commemorative portraits in the opening section of this volume were written entirely in Chinese characters, often in a combination of prose and verse. An inscription in Chinese carried with it a cachet of authority, dignity, and propriety.

Chinese characters may be written in a variety of different scripts distinguished by the level of cursiveness and abbreviation. The three basic types encountered in the manuscripts that follow may be broadly classified as standard (*kai*), semicursive (*gyō*), and cursive (*sō*). Excerpts from a poem inscription by Emperor Go-Yōzei offers a useful guide to identifying the varieties of different writing systems and scripts (fig. 61). The same Chinese character *haru*, "spring" is found both at the top of the far right column (where it forms part of the headnote) as well as at the top of the far left column. In the first instance the character is written in a highly legible semicursive script, with only a few of its individual strokes

connected; in its second appearance, where it is harmoniously integrated into the poem, written primarily in *kana*, it is inscribed in fully cursive script.

While *kana* were originally based on highly cursive forms of Chinese characters, by the ninth century it had evolved as a distinct writing system with its own set of aesthetic priorities. Yet, *kana* texts are not always easy to decipher, even for those who read Japanese, since many of the characters differ from the ones in use in modern-day Japan. *Kana* are often written in variant forms, and each phoneme can be represented by any one of three, four, or sometimes more variations. Only at the end of the nineteenth century did publishers adopt standardized *kana* forms. Moreover, a highly stylized or idiosyncratic calligraphic style may sacrifice legibility to beauty. "Anyone who has been asked to read an inscription on a painting or even the text of a printed book of the seventeenth century," Donald Keene has wistfully observed, "will know to what extraordinary extremes of non-communication this love of beauty carried Japanese writing."[2]

CALLIGRAPHY AND TEA

One of the important factors in the development of calligraphy during the Momoyama period was its central role in the tea ceremony. First of all, tea gatherings provided the opportunity to view rare works of calligraphy of the past. Fragments of ancient handscrolls, prized for both their poetry and their calligraphy, known as *kohitsu gire* (fragments of ancient calligraphy), were often displayed in tea alcoves. Also the Momoyama period witnessed the beginning of the custom of compiling albums of specimens of calligraphy of past masters, which were called *tekagami*, "mirrors of the hand." While we may flinch when we hear tales of lovely scrolls being cut up to become tea hangings or to provide the snippets required for some connoisseur's scrapbook, this procedure of dissecting works of art allowed the dissemination to a wider audience of excellent examples of calligraphy that had previously been jealously guarded by courtiers. Just as tea ceremony fostered the growth of calligraphy connoisseurship in Japan, many ancient and fragile works of Heian calligraphy owe their very survival (though sometimes in a dismembered state) to their treasured status as *chagake*, "tea hangings."

Fig. 61 Details of a New Year's Poem, by Emperor Go-Yōzei, cat. no. 70.

Throughout the evolution of the tea ceremony, two kinds of hanging scrolls were used in parallel; calligraphy written by Zen priests, collectively referred to as *bokuseki*, "ink traces," which were prized for their spiritual and didactic qualities; and *uta gire*, "poem fragments," which harked back to courtly ideals. As a rule, tea masters would carefully consider seasonal allusions in a poem scroll or painting before deciding on modes of display in the tearoom.

More than any other single master, it was Sen no Rikyū (1522–91) who help to shape the codes of the tea ceremony (see p. 205). In Rikyū's designs for the tearoom, the focal point was the *tokonoma*, where flower arrangements or hanging scrolls were displayed. One of the primary early writings on the tea ceremony, *Nampōroku* (The Records of Nampō), compiled by one of Rikyū's pupils and rediscovered in the late seventeenth century, records the tea master's teachings on various subjects. Rikyū is reputed to have said of calligraphy: "There is no 'utensil' more important than the hanging scroll, for it allows the host and guests to immerse themselves in the spirit of the tea ceremony. By revering the spirit of its words, one can appreciate the virtue of the person who wrote it." This passage, the locus classicus on the use of scrolls in the tea ceremony, helped to reinforce the practice of using calligraphy by Zen masters or famous cultural figures rather than paintings.

Rikyū himself owned a number of *bokuseki* by famous Zen masters of the medieval times. On rare occasions Rikyū also used calligraphy by living priests, such as Kokei Sōchin (1532–97) who, though ten years his junior, was his Zen master and personal confidant for nearly thirty years. Sōchin's dry, acerbic calligraphic style is suggested by his inscription on the portrait of Oda Nobunaga (cat. no. 1). While a eulogy for a memorial portrait was not an occasion for a priest to attempt a more dramatic calligraphic statement, the handwriting still reveals a sturdy simplicity that reflects Zen values.

Records reveal that Furuta Oribe (1543–1615), one of Rikyū's successors, commonly displayed works of calligraphy by living priests or prominent cultural figures. Although it had been the convention to display a calligraphy scroll during the first sitting of a gathering and flowers during the second, Oribe often used both calligraphy and flowers in the first sitting and removed the flowers for the second. Just as Oribe had a predilection for misshapened tewares (see cat. no. 89), so also he used unorthodox, often illegible, calligraphy which was in no way considered distracting to the mood of the tea gathering.

Kobori Enshū (1579–1647), the noted designer of teahouses and gardens who in his youth had studied with Furuta Oribe, also emphasized the role of calligraphy in the tea ceremony. According to surviving records of his tea gatherings, he nearly always displayed calligraphy, occasionally using precious examples of the work of Fujiwara no Teika, poet and editor of Japanese literary classics. Enshū himself was an assiduous practitioner of Teika-style calligraphy and owned a rare early manuscript copy of a short treatise on calligraphy by Teika, whose calligraphy was thought to manifest unaffected refinement (*kirei sabi*), the aesthetic ideal promoted by Enshū. Its squat, slightly abrupt and distorted lines appealed to Enshū in the same way as did teaware molded in dynamic, expressive and irregular forms. Yet Enshū retained an awareness of courtly sentiment not found in Oribe's outright iconoclasm. A scroll of Japanese and Chinese poems – some calligraphed in the distinctive style of Teika – by the tea master

Fig. 62 Inscription by Shun'oku Sōen. Detail of *Portrait of Sen no Rikyū*, cat. no. 5.

Shōkadō Shōjō shows an indebtedness to the Teika influence, no doubt through the mediation of Enshū (see cat. no. 77).

Although court calligraphy enjoyed a revival during the early seventeenth century, *bokuseki* (which were always written in classical Chinese) never fell out of fashion. Enshū frequently used examples of calligraphy by his own Zen master, Shun'oku Sōen (1529–1611), as did other tea practitioners who studied Zen at Daitokuji. Sōen's calligraphy is admirably represented here by the inscription on the portrait of Sen no Rikyū (cat. no. 5; detail fig. 62). The brushwork of the inscription, which reads from left to right, is forceful and unpretentious in the spirit of Zen, but still manages to intimate a sense of refinement appropriate for a eulogy of a great tea master. Several of the characters in the first three columns which comprise the poem (on the far left) are executed with long dagger-like final vertical strokes. In the first column these strokes form an imaginary axis upon which the entire column is sturdily balanced. To prevent the inscription from having an overly static appearance, several characters have flaring diagonal strokes, that break the bounds of the columns, without however upsetting the overall balance of the composition.

One-line sayings (*ichigyō mono* or *ichigyō sho*) written by Zen priests in bold, oversize characters were another variety of *bokuseki* that became especially popular beginning in the early seventeenth century. Not only were *ichigyō mono* by living priests readily available, but the large size of the characters also made them easier to read in the dimly lit tearooms. Their brevity made them easier to decipher than the long, often obscure, inscriptions on earlier *bokuseki* by Chinese or Japanese masters, which were often written in diminutive Chinese characters. The pair of scrolls inscribed by Emperor Go-Yōzei – reading "Dragon and Tiger" and "Plum and Bamboo" – are created in the format of an *ichigyōmono*, and reflect the imperial calligrapher's deep affinity for Zen aesthetics.

Since Rikyū's time there has been a steady decline in the emphasis placed on the didactic message of *bokuseki* and a parallel increase in the attention given to its expressive aspects, especially

Fig. 63 *Poem and Cypress Trees*, calligraphy by Konoe Nobutada, painting attributed to Hasegawa Tōhaku. Six-panel screen, ca 1600–10. Zenrinji, Kyoto.

since brushwork was thought to express in subtle ways the spiritual enlightenment of the writer: for instance, splattered ink may be taken to suggest will power, and "flying-white" to suggest spontaneity. Out of this belief also emerged the practice of using pages from the journals or letters of eminent tea masters as tea scrolls, even though these were not originally conceived as calligraphic compositions.

THE THREE BRUSHES OF KAN'EI

Tea gatherings were also frequently the setting for the enjoyment of poem scrolls and *shikishi* (poem cards) of the variety created by Kōetsu, calligrapher of the *Crane Scroll*. Kōetsu studied the etiquette of tea ceremony with Oribe and was in regular contact with members of the warrior-class tea practitioners. Though born to a family of sword specialists who had served Ashikaga shoguns and various warlords, Kōetsu's tastes were more closely attuned to courtly sensibilities. He was representative of members of the cultured elite of the capital during the Momoyama period who encouraged a revival of traditional aristocratic aesthetics in painting and calligraphy (cat. no. 74).

Kōetsu as a youth no doubt had access to a variety of models of orthodox court calligraphy, and in his late thirties is said to have received training under the tutelage of Prince Sonchō, abbot of the Shōren'in, which was both a temple and calligraphy training center for court calligraphers (see cat. no. 68). We may assume that Kōetsu's primary motive in visiting the Shōren'in was to have access to ancient examples of Japanese and Chinese calligraphy preserved there. These models could be used in various ways, either slavishly copied (as beginners were encouraged to do), or used as the basis for a free reinterpretation in an individual style (as was the wont of a talented calligrapher of Kōetsu's status).

The *Zoku kinsei kijinden* (Extraordinary People of Early Modern Times, Continued), records a conversation between the courtier-calligrapher Nobutada and Kōetsu:

Konoe Nobutada (Sammyakuin) asked Kōetsu, "Who do you consider the greatest calligraphers in the realm? Kōetsu replied, "Putting aside the question of who is number one,

you, Nobutada, are the second. The third is the priest from Hachiman (Shōkadō Shōjō)." Then Sammyakuin pressed Kōetsu, asking, "Who, then, is the best?" Kōetsu simply said, "Most humbly, it is myself."[3]

This quotation may be the original inspiration of the term *Kan'ei sampitsu*, or "The Three [Great] Brushes of the Kan'ei [Period]," which during the nineteenth century came to be widely used to refer to Kōetsu, Nobutada, and the priest-painter Shōkado Shōjō (see cat. no. 77), three of the foremost calligraphers of the early seventeenth century, all of whom were active long before the beginning of the Kan'ei period (1624–44). The term seems particularly anachronistic in the case of Nobutada, who died in 1614, a decade before the Kan'ei period began. Yet, it serves as a reminder that although the stylistic innovations of each of the three were shaped during the Momoyama period, both Kōetsu (d. 1637) and Shōjō (d. 1639) were active through the 1630s.

Among Nobutada's masterpieces is a six-panel screen that includes a *waka* poem – energetically inscribed in oversized *kana* – surrounding a sensitively brushed ink painting of a cypress grove. Recent scholarship has attributed the painting to Hasegawa Tōhaku, based on a stylistic comparison to the brushwork and artistic expression of his famous *Pines in Mist* (fig. 56).[4] On an immediate visual level, even without a translation of the text, it can be seen that the calligraphy and painting of this screen work together nicely in an attractive unified composition. A sense of spatial recession is suggested through the careful modulation of the light and dark ink tones and the effective use of empty space. The close proximity of the painting to the calligraphy may also serve as a reminder that the similar modulation of ink tones used by Japanese calligraphers – especially prevalent in works of *kana* calligraphy – was a highly desirable aesthetic effect. If we view calligraphy as painting, the varying tones of ink, created as the brush is re-inked and allowed to go dry, create a similar illusion of perspective. Similarly, the function of empty space in a composition is just as important as the inscribed shapes.

A further dimension of text-image interrelationship in this screen composition is revealed by attempting to read the text. It turns out that certain crucial words are missing from the poem, which

Fig. 64. Detail of a scroll of poems commemorating Emperor Go-Yōzei's visit to the Jurakutei Palace, calligraphy by Karasumaru Mitsuhiro. Early seventeenth century. Kyoto National Museum.

derives from the *Shinkokinshū* (no. 966), an imperially commissioned *waka* anthology of the early thirteenth century. The following transcription reflects the actual lineation of the poem as calligraphed on the screen; the words from the poem in brackets are missing in Nobutada's rendition:

hatsuseyama
yūkoe
kurete yado to- Evening descends
eba As we cross Mount Hatsuse.
[Miwa no hibara ni] When we inquire about lodgings,
akikaze Autumn winds gust
zo [Through the cypresses of Miwa].
fuku

The reader will immediately realize that calligrapher and artist collaborated to create a clever rebus of sorts: the painting of cypresses is meant to compensate for the missing words. This technique of creating poems partially inscribed in kana and partially in pictures was also often used to interesting effect in lacquer designs.

Though not numbered among the traditional Three Brushes of Kan'ei, the high-ranking courtier Karasumaru Mitsuhiro (1579–1638) may be granted honorary status as the "Fourth Brush" of Kan'ei. Active in the same tea circles as many of the figures mentioned above, he was best known for his cursive *kana* calligraphy. Having studied *waka* under Hosokawa Yūsai (see cat. no. 17), he also established a lasting reputation as a poet. The style of his calligraphy, like Kōetsu's, harkens back to classical court models, but at the same time partakes of a Zen-inspired eccentricity. He was among the most radical stylists of the era and it is said that some of his contemporaries even complained they sometimes could not decipher his poetry inscriptions..

The example illustrated (fig.64) here is a section from a scroll of poems recording the *waka* composed during a poetry gathering during the famous visit of Emperor Go-Yōzei to Hideyoshi's Jurakutei mansion in the fourth month of 1588 (see pp. 36–8 and cat. no. 25). Mitsuhiro's calligraphic rendition of the poems, probably created a decade or two after the event, is based on a transcript made by an official scribe. Even to the untutored eye, it is possible to detect in the ebullient brushwork a wide array of calligraphic special effects, from dryly brushed strokes to characters rendered with a brush so moist that ink seeps into the surrounding paper – a desirable effect as long as it was not overdone. In stunning contrast to the dynamically brushed dry strokes, certain places reveal strands of *kana* connected by ligatures so fine and elegant it is hard to imagine they were inscribed with the same brush.

The scroll opens with two scratchy characters announcing the subject of the poems to follow: *gyō-kō*, "Imperial Procession." The next column of Chinese characters records the name of the author of the first *waka* praising the imperial visit: *kampaku* Toyotomi Hideyoshi, referring to the military leader by his court title, meaning imperial regent. While the historical circumstances behind the creation of the scroll may invite rumination on the irony of a warlord hosting a poetry party for an emperor, Mitsuhiro's calligraphy presents an equally remarkable set of stylistic juxtapositions. This impressive array of brushwork ranges from the extravagance of a bold individual style to subdued brushwork executed according to the dictates of courtly convention – reflecting we might say the contradictory aesthetic tendencies of the entire era.

NOTES:

1. Waley 1949, 13.
2. Keene 1976, 122.
3. Translation from Mizuo 1983, 39.
4. Tokyo National Musuem 1991, no. 196.

FURTHER READING

Shen Fu, Glenn D. Lowry, and Ann Yonemura, *From Concept to Context: Approaches to Asian and Islamic Calligraphy* (Washington, D.C.: Freer Gallery of Art, 1986).

Yujiro Nakata, *The Art of Japanese Calligraphy*, (New York: Weatherhill/Heibonsha, 1973).

John M. Rosenfield, and Fumiko and Edwin A. Cranston, *The Courtly Tradition in Japanese Art and Literature* (Cambridge: Harvard University/Fogg Art Museum, 1973).

Yoshiaki Shimizu and John M. Rosenfield, *Masters of Japanese Calligraphy: 8th–19th Century* (New York: The Asia Society Galleries and Japan House Gallery, 1984).

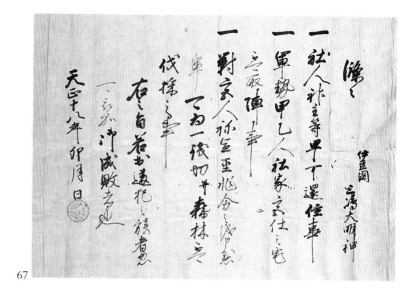

66 67

66. PROHIBITIONS

Seal of Toyotomi Hideyoshi
Dated 1589
Ink on paper; 46 x 66 cm
Mishima Taisha, Shizuoka Prefecture
Important Cultural Property

67. ORDINANCES

Seal of Toyotomi Hideyoshi
Dated 1590
Ink on paper; 46 x 66 cm
Mishima Taisha, Shizuoka Prefecture
Important Cultural Property

A distinctive characteristic of Hideyoshi's policy-making process was his reliance on personal correspondence. Rather than making universal pronouncements, policy was often created on a case-by-case basis. Hideyoshi's propensity for letter writing is suggested by the survival of over one-hundred letters written in his own hand – surely only a fraction of what he actually wrote. Among the most interesting are those of a personal nature, including a number addressed to his wife and mother.

The overwhelming majority of the surviving letters and documents bearing Hideyoshi's signature or seal, however, were inscribed by one of the warlord's personal scribes. Extant documents of this variety number in the hundreds. If the letter or document required the warlord's personal stamp of authority, Hideyoshi added his own handwritten *kaō* (personal cipher), a form of highly stylized signature (see cat. no. 112a). Other documents of purely administrative nature were simply impressed with Hideyoshi's official seal, such as the two examples illustrated here. Still it is reasonable to assume that Hideyoshi personally approved all documents that bear his seal. The legend on the round vermilion seal reads *Ryū*, or "Dragon" – selected no doubt for its evocation of power. Sealed documents of this variety – generically called *shuinjō*, "vermilion-seal documents" –

symbolize Hideyoshi's method of government by written proclamation.

These two documents are written entirely in *hentai kambun* (a Japanized version of classical Chinese), using unembellished official language common to official documents earlier produced by the Ashikaga shogunate. While the documents do not bear the name of the scribe, both the language and handwriting style closely resemble that found on similar documents drafted during the age of Nobunaga. In fact, one of Nobunaga's scribes later served under Hideyoshi, which may help to account for the overlap in both content and calligraphic conventions used in documents issued under the seal of the respective warlords.

Continuing a policy established by Nobunaga, Hideyoshi sought to reassure members of the court, as well as temple and shrine officials that troops would not seize buildings or pillage surrounding forests and farmland. To this end, Hideyoshi issued documents bearing his seal that could be posted publicly at shrines and temples. The lists of prohibitions here issued on behalf of Mishma Shrine in Izu, are directed primarily at military

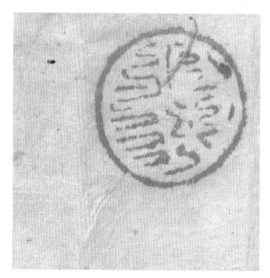

troops. They date to a crucial period in Hideyoshi's career, 1589 to 1590, when the Toyotomi clan was on the verge of bringing the entire country under their control. Documents of nearly identical wording that are preserved in other temples and shrines suggest that such pillaging of provincial temples and shrines by vagabond troops was widespread. The first document reads:

Prohibitions:
Presented to the Great Shrine [of Mishima]
Item: Acts of violence or disturbances by military troops, whomever they may be.
Item: Setting fires.
Item: Improper treatment of commoners or farmers.
Anyone found in violation of any of the above mentioned items will be summarily prosecuted.
Twelfth Month of Tenshō 17 (1589)
[Hideyoshi's vermilion seal]

The second document, dated a year later, indicates that shrine buildings had been taken over as barracks. It reads:

Ordinances:
Presented to Mishima Daimyōjin Shrine, Izu Province
Item: Head priests and shrine personnel may return to their residences.
Item: Military troops, whoever they might be, should not seize the houses of temple priests or shrine officials for use as barracks.
Item: There should be no improper treatment of shrine officials, priests or priestesses. Confiscation of estates of the deceased or the cutting down of trees in the forests is prohibited.
Anyone found in violation of the above ordinances, will be summarily prosecuted.
Fourth month of Tenshō 18 (1590)
[Hideyoshi's vermilion seal]

JTC

References:Berry 1982, 101–2; Berry 1983, 67–9; Sugiyama 1990, 348–55.

68. Poems by Fujiwara no Teika

Calligraphy by Prince Sonchō (1552-97)
Dated 1584
Handscroll; ink on paper
33.1 x 480 cm
Kyoto National Museum

In contrast to the brusque, somewhat perfunctorily brushed Chinese characters of the official documents of the previous two entries, these gently flowing strands reflect the refinement and graceful beauty attainable by Japanese court calligraphy. Almost entirely written in *kana*, with a small interspersing of Chinese characters in cursive script, the reader may follow the movements of the calligrapher's brush as it moved down each column, sometimes rapidly, and at other times slowing to write certain characters with thicker strokes. Each of the thirty-one-syllable *waka* (court verses) is contrived to fill out two columns. As a rule the brush was re-inked at the beginning of a new poem (thus the first character of each poem is set off by denser ink); the second column of each poem is slightly indented from the top. In between the two columns of a single *waka*, near the bottom, one or two *kana* characters are squeezed into the margin to provide a further calligraphic link between the two parts of the verse.

The calligrapher Prince Sonchō was the head of the Shōren'in lineage during the era of Nobunaga and Hideyoshi, a time when palace and temples were at the mercy of warlords. At age eleven, Sonchō, adopted son of Emperor Ōgimachi, took Buddhist vows, shaved his head, and began the life of a monk at Shōren'in, a subtemple of the Enryakuji – the vast temple complex on Mount Hiei in the northeastern outskirts of Kyoto. Shōren'in had also served, since the fourteenth century, as the primary training center for aristocracy, which meant that during his teens Sonchō received traditional training in court calligraphy styles.

During Nobunaga's reign of terror against the Buddhist clergy, which resulted in the destruction of the Enryakuji Temple complex in 1571, Sonchō took refuge at Danzan Shrine in the Nara area. A few years later, Sonchō returned to the capital and assumed responsibilities as abbot of Shōren'in and directed the reconstruction of its buildings. Throughout his priestly career, Prince Sonchō also devoted himself to calligraphy studies, and authored several tracts on the subject.

Among the pupils who came to receive instruction at the Shōren'in during 1590s, while Sonchō was still the head of the temple

and calligraphy academy, were Hon'ami Kōetsu, the calligrapher of *The Crane Scroll* (cat. no. 74) and Shōkadō Shōjō, who transcribed the scroll of Japanese and Chinese poems described in the last entry of this section. Even a cursory comparison of their respective works reveals that neither Kōetsu or Shōkadō felt compelled to adhere to Shōren'in conventions (though at least Shōkadō had mastered them). Both calligraphers, rather, returned to an earlier, more innovative stage of court calligraphy for their inspiration.

The poems on this scroll appear to be a random selection of *waka* poems by the eminent courtier-poet Fujiwara no Teika (1162–1241), taken from his *Shūi gusō* (Meager Gleanings), compiled in 1216 by the poet himself. The anthology was no doubt intended by Teika to serve as a guide to his descendants in the principles of poetic composition. Sonchō's transcription opens with clusters of poems on themes of the four seasons, and concludes with individual poems on selected poetic topics.

JTC

Reference: Shimizu and Rosenfield 1984, 81, nos 30–2.

69. "DRAGON AND TIGER" "PLUM AND BAMBOO"

Calligraphy by Emperor Go-Yōzei (1571–1617)
Early seventeenth century
Pair of hanging scrolls; ink on paper
Each 125.0 x 51.4 cm
Hōkongōin, Kyoto
Important Art Object

Each hanging scroll is inscribed with a pair of powerfully brushed Chinese characters: "Dragon and Tiger" (ryū ko) on the right, and "Plum and Bamboo" (bai chiku) on the left. Our interpretation of the characters, each of which bears multiple symbolic associations in East Asian art and literature, is affected by the knowledge that the calligrapher is Emperor Go-Yōzei (see cat. no. 18). According to Chinese cosmology, the dragon rules the skies, the tiger controls the earth; together they symbolize the orderly administration of the entire universe. Dragon and tiger motifs were commonly found in imperial robes and regalia in both China and Japan. More specifically, the dragon and tiger symbolized the relationship of the emperor to his ministers.

In an interesting calligraphic flourish, Go-Yōzei rendered the final stroke of "Tiger" (the lower character of the right scroll) to suggest a long tiger's tail. While Chinese characters do not usually lend themselves to such pictographic appropriation, here we may suppose the calligrapher could not resist the obvious.

Plum and bamboo are also among the most cherished of East Asian literary and artistic themes. Together with the pine, they are traditionally referred to as the "Three Gentleman" of Chinese painting. In this context, however, we may suppose the plum was selected for its symbolic connotations of virtue and endurance. It was considered a hardy tree because it blooms early in spring. Bamboo represents endurance through flexibility, a trait considered essential to a good ruler. Bamboo is also commonly associated with tigers. The vertical strokes of the character for bamboo – the lower one on the left scroll – are rendered with great force, making an almost abstract image with clear pictographic origins.

The use of "flying-white" technique – created by extremely rapid movement of a slightly dry brush – contrasts effectively with the splattering of ink created at places where a re-inked brush slapped the paper. The bold energy of the calligrapher's original brush movements is conveyed to readers of later generations. Go-Yōzei's calligraphy in this mode recalls his deep affinity for Zen calligraphy, which is also often inscribed in oversize characters in a similar bold, expressive mode.

There also survives a shikishi poem card inscribed by the Emperor Go-Yōzei, remounted as a hanging scroll that includes the same four characters (Komatsu 1982, no. 28).

JTC

References: Koresawa 1978, no. 30.

70. NEW YEAR'S POEM

Calligraphy by Emperor Go-Yōzei (1571–1617)
Early seventeenth century
Hanging scroll; ink on paper
37.9 x 51.8 cm
Kyoto National Museum

In contrast to Emperor Go-Yōzei's boldly brushed, oversized Chinese characters of the previous entry, here we see a waka, or thirty-one-syllable Japanese verse, executed in diminutive kana script. Comparing the two examples, we can see how one person can work in a array of different calligraphic styles. The first two columns on the right, inscribed in semicursive Chinese characters, form an abbreviated headnote, "A waka composed on a spring day, on the lovely color of plum blossoms." The next four strands of characters – almost entirely in kana – comprise the poem proper. Although waka is composed in five lines of 5-7-5-7-7 syllables respectively, calligraphers felt no compunction to adhere to these prosodic constraints when transcribing a poem. In fact, as a rule the calligrapher avoided logical divisions of lines and words. Rather, the characters were usually set out according to a seemingly random arrangement of columns – called chirashigaki, or "scattered writing." By the late medieval period many of the favorite arrangements of chirashigaki had become convention.

For instance, the present poem is inscribed in one of the most popular formats used for this variety of wakagaishi, or kaishi ("breast paper" carried folded in one's robes) inscribed with waka. Here the compositional scheme is called sangyō sanji, or "three columns and three characters," referring to the calligrapher's contrivance to create three full-length columns of writing, and leave only three characters for the fourth column. Such an arrangement lent a sense of balance to the wakagaishi as a self-contained calligraphic composition. In this work, the Emperor Go-Yōzei represented the four syllables of harukaze (spring breeze) by writing haru in a single Chinese character and kaze with two kana. The word nioi (fragrance) is split between columns. Here the line division of the romanization reflects the actual divisions of the vertical columns:

tagui naki iro koso
arame ume no hana nio-
i mo komoru chiyo no
harukaze

In lovely colors
Without peer,
The fragrance of plum blossoms
Fills the spring winds
For a thousand ages.

The poem uses conventional spring imagery to suggest that all is well in the imperial realm, destined to last for "a thousand ages." The symbolic associations of plum blossoms were discussed in the previous entry.

JTC

189

71. New Year's Poem

Calligraphy by Emperor Go-Mizunoo (1596–1680)
Circa late 1620s to early 1630s
Hanging scroll; ink on paper
29.2 x. 42.8 cm
Shōgoin, Kyoto

These lonely strands of unassuming *kana* calligraphy on undecorated paper in a simple silk mounting bely the imperial status of the calligrapher. Emperor Go-Mizunoo (also pronounced Go-Minoo; 1596–1680), was the third son of Go-Yōzei, and in 1611 he ascended the throne as Japan's one-hundred and eighth sovereign.

The two Chinese characters inscribed to the right of the poem indicate that it was composed as a *shigō*, the first poem one writes during the New Year season. It was common to write poems of this variety during the *kakizome* "first writing" ceremony held on second day of the year. This *wakagaishi* is inscribed in two long columns with a short strand of kana tucked in between – broadly resembling the format used by Prince Sonchō in his transcription of Teika's poems (cat. no. 68). The romanization of the poem reflects the division of columns in the original:

kono haru ni semete odoroku mi
 tomo kana
haji ōshi chō inochi nagasa o

Now spring has come,
What an unexpected place
I find myself in.
Though dishonor hangs heavy
May I be granted long life.

In contrast to the celebratory tenor of most New Year's poem Emperor Go-Mizunoo's composition is cast in a melancholy tone. Unfortunately the poem is not dated, nor do we know the exact circumstances under which it was written, but it may be speculated that it was written sometime shortly before or after his abdication in 1629. *Haji* (dishonor or shame) is a most unusual topic for a court verse.

It is interesting to compare this *shigō* (first poem of the year) to a *shigō* composed in 1624 by the noted Rinzai Zen priest Takuan Sōhō (1573-1645), which includes two poems extolling the throne (in the Richard and Peggy Danziger collection, New York). Takuan's poems have a similar tone of resignation. Keeping in mind Takuan's long-standing support of Emperor Go-Mizunoo, we may speculate that their respective poems were written in response to the same state of affairs that affected both imperial and religious institutions during the 1620s.

In 1620, Go-Mizunoo had taken as his empress the daughter of the second shogun, Hidetada – a reminder that by this time the

Tokugawa clan was already firmly establishing itself as the real power behind the throne. While his father-in-law consolidated his power, Go-Mizunoo watched the power of the imperial family erode away. Hidetada had issued ordinances that placed restrictions on the emperor and aristocracy. In 1627 Takuan and other Zen priests protested when the shogun cancelled a number of imperial appointments – the so-called Purple Robe Incident. By 1629, Go-Mizunoo felt powerless and transferred the imperial regalia to Hidetada's granddaughter, who ascended the throne to become Empress Meishō.

Although Go-Mizunoo continued to play a role in matters of state as a retired emperor, his primary interests were cultural. He was an ardent student of the Japanese classics, accomplished poet, and expert in flower arrangement. He is perhaps best remembered for building the Shūgakuin Detached Palace with its lovely strolling gardens, in the northeastern outskirts of Kyoto. After his death, his remains were interred at Sennyūji, the imperial mortuary temple. Sennyūji is also the repository for many important imperial calligraphies, including the eulogy Go-Mizunoo had written for his mother, described in the following entry.

JTC

References: Shimizu and Rosengfield 1984, no.58.

72. EULOGY FOR EMPRESS CHŪKAMON'IN

Calligraphy by official court scribe
Signed by Emperor Go-Mizunoo
Dated 1636
Handscroll; ink on decorated paper
44.2 x 168.0 cm
Sennyūji, Kyoto

The handscroll includes the text of a eulogy delivered during the memorial service held on the seventh anniversary of the death of Chūkamon'in (1575–1630), empress of Emperor Go-Yōzei and mother of Emperor Go-Mizunoo. Before marrying into the imperial family she was known as Konoe Sakiko, the younger sister of the noted courtier-calligrapher Konoe Nobutada (1565-1614). Sakiko acquired a reputation as a talented calligrapher in her own right. She studied the orthodox court style of the Shōren'in school, and copied models previously used by her husband, Emperor Go-Yōzei, but also left behind a number of letters revealing a bold, dramatic individual style (Iijima 1975, 498).

The memorial services for the empress were conducted at Sennyūji, a temple in the Higashiyama district of Kyoto, that since the twelfth century had served as the imperial mortuary temple and where the remains of many members of the imperial family are interred (see cat. no. 20). The eulogy was transcribed at the behest of Emperor Go-Mizunoo, who placed his signature in the colophon, which is dated the third day of the seventh month of Kan'ei 13 (1636). The two large characters near the bottom of the last (far left) column read "Kotohito," Go-Mizunoo's given name (see detail). The text of the eulogy, rendered in classical Chinese prose with great rhetorical flourish, is written in the first person (but probably drafted by a court scholar). The emperor states that "though years have passed, I can never forget the tender care of my beloved mother . . . Gentle by nature, noble in bearing, she was regarded by all as a model of decorum."

The text was transcribed by an official court scribe. Although the scribe may have been a high-ranking courtier, it was not customary for a scribe to include his name on a document prepared for the emperor. The main text, arranged in twenty-five columns of thirteen or fourteen characters, is inscribed in slightly cursivized standard script. The handwriting does not betray the mark of an individual style, nor does it try to impress. Legibility and attractiveness were the goals of the court scribe, not personal expression. The fine-grained *torinoko* (yellowish-brown "chicken egg") paper is decorated with dense clusters of small flakes of gold and silver, and filaments of silver leaf. The silver has oxidized over the years, giving the document a more subdued tone, which seems more in keeping with its somber associations.

JTC

191

73. THE *LOTUS SUTRA*

Early seventeenth century
One handscroll; gold pigment on dyed paper
Height 29.2
Osaka Aoyama Junior College

Since ancient times, sutras were often copied by nobles as a spiritual exercise and as a means of acquiring religious merit. For those not up to the time-consuming task, commissioning others to copy sutras was also considered to bring merit to the sponsor. This tradition can be traced back to the official entry of Buddhism into Japan during the sixth century, when members of the imperial family and the court diligently carried out the study, recitation, and copying of sutras.

This impressive example from an original set of eight scrolls of the Lotus Sutra, commissioned by Empress Tōfukumon'in (1607–78), follows in that tradition. Tōfukumon'in, daughter of the second Tokugawa shogun, Hidetada, was betrothed to Emperor Go-Mizunoo – a demonstration of how the Tokugawa shoguns wished to consolidate their control of court affairs through marriage politics. Tōfukumon'in, a major patron of the arts, is also thought to have donated the exquisite Sanraku paintings of peonies and plums to Daikakuji (cat. nos 51–2).

Buddhist sutras – originally written in Pali or Sanskrit – had been translated into Chinese over the course of centuries, and through the early medieval period Japanese Buddhism relied on the labor-intensive practice of *shakyō* (sutra copying) to provide texts for the ever-growing number of temples. Printed versions of sutras were already being used on a widespread basis in China by the tenth century, and a printed version of the entire Buddhist canon was available in 983. But in Japan hand-copying remained the preferred and primary means of reproducing texts until well into the medieval period, due both to the relatively late acceptance of printing technology, and partly to a well-entrenched belief in the religious merit associated with the manual copying of sutras.

During ancient times, both professional sutra copyists and aristocrats (male and female) copied sutras in the same special variety of standard script called "sutra script form" (*shakyō-tai*), which was an eminently legible though slightly-flattened script based on Sui (ca 581–618) and T'ang (618–ca 907) models. Each stroke was executed rapidly, but distinctly and firmly. By the end of the Nara period, however, a softer more rounded style had gradually evolved that anticipated the development of the so-called *wayō* (Japanese-style) calligraphy later to emerge in the tenth century. The present example harkens back to the variety of decorated sutras produced during the tenth and eleventh centuries.

Sutras were usually written in columns of seventeen characters, following conventions that were established in China during the Six Dynasties period. Decorated sutras (*sōshoku kyō*) are often mistakenly imagined to begin with the tenth century, but already in the eighth century aristocratic patrons sometimes commissioned texts to be inscribed in gold or silver on paper dyed indigo or deep purple. Inscribing sutras on blue or purple paper with gold or silver characters remained a standard practice through the centuries, as demonstrated by the present example. Sutras commissioned by wealthy patrons were often accompanied by frontispiece illustrations, rendered in gold or silver line drawings, connected to the message of the sutra with varying degrees of literalness, or depicting Buddhist deities.

The popularity of the Lotus Sutra as a text for copying is partly due to the teachings of the sutra itself, which promises merit and reward to those who copy the text or have it copied or who treat it with veneration. This reverence for the text as sacred object, reflective of the general respect for the written word and for calligraphy throughout Japanese history, motivated the artisans who so assiduously worked on decorated papers, mountings, and frontispiece illustrations for sutra texts, with care not unlike that lavished by medieval Christian monks and nuns on illuminated gospels and psalters.

The reliance on the Lotus Sutra as a means to acquire salvation is demonstrated by the frequent appearance on memorial portraits of the phrase *Namu myōhō renge kyō*, "Hail to the Sutra of the Lotus of the True Law." Such inscriptions are commonly referred to as *hige daimoku*, literally, "mustached invocations," because the characters are inscribed in a bold calligraphic style, with final strokes of most of the characters flaring outward to the right and left resembling mustaches (see cat. no. 14; figs 54, 55). These ubiquitously reproduced inscriptions are said to be based on a version inscribed by Priest Nichiren (1222–82), the founder of a sect of Buddhism that advocated faith in the teachings of the Lotus Sutra as a means to salvation.

In dramatic contrast to the forceful handwriting of Nichiren or the writings of Zen monks and nuns whose brushstrokes were thought to reflect their spiritual attainments, sutra copyists were compelled to follow convention and avoid individual interpretation. All the same, the use of a boldly inscribed standard script lent an aura of unwavering truth and authority to these sacred texts. Amid a large corpus of surviving sutra manuscripts executed in a routine and sometimes slipshod fashion, examples such as the one illustrated here are prized for their strength of brushwork and unpretentious dignity. A Western viewer unfamiliar with the conventions of East Asian calligraphy may appreciate the regular sutra scripts as similar to medieval gothic and italic scripts in their aesthetic of uniformity, their harmonious spacing between words and letters, and the proportion and balance within each letter.

JTC

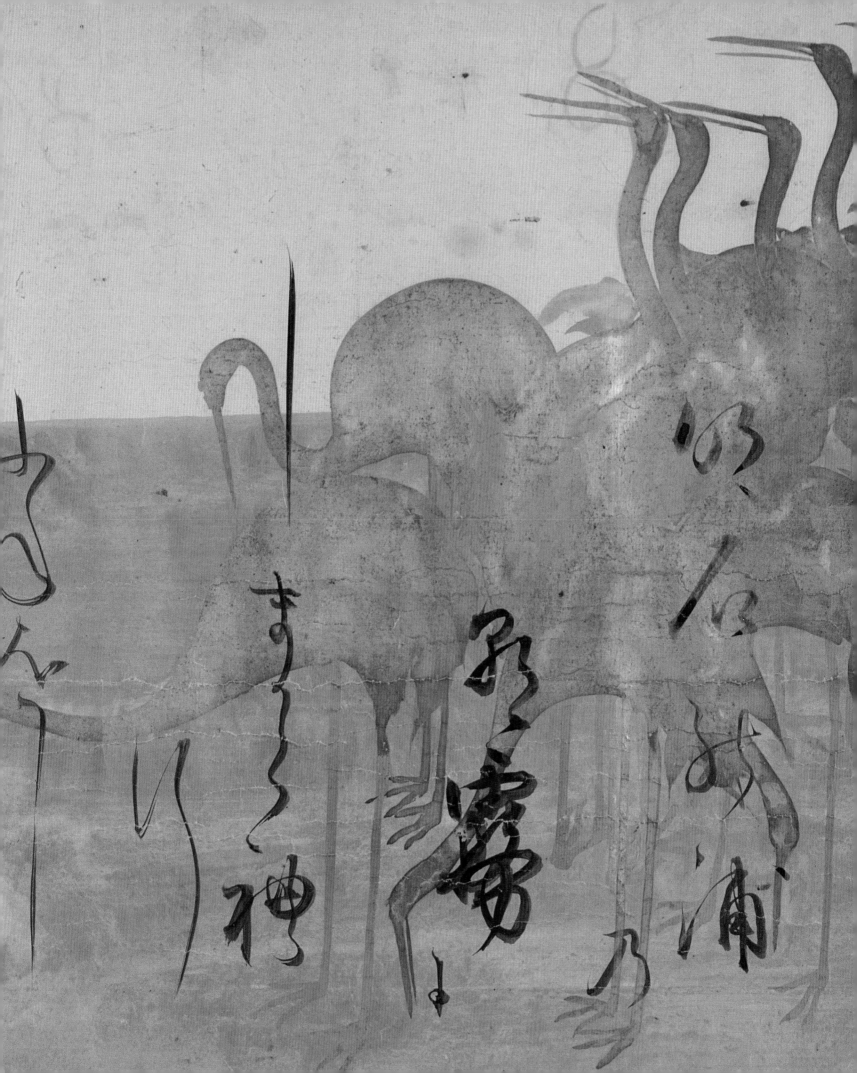

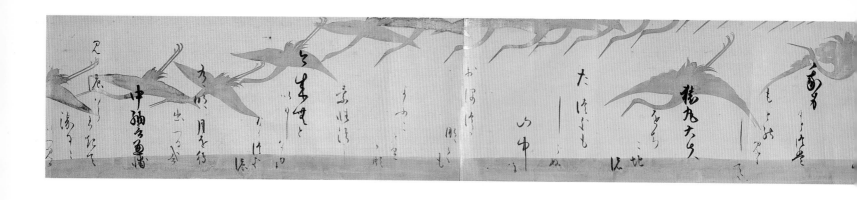

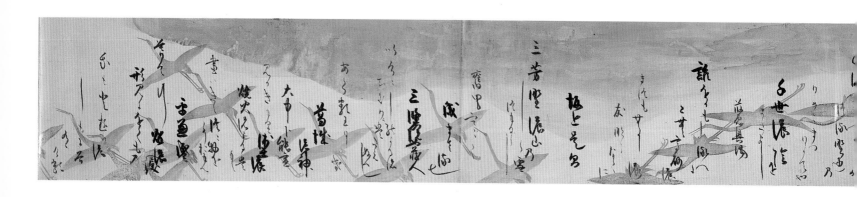

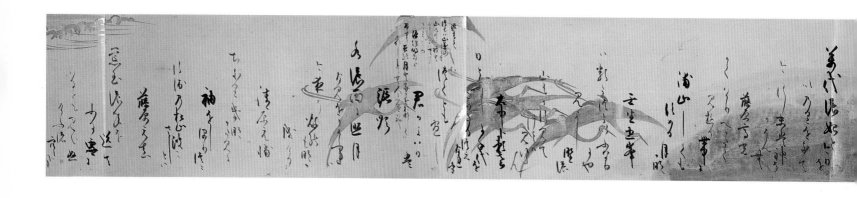

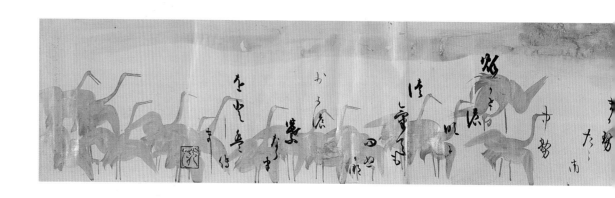

74. THE CRANE SCROLL

Calligraphy by Hon'ami Kōetsu (1558–1637)
Underpainting attributed to Tawaraya Sōtatsu (d. ca1643)
Circa 1605–15
Handscroll; ink, silver and gold pigments on paper
34.1 x 1356.0 cm
Kyoto National Museum
Important Cultural Property

A flock of elegant silver cranes takes wing from a golden shore. In their migration across the scroll, they glide through clouds of gold, sometimes in graceful formation, other times frolicking in playful dances. The lavish gold and silver underpainting, attributed to Tawaraya Sōtatsu, captures the eye first, however it was not intended to be viewed as a self-sustaining composition, but rather as a background to highlight the darkly inked strokes created by the calligrapher's brush. Boldly inscribed by Hon'ami Kōetsu in his distinctive calligraphic style, the texts include famous court verses, one by each the Thirty-six Immortal Poets – famous poets of ancient Japan. The poems are not related to cranes in any direct fashion, though we may suppose that the crane motif was selected for its general poetic and auspicious connotations.

The scroll, almost fifteen meters long, was designed to be viewed section by section: as one cluster of poems was read or recited the viewer would roll up the scroll and then unfurl the next. The columns of characters, primarily *kana* with a harmonious admixture of *kanji*, vary greatly in length and are randomly spaced – not so much in deference to or in perfect harmony with the underpainting of cranes but rather according to their own rhythm – the vertical columns often working in effective syncopation with the horizontal leitmotif of cranes. To make sure all of the poems fit into the allotted space, the calligrapher compressed columns in the middle sections of the scroll, and brushed some of the poems with markedly smaller characters.

As mentioned in the Introduction, Kōetsu was the scion of a family of sword specialists, who cleaned, polished and appraised swords for many of the prominent military families of the age. The connoisseur's eye he developed for the elegant perfection of well-made blades and sword furnishings informed his highly refined aesthetic code, which embraced a simplicity of statement, boldness of expression, and perfection of technique. He applied these principles not only as a calligrapher, but as a ceramicist who created understated Raku tea bowls (cat. no. 83), and as an influential innovator in lacquer inlay (cat. no. 120).

There is no seal or signature to identify the artist of the underpainting as Sōtatsu, but the attribution is based on evidence of close collaboration between Kōetsu and Sōtatsu in the creation of similar poem scrolls and *shikishi* (poem cards) during the first decade or so of the seventeenth century. Sōtatsu's individual accomplishments as a painter are admirably represented in this volume by the dramatic pair of screens *Wind and Thunder Gods* (cat. no. 65).

Sōtatsu assimilated the prevailing aesthetic tendencies of Momoyama painting and decorative techniques, but reinterpreted them in radical new ways. While Kanō painters often used gold backgrounds in screen paintings created for warlord patrons to suggest an aura of overbearing authority, this is not a sentiment felt in Sōtatsu's works. Although Sōtatsu no doubt created many of his works for a wealthy merchant clientele, he did not use gold as a crass symbol of the ostentation of the nouveau riche. Nor did he employ it in merely to achieve decorative motifs. For Sōtatsu, gold embraced a wholesome brightness, an all-encompassing sense of well-being and abundance. Dispensing with the bold outlines characteristic of Kanō bird-and-flower painting, Sōtatsu created the abstract forms of cranes here without outline (and in fact without any detectable underdrawing). In contrast to the statically posed birds of Kanō landscapes, the artist creates a sense of progression and rhythmical movement.

Though a number of poem scrolls of this variety were created by Kōetsu and his followers, most were subsequently cut into smaller sections (usually comprising only one or two poems) and remounted as hanging scrolls suitable for display in an alcove. This scroll, which only came to light in the early 1960s and fortuitously remains intact, offers a special opportunity to view a Kōetsu poem scroll as it was originally conceived. Kōetsu's famous *Deer Scroll*, to which this work is stylistically related, includes underpainting of a herd of deer rendered entirely in gold and silver. The *Deer Scroll* remained complete until 1935, when it was divided into sections; Seattle Art Museum eventually acquired the intact second half.

The *Deer Scroll* bears the artist's "Tokuyūsai" signature and round vermilion "I'nen" seal, which was used by the Sōtatsu studio. The *Crane Scroll*, while unsigned, is impressed with a square black seal reading "Kōetsu," and a seal reading "Kamishi Sōji," which is generally thought to be the name of the papermaker who supplied Kōetsu and Sōtatsu with the fine paper used for many of their collaborative projects. While various scholars have attempted to establish a strict chronological framework for these Kōetsu-Sōtatsu collaborations on the basis of stylistic analysis of the calligraphy or painting, much remains in the realm of conjecture due to the dearth of dated works by either artist. There is general consensus however that these poetry scrolls were probably created prior to Kōetsu's move to Takagamine in 1615, probably around 1610, when the two artists seem to have been working very closely.

JTC

References: Day 1990; Mizuo 1983; Seattle Art Museum 1987, 170-3 (on the *Deer Scroll*); Yamane 1962; Yamane 1978.

75. SAGABON EDITION OF *ESSAYS IN IDLENESS*

Published by Suminokura Soan (1571–1632)
First decade of the seventeenth century
Volume one of two bound volumes
Ink on lightly colored paper with mica-printed designs
27.5 x 21.0 cm
Osaka Aoyama Junior College

76. SAGABON EDITION OF *TALES OF ISE*

Published by Suminokura Soan (1571–1632)
Dated 1608
Two bound volumes
27.1 x 19.4
Osaka Aoyama Junior College

At first glance it may be hard to tell that these volumes were printed with movable wooden type. The connected characters appear to be written with a brush, but close examination reveals that no more than two or three *kana* characters are connected. Also there is a uniformity to the ink tone that would be impossible to achieve with the writing brush.

In comparison with China, the use of printing in Japan was relatively delayed. Presses of the variety used to create the volumes illustrated here were first used in Japan during the 1590s, having been brought back to Japan after Hideyoshi's invasions of Korea. Also, Jesuit missionaries had begun printing books using wooden type, and between 1591 and 1610 some fifty books in Latin, Portuguese, and Japanese were published. These publications were primarily Christian religious tracts or language texts, with a selection of Western and Japanese literary works. *Aesop's Fables* was among the first Western books published in Japanese.

The publisher of these deluxe editions of the Japanese classics was Suminokura Soan, son of Ryōi, whose portrait sculpture is described above (cat. no. 19). The Suminokura family was representative of the emerging *machishū* (wealthy merchant) class who became the major patrons of the tea ceremony and related arts in the capital during the early seventeenth century. The family was licensed by the government to operate trading ships that made ports-of-call in Tonkin (North Vietnam). The peak of their trading activities lasted from 1603 to 1611, which roughly corresponds to the period when the Sagabon editions were being published.

Soan was an avid student of literature and generous patron of the arts. He commissioned works by Hon'ami Kōetsu, and apparently also studied calligraphy under his tutelage. Soan's enthusiasm and discretionary income allowed him to set up a press in the Saga district, in the western outskirts of the capital, that produced deluxe editions of Japanese classics and librettos of Noh plays (the latter had sumptuous printed covers, made in conjunction with the Sōtatsu studio). Sagabon, the name by which these volumes are usually called, literally means "Saga editions." While it is customary to describe the calligraphy of these works as being in the Kōetsu style, it is reasonable to assume that Soan produced the models for the type himself – recalling that Soan was profoundly influenced by Kōetsu's refined calligraphic aesthetic, which in turn ultimately derived from Heian court styles.

The first book illustrated here is the fourteenth-century classic *Tsurezuregusa* (Essays in Idleness) by Priest Kenkō. The first page of the volume, shown here beside the cover, opens with the famous lines:

What a strange, demented feeling it gives me when I realize I have spent whole days before this inkstone, with nothing better to do, jotting down at random whatever nonsensical thoughts have entered my head . . .

(trans., Keene 1967, 3).

This self-deprecatory statement prefaces a collection of Kenkō's miscellaneous reflections on the life and habits of emperors and courtiers, priests and peasants of his age – a book replete with worldly wisdom, religious and poetic

insight, and a healthy dose of humor – which during the seventeenth century assumed status as one of the most popular works of the Japanese literary canon. Soan's publication of this work played an essential first step in its wider dissemination to the public.

Similarly, the Sagabon versions of *Ise monogatari* (Tales of Ise), which were published in ten separate editions, allowed this tenth-century collection of poem tales to assume its place as one of the best-known Japanese classics. The book consists of 125 brief chapters, each usually centering on a poem or two, recounting incidents in the life of an unnamed Heian courtier and various companions. While focusing on emotions of nostaligia and unrequited love, the various episodes combine to present an elegant picture of an age when every courtier of high standing was expected to have mastered the art of poetry.

The section illustrated here is from Chapter 101 of *Tales of Ise*. It reads in part:

It happened that Yukihira, whose tastes were most refined, had arranged several sprays of flowers in a vase, among them a remarkable cluster of wisteria blooms over three feet long. The guests began to compose poems about the wisteria, and were just finishing when the host was joined by his younger brother, who had been told of the festivities. They caught hold of the newcomer, demanding a poem. At first he tried to decline, since he knew little of the art of poetry, but they refused to let him off. He recited:

saku hana no
shita ni kakururu
hito ōmi
arishi ni masaru
fuji no kage kamo

Longer than ever before
Is the wisteria's shadow –
How many are those
Who shelter beneath
Its blossoms!

"What is the point of your poem?" someone asked. "I was thinking about the Chancellor's brilliant career and the splendid accomplishments of other members of the Fujiwara family," he replied. The critics were satisfied.

(trans, McCullough 1968, 139)

The anonymous woodblock-printed illustrations of these *Ise* editions are derived from hand-drawn manuscripts with limited circulation. They helped to codify the iconography for each chapter of this great classic, while providing inspiration for the popular illustrated editions that were soon to follow.

JTC

77. Japanese and Chinese Poems for Recitation (Wakan rōeishū)

Calligraphy by Shōkadō Shōjō (1584-1639)
Circa 1620s-30s
Handscroll; ink on decorated paper
29.3 x 450.0 cm
Kyoto National Museum

This distinguished scroll of Japanese and Chinese poems – inscribed on grayish-blue paper decorated with a repeating pattern of floral and geometric motifs – bears the seals of Shōkadō Shōjō, one of the "Three Brushes of Kan'ei," along with Hon'ami Kōetsu and Konoe Nobutada.

Shōkadō was a priest of the Shingon sect of Buddhism, whose varied artistic interests brought him in close contact with many important cultural, religious, and political figures of the day. The frequent venue for their meetings was the tea ceremony room. Though Shōjō's lasting reputation is that of a talented calligrapher, Kendall H. Brown has suggested that Shōjō may also be regarded as a "tea painter" who worked in the idiom of the Kanō style of Chinese ink painting, but created works that reflected the tastes of his circle of fellow tea adepts (Brown 1987). Shōkadō's painting and calligraphy were especially influenced by the tea aesthetic promoted by Kobori Enshū.

A true assessment of Shōkadō's achievements as a painter or calligrapher, however, has always been greatly complicated by proliferation of works of dubious authenticity – made by his followers or by forgers to fill the demand for works by Shōkadō to use in the tearoom. Shōkadō's own role as a practitioner of tea ceremony is

briefly mentioned below in entry describing a bamboo tea scoop he carved (cat. no. 78).

The poems inscribed here are from the *Wakan rōeishū* (Japanese and Chinese Poems for Recitation), an anthology of *waka* and Chinese verse couplets compiled circa 1013 by Fujiwara no Kintō (966–1041). The majority of the Chinese couplets in this anthology are by the T'ang-dynasty poet Po Chü-i (772–846), who was by far the most popular Chinese poet among Heian courtiers. The poems were grouped according to themes, with Japanese poems placed side by side with Chinese ones. Not only did it serve as a *vade mecum* for poetry composition, it was well suited as a text for calligraphy models because the poems were written in both Japanese *kana* and Chinese characters.

The first couplet illustrated here (on the far right of the right plate), extracted from a longer poem by Po Chü-i (*Wakan rōeishū*, no. 18), is inscribed in Chinese characters:

Beneath the blossoms,
The view is so lovely
We forget to return home.
Alongside a cask of wine,
Drinking more and more
A spring breeze rises up.

In the standard editions of the anthology this spring poem is followed by several more couplets of Chinese verse, but here it is coupled with a *waka* on the theme of a spring outing, which appears later in the anthology (*Wakan rōeishū*, no. 25). The poem is based on an earlier poem by Yamabe no Akahito (fl. 724-37) found in the *Man'yōshū*, only the last two lines were altered to replace a reference of garlands of plum blossoms to cherry blossoms:

momoshiki no
ōmiya hito wa
itoma are ya
sakura ga sashite
kyō mo kurashitsu

Those courtiers and ladies
Of the sturdy imperial palace
Must have so much free time!
They can while the day away
With cherry blossoms in their hair.

The suggestion is that the men and women of the palace have taken a day off to enjoy a spring outing during which they place sprigs of cherry blossoms in their hair.

The final poem on the scroll (middle of left plate) is a love poem (*Wakan rōeishū*, no. 358) from the section of the anthology titled "Winter Nights":

omoikane
imogari yukeba
fuyu no yo no
kawakaze samumi
chidori naku nari

Setting out for my lover's house
Carried by thoughts of love
This winter's night
I feel the cold river breeze
As plovers cry.

Plovers (*chidori*) in Japanese court poetry are associated with winter and melancholy thoughts of love or separation.

The first poem in Chinese is rendered in what may considered the characteristic Shōkadō style, in an unpretentious manner, with a natural easy-going flow. Shōkadō had studied in the Shōren'in school under Prince Sonchō, who, as mentioned below, was an exemplar of the orthodox court style which was marked by an

overall refined demeanor (cat. no. 68). The two Japanese poems illustrated here (and translated above), however, do not exhibit Shōkadō's usual style – the one he learned from Prince Sonchō and Konoe Nobutada. Rather Shōkadō purposely inscribed these two poems in a mode that was not his own: one associated with Fujiwara no Teika, the influential *waka* poet, critic, and aesthetic arbiter the of late twelfth and early thirteenth centuries. According to the colophon, the calligrapher altered his style on purpose according to the wishes of the (unnamed) person who commissioned the scroll. Calligraphers were expected to be able to work in a wide array of scripts and styles, of varying degrees of formality and expressiveness depending on the commission.

The detail shows two sets of characters taken from poems translated above. On the right is a compound which reads in Japanese *haru kaze* (C: *ch'un feng*), "spring breeze." Beside it is a compound that reads *kawa kaze*, "river breeze." Comparing the way the character *kaze*, "breeze" is written in each compound helps distinguish the two styles. In contrast to the relatively smooth strokes and gentle curves of Shōkadō's typical style, the Teika style has a blockish quality, often with acutely angled turns. Horizontal strokes are sometimes exaggeratedly heavy.

As mentioned in the introduction to this section, there was a great revival of Teika-style calligraphy among tea masters during the Momoyama period. Among Shōkadō's surviving correspondence there is a letter addressed to Kobori Enshū written in the Teika style; also extant is a manuscript with calligraphy by both Enshū and Shōkadō, some in a

distinctive Teika style (Gotoh Musuem 1987, nos 86, 188). Enshū's own tea diary records that Shōkadō was a frequent guest at his tea gatherings during the mid-1620s, and we may suppose that this work in a similar style dates to sometime between this time and his death in 1639.

JTC

References: Brown 1987; Haruna 1971, 261-3; Rosenfield and Shimizu 1984, 205-6; nos 96-102; Yamato Bunkakan 1993, no. 52.

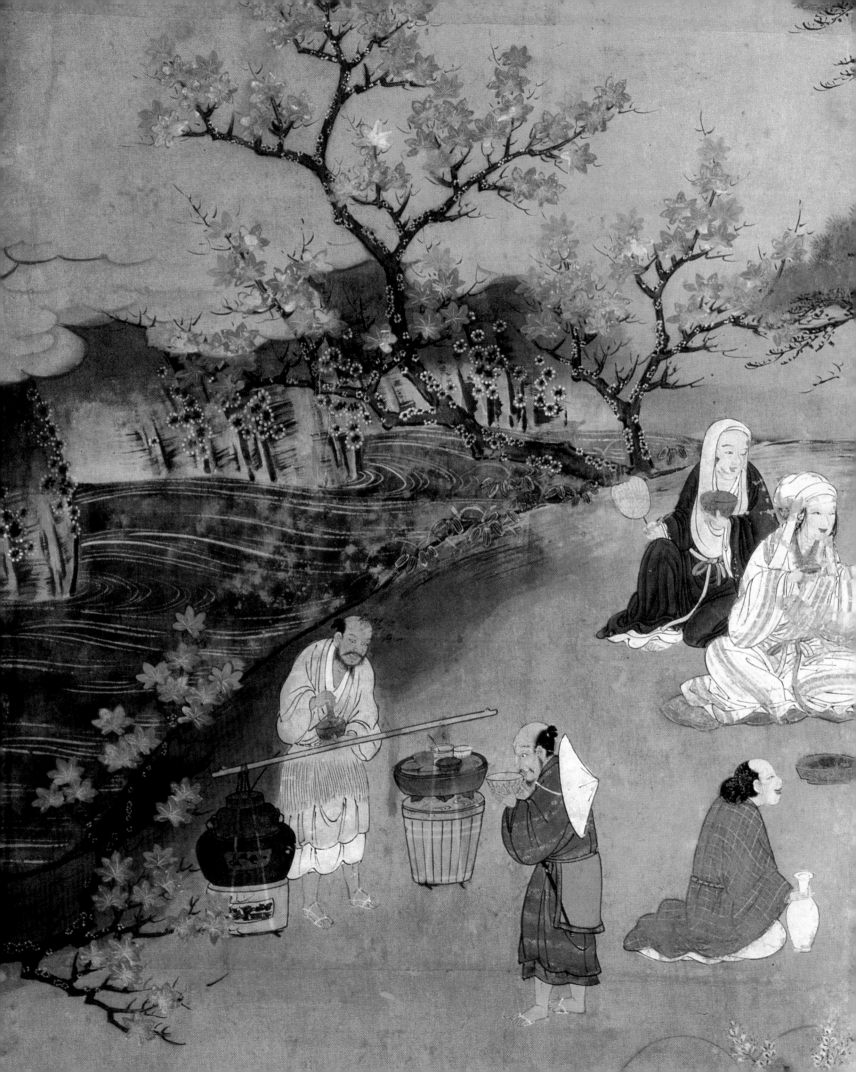

Tea Ceremony Utensils & Ceramics

NICOLE C. ROUSMANIERE

Tea was brought to Japan from China by Buddhist priests returning from studies on the mainland, and was originally associated with Buddhist temples. *Dancha*, a type of brick tea, was likely introduced in the ninth century, but did not become popular. Tea drinking only took root in Japan after the priest Eisai (1141–1215) imported a new way of drinking tea from Sung China in the late twelfth century. In this method, powdered green tea, called *matcha*, is scooped into a bowl, water is added, and the powder and water are mixed together with a bamboo whisk. This tea quickly spread beyond the temples to become a valued ingredient in social entertainments, often drunk in conjunction with the enjoyment of poetry and music. By the fourteenth century, tea was a viable commercial product, marketed as whole dried leaves packed in special tea jars that helped to preserve their flavor.

Tea was a popular beverage in the Momoyama period. Freshly whisked tea (served in simple ceramic bowls) was sold as a refreshment at tea stalls in front of shrines and temples and by itinerant tea vendors at famous scenic spots, such as Mount Takao. No ceremony was involved and the utensils were ordinary and inexpensive. Several paintings in the catalogue show this type of tea drinking (fig. 65).

Formal rules first began to influence the preparation and presentation of tea in the mid-fourteenth century, and tea's long association with the Zen establishment aided the spread of these practices among the warrior class. The tea ceremony can be said to have begun when principles of aesthetic discrimination and refined behavior came to dominate the partaking of tea, especially when it took place in a special setting, the tearoom, deliberately set apart from the routines of daily life. The word *chanoyu* ("hot water for tea"), which is the Japanese term usually translated as "tea ceremo-

ny," first appears in the early Muromachi period. But the tea ceremony involves much more than just making and drinking tea. It incorporates many other practices that enrich the interpersonal relationship of the host with his guests, including the preparation of the charcoal fire to heat the water, cooking and serving food, and arranging the *tokonoma* (an alcove in the tea room where calligraphy, art, and flowers may be displayed). All these acts, done with care and attention, are links that help to bind the host and guests together for that moment alone.

In a complete formal tea ceremony, guests normally would pass through a garden, and enter an immaculately clean room suffused with the gentle sound of water boiling over a lit hearth. After viewing the arrangement of the tea room, paying special attention to the *tokonoma*, the guests may be offered a light meal (*kaiseki*) with sake and then some sweets (fig. 67). The tea is made after the sweets are consumed. Usually a thick mixture of tea (*koicha*) is served first, and all the guests partake in turn from the same bowl. Next a thin tea (*usucha*) is served, and each guest receives their own bowl. After the tea is drunk, the utensils are passed around and the guests discuss them, admiring their features and appreciating their history. But the spirit of the tea ceremony at its most basic and essential level remains one of sharing – sharing tea, refined taste, and an exquisite appreciation of the moment. In Rikyū's words (as recorded by a Zen priest): "It is enough if the dwelling one uses does not leak water and food served suffices to stave off hunger. This is in accordance with the teachings of Buddha and is the essence of the tea ceremony. First we fetch the water and gather the firewood. Then we boil the water and prepare the tea. After offering some to Buddha, we serve our guests. Finally we serve ourselves."[1]

During the Momoyama period, the tearoom mood was set by a scroll of calligraphy, or sometimes a painting, hung in the *tokonoma*. The object next in importance was the tea caddy, and then the tea scoop and flower container, with the tea bowl and tea leaf jar following. Other items, such as the kettle, the fresh water

Fig. 65. Itinerant tea vendor, detail of *Maple Viewing at Mount Takao*, cat. no. 27.

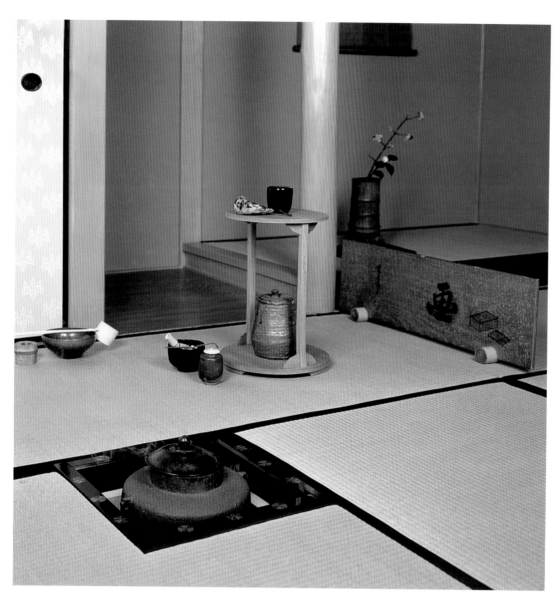

jar, lid rest, incense box, charcoal carrier, bowl for dampened ash, iron-tipped chopsticks, metal spoon, the waste-water jar, and feathers for cleaning off the ash then followed in sequence. Each of these utensils would take on a special power inside the tea room where it became part of an organic whole expressing that specific event. Figure 66 shows an assemblage of tea ceremony implements associated with the tea master, Sen no Rikyū and his descendants.

The tea ceremony functioned as a synthesis of many forms of Japanese art. A tea devotee was expected to have a thorough knowledge of tea, ceramics, utensils, poetry, calligraphy, painting, flower arranging, garden design, architecture, and food preparation, and to be able to express his imagination, wit and taste through his orchestration of tea gatherings as well as his participation as a guest at tea ceremonies organized by others. The tea ceremony can be considered as a type of performance art. No two meetings were ever alike, as no two objects in the tea ceremony were ever identical. The practitioner had to keep in mind his guests, the season, the time of day, their previous meetings, as well as the utensils. Momoyama-period tea ceremonies stressed creativity and invention as well as the collection and connoisseurship of objects and the mutual ties among participants.

HISTORY OF TEA CEREMONY

The development of the tea ceremony is usually traced back to Murata Shukō (also pronounced Jukō; 1422–1502). Shukō, born in Nara as the son of a blind monk, was adopted by a powerful merchant family there. He came to prominence in the world of tea following the Ōnin War (1467–77), which displaced many of the old powerful families and led to the dispersal of their estates and the loss of their possessions, including their prized tea utensils, most of which were of Chinese origin. As a member of the new tea elite, Shukō forever changed the rules of the tea ceremony by substituting lower-grade Chinese wares and Japanese-made brown-glazed *temmoku* tea bowls from the Seto kilns for the Chinese *Chien*-ware bowls that had been the standard for tea bowls; by reducing the number of utensils; and by greatly simplifying the tea room. Shukō's austere aesthetic was a direct response to the social realities of the day, as old family collections were destroyed and the growing number of tea devotees sought suitable utensils. Shukō was also responsible for the shift in style of the room considered appropriate for serving tea. Rather than the large audience rooms of grand buildings, he favored smaller, sparsely decorated rooms created

especially for tea in quiet, secluded areas. In response to the new economic realities, Shukō's style of tea focused on intellectual accomplishments, such as linked poetry, rather than on displays of material wealth.

The son of a wealthy tanner in Sakai, Takeno Jōō (1502–55) moved to Kyoto in 1525 and became a disciple of Shukō's tea style. Following Shukō's preferences, Jōō performed the tea ceremony in an informal room, favoring even greater simplicity than Shukō. Locally produced ceramics and crafts began to assume greater importance in the tea ceremony in the late Muromachi period, due at least in part to Jōō's influence. Ceramic kilns opened, and older kilns, like Shigaraki, expanded their capacity to meet the new demand. The first documented use of a Japanese-made tea bowl in a tea ceremony was in 1547.[2] Jōō also simplified and set the standard of the *kaiseki* cuisine that accompanies the tea ceremony. Earlier the meal had consisted of elaborate dishes brought out to each guest on numerous individual trays. Jōō reduced the meal to soup, rice, and two side-dishes, such as a dish prepared with vinegar and something broiled (fig. 67).

When Jōō returned to Sakai in 1540, he instructed Sen no Rikyū (1521–91)in tea ceremony etiquette. Rikyū, son of a Sakai wholesaler, went on to become one of several tea masters serving Oda Nobunaga, beginning in 1575. He was sole tea advisor to Toyotomi Hideyoshi from 1582 until 1591, when Hideyoshi ordered him to commit suicide. During his time with Hideyoshi, Rikyū became the central figure in the tea ceremony, leading it far from its initial focus on things Chinese, and into entirely new territory. Rikyū encouraged the use of humble Korean bowls and Southeast Asian wares, as well as a host of newly "found" local wares, which were appropriated from their everyday functions in order to serve as aesthetic objects in the tea setting. Rikyū sharpened the focus of the new style of tea ceremony, called *wabicha* (*wabi*-style tea), that had been taking shape under Shukō and Jōō and others, and molded it into what we know of today as the tea ceremony, with its emphasis on intimacy, simplicity, and quiet elegance. The aesthetic quality of *wabi* encourages restraint in expression and cherishes the unaffected beauty associated with loneliness, poverty, or rusticity.[3]

Although aesthetics were central to the tea ceremony, other forces and interests were also at work. Some tea ceremonies were little more than decorous social gatherings, and others were frank displays of wealth and rare possessions. Above all, the political dimension of the tea ceremony should not be overlooked. Nobunaga and Hideyoshi regulated which of their vassals had the right to perform the tea ceremony. Hideyoshi only received the right from Nobunaga to hold tea ceremonies after a victory in a battle of 1578. Rikyū, by his activities as Hideyoshi's tea master, gained tremendous political and economic power, with the result that he offended Hideyoshi. In 1591, the year after he fully unified Japan, Hideyoshi ordered Rikyū to commit suicide. The reasons are unclear, although explanations have included such speculations as the refusal of Rikyū's daughter to submit to Hideyoshi's will (she committed suicide a month before her father), an offense to Hideyoshi's dignity by allowing a statue of Rikyū to be erected on the Daitokuji Temple gate, and a pricing racket that Rikyū is rumored to have set up for the selling of tea objects. Whatever the

Fig. 67 Reconstruction of a *kaiseki* meal served by Sen no Rikyū in 1590. Photograph by Yano Tatehiko. After Varley and Kumakura 1989, pl. 20.

true cause, Rikyū's ritual suicide at the Jurakutei Palace on the twenty-eighth day of the second month of 1591 diminished the part played by the politics of tea.[4]

Rikyū's son Sen Dōan and step-son Sen Shōan went into hiding in the countryside under the protection of regional lords, and his student, the daimyo Furuta Oribe (1544–1615) succeeded Rikyū as the most important tea master of the time. Oribe, originally from the Mino area which produced the Seto and Mino ceramics, served Hideyoshi as tea master after Rikyū's death, but fought on the side of the Tokugawa during the battle of Sekigahara and had his fief increased as a result. His political rise was confirmed when he became the official tea master to the second shogun Tokugawa Hidetada in 1610. Aesthetically, while he followed his teacher Rikyū in certain aspects of tea, especially in regards to cuisine, his taste for ceramics and tea objects differed quite dramatically. He favored wares with an individual flavor, lavishing particular praise on the fresh water jar named *Yaburebukuro*, or "Burst Bag" (cat. no. 89). He also is said to have patronized specific kilns that produced wares fitting his tea style, such as Iga and Mino.

Many tales handed down by generations of tea masters illustrate the passionate dedication of great tea masters like Rikyū and Oribe to their art. It is said, for example, that in 1614, during the Tokugawa siege of Osaka Castle in which Oribe was a participant, he was grazed on the neck by a bullet, while he was standing in a grove cutting bamboo to make a tea scoop. But artistic genius could not save these great aesthetes from the uncertainties of

Momoyama life. In 1615, for reasons that are not altogether clear, but that seem to be related to his or his sons' mixed loyalties towards Toyotomi Hideyori, Oribe, like Rikyū before him, was forced to commit ritual suicide, thus ending the last manifestation of Momoyama-style tea.

Edo-period tea taste was not dominated by a single style, but allowed for multiple tea styles often defined by lineage to a specific Momoyama-period tea master. Rikyū's style was continued in Kyoto by his step-grandson Sen Sōtan (the son of Shōan). Sōtan's three sons each formed their own tea schools: Fushin'an (Omotesenke), Konnichian (Urasenke), and Kankyōan (Mushanokōji Senke). But perhaps one of the most influential early-Edo tea masters was Kobori Enshū, a daimyo with a small 10,000 koku fief in Ōmi (Shiga Prefecture). In 1637, Enshū became the official tea master to the third Tokugawa shogun, Iemitsu, and left a strong mark on the tea world with his distinctive style. Enshū redefined tea taste by combining elements from the austerity and simplicity of Rikyū's style of tea with the emphasis on bold originality stressed by Furuta Oribe, resulting in a style of restrained elegance, a hallmark of the new Edo period which is sometimes called "daimyo" tea taste. Enshū is said to have been particularly partial to seven kilns, one of which produced Takatori ware (see cat. no. 105). By Enshū's time the definition of the tea master as a creative artist had become so encompassing that Enshū also became famous for his garden design. And the tea man's prestige as an arbiter of taste had become so widely accepted that Enshū began the practice of naming tea objects that belonged to himself and others and inscribing those names on the boxes that protected them in storage, a practice that reaffirmed a focus on collecting and connoisseurship and that has continued to the present.

Ceramics

RAKU WARE

Only one type of Momoyama ceramic, Raku ware, was invented specifically for the tea ceremony. During the late 1570s, Rikyū discovered an artisan named Chōjirō making roof tiles (perhaps similar to the ones he later made for Hideyoshi's Jurakutei palace in Kyoto). Rikyū was so impressed by the roof tiles that he asked Chōjirō to create some teabowls. Chōjirō appears to have started making such teabowls according to Rikyū's specifications before 1580 (see cat. no. 81). Although the teabowls are referred to as the work of Chōjirō himself, he ran a workshop and it is likely that more than one person might have worked on a specific teabowl.

The process Chōjirō and his workshop used for producing the teabowls, still in use, was similar to the method they had been using to make roof tiles. They used a soft earthenware clay that was local to the Kyoto area, and carved the teabowls (including the footring) by hand with a spatula without the use of a potter's wheel. This technique imparts a sculptured aesthetic to the end product. The bowl was then covered entirely with a low-fire colored glaze. Black glaze was made by mixing lead with a crushed ferrous rock found in the bed of the Kamo River in Kyoto.

The bowl was placed in a saggar (ceramic box) inside a cylindrical updraft kiln and fired for a short period of time. Once the glaze matured, the bowl was immediately removed from the hot kiln (normally around 1100°C) with tongs and allowed to cool quickly in the open air. This method produced a light porous teabowl that held the heat and insulated the user's hands against the hot liquid.[5] There are two main types of Raku ware, red Raku and black Raku. Early Raku bowls tend to be in the half-cylinder (hanzutsu) shape with straight sides and rounded lower body. It is interesting to note that Rikyū is said to have preferred the black Raku ware bowls, as more in keeping with his type of simple tea ceremony, wabicha. The Raku family name originated with the second generation Raku potter Jōkei, but the Raku lineage was solidified by the third generation Raku ware potter, Nonkō (also known as Dōnyū), who was patronized by Sen Sōtan (Rikyū's step-grandson) and Hon'ami Kōetsu. He developed the two glazes for which later Raku tea bowls are famous – the lustrous clear glaze and the highly viscous glaze (makugusuri).

BIZEN KILNS

Three types of ceramics were especially famous in the Momoyama period for their unglazed appearance: Bizen, Iga, and Shigaraki. All three kiln groups produced unusual color formations and tones, which were due partly to deliberate manipulation of the kiln atmosphere and sometimes due to accidental deposits of ash that fused on surfaces during the firing.

Bizen ware is perhaps one of Japan's most distinctive unglazed ceramics and best embodies the Momoyama aesthetic of simple, bold elegance. Its strong shapes with a reddish-brown stone-hard body and occasional fire-marks (hidasuki) are instantly recognizable. Medieval Bizen kilns produced wares for daily use, but with the newly invigorated economic climate in the Momoyama period, Bizen kilns, in addition to daily use objects, started to produce specialty items that were higher both in quality and price along with the daily use objects. In particular sake flasks (tokkuri; cat. no. 86), flower containers (hanaike), and other tea-related items were made in large quantities.

A Bizen kiln firing in the Momoyama period was an impressive event. The single-chamber kilns, following a natural incline, were up to fifty meters long, about four meters wide and two meters high, and were able to fire thousands of pieces at one time. Edo period documents record that the Bizen firing process took from thirty to forty days for large kilns and used over a hundred metric tons of pine. Because of the stacking technique, the intense heat (from 1200–60°C) and the length of firing, many pieces took on a distinctive appearance that could not be duplicated.

IGA KILNS

Among the many kilns active during the Momoyama period, the Iga kilns, which had a long history of producing utilitarian wares, may have produced the largest amount of tea-related ceramics. The earliest record of Iga ware used in a tea ceremony was noted by Rikyū in detailing a tea ceremony that he held for Tokugawa Ieyasu using newly made ceramics, including an Iga water jar, a black Seto teabowl and a Seto tea caddy. The Iga kilns used an oxidizing atmosphere, which imparted a distinctive dark brown color to stoneware. During the Momoyama period, Iga wares were produced in unique and often distorted shapes. Moreover, special

extra-long firing techniques created stone-hard ceramic bodies with interesting surfaces which made them popular among Momoyama and early-Edo tea practitioners. One extreme example of the results of this long firing process is the famous water jar called *Yaburebukuro*, or "Burst Bag" (cat. no. 89).

Momoyama-period Iga tea utensils were most likely produced under the patronage of Tsutsui Sadatsugu, the feudal lord of Iga province from 1585 to 1608. Sadatsugu probably received guidance from Rikyū, and was said to have been a student of Oribe. Sadatsugu, accused of a crime by the Tokugawa government, lost his lordship in 1608 and was sent into exile in northern Japan. As a consequence, few references to him appear in written records. After Sadatsugu's banishment, Tōdō Takatora became the lord of Iga Province in 1608. Takatora also had close ties to tea masters: he was present at Oribe's suicide; he personally confiscated Oribe's tea utensils from his house; he received Oribe's house after Oribe's death; and finally his own daughter married Kobori Enshū, and Takatora gave them Oribe's house to live in.

Prior to the Momoyama period, Iga potters often used the nearby Shigaraki clay. The potters from the two kiln groups appear to have had contact, and as a result, it is sometimes difficult to differentiate between the two wares.

Shigaraki Kilns

Ceramics from the Shigaraki kilns, some thirty kilometers southeast of Kyoto, are particularly famous for their peach-blossom color and the large quartz and feldspar grains that crack and burst when incompletely melted in the kiln. During the firing process, the exposed ceramics were often covered in a natural ash glaze that ranges from a deep green to reddish-brown color. Like Bizen ware, the Shigaraki kilns were known for their utilitarian products, but starting in the late Muromachi period the kilns also began to produce items specially designed for the tea ceremony. In comparison with the products of the nearby Iga kilns, Momoyama-period Shigaraki shapes tended to be more restrained, with clay forms worked to exhibit more natural expressions. Shigaraki wares were closer to the aesthetic advocated by Rikyū. Iga ware, on the other hand, was pushed to extremes with distorted and unusual shapes that are more in line with the tea aesthetic of Furuta Oribe, emphasizing individualistic and often exuberant expression. A water jar with a Shigaraki body and Iga lid (cat. no. 87) represents a fusion of the two aesthetics.

Seto and Mino Kilns

The Seto potters, who had been producing Chinese-inspired glazed ceramics throughout the Muromachi period, migrated the short distance from Owari Province (Aichi Prefecture) to Mino Province (Gifu Prefecture) in the mid-sixteenth century to escape the endemic civil unrest in the area. Promised safe passage and protection by Nobunaga, the potters settled in land under his direct control. Kilns were established and the Mino potters found themselves deluged with orders for glazed ceramics, mostly as a result of the growth in the tea ceremony. Glazed ceramics – especially teabowls – had become the rage of the day. While based on Chinese prototypes these wares were made with specific Japanese uses and aesthetic requirements in mind; their shapes, glazes and decoration all reflected their eventual use in the tea ceremony or in the *kaiseki* meal.

White-glazed stonewares of the Mino kilns also satisfied the growing demand for Chinese underglaze-decorated porcelain. Decorated Shino wares (*e-Shino*) made at the Mino kilns were first produced sometime in the 1570s, and were the first Japanese ceramics to have painted designs on the ceramic body. Designs were painted with a brush dipped in brown iron-oxide and placed directly on the body of the ceramic underneath the glaze. The piece would then be covered with a semi-opaque feldspathic glaze and fired in a single chamber kiln. This process produces a soft, creamy-white glazed ceramic that loosely resembles porcelain. While the painted motifs were sometimes Chinese in origin, with designs including Chinese landscapes, deer and mythical beasts, other scenes were more Japanese in conception featuring designs of plants with poetic links to the seasons or to Japanese literary classics, especially *The Tale of Genji* and *Tales of Ise* (see cat. no. 93).

The Mino kilns also produced other types of wares from the mid-sixteenth century to the early 1600s, including: plain Seto (*muji Seto*); ash glaze with feldspar Shino (*hai Shino*), Gray Shino (*nezumi Shino*), Crimson Shino (*beni Shino*), Red Shino (*aka Shino*), Marbled Shino (*neriage Shino*), Seto Black (*Seto kuro*), and Yellow Seto (*ki Seto*). These last two types deserve special mention. The Seto Black wares were made by removing a black glazed stoneware vessel directly from a hot kiln just at the point of glaze maturation, and allowing it to cool in the open air. This drastic change of temperature caused the thick glaze to turn a deep glossy black.

Yellow Seto ware, with its distinctive opaque yellow glaze, was fired at the same kilns as other Shino and Seto Black wares during the Momoyama period. Its so-called "fried bean-curd" glaze (*aburagede*) was a Momoyama innovation that probably came about as the Mino potters were trying to emulate Chinese celadons. The type of iron-laden ash glaze used on the Yellow Seto wares turns into a celadon glaze during a reduction (oxygen-deprived) atmosphere in a kiln, and a pale yellow during an oxidation (oxygen-rich) atmosphere.

Oribe ware, produced mostly from the early 1600s to the 1630s, was a result of technological innovation at the Mino kilns

Fig. 68. Excavation of an early seventeenth-century Karatsu kiln, Kameyo Tani kiln, Takeo City.

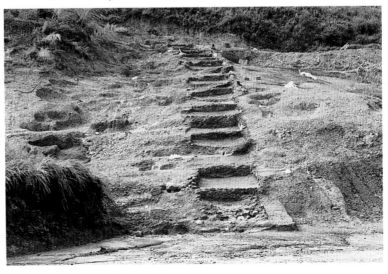

(see cat. nos 97–9). Distinctive decorative effects combining bright green-blue glaze and clear underglaze iron-oxide painting were characteristic of Oribe ware. These were made possible by the introduction of *noborigama* (climbing kilns; fig. 68) from the Karatsu area on the southern island of Kyushu (and originally adopted from Korea or China), which enabled high temperature firings with consistent results and large capacities. The *noborigama* was built along a natural incline with multiple stepped chambers. Wares were stacked inside each one using shelves and sometimes saggars. Each chamber had its own entrance with a peep/stoking hole for use during firing. The fire box was at the base and when the flame reached the first step in the chamber it was pulled upwards and then back down through flues at the back of each chamber. Thus the potters had more control of the atmosphere of the kiln, higher temperatures could be reached, and the kiln fired more evenly and quickly. In the multiple chambers many more ceramics could be fired at one time.

During the late Momoyama period, Katō Kagenobu, a potter at one of the Mino kilns, is said to have traveled down to the Karatsu area in Kyushu and to have observed the potting and firing process, bringing back Karatsu's secrets to the Mino kilns. Whether the technology transfer was clandestine or official, the Karatsu-Mino connection was certainly mutually beneficial. From the 1600s onward, Mino kilns started to produce Karatsu-style wares, and the Karatsu kilns started to produce Mino-style wares. Most of these Mino-influenced Karatsu wares were made in an Oribe style (see cat. no. 103). At the same time, Mino kilns also made Iga-style wares, reflecting the popularity of ceramics that transcended specific ware styles.

Karatsu Kilns

Many of the important kilns formed during the Momoyama period were producing Korean-styled pottery, with quite a few grouped around the port town of Karatsu in Hizen Province (Saga Prefecture), and thus the ware was called "Karatsu ware." The Karatsu kilns were mostly situated near the coast which looks toward the Korean peninsula, and close to Nagoya Castle, which was the launching point for Hideyoshi's two ill-fated invasions of Korea in 1592 and 1597. Hideyoshi's troops are known to have brought back to Japan numbers of Korean artisans, including many potters – so many that in Japan the invasions are often called "the Pottery Wars." The resettlement of Korean potters on the fiefs of the lords who had invaded their country rapidly created ceramic centers reflecting Korean influence in the areas around Hagi, Satsuma, Takatori, and Agano, as well as Karatsu.

Some of the innovations introduced by these Korean potters included the kickwheel for throwing ceramics, specific potting techniques like the use of a paddle and anvil to make ceramic walls both thin and strong, and, most importantly, the split-bamboo style of climbing kiln for firing ceramics at high temperatures. The exact location of the prototype for the Japanese early climbing kiln is not yet clear, but it appears that certain Korean style kilns were quickly adapted in Japan to meet specific local requirements. Figure 68 shows an excavation of an early seventeenth-century Takeo Karatsu kiln with seventeen stepped chambers, which is thought to have fired the Karatsu ware tea leaf jar discussed below (cat. no. 101).

Karatsu ware's beginnings are certainly Korean, but they may predate Hideyoshi's invasions of the Korean Peninsula. This is surmised from the discovery of a well formed tea jar with an inscription dated 1592 that has been preserved at the Seibo Shrine in Kazamoto on Iki Island off the north coast of Kyushu. In this same year Hideyoshi launched the invasions, making it impossible for a Karatsu kiln producing fine wares to be solely the result of his plundering.

Takatori Kilns

The Takatori kilns were founded by Korean potters forcibly resettled in Japan after the Korean invasions of 1592 and 1597. Several accounts of the origins of Takatori ware are recorded. One of the more prevalent stories states that the famous general Katō Kiyomasa brought back a potter known by the Japanese name of Ido Shinkurō, and set him up with a kiln in Higo Province. Shinkurō was subsequently invited by Kuroda Nagamasa, the new lord of Chikuzen Province, to come and start a kiln in the Takatori area (cat. no. 105). Whatever its origins, Takatori ware was started soon after Kuroda Nagamasa became lord of Chikuzen, sometime around 1596. The ware takes its name from the surrounding area.

The first known Takatori kiln was called Eimanji Takuma and dates to the Keichō period (1596–1614). It is located east of Nogata city, at the base of the Takatori Mountains. The second Takatori kiln was called Uchigaso and was fired from about 1614 to 1624. It was from this kiln that the set of five dishes in the exhibition was made (cat. no. 105). The Uchigaso kiln was located on the north face of the Takatori Mountains near the Fukuchi River. Uchigaso kiln products include a wide variety of wares, from everyday items to teaware and specialty products like water droppers and brush holders. Takatori ware was especially cherished by the early Edo period tea master Kobori Enshū.

Hizen Kilns

In nearby Hizen Province during the same period as the Uchigaso kilns, Japanese porcelain production began near the town of Arita in northwestern Kyushu. In the past these wares have been known both as Arita ware, after the town where many of the porcelain producing kilns were located, or more familiarly, as Imari ware, after the port from which they were exported. They are now more properly termed Hizen ware, after the name of the domain whose leaders sponsored their production.

The very first porcelains date to the 1610s and were fired together with Karatsu stoneware (see cat. nos 101–4) in the recently introduced climbing kilns (*noborigama*). These kilns could produce the temperature of approximately 1320°C required for making porcelain. For about a decade, until around 1620, both forms of ceramic were fired in the same kiln and sometimes stacked on top of each other. Because of market demand and new firing techniques, Hizen kilns began to specialize in one or the other type of ceramics. Kilns specializing only in porcelain began to appear in the 1620s, and a range of vessels started to be produced. Underglaze cobalt-blue, brown iron-oxide as well as a cobalt-saturated glaze, an iron glaze and a celadon glaze were the main colorants, along with occasional copper-red decoration.

In 1637, the kilns in the town of Arita were reorganized by

the Hizen domain with a consequent upgrade in quality and production. Kilns on the outskirts of Arita pursued similar markets throughout Japan and occasionally in Southeast Asia, often with striking and innovative designs but without the strict quality control (cat. no. 106).

The overglaze enamel technique was introduced into the Arita area in the 1640s, probably from China. This allowed different colors to be used in the ceramic design. After the ceramic piece was potted and allowed to dry, underglaze pigments like cobalt-blue, copper-red or iron oxide would be painted directly onto the ceramic surface. Then the ceramic would be glazed and fired at a temperature exceeding 1320°C, which was needed for porcelain to become fully vitrified. After the ceramic was removed from the kiln, overglaze enamels could be applied. Then glazes were often added in conjunction with the underglaze blue design. Different overglaze enamels mature at varying temperatures, and so the pigments that fired at the highest temperature were first placed in a muffle kiln, or a single chamber kiln. This fired only at low temperatures and was sometimes located in an area separate from the main kiln. Then other enamels would be fired at successively lower temperatures. In this way the piece would be fired several times, depending on the color and number of overglaze enamels painted on its surface.

To control quality, production and revenues, an overglaze enamel atelier (aka-e machi) was created in Arita by the domain where most of the overglaze enamels were produced. Overglaze enamellers were licensed by the domain and they produced a variety of different styles, including the famous Edo period Kakiemon and Old Imari export styles.

Overglaze enamels were also made at Arita regional kilns, often producing spectacular results, such as the Kokutani-style wares discussed below (cat. nos 108–9). Although the domain tried to keep the porcelain and enamel technique strictly within the Hizen borders, by the 1650s porcelain production as well as the overglaze enamel technique had spread to the neighboring Hirado Island, Higo Province, and as far north as Himeji (Himetani Ware), but production at these alternative sites was short-lived. The inception of porcelain production in Hizen coincided with drastic curtailment in ceramic exports from China. The Dutch East India Company, desiring to maintain a constant supply of trade porcelain to Southeast Asia and Europe, started commissioning pieces from Hizen in the late 1660s. By this time Hizen was no longer supplying ceramics suitable for use in the tea ceremony as they had earlier, but rather produced for trade to overseas markets and for households all over Japan.

NOTES:

1. Translation from Varley and Kumakura 1989, 20.
2. See Itō 1994, 226.
3. For a thorough discussion of the concept of *wabi* in a broader historical context, see Haga 1989.
4. The political implications of Rikyū's suicide are discussed in Bodart 1977. See also Varley and Elison 1981, 220–2.
5. The method of removing a glazed ceramic from a kiln during the firing process was developed at the Mino kilns in the mid-1550s with Seto Black ware. The two wares share the same deep black glaze, but they are formed quite differently and are made from different materials, and as such are quite distinct from each other.

FURTHER READING:

Louise Allison Cort, *Seto and Mino Ceramics* (Washington, D.C.: Freer Gallery of Art, 1992).

Louise Allison Cort, *Shigaraki, Potter's Valley* (New York: Kodansha International, 1978).

Seizo Hayashiya, et al., *Chanoyu: Japanese Tea Ceremony* (New York: Japan Society, 1979).

Varley, Paul and Kumakura Isao, eds., *Tea in Japan: Essays on the History of Chanoyu* (Honolulu: University of Hawaii Press, 1989).

Richard L. Wilson, *Inside Japanese Ceramics: A Primer of Materials, Techniques, and Traditions* (New York: Weatherhill, 1995).

78. TEA SCOOP, NAMED SAKAI

Carved by Shōkadō Shōjō (1584–1639)
Early seventeenth century
Scoop: carved bamboo; case: bamboo
Scoop length 18.1 cm; case length 21 cm
Tokyo National Museum

Tea scoops (*chashaku*) are one of the few utensils that can be made without professional artisan skills. The bamboo is carved from a single piece of cane, making sure that the handle of the tea scoop is the part furthest from the root end, so that the handle will symbolically grow out of the scoop. The usual positioning of a bamboo node at mid-handle follows guidelines established by Sen no Rikyū (1522–91), but the exact proportions of the scoop and handle can vary. Shōkadō has carved a narrow bowl and given it a smooth shallow curve that seems quiet and confident. (The curve could have been angular and the bowl wider and deeper, giving a rough boisterous impression.) This particular scoop also has a case, inscribed in ink with the name *Sakai*, probably referring to the port city of Sakai where wealthy merchants were enthusiastic supporters of the tea ceremony.

The smooth elegant lines of this tea scoop suggest the refined taste of the famous

calligrapher Shōkadō, who was also a noted painter and practitioner of the tea ceremony (see cat. no. 77). Tea scoops are traditionally made by their owners, and this one of white bamboo has subtleties designed to express Shōkadō's courtly interests. His father was associated with Kōfukuji, the Fujiwara family Buddhist temple in Nara, and Shōkadō was briefly employed by Konoe Nobutada (1565–1614), a member of the aristocratic Fujiwara clan and a noted scholar and calligrapher. Although Shōkadō became a Buddhist monk at the Shinto-Buddhist shrine of Iwashimizu Hachiman located between Nara and Kyoto, he continued throughout his life to have contacts with the Kyoto aristocracy and with the newly empowered military who were cultivating court connections. Among those friends was Kobori Enshū (1579–1647), a daimyo with extraordinary talents in architecture, garden design, and the tea ceremony. As Enshū developed a distinctive tea tradition that explored ideas of elegance and loneliness (*kirei sabi*), Shōkadō further refined these concepts in tea gatherings that brought together members of the aristocracy, military, and Buddhist communities. In 1626 Shōkadō played a crucial role in the official visit of

Emperor Go-Mizunoo to Nijō Castle to meet with the shogun Tokugawa Hidetada and his son Iemitsu. Shōkadō was also close with the Zen prelates Takuan Sōhō (1573–1645) and Kōgetsu Sōgan (1574–1643) of Daitokuji in Kyoto, an important monastery with close imperial ties. Over the years, Shōkadō collected a variety of tea utensils which became known as the "Hachiman Meibutsu" (famous objects of Hachiman Shrine).

BAC

References: Tokyo 1980, 177; Anderson 1991, 189–90; Ikeda 1988, 7–31; Shimizu and Rosenfield 1984, 204–6 (on Shōkadō Shōjō's calligraphy); Varley and Kumakura 1989, 156.

79. FLOWER CONTAINER, NAMED FUKE

Sen no Sōtan (1578–1658)
Early seventeenth century
Bamboo
Height 30.9 cm; Diameter 12.0 cm
Fukuoka Art Museum, Fukuoka

Although simply a cut-section of bamboo, the outlines and coloration of this flower vase have great complexity and beauty. It was made by the noted tea master Sōtan, the son of Sen Shōan (1546–1614) who was the adopted son of Sen no Rikyū. Sōtan's bamboo vase continues Rikyū's tradition of using cut bamboo sections for flower containers. In 1590 while on the Odawara military campaign with Hideyoshi, Rikyū made three bamboo vases for use in camp, one of which was called *Onjōji* and later given to Shōan. Like *Onjōji*, Sōtan's vase exposes two joints of the stalk. This type of single-opening flower container (*ichijūgiri hanaire*) can be hung on the wall of a tearoom alcove (*tokonoma*), with just a single blossom or branch inserted. Its rather humble appearance is in deliberate contrast to finely crafted ceramic vases. Its subtle textures and golden patina discoloring allow a quiet appreciation of its natural materials. The vase is named *Fuke* which can be translated as "Ordinary Transformation," suggesting that the change in form from growing bamboo to flower container is an unexceptional change.

Following Rikyū's suicide, the Sen family was dispersed, but by 1594 Shōan had returned to Kyoto to continue Rikyū's teachings. Shōan and Sōtan moved Rikyū's personal property from Hideyoshi's compound at Jurakutei to a site in northwest Kyoto, where the Omotesenke and Urasenke compounds are still located. On Shōan's death in 1614, Sōtan chose a simple life for himself, avoiding the political arena that had destroyed his grandfather. Called "Kojiki Sōtan" (Beggar Sōtan), he advocated the rustic *wabi*-style of tea Rikyū had promoted. He saw beauty in simple forms of modest materials. Sōtan had studied Zen at Daitokuji and emphasized the spiritual aspects of tea over the opulent practices prevalent in the early seventeenth century. He continued to prefer the rough surfaced pottery from Shigaraki and the Raku ware teabowls of Tanaka Chōjirō (1516–92) over the more popular smoothly glazed Kyoto ceramics.

BAC

Reference: Hamamoto 1988, 52–3.

80. TEA CEREMONY KETTLE, NAMED ASHIYA ONJŌJI

Early seventeenth century
Cast iron kettle with lid
Height 15.5 cm; diameter 27.3 cm
Tokyo National Museum

Two important tea masters are associated with this cast iron tea kettle. The wooden box containing the vessel has an inscription inside by Kobori Enshū (1579–1647), one of the foremost figures in Japanese arts during the early seventeenth century (see introductory essay). As a connoisseur of tea utensils, Enshū greatly appreciated both the design and the history of each vessel, which would explain his interest in this particular kettle with its muscular form and acquired patina. Later the kettle entered the collection of Matsudaira Fumai (1751–1818), the seventh daimyo of Matsu Castle in Izumo Province and a renowned collector of *meibutsu* (famous objects) associated with the tea ceremony.

This type of cast iron tea kettle is known as Old Ashiya ware, referring to the Ashiya River (now called Onga River) in northern Kyushu where such items were produced from the thirteenth through seventeenth centuries. Although this piece is unsigned and undated, it was probably cast in the sixteenth century, before Ashiya iron workers relocated to the Kyoto and Edo areas where there was a burgeoning demand for tea ceremony kettles

(*kama*). Old Ashiya ware is noted for several characteristic design elements seen here, including the rough *ararehada*, "hailstone pattern," on the mid-section and the delicate relief depictions of grasses on the shoulder area. This kettle has the three characters making up the word "Onjōji" cast into the shoulder surface, which probably refers to the Buddhist temple of Onjōji, located near Kyoto on the shores of Lake Biwa at the base of Mount Hiei.

BAC

References: Suzuki 1981.

81. Teabowl, named Kamiyaguro

Black Raku ware
Chōjirō (1516–92)
Late sixteenth century
Stoneware with applied glaze
Height 7.2 cm
The Seikadō Bunko Art Museum, Tokyo

This teabowl (chawan) is an excellent example of early Raku ware. Its slightly distorted form in a classic half-cylinder (hanzutsu) shape feels as if the sides were gently folded over from the outside into the inside with the mouth actually pulled inward. This creates a soft line that is enforced by the wavy curves of the lip making the bowl easy to hold and pleasant to drink from. There are indentations around the waist and base of the vessel purposefully made by a fashioning tool, which also allow easy holding. This style fits with the wishes of Rikyū, who wanted a teabowl to be pleasurablet to use and informal in feeling. The low footring is rather small for the size of the vessel, and is markedly round. A black glaze covers the entire exterior of the vessel including the footring.

The name of the bowl, Kamiyaguro, or "Kamiya Black," refers to Kamiya Sōtan (1551–1635), a wealthy merchant and noted tea master of Hakata, Kyushu. Sōtan is said to have commissioned this bowl for a tea gathering attended by Hideyoshi, who was in Kyushu during a military campaign to subjugate the southern island of Japan. Sōtan kept records of visits by Hideyoshi and other dignitaries to participate in tea gatherings in his tea diaries, *Sōtan nikki*.

NCR

References: Cunningham 1991, no. 92; Wilson 1995, 166–8 (on Raku ware).

82. "Chinese Lion" Incense Burner

Raku ware
Tanaka Sōkei (act. mid- to late 16th century)
Dated 1595 (the head is a later addition)
Earthenware with a sansai (three-color) applied glaze
Height 27.3 cm; maximum diameter 23.4 cm
Umezawa Kinenkan Museum, Tokyo

The "Chinese lion" (karashishi), also known as "lion dog" (koma inu), is a mythical animal whose origins can be traced back to ancient Chinese and Central Asian legends (see cat. no. 46). In Japan, lion-dogs made of stone or wood functioned as paired guardians of Shinto shrines. Often they appear with one mouth open and one mouth closed, voicing the sounds *a* and *un*, the first and last syllables in the Sanskrit alphabet. In the Kamakura and Muromachi periods, glazed stoneware Chinese lions were produced at the Seto kilns. The Nezu Institute of Fine Arts possesses a Muromachi-period Seto Chinese lion sculpture, once owned by Sen no Rikyū, that was used as an incense burner. During the Momoyama period, other kilns occasionally made stoneware Chinese lions.

The body of this incense burner (kōro) is dramatically covered with a light brown iron-oxide and green copper-oxide glaze. Loose *karakusa* (Chinese grass) swirls are incised into the body, adding both pattern and movement to the sculpture. Similar techniques were used to create the famous Raku ware *sansai* (three-color) shallow bowl with an etched design of two melons on the interior, and Chinese lions and peonies on the exterior, attributed to Chōjirō (Tokyo National Museum). Both works make use of green and yellow-brown glazes over an incised surface, suggesting that they are styled on the then popular southern Chinese Ming-period ceramics called Kōchi ware (Cochin) in Japan. The head with attached strap handle – which has a different color glaze coloration – is a later addition made by the seventh-generation Raku potter Chōnyū (d. 1770).

This incense burner bears an inscription on the stomach containing the potter's name and the date of production: "Tanaka Tenka ichi Sōkei, aged sixty, auspicious day in the ninth month of Bunroku 4 (1595)." It is accompanied by Sōkei's stylized signature and a "Raku" seal. Sōkei made another extremely similar black Raku ware Chinese lion (Tekisui Museum, Osaka) which is also signed "Tenka ichi" (first in the realm).

NCR

Reference: Nezu 1972, 110–11, pls 72–3.

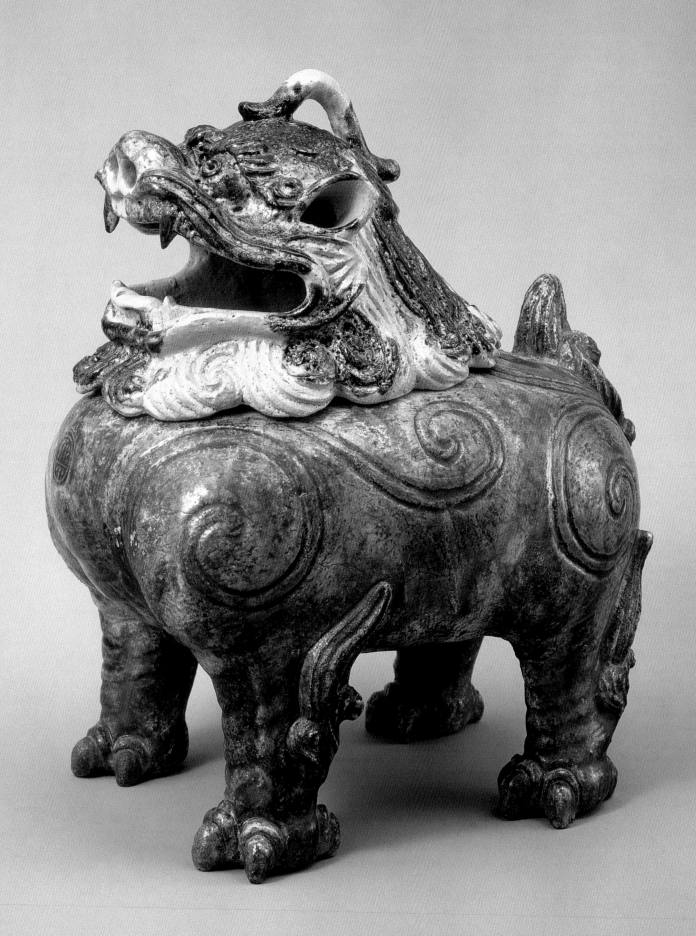

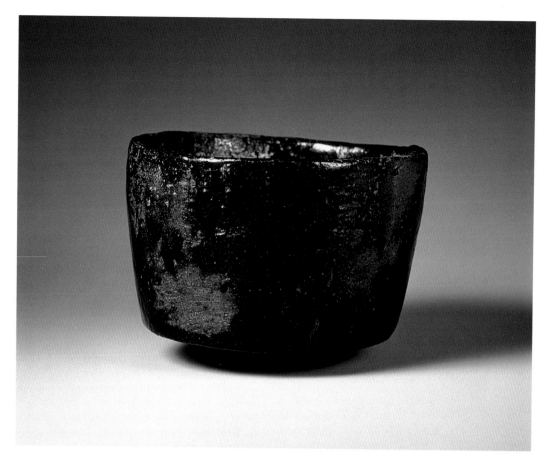

83. Teabowl, named Shichiri

Black Raku ware
Hon'ami Kōetsu (1558–1637)
Early seventeenth century
Earthenware with applied glaze
Height 8.6 cm; diameter 12.2 cm
The Gotoh Museum, Tokyo

The third-generation Raku ware potter, Nonkō (also known as Dōnyū), is said to have instructed the multi-talented artist Hon'ami Kōetsu (1588–1637) on the production of Raku ware. Kōetsu's many accomplishments are worth noting, he came from a line of sword connoisseurs, but was well known as a calligrapher and lacquer designer as well as a potter. From 1615 onward, Kōetsu ran a creative community north of Kyoto called Takagamine. There he oversaw a number of artisans involved in all different types of media.

Raku ware during Kōetsu's time was known both as Raku and as *Imayaki,* or "newly made ware." A good number of Raku ware sherds have been excavated at Momoyama-period sites in Kyoto and Sakai. That Kōetsu would be attracted to the ware seems natural, as it offered the most sculptural ceramic form of the period. Raku ware was not made on the potter's wheel, but carved from a block of earthenware with the use of a *hera* (spatula). The ware was made in Kyoto, where Kōetsu lived, as had Chōjirō, the first Raku ware potter. Kōetsu made both red and black Raku ware bowls. While the Kōetsu piece shares with the Chōjirō "Kamiyaguro"

teabowl the *hanzutsu* (half-cylinder) shape, it also displays a delicate four petal shape that is somewhat reminiscent of early Chinese wares that were imported into Japan during the Kamakura and Muromachi periods. The petal shape was made by gently pressing a spatula vertically against the still soft clay body. The bowl has a strong sculptural presence, forgoing Chōjirō's soft curves for straight sides that widen at the mouth.

The entire body both inside and out as well as the footring was covered with a glossy black glaze made from iron and Kamogawa River stone. But various areas around the body have been intentionally scraped away revealing the lighter brown earthenware body under the glaze, a technique which adds considerable texture to the piece. Indeed, the scraped areas contribute a pictorial quality to the otherwise solid surface. The tactile effect must be as pleasing as the visual.

The bowl "Shichiri" was named after one of its early owners, Shichiri Hikoemon, whose name is found on the wrapping paper of the outer box. The wrapping paper also bears the name of Iseya Kiyozaemon, a subsequent owner of the piece. During the last century it was owned by the famous industrialist and tea collector, Masuda Takashi (also known by his tea name, Masuda Don'ō, 1848–1938), before coming into the collection of Gotō Keita.

NCR

References: Hayashiya 1990, 460; Metropolitan 1975, no. 65.

84. Water Jar

Bizen ware
Late sixteenth century
Stoneware with *ishihaze* (stone eruption) design
Height 17 cm; diameter mouth 20 cm; waist 19.3 cm;
base 17 cm
Okayama Prefectural Museum, Okayama

Bizen wares, like this water jar (*mizusashi*), were
mostly hand built from a potter's wheel. To
form this vessel, the potter would have first
placed a round disc of clay on a turning wheel,
and then added on top of it the appropriate
amount of clay to form the rest of the vessel.
The vessel would start to take shape with the
potter pulling and forming it with the use of a
bamboo spatula while the wheel slowly rotated.
The end result, as seen here, is a slightly warped,
but well-shaped jar that benefited from the
dynamic use of a spatula to form the neck and
base as well as seemingly random cuts on the
body itself. The base is sharply formed and
purposefully misshapen, adding another level to
what at first glance appears to be a simple piece.
There are four slightly raised well formed feet
on the base that would not be visible when the
jar is placed on a tatami mat. The jar is in the
arrow mouth shape (*yahazuguchi*), and is made so
that a lid can rest inside the mouth. Along the
outside of the rim there is an x-shaped stone
eruption (*ishihaze*) that was much desired in tea
ceremony ceramics. Where the body of the
ceramic faced the fire, seed-shaped specks of
natural ash glaze formed, which are called *goma*

or "sesame seeds" by tea practitioners.

This vessel would have been used as a water
jar during the tea ceremony, and combined with
other wares from different kilns according to the
tea master's taste and style.

NCR

References: Okayama 1991, 34, 112; Sakai 1993, 62–3;
Uenishi 1984, 7–22; Wilson 1995, 155–8.

85. LARGE DISH

Bizen ware
Late sixteenth century
Stoneware with *hidasuki* (flame-scorched) design
Height 8.8 cm; diameter 50.8 cm; footring 27.4 cm
Okayama Prefectural Museum, Okayama

This large dish (*ōzara*) was one of more than three hundred ceramic pieces that were recovered in the 1930s from a Momoyama period Japanese shipwreck in the Inland Sea in Kagawa Prefecture, near the Naoshima area. Until these came to light, it was not thought that Bizen fired large dishes. Three examples are known from the wreck.

While these large dishes are not representative of Bizen ware of the Momoyama period because of their size, they do serve as a reminder of the entrepreneurial spirit that characterized the period. Before it sank, the ship carrying these large dishes was most likely en route to Nagasaki or Hakata, the port cities in the southern island of Kyushu that catered to the burgeoning Southeast Asia trade. None of these large Bizen dishes are known to have been handed down in collections in Japan, and it is hard to imagine their use in traditional Japanese cuisine, which favors the use of individual trays (*ozen*) and small dishes.

This large plate is remarkably well formed for its size, with a slightly inturned rim and a flat base. The large area on the interior of the dish is covered with a *hidasuki* or fire-cord design that, while appearing accidental, was intentionally encouraged by the special wrapping of rice straw (*wara*) and, most importantly, the careful placement within the firing chamber. The high alkaline content in the rice straw reacted with the iron content in the ceramic body to create a red scorch fire-cord mark. The term *hidasuki* is derived from the scarlet cords used to tie up sleeves when working.

The *hidasuki* design on the interior of this dish resembles a net pattern. From a quick comparison of the exterior and the interior of the piece it is easy to see the effect of the direct flame in the kiln chamber on the straw ash wrapping. The interior of the dish with the buff colored clay and the scarlet flame-cord marks was protected from direct contact with the flame, having been probably covered by another large dish. The exterior of the dish is generally darker with less defined flame-cord marks. Certain areas of the dish are lacking in original luster as a result of the piece's lengthy immersion in the sea. There is a potter's mark (called *kamajirushi*, or *tōin*) incised on the base. Kiln marks are common on Bizen ware, but they have not yet been identified with specific potters or kilns.

NCR

References: Okayama 1991, 35, 112–13; Uenishi 1984.

86. LARGE SAKE FLASK

Bizen ware
Late sixteenth century
Stoneware with *hidasuki* (flame-scorched) design
Height: 30.2 cm; diameter: waist 22.5 cm; mouth 9.2
cm; base 16.2
Okayama Prefectural Museum, Okayama

This large sake flask (*ōdokkuri*), capable of
holding 5.6 liters of liquid, was made with a
special type of fine grain clay. The body was
formed carefully with a sharp and exaggerated
mouth which flares upward and a thin neck
which gracefully curves to a fully formed body.
Great care was taken in firing this sake flask and
as a result hardly any warpage can be detected.
Because of the type of iron-rich clay that Bizen
potters used, firing temperatures were relatively
low (1200–60°C) and firing times extremely
long, which often caused the pieces to distort.
This flask was wrapped in rice straw (*wara*) and

placed in a saggar (ceramic box) to ensure that
fluctuations in the atmosphere of the kiln during
the extended firing would be modified so as not
to affect the color of the piece and not to impart
kiln grit on the body of the piece.

The Bizen potters were certainly aware that
the contrast between the buff areas and the
flame-cord areas on a ceramic surface were
strongest when the piece was not exposed to
direct flames inside the kiln. By wrapping the
piece in rice straw and placing it in a saggar, in
an advantageous position in the kiln, the potter
succeeded in creating the striking flame-cord
mark. This mark starting at the mouth stretches
down the neck and shoulder and reaches out
two fingers on to the belly of the piece. Here
the contrast between the buff body and the
scorching red flame-cord is at its most striking.
There is a kiln mark incised into the base of the
vessel that resembles the Japanese character *kami*

(upper). Recently similar sherds have been
found at the Minami Ōgama kiln, and it is
possible that the vessel was fired there.

NCR

References: Okayama 1991, 35, 113; Shimizu 1988, 304,
306–7; Uenishi 1984.

87. WATER JAR

> Shigaraki ware with Iga-ware lid
> Body: Late sixteenth century
> Lid: Seventeenth or eighteenth century
> Stoneware with natural ash glaze
> Height without lid: 20.3 cm; diameter: opening 14.6 cm; base 17.8 cm
> Hayashibara Museum of Art, Okayama

This Shigaraki ware water jar (*mizusashi*) was certainly produced for use in the tea ceremony. It is covered with a natural ash glaze, known as *bidoroyū,* that was formed in the kiln. The glaze color runs from a deep green to a light brown. The body is of a specific type called *kasanemochi,* or "stacked rice cakes." Several water jars with this form are known today. The distinctive shape probably originally derived from a gourd-shaped vessel that has auspicious connotations.

The stacked rice cake form was also made at the same period in the Iga ware kilns, and there is a similar example in the Tekisui Museum in Osaka. Here in the Shigaraki ware piece, the stacked rice cake shape was pushed to an extreme with its tightly restricted waist and bulging body. This piece is a classic Momoyama period ceramic ware which the viewer can compare with the Iga water jar, another typical Momoyama vessel (cat. no. 89). The body itself

has no applied decoration with the exception of two non-functional horizontally attached ears. The design pattern evident on the natural ash glaze comes from the placement in the kiln in relation to the fire box and to the other ceramics. Inside the mouth a double **x** potter's mark is visible.

The glazed lid was added later during the Edo period and has a swirl pattern incised on it with a prominent knob in a jewel shape that differs in style from the vessel. The lid was not made in Shigaraki kilns, but in the nearby Iga kilns, probably sometime in the late seventeenth or eighteenth centuries, perhaps as a replacement for a lost original.

NCR

References: Cort 1979, 127–82, 343–52; Hayashibara 1989, 163, 222; Kawahara 1977, 1–10.

88. FLOWER CONTAINER

> Iga ware
> Circa 1600, prior to 1608
> Unglazed stoneware
> Height: 25.1 cm; diameter: opening 15.3 cm; base 11.8 cm
> Fukuoka Art Museum, Fukuoka

The prominent tea master Furuta Oribe is known to have favored Iga ware because of its distinctive – naturally or intentionally distorted – shapes. Entries in Oribe's tea diary dating from 1601 to 1608 confirm his use of Iga ware water jars (*mizusashi*) and flower containers (*hanaike*). Flower pots and water jars were the main tea wares produced in the Iga kilns during the late sixteenth and early seventeenth centuries. Most of the flower pots were used for hanging on the wall, but occasionally the holes were filled with clay and they were placed inside the *tokonoma* (alcove).

With its enlarged and bent lip and restricted waist, this unglazed cylindrical flower pot probably belongs to the period when Tsutsui Sadatsugu, feudal lord of Iga Province (1585–1608), patronized the Iga kilns. The extended out-turned lip of the piece is one of its most striking features, and is described as a *tsubaguchi* (mouth like a Japanese sword guard). The waist is cinched, breaking up the long vertical cylinder of the body. The ceramic is

fired a deep red-brown color and there is a single x potter's or merchant's mark visible inside the mouth of the vessel. It was possibly fired in the Makiyama kiln in Ayama, Mie Prefecture.

This flower container is quite similar in shape and date to one known as "Namazume" (Raw Fingernails), which was owned by Furuta Oribe and given to his student Ueda Sōkō with great reluctance. The container's importance to Oribe is revealed through a letter that he wrote to Sōkō. Still preserved with the piece, it contains the sentence, "Parting with this flower vase, I feel as if my fingernails are being ripped off."

NCR

References: Fukuoka 1992, 125; Hayashiya 197, 1–3, 66; Kawahara 1986 (Oribe's letter to Ueda Sōkō is cited on page 16).

89. WATER JAR, NAMED YABUREBUKURO

Iga ware
Circa 1600, before 1608
Stoneware with applied glaze
Height: 21.3 cm; diameter: 12.3–12.5 cm; base 17.5 cm
The Gotoh Museum, Tokyo
Important Cultural Property

This jar, once used as a tea-ceremony water jar, is a particularly fine example of Ko-Iga (Old Iga) production. The body is made of a gray white fine particle stoneware and was thrown on a wheel. The upper body is decorated with seven horizontal incisions which give a wrapped effect to the neck. This horizontal emphasis is offset by the two vertically placed square ears and the large, accidentally produced cracks on the lower body. A fair amount of kiln debris that attached itself to the piece during the firing process, indicating that it was not fired in a saggar (ceramic box). The green-colored natural ash glaze has turned brown in places. During the firing process, the piece partially collapsed on itself, which accounts for the deep fissures present on the lower body and sides as well. The piece was non-functional when it was removed from the kiln because the deep fissures cut into the inside of the body, and it could not hold water. The jar also leaned to one side to such an extent that it could not sit evenly.

The piece was handed down in the Tōdō family, the Iga province's feudal lord, and perhaps at one point was owned by Furuta Oribe. In a letter to Ōno Harufusa that once accompanied the jar, Oribe states that though the piece is cracked, he considered it an exceptional piece and that it should be repaired and used, for no other like it will never be made. Its name *Yaburebukuro*, literally "Burst Bag", refers to the kiln damage that occurred during the long firing process. The vertical cracks formed on the lower half of the piece actually resemble a torn sack. In order to be used as a water jar, the fissures were reinforced with lacquer and the warped bottom had feet added so that it would rest on a level plane.

This work is representative of the aesthetic preferences of Oribe, who was the leader of the tea world after Rikyū's death in 1591 until his own in 1615. Oribe advocated free-form individualistic designs with abstract patterns and naturally-produced strong glaze effects. He enjoyed wares that were unique and that stood out, purposefully turning away from the earlier *wabi* (restrained) tea style shaped by his mentor, Rikyū. Because of his preference for rigorous shapes that make bold statements, as seen in this water jar, Oribe helped shape later Momoyama tastes in teaware.

Earlier this century this jar was simply referred to as a *kagogata mizusashi*, or a "basket-shaped water jar." It was bestowed the name *Yaburebukuro* in 1955, when it designated an Important Cultural Property by the Japanese Agency for Cultural Affairs. The name probably derives from another Iga ware water jar named *Yaburebukuro*, handed down in the Matsushita family, that is also a registered Important Cultural Property.

NCR

References: Aichi-ken Tōji Shiryōkan 1995, 46–7; Hayashiya 1977, 1–3, 66; Kawahara 1986.

90. TEA CADDY

Seto ware
Early seventeenth century
Stoneware with iron-rich glaze; ivory lid
Height 7.4 cm; diameter: mouth 3.1 cm; waist 6.3 cm;
base 4.5 cm
Aichi Prefectural Ceramics Museum, Aichi

Tea caddies (*chaire*), used to hold the freshly
ground and powdered tea leaves required in the
tea ceremony, were among the most prized
possessions of tea practitioners. They were
classified according to the shape of the mouth,
shoulder, body, hips, or foot. This example, for
instance, is of the classical *katatsuki*, "square-
shouldered," type. It is closely based on Chinese
prototypes, which seem to have entered Japan as
medicine containers. Sometime during the
Muromachi period small containers of this type
were made to serve as tea caddies.

The sides and mouth of the rim of this
example are extremely thin, making it light to
hold. Two applications of iron-rich glaze give
the surface a distinctive pattern of undulating
dark and light brown; the bottom was left
unglazed. The base bears a cord-cut mark with a
shell-pattern shape that was appreciated by tea
connoisseurs.

The ivory lid and three elegant fabric storage
bags (*shifuku*) custom made for it testify to the
high esteem in which this tea caddy was held.
One bag has a navy-blue ground with a woven
gold pattern of grapes and leaves; the second has
a red ground with a woven stylized peony
pattern; and the third bag has an embroidered
roundel pattern of bird and grasses.

NCR

91. TEABOWL, NAMED HARUGASUMI

Yellow Seto ware
Late sixteenth century
Stoneware with incised design and applied glaze
Height: 6.6 cm; maximum diameter 11.7 cm; base 7.6 cm
Idemitsu Museum of Arts, Tokyo

This Yellow Seto ware's current use as a teabowl seems appropriate if one imagines the bright green powdered tea (*matcha*) set off by the yellow glaze and reflected in the flecks of green glaze on the outside of the bowl. This wonderfully thin walled teabowl is appropriately named "Harugasumi" (Spring Mist), an apt description of its delicate and chaste quality.

Extremely few Momoyama-period Yellow Seto teabowls seem to have been produced. Most of the pieces known currently as Yellow Seto teabowls were originally made as *mukōzuke*, or side dishes used during the *kaiseki* meal associated with the tea ceremony. This bowl is no exception, and was probably converted into a teabowl during the late Edo period. A *mukōzuke* was used to hold a small portion of food, often some pickles or a bit of fish or vegetable. The shape of the bowl (*dōhimo*) was designed to suit its original purpose as a food container, with a wide mouth, out-turned lip, relatively straight sides and a double band around the waist serving as a ground line for the incised design above. The two designs, one on each side, are of a stylized plum branch and a leaf spray. The incised design is highlighted with a splash of brown iron-oxide and a green glaze that was sometimes copper-oxide or sometimes copper sulfate. This bowl was manufactured in Mino, Gifu Prefecture, probably at the Ōhira kiln group.

NCR

References: Furukawa 1983, 5–10. Hayashiya 1988, 40–2; Musée Cernuschi 1995, 82-3.

Decorated Shino ware
Late sixteenth century
Stoneware with applied glaze
Design painted in iron-oxide
Height: 11.3 cm; diameter: mouth 12.5 cm; footring 7.6 cm
Tokyo National Museum, Tokyo

This bowl is named "Hashihime" (The Lady at the Bridge), probably because of the bridge design painted on the bowl. In Japanese lore, a heavenly protectress is associated with bridges, and here we can find a parallel in literature in a chapter heading from *The Tale of Genji*, an eleventh-century narrative of court life. Ceramics decorated with this bridge motif are also referred to as being in the Sumiyoshi style, after the Sumiyoshi Shrine in Osaka, famous for its arched bridge. This motif was popular during the period, appearing on lacquers and textiles as well as ceramics from other areas such as Karatsu.

This is a relatively large teabowl (*chawan*) with a strong form that expands at the base and tapers in slightly at the mouth. On one side there is the painting of a bridge and on the other side a painting of a hut, both done in a fluent if abbreviated style in brown iron-oxide, clearly visible through the rich feldspathic glaze that covers the piece entirely down to its base. There is a similarly decorated, but wider mouthed

92

92. WATER JAR

Decorated Shino ware
Late sixteenth century
Stoneware with applied glaze
Design painted in iron-oxide
Height 18.7 cm; diameter 19.4 cm; base 18.5 cm
Nezu Institute of Fine Arts, Tokyo

This water jar (*mizusashi*) has a design of two reeds on one side, and on the other, three mountains with a pine tree on the top and bottom of each mountain. The mountain and reed design sets up a wave of undulations that unifies the piece by means of the softly painted curves. The reeds are depicted in extremely close view and the mountains in distant outlines, both following the same pictorial rhythm.

As a result of the firing, the iron-oxide painting on the piece has turned different shades from deep red to almost black, creating a full color spectrum, which is played off beautifully against the soft white of the glaze. Around the mouth and base a roll of clay has been added which gives the jar a sculptural feel, and the mouth is fashioned in the *yahazuguchi*, "arrow mouth," style. Similarly sized Shino ware water jars have been excavated recently from Kyoto, proving that the Mino kilns did indeed produce such shapes.

NCR

References: Kuroda 1984, 5–16; Narasaki 1976, 1–6; Shimizu 1988, 307.

93

Shino ware teabowl in the Burke Collection. The Burke piece also has a design of a bridge and a hut, and a potter's mark (or perhaps buyer's mark) of two pine needles inside the footring. It seems safe to assume that both pieces were probably made at the same kiln around the same period.

NCR

References: Hayashiya 1979, 108; Murase 1975, 318–20.

94. BOWL

Decorated Shino ware
Early seventeenth century
Stoneware with applied glaze
Design painted in iron-oxide
Height 8.3 cm; diameter 27.8 cm
Tokyo National Museum

This Shino ware bowl (*hachi*) is an excellent example of a ceramic fired in the new type of kiln that existed in the Mino area at the beginning of the seventeenth century. During the sixteenth century the potters at Seto and Mino used a kiln called an *ōgama* (big kiln), described in the introduction to this section. One effect of the new kiln technology on Decorated Shino ware, evident on this piece, is the maturation of the feldspathic glaze. With the higher temperatures and more even firings made possible by the *noborigama* (climbing kiln), the semi-opacity of the feldspathic glaze that had previously covered the pieces, often obscuring the underpainting and crawling into droplets, was reduced and even eliminated. Underpainting like this one of a craggy pine with a ground line and a geometric border in iron-oxide is clearly visible on top of a clean white background. Motifs of a strongly shaped pine tree appear not only on contemporaneous Karatsu and Hizen ware, but also in screen and *fusuma* paintings of the Tosa and Kanō ateliers.

This bowl was potted on a wheel and then finished by hand, so that the rim makes an uneven circle, giving the piece an individualized feel that accords with Furuta Oribe's style of the tea ceremony. Three feet are attached to the circular bottom.

NCR

References: Faulkner and Impey 1981, 23–37; Okayama 1981, pl. 17.

95. Teabowl, named Yamanoha

Gray Shino Ware
Late sixteenth century
Stoneware decorated with slip and applied glaze
Height: 8.2-8.8 cm; diameter: 13.1-14.3 cm; footring
5.5-6.1 cm
Nezu Institute of Fine Arts, Tokyo
Important Art Object

This teabowl known as *Yamanoha* (Mountain Ridge), is considered a perfect pair with the Gotoh Museum's Gray Shino teabowl known as *Mine no Momoji* (Maple Trees on the Summit), which formerly belonged to the Kuki family. They are considered the two best examples of Gray Shino ware. The finest Shino ware pieces were fired between 1575 and the early 1600s in single chamber kilns. This type of firing, along with appropriate materials, produced what is prized about these pieces: the milky-white viscous texture of the glaze, which gathers or crawls in certain areas and has pin-hole marks in others.

Shino ware was formed by the taste of the tea masters for use in tea and tea-related activities. Tea taste is apparent not only in the glazing of the piece, but also in the style of decoration and in shape of the bowl.

Gray Shino decoration was created by applying a thick coat of iron-rich slip (*oni-ita*) over the whitish colored stoneware vessel, and incising a design into the slip so that the body

underneath is revealed. The entire piece is then covered with a feldspathic glaze and fired. Once removed from the kiln, the incised pattern appears white and the background gray.

This piece has a strong form, rising from a small notched footring; the bowl flares out at a sharp angle to a full, well proportioned body. The lip of the bowl is purposely thickened and

has an undulating line, possibly to make drinking from it more pleasurable. Inside the footring there is a "well-curb shape" (*igeta*) kiln mark. This tea bowl was manufactured in the Mino area, Gifu Prefecture, probably the Kamashita kiln at Ogaya.

NCR

Reference: Nezu 1984, 25, 196.

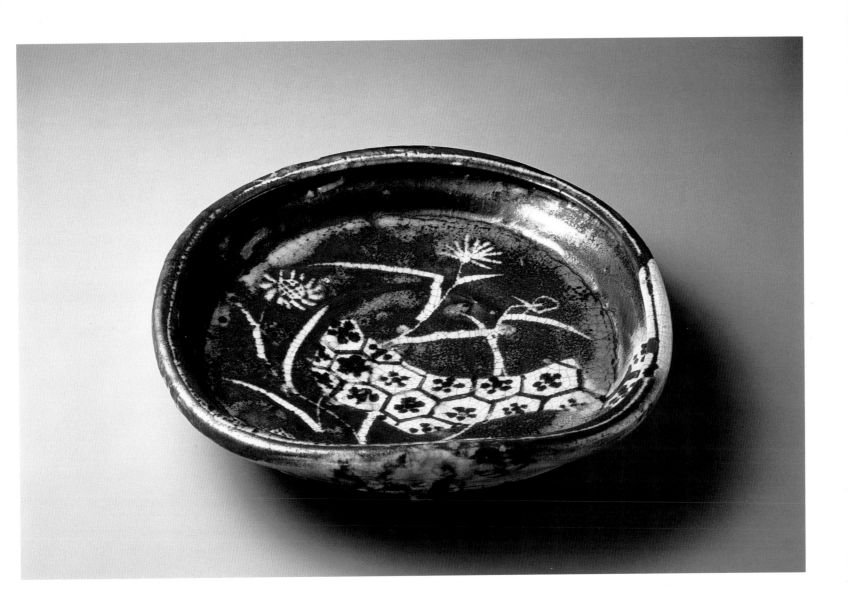

96. Large Bowl

Gray Shino ware
Late sixteenth–early seventeenth century
Stoneware decorated with slip and applied glaze
Height 6.3 cm; diameter 25.3 x 26.6 cm
The Gotoh Museum, Tokyo

This bowl is fresh evidence of the inventive spirit of the Mino potters. Its decoration includes not only the incising through iron-rich slip common in Gray Shino ware, but also an interesting application of the slip that leaves a cloud shape area uncovered. The area was then painted with iron-oxide in a geometric design. Thus a complex pattern that plays with negative and positive space is achieved with the minimum use of pigments. Three incised flowers appear in three different stages of development, from the youngest on the right, still in bud form, to a fully blossoming flower on the left of the bowl. The painting on the unslipped area depicts mist intertwining among the flowers with a *bishomon* pattern reminiscent of the treatment of mist on certain gold covered

screens from the same period. Perhaps because the feldspathic glaze that covers the bowl was applied thinly, or because the iron-rich slip was especially thick, the design stands out clearly in a bright white against a very dark background, giving an unusually strong graphic presence to the work.

This large flat bowl (*taira hachi*) functioned as a serving dish for food. The bowl's edges were inturned while the clay was still pliable in order to form a more square shape within its round form. There are three feet attached to the base and six spur marks used during the firing are clearly visible, as well as a clear set of fingerprints on the exterior edge of the bowl. It was manufactured in the Mino area, Gifu Prefecture, probably in the Kushiri area kilns.

NCR

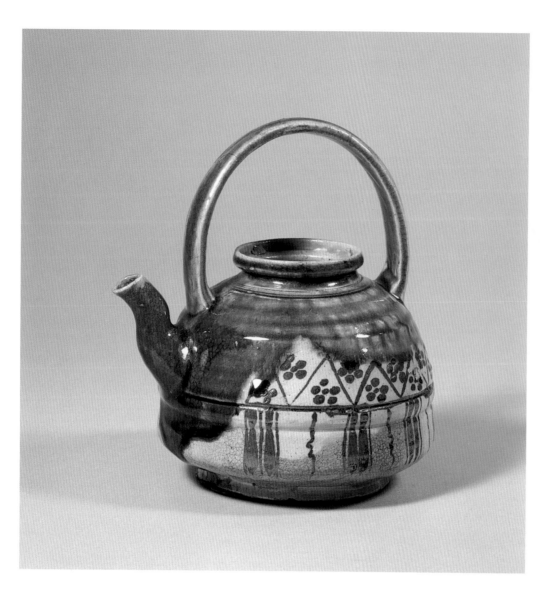

painting on the lower half of the vessel is partially covered with copper green glaze in an asymmetrical fashion. The painted designs appear to be influenced by contemporary textile techniques such as *tsujigahana* (stitch-resist tie-dyeing). There was much fluidity among the various artisan communities at the time, and there were numerous fabric designers in Okaya and Ōhira, the main Oribe ware kiln areas; influence from cloth producers seems natural.

The green glaze covers the loop handle, neck and spout of this delicately shaped ewer. The painted decoration above the waist of the vessel is in a saw tooth pattern with six-circle designs, painted in each triangle. This six-circle design, resembling a stylized plum blossom or Japanese heraldic crest, was also found on late Ming period export porcelains. The waist of the vessel has one bow string line and from it, running towards the base, is a pattern of stripes. The ewer would have been topped by a lid that has subsequently been lost.

NCR

References: Fujioka 1977; Takeuchi 1976, 255–67.

97. EWER

Green Oribe ware
Early seventeenth century
Stoneware with applied glaze and iron-oxide painted design
Height 19.5 cm
Gifu City Museum of History

Oribe ware when it was produced in the early seventeenth century was known as *imayaki* (newly-made ware), or more commonly, as Seto ware, after the nearby medieval Seto kilns. But by the end of the seventeenth century this type of ware began to be known by the name Oribe. The name seems to have been taken from the famous tea master Furuta Oribe who lived during the time when these wares were made, and is known to have owned and used them. Oribe's exact relation to the Oribe kilns is unclear, but, the design of pieces such as this do reflect Oribe's aesthetic preference for dynamic, individualized, and irregular forms and patterns.

This ewer is a classic example of Green Oribe (*ao Oribe*) ware combining painted pattern with solid glaze. Here the iron-oxide geometric

98. Square Dish

Oribe ware
Early seventeenth century
Stoneware with applied glaze and iron-oxide design
Height 6.9 cm; diameter 20.6 cm
Nagoya City Museum, Aichi

This square food serving dish with its floral and abstract design is an example of Narumi Oribe ware. This type of design utilizes both red and white clay on the same piece. Iron-oxide painting is applied over a white slip on the red clay. Green glaze is applied over a white clay section on one corner. The combination of green, white, red and brown makes Narumi Oribe one of the most colorful and sought after Oribe ware styles. This piece was made in a mold with both red and white colored clay pressed in together. Shrinkage rates vary in different types of clay, and the potter must be careful or the piece could easily crack in the kiln. In this dish, the potter has successfully used the green glaze as a ground line for the six floral buds that spring from the corner of the dish. The rest of the dish is covered with stripes and checks in white, outlined in iron-oxide.

NCR

References: Fujioka 1977; Takeuchi 1976, 255–67.

99. Set of Five Side Dishes

Oribe ware
Early seventeenth century
Stoneware with applied glaze and iron-oxide painted design
Height 4.3–4.5 cm; diameter 10.7–14.7 cm
Aichi Prefectural Ceramics Museum, Aichi

Certain *mukōzuke* (side dishes) were made in sets with similar shapes and motifs, such as the Karatsu ware set described below (cat. no. 102), while others, such as this set of five side dishes, were assembled after the firing either at the kilns or at the store, or by the owner. This set of side dishes was all fired around the same time, perhaps even in the same kiln, but they are all slightly different. Three of the dishes, while shaped differently, have a similar style of decoration and were probably made together. The interior designs on these three pieces are based on plum blossoms, one with a plum tree, one with a plum branch and one just with a scattered and stylized blossom. The exteriors of these pieces have a geometric line pattern, alternating with copper glaze that covers both the exterior and interior edges. One of the other dishes has an interesting abstract form of two plovers facing each other on the interior, and various isolated motifs on the exterior, for example a clove and a pine. The edges of this dish are also covered with green glaze and some of the motifs are painted, not in the standard iron-oxide, but with an iron-laden red slip. The remaining dish has no iron-oxide painting, but a complicated design in a saw tooth pattern of copper green glaze. All the dishes were formed in a mold and have three attached feet.

NCR

References: Fujioka 1977; Takeuchi 1976, 255–67.

(oxygen-rich) atmosphere in the kiln in which the piece was fired, the body turned a deep red-brown. This pot is famous for its striking brown iron-oxide design of branches of a leafless tree covered with clusters of three dots that are often described as persimmons, but more likely were intended to represent stylized plum blossoms. These dynamic groupings of three are echoed under the three ears with three discs of clay that have been added as decoration, as well as two round discs on either side of each ear by the neck of the vessel. These small discs were then covered with iron-oxide, incorporating them into the overall tree design. It has been suggested that the clusters of three discs on this piece might possibly represent a daimyo family crest.

The glaze covering the vessel and the painted decoration is feldspathic, with earth and ash mixed in, imparting a warm feeling to the jar. This is a particularly fine example of Decorated Karatsu (*e-Garatsu*), but Decorated Karatsu pieces represent only a small fraction of the overall Karatsu production. Over 90% of the Karatsu wares produced in the Momoyama and early Edo periods were plain undecorated green glazed dishes, bowls and jars for every day use. The demand for this type of Karatsu ware started to wane when Hizen province began to produce porcelain, but the demand for specialty Karatsu ware tea ceramics remained constant. The tea ceramics were produced mostly at two Karatsu kilns, Dōzono and Kameyano Tani kiln, and this ware was thought to be fired at the Kameyano Tani kiln in Takeo City, which is pictured in figure 68 in the introduction to this section.

NCR

References: Nakayama 1994, 80; Nakazato 1983; Trubner and Mikami 1981, 106–7.

100. TEABOWL, NAMED SAWARABI

Black Oribe ware
Early seventeenth century
Stoneware with applied glaze
Design painted in iron-oxide
Height 9.7 cm; diameter 9.3 cm; footring 5.3 cm
Fukuoka Art Museum, Fukuoka

Black Oribe ware (*kuro Oribe*) is known for its original shapes and distinctive black glaze. Using a process similar to Raku ware, a Black Oribe piece is removed from the kiln just after the glaze matures and is quickly cooled. The shape of this teabowl is called a *tsutsu chawan*, or cylindrical teabowl. The rim has a soft flowing line with an indentation under the lip, possibly to make drinking from the bowl more satisfying. The body was formed on a potter's wheel but then, as with most Black Oribe ware, intentionally distorted. A low, round footring was added by hand with a potter's mark clearly visible inside the footring. The body was dipped into the iron-oxide glaze in two stages, glazing the entire interior and exterior with the exception of a triangular space on one side of the teabowl. In this triangle two fern sprouts (*sawarabi*) painted in brown iron-oxide are shooting up to the left, giving the teabowl its name, expressing the feeling that finally it is spring!

NCR

Reference: Fukuoka 1992, 124.

101. TEA-LEAF JAR

Decorated Karatsu Ware
Early seventeenth century
Stoneware with applied glaze
Design painted in iron-oxide
Height 17.1 cm; maximum diameter 17.5 cm; mouth 9.4 cm; base 8 cm
Idemitsu Museum of Arts, Tokyo

The high quality of both potting and decoration reveals that this jar was not just a utilitarian product. The mouth opening is quite large, and it was probably used as a tea-leaf jar (*chatsubo*) for the tea ceremony. The green tea leaves used in the tea ceremony are of made from an early crop of young flowery upper leaves that are picked in the spring. The newly picked leaves would be placed in jars like this and stored in a cool, dry place. Perhaps because of its exceptional quality, this container might have been used for high-quality tea leaves that were picked in the spring and that had to be kept dry throughout the moist summer. The three loop ears around the neck of the jar would have had a silk cord running through them to help secure the lid. The tea leaves would be taken from this type of jar to be ground into powder right before the tea ceremony and then placed in a small tea caddy (*chaire*) for immediate use.

The potting of the body is rather heavy and typical of Karatsu ware. Due to the oxidizing

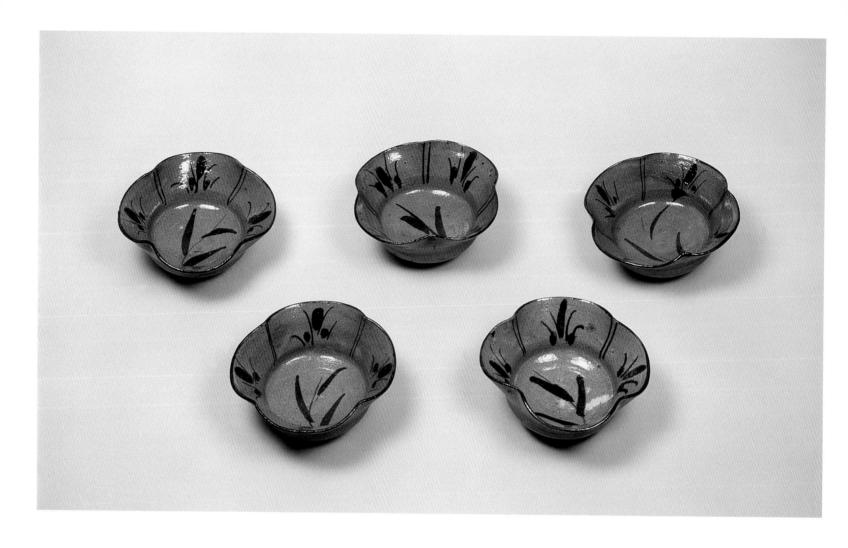

102. FIVE SIDE DISHES

Decorated Karatsu ware
Early seventeenth century
Stoneware with applied glaze
Design painted in iron-oxide
Height 5.9 cm
Diameter 12.9 cm; footring 4.7 cm
Aichi Prefectural Ceramics Museum, Aichi

This set of five relatively deep dishes (*mukōzuke*) was made for use in the *kaiseki* meal which accompanied the tea ceremony. The *kaiseki* meal developed into its present form during the latter half of the sixteenth century. Based on the more elaborate *honzen ryōri* – an individual serving tray with legs, filled with food dishes that would be set in front of each guest – the *kaiseki* meal pared the serving of food down to the ideal "one soup and three side dishes" on a flat or slightly raised tray. The soup would normally be made from *miso* (fermented soy bean paste), and the side dishes consisted of raw fish marinated in vinegar, or a vegetable or fish salad in vinegar dressing or thick sauce. These were served with rice. Because side dishes were placed towards the rear of the serving tray behind the soup and the rice, the dish was called a *mukōzuke*, literally, "attached to the rear." Other dishes, if warranted, were brought in separately by the

host of the tea ceremony. This style of *kaiseki* meal developed out of the form of tea called *wabicha*, popularized in Kyoto and Sakai among the merchant classes in the late Muromachi and Momoyama periods by Murata Shukō and Sen no Rikyū (fig. 67).

Louise Allison Cort characterized the practitioners of this new type of tea as follows: "escaping momentarily from their prosperous circumstances, they sought to express the aesthetic of *wabi*, transformed from the word's original meaning of 'pitiable poverty' to a positive mood of cultivated asceticism" (Cort 1990, 13, 15). The type of ceramics that were used in Momoyama *kaiseki* meals reflects the concepts of simplicity and rusticity implicit in the term *wabi*. Chinese wares were in general rejected for the more utilitarian Korean and Japanese ceramics, especially those in a "Korean" style that became very popular among tea circles.

This set of five dishes is a classic example of the type of Korean influenced ceramic that would have appealed to practitioners of *wabicha* tea style. The decoration is paired down to a few simple swift brush stokes of brown iron-oxide depicting stylized flowers and grasses on the interior of the dish, leaving the exterior

completely undecorated. The dishes were quickly potted on a kick wheel, and the edges were hand-formed to make a petal-shaped dish. The footring was also formed on the wheel (turning in the opposite direction). These dishes display the cut marks from the spatula that was used to create them. Almost completely covered with a feldspathic glaze, the dishes rest on the unglazed footring so that the pieces would not adhere to any surface during the firing process. The semi-opaque feldspathic glaze gives a soft feel, and while these pieces are in the true Karatsu style of ceramic both in form and design, influence from the Mino kilns can be discerned in the shape and also the style of the painted design. Similar examples have been uncovered at the Kameyano Tani and Ichinose Kōraijin kilns, and it is thought that this set of dishes was probably fired at one of these kilns.

NCR

References: Becker 1986, 37–53; Cort 1990, 9–36; Nakazato 1983, 5–15.

103. FOUR-SIDED BOWL

Decorated Karatsu ware
Early seventeenth century
Stoneware with applied glaze and iron-oxide painted
design
Height 8.6 cm; maximum diameter 26.6 cm; footring
7.8 cm
Idemitsu Museum of Arts, Tokyo

This small bowl is a classic example of Oribe style rendered in a Karatsu idiom. Although these wares were mutually influential, each retained its own identity in production methods, materials and style of design application. The bowl was potted on a kickwheel (a similar Oribe ware piece would most likely be hand constructed with the use of a mold) with a very small footing for its overall diameter. The sides were then folded over to form a square shape. The interior, visible through a frame created by the four bent-over sides has a beautifully executed mountainside scene viewed from afar, with two mountains edged with small pine trees and one large tree (a more schematized version of the tree depicted in cat. no. 101), jutting from the side of the large mountain. This pictorial scene is framed by the geometric designs painted on the exterior of the folded sides, alternating with two horizontal strokes and

five vertical ones.

The mixing of geometric and pictorial motifs is typical of the Oribe style, but here it is executed in a loose spontaneous hand that exemplifies the best of Karatsu-ware style. A feldspathic glaze covers most of the piece, leaving the footring and the very edge of the base bare. This piece is thought to have been fired at the Uchida Saraya Kiln.

NCR

References: Hayashiya 1989, 77, 125; Musée Cernuschi 1995, 248–9; Nakayama 1994, 90.

104. HEXAGONAL FLOWER CONTAINER

Korean-style Karatsu ware
Early seventeenth century
Stoneware with applied ash and straw glaze
Height 23.6 cm; maximum diameter 12.4 cm; base 10 cm
Idemitsu Museum of Arts, Tokyo

This flower container is one of the most exquisite examples of Korean Karatsu ware (*Chōsen-Garatsu*) extant. This is typified by a combination of a dark iron-rich glaze and a white rice-straw ash glaze (*warabaiyū*) covering a piece either partially or wholly. Generally a Korean Karatsu piece's only non-sculptural decoration is the patterning created through the combination of these colored glazes. While called Korean Karatsu, this glaze combination has not yet been found at a Korean kiln site, although these same glazes often appear separately. It is possible that further excavations in Korea will turn up a prototype, and it has even been speculated that this glaze combination occurred in northern Korea. Until further evidence emerges, the glaze combination can be viewed as a Korean-influenced Japanese invention.

On this six-sided flower container (*hanaike*), the white straw ash glaze contrasts vividly with the dark iron-oxide brown glaze. Where they meet, about one third of the way down the vase, a delicate but jagged line pattern is formed, giving the impression of melting snow. First the iron brown glaze was thinly applied, and on top of it a thick layer of the white straw ash was added. The reverse combination also occurs in Korean Karatsu wares. The piece was made by a paddling technique for which Karatsu is famous, and the paddle marks are visible if one peers inside the vessel. The paddling technique enabled the potter to make the sides quite thin, and the vessel consequently is surprisingly light to hold. One unusual feature is the design of grasses visible under the brown iron-oxide glaze incised on the six flattened sides. The base of the vessel is also thinly covered with glaze.

There are two holes drilled on opposite sides of the lip of the container so that it could be hung in a *tokonoma* (alcove) from either side. The overall design is quite sophisticated, with two well-formed ears on its neck and a mouth that is restricted at the opening to hold a small grouping of flowers or leafy plants. This flower container is thought to have been fired at the Fujin-Kawachi kiln, which operated under the patronage of the Matsuura daimyo.

NCR

References: Musée Cernuschi 1995, 184–5; Nakayama 1994, 82; Nakazato 1983, 5–15.

105. SET OF FIVE SIDE DISHES IN FOLDED-LETTER SHAPE

Takatori Ware
Circa 1615–30
Stoneware with applied glaze
Height 2.7 cm; diameter 19 x 10.4 cm; base 16.7 x 9 cm
Kyushu Ceramic Museum, Saga

The glaze on the five dishes with the mixing of white and dark colors is stylistically similar to the nearby Korean Karatsu wares (see cat. no. 104). But while the glaze technology resembles Karatsu wares, the shape of the dishes and method of application of the glaze is a classic example of Takatori production. This tied-paper or letter shape, a type of origami often used in tying written letters, is not found among Karatsu ware shapes. These pieces that were made for use in the *kaiseki* meal accompanying the tea ceremony as *mukōzuke* (side dishes) are made in a mold and have a flat base. The glaze was carefully applied so that the area where the two types of glaze met would form an undulating pattern breaking up and softening the stiff geometry set by the tied-paper shape.

NCR

References: Kozuru 1981, 10–14; Kyushu Ceramic Museum 1992; Nishida and Ozaki 1992.

106. LARGE DISH

Hizen ware
Circa 1630s
Porcelain with applied glaze
underglaze cobalt-blue decoration
Height 12.8 cm; diameter 45.8 cm
Kyushu Ceramic Museum, Saga

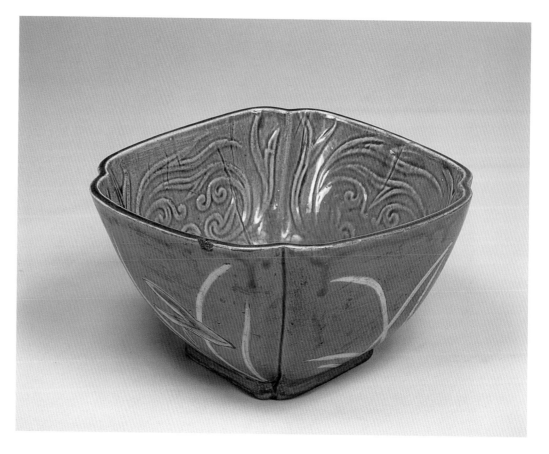

Dishes such as this are the first pieces in Japan where a large white porcelain surface was decorated in a painterly fashion. The schematized landscapes of many ceramic designs dating to the 1630s and 1640s reflect contemporary Kanō-style ink painting of idealized Chinese scenes.

On this plate the painted landscape depicts a slightly condensed scene of a Chinese pavilion and a stately pine behind it with rocks, mountains near and distant, as well as an expanse of water with two boats skimming across the surface. Clouds are scattered towards the top of the composition in the shape of *ruyi*-head motifs. More *ruyi*-head motifs are painted in a band pattern around the out-turned rim which frames the dish.

The small size of the footring reveals the limited technology available to the potter in the 1630s, footrings gradually started to increase in size as kiln tool technology developed in the late 1640s. The dish was fired at the Yanbeta number 3 kiln in the Arita area, Saga Prefecture.

NCR

References: Ishikawa 1987, 24, 136; Nishida and Ōhashi 1988.

107. MOLDED SQUARE BOWL

Hizen ware
Circa 1630s
Applied glaze porcelain with cobalt-blue underglaze
Height 11.1 cm; diameter 19.2 x 21.3 cm; footring 9.1 cm
Tokyo National Museum

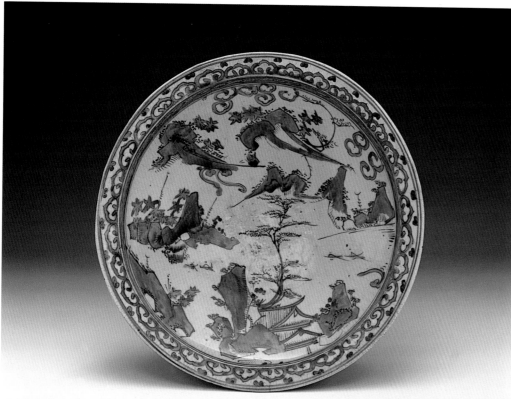

Early Japanese porcelain was mostly decorated with underglaze cobalt-blue, but from the 1630s new methods of decoration were increasingly explored. Underglaze copper-red started to be used as well as brown iron-oxide and different color glazes. Some of these new styles are quite modern in design. This bowl is from one of the peripheral Arita kilns called Yamagoya (1620–50) that is known for its experiments with brown, yellow (both iron based) and blue (cobalt) glaze used in varying combination with molded and painted designs. The bowl is an excellent example of the heightened artistic creativity in Arita during the 1630s and 1640s.

This foliated bowl was made with the use of a press mold that was placed inside the bowl. The decoration on the interior was made by the mold, and small wrinkles on the sides created by pressing the mold can still be seen in numerous places. The interior was decorated with a light relief stylized *karakusa* (Chinese grass) design and in the middle there is a stamped floral leaf design. Most of the vessel was covered in a light iron-based yellow/brown glaze, leaving areas of the exterior in the shape of water plantains and flowering grasses that expose the white porcelain body underneath with the designs finished in underglaze cobalt-blue. The entire piece was then covered with a clear glaze.

Although loosely based on Ming period Chinese prototypes, the execution and overall design of this bowl is clearly aligned with the emerging ceramic taste of the Edo period.

NCR

Reference: Ōhashi 1989.

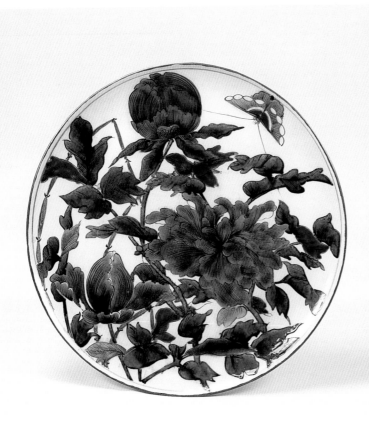

108. LARGE KOKUTANI-STYLE DISH

Hizen ware
Circa 1640s
Applied glaze porcelain with cobalt-blue underglaze
Overglaze polychrome decoration
Height 4.4 cm; diameter 34.7 cm; footring 19.3 cm
Tokyo National Museum, Tokyo

This large plate (*ōzara*) was less functional in light of Japanese cuisine, and perhaps served a more aesthetic purpose, almost like a painting. Many designs on these large Kokutani-style dishes are quite similar to contemporary screen painting, and were made for similar audiences. The use of quantities of deep purple, green and yellow overglaze enamel, and the drawing of large scale peonies are attributes of the Kokutani-style.

This dish is extremely flat with the edge raised slightly. Among the Kokutani-style wares this shape is rather rare. The lip of the dish is painted with a band of iron-oxide (*kuchi-beni*), and the peony, butterfly and scouring rush pattern come right to the edge. The motifs are outlined with a thin dark brown line, and occasionally the overglaze colors do not fill the delineated area. Only the butterfly's antennae and the scouring rush are depicted in red enamel without a brown outline. The exterior of the dish is decorated with a peony flowering scroll in underglaze cobalt-blue. The Chinese character for "good luck" (*fuku*) is inscribed in block style inside the footring. The outer rim of the footring is decorated with a banded comb pattern.

NCR

References: Arakawa 1992, 50–63; Kyushu Ceramic Museum 1991; Ōhashi 1989.

109. LARGE KOKUTANI-STYLE SAKE EWER

Hizen ware
Circa 1640s
Porcelain with polychrome enamels
Underglaze cobalt-blue decoration
Height 19.4 cm; width 22.5 cm; diameter 13.2 cm
Agency for Cultural Affairs, Tokyo
Important Cultural Property

This sake ewer (*chōshi*) is a particularly fine example of the inventiveness and artistic energy that infused early Arita-area kilns like Maruo and Yanbeta that were firing works in the Kokutani-style. This shape is clearly derived from metal prototypes. Altogether there are three known porcelain Kokutani-style ewers that have a similar shape, with the other two housed in the MOA Museum in Atami, and the Tokyo National Museum. This ewer, because of the dynamic application of overglaze enamels and painterly rendition of the Chinese lion and peony motifs (*karashishi botan*) as well as the finely formed body, is considered the finest example among the three.

The mouth of the ewer is quite large and covered with a lid with a knob top. Sherds with an identical knob lid have been found at the Maruo kiln group and it can be assumed that this piece was fired there. The handle is decorated in a stylized chrysanthemum scroll in underglaze cobalt-blue, perhaps because the overglaze colors used extensively on the body were known to wear down with repeated handling. While most of the vessel and lid were covered with a clear glaze after the underglaze decoration had been applied to the handle, the mouth of the vessel, where the lid rests, was not covered in this clear glaze because the lid would have been fired in place on the ewer during the main firing to allow for a perfect fit. Since these edges around the mouth were left unglazed, they were covered with a yellow overglaze enamel directly on the biscuit.

NCR

References: Arakawa 1992, 50–63; Kyushu Ceramic Museum 1991; Ōhashi 1989; Shimizu 1988, 324–5

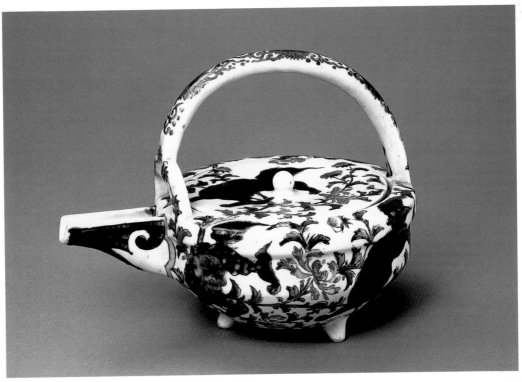

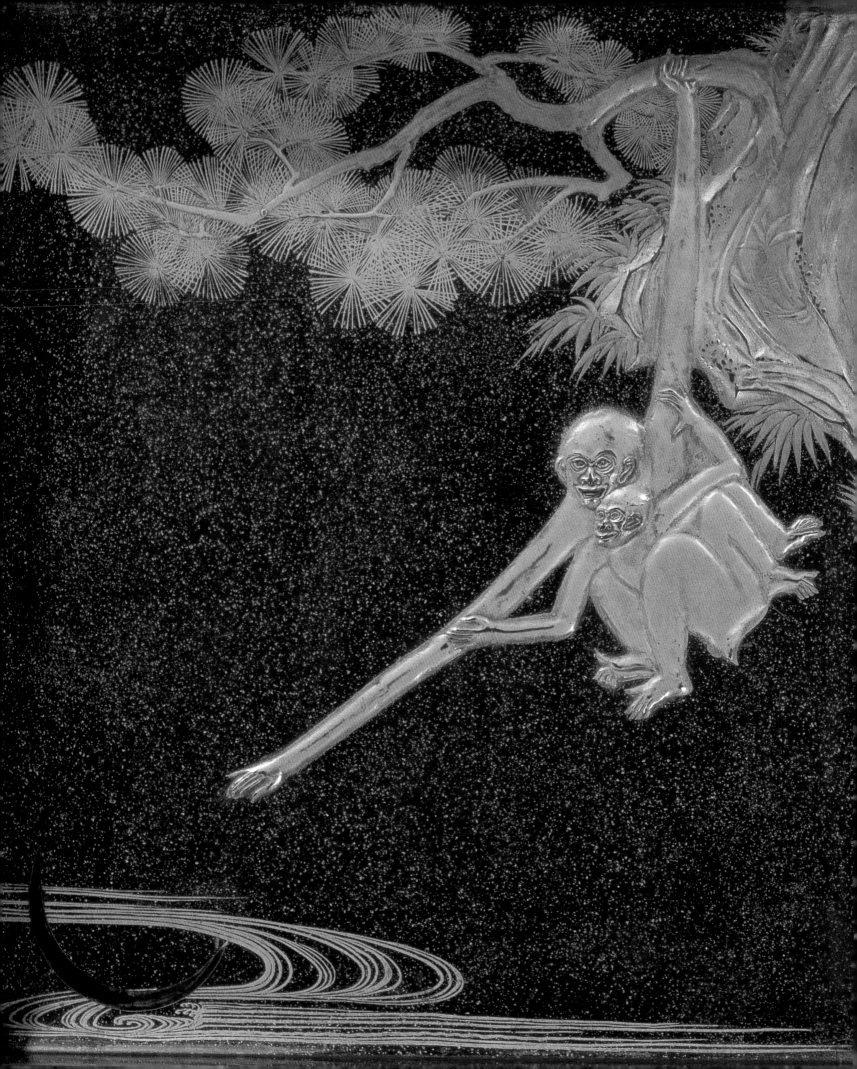

Lacquer & Metalwork

Andrew J. Pekarik

Despite its relative brevity, the Momoyama period played an important role in the development of Japanese lacquer. The vast castle-building projects of the time, coupled with economic prosperity and an abundance of gold and silver set the stage for a dramatic increase in demand for lacquer decorated with designs of sprinkled gold and silver. Interior spaces needed to be decorated and furnished, and the spirit of competition and impressive display encouraged clients to vie with one another in commissioning new work.

Lacquerers responded to this situation imaginatively. Lacquer-making is a demanding and exacting art. Raw lacquer, the sap of the lacquer tree, is difficult to handle because it induces allergic reactions in most people. A lacquerer must develop and maintain immunity through constant exposure. The viscous sap is thinly applied to a prepared surface, and hardens in an atmosphere of very high humidity. During the hardening process it is susceptible to stray fragments of dust that would mar its surface. Once it has set it must be polished, usually with water and small pieces of soft stone or charcoal. Layer on layer is applied until an adequate surface has been created. If it is to be decorated, as all the items in this exhibition are, the design must be applied and polished as well. Altogether a high-quality lacquer object can take from months to years of effort as it advances through all the necessary stages from the preparation of a wooden base to the final polishing.

The principle decorative technique used in these lacquers is a traditional Japanese method called *maki-e* (pronounced *mah-key-eh*), literally, "sprinkled design," because the design is first drawn in lacquer and then metal powders or flakes (usually gold, silver or a mixture of the two) are sprinkled over the drawing before the lacquer hardens. The powders stick to the drawn lines or areas. Traditionally the designs for *maki-e* were drawn first in ink on paper

and then transferred to the object, but the level of demand during the Momoyama period forced lacquerers to find some shortcuts. The result of these changes was a loosening and invigoration of the drawings themselves.

Instead of transferring designs from paper drawings to the object surface, Momoyama lacquerers tended to draw directly on the object with the raw lacquer (sometimes using a contrasting color so that they could follow their drawing more easily). To achieve different tones and textures in the image they varied the kinds of powder or flakes that they applied. Areas where large flakes were set deeply into orange-tinted lacquer are known as *nashiji* ("pear-skin ground") because they tended to have slightly textured surfaces. Traditionally this technique was used as an overall ground for large undecorated areas such as the backs or bottoms of objects. In the Momoyama period *nashiji* was also used to create contrasting areas within a design. This distinctive technique is called *e-nashiji*, "pictorial *nashiji*."

In a complex design where thin lines needed to be visible, such as in the veins of *maki-e* leaves, the traditional technique was either to sprinkle them with a different powder, to raise the lines, or to leave them in reserve. These methods are time-consuming. Momoyama lacquerers often employed the technique of using a sharp point as a drawing tool to etch thin lines into the design (called *harigaki*, "needle drawing"). Finally, Momoyama lacquerers tended to use fewer layers of protective lacquer on top of finished *maki-e* designs, so that the designs themselves were fragile and now often show distinctive wear.

Scholars of Japanese lacquer have divided the *maki-e* works of the Momoyama period into four major categories based on the style of the decoration.[1] First are the objects that continued the techniques and styles of the preceding period. The writing utensil box is an example of this type (cat. no. 110).

The largest category of Momoyama-period lacquers is called Kōdaiji *maki-e* or Kōdaiji lacquers. The style derives its name from

Fig. 69 Monkeys reaching for the reflection of the moon, interior of a writing utensil box, detail of cat. no. 110.

Fig. 70. Doors of Hideyoshi's miniature shrine, ca. 1596. Tamaya ("Sanctuary"), Kōdaiji, Kyoto.

that objects would function properly while maintaining the appropriate symbolic allusions. This subtlety of content was reduced somewhat in the Momoyama period by the high level of demand and by the lower level of erudition among the warrior clientele, accounting for the abundance of autumn grass motifs, which are generically poetic without requiring specific literary training. As if in exchange, the circumstances of the times brought new creative energy to the lacquer-making process along with the inspiration of foreign influences.

The metal arts also flourished during this time. The extensive building projects of the Momoyama period actively engaged metalworkers in the creation of decorative architectural fittings and temple implements. The patronage of the warrior class also encouraged the development of sophisticated decorating techniques for sword fittings, stirrups, and other military accoutrements (see pp. 261–2). The events of this period offered some new opportunities for metalworkers, as well. On the military side, the European introduction of firearms gave rise to gunmaking in Japan (see cat. no. 133), while, on the cultural side, the popularity of the tea ceremony fostered the expanded production of subtly beautiful kettles for boiling water (see cat. no. 80).

While many great metal artists of the period, such as the renowned mirror-maker Ao Ietsugu, continued to use traditional shapes and materials, the abundance of precious metals resulting from the opening of new mines throughout the country tempted some patrons to commission gold or silver versions of common items. The most famous example of this extravagance is the set of solid-gold tea implements that Hideyoshi ordered for use in his gold-plated portable teahouse (fig. 18). Ieyasu's silver washing bowl and towel rack also reflect this trend (see cat. nos 127, 128).

one of its best examples, the interior decorations in the mausoleum established for Hideyoshi by his wife at Kōdaiji, a temple in Kyoto (fig. 70).[2] Kōdaiji-style lacquer decoration favors designs of autumn grasses and flowers, and employs the expressive, time-saving techniques developed at this time: direct drawing, pictorial *nashiji*, and needle-drawing. Catalogue numbers 116 and 117 are typical examples.

The third category is called Namban lacquers, after the word used to describe Europeans in Momoyama Japan.[3] These works were commissioned by Europeans for export and also for use in churches in Japan. They featured some of the same techniques as Kōdaiji wares (they were, after all, made by the same lacquer artists under similar production pressures) but they also used extensive mother-of-pearl inlay and followed the shapes and designs dictated by the clients (see cat. nos 122–6).

The fourth category contains those works associated with the great connoisseur and designer Hon'ami Kōetsu (1558–1637). Although there is no evidence that Kōetsu was himself a lacquerer, he seems to have played a creative design role. Kōetsu *maki-e* are characterized by themes from classical literature which are depicted in unique ways, usually as isolated close-ups, and also by unusual shapes and materials. Techniques of execution in Kōetsu-style lacquers tend to be traditional (see cat. nos 119, 120).

Little is known about the actual working practices of Momoyama lacquerers, only a handful of whom are known by name. It seems that they generally worked in small shops of three or four people relying on subcontractors for materials and components.[4] These shops came together as collaborative partnerships when undertaking large or difficult orders.

Because lacquer was a luxury commodity long associated with artistic pursuits and the highest levels of aristocratic sophistication, lacquerers traditionally worked closely with their clients to ensure

NOTES

1. See, for example, Suzuki Norio, "Lacquerware in the 16th Century," in Cunningham 1991, 105–8.
2. These lacquer decorations were originally created for Hideyoshi's Fushimi Castle and later moved to Kōdaiji.
3. For an introduction to Kōdaiji and Namban lacquers, see Haino Akio, "The Momoyama Flowering: Kōdai-ji and Namban Lacquer," in Watt and Ford 1991, 163–73.
4. For a contemporary illustration of *maki-e* artists at work in the Momoyama period, see Pekarik 1980, 25.

FURTHER READING

N.S. Brommelle and Perry Smith, eds., *Urushi: Proceedings of the Urushi Study Group, June 10-27, 1985, Tokyo* (Marina del Rey, Calif.: The Getty Conservation Institute, 1985).

Barbra Teri Okada, *Symbol and Substance in Japanese Lacquer: Lacquer Boxes from the Collection of Elaine Ehrenkranz* (New York: Weatherhill, 1995).

Andrew J. Pekarik, *Japanese Lacquer, 1600–1900: Selections from the Charles A. Greenfield Collection* (New York: The Metropolitan Museum of Art, 1980).

Beatrix von Ragué, *A History of Japanese Lacquerwork*, trans. Annie R. de Wasserman (Toronto: University of Toronto Press, 1976).

James C.Y. Watt and Barbara Brennan Ford, *East Asian Lacquer: The Florence and Herbert Irving Collection* (New York: The Metropolitan Museum of Art, 1991).

Ann Yonemura, *Japanese Lacquer* (Washington, D.C.: Freer Gallery, 1979).

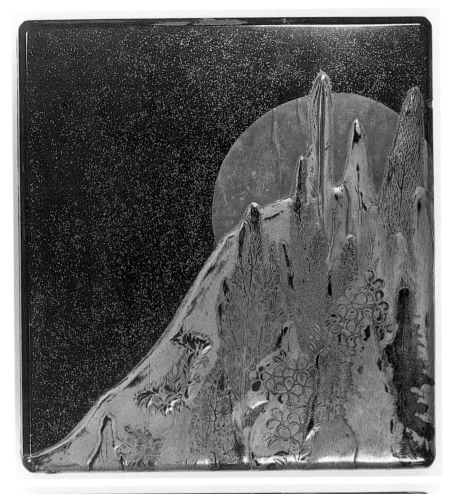

110. Writing Utensil Box with Designs of Hatsuse Mountain Landscape (exterior) and Monkeys (interior)

Late sixteenth century
Lacquer on wood base
Hiramaki-e, *takamaki-e*, applied metal
22.4 x 21.2 x 4.5 cm
Agency for Cultural Affairs
Important Cultural Property

Writing boxes were very important lacquer objects because they held the tools of personal reminiscence, correspondence, and poetic expression–the ink and brushes needed for writing. In this box, the tray below originally held brushes and inksticks. The round metal water-dropper that sits in a depression on the upper left side was used to add some water to the inkstone on which the inkstick was rubbed to make ink. The inkstone also sits in a fitted space, to keep it from moving around as the inkstick is rubbed on it.

Perhaps because the act of writing linked these boxes directly to literature, it became customary in the Muromachi period to decorate them with designs that encoded poems. Sometimes part of the text itself was written into the design to ensure that the poem was properly identified. The design on this box seems to carry that tradition forward, although no specific words were included in the design.

A poem by Fujiwara no Yoshitsune (1169–1206), first published in 1439 (in the *Shinshoku kokin wakashū,* no. 210), has been singled out traditionally as the source for the design on the outside of the lid:

> *hatsuseyama*
> *hana ni harukaze*
> *fukihatete*
> *kumo naki mine ni*
> *ariake no tsuki*
>
> Hatsuse Mountain –
> All the blossoms have scattered
> Blown by the spring wind
> And beside its cloudless peak
> A full moon in the dawn sky.

This poem fits the illustration extremely well. The cherry blossoms are drawn out of scale with the rest of the design and are not attached to any branches. The trees on the mountain include *hinoki* (cypress) that, along with the cherry tree, are sometimes associated with Hatsuse Mountain in classical poetry. And there is no mistaking the large, applied-silver moon in the cloudless sky.

The design on the inside of the lid (fig. 69) shows a monkey with its offspring reaching for the reflection of the thin-slivered moon in water (here the applied silver has been lost). This subject is based on images in Chinese painting. The theme is Buddhist and can be traced back to an Indian text on monastic rules that was translated into Chinese in the third century (*Sōgiritsu* in Japanese). The Buddha told the story of a monkey who looked down a well and was very upset to see a reflection of the moon at

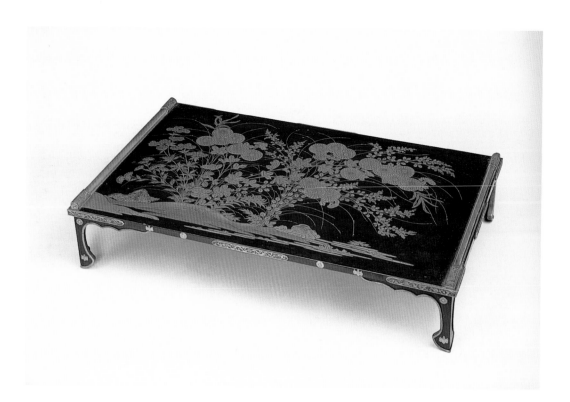

the bottom. "The moon has fallen into the well," the monkey cried out to the other monkeys in the troop, "let's save it!" So they linked themselves together in a chain suspended from a branch over the well. The branch broke under the weight and all the monkeys died.

What brings these two moon themes together on the same writing box? The link may be the famous temple, Hasedera, located at Hatsuse Mountain. The image that most frequently accompanies Hatsuse Mountain in poetry is the sound of the temple bell at Hasedera. In the Momoyama period Hideyoshi and his younger stepbrother, Toyotomi Hidenaga (ca.1540–91), reconstructed Hasedera and revived it as headquarters for one of the principal sects of Shingon Buddhism. (The previous headquarters, Negoroji, was destroyed by Hideyoshi in 1585, probably because its warrior monks resisted his authority.)

Meditation on the moon is a fundamental practice in Shingon Buddhism (see Masaki 1993). From the earliest times in the Buddhist tradition, the full moon has symbolized enlightenment and monkeys have been associated with delusion. The foolish monkey mistakes the reflection for the moon, risking its life for an illusion. The dedicated monk focuses on the real moon, not distracted by attachments which, like the cherry blossoms blown from their branches by the warm spring breeze, have been swept from his heart.

This writing box would have been a most appropriate commission or gift for the newly powerful Hasedera in the Momoyama period.

AJP

Reference: Cunningham 1991, no. 44.

111. WRITING TABLE WITH DESIGN OF AUTUMN GRASSES

Late sixteenth century
Lacquer on wood base
Hiramaki-e, takamaki-e
11.2 x 58.2 x 34.2 cm
Myōhōin, Kyoto
Important Cultural Property

This table may have belonged to Hideyoshi. His crests, the chrysanthemum and the flowering paulownia, appear on its sides and legs.

Tables like this are called *bundai* ("text stands"). They held books, scrolls and poem cards, especially during poetry competitions or linked-verse gatherings. The raised borders at the left and right edge prevented scrolls from rolling off the table.

The design on the table top presents an arrangement of flowering autumn plants. Chrysanthemums are most prominent, along with a variety of chrysanthemum called *fujibakama* ("purple trousers") on the far left, and flowering *hagi* (often translated as "bush clover") on the right. Thin blades of grass with drops of dew form another key design element. The flowers and grasses were made with the relief technique called *takamaki-e*, in which a paste made of lacquer mixed with powder (usually clay or charcoal) is used to sculpt the design above the surface of the black-lacquered ground.

Autumn was the favorite season of Japanese poets. Innumerable verses trace the range of feelings brought on by the season, from the first cool breezes signaling summer's end to the desolate darkness of approaching winter. Autumn poems, in general, emphasize loss, but this is also the season of the last flowering of the spectacular chrysanthemums and the more subtle and gentle blossoms of plants like the *fujibakama* and *hagi*. The poignancy of this passing moment finds its key metaphor in the dew on the grasses. Life and love are fragile like the dew, said the poets.

The design on this table does not refer to a specific poem but to the complete corpus of autumn poetry and its implicit message of living fully in the passing moment. The theme of autumn flowers and grasses became the dominant design motif for lacquer in the Momoyama period. It is found on objects that belonged to Hideyoshi, on the interior decoration of the mausoleum of the temple called Kōdaiji set up in his memory by his widow (fig. 70), and on a number of similar lacquers (collectively called Kōdaiji-style lacquers), as well as on the export lacquer wares (called Namban lacquers) that were distinctive products of the time.

AJP

Reference: Shimizu 1988, no. 223.

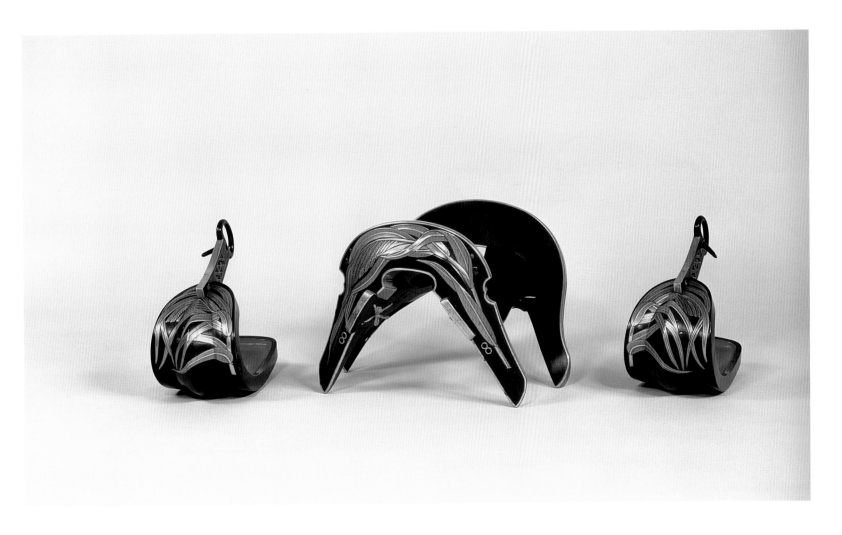

112. SADDLE AND STIRRUPS WITH DESIGN OF REEDS AND DEW

Late sixteenth century
Lacquer on wood
Takamaki-e, applied metal, metal inlay
Saddle: 36.7 x 28.2 cm
Stirrups: 28.8 x 27 cm
Tokyo National Museum
Important Cultural Property

The military aristocracy of feudal Japan prided itself on its integration of warrior skills and refined arts. Since at least as early as the Heian period warlords owned and used saddles with elegant lacquered designs, some of which explicitly referred to classical poems. This saddle was owned by Hideyoshi, according to a surviving sketch of the saddle design attributed to Kanō Eitoku (cat. no. 112a) that bears the notation, "Middle of the first month, fifth year of Tenshō [1577] Hideyoshi," accompanied by Hideyoshi's *kaō* (a distinctive calligraphic mark that functioned like a signature). Yet an inscription on the saddle, "Ninth month, second year of Bun'an [1445]," suggests that it is an older structure that was redecorated for Hideyoshi.

The highly original design shows a single stalk of flowering reed on each decorated surface. The reeds bend elegantly as their leaves twist and curl energetically. Large dots of inlaid-silver dew accent the grass. The design could be thought of as a bold, sharply focused restatement of the same generic autumn grasses theme that is so pervasive in Momoyama lacquer, especially in Kōdaiji and Namban lacquers. But one detail stands out. As the preparatory drawing shows even more clearly than the finished work, the end of the stalk is depicted in the design as if it had been cut by a sharp blade. Almost all grass designs in Momoyama lacquer imply that the grass is somehow rooted, no matter how abstract the decorative context. It seems possible that

Cat. no. 112a. Kanō Eitoku: Preliminary drawing for a lacquer saddle. Tokyo National Museum.

something more might have been meant in the design, perhaps even a reference to the traditional poetic pun that links two homonyms: *kariho* meaning "cut reed-head" (a symbol for autumn) and *kariho* meaning "borrowed hut" (referring to a primitive lodging where a traveler stops for the night).

An example of this pun in poetry is the travel verse by Fujiwara no Michitoshi (1047–99) published in the imperial anthology *Shinchokusen wakashū* (no. 517):

> *isogu tomo*
> *kyō wa tomaramu*
> *tabine suru*
> *ashi no kariho ni*
> *momiji chirikeri*
>
> Though I must hurry
> I will stop here for the night.
> By the borrowed hut
> With cut reeds, where travelers stay,
> The autumn leaves are falling.

The *takamaki-e* technique, which sculpts the reed in three dimensions, is especially well-suited to this design. It makes the cut stalks seem physically independent of the black lacquer background, even as the bent reeds flawlessly accommodate the shapes of the saddle and stirrups.

AJP

Reference: Shimizu 1988, no. 219.

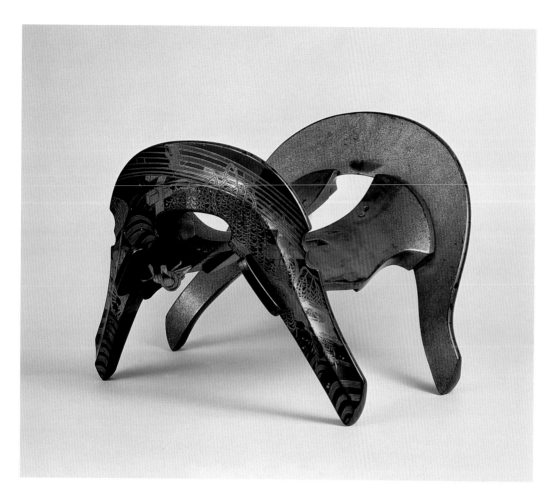

adapting this complex theme to the shape of the saddle. The bridge and waves curve naturally but other elements, such as the willow, waterwheel and rock-filled basket, had to be shown in suggestive fragments.

Gold dots, often shown here in pairs set among the billowing waves, describe bubbles generated by the rapidly flowing water. They immediately bring to mind the famous opening lines of a contemplative essay *Hōjōki* (The Account of My Hut) written by Kamo no Chōmei (ca.1155–1216) in 1212, just after the terrible struggles between the Taira and the Minamoto had ended:

> The flow of the river is ceaseless and its water is never the same. The bubbles that float in the pools, now vanishing, now forming, are not of long duration: so in the world are man and his dwellings (trans., Keene 1955, 197).

There is no record of who owned this saddle (the *kaō* following the date in the inscription, "Third month, thirteenth year of Tenshō [1585]," has not been identified). The chrysanthemum crest drawn in silver *maki-e* on the ends of the saddle body could refer to any number of warlords. Whoever he was, he would have fully appreciated both the message of courage in battle suggested by the Uji Bridge and that of the fragility of life implied by the bubbles on the water.

AJP

113. SADDLE WITH DESIGNS OF RIVER, BRIDGE, AND WILLOW

Circa 1585
Lacquer on wood base
Hiramaki-e
37.6 x 30 cm
Equine Museum of Japan, Kanagawa

The curved bridge, willow trees, water wheel, and basket of stones (used on river banks to limit erosion) are standard references for the bridge over the Uji River, outside of Kyoto. This theme became very popular in the Momoyama period and appears on screen paintings, lacquers and ceramics. Most illustrations of the Uji Bridge theme were probably inspired by a wide range of literary references, especially to classical poetry and *The Tale of Genji* (see cat. no. 63). Uji Bridge was revered as a scenic site with rich poetic overtones (see Takeuchi 1995).

The Uji Bridge was also the location of a bloody battle in the twelfth century that was immortalized by its dramatic telling in the great war tale *Heike monogatari* (The Tale of the Heike), which recounted the armed conflicts between the Taira and the Minamoto clans at the end of the Heian period. What more appropriate decoration could a saddle have than a poetic reference to a place where famous warriors demonstrated extraordinary courage?

The artist faced a considerable challenge in

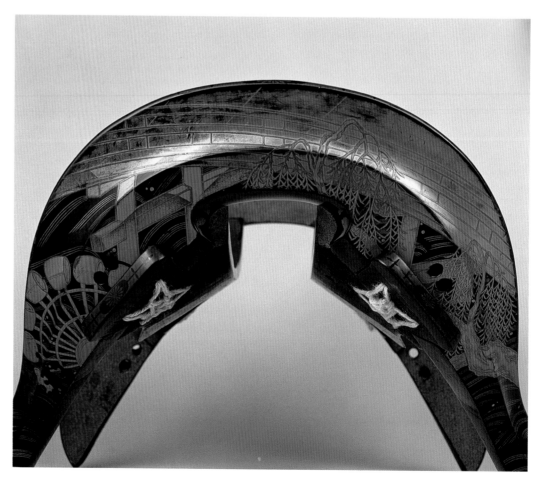

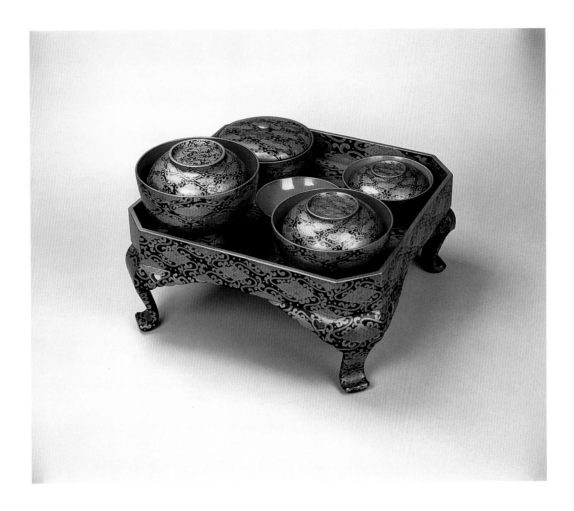

114. FOUR-LEGGED CEREMONIAL TRAY AND FOOD CONTAINERS WITH STYLIZED CLOUD AND GRASS DESIGNS

Late sixteenth century
Lacquer on wood base
Hiramaki-e
Tray: 33.3 x 33.3 x 14.3 cm
Myōhōin, Kyoto

At Momoyama-period banquets each guest was provided with a matching set of three trays like this one, covered with containers holding rice, fish, meat, soup, vegetables, and other delicacies. The three containers with rounded lids were designed to fit inside one another as a nested set, so that they are easier to store. The largest of the three would have been used for rice, the next largest for soup. The contents of the other dishes varied according to the menu and the season.

The complex etiquette for using utensils like these was recorded by a Spaniard, Bernardino de Avila Girón, who lived in Japan during the Momoyama period:

> You must first take the sticks in one hand and tap the table with their points in order to adjust them properly. Then you must raise the *goki* [rice bowl] and take three morsels of rice, and then you must put the bowl back on the table, back on the table, I say, and nowhere else. Then you take the *kowan* (or bowl) of *shiru* [soup], drink a little, and then put it down. You next lift up the *goki* once

more, take two morsels of rice and then put the bowl down again. Then once more the *kowan* and one or two mouthfuls of *shiru*; then for the third time you raise the *goki* of rice and take one morsel. And then, if you so wish, you may sip the *shiru* and help yourself from all the other available dishes until you can no more or there is nothing left (trans., Cooper 1965, 195).

The visual effect of this set is especially elaborate, as virtually all the outer surfaces are covered with a complex intertwining design of lozenges and arabesques, a motif known as *kumo karakusa* ("clouds and Chinese vines"). These trays and bowls are said to have belonged to Hideyoshi and represent the more flamboyant side of his taste. The black and gold decorations on the exteriors of the covered bowls contrast effectively with their plain red interiors. The natural color of lacquer is a translucent brown. Coloring agents were added to the lacquer to create black (usually using iron or lampblack) or red (using hematite or cinnabar). Opening one of these bowls at a banquet meal would have been a dramatic event, as the steaming, carefully composed food was suddenly revealed against the bright monochrome background.

AJP

Reference: Cunningham 1991, no. 50.

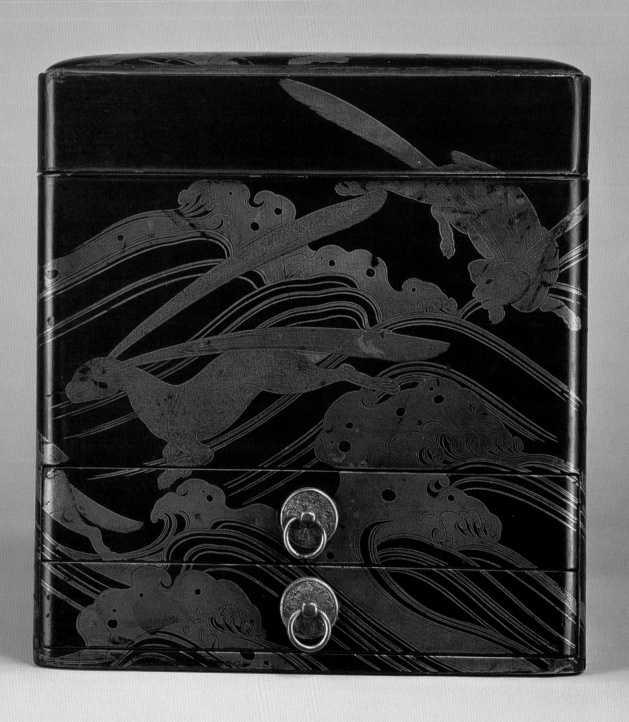

Late sixteenth–early seventeenth century
Lacquer on wood base
Hiramaki-e
27.8 x 21.5 x 23.7 cm
Tokyo National Museum

Portable comb boxes were a basic accoutrement for elite women in the Momoyama period and later. Although this box no longer includes its contents, it probably once held a square bronze mirror (and possibly a collapsible stand for the mirror), as well as a set of combs, brushes, tweezers, razors, ear picks, and small containers for essential cosmetics, including hair pomade and white face powder. The lowest drawer in the box originally held an inkstone and brushes, a standard feature of traveling cosmetic cases like this one. Apparently the implements required to brush a thoughtful note were no less essential than the tools needed to maintain a fashionable appearance. The two metal loops on the side of the box originally had thick cords attached. These cords were tied on the top of the box to secure the lid in place during transport.

The striking design of long-eared rabbits dashing across the waves was a new, popular image in the Momoyama period, one that is also found on clothing and ceramics (see fig. 75 and cat. no. 27b). The subject is thought to have a rather elaborate and elevated origin in the Noh drama called *Chikubushima* (Chikubu Island). In that play a courtier on pilgrimage to Chikubushima is crossing Lake Biwa in a boat and expresses his appreciation of the striking scenery in involved metaphorical language rooted in Chinese poetry: "the reflected green of the trees has sunken into the lake and fish now climb their trunks; the moon floats over the water, and do rabbits now run over the waves?"

In Asian legend, from India through Japan, rabbits live on the moon, and the poet, observing the reflected moonlight gliding over the water as the boat crosses to the island, suggests that this implies that rabbits are running over the waves.

It seems a long way from this stilted, overwrought metaphor to the madly scampering rabbits drawn by the lacquer artist. The quiet lake of the poet has become a froth of billowing waves. There may have been additional, intermediate sources that account for the sudden popularity of this motif. The unusually long ears on the rabbits shown here and on other rabbit and wave designs have been traced back to Persian sources and may be an indirect reflection of Japan's inclusion on international trade routes during the Momoyama period (Iwasaki 1985, 86).

AJP

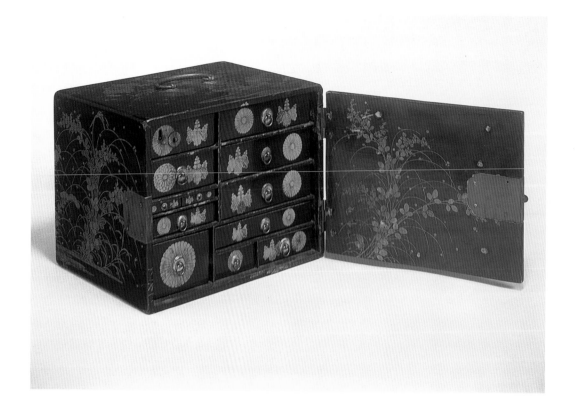

116. PORTABLE CHEST OF DRAWERS FOR INCENSE WITH DESIGN OF AUTUMN GRASSES

Late sixteenth–early seventeenth century
Lacquer on wood base
Hiramaki-e
18.8 x 24.4 x 19.2 cm
Tokyo National Museum

Incense has a long history in Japan. Since at least the Nara and Heian periods, aromatic woods, spices and other materials were powdered and mixed in distinctive proportions. Such incense was commonly used to scent clothing by suspending robes around the burning incense until they were steeped in an attractive scent. The taste, sensitivity, and creativity of Heian courtiers could be judged from the quality of their personally mixed fragrances.

The appreciation of incense reached new heights in the Muromachi period with the development of the incense ceremony. Trade missions brought logs of exotic, tropical woods to Japan from Southeast Asia. The fragrances of these woods were enjoyed in a precise, controlled way by warming a tiny splinter of the material on a small square of mica in a hand-held incense cup which contained a small piece of burning charcoal in a bed of ash. By cupping one's hand around the top of the cup and raising it to the nose, one could inhale the delicate scent of the heated wood.

The incense ceremony centered on appreciating the subtle differences among these rare woods. The source logs were given names that referenced the themes of classical literature, and even specific poems or novels. As in the tea ceremony, which developed around the same time, a social dimension – a gathering of aesthetically minded friends–and a private dimension – a focused concentration on the senses–were brought together in a symbolic environment that drew on centuries of artistic tradition. In the Momoyama period every well-bred woman was expected to be familiar with the delicate pleasures of the incense ceremony, and to own a fine set of appropriate tools.

As the different-sized drawers of this box suggest, an individual might have large portions of some logs and only tiny fragments of others, depending on their rarity and fame. Each drawer (except for two) is marked with two crests, the chrysanthemum and the paulownia. The chrysanthemum crest (note that one of them is drawn differently from all the others) originally belonged to the imperial household. In the Muromachi period the emperor gave a few individuals the right to use it, and this practice was extended in the Momoyama period to the degree that some powerful individuals apparently took the crest without permission and prohibitions had to be issued. The weaker the court became, the more the crest was used.

Hideyoshi was granted the use of the chrysanthemum crest and he displayed it with great pride. It was one of many ways that he drew upon traditional symbols of the aristocracy to add legitimacy to his position as de facto ruler of Japan.

Along with the chrysanthemum crest, Hideyoshi also used the design of the flowering paulownia. This symbol, too, was originally associated with the emperor, since it referred to a Chinese legend that the phoenix would alight in a special type of paulownia tree in the age of a righteous ruler. During the Muromachi period the paulownia crest was regularly given by the emperor to the Ashikaga shogun. Although Hideyoshi never took the title of shogun, the emperor granted him use of the paulownia crest.

The designs of autumn flowers and grasses on the outside of this box and the inside of the lid are typical examples of the Kōdaiji style of lacquer. The drawing of the thin blades of the grasses, in particular, shows the loose, spontaneous spirit that is prized in Kōdaiji lacquer designs.

AJP

246

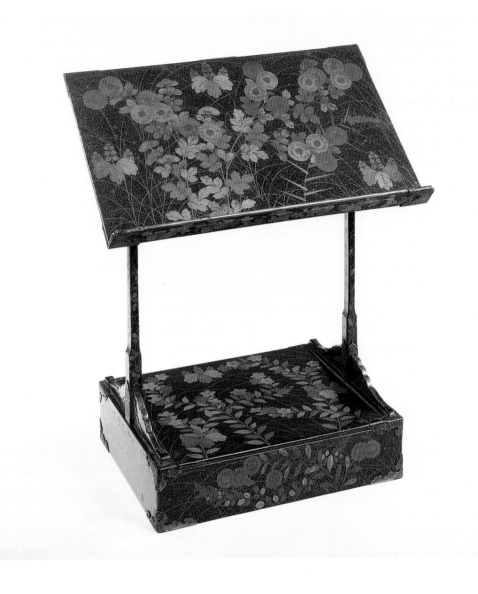

117. Bookstand with Designs of Autumn Grasses

Late sixteenth–early seventeenth century
Hiramaki-e
29.2 x 37.5 x 57 cm
Tokyo National Museum

This bookstand (*kendai*) was used to hold texts while reading or chanting. It is thought to have belonged to Hideyoshi and has his paulownia crests and chrysanthemum crests cleverly worked into the design. The paulownia crests float rather sparsely and unobtrusively within the design, and the chrysanthemum crests are suggested by chrysanthemum flowers, almost all of which present themselves from the same directly frontal view. Even more subtly, crests are worked into the metalwork that protects joints and other vulnerable areas on the stand. The overall design implies an atmosphere of casual opulence and restrained authority. We can easily imagine Hideyoshi sitting in front of this stand to practice his Noh chanting.

The stand is a typical example of Kōdaiji lacquer, but if we compare it to the incense box (cat. no. 116) we can see how broad a range of style and technique is contained beneath that rubric. Like the incense box, the bookstand is decorated with autumn flowers and grasses, although their overall composition is more scattered and the scale of the flowers is larger. The drops of dew are much less obvious on the bookstand and the background is evenly sprinkled with gold flakes, creating a richer, more decorative appearance. Both use the standard Kōdaiji techniques of pictorial *nashiji* (*e-nashiji*), needle-drawing (*harigaki*), and freely drawn grasses. But there are also differences in the application of the lacquer. Drawn areas on the recitation stand are thicker, more heavily sprinkled with gold, and more thickly coated with transparent layers of lacquer that were subsequently polished. In general we can say that the recitation stand is a more extravagant, and perhaps slightly later production than the incense box.

Note the lid on the base of the stand which allows it to serve as storage for texts.

AJP

Late sixteenth–early seventeenth century
Lacquer on wood base
Hiramaki-e
28.5 x 11.4 cm
Tokyo National Museum

This object is the central core of a drum used in
the Noh drama. It was carved from a single
block of wood and lacquered on its outer
surfaces. In order to complete the drum, two
disks of stretched leather (oxhide or horsehide)
were placed at either end and laced to one
another with crisscrossing cords. Tightening the
cords increased the tension on the drum heads.
The drum was played by grasping the cords with
the left hand and positioning the drum over the
left hip. The right hand was swung across the
front of the body to strike the drum.

This drum type, called *ōtsuzumi*, (or,
alternatively, *ōkawa*) is a key instrument in the
Noh drama. It produces a sharp, percussive
sound, highlighted by the vocalization of the
drummer. The other drum regularly used in Noh
plays, the *kotsuzumi*, is slightly smaller, is held
over the left shoulder, and has a softer sound.

The idea of decorating the cores of these
drums seems to have been an innovation of this
period, reflecting the elevated status of Noh
among the ruling elite. Hideyoshi loved Noh so
much that he himself performed, even before the
emperor, and forced other warlords to perform
with him. His vassals echoed his enthusiasm by
sponsoring Noh troupes and performances.

Since no prior tradition had established the
appropriate design themes for drum cores, the
images that appear on these drum cores are often
unique. In this case holly leaves and blank sheets
of paper overlap in a way that suggests that they
are being scattered by the wind.

Holly is an unusual theme in Japanese lacquer
decoration. The holly plant is not a subject of
classical poetry and its cultural references are
pretty much restricted to the Setsubun
ceremony, the celebration of the change of
season from winter to spring, when sprigs of
holly were used. Although holly is an evergreen,
the lacquer artist has chosen to draw only the
dead leaves that have fallen from the plant.
Irregular patches of contrasting *maki-e*
techniques on the leaves subtly imply that the
leaves are blighted.

The sheets of paper blown along with the
dead leaves are blank poem cards (called
shikishi). Are these the pages on which the first
poems of the Spring will be written? Have they
been blown away from the poet, along with the
detritus of winter, in a warm spring breeze?

AJP

119. Set of Shelves with Designs from *The Tale of Genji*

Late sixteenth–early seventeenth century
Lacquer on wood base
Hiramaki-e, takamaki-e, mother-of-pearl inlay, applied metal
65.5 x 72.5 x 33 cm
Agency for Cultural Affairs
Important Cultural Property

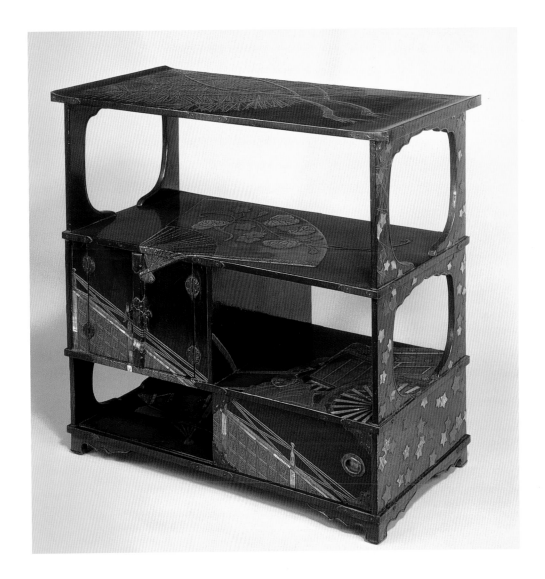

Three-tiered shelves of this type, called *zushidana*, were considered essential furnishings for the upper levels of society. They served as display stands that held the boxes of materials and implements used for cosmetics, incense appreciation, and writing.

Each shelf of this stand features a bold motif that refers to some part of *The Tale of Genji*, the world's first novel and the great classic of Japanese literature. The two small pine trees on the top of the stand refer to the "Hatsune" chapter (chapter 23, translated as "The First Warbler"). That chapter opens with Prince Genji, on New Year's Day, setting out to visit each of his lady loves, most of whom he had established in various parts of his mansion by this point in the story. We might call this Genji's moment of romantic triumph. Near the beginning of every year, on the first day designated according to the traditional calendar as the day of the rat (*ne no hi*), it was the custom to present seedling pines, like the two shown in this design, as marks of longevity. The New Year's day that opens the "Hatsune" chapter happened also to be the day of the rat and, as Genji makes his visits, the young girls attending the mansion's great ladies were busy gathering the seedling pines.

The second level of the stand shows a folding fan with a sprig of blossoms from a gourd vine (*yūgao,* literally, "evening faces"). This refers to a dark incident near the beginning of the novel (chapter 4, "Evening Faces"), in which Genji is drawn to a woman of lower status who gives him *yūgao* blossoms on a perfumed fan with an alluring verse. Genji installs her in a deserted villa where he can stay with her secretly, but, suddenly and mysteriously, she dies.

The third level of the stand refers to another of Genji's secret loves, known as Utsusemi ("Shell of the Locust"), the wife of a vice-governor. After not having visited her for a long time, Genji encounters her at a barrier gate to the city, illustrated here as a fence that runs diagonally across the front of the shelves (chapter 16, "The Gatehouse"). Both Genji and Utsusemi were invisible to one another as they rode in their curtained, ox-drawn carriages, but soon afterwards they exchanged poems expressing their complex feelings.

The lowest level of the stand shows a fan with a bridge. This probably refers not to any single incident, but to the title of chapter 45, "The Lady at the Bridge," or collectively to the last ten chapters of the novel. These chapters are set near the Uji River, famous for its bridge, and feature intrigues involving the generation after Genji, specifically two noblemen from Kyoto and three sisters living in seclusion at Uji. As a whole, then, the stand conveys a consistent message of romantic love. On the sides of the stand and inside the doors, Autumn pine needles and maple leaves scatter as if in comment on the transitory nature of these involvements. The maple leaves have sometimes been interpreted as a reference to chapter 7, "The Festival of the Autumn Leaves" (*Momiji no ga*).

This stand, remarkable for the boldness of its design, the integration of its classical, literary references, and the skill of its execution, is one of the masterpieces associated with Hon'ami Kōetsu.

AJP

References: Shimizu 1988, no. 221; Cunningham 1991, no 56.

120. WRITING UTENSIL BOX WITH DESIGNS OF A BOAT IN REEDS AND PLOVERS

Attributed to Hon'ami Kōetsu (1558–1637)
Early seventeenth century
Lacquer on wood base
Hiramaki-e, takamaki-e, and applied metal
23.6 x 22.4 x 4.2 cm
Tokyo National Museum, Tokyo
Important Cultural Property

The daring of Momoyama artists often grew out of a close study of the past. This writing box embodies the Momoyama spirit. It is poetically, enigmatically classic in decoration, but revolutionary in its materials.

The subject matter of the design on its lid – a fishing boat, reeds, water, birds – alludes to poems written nearly five-hundred years earlier. In this way it continues the tradition of literary themes for writing boxes that was firmly established in the preceding Muromachi period. But the curved shape of the lid and the material used for the boat mark a break with the past. This artist moved forward by looking back.

He may even have looked back at specific images. In a twelfth-century anthology of poetry written on collages of decorated paper, a set of books that is one of the great masterpieces of Japanese art, appears a design of a boat prow among reeds that is strikingly similar (cat. no. 120a). In both cases the image calls to mind poems of fishing boats, especially at Naniwa Bay (near present-day Osaka) where the tall reeds supplied poets with countless metaphors.

From the beginning of recorded Japanese history, poetry played a central role in court culture. The form of verse known as *waka* ("Japanese poem") was so simple in form (with a metric structure of 5-7-5-7-7 syllables in its five lines) and so restricted in its permitted images that nearly anyone could compose a passable example but only a true poet could say something profound. From the ninth century on emperors and courtiers composed verses, sponsored competitions, and compiled anthologies. The central canon of this lyrical outpouring is the set of twenty-one imperially sponsored anthologies compiled between 905 and 1439.

Within this tradition, reeds like those in the design on this box were often associated with Naniwa Bay, and the flocks of small birds, called *chidori* (plovers), were almost always linked to winter. There is no way to know for sure whether the lacquer artist had a particular poem in mind, but one that would certainly fit the scene was written by a Buddhist priest, Dōgen (1237–1304), published in 1312 in the imperially sponsored anthology *Gyokuyō wakashū* (no. 926):

amaobune
sashite michikuru
yūshio no
iyamashi ni naku
tomo chidori kana

The fishermen's boat
Had just been beached and tied as
The evening tide
Rose and rose, still more and more
Flocks of plovers are crying.

The defenseless plovers and the rising tide imply a state of insecurity and unrest that is clearer in a poem by Emperor Go-Saga (1220–72, r. 1242–6) published in the same anthology (no. 921) just a few poems away from Dōgen's verse:

kono yūbe
shio michikurashi
naniwagata
ashibe no chidori
koe sawagu nari

As the sun goes down
It seems the tide is rising
On Naniwa bay.
I hear the plovers upset
Near the shore covered with reeds.

In this design the swelling water in the lower right-hand corner illustrates the incoming tide, as the birds whirl in confusion. More whirling plovers are depicted inside the lid of the box, and on the tray that sits beside the inkstone inside the body of the box. Oncoming night, disturbance, defenselessness, winter, cold, the empty boat–all suggest a somber mood, unlike the proud gaiety we associate with much Momoyama-period art. But the time was still unsettled. Thousands died miserably at the hands of Nobunaga, in Hideyoshi's Korean campaign, and, perhaps most spectacularly, in the razing of Osaka Castle (near Naniwa Bay) by Ieyasu in 1615. There were many appropriate occasions in Momoyama Japan for the feelings of unease implied by the imagery on this writing box.

Artistically, this box shows some marked advances. Japanese lacquer is a conservative art.

Shapes and designs usually shifted gradually and subtly over time–except in the Momoyama period. Hon'ami Kōetsu is particularly credited with influencing new developments in Japanese lacquer at this time, and this box has long been associated with him. One distinctive feature of writing boxes associated with Kōetsu is the arrangement of the inside. Instead of sitting in the middle, the inkstone in Kōetsu-style boxes is positioned to one side and usually is accompanied by a plain, rectangular water-dropper.

Another of the innovations generally attributed to Kōetsu is the use of new materials. Unlike earlier designs, that were executed primarily in gold, silver, or mixtures of the two precious metals, large areas defining the boat are made of applied sheets of lead. Placing this rough, base metal in the center of a gold-sprinkled design with carefully polished surfaces is a striking departure, but one that suits the mood of the box. Time has made the surface of the metal more harmonious with the whole, as frequent use has worn away some of the plovers and many of the reeds that were drawn over the boat. Age suits this box well.

AJP

Cat. no. 120a. Two pages from the *Shigeyuki shū* section of the *Sanjūrokunin shū*, ca. 1112. Nishi Honganji, Kyoto.

121. Container for Noh Librettos with Design of Autumn Grasses

Late sixteenth century
Lacquer on wood base
Hiramaki-e, mother-of-pearl inlay, applied metal
27.7 x 26.3 x 40.5 cm
The Seikadō Bunko Art Museum, Tokyo
Important Art Object

This box for Noh librettos reflects the high regard for Noh as a literary as well as a performing art. Its construction (a book container with interior compartments, door, and handle) and its design (flowers and grasses accompanied by text) suggest the boxes traditionally made for poetry anthologies and major classical texts, such as *The Tale of Genji*.

Noh texts include evocative assemblages of poetic language that establish a mood, a setting and an emotional portrait in a suggestive, almost mysterious way. Before the Momoyama period, the classical poems (*waka*) frequently quoted in Noh librettos would have been fully accessible only to the elite members of the audience. Throughout the Muromachi period literacy had been restricted to the nobility, the clergy, and senior military. Textual knowledge, both of poetry and of Noh, was passed from teacher to pupil privately, in ways that emphasized secrecy and exclusivity.

In the Momoyama period literary knowledge became widely available and both texts and commentaries were disseminated by public lectures and printed editions. Hon'ami Kōetsu, whose Sagabon editions presented Noh texts on decorated papers in the style of traditional poetry, played an important role in this movement.

The script incorporated into the design of this box uses a style very close to the calligraphy of Kōetsu's Sagabon (cat. nos 75, 76). Each phrase presents the title of a Noh drama. Altogether there are about one-hundred titles on the box. Some are created out of inlaid mother-of-pearl, others are drawn with lead sheeting or silver *maki-e*. At the same time that these scattered words look backwards by suggesting the poetic phrases used in some designs of the Muromachi period (especially for writing boxes), they also depart from prior tradition because the words bear no coherent relationship to the natural imagery of flowers and grasses.

The autumn foliage consists of two types of flowers, *nadeshiko* (dianthus) and wild chrysanthemums, and one kind of pampas grass, *suzuki*. The flowers are drawn in gold *maki-e* and the grass in silver *maki-e*. The design is more subdued than the typical Momoyama display of autumn grasses (e.g., cat. nos 111, 116, 117).

AJP

(which in turn suggests a monstrance, a receptacle for public display of the consecrated Host) standing on it. Below the letter "H" is a depiction of three nails, a further reference to the crucifixion. The radiating circle surrounding these elements in turn suggests the Host itself, the sacrament at the center of the Catholic Mass. The missal stand was used on the altar to hold the text of the Mass.

The missal stand is constructed from a single piece of wood, in the same way as are the traditional reading stands for the Koran used in Islamic countries. The hinging area was carved on each side separately and the single board was sliced into two thinner sections that were then free to move.

The design sensibilities of Namban lacquers differ substantially from those of lacquers made for Japanese clients. Both the stand and the box, for example, reflect strong interests in symmetry and order. On the missal stand the exaggerated chrysanthemum plant to the right of the Jesuit emblem is matched by an equally elongated bell flower, and on the lower front a gourd vine mirrors a maple tree. Frames and borders, formed either by drawn or inlaid lines, loose scrollwork, or geometric patterns divide the forms into discrete sections. On the small cylindrical box the overall surface is defined by seven such dividing lines. This subordination of decoration to shape is at the other extreme from the set of shelves decorated with designs from *The Tale of Genji* (cat. no. 119), where the decoration shows a more dynamic relationship with the shape of the object.

122. MISSAL STAND WITH DESIGNS OF AUTUMN GRASSES AND IHS MOTIF

Late sixteenth–early seventeenth century
Lacquer on wood base
Hiramaki-e, mother-of-pearl inlay
46.6 x 32 x 35 cm
Namban Bunkakan Museum, Osaka

123. CYLINDRICAL SACRAMENT BOX WITH IHS MOTIF

Late sixteenth–early seventeenth century
Hiramaki-e, mother-of-pearl inlay
11.1 x 9.3 cm
Namban Bunkakan Museum, Osaka

Jesuit missionaries were active in Japan from as early as 1549, when Saint Francis Xavier arrived in Kagoshima, and these two items, a folding missal stand and a ciborium (a container for the Host used in the Eucharist), prominently feature the emblem of the Society of Jesus. The letters IHS stand for the name Jesus, either as the Latinized version of the first three letters of the Greek IHΣΟΥΣ (Jesus) or as the abbreviation for *Iesus Hominum Salvator* (Jesus, Savior of Mankind). The cross-bar in the letter "H" is elongated so that it resembles an altar with a cross

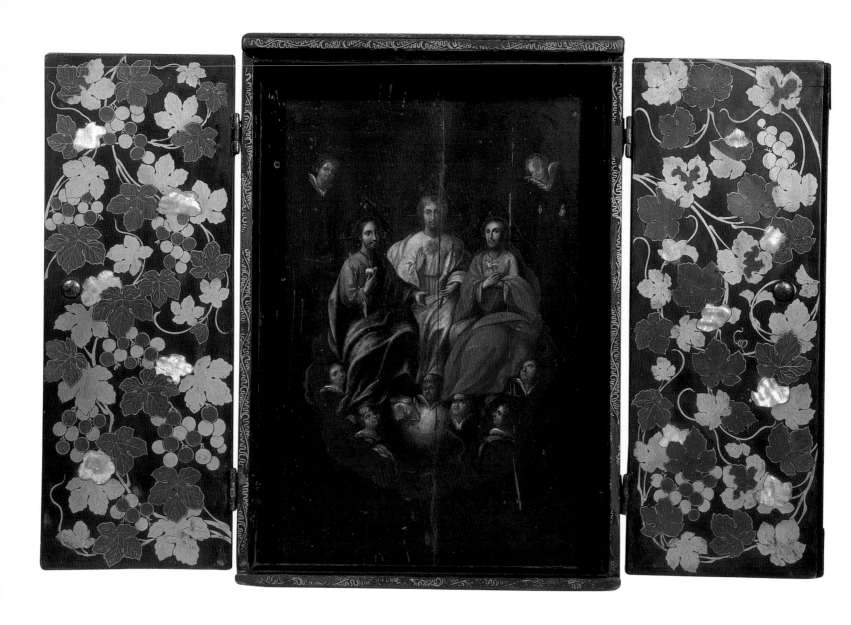

Namban lacquers seem to have been produced much more quickly and casually than other Japanese lacquers. Typically Namban lacquers were made by directly sketching a design on the raw wood (unlike most Japanese lacquer boxes, where the wood base was first covered with a cloth soaked in a lacquer mixture in order to stabilize and strengthen the base material), gluing down small shell pieces where they were desired and then coating the entire object up to the level of the shell pieces with *sabi urushi* (a mixture of clay and lacquer traditionally used to prepare the under-surface of lacquered objects). Then a few coats of black lacquer were applied over the entire surface. After the lacquer hardened it was scraped or polished away from the top of the shell pieces and the final design was applied using the same *hiramaki-e* techniques that had been perfected in Kōdaiji-style lacquers (see the description of a restoration of similar Namban lacquer in Kesel [n.d.], 39–42).

The maker of the cylindrical box clearly took a further short cut when he used randomly shaped fragments of shell that had not been cut to the shapes of the leaves that they were intended to represent. The *maki-e* artist incorporated many of the mother-of-pearl fragments into the design as he improvized the vine, in a way that suggests the insect-eaten leaves frequently seen in Kōdaiji lacquers. But in some cases he was forced to let the shell extend beyond the borders of the design element. By comparison the reading stand was made with greater care and attention.

AJP

124. PORTABLE ALTAR WITH DEPICTION OF THE TRINITY

Late sixteenth–early seventeenth century
Lacquer on wood base
Hiramaki-e, mother-of-pearl inlay
41.3 x 29.8 x 52 cm
Agency for Cultural Affairs

Although international trade with Japan during the Momoyama period was based on the exchange of Chinese silk for Japanese silver, the Portuguese Jesuits also took advantage of the flourishing lacquer industry to supply their new churches with religious utensils made in Japan and to export some Japanese lacquer to the home market in Europe. The shapes, decorations, and techniques of these lacquers, known collectively as Namban lacquer, show that they were based as much on European as on Japanese design ideas.

This devotional object, a portable altar, uses the basic triptych format of European altarpieces, with two side doors that close over a central image. The inside decoration of the doors features meandering grape vines executed in gold and silver *hiramaki-e* with mother-of-pearl accents. The outside decoration shows long-tailed birds in camellia bushes. Although the vine design is energetic and free-wheeling, the producers left signs of undue haste. The design on the inside of the right-hand door, for example, seems to be upside down. The schematic scroll work motif around the edge of the central section, a typical Namban lacquer element known as Namban *karakusa* ("Namban vine"), also seems quickly and casually executed in comparison to more traditional decorative methods (compare the related motif on the tray and food containers, cat. no. 114).

The central icon, an oil painting of the Trinity, may have been produced in Europe, but there is also a possibility that it could have been painted in Japan, either by Jesuit artists or by one of their Japanese pupils. Giovanni Niccolo (1560–after 1623), an Italian Jesuit painter, for example, arrived in Japan in 1583 and soon after founded the Academy of St Luke, where he taught painting and engraving to Japanese converts. Copying European models, these painting students displayed high levels of accomplishment, to the degree that some missionaries claimed they could not tell the difference between the originals and the copies (Cooper 1971, 148). The students of Niccolo provided religious paintings for new churches throughout Japan.

The Jesuit interest in the production of icons and church utensils was not limited to the requirements of the local missions. Jesuits participated actively in the trade between Japan and Macao because the funding provided to them by Portugal and the Pope fell well short of their expenses in Japan. Nagasaki, the principal port for Japan's overseas trade during this period, belonged to the Jesuits from 1570, when they received it as a gift from the Christian daimyo

Ōmura Sumitada Dom Bartolomeu (1532–87), until Hideyoshi confiscated it in 1588. Even when their subsidies rose and their superiors explicitly forbade commercial activities, the Jesuits persisted (Takase 1976). Although their primary trading activity seems to have been the exchange of silver for silk in Macao, they also profited from the commissioning and sale of Namban lacquer in Europe, where most examples are found today. Virtually all Namban lacquer in Japan with Christian themes was destroyed during the persecutions of the Christians under the Tokugawa regime. Most examples in Japanese collections today, including this altar, have been purchased in Europe and America within the last twenty years.

AJP

125

126

125. Tray with Landscape Design

Late sixteenth century
Lacquer on wood base
Hiramaki-e, mother-of-pearl inlay
60 x 6.4 cm
Agency for Cultural Affairs, Tokyo

126. Domed Chest with Designs of Grasses, Flowers, Birds, and Animals

Late sixteenth–early seventeenth century
Lacquer on wood base
Hiramaki-e, mother-of-pearl inlay
38.8 x 77.8 x 47.3 cm
Namban Bunkakan Museum, Osaka

Unlike the other Namban lacquers in this exhibition, this tray and box contain no references to Jesuits or Christianity. The domed chest, whose shape derives from European models, is a standard item among Namban lacquers. Produced in a range of sizes, from about the size of a pocketbook to the size of a traveling trunk, these chests were probably used for a range of storage purposes, depending on the interests and needs of their owners.

On large objects like this chest, the density of decoration that characterizes Namban lacquers seems particularly intense. The trees, plants, flowers and birds crowd against one another in tropical profusion. The design on the tray also seeks to cover every part of the surface, but its nearly equal balance between landscape and geometric abstraction creates a more harmonious effect.

Both of these objects stand out because of their mother-of-pearl inlay. Although Japanese lacquerers had employed shell inlays for hundreds of years before the Momoyama period, the technique reached an unprecedented level of popularity in Namban lacquers. Scholars of Japanese lacquer history generally cite two sources to account for this sudden increase in interest. One source came with the Portuguese from their experience in India. As part of their trade through the port of Goa, the Portuguese commissioned Indian craftsmen to produce boxes and other items decorated with wood and ivory inlays. By combining this sensibility with traditional Japanese techniques and subjects they devised the unique Namban decorative style. A second source may have been Hideyoshi's invasion of Korea. Korean lacquer ware makes abundant use of mother-of-pearl and may have provided new inspiration to Japanese craftsmen. Like the Momoyama period itself, Namban lacquers are energetic and eclectic.

In several ways the tray stands out as a distinct type, considerably more sophisticated than most Namban lacquers. It exhibits a much higher level of craftsmanship and a broader range of technique. Compare, for example, the border drawing around the rim with similar border designs on any of the other Namban lacquers in this exhibition – on the tray it is more carefully drawn and more complex. Notice also the precision with which all the shell pieces have been cut, even complex shapes like the curling borders of the landscape design.

The decorations on both of these objects draw on foreign models, especially the peacock and the "Chinese lions" (*karashishi*) on the chest and the landscape design on the tray. The placement of the designs on the chest seems to suggest that it was meant for display, since the primary decoration is on the front half of the lid and the front panel, while the other half of the lid and the back are filled in with a design of wandering gourd vines. The two end panels are similarly decorated with secondary designs of gourd vines and orange trees. The tray may also have been intended more as a decorative than a functional item, since its fragile surface shows few signs of wear.

AJP

could have used to pour water over his master's hands, although no such pitcher has survived as part of this set.

Ieyasu's crest – three *aoi* leaves in a circle – appears prominently on the rack. *(Aoi,* often translated as "hollyhock," is a short-stemmed grass with heart-shaped leaves that is also associated with Kamo Shrine and the Aoi Festival.) Wisteria crests decorate the basin. The background patterns of linked circles on the towel rack and the basin is traditionally called *shippō tsunagi* ("linked seven treasures") and, as if suggesting piles of coins, it alludes to wealth and good fortune.

The extravagant use of so much silver to make such relatively ordinary objects reminds us that both silver and gold were especially abundant in the Momoyama period due to the opening of new mines. As Nobunaga and Hideyoshi imposed their order on Japan, local daimyo turned more of their effort from conducting war to developing their economic interests. In the latter half of the sixteenth century they opened more than fifty gold mines and thirty silver mines (Iwao 1976, 5). In the sixteenth century Japan accounted for more than one-third of the world's total production of silver (Sakamoto 1993, fn. 7).

This new wealth in gold and silver helped pay for the daimyo lifestyle, support the armies, and reward loyal retainers. It also provided the basis for Japan's foreign trade. Silver was more valuable relative to gold in China than in Japan, but Japanese daimyo could not take advantage of that difference directly since China had banned trade with Japan in 1557. The Portuguese became the essential middlemen, primarily

127. TOWEL RACK WITH *AOI* CRESTS

Late sixteenth–early seventeenth century
Engraved sheets of silver over wood
60.5 x 57.5 cm
Kunōzan Tōshōgū, Shizuoka
Important Cultural Property

128. WASHING BOWL WITH WISTERIA CRESTS

Late sixteenth–early seventeenth century
Silver
25.1 x 14.1 cm
Kunōzan Tōshōgū, Shizuoka
Important Cultural Property

These two items belonged to Tokugawa Ieyasu, according to the record of his possessions made just after his death. The basin (a type called *mimidarai)* was used for washing hands and the rack was used for a hand towel. Usually these everyday domestic utensils were made of lacquer. In this case, they are made in silver, befitting the unusual wealth and station of their owner. We can imagine that this ensemble of luxurious implements was probably completed by a silver pitcher which Ieyasu's attendant

through the port of Macao, exchanging Japanese silver for Chinese silk and gold.

Ieyasu strongly supported this commerce and the nation benefitted from it both financially and culturally. When Ieyasu became the ruler of Japan, after Hideyoshi's death, he took maximum financial advantage of his ability to influence the importation of silk and gold. As a result he became extremely wealthy. When he died in 1616 his estate included 183,750 kilograms (over four tons) of gold (Iwao 1976, 8).

AJP

129. MIRROR WITH DESIGNS OF PAULOWNIA, CRANES, AND TURTLE

Early seventeenth century
Cast bronze
22.6 cm
Tokyo National Museum, Tokyo

The undecorated side of this mirror is its reflective surface. The back features a design of a turtle and two cranes against a backdrop of paulownia crests. Originally a cord passed through the holes in the central, turtle-shaped knob, and the mirror could have been held from that cord or could have been set on a mirror stand when in use.

The turtle and cranes refer to Mount Hōrai, the imaginary island of Taoist immortals, where there is no aging and no death. Both the turtle and the crane are symbols of longevity and good fortune in China, Korea, and Japan and they are illustrated innumerable times in East Asian art. Mount Hōrai was a familiar subject for mirror decoration throughout the Muromachi period. The idea of combining the cranes and turtle in an iconic arrangement with their beaks touching appeared elsewhere in sixteenth-century mirrors, but the regular, surface-covering pattern of paulownia crests seen in this example is probably

a Momoyama innovation. Later mirror designs became even more patterned and decorative.

Mirrors with handles were becoming popular in the Momoyama period, so this mirror is conservative in shape. The maker identified himself on the mirror as Tenkaichi Ao. *Tenkaichi* ("first in the realm") is an honorific term given first by Nobunaga (and subsequently by Hideyoshi, as well) to craftsmen in various fields, including mirror-making. Tenkaichi Ao refers to Ao Ietsugu, a renowned mirror-maker of the time. The Tenkaichi honorific came to be used so widely and indiscriminately that in the early Edo period (1682) its use was prohibited.

AJP

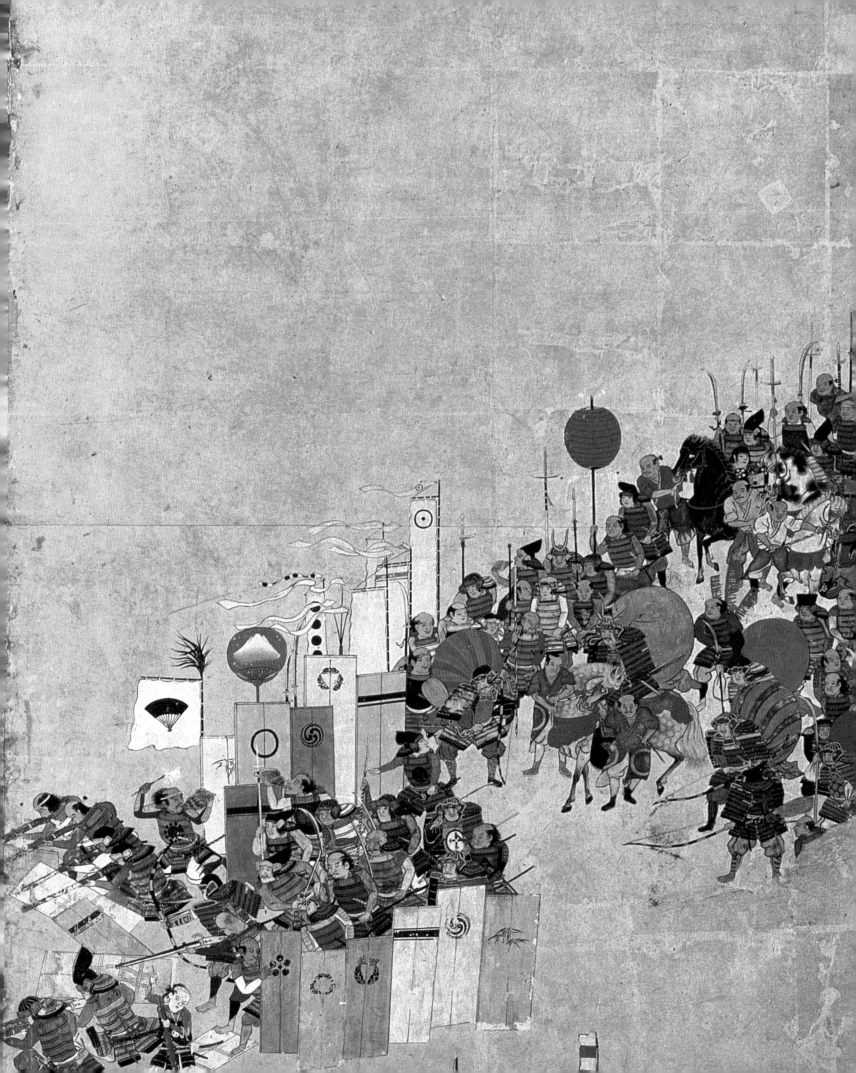

Arms & Armor

Bruce A. Coats

Having been born into the house of a warrior, one's intentions should be to grasp the long and short swords and to die.[1]

These fateful words of the famous warrior Katō Kiyomasa (1562–1611; see cat. no. 10) forcefully state that a samurai's primary concern should be with warfare and weapons, with brave actions, and a manly death. To achieve that end, Japanese warriors have commissioned skilled craftsmen to make the best possible swords, armor, and other instruments of battle. Particularly during the sixteenth century, a period of nearly constant warfare in Japan, military men needed suppliers who worked quickly, skillfully, and with invention. The prestige accorded samurai weapons and armor is further suggested by evidence that some of Japan's most famous artists were commissioned to decorate display pieces; for instance, Eitoku's design for a lacquer saddle (cat. no. 112) or the delicate paintings of pines by Mitsunobu on a set of armor designed for Hideyoshi's son (cat. no. 139).

During the Momoyama period, as armies greatly expanded in size, as battle tactics rapidly changed, and as military leaders became increasingly wealthy through ruthless conquest and booty, swordsmiths and armorers swiftly made technical innovations and produced new types of swords (shintō) and armor (tōsei gusoku). Wearing two swords of different lengths (daishō) – hung together on the left side in lacquered scabbards from a belt – now became fashionable. Long swords (katana) were made slightly shorter and given less curve than swords (tachi) of previous generations. Both the short sword (wakizashi) and katana were worn with blades up, rather than down as before, to allow warriors to unsheathe them more easily. Sword hilts became more elaborate, with silk cord wrappings over nubby sharkskin panels and small metal fittings (menuki) that reportedly improved the warrior's grip. Scabbards

were richly ornamented with patterns and fields of gold, silver, and colors set into glistening lacquered surfaces. Set into most scabbards near the hilt were small skewers (kogai) and blades (kozuka) that were both utilitarian and decorative; sword guards (tsuba) became more elaborately ornamented with raised designs and inlays. Often such sword paraphernalia was partially or fully gilded so that the wakizashi and katana made a brilliant display of wealth and taste as a samurai strode among his troops.

In the sixteenth century armor, too, changed significantly, becoming more lightweight and flexible to allow quick body movements. To make armor more impervious to swords, spears, arrows and bullets, smooth thin iron panels replaced cumbersome layers of lacquered leather and iron scales (kozane) that were intricately tied with elaborate silk lacings. The armor connoisseur Sakakibara Kōzan, writing in the eighteenth century, comments on such old-style lacing:

> A large quantity of lacing is a disadvantage. When soaked with water it becomes very heavy and cannot be quickly dried; so that in summer it is oppressive and in winter liable to freeze. Moreover, no amount of washing will completely free the lacing from any mud which may have penetrated it, and on long and distant campaigns it becomes evil smelling and overrun by ants and lice, with consequent ill-effects on the health of the wearer. It is also easily damaged because it will retain a spear instead of letting it glide off harmlessly.[2]

Since many battles were fought on foot rather than horseback, and with mass troop charges rather than by individual combat, sixteenth century warriors needed armor that was practical and protective rather than stiff and bulky. For footsoldiers (ashigaru) in particular, segmented armor and light-weight helmets could be quickly donned and easily stowed. But for the troop commanders, impressive body covers and elaborate helmets with enormous personal insignias attached would help troops identify where their leaders were positioned in battle. As seen in this exhibit, some daimyo had

Fig. 71. Hasegawa Tōi: *The Summer Siege at Osaka Castle*, detail of cat. no. 22.

261

spectacular gear, which testified to their flamboyant tastes and newly acquired funds (see fig. 71). The ultimate expression of this tendency in an item of personal attire is one of Ieyasu's suits of dress armor, where every component is completely overlaid with gold (fig. 72).

Just as military leaders found it essential to have the recently introduced firearms from Europe and China, so they wanted to wear fashionable European-style armor, with chain mail and Western fabrics. European armor was especially influential in both the design of helmets and of the segmented cuirass. Japanese production of Western-style armor was quite widespread within a few years of the first Europeans visiting Japan on trade missions. While Kyoto and Sakai were the most important centers of armor and weapons production, particularly of fine-quality swords and mass-produced matchlocks, regional military leaders tried to encourage their local craftsmen to manufacture war equipment as well. The quality of most Momoyama armor was probably not high, due to the enormous quantity and rushed production required by war, but the few heirloom pieces that have survived in shrines, temples, and family treasuries are superb examples of the innovative techniques employed in the late sixteenth and early seventeenth centuries. This era is often considered the high point in Japanese sword and armor arts.

NOTES:

1. Wilson 1982, 131.
2. Sakakibara 1963, 93; also quoted in Bottomley and Hopson 1988, 87.

FURTHER READING:

Walter Compton, et al., *Nippon-Tō: Art Swords of Japan* (New York: Japan Society, 1976).

Ian Bottomley and Anthony Hopson, *Arms and Armour of the Samurai: The History of Weaponry in Ancient Japan* (Greenwich: Bison Books, 1988).

Basil W. Robinson, *Arms and Armour of Old Japan* (London: H.M.S.O., 1951).

H. Russell Robinson, *Japanese Armor and Arms* (New York: Crown, 1969).

Sakakibara Kōzan, *The Manufacture of Armour and Helmets in Sixteenth Century Japan,* trans. T. Wakameda, revised by A.J. Koop and Hogitarō Inada in 1912; edited by H. Russell Robinson in 1962 (Rutland, Vermont and Tokyo: Charles E. Tuttle, 1963).

Kanzan Satō, *The Japanese Sword,* trans. Joe Earle (New York: Kodansha International, 1983).

Spectacular Helmets of Japan: 16th–19th Century (New York: Japan Society, 1985).

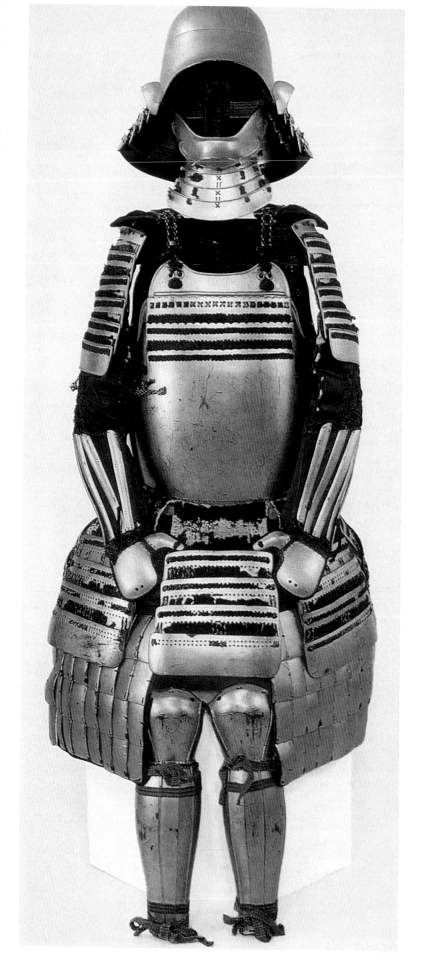

Fig. 72 Ceremonial armor of Tokugawa Ieyasu, ca 1590–1616. Kunōzan Tōshōgū, Shizuoka.

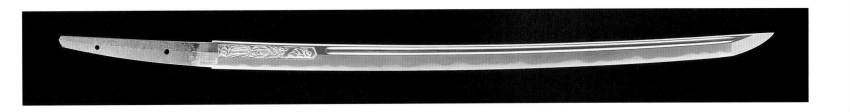

130. Long Sword

Umetada Myōju (1558–1631)
Dated 1598
Forged steel
Length 82.5 cm
Kyoto National Museum
Important Cultural Property

The design of swords changed significantly around the end of the sixteenth century, and Umetada Myōju is often called the "Father of the New-style Sword," producing extraordinary new swords (shintō) and sword guards (tsuba). The Umetada family had long served the Ashikaga shoguns during the Muromachi period and claimed descent from the famous Sanjō Munechika who made swords in Kyoto during the tenth century (Sato 1983, 24, 158). Sword making was a hereditary trade, and swordsmiths were required to have not only technical expertise but also a mastery of certain Shinto and Buddhist rituals that accompanied the production of swords.

Myōju is noted for the finely-detailed carving (horimono) of dragons and Buddhist deities (on this sword Fudō Myōō) that he applied to the sword blades and for the innovative use of inlaid metals to produce a variety of vivid colors on tsuba.

This blade bears the date Keichō 3 (1598) and the unusual inscription "I disapprove of giving it to others," indicating that Myōju intended the sword to be treasured as a family heirloom (Kyoto 1990, 137). On the other side of the tang, he has incised his name and his place of residence, Nishijin, an area in northwest Kyoto where many artisan families settled in the Momoyama period. Nearby lived the noted calligrapher, painter and ceramicist Hon'ami Kōetsu (1588–1637), whose family had long been sword polishers and appraisers. Myōju's tsuba designs are often compared to Kōetsu's paintings and decorated paper designs, with their interest in bold forms and intense colors.

Japanese swords are remarkable for their construction and durability. Hard steel is wrapped around a softer steel core, giving the blade both rigidity and flexibility, so that the sharp steel edge will not break with a blow. The softer steel core gives thickness to the back and tapers toward the cutting edge, which is only composed of tempered steel. The distinctive pattern (hamon) along the razor-sharp edge, formed during the heat-treating process, reveals the crystalline molecular structure (nie) of the layered tempered steel. This sword is wider than usual, giving greater emphasis to the hamon. The tapered point has a particularly long curve, and the body of the blade has an elegant sweep; these features are quite different from Muromachi period sword designs which had blunter points and deeper arcs to the body.

BAC

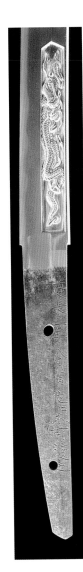

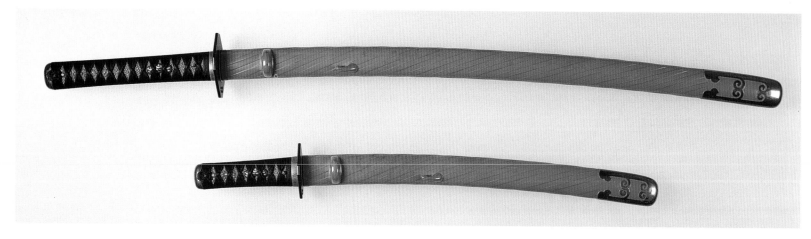

131

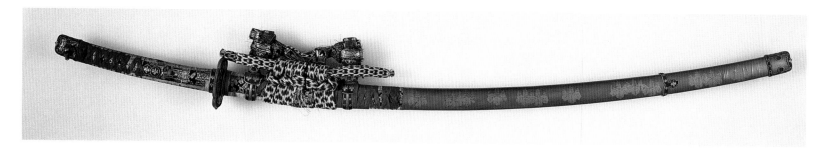

132

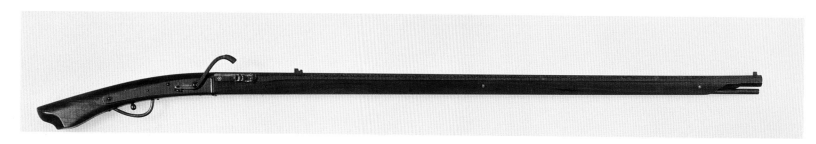

133

131. SET OF LONG AND SHORT SWORD SCABBARDS

Early seventeenth century
Red lacquered wood, sharkskin, silk, gold, silver, brass, and *shakudō* (copper and gold alloy)
Length 101 x 63.8 cm
Hikone Castle Museum, Shiga

Ii Naomasa (1561–1602) was one of Tokugawa Ieyasu's chief supporters, having served him since the age of fourteen. Naomasa had distinguished ancestors, with his family history dating back to the eleventh century when Ii Tomoyasu was appointed governor of Totomi Province (in Shizuoka Prefecture). In 1562 Naomasa's father was murdered, and Ii lands were confiscated by the Imagawa clan. The baby Naomasa was hidden away and survived to become the twenty-fourth generation head of his clan. Following Ieyasu's defeat of Ishida Mitsunari (1563–1600) at the Battle of Sekigahara, Naomasa was ordered to lay siege to Sawayama Castle, Ishida's stronghold on the shore of Lake Biwa near Kyoto (northwest of the site of Hikone Castle). Although Naomasa negotiated a surrender of the castle, it was set afire, resulting in the final destruction of the Ishida family. For his loyalty to Ieyasu and in recognition of his wise counsel over many decades, Naomasa was awarded the strategically important fief of Hikone, located along the eastern shore of Lake Biwa. Hikone Castle was begun in 1603 and under construction for over twenty years. Its three-story tower, inner walls and various outbuildings are still extant, giving extraordinary evidence for feudal architecture of the Momoyama period (see fig. 3).

Naomasa established the tradition of having red lacquered armor and accessories for members of his family. This pair of sword mountings (*daishō goshirae*) are typical of that distinctive style, with both the wooden sword sheath and the stingray-skin hilt covers lacquered red. The ends of both the sheath and pommel have decorative silver fittings. Horn eyelets on the sheath would have held the silk cords that tie the swords to the waist. The hilt also has small metal fittings (*menuki*) and a collar (*fuchi*) decorated with mandarin oranges, the Ii family crest.

The wearing of two swords in the *daishō* arrangement, with the long sword (*katana*) and short sword (*wakizashi*) hung blade up, became popular in the Momoyama period. Typically *katana* were used for battles and *wakizashi* for self-defense, so that when a warrior entered into a building, he left his *katana* on a rack in the vestibule and only carried his *wakizashi* indoors. The elaborate decoration on sword mounts thus became another way of displaying wealth and taste.

BAC

Reference: Shimizu 1988, nos 167–9.

132. PRESENTATION SWORD

Early seventeenth century
Maki-e lacquered wood, silk, leather, gold, silver, and *shakudō* (copper and gold alloy)
Length 120.6 cm
Kunōzan Tōshōgū, Shizuoka
National Treasure

This elaborately wrapped presentation sword (*itomaki no tachi*) was presented by Tokugawa Hidetada (1579–1632) to the Shinto shrine dedicated to his father Ieyasu at Kunōzan Tōshōgū in Suruga Province (Shizuoka Prefecture). To insure an orderly succession, Ieyasu abdicated the position of shogun to Hidetada in 1605, and retired to build Sumpu Castle near Kunōzan. Hidetada distinguished himself in battle and became a shrewd political manipulator. In 1603 Hidetada, with Ieyasu, arranged for his six-year-old daughter Senhime (1597–1666) to marry Hideyoshi's ten-year-old heir, Toyotomi Hideyori (1593–1615), although in 1615 Hidetada found it necessary to destroy Hideyori in the Battle of Osaka. In 1620 Hidetada arranged the marriage of his twelve-year-old daughter Kazuko (later known as Tōfukumon'in, 1607–78) to Emperor Go-Mizunoo (see cat. nos 71, 72), in order to re-establish the practice by which regents controlled the throne through marriage, as was done by the Fujiwara family in the Heian period. In 1629 Go-Mizunoo unexpectedly resigned, and Hidetada's granddaughter became Empress Meishō (1623–96, r. 1630–43), Japan's first woman ruler in over 850 years.

In addition to such matrimonial alliances to secure his political control, Hidetada actively promoted the deification of Ieyasu as the Shinto deity Tōshō Daigongen (see cat. no. 12). In 1617 Hidetada built an elaborate shrine complex at Kunōzan where Ieyasu's remains were temporarily interred – later they were removed to Nikkō Tōshōgū north of Edo (Tokyo) where a magnificent mausoleum complex was constructed in the 1630s. As part of the dedication of the Kunōzan Tōshōgū, Hidetada contributed this presentation sword and mounting. The wooden scabbard has been coated with *maki-e* lacquer and decorated with paulownia leaf designs. The leather-cased hilt is also lacquered and ornamented with gold and silver. The extensive silk cord wrappings, with crisscross lacings on both the hilt and sheath, give this *itomaki no tachi* its distinctive appearance.

BAC

133. MATCHLOCK OWNED BY TOKUGAWA IEYASU

Noda Zenshirō Kiyotaka (dates unknown)
Late sixteenth–early seventeenth century
Iron barrel; wood stock with brass fittings
Length 140.5 cm
Kunōzan Tōshōgū, Shizuoka
Important Cultural Property

Guns were introduced to Japan in 1543 by Europeans, reportedly when a Chinese trade ship carrying three Portuguese adventurers was blown ashore by a typhoon at Tanegashima, an island off the southern coast of Kyushu. When the military commander of the area saw their arquebuses (long guns operated by a matchlock), he purchased two and immediately assigned his swordsmiths to create copies. Quickly the production and use of guns spread, so that matchlocks were a major factor in the battles to unify Japan during the 1570s and 1580s. While some guns continued to be made in Kyushu, Kyoto and the nearby port city of Sakai became major centers for manufacturing guns in the late sixteenth century. These new weapons were widely used by both army officers and footsoldiers (*ashigaru*). This example was owned by the shogun Tokugawa Ieyasu (1542–1616) and donated to the Shinto shrine of Kunōzan Tōshōgū that was established in his memory.

Japanese guns (*teppō*) were patterned after European matchlocks, whereby gunpowder in the barrel was ignited by a "match" or smoldering cord that was held by a serpentine, the S-shaped lever which inserted a spark into the priming powder. The Japanese serpentine pivoted forward into the touch-hole when activated by a spring attached to the trigger, but European matchlocks commonly had the serpentine directly connected to the trigger, pivoting back into the touch-hole. When firing the *teppō*, the stock was pressed against the cheek, and thus the Japanese serpentine rotated away from the face. The iron barrel was filled from the muzzle with powder and iron balls, using a wooden ramrod stored below the barrel. The touch-hole was covered with a moveable brass plate, to keep the priming powder dry. In bad weather, lacquered covers could be added to protect the firing mechanisms. Additional gunpowder and bullets were carried in pouches hung from a belt, and well trained *ashigaru* could reload rapidly. When on the march, foot soldiers could sling the matchlock across their backs, along with spare ramrods.

The introduction of matchlocks revolutionized warfare in Japan during the sixteenth century, changing battle strategies, armor, and personal conduct. After peace was established in the seventeenth century, the new military government strictly controlled the availability and use of guns.

BAC

References: Bottomley and Hopson 1988, 124-33; Turnbull 1977, 137-40; Perrin 1979, 5-8.

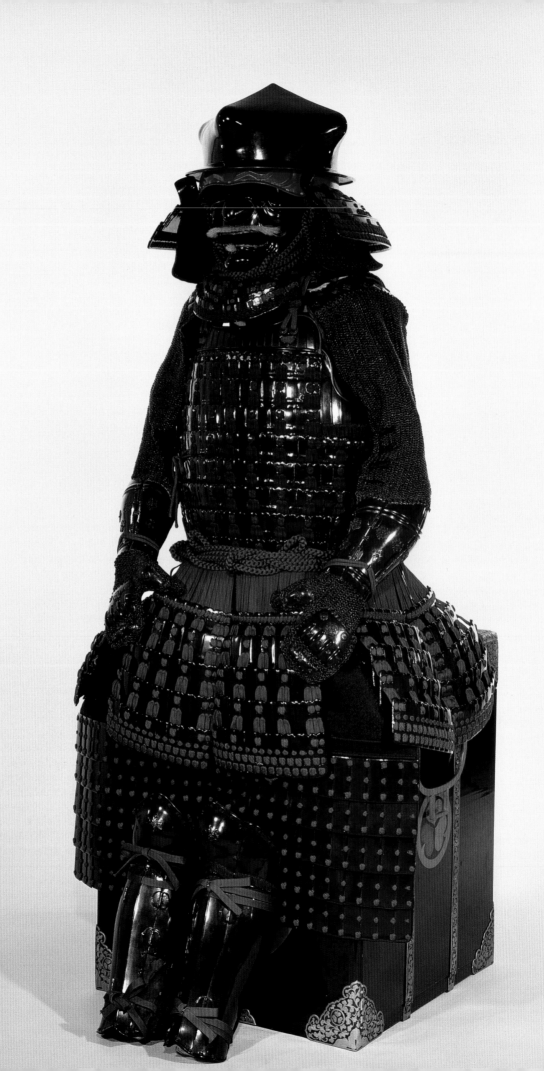

134. SET OF ARMOR USED BY TOKUGAWA IEYASU

Late sixteenth century
Helmet: lacquered iron and leather, silk lacings
Mask: lacquered iron
Cuirass and accessories: lacquered iron, leather, silk lacings
Armor height 146.5 cm
Kunōzan Tōshōgū, Shizuoka
Important Cultural Property

According to shrine traditions, Ieyasu had a dream vision of the god of wealth, Daikokuten – who is also counted with Bishamonten and Marishiten as one of three Japanese gods of war – and subsequently ordered a helmet made in the shape of the god's cloth hat. Later, the great warlord is said to have worn this helmet and armor at the Battle of Sekigahara in 1600, the crucial victory that decided Japanese history for the next two-hundred and fifty years. Upon Ieyasu's death, the armor was initially presented to the Shinto shrine established in his memory at Kunōzan in Suruga Province, but in 1647 it was removed to Edo Castle, where it served as a model for armor made for succeeding generations of Tokugawa warriors. In 1882 this "dream inspired" armor was returned to the Kunōzan Tōshōgū.

Ieyasu's armor is an extraordinarily fine example of the "modern equipment" (*tōsei gusoku*) which developed during the late sixteenth century in response to dramatic changes in warfare and to the influences of European armor design. Warriors needed to move quickly and required a more flexible segmented cuirass. To protect the torso against gunshots and sword blows, the cuirass is composed of thin iron plates, lacquered and tied with silk in overlapping tiers. The front and back panels are hinged under the left arm and laced on the right side. The upper arms are clad with chain mail, showing Western influence, while the lower arms and legs are covered by segmented iron casings. The gauntlets combine lacquered panels and chain mail, as does the protective skirt (*kusazuri*). Lacquered leather pieces are sewn with silk cords to make up the apron (*haidate*). Suspended from the helmet are layered iron panels of the neck guard (*shikoro*) and, for extra protection, chain mail segments lined with silk. A lacquered iron mask covers the lower half of the face, and a collar protects the throat. Originally the helmet sported several ornaments on the front, including a small horned animal head made of wood, a gold circle and a wreath of fern leaves made of gold-leafed leather, but the support structure for these pieces is now missing. The entire ensemble would have made an impressive appearance on the battlefield, and its innovative design allowed Ieyasu to both ride horseback and stride vigorously. Originally the armor was lacquered black, but this has changed to a mellow brown.

BAC

Reference: Shimizu 1988, no. 154.

135. FLAG OF THE DATE CLAN

Early seventeenth century
Red ink on silk
247.7 x 201.5 cm
Sendai City Museum, Miyagi

136. SET OF ARMOR OWNED BY DATE MASAMUNE

Early seventeenth century
Helmet: lacquered iron, silk lacings
Mask: lacquered iron, hair
Cuirass and accessories: lacquered iron, leather, silk lacings
Armor overall height 141 cm
Sendai City Museum, Miyagi

This impressive set of black lacquered armor pieces belonged to Date Masamune (1567–1636), who became one of the richest daimyo in Japan through skillful military campaigns, shrewd political alliances, and innovative government policies. As the eldest son of Date Terumune (1543–84), he became head of his clan at age seventeen when his father was murdered. By 1588 Masamune had avenged his father's death and begun campaigns to expand his clan territorial holdings in Dewa Province, in the western part of northern Japan, and in adjacent Aizu. Because he remained neutral in 1590 when Hideyoshi attacked the Hōjō at nearby Odawara, Masamune was required to surrender Aizu to Hideyoshi and to appear before the dictator in Kyoto the following year.

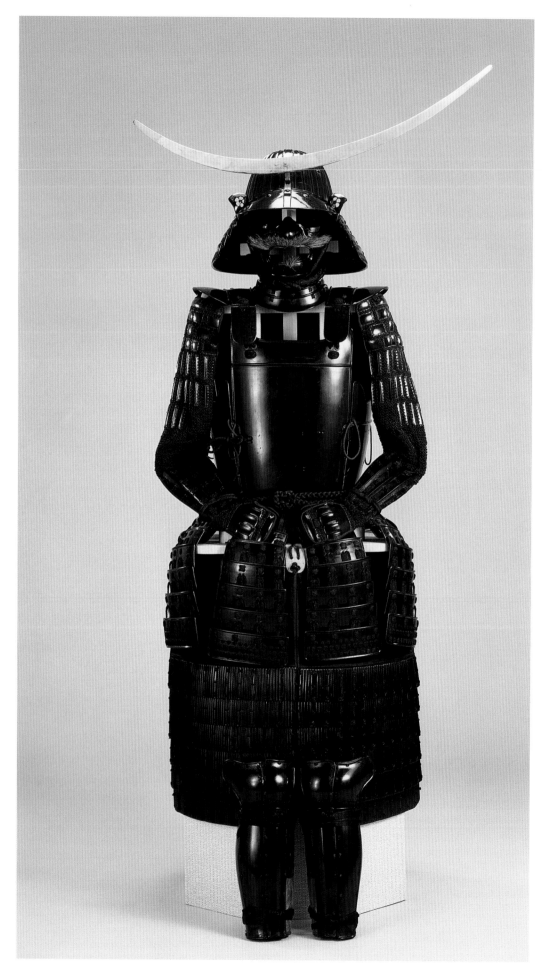

The tea master Sen no Rikyū (see cat. no. 5) is believed to have been involved in the delicate negotiations which resulted in Masamune's affirming his allegiance to Hideyoshi. In 1592, and again in 1597, Masamune supported Hideyoshi's Korean invasions, and proved to be an important adviser.

Following the Battle of Sekigahara in 1600, Date Masamune was awarded the Sendai domain from Ieyasu, who had also married one of his sons to a Date daughter. In the strategic Sendai territories northeast of Edo, Masamune began extensive programs of land reclamation, waterway improvements, and revitalization of the salt industry and the mining of gold and silver. To encourage trade, he had Sendai carpenters build a galleon, with advice from Spanish visitors, and in 1613 Masamune sent Hasekura Tsunenaga (1571–1622) on a voyage to Mexico. Hasekura circled the globe, meeting with King Philip III of Spain and Pope Paul V, before returning to Sendai in 1620. By then, however, Japan had begun closing itself to foreigners, and Masamune's interests had shifted. As an ardent advocate of the arts, Masamune invited Kyoto and Edo artists to Sendai. Members of the Kanō studios provided paintings for the elaborate Zen temple of Zuiganji. Masamune had studied tea with Furuta Oribe (1544–1615) and supported the development in Sendai of the tea ceremony, the incense ceremony, poetry and calligraphy competitions, and Noh performances.

While Masamune's helmet sports a dramatically oversized crescent moon of gilt leather, the rest of his armor is elegantly understated, with black-lacquered iron and leather pieces held together with blue silk cords. The cuirass is rather European in appearance, with five solid panels covering the front, back, left side, and upper and lower right side. The chain mail of the sleeves has additional iron splints for greater protection, and the apron (*haidate*) is composed of rectangular iron plates that are lacquered black. One of three similar sets of armor ordered by Masamune, this one was awarded to a retainer, another is still owned by the Date family, and a third was interred with Masamune's remains.

The silk battleflag with the Date insignia would have been raised to mark the commander's position and encourage his troops. The emblem of the rising sun also became the motif of Japan's modern national flag.

BAC

Reference: Shimizu 1988, no. 161.

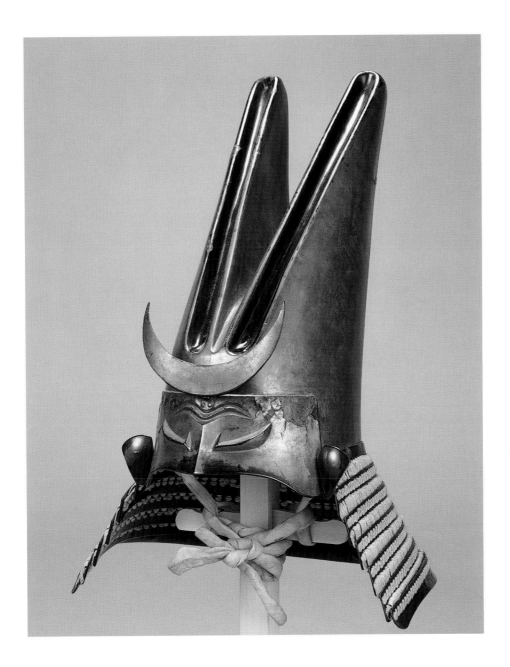

137. Helmet with "Rabbit Ears"

Late sixteenth–early seventeenth century
Silver and lacquered iron, silk lacings
Height 68.8 cm
National Museum of History and Ethnology, Chiba

According to Japanese folklore, the surface of the moon is thought to show a rabbit standing next to a mortar and holding a pestle with which to mix the elixir of immortality. Thus the presence of the crescent moon on this helmet has led commentators to refer to the stylized ear-shapes as "rabbit ears." In East Asian tradition, rabbits also have an auspicious association with longevity, and so this image could be interpreted as an appropriate talisman for a samurai. Again, a reference to immortality might help a warrior marshal his energies before battle, and his troops might be inspired seeing this helmet in the midst of combat. Another helmet with "rabbit ears" of a different design

was made for Tōdō Takatora (1556–1630), who as daimyo of Ise Province was involved in the destruction of Osaka Castle in 1615 and its rebuilding between 1620 and 1629.

Eccentric helmets became popular among samurai in the late sixteenth century and continued in fashion through the early seventeenth. Hideyoshi frequently wore a "sunburst crest" of spike-shapes radiating from the back of his helmet. Ieyasu's helmet usually bore a "fern-leaf crest" of gilt leather, as originally decorated his armor (cat. no. 134), but he also had special headgear made. Reportedly when Hideyoshi once referred to Ieyasu as the "Cow of Kantō" (the Eastern provinces), Ieyasu had a suit of armor made from leather and a helmet fitted with enormous horns (Turnbull 1977, 194). Kuroda Nagamasa sported a helmet with water buffalo horns (cat. no. 138), Honda Tadakatsu's had deer antlers (cat. no. 15). Such exotic innovations to helmet design dwindled

after the Tokugawa government established peace and the need for armor decreased. Still, the importance of headgear is noted by the samurai Yamamoto Tsunetomo (1658–1719) in his guide to warrior conduct, *Hagakure*:

> While ornament on armor is unnecessary, one should be very careful about the appearance of his helmet. It is something that accompanies his head to the enemy camp (Yamamoto 1979, 159).

When daimyo of later generations desired sets of armor, they usually commissioned new pieces modeled on those articles which had belonged to illustrious ancestors.

BAC

References: Japan Society 1985, 58–9, 68–9, 76–7 (for various illustrations of helmets with "rabbit ears"); Shimizu 1988, nos 146–69 (for examples of various types of helmets).

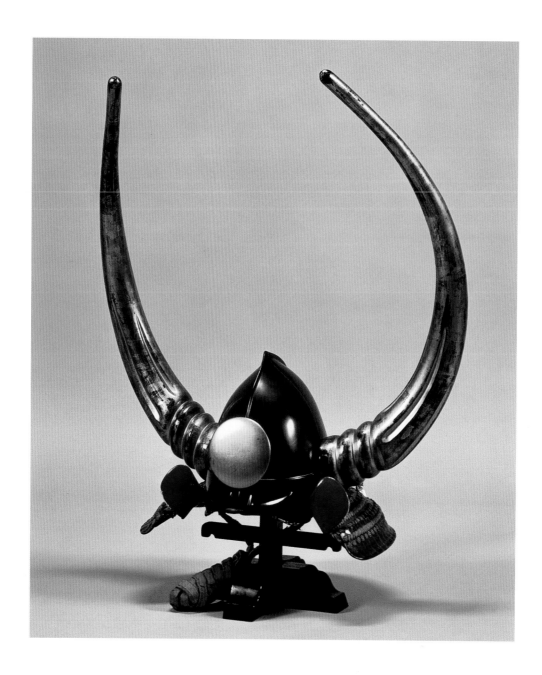

138. HELMET OWNED BY KURODA NAGAMASA

Late sixteenth–early seventeenth century
Iron, leather, lacquered wood with silk lacing and lining
Height 98.0 cm
Fukuoka City Museum, Fukuoka
Important Cultural Property

This striking helmet belonged to Kuroda Nagamasa (1568–1623; see cat. no. 16), one of the leading military figures in the late sixteenth century who fought alongside Hideyoshi and Ieyasu. His father was the famous Christian daimyo Kuroda Yoshitaka (1546–1604), and Nagamasa was baptized as a youth but later returned to the Buddhist faith. Given control of a strategic domain in northern Kyushu, Yoshitaka and then Nagamasa were crucial figures in the efforts to consolidate Japan and in the Korean invasions. Reportedly Nagamasa wore this helmet at the Battle of Sekigahara in 1600, when he protected Ieyasu's right flank against the main forces of Ishida Mitsunari and helped guarantee Ieyasu's victory.

Nagamasa's helmet is shaped like a Spanish-style morion (helmet worn by common soldiers) with smooth solid plates forming each side and a crest running down the middle. This "peach-shaped helmet" (*momonari kabuto*) proved extremely popular in the Momoyama period because swords and arrows were easily deflected off its smooth surfaces. To this European-style helmet were added the traditional Japanese neck guard (*shikoro*), a gilt disk insignia over the forehead, and enormous buffalo horns of carved wood, covered with lacquer and gilt. Such spectacular headgear would help soldiers identify where their field commanders were located, while the powerful symbolic aspects of horns and sun-like discs were also significant.

BAC

139. CHILD'S ARMOR MADE FOR TOYOTOMI SUTEMARU

Late sixteenth century
Breastplate: lacquered iron and leather, with silk lacings
Skirt: lacquered leather, with silk lacings
Helmet: iron, with silk lacings
Armor overall height 38.8 cm
Helmet height 15.5 x diameter 24.3 cm
Myōshinji, Kyoto
Important Cultural Property

Toyotomi Hideyoshi (1536–98) had long been childless, so the birth of his son was greatly celebrated. Sutemaru (1589–91) was affectionately called "Tsurumatsu," alluding to cranes (*tsuru*) and pines (*matsu*), symbols of longevity. Both motifs, along with evergreen bamboo, appear on the cuirass of this miniature suit of armor. The delicately brushed paintings are thought to be by Kanō Mitsunobu (1565–1608), whose distinctive style included such

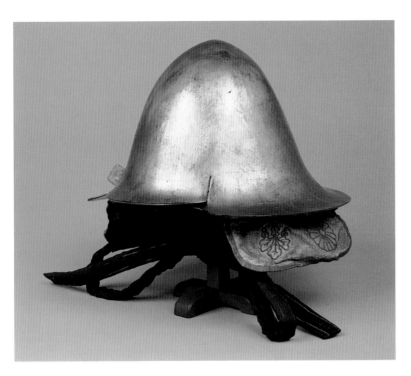

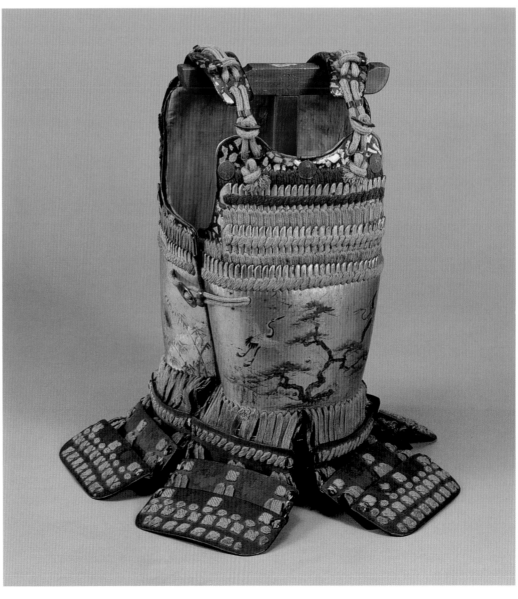

spindly pines (Miya 1982, 134). It was not uncommon for the Kanō artists to decorate military fittings; among the sketches of Kanō Eitoku (1543–90) is a design for a saddle, which was made in 1577 (see cat. fig. 112a).

Such miniature armor was probably commissioned for display and for young Sutemaru to play with as he learned about warrior virtues and his role as heir to Hideyoshi. The main body of the cuirass is of gilt and lacquered leather which wraps around the torso in a single piece, fastened under the right arm. Gold, red and purple silk lacings fasten this piece to the segmented harness made up of lacquered gilt leather pieces and iron scales (*kozane*) and to the skirt (*kusazuri*) with its leather panels decorated with lacquer and silver. This style of armor, called *domaru* ("torso encircled"), was popular in the medieval period and not currently in fashion during the late sixteenth century. The helmet, too, is simple in design and not typical of the elaborate constructions that predominated in the Momoyama period. Perhaps Hideyoshi wanted to see his son as a warrior in an age-old tradition, wearing armor of past eras. Unfortunately, the boy died when he was three years old.

BAC

140. CHILD'S ARMOR MADE FOR TOYOTOMI SUTEMARU

Late sixteenth century
Breastplate: lacquered iron and leather, with silk lacings
Skirt: lacquered leather, with silk lacings
Armor height 33.6 cm
Myōshinji, Kyoto
Important Cultural Property

Slightly smaller than the previous example, this miniature cuirass was also made for Sutemaru. It was part of a group of objects which belonged to the boy and were given on his death at age three to Shōunji, a temple established in his memory. The items were later transferred to Myōshinji when Shōunji was destroyed, and the Gyokuhōin subtemple serves as Sutemaru's memorial chapel. Crane, pine, and bamboo motifs are delicately painted on the leather parts of the cuirass, while metal medallions with stylized chrysanthemum designs decorating both the breastplate and skirt give it a slightly more formal appearance than the previous example.

BAC

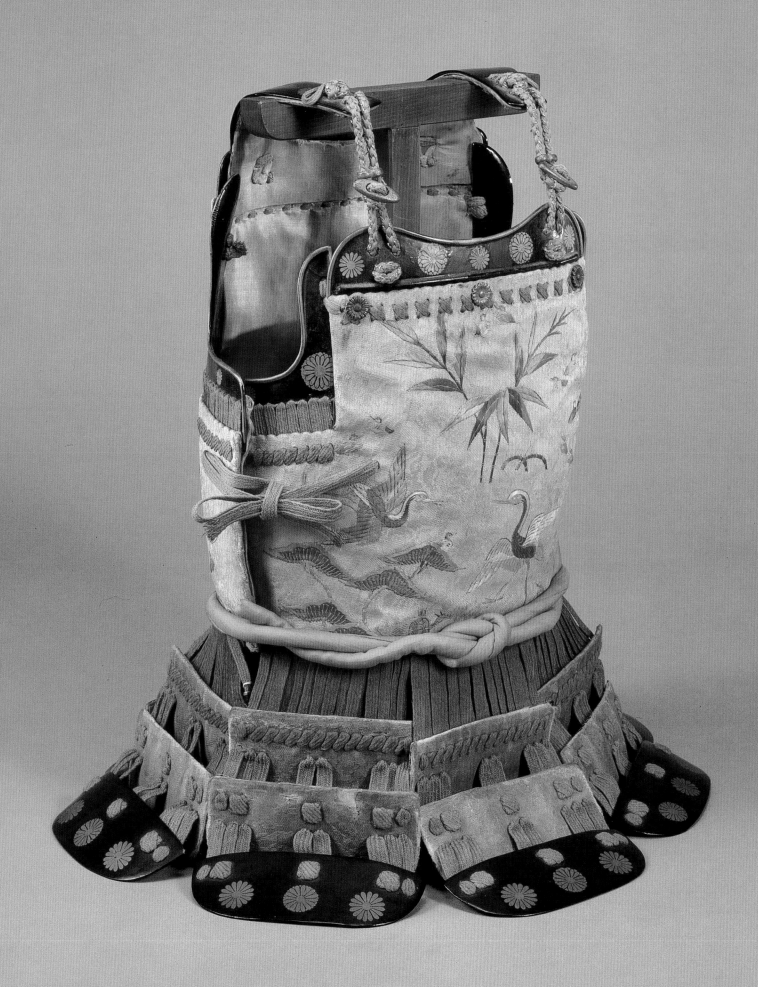

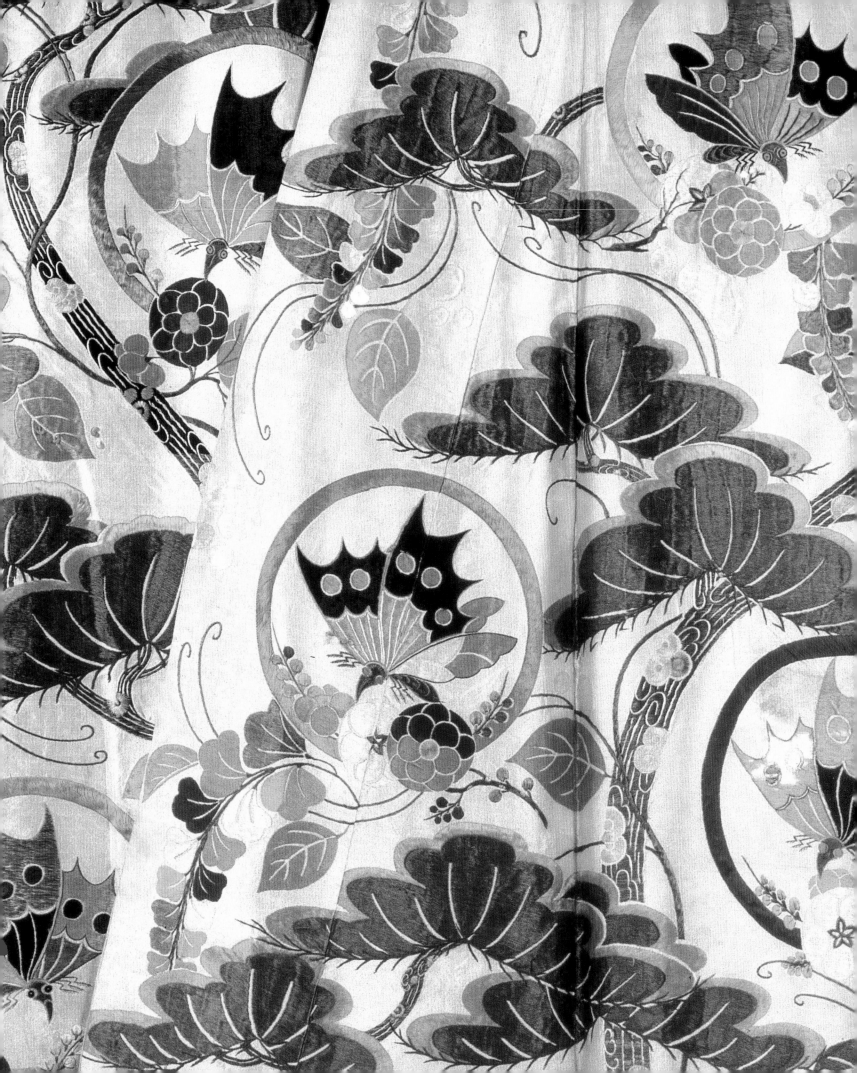

Textiles

CHRISTINE GUTH

Dress, often considered a peripheral and even inconsequential aspect of art in the West, was a fundamental form of artistic expression in Momoyama Japan. Clothing not only shares many of the design principles, styles, and motifs found in painting, lacquer, ceramics and other arts, but conveys important messages about the social, economic, and political character of the period.

Various types of apparel were worn during this era, but the principal form of dress among men and women of all classes was the *kosode*, the prototype of the modern kimono. The term *kosode* ("small sleeves") refers to the narrow wrist openings, which distinguished this garment from the *ōsode* ("large sleeves"), under which it was originally worn. The elevation of the *kosode* from undergarment to fashionable outerwear came about in response to the dramatic social changes that marked the sixteenth century. These changes were liberating for both sexes, but especially for women of elevated social class, since this attire enabled them to participate more freely in public recreational activities such as theater, seasonal picnics, and dancing. The vivid colors, unfettered designs, and technical virtuosity of the fashionable attire worn by both men and women on such occasions contributed to the public pageantry that was such a conspicuous feature of Momoyama culture.

Unlike post-Renaissance Western clothing, which is cut and tailored to follow the contours of the body, the *kosode* is a loose-fitting, unstructured garment. During the Momoyama period, it was worn with a narrow sash rather than the wide, constricting *obi* that later came into vogue. Minor changes in the width of the body and sleeves distinguish *kosode* of the Momoyama from those of the Edo, but changes in fashion are evident primarily in decor rather than cut.

Fashioned from a single length of fabric about thirty-six centimeters wide, the *kosode* is comprised of only seven pieces: two lengths draped over the shoulders and joined with straight seams down the center and sides for the front and back; two shorter pieces sewn together for the sleeves; two panels for the overlap in the front; and a long collar and neckband. This simple and uniform design not only made for very little waste, but also permitted easy disassembling and rearrangement of the various components of a single or even of several different garments. Extending the life of a costly silken *kosode* in this way was a common practice.

The unstructured shape of the *kosode* offered much more than practical advantages, however. Its broad, two-dimensional expanse also encouraged textile designers to visualize its surface much as a painter might a hanging scroll or screen. Indeed, the bold aesthetic of popular motifs, such as standing trees with outstretched branches, has much in common with that of screen painting (fig. 73). In addition to large, unified compositions that extend uninterruptedly from collar to hem, designers also devised stunning decor by dividing the back and front of the garment into diagonals filled with contrasting geometric and naturalistic motifs or in alternating bands decorated with different patterns (see cat. no. 142). Such contrasts in color, rhythm, and motif, seen also in lacquers and ceramics, were part of the new shared visual language that distinguishes the arts of the Momoyama period.

A wide range of techniques was employed in the decoration of *kosode,* but non-loom techniques, which allowed for greater freedom of expression, predominated. Among these were various forms of tie-dye (*shibori*), a combination of embroidery and applied gold or silver leaf (*nuihaku*), and above all, a complex technique known today as *tsujigahana*.[1] The origins of this term are unclear, and usage varies among scholars, but *tsujigahana* (literally, "flowers at the crossings") generally refers to a combination of tie-dyeing and hand painting. The production of the most elaborate *tsujigahana*, combining *shibori*-dyeing, hand painting, embroidery, and gold foil, was so time-consuming and expensive that it was probably made primarily for the elite. The contrast between the softly blurred contours and often muted tones of *tsujigahana* textiles and the crisp delineation and gold

Fig. 73. Swallowtail butterfly roundel, detail of cat. no. 148.

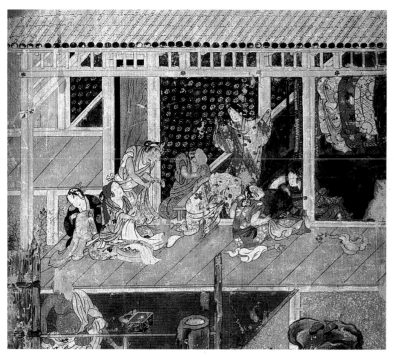

Fig. 74. Dyers, detail from *Shokunin zukushi-e* by Kanō Yoshinobu.

Fig. 75. Detail of rabbit and wave motif on a robe owned by Tokugawa Ieyasu.

and silver sheen of *nuihaku* reveals the same contrapuntal impulses evident in other aspects of Momoyama culture.

Momoyama Japan was exceptionally cosmopolitan in outlook, with fashions influenced by China, Southeast Asia, and even Europe. Technical innovations, such as *nuihaku*, were Japanese adaptations of Chinese techniques. Some patterns that enjoyed favor during this era may have been influenced by chintzes, calicos, and batiks imported from Southeast Asia. The vogue for capes, hats, pantaloons, and even crucifixes, so painstakingly recorded in both written records and paintings of the period, was sparked by contact with Portuguese and Spanish missionaries and traders. The adoption of

wool for making campaign jackets (*jimbaori*) worn over armor also followed from its introduction by European traders (see cat. no. 141).

The weavers and dyers of Kyoto, the center of luxury textile production since ancient times, supplied most of the silk garments worn by the elite. During the Ōnin War (1467–77), many craftsmen had fled the city for Sakai and other provincial centers, but Hideyoshi encouraged their return when he assumed control of the city. As textile production resumed its central role in the urban economy, Nishijin, the name of the district in northwest Kyoto where the looms were concentrated, became synonymous with the finest, most sought-after silks.

The importance of weavers and dyers in the urban economy is evident from their inclusion among the craftsmen represented in sets of paintings of the various professions (*shokunin zukushi*). A painting from such a series by Kanō Yoshinobu (1552–1640) records the activities of dyers in exceptional detail (fig. 74). In the foreground, seated on the veranda of the workshop, women are stitching, binding, and hand-painting fabrics. Two stretches of bound and capped fabric lie nearby. Inside the workshop another woman holds up for approval a completed garment decorated with a striking diagonal decor. Other luxurious garments are draped over the lacquer rack behind her.

Close personal ties between artists involved in textile production and those in other media fostered much artistic cross-fertilization. The history of the Ogata family, owners of the Kariganeya, is emblematic of this development. Located a few blocks south of Nishijin and west of the Imperial palace, the Kariganeya was the leading purveyor of fine textiles during the late sixteenth and seventeenth centuries. Ogata Dōhaku (d.1604), the first member of this influential Kyoto family whose life is well documented, was married to the elder sister of Hon'ami Kōetsu (1558–1637), one of the leading aesthetes of the era (see cat. no. 74). As the owner of a plot of land on Takagamine, where Kōetsu and many craftsmen settled in 1615, his son Sōhaku (1570–1631), continued to maintain ties to the artistic circle of this brilliant innovator. Such relationships lay the foundations for the unified aesthetic outlook of the Rimpa movement in which Sōhaku's descendants Kōrin (1658–1716) and Kenzan (1663–1743) would play a central role. The lively rabbits running through waves decorating a robe that belonged to Ieyasu (fig. 75) offer a telling example of the shared approach to design and motifs found in such diverse areas as textiles, painting, ceramics, lacquer, and printed books throughout the seventeenth century (see cat. no. 115).

Surviving record books from the Kariganeya offer tantalizing clues to both the patterns of patronage and of taste during this period. The three daughters of Asai Nagamasa – Hideyoshi's consort Yodogimi, the warlord Kyōgoku Takatsugu's spouse Ohatsu, and Tokugawa Hidetada's spouse Oeyo – were prominent among the Kariganeya's clients. When Oeyo married Hidetada, Ogata Sōhaku, the then master of Kariganeya was even included in the wedding retinue. During the years between 1588 and 1592, when garments with standing tree decor were in vogue, Hideyoshi's household placed several orders for robes decorated in this way. In 1602, Ieyasu ordered a wadded cloak (*dōbuku*) with a random pattern of wild ginger (*aoi*) crests and leaves on purple ground. This robe is believed

Fig. 76. Detail from a commemorative portrait of Kaihō Yūshō and his wife, attributed to Kaihō Yūchiku. Early eighteenth century. Kaihō Hiroshi Collection, Kyoto.

to correspond to one still preserved in the Tokugawa collection. A portrait of Ieyasu's daughter Seitokuin shows her wearing a similar robe that had belonged to her father (cat. no. 13).

In an era when hierarchies of power and prestige were in constant flux, dress provided an important means of creating and projecting individual and family image. Ornamental crests (*mon*), which identified the wearer as a member of a particular household, were incorporated into the designs on clothing and other possessions (see cat. no. 144). Men donned Portuguese style capes, pantaloons, hats, and even rosaries and crucifixes. More than a fashion fad, adoption of this exotic dress gave their wearers the cachet of power.

Although the relationship between status and dress among men and women was deeply rooted in Japanese culture, so intense was the preoccupation with personal appearance that even the chronicles of the period remarked on it. In the early seventeenth century, the *Keichō kembunki* noted:

> Not only the great warlords of today but warriors of every class are concerned with beauty, wearing colorfully woven and embroidered fine silks (*ryōrakinshū*) The warriors also decorate themselves according to their status, making up their appearance, and spending all their pay on clothing. It is a peaceful time now, so they put their arrows away in quivers, and swords in boxes to devote themselves solely to worldly pleasures. It is just amazing to hear of and see these beautiful robes everywhere. Such things were unheard of before.[2]

If the universal adoption of the *kosode* made social distinctions more muted than they had been, fine silk clothing remained a major investment. Like precious teawares, garments were valued as symbols of wealth and declarations of personal taste, whose exchange confirmed personal relationships. Unlike teawares, however, which vassals often presented to their lords as signs of their obligation, the presentation of an article of clothing such as a *kosode* or the cloak (*dōbuku*) worn over it, was exclusively from superior to inferior. Garments were given as rewards for distinguished military or other service (see cat. no. 142), as tokens of favor to family members (see cat no. 13), and to actors and artists. Ownership of such a garment was a source of great pride: in a commemorative portrait of his grandfather the famous painter Kaihō Yūshō and his wife, Yūchiku, has shown the latter with her back toward the viewer so as to better highlight her *kosode*, which had been a gift from Tokugawa Iemitsu (fig. 76).

Since portrait and genre paintings depict men and women wearing clothing of similar patterns and colors, it is often argued that gender distinctions were minimal in Momoyama dress. While this may be true, this blurring of gender lines was a subject of considerable concern in some circles. The comments of Kawamura Seishin, a retainer of the Ise family who lived into the 1570s, attest to the changing aesthetic norms. "While *tsujigahana* may be well suited to women and children," he asked, "is it really proper for men as well?"[3]

Decoding the symbolic language of Momoyama dress is difficult because so few examples have been preserved. Moreover, most garments that are still intact belonged to men and, of these, garments worn or owned by the great heroes of the age are in the majority. The same talismanic qualities apparently did not apply to women's garments. Some of these male garments are now in the possession of shrines and temples, while others are still treasured by the families to whose ancestors they were presented. Noh troupes whose forebears enjoyed the patronage of the great warlords own many particularly sumptuous *kosode*, which they adapted for use as Noh costumes. Women's garments, on the other hand, generally survive only in fragmentary form, having been cut up and refashioned into altar cloths and other useful articles by the temples and shrines to which they were donated after their owners' deaths.

NOTES:

1. There is much difference of opinion surrounding the use and translation of the terms *shibori* and *tsujigahana*. On the former see Wada, Rice, and Barton 1983, 7. On the latter, see Stinchecum 1984, 41–3; and Itō 1985, 187–93.
2. Cited in Maruyama 1988, 11.
3. Itō 1985, 21.

FURTHER READING

Dale Carolyn Gluckman and Sharon Sadako Takeda, et al., *When Art Became Fashion: Kosode in Edo-Period Japan* (Los Angeles: Los Angeles County Museum, 1992).

Itō Toshiko, *Tsujigahana: The Flower of Japanese Textile Art*, trans. Monica Bethe (New York: Kodansha, 1985).

Noma Seiroku, *Japanese Costume and Textile Arts*, trans. A. Nikovskis (New York/Tokyo: Weatherhill/Heibonsha, 1974).

North Carolina Museum of Art, *Robes of Elegance: Japanese Kimonos of the 16th-20th Centuries* (Raleigh: North Carolina Museum of Art, 1988).

Amanda Mayer Stinchecum, et al., *Kosode: 16th-19th Century Textiles from the Nomura Collection* (New York: Japan Society and Kodansha, 1984).

Wada Yoshiko, Mary Kellogg Rice, and Jane Barton, *Shibori: The Inventive Art of Japanese Shaped Resist Dyeing* (Tokyo: Kodansha, 1983).

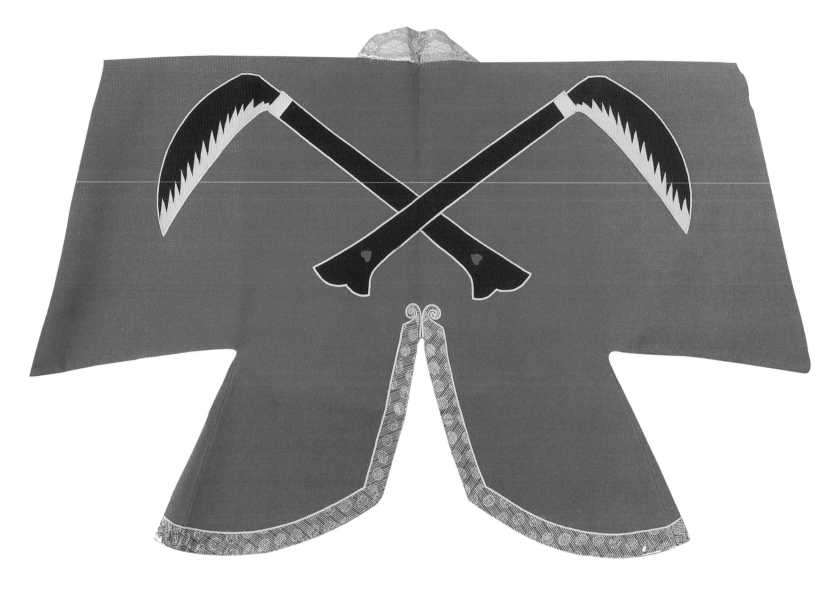

141. *JIMBAORI* WITH INSET DESIGN OF CROSSED SICKLES

Circa 1600
Kirihame and appliqué on wool
77.0 x 104.0 cm
Tokyo National Museum

Little known in Japan before the sixteenth century, wool was among the treasured goods popularized by the Portuguese. Because of its value as a status symbol and its warmth, woolen cloth was much sought after by sixteenth-century warlords for making campaign jackets (*jimbaori*) worn over armor. The vogue for such exotic fashions was short-lived, but its legacy is evident in the modern Japanese term word for wool, *rasha*, which derives from the Portuguese *raxa*.

This flashy vermilion jacket is said to have belonged to Kobayakawa Hideaki (1577–1602), a nephew of Hideyoshi who later swore allegiance to Ieyasu. Since Hideyoshi himself was much taken with western clothing, many of those in his entourage also adopted it. Unlike Japanese garments, which are characterized by straight hems, this *jimbaori* has an unusual curving hem slashed in the center of the back

like a swallowtail coat, a feature that no doubt made it well suited for wearing while on horseback. If not directly patterned after a Portuguese jacket, its curvilinear lines reflect the influence of European tailoring.

The large crossed sickles decorating the back echo the dramatic angles formed by the hem and sleeves. To create this simple yet striking decor, holes were cut in the garment and matching black and white pieces were carefully fitted in to form the blades, a technique known as *kirihame*. The handles of the sickles were appliquéd directly over the red wool. The sickle motif had symbolic protective properties because of its association with the deity of the Suwa Shrine, whose sacred emblem (*shintai*) it is. Gold thread highlights the hemline, which has designs of chrysanthemums and stripes. Peonies decorate the collar, and buttons close the front panels. The white damask lining of the jacket is embroidered in blue and green silk with the Chinese character for "eternity."

CG

References: Maruyama 1994, fig. 123; Metropolitan 1975, no. 48; Shimizu 1988, no. 266.

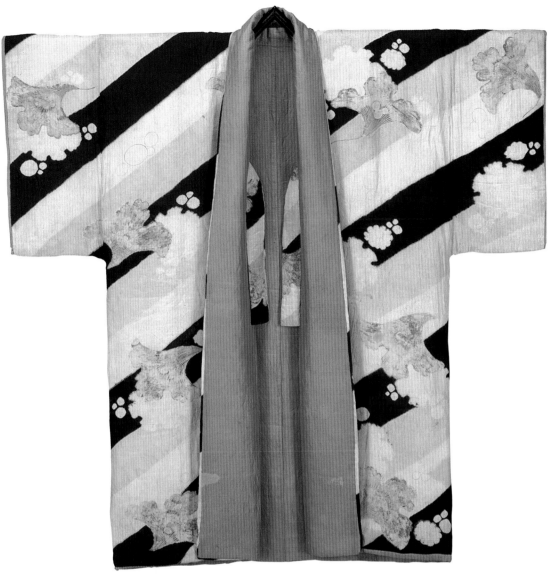

142. DŌBUKU WITH DESIGN OF GINGKO LEAVES AND SNOWFLAKES ON DIAGONALLY PATTERNED GROUND

Circa 1602
Tsujigahana and silver leaf on plain-weave silk (*nerinuki*)
120.5 x 57.0 cm
Tokyo National Museum
Important Cultural Property

Both Hideyoshi and Ieyasu often presented personal garments as rewards to their generals after victory in battle or to retainers who had performed distinguished service. This *dōbuku*, a short, wide-sleeved jacket worn by men over the *kosode*, is among the rare surviving examples of this practice. Ieyasu presented this *dōbuku* in 1602 to Yoshioka Hayato, a surveyor at the Iwami silver mines. Given its exceptional design and technical virtuosity, it no doubt came from his personal wardrobe. Although the exact date of its manufacture is not known, it is likely to have been made during the Keichō era (1596–1615), when order books from the Kariganeya indicate that the gingko motif was especially popular. Because of the prestige

associated with ownership of a garment that had belonged to the great warlords of the period, most surviving dated and documented garments from the Momoyama period can be traced to Hideyoshi, Ieyasu, or other notable figures of the era. Of these, *tsujigahana* style garments belonging to Ieyasu are in the majority.

During the Momoyama period, gender distinctions were not sharply defined in *kosode* style, color, or design, so it is often difficult to determine for whom they were originally made. *Dōbuku*, however, were worn exclusively by men, loosely tied by a cord at the chest. Fashionable among sword-bearing warriors, they generally feature flared gores to accommodate the long blade. This one, however, has a small slit under the left sleeve.

Boldly contrasting geometric and pictorial motifs make this an unusually arresting *dōbuku*. Clusters of gingko leaves and snowflakes float against a ground of diagonal bands dyed using the stitch-resist technique in contrasting tones of cream, pale blue, and deep purple. These stripes extend uninterruptedly from hem to sleeve on

both the front and the back of the garment. The large, subtly shaded and veined gingko leaves were executed using pigments mixed with powdered silver, an unusual technique testifying to the skill and inventiveness of the craftsmen who created it. Small delicate snowflakes were lightly brushed in ink over the cream colored areas. The technical difficulty involved in the creation of this garment is reflected in the many notations for dyers and sewers still faintly visible on the various parts of the robe.

CG

References: Itō 1985, pl. 110; Kyoto 1977, no. 28.

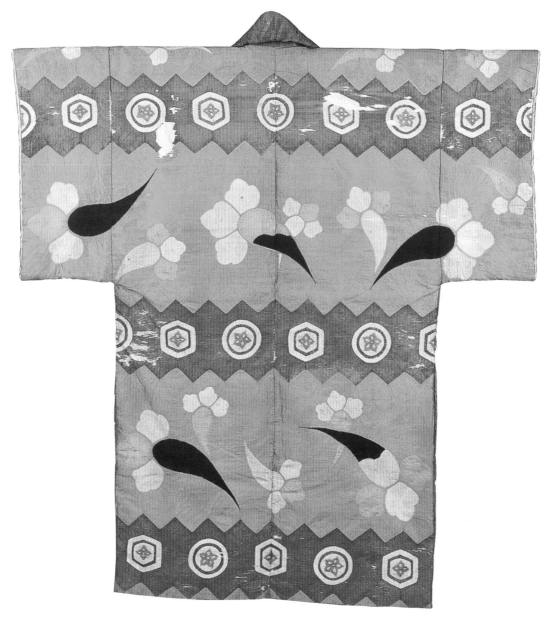

143. *DŌBUKU* WITH DESIGN OF CLOVES ON PARTI-COLORED GROUND

Circa 1603
Tsujigahana on plain-weave silk (*nerinuki*)
120.5 x 126 cm
Kiyomizudera, Shimane
Important Cultural Property

This *dōbuku* is thought to have been given in 1603 by Ieyasu to Yasuhara Dembei, the administrator of the Iwami silver mines, in recognition of his discovery of a new silver vein that became a major source of wealth for Ieyasu and his allies. Ieyasu's gift was treasured by the Yasuhara house until 1684 when it was donated to the Kiyomizudera, which still preserves it.

The robe has a parti-colored background formed by sawtoothed bands of vermilion and gold. A playful arrangement of cloves enlivens the wide red band while a more sedate arrangement of hexagons and circles, each containing flowers, fills the narrow band. Small notations to the dyers are visible on the stems

and buds of several of the cloves. To create this complex pattern, the fabric was stitched, rebound, and immersed in the dye vat numerous times. The bold conception of the design and exceptionally high quality of the *tsujigahana* style resist dyeing make this well documented *dōbuku* a landmark in Momoyama textile history.

Like their counterparts in lacquer and ceramics, textile designers often drew on familiar plants, animals, and even commonplace articles of everyday life to create strikingly inventive designs. Though uncommon in textiles, cloves figure frequently in ceramic design. Their popularity as a decorative motif may reflect their much esteemed medicinal properties: since the Heian period cloves were ranked among the seven treasures. Because of their auspicious connotations, cloves also figure in many family crests.

CG

References: Itō 1985, pl. 6; Kyoto 1977, no. 30; Metropolitan 1975, no. 49.

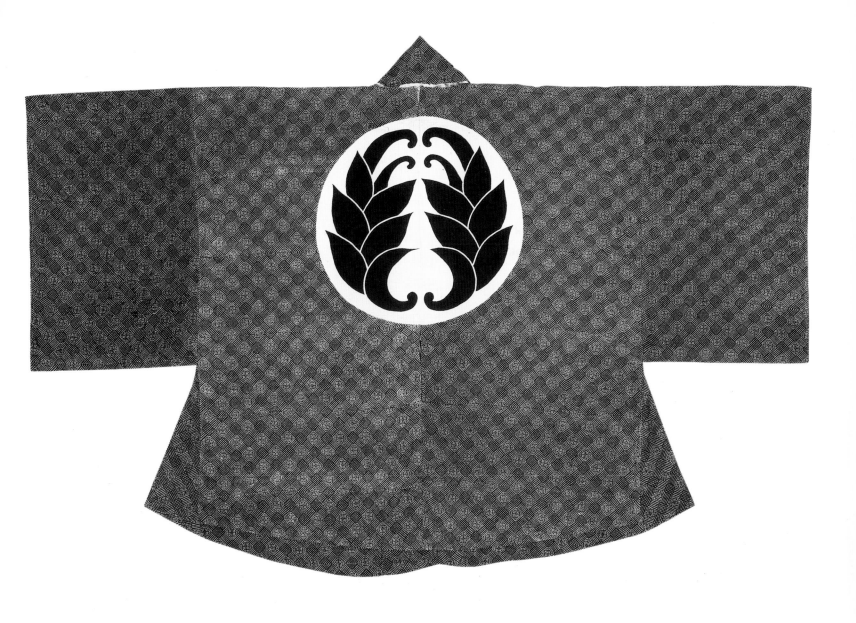

144. *DŌBUKU* WITH CREST ON BLUE
PATTERNED GROUND

Early seventeenth century
Silk with stencil dyed designs, black ink
87 x 141 cm
Agency for Cultural Affairs

The conservative color and decor of this *dōbuku*
is in sharp contrast to the previous two
examples, but its aesthetic restraint belies the
extraordinary craftsmanship that went into its
manufacture. The intricate design of black
interlocking squares on a blue ground is typical
of the stencil dyed *komon* ("minute motif")
patterns that came into fashion in the early
seventeenth century and remained popular
among daimyos and warriors throughout the
Edo period, especially for designs on *hakama*.
The *dōbuku*, though usually a three-quarter or
full-length coat, was often adapted to
accommodate individual taste or requirements.
This example has a relatively short curving hem,
resembling that of a *jimbaori*, and is reversible.

The large family crest (*mon*) representing
facing ginger (*Zingiber moiga*) sprouts that
decorates the back is that of the Inagaki family,
in whose possession the *dōbuku* was until quite
recently. Either Inagaki Nagashige (1539–1603),
who served Ieyasu, or his son Shigetsuna is
thought to have worn it.

While garments with small-scale motifs have
attracted less scholarly attention on the part of
textile historians than their more flamboyant,
multicolored counterparts, several outstanding
examples associated with figures of the sixteenth
and early seventeenth centuries have survived.
The oldest of these is a *dōbuku* with a small six-
petaled flowers on a yellow ground that
belonged to the warlord Uesugi Kenshin, now
in the Uesugi Shrine.

CG

References: Maruyama 1994; Shimizu 1988, no. 264.

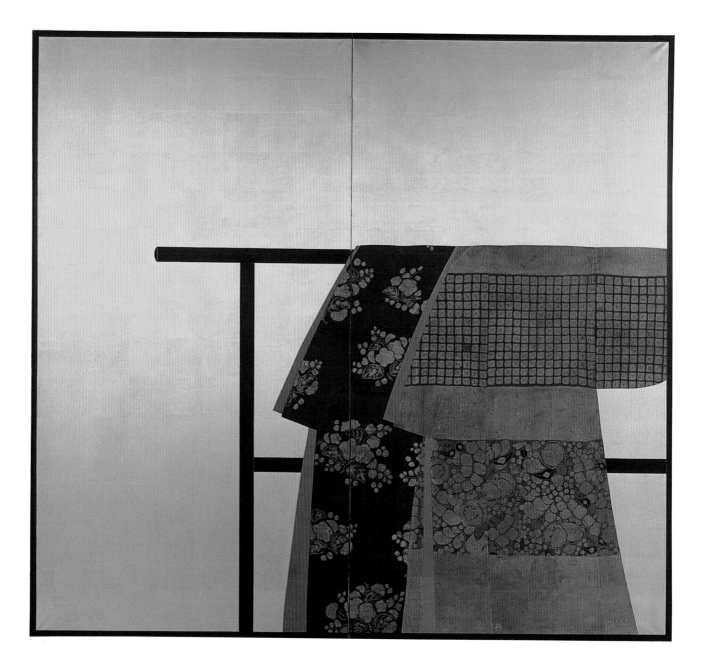

145. SCREEN WITH TWO KOSODE

Late sixteenth–early seventeenth century
Two-panel folding screen
Silk textiles mounted on paper with ink and colors
Left *kosode*: *tsujigahana* style; design of bellflowers and camellia on divided ground; tie-dyeing (*shibori*) on brown and white plain-weave silk (*nerinuki*)
Right *kosode*: design of flowers and clouds; tie-dyeing (*shibori*), embroidery, and gold leaf (*surihaku*) on black plain-weave silk (*nerinuki*)
190.2 x 173.4 cm
National Museum of History and Ethnology, Chiba

Two fragments of contrasting color and design are mounted on a folding screen as if casually draped over a clothing rack. The one on the left features a loose arrangement of large silhouetted camellia and Chinese bellflowers on a particolored ground of alternating wavy bands of cream and red, now faded to brown. On the right, a profusion of minute, densely spaced flowers and clouds float over a dark silk ground.

Both fragments originally formed part of a *kosode*, the "small sleeved" garment (in reference to the size of the wrist opening) that was adopted in the sixteenth century as the daily wear for men and women of all classes.

Comparatively few textiles have survived from the Momoyama period, and many that have are in fragmentary form. At a time when antique clothing was not held in high esteem in Japan, Nomura Shōjirō (1879–1943), a pioneer collector and dealer in antique clothing, assembled an exceptional collection that exhibits the high level of design, technique, and color sensibility characteristic of the textile arts from the sixteenth through the nineteenth centuries. It included both intact garments and fragments acquired from households where they had been handed down over the generations and from temples and shrines where they had been donated after their owners' deaths.

Nomura also devised this imaginative method of preserving and displaying textile fragments. In so doing, he drew inspiration from a kind of trompe l'oeil screen painting that was popular in the late sixteenth and seventeenth centuries featuring an assortment of beautiful garments casually draped over a clothing rack as if their owners had just disrobed. In this genre of screen painting, known suggestively as "Whose Sleeves" (*tagasode*), the physical setting is often suggested by the addition of musical instruments, incense burners, and other articles commonly found in women's private chambers. For Nomura, however, recreating the historical context in which the garments were worn was overshadowed in importance by his desire to see them appreciated as an art form on a par with painting.

CG

References: Gluckman and Takeda 1992, no. 2; Stinchecum 1984, no. 4.

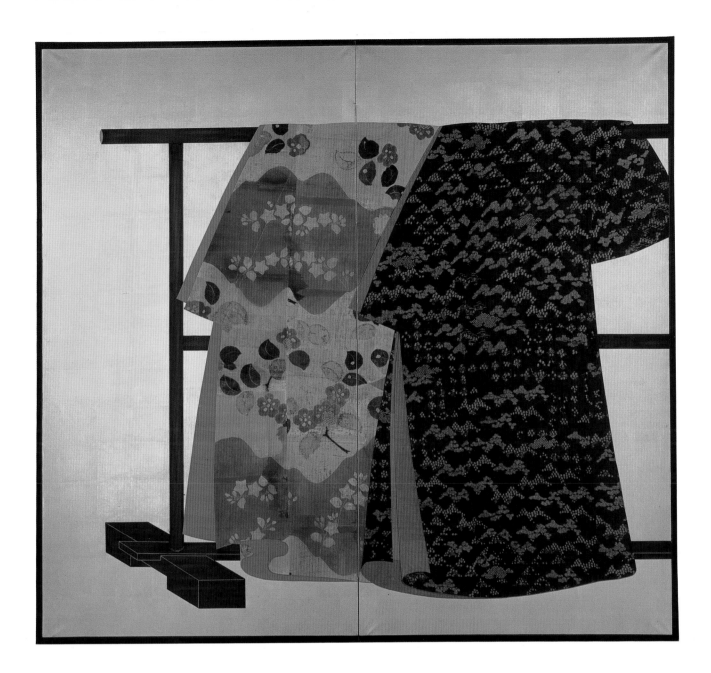

146. SCREEN WITH TWO *KOSODE*

Late sixteenth–early seventeenth century
Two-panel folding screen
Silk textiles mounted on paper with ink and colors
Left *kosode*: *tsujigahana* style; design of scattered floral
motif; tie-dyeing (*shibori*) on purple plain-weave silk
(*nerinuki*)
Right *kosode*: *tsujigahana* style; design of white squares on
horizontal brown band, and white camellias and wisteria
on horizontal green band; tie-dyeing (*shibori*) and ink
painting on white plain-weave (*nerinuki*) silk
190.5 x 173.4 cm
National Museum of History and Ethnology, Chiba

These two fragments exemplify the style of
textile decor that has come to be known by the
poetic name *tsujigahana*, "flowers at the
crossings," characteristic of garments created in
the late sixteenth and early seventeenth
centuries. *Tsujigahana* refers to a combination of
non-loom decorative techniques, principally tie-
dyeing, but also hand-painting, embroidery, and

the application of metallic foil. Because of its
receptivity to such decorative treatment, plain-
weave silk, distinguished by a glossed weft and
unglossed warp, was the fabric of choice for
tsujigahana. The advent of *tsujigahana* made
possible a freedom of expression not possible in
woven designs.

The fragment on the left, with a floral pattern
reserved in white against a purple ground,
exhibits the basic form of *tsujigahana*. The leaves
and stems were made using a stitch reserve, in
which the outlines were first stitched with a bast
fiber using very fine stitches then tightly bound
with hemp fiber to prevent dye penetration.
The larger blossoms were made using a variation
in which outlines were stitched, pulled tight,
then capped with a protective bamboo sheath
before dyeing. The tiny needle holes still visible
around the contours of each component enable
one to visualize the time-consuming process

required in the creation of these elaborate
designs.

Both bands of the fragment on the right were
made using the stitch-resist technique, but the
mosaic-like arrangement of camellia and wisteria
was enhanced by shading the outlines of the
petals and leaves in black ink. This handpainting
both softens the contours of the design and
imparts a feeling of mellow elegance. Camellia
combined with wisteria was a popular
decorative motif in the late sixteenth century.
Surviving examples include a collar of a *kosode*
made between 1595 and 1599 for Hideyoshi's
concubine, Lady Fushimi.

CG

References: Gluckman and Takeda 1993, no. 1; Stinchecum
1984, no. 1.

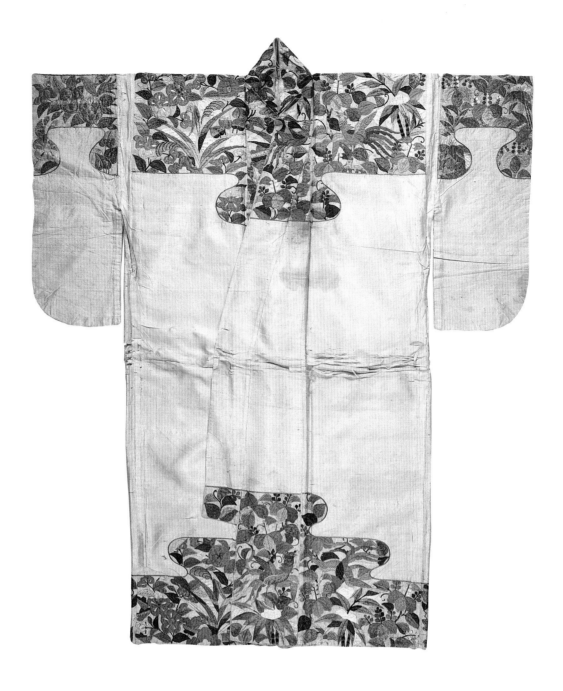

147. Noh robe with Design of Paulownia, Bamboo, Phoenix, Cherries, and Reeds

Late sixteenth century
Embroidery (*nuihaku*) and metallic foil (*surihaku*) on plain-weave silk (*nerinuki*)
120 x 111 cm
Tokyo National Museum
Important Cultural Property

The decoration of this robe is confined to undulating bands at the shoulders and hem, a popular sixteenth-century style known as "shoulders and hem" (*katasuso*), whose restrained elegance reflects older traditions in textile design. The paulownia, bamboo, phoenix, cherries and reeds are densely embroidered in multi-colored threads without respect to scale or setting. Metallic foil, now largely worn off, once filled in the small spaces between the embroidery. The opulence of this decor is offset by the lustrous expanse of white plain-weave silk.

The "shoulder and hem" style originated when the *kosode* was still an undergarment and decoration was limited to those areas visible when the wearer moved or slipped the outer robe off the shoulders. Overall designs incorporating stylized sandbars or bands of clouds figured in textile decor as early as the Heian period (794–1185), but a reclining woman dressed in a *kosode* of this type depicted in *Kasuga gongen genki-e* (Miraculous Tales of the Kasuga Deities), a narrative handscroll painted in 1309 by the court artist Takashina Takakane, offers the earliest evidence of the shoulder and hem arrangement. Numerous surviving examples of *kosode* of this type attest to its enduring popularity in the sixteenth century.

During the Momoyama period, Noh costumes were not yet made specifically for the stage or clearly differentiated according to role, and it was not uncommon for an actor to don a *kosode* presented him by an appreciative patron. The elegant and uncluttered look of *kosode* with *katasuso* decor was deemed especially suited to female roles.

CG

Reference: Morse 1989.

284

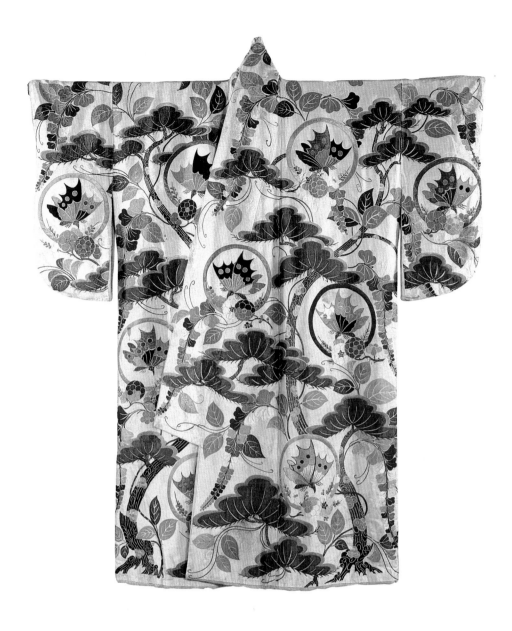

148. Noh Robe with Designs of Snow-
covered Willows and Swallowtail
Butterflies

Late sixteenth-early seventeenth century
Embroidery (*nuihaku*) on plain-weave silk (*nerinuki*)
127.3 x 121.2 cm
Kasuga Shrine, Gifu
Important Cultural Property

A slender willow with graceful snow-laden
branches rises from the hem to encompass the
whole back and sleeves of this robe. Here and
there, swallow-tailed butterflies, each caught
within multicolored roundels, hover in its
branches. Each motif is embroidered using long
floating stitches of multicolored floss. Gold
thread provides accents in the trunk of the tree.
In contrast to the densely padded embroidery of
the robes in catalogue numbers 147 and 150,

embroidery is used sparingly here, highlighting
the vibrant red silk ground.

Standing trees were a favorite seasonal motif
on *kosode* since their trunks and branches lent
themselves particularly well to a unified design
that included both vertical and horizontal
elements. The straight lines and simple construc-
tion of the *kosode* made it an ideal foil for such
pictorial treatment. Records of the Kariganeya
workshop, the main supplier of luxury clothing
to Hideyoshi and his household, reveal that
between 1588 and 1600 there were many orders
for garments decorated with standing quince,
willows, pines, gingkoes and plums. The variety
of trees figuring in garment design closely
parallels that in paintings of the same period.

Willows were traditionally associated with
women, and many classical poems liken the
gentle stirring of willow branches to a woman's

breeze-blown hair, but snow-covered willows,
because of their resilience, were metaphors for
masculine strength. Although this *kosode* came to
be used as a Noh costume for young female
roles, a short coat (*dōbuku*)in Uesugi Shrine,
which once belonged to the warlord Uesugi
Kenshin (1530–78), suggests that in the sixteenth
century, garments with this motif were also worn
by men.

CG

References: Cunningham 1991, 65; Itō 1985; Metropolitan
1975, no. 53.

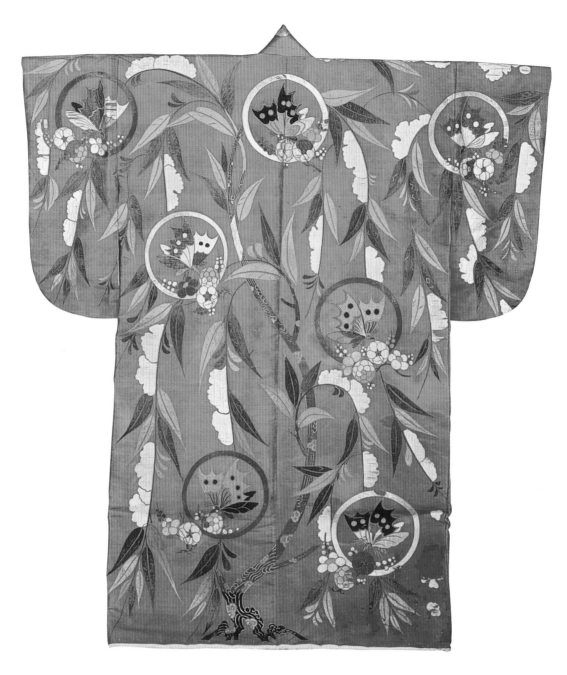

149. NOH ROBE WITH DESIGN OF PINES AND WISTERIA WITH BUTTERFLIES IN ROUNDELS

Late sixteenth century
Embroidery (*nuihaku*) and metallic leaf (*surihaku*) on plain-weave silk (*nerinuki*)
128.5 x 60.0 cm
Kasuga Shrine, Gifu
Important Cultural Property

Embroidery, silver and gold leaf are combined to create the wisteria entwined pines, butterflies and roundels that decorate this sumptuous robe. It resembles the previous one in composition, but the densely stitched green masses of the pine boughs give the decor a more horizontal emphasis. This is offset by the profusion of long feathery wisteria hanging from its branches.

Wisteria entwined pine was traditionally associated with the Kasuga Shrine in Nara, since the Fujiwara, who founded this shrine in the eighth century, had adopted wisteria for their family crest. The Kasuga Shrine in Seki City, which owns both this robe and the previous one, was a branch of that Nara institution. Founded in the fourteenth century by local swordsmiths who adopted the Kasuga deities as their special protectors, it was the site of Noh performances during the Muromachi and Momoyama periods. The long narrow sleeves of this robe reflect sixteenth-century *kosode* style.

CG

References: *Jūyō bunkazai* 1976, no. 9.

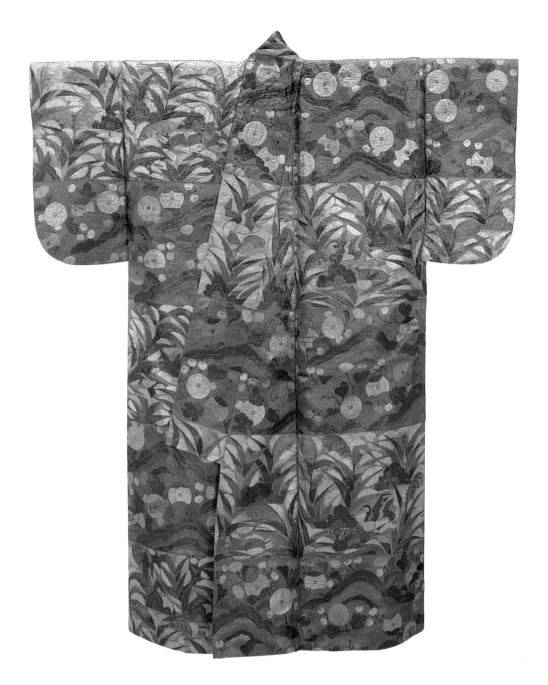

150. Noh Robe with Design of Chrysanthemums, Reeds, and Waterfowl on alternating red and white square grounds

Late sixteenth–early seventeenth century
Embroidery (*nuihaku*) with gold and silk foil (*surihaku*)
on plain-weave silk (*nerinuki*)
130 x 116 cm
Tokyo National Museum
Important Cultural Property

This robe illustrates the "alternating sides," or *dangawari* style of *kosode* popular in the sixteenth and seventeenth centuries that was perpetuated in Noh costumes long after it fell out of fashion for daily wear. Richly embroidered scenes of mandarin ducks among snow-covered reeds alternate with scenes of chrysanthemum blossoms floating over rolling hills to create evocative spring and autumn landscapes. The

contrasting white and red background, colors traditionally associated with early spring and autumn respectively, reinforces the seasonal overtones.

The elaborate embroidery is executed using long float stitches of untwisted, multicolored floss held in place only at the edges of the design, a technique influenced by fabrics imported from Ming China. In lieu of the floss wrapped in gold or silver paper used in China, however, Japanese embroiderers applied silver and gold foil to enhance the spaces between the embroidered motifs. Unstinting care was lavished in the rendering of each detail to produce a garment of opulent splendor.

The practice of piecing together garments from patches of contrasting colors and design probably arose in response to practical rather than decorative imperatives. Silken garments

were extremely valuable, and this compartmentalized approach made it easy to move worn sections of the garment to less conspicuous areas as needed, thus prolonging their life. As a result of retailoring, however, the alternating design does not extend to the sleeves.

This robe is one of two now in the Tokyo National Museum that formerly belonged to the Komparu, one of the five major schools of Noh. The Komparu were especially influential in the sixteenth century, and later enjoyed the patronage of Tokugawa Ieyasu's son Yoshinao, the founder of the Owari branch of the Tokugawa line.

CG

References: Cunningham 1991 no. 64; Kennedy 1990, 95; Takeda 1992, no. 109.

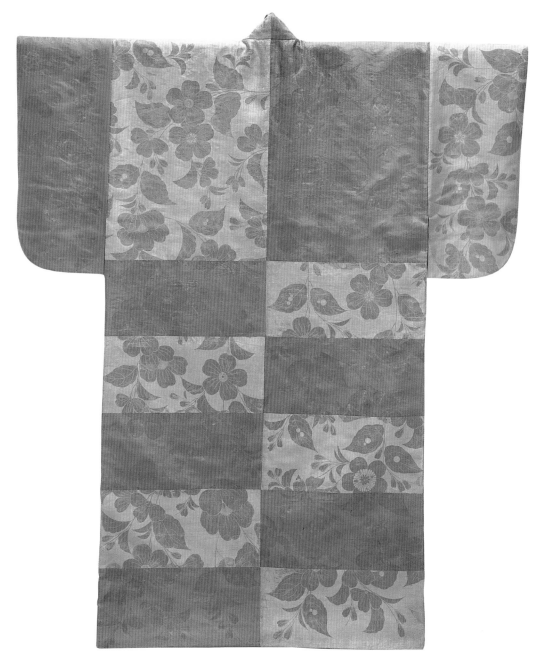

151. Noh Robe with Design of Weeping Cherries in alternating red and white bands

Late sixteenth–early seventeenth century
Gold foil (*surihaku*) on plain-weave silk (*nerinuki*)
132 x 58 cm
Hayashibara Museum of Art, Okayama
Important Cultural Property

Fashioned in the *dangawari* manner from blocks of contrasting colors but similar designs, this robe exhibits a stylish elegance associated with the courtly tradition of the Heian period (794–1185). Two large patches of red and white plain-weave silk with gold foil designs of branches of weeping cherry extend from the shoulders to just above the waist. Below these, five smaller patches are stitched together at the center of the back. The randomly arranged floral sprays were created by pasting thin layers of gold

foil over the parti-colored silk, a technique known as *surihaku*. Despite their seeming uniformity, they are in fact represented from many vantage points: some frontal view, others in three quarter view, and still others in profile. The uneven size of the red and white blocks as well as the difference in style, scale, and arrangement of the floral sprays indicates that this robe was pieced together from parts of two different garments. On stage, it would have been worn as an inner robe for an actor playing a female role.

Cherry blossoms, emblematic of evanescence, were among the classical aristocratic literary themes adapted by artists of the Momoyama era for a wide range of formats and media. The flat, decorative arrangement of the cherry blossoms on this robe recalls that figuring on the woodblock printed covers of so-called Sagabon,

luxury editions of Japanese classics produced between 1600 and 1615 by Hon'ami Kōetsu (cat. nos 75, 76). Similar printed designs are also found on the long handscrolls and squares of decorated paper (*shikishi*) Tawaraya Sōtatsu and his workshop created for inscribing court poetry. Although little is known of the identities of the artists involved in textile design, it is likely that Kōetsu, Sōtatsu and artists of their circle were closely allied to the craftsmen in Kyoto's Nishijin district who fashioned luxurious garments for the aristocratic and military elite.

CG

References: Kirihata 1988; Takeda 1992, no. 111; Tsuji 1991, no. 51.

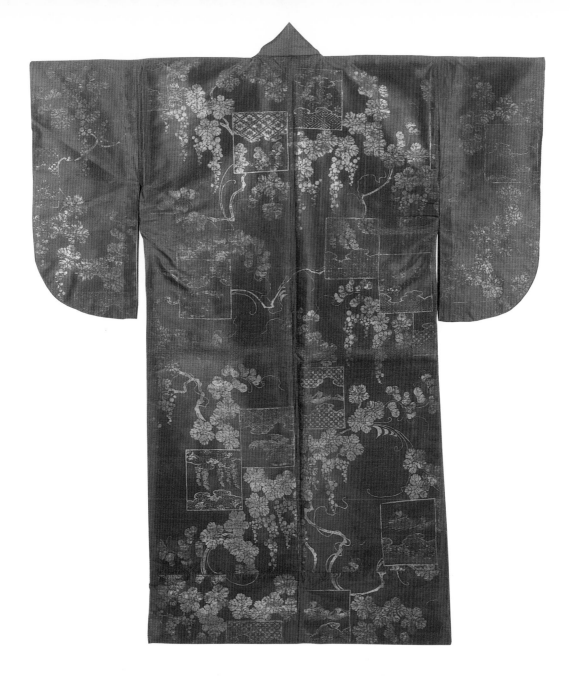

152. Noh Robe with Design of Grape Vines and Decorative Papers

Late sixteenth–early seventeenth century
Gold foil (*surihaku*) on purple plain-weave silk (*nerinuki*)
103.9 x 48.5 cm
Tokyo National Museum
Important Cultural Property

The shimmering gold of the trailing grapevine laden with ripe fruit and the square decorative papers (*shikishi*) silhouetted against the plain purple silk give this robe an elegant simplicity and clarity of design. It was embellished by the application of gold foil (*surihaku*), a decorative technique more commonly used in combination with other techniques. The crispness and delicacy of the design suggest that it was applied with the aid of a stencil.

Grapes first became a popular decorative motif in the eighth century, when they were introduced to Japan via silk textiles and other articles imported from China and beyond. Emblems of prosperity and abundance, they enjoyed renewed popularity in the lacquer, ceramics, and textiles of the late sixteenth and early seventeenth centuries, a period comparable to the eighth century in terms of its cosmopolitanism. In the decor of this garment, however, this exotic motif has been reconfigured to conform to native aesthetic sensibilities by the superimposition of decorated poem papers over the scrolling vines. Paintings of flowering trees with poems inscribed on long cards suspended from their branches, a popular Yamato-e theme, no doubt inspired this imaginative treatment. Although each of the square papers on this robe is meticulously decorated with a landscape or other motif, no poems are inscribed on them.

The narrow proportions of the robe and sleeves are typical of the late sixteenth century. This robe may have been adapted for theatrical use when this style went out of fashion in the seventeenth century. Preserved in the collection of the Komparu family of Noh actors, it was used as a costume for a child's role.

CG

References: Kennedy 1990, 98; Kyoto 1977, no. 75; Tsuji 1991, no. 52.

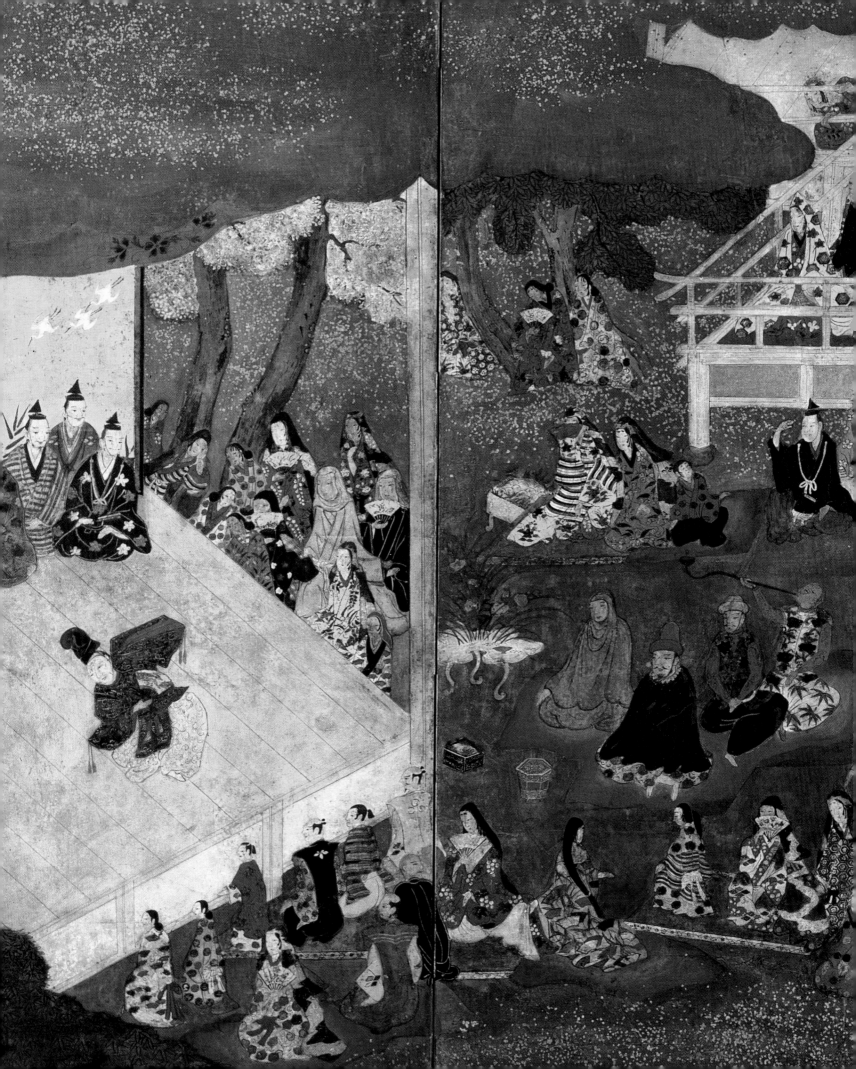

Noh Masks

ANDREW J. PEKARIK

Noh developed in the mid-fourteenth century out of provincial theatrical forms, thanks primarily to the efforts of a family of actors and the sponsorship of the Ashikaga shoguns. The creative geniuses behind the birth of Noh were Kanze Kan'ami Kiyotsugu (1333–84) and, especially, his son, Kanze Zeami Motokiyo (1363–1443). Through their acting, authorship of new plays, theoretical thinking, and day-to-day leadership of the Kanze family troupe they established Noh as a sophisticated art form. The shogun Ashikaga Yoshimitsu (1358–1408), only sixteen years old when he first saw Kan'ami and Zeami perform, became a patron of the troupe and ensured the transformation of Noh from a rural theater of local shrines and temples to an urban art.

Noh drama, as developed by Zeami, embraces abstraction. Characters may be based on historical figures or events, but the drama is structured to emphasize the archetypal emotions that they embody. At the heart of each play is a central figure (called the *shite*, pronounced "shteh") whose mental and spiritual condition is the essence of the play. In the first half of the play this figure may appear in a physical form that hides his/her true nature. In the second half of the play the full expression of the central figure is realized through song and, especially, through the dance that forms the climax of each Noh play. The performance is most successful when the mind of the viewer merges with the mood of the main character or incident. Every detail of the production is carefully constructed to support this experience, but in a way that avoids superficial realism and that defies logical analysis. Actors train intensively to make their art effortless.

Noh flourished in the Momoyama Period thanks to the strong support of Hideyoshi. Hideyoshi patronized all four of the major Noh troupes of the time, the Komparu, Kanze, Kongō, and

Hōshō and took acting lessons from Kurematsu Shinkuro of the Komparu school.[1] Hideyoshi was passionately enthusiastic about Noh. For a three-day marathon of Noh at the Imperial Court, for example, Hideyoshi personally performed in sixteen of the twenty-eight plays presented.[2] He also commissioned new plays to be written, featuring himself as the central figure.

A screen in the Kobe City Museum depicts a Noh performance that was held to celebrate one of Emperor Go-Yōzei's visits to Hideyoshi's palatial mansion, the Jurakutei, either the visit in 1588 or the one in 1592 (cat. no. 26). One section of the screen shows a Noh actor, backed by musicians and a chorus, dancing energetically on a temporary stage; his role is traditionally identified as Okina, the deity whose invocation makes the beginning of a full program of Noh performances (fig. 77).

Amateur Noh performance was popular in the sixteenth century among a wide range of social classes, not just the military elite. The popular pressure for more dramatic action and larger spectacle influenced even the professional troupes, moving them in directions somewhat counter to the ideals of Zeami. In the seven-day Hōkoku Festival of 1604, which commemorated the seventh anniversary of Hideyoshi's death, for example, the first Noh play of the event was performed by the heads of all four schools dancing together to the accompaniment of four large drums and sixteen smaller drums (see cat. no. 118).

When Tokugawa Ieyasu succeeded as ruler of Japan, he made Noh the official ceremonial art of the Tokugawa shogunate. The style of performance shifted away from the dramatic mode favored by Hideyoshi back towards the more reflective approach originated by Zeami. As part of this change, the pace of performance also slowed considerably. In the Momoyama period Noh plays were at least one-third faster than throughout the Edo period or today.

Since the time of Zeami, nearly all central figures in Noh plays wear masks. Some subordinate characters also wear masks. The mask is a very important element in the performance. In the first

Fig. 77. Noh Performance, detail of cat. no. 26.

place it helps the actor to establish his interpretation. By choosing a particular mask from among a range of options, the actor sets the general direction of the performance. Before he enters the theater the actor carefully studies his mask, using it to help him enter the spirit of the part. Through the mask, the actor becomes the character he portrays.

Because most masks are smaller than an actor's face and have only small holes in the eyes, the masked actor cannot see very well. He must use glimpses of the corner pillars on the stage and his feel of the stage boards themselves to orient himself. In addition to the practical difficulties of using masks, the actor must also master the expressive subtleties. Although the expressions of the mask are carved and painted, the experienced actor is able to suggest shifts of feeling by the way he tilts the mask, up or down, right or left, and by the speed with which he moves it. Lifting the mask, for example, makes the expression look lighter, both literally and figuratively, while lowering it darkens it. When we see the mask in a display or photograph, we can grasp only a fraction of the expressive range of which it is capable.

In the Momoyama period (and before) actors had a relatively broad range of options for mask types in many roles, especially those of young women. With the standardization of Noh in the Edo period, these choices became more limited – sometimes established as school traditions. Even when the mask type is preordained, however, the small differences between individual masks are closely appreciated and guide interpretation.

There are about eighty major mask types in use today. Each school used its best masks as the prototypes for later copies of their type. Because of the difficulty of copying a mask, however, most of these later versions could be more accurately called reinterpretations than copies. In some cases the name given to the mask type preserves the name of the carver who first made it (e.g., the *Hannya* mask invented by Hannyabō). In other cases the name may describe the face (*Rōjo*, for example, means "old woman").

Noh masks are carved from Japanese cypress (*hinoki*), the same wood used in the construction of the Noh stage and pillars. The shape of the face is roughed out with saws and then carved with chisels, sanded, coated with gesso, and painted. In some cases bright brass eyes or teeth are also applied. The marks of the chisel create a pattern on the inside of the mask, which is usually lacquered. Starting in the Momoyama period, Noh mask carving became an acknowledged profession and makers began to sign their work. The mark of the carver may appear on the inside as either a brand, a signature, or a distinctive design. Names were sometimes added to older masks to reflect attributions.

NOTES

1. The fifth major school of Noh today, the Kita school, was formed in the early Edo period.
2. Nakamura 1971, 126–7. Nakamura also notes that the Portuguese Jesuits used Noh to propagate Christianity in a new style of Noh called "Christian Noh."
3. Malm 1981, 181–4.
4. Inoura and Kawatake 1981, 97.

FURTHER READING

Thomas Blenman Hare, *Zeami's Style: The Noh Plays of Zeami Motokiyo* (Stanford: Stanford University Press, 1986).

Donald Keene, *Nō: The Classical Theatre of Japan* (Tokyo: Kodansha, 1966).

J. Thomas Rimer and Yamazaki Masakazu, trans., *On the Art of the Nō Drama: The Major Treatises of Zeami* (Princeton: Princeton University Press, 1984).

Royall Tyler, trans., *Japanese Nō Dramas* (London: Penguin, 1992).

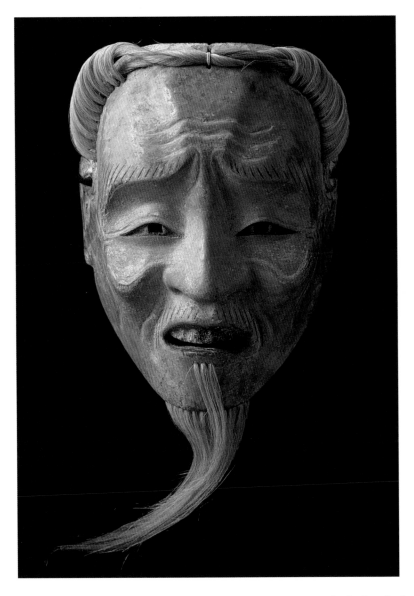

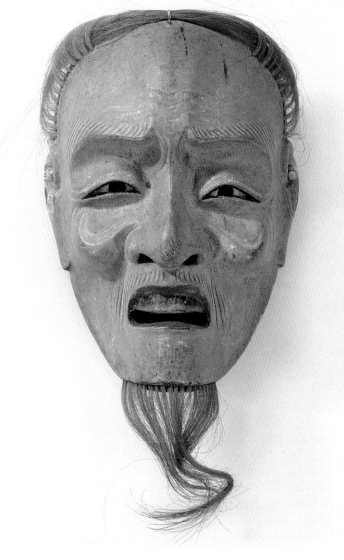

153. *KOJŌ*

Early to mid-sixteenth century
Pigments over wood, flax fiber
20.7 x 15.4 cm
Mitsui Bunko, Tokyo
Important Art Object

154. *AKOBUJŌ*

Early seventeenth century
Pigments over wood, horse hair
21.5 x 15.7 cm
Tokyo National Museum

Both of these masks describe the faces of old men using a similar expression – furrowed brow, bags of skin under the eyes, sunken cheeks, downturned mouth, wispy beard, and hair drawn across a bald head.

Since this *Kojō* mask is older than the *Akobujō* mask, we can presume that it is closer to the prototype. A lacquer inscription on the inside of the mask by the carver Deme Mitsushige (d.1719) even attributes this mask to Koushi Kiyomitsu, who is said to have made the first

Kojō mask. A close look reveals key differences between the *Kojō* mask and the *Akobujō* mask. In particular, the ways that the eyebrows come together, the shape of the mouth and the lines that accent it, and the curve of the chin all tend to make the later mask, *Akobujō*, seem subtly less intense and less refined than the *Kojō* mask.

Before Zeami's time masks of old men tended to show open, smiling faces, but under the influence of Zeami's aesthetics, from his time forward they became more somber. The expression on this Muromachi period *Kojō* is beautifully ambiguous, while the later *Akobujō* mask has virtually abandoned any hint of lightness. Zeami maintained that it was particularly difficult to portray old men, because the actor needed to communicate "an air of divinity and utter tranquillity" (Hare 1986, 66). The *Kojō* mask type, in particular, is used to portray deities appearing in the form of old men. A classic example of such a role is the central figure in *Takasago*, written by Zeami.

Takasago, an auspicious drama celebrating conjugal happiness, longevity, and poetry

through the symbolism of an aged couple and twin pine trees, is still regularly performed today. An old man (portrayed with the *Kojō* mask) appears in the first act raking fallen pine needles on the shore. Gradually, through densely allusive language that draws on centuries of poetic tradition, he is revealed as the god of Sumiyoshi. After a costume and mask change that represents our new perception of his identity, he returns to the stage to dance joyously in the final climax of the play.

Although *Akobujō* can also be used to represent an old man who is, in fact, the embodiment of a supernatural being, the spirit is that of a person rather than a god. A typical use of the *Akobujō* mask is in the first half of the play *Unrin'in*, where it represents the spirit of the famous Heian-period poet Ariwara no Narihira (825–80) appearing as an old man. As in *Takasago*, the main actor returns to the stage in the second half of the drama in a new costume and mask that portray the central spirit without disguise.

AJP

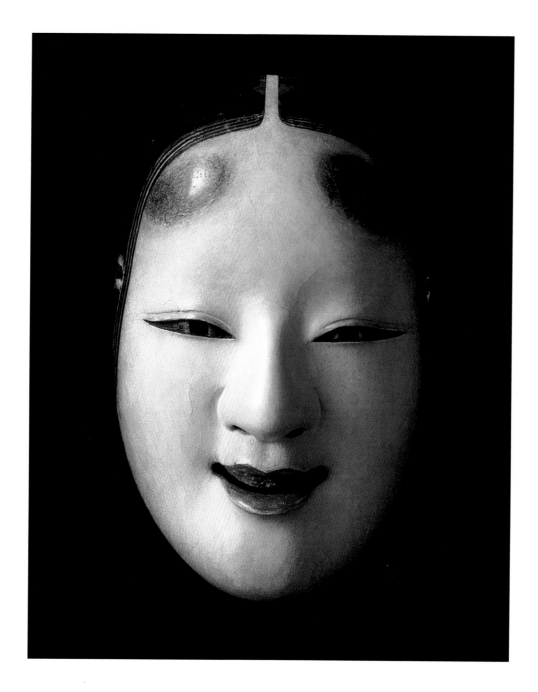

155. *KO-OMOTE*

Mid-sixteenth century
Pigments over wood
20.8 x 13.2 cm
Mitsui Bunko, Tokyo
Important Art Object

Ko-omote represents the smiling face of a young woman. Her features are smooth and rounded and reflect ideals of beauty that had been established at the court since the Heian period, including shaved eyebrows that are repainted near the top of a high forehead, hair parted in the center and falling evenly to each side, and blackened teeth. Youth is suggested by the smile, the fullness of cheeks and chin, and the dimples at the ends of the mouth.

Unlike the masks of old men and some other types, masks of women do not include ears and sometimes seem to depend as much on painting as on carving for their expressions. Every detail is finely nuanced, so that even the thickness of the painted eyebrows or the precise arrangement of hair strands on the side of the face can suggest differences in character and interpretation that can inspire the actor's performance. In *Ko-omote* masks the strands of hair at the edge of the face fall straight and even, suggesting that this innocent youth, in her late teens, has not yet known adversity.

Hideyoshi owned three *Ko-omote* masks from the Muromachi period that he especially prized. The masks, which he named "Snow," "Moon," and "Flower," were attributed to the fifteenth-century carver Ishikawa Tatsuemon Shigemasa. This *Ko-omote* mask is in the lineage of Tatsuemon's "Flower" mask.

Ko-omote masks are most frequently used today for young women in minor roles.

Traditionally (and still by the Komparu and Kita schools) they were used for the central figure in a number of plays featuring a young woman, such as Matsukaze, in the masterpiece of that name written by Kan'ami and revised by Zeami. In *Matsukaze*, the spirits of two young sisters, Matsukaze ("Pine Breeze") and Murasame ("Autumn Rain"), appear to a priest in a dream. They were poor fisher girls who had fallen in love with a poet, Ariwara no Yukihira (818–93), who had been exiled to their isolated coast, and they had died of longing when he returned to the capital. In a powerful interweaving of quotations from Yukihira's poems, natural images, and dialogue, the two sisters express the intensity of their longing and attachment, a bond so strong that it prevents their spirits from finding release.

AJP

294

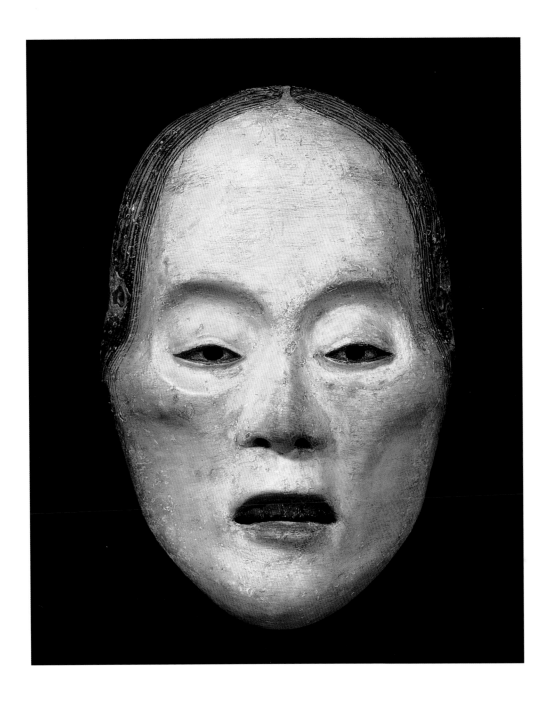

156. Rōjo

Mid-sixteenth century
Pigments over wood
20.4 x 15.4 cm
Mitsui Bunko, Tokyo
Important Art Object

Rōjo, the name of this mask type, means "old woman," and her age is expressed in her sunken eyes, sunken cheeks and thin-lipped, down-turned mouth. But this mask is used only for one particular old woman, the poet Ono no Komachi.

Ono no Komachi, who wrote in the early Heian period (ninth century), was renowned for her passionate poetry and, as a result, she developed a legendary, posthumous reputation for great beauty and profligate love affairs. Characteristically the Noh drama preferred to consider this legendary Komachi not in her hot-blooded youth but in the last moments of her life, as this once-desired beauty faces death.

The mask for this role must enable the actor to suggest echoes of great beauty and sensitivity as well as the scars of time. The subtle asymmetries of this Rōjo mask would provide an actor with an extensive range of expressive possibilities.

Rōjo is only one of several masks that an actor could choose to play the aging Komachi. The choice of mask guides and reflects his interpretation. The aged Komachi is considered the most difficult female role that an actor can play, and it is only performed by elderly men, who are presumed to have both the necessary depth of skill and life experience. Of the five currently performed plays on the Komachi theme, the pinnacle is *Sekidera Komachi*, a play attributed to Zeami, and the one considered the most elevated and most difficult of all Noh plays.

The play *Sekidera Komachi* contains virtually no action. The abbot of Sekidera, a temple east of Kyoto, brings two of his priests and a child to talk to the woman poet, over one-hundred years old, who lives in a hut near the temple. As they talk she admits that she is Ono no Komachi and with great sorrow, using quotations from her poetry and that of others, she tells her story and expresses her longing for the past. The dialogue itself exemplifies the power of poetry to re-animate and communicate complex emotions. Despite her deep sense of loss, Komachi is still alive to beauty and when, at the climax of the play, the child dances, Komachi struggles to her feet and briefly dances before collapsing in tears.

AJP

295

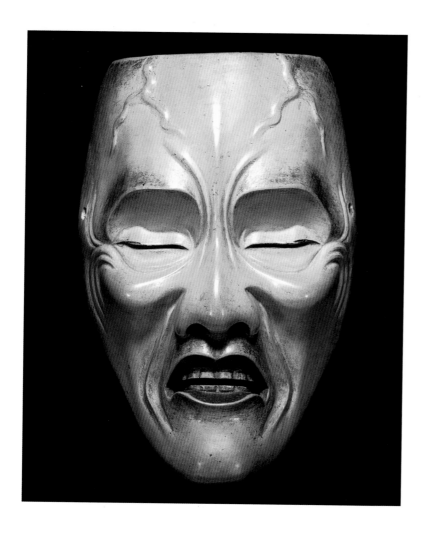

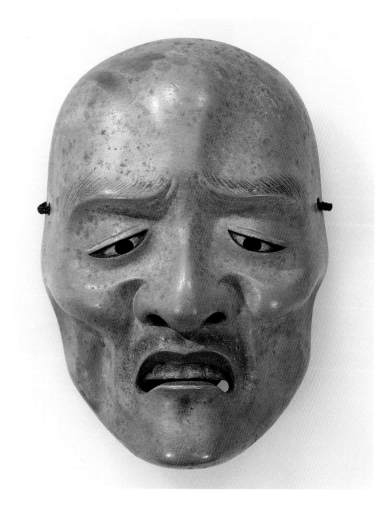

157. *KAGEKIYO*

Late sixteenth century
Pigments over wood
20.3 x 14.4 cm.
Mitsui Bunko, Tokyo

158. *SHUNKAN*

Early seventeenth century
Pigments over wood
20.9 x 14.6 cm
Tokyo National Museum

Unlike most of the other masks in this exhibition, which can be used in a number of different plays, these two masks can only be used in one play each, *Kagekiyo* and *Shunkan*. The plays are named after their central characters, historical figures of the late Heian period, both of whom were exiled for political offenses.

The Noh plays *Kagekiyo* and *Shunkan* portray these men not at the peak of their success and glory but at their moment of deepest despair. Taira no Kagekiyo, once a renowned warrior, is now a blind beggar. The mask signals his blindness by using slits as eyes. (Ironically the masks of blind men, because of these downward-pointing slits, afford the actors who wear them greater visibility than any other

mask.) This beautiful *Kagekiyo* mask, attributed to the renowned mask carver Deme Mitsuteru, conveys suffering by the bulging forehead veins and the deep lines around the mouth. The carver achieves a distinctive expression that seems free from attachment to a prototype. At the same time, he emphasized formal qualities in the shapes of the facial features, such as the curves of the nostrils which echo the curves of the mouth, or the lines between the eyes which harmonize with the lines on the sides of the mouth. Slight asymmetries keep the expression dynamic.

Shunkan (1143?–79), a Buddhist priest, was exiled in 1177 to a remote island in southern Kyushu. According to the play, after he had spent some time on the island along with two fellow exiles, a general pardon was issued and all exiles were permitted to return to the capital – except Shunkan. *Shunkan* describes the arrival of the government official on the island, the reading of the pardon that excludes Shunkan and the departure of his friends. The expression of the *Shunkan* mask embodies despair, abandonment and confusion, especially through the tilt of the eyes. The story of Shunkan's distress also became a popular dramatic theme in the Bunraku puppet theater and Kabuki.

AJP

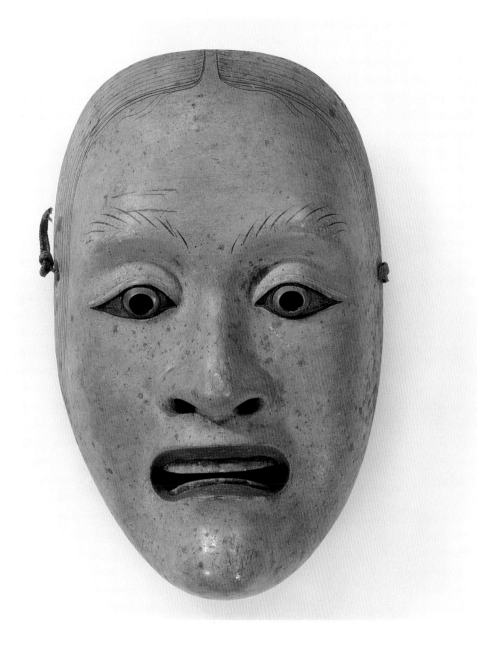

159. *YAMAMBA*

Early seventeenth century
Pigments over wood
21.1 x 13.3 cm
Tokyo National Museum, Tokyo

Yamamba (alternatively pronounced "Yama-uba") describes an otherworldly being who lives deep in the mountains. As the goddess of the mountains, Yamamba lives far outside the human community and is both respected and feared. Sometimes described as a demon or ogre (*Yama-uba* means "old woman of the mountain"), she appears in numerous old legends.

The *Yamamba* mask is used in only one Noh play, *Yamamba*, written by Zeami in his later years, after he had experienced disfavor, exile, and personal disappointment, and it reflects a deeply Buddhist vision. In the play a young dancer, known as Yamamba because of her powerfully evocative performance impersonating the mountain goddess, travels on a pilgrimage through the mountains and meets the real Yamamba, who is portrayed in the first half of the play with a mask used to represent middle-aged women (*Fukai*). After revealing her true identity to the girl, she returns in the second half of the play, wearing the *Yamamba* mask, and through dance and poetic song reveals the depth of her feeling. She describes herself as suspended between two worlds, the human world and the supernatural world, the world of attachment and the world beyond all emotion. On the one hand she, too, longs for spring blossoms and the autumn moon, while on the other hand she merges with streams, clouds and the mountains themselves.

The face of Yamamba is described in the play itself by Yamamba and the dancer together:

DANCER: you, human in form
CRONE: yet crowned with a snarl of
 snowy weeds:
DANCER: whose pupils shine like stars,
CRONE: whose face in hue
DANCER: glows ruddy bright
CRONE: as any red-daubed demon tile
 glowering from the eaves.
 (Tyler 1992, 323)

Bulging eyes inlaid with gold metal, long animal-like eyebrows, stray hairs on her forehead, and red coloring give the *Yamamba* mask a wild and mysterious look.

AJP

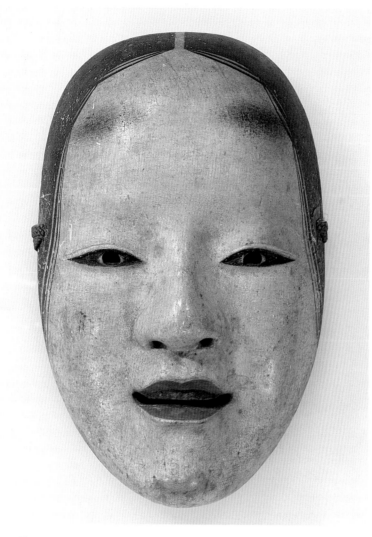

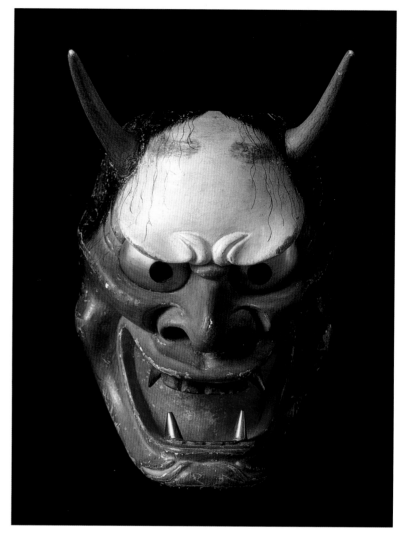

160. ŌMI-ONNA

Early seventeenth century
Pigments over wood
20.9 x 13.3 cm
Tokyo National Museum

161. JA

Mid-sixteenth century
Pigments over wood
20.4 x 15.4 cm
Mitsui Bunko, Tokyo
Important Art Object

162. HANNYA

Early seventeenth century
Pigments over wood
21.1 x 16.6 cm
Tokyo National Museum, Tokyo

The *Ōmi-onna* mask seems at first glance very close to the sweet young girl portrayed in the *Ko-omote* mask. A stronger definition of the cheekbones and chin, and, especially, the looped strands of hair at her temples, indicate, however, that she is older and more experienced – a woman closer to thirty years old than twenty years old. Because the *Ōmi-onna* mask type is thought to suggest an element of passion, it is often chosen for the central figure in the first half of the play *Dōjōji*, one of the most dramatic in the repertoire.

In *Dōjōji* a young girl appears as a dancer who, after dancing in the temple courtyard, disappears into a huge, new bronze bell. We soon learn that she is, in fact, the vengeful spirit of a girl whose father had led her to believe that a priest would marry her. When the priest refused her, she turned into a demon, pursued him, found him hiding inside a bell and wrapping her serpent body around the bell, had burned him to death. Now the angry spirit has returned to the temple to damage the new bell. As the bell is raised in the second part of the

play, the dancer, now revealed as a demon, emerges.

The actor has a choice of two mask types for this second half of the play, either *Hannya*, which shows the vengeful woman with fangs, glittering eyes and horns, or *Ja*, an even more extreme form, with a wider mouth, larger fangs and drastically distorted features. Only the traces of the painted eyebrows and the strands of hair tell us that this is the same being as the young woman with the *Ōmi-onna* face. In the *Hannya* mask there is more connection to human form and we might even be able to feel some compassion for the intensity of attachment that has driven this woman to her mad, destructive condition. But the *Ja* mask takes this extreme of emotion beyond the range of ordinary understanding. The wildly disordered hair on the forehead of the *Ja* mask symbolizes her degree of unrestrained derangement. Her transformation is otherworldly. In choosing between these two masks, the actor selects a personal interpretation of the role.

AJP

298

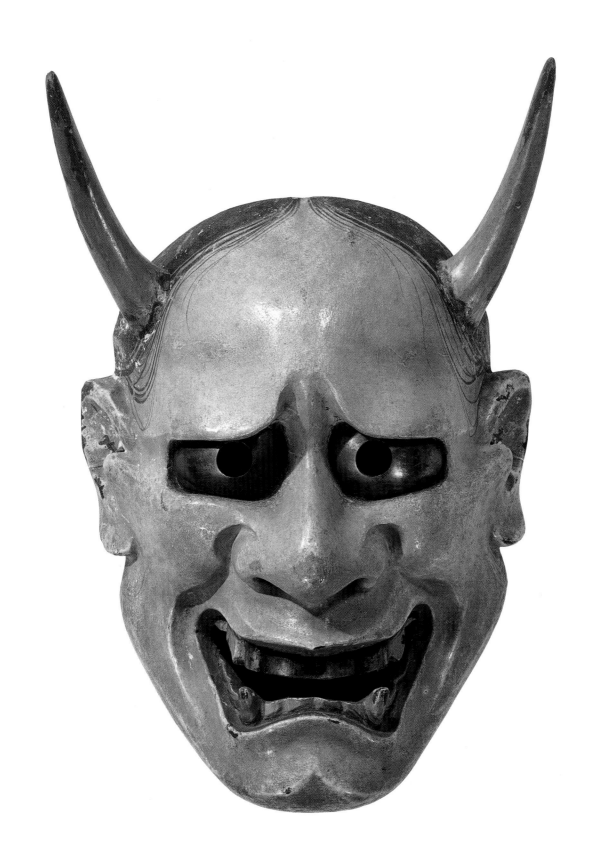

Glossary

bakufu, "tent headquarters." Military government headed by a shogun.

byōbu, "wind screen." Portable, folding screen used to divide interior spaces and for decoration in traditional Japanese architecture; *byōbu-e* are paintings on folding screens.

chanoyu, "hot water for tea." Japanese tea ceremony.

chashitsu, "tea chamber." Small room designed especially for tea ceremony gatherings.

daimyō, "great names." Provincial feudal lords granted fiefs by the shogun or chief military leader.

dangawari, "different levels." Pattern of alternating blocks of different material, color, or motifs popular in textile design.

dōbuku. Man's jacket, generally worn over other clothing or armor.

Edo (modern-day Tokyo). City that served as the seat of power for the Tokugawa family. The Edo period (1615–1868) refers to the age when Tokugawa shoguns ruled Japan; often used interchangeably with Tokugawa period.

e-nashiji, "pictorial *nashiji*." Use of the *nashiji* technique to depict a design element with a *maki-e* lacquer decoration, rather than as an overall decorative surface; a characteristic feature of Kōdaiji-style lacquers, where it is often used to create contrasting effects. See *nashiji*.

fūryū odori, "dances of the flowing wind." Public dancing, often involving hundreds of participants, which was in great vogue during the sixteenth and early seventeenth centuries.

fusuma. Interior sliding screens used to divide rooms; *fusuma-e* refers to paintings on such screens.

go. Strategic board game. One of the traditional four accomplishments.

harigaki, "needle-drawing." Lacquer decorating method, associated with the Kōdaiji lacquer style. After sprinkling metal powders over wet lacquer to create a design, the lacquerer allowed the design to harden and then added linear detail to the design by scratching through the powdered decoration with a sharp point. See *kakiwari*.

hiramaki-e, "level sprinkled design." *Maki-e* decorations created by drawing the design directly on the surface and then sprinkling metal powder on the wet areas; the design rises above the ground only as far as the thickness of the lacquer used to draw it. See *takamaki-e*.

jimbaori. Campaign jacket; short garment worn over armor by warriors.

kaiseki. Light meal served before a formal tea ceremony.

kakiwari, "drawn separately." Method of drawing details within sprinkled designs (*maki-e*). In *kakiwari* the details are left in reserve, so that the color of the ground contrasts with the sprinkled areas around them. See *harigaki*.

kampaku. Official court title bestowed upon the regent to an emperor. Hideyoshi was granted this title in 1585 by Emperor Go-Yōzei.

kana, "makeshift names." Japanese phonetic syllabary.

kanga, "Han-dynasty pictures." A term first used in the Edo period to describe paintings based on traditional Chinese painting styles and subjects; refers both to ink paintings in monochrome or in light colors favored by painters in Zen (Ch'an) circles as well as paintings in an academic mode, often employing rich colors.

kanji, "Han-Dynasty characters." Japanese term for Chinese characters.

Kantō. Northeastern part of Honshū, the main island of Japan, centering on Edo (modern-day Tokyo).

katasuso, "shoulders and hem." Garment design in which the decor is confined to areas around the shoulders and hem.

kirihame (also *kiribame*), "cut insert." Technique in which fabric pieces are cut and fitted into holes cut into a garment.

komon, "minute pattern." Small-scale repeat pattern in a single color usually against a colored ground.

kosode, "small sleeves." Garment with small wrist openings originally worn as an undergarment that was widely adopted as a form of daily wear during the Momoyama period; also the basis for Noh robes.

koto (C: *ch'in*). A zither-like instrument with thirteen strings, played with picks. One of the traditional four accomplishments.

maki-e, "sprinkled design." Primary method of Japanese lacquer decoration in which the design is drawn in lacquer on the prepared surface. While the drawn design is still wet, metal powders are evenly sprinkled over it; the powders cling to the sticky lacquer and are bound to it as the lacquer hardens. Usually the design is then covered with a protective coating of transparent lacquer and the metal powders are carefully polished. See *hiramaki-e*, *takamaki-e*, and *makihanashi*.

makihanashi, "sprinkled and left alone." Sprinkled design that was left as it was after the sprinkled design hardened; in other words, no protective cover coating of clear lacquer was applied and the metal flakes were not polished after the design hardened.

Momoyama, "Peach Blossom Hill." An area southeast of Kyoto where Toyotomi Hideyoshi built his Fushimi Castle. The Momoyama period (1573–1615) refers to the period when a number of powerful warlords fought to bring the country under a single, unified authority.

mon. Family crests, often used as part of textile design or represented in large scale on the back of a garment.

nashiji, "pear-skin ground." Lacquering technique often used for applying a uniform decorative surface to large, but less important

areas, such as the insides of drawers or the bottoms of boxes. *Nashiji* consists of relatively large metal flakes with irregular shapes suspended in many layers of *nashiji urushi* ("*nashiji* lacquer"), a highly translucent lacquer that has been tinted orange. The name "pear skin ground" derives from the fact that the final surface can have a slight texture. See *e-nashi*.

Nishijin, "western camp." District in northwest Kyoto that became the center of textile production in the sixteenth century.

noborigama, "climbing kiln." Type of multi-chamber kiln developed in the early seventeenth century that had a much larger capacity than earlier kilns, and which allowed a variety of wares with different firing requirements to be fired at the same time; crucial to the development of Mino and Seto ceramics.

nuihaku, "embroidery and foil." Decorative technique for textiles using embroidery combined with gold foil, and by extension, a Noh costume made in this manner worn as an inner robe for female roles.

Rakuchū rakugai-zu, "Scenes In and Around the Capital." Panoramic views of Kyoto and its surrounding areas; important subject of early Japanese genre painting.

sabi urushi. Putty-like mixture of lacquer and powdered clay that is used as a base coating or as a medium for sculpting design details. See *takamaki-e.*

shakudō. Alloy of copper and gold, patinated black.

shamisen, "three strings." Banjo-like instrument with three strings, based on Okinawan prototypes brought to Japan in the fifteenth century; during the seventeenth century was adopted for use in Kabuki and Jōruri (puppet theater).

shibori, "wrung" or "squeezed." Term used to denote a variety of ways of decorating fabric by tightly binding with thread and or capping with a bamboo sheath the cloth to prevent dye penetration before immersion dying; by extension resist-dyed textiles

surihaku, "metal foil." Decorative technique for textiles in which metal foil is impressed on a design first drawn in paste; and by extension, a Noh robe for female roles.

taikō. Retired regent; official court title bestowed upon a regent who abdicates the post in favor of his son; especially used to refer to Hideyoshi, who was granted the title by Emperor Ōgimachi in 1592.

takamaki-e, "raised sprinkled design." Decoration that is raised above the surface of an object because parts of it were sculpted in *sabi urushi* before the final coating of metal powders were sprinkled. See *hiramaki-e.*

tokonoma. Alcove for displaying hanging scrolls, flower arrangements, or other objects.

tsujigahana, "flowers at the crossings." Decorative technique and style combining tie-dye and hand painting popular in the Momoyama period.

urushi, "lacquer." Sap of the urushi tree, refined to remove water and impurities. When applied in thin coats and left in a very humid atmosphere it hardens and forms a tough surface that is impermeable to liquids and that can be polished to a high gloss.

wabi. Aesthetic concept central to the tea ceremony which places an emphasis on restraint in expression and cherishes the unaffected beauty associated with loneliness, poverty, or rusticity.

waka, "Japanese poem." Thirty-one syllable court verse.

yamato-e, "Japanese pictures." Paintings of native subjects in a style associated with the imperial court and traditional culture.

Chronological Tables

compiled by Suzy Sloan Jones

	POLITICAL & MILITARY HISTORY	CULTURAL HISTORY (dates of works of art are often only approximations)	WORLD HISTORY
1338	Ashikaga Takauji appointed shogun; Ashikaga *bakufu* (military government) is established with its headquarters in Kyoto.		Zenith of Arabic civilization in Granada under Yusuf I and his son Muhammad V (1333–91).
1367	Yoshimitsu becomes the third Ashikaga shogun, relinquishes the post in 1394 to become *daijō daijin* (great minister of state).		
1397		Yoshimitsu builds the Kinkaku ("Golden Pavilion"; fig. 4) in the Kitayama district of Kyoto.	
1467	Outbreak of the Ōnin War. In the decade that follows, Kyoto is destroyed by warfare and central authority collapses. Beginning of the *Sengoku jidai*, or the "Age of the Country at War."		Turks conquer Constantinople in 1453, Bosnia in 1463, Herzegovina in 1467.
1477	End of the Ōnin War.		
1482		The retired shogun Ashikaga Yoshimasa begins building the Higashiyama Villa, site of the Ginkaku ("Silver Pavilion"; fig. 5) and the Tōgudō (fig. 6).	Portuguese settle on Gold Coast.
1483		Kanō Masanobu paints *Eight Views of the Hsiao and Hsiang Rivers* for Yoshimasa.	
1490	Death of Yoshimasa.		
1500		The Gion Festival, not held since the Ōnin War, is revived in Kyoto.	Cabral discovers Brazilian coast and claims it for Portugal.
1502		Death of the tea master Murata Shukō.	
1506		Death of the painter Tōyō Sesshū (b. 1420).	
1507		Tosa Mitsunobu paints a set of folding screens depicting scenes of Kyoto, a prototype of later *Rakuchū rakugai-zu* (cat. nos 23-4).	Michelangelo begins painting the ceiling of the Sistine Chapel.
1513		Kanō Motonobu and Sōami paint screens for the Abbot's Quarters of the Daisen'in, Kyoto.	
1522		Sen no Rikyū born (cat. no. 5).	
1529		Motonobu paints screens for the palace.	
1530	Discovery of a silver mine in Iwami.	Death of Masanobu (b. 1434).	
1532	Ikkō sectarians attack the Nichiren temple Kemponji in Sakai and force Miyoshi Motonaga to commit suicide. Adherents of the Nichiren sect in Kyoto form the "Lotus Confederation" (*Hokke ikki*); arm themselves, and seize control of the capital. Yamashina Honganji is destroyed by the forces of the Lotus Confederation; Ishiyama Honganji of Osaka becomes the headquarters of the True Pure Land sect.		Pizarro begins conquest of Peru (1532–4).
1534	Oda Nobunaga born.		
1536	Toyotomi Hideyoshi probably born this year, though some sources indicate 1537.	Ishiyama Honganji begins to regularly sponsor Noh performances.	
1539	Miyoshi Nagayoshi (Chōkei) and allies occupy Kyoto.	Kanō Motonobu begins a project to create the paintings for the Ishiyama Honganji.	Spain annexes Cuba.
1540	Widespread epidemic in the capital.		
1541		Kanō Motonobu is commissioned by the daimyo Ōuchi Yoshitaka to paint gold screens and fans for the Chinese trade.	
1542	Opening of the Ikuno silver mine in Tajima Province.		

1543	First Portuguese traders arrive in Japan, setting ashore at Tanegashima. Western firearms introduced. Tokugawa Ieyasu born (31 January; Tembun 11/12/26). Miyoshi Chōkei takes control of the port city of Sakai.	Kanō Eitoku born. Kanō Motonobu paints screens for the Abbot's Quarters of the Reiun'in, Myōshinji.	Copernicus publishes *De Revolutione Orbium Celestium* describing his theory of a heliocentric universe.
1544		The shogunate prohibits *furyū* dancing in Kyoto.	
1545	Japanese pirates attack China.		
1548	Portuguese ships arrive in Bungo Province, marking the beginning of trade at Kyushu ports. Last official trade voyage to China. Birth of Onene, later known as Kita no Mandokoro or Kōdaiin (fig. 30).		
1549	Francis Xavier, the first Jesuit to reach Japan, arrives in Kagoshima and establishes a Christian mission.		
1555	Nobunaga seizes control of Kiyosu Castle.	Death of the tea master Takeno Jōō (b. 1502).	
1556			Akbar the Great becomes Mogul emperor of India.
1557			Portuguese land in Macao.
1558	Hideyoshi (then known as Kinoshita Tōkichirō) becomes a retainer of Nobunaga.		In England, Elizabeth I becomes queen.
1559	Nobunaga becomes military leader of Owari. Portuguese Jesuit missionary Gaspar Vilela arrives in Kyoto.	Death of Motonobu. Birth of Kanō Sanraku.	
1560	Nobunaga defeats Imagawa Yoshimoto at Okehazama and begins his rise to power.	The shogun Ashikaga Yoshiteru presents three pairs of polychrome and gold screens by Kanō and Tosa painters to the imperial court.	
1561	Uesugi Kenshin and Takeda Shingen meet in battle again at Kawanakajima. Onene is married to Hideyoshi.	Kano Mitsunobu born.	
1562	Nobunaga and Ieyasu form an alliance.		Start of the Huguenot War.
1563		Kanō Shōei paints an enormous *Nehan-zu* (*Parinirvana of the Buddha*) for Daitokuji.	
1564	Death of Miyoshi Chōkei (b. 1522/3); his vassal Matsunaga Hisahide takes over as the most powerful warlord in the provinces surrounding the capital. Arrival of Father Frois in Kyoto, in charge of Jesuit mission 1564-87.		Death of Michelangelo.
1565	Hisahide and Miyoshi clan destroy the shogun Ashikaga Yoshiteru; Ashikaga *bakufu* palace burned. Oichi no Kata is betrothed to Asai Nagamasa (cat. no. 2).		Spaniards destroy Huguenot colony in Florida.
1566	Fighting between Hisahide and the Miyoshi clan threatens the city of Sakai.	Kanō Eitoku's sliding-screen paintings *Birds and Flowers of the Four Seasons* and *The Four Accomplishments* created for the Jukōin, Daitokuji (cat. nos 44-5).	
1567	Nobunaga reduces the castle town of Inabayama, renames it Gifu. Battle between Matsunaga and Miyoshi clans at Nara, Daibutsuden of Tōdaiji is destroyed by fire. Nobunaga begins to use seal reading *Tenka fubu*, "Rule the Empire by Force," (fig. 9).	Kanō Eitoku, and assistants begin painting sliding screens for the *kampaku* Konoe Sakihisa.	
1568	Nobunaga enters Kyoto, and appoints Ashikaga Yoshiaki shogun. Matsunaga Hisahide submits to Nobunaga, presenting him with a precious tea caddy to seal their alliance.	Catholic churches (Nambanji) built in Kyoto and Nagasaki.	
1569	Nobunaga gives official permission for Christian proselytizing in Kyoto. The Miyoshi clan, based in Sakai, attack the shogun Yoshiaki, but are repulsed from Kyoto (January); Nobunaga lays siege to Sakai until the city submits in the summer.	*Ema* (votive paintings) of horses by Kanō Hideyori (cat. no. 35).	Gerard Mercator's *Map of the World*; marking the beginning of modern cartography.
1570	Ikkō soldier-monks overcome Nobunaga's troops near Kyoto, leading to the beginning of Nobunaga's "Ten Years' War" against the Honganji and adherents of the True Pure Land (Jōdo Shinshū) sect.		
1571	Nobunaga burns the Buddhist temple Enryakuji, the headquarters of the Tendai sect, on Mount Hiei.	*Fūryū* dancing enjoys great popularity during the Bon Festival season in Kyoto.	Pope Pius V signs alliance with Spain and Venice to fight Turks; Battle of Lepanto fought in the straits between the Gulf of Corinth and the Ionian Sea; Christian naval forces of Spain, Rome, Venice and Genoa defeated the fleet of the Ottoman Turks (cat. no. 39). Spaniards establish the port city of Manila.
1573	Hideyoshi adopts family name Hashiba. Takeda Shingen defeats the allied forces of Ieyasu and Nobunaga at Mikatagahara (6 January; Genki 3/12/3) and strikes westward. Encouraged by Shingen's progress, the shogun Yoshiaki breaks openly with Nobunaga (March). Ashikaga Yoshiaki deposed by Nobunaga; end of the Ashikaga shogunate (August). Takeda Shingen dies (cat. no. 3).		
1574	Ikkō sectarians take over the province of Echizen (May); Nobunaga destroys the Ikkō forces at Nagashima, (October). Katō Kiyomasa becomes follower of Hideyoshi (cat. no. 10).		
1575	Battle of Nagashino against Takeda Katsuyori, the first effective use of muskets in Japan (cat. no 21); Nobunaga defeats Takeda Katsuyori and takes over control of Echizen from the True Pure Land sect.	Sen no Rikyū appointed as one of Nobunaga's tea masters.	

1576	Shibata Katsuie, a retainer of Nobunaga, conducts a "sword hunt" in Echizen province and commands the peasants to confine themselves to farming and rebellious religious groups are suppressed.	Eitoku and his studio commissioned by Nobunaga to create paintings for Azuchi Castle.	
1577	Nobunaga declares his castle town of Azuchi a duty-free market. Matsunaga Hisahide turns against Nobunaga, but is defeated and commits suicide.		Sir Francis Drake embarks on circumnavigation of the world via Cape Horn.
1578	Daimyo Ōtomo Sōrin (Yoshishige) converts to Catholicism. Death of Uesugi Kenshin.	Nobunaga grants Hideyoshi the right to hold formal tea ceremonies.	
1579	Nobunaga orders the Azuchi Disputation between priests of the Pure Land and the Nichiren sects, declares the Nichiren priests the losers, and orders three of their principals executed.	Azuchi Castle becomes Nobunaga's official residence (figs 10–14).	
1580	The Kyushu daimyo Ōmura Sumitada cedes Nagasaki and surrounding areas to the Society of Jesus. Ishiyama Honganji surrenders to Nobunaga (September), and religious uprisings in Kaga Province are subdued Shibata Katsuie (December); "Ten Year's War" against the True Pure Land sect comes to an end.	Nambanji (Catholic church) established at Azuchi.	Portugal and Spain united under Philip II.
1581	Nobunaga campaigns against Kongōbuji, the headquarters of the Shingon sect on Mount Kōya.	Nobunaga presents a screen painting of Azuchi (now lost) by Eitoku to the Jesuit priest Alexandro Valignano, which is taken to Rome as a gift for the Pope. Hideyoshi begins construction on a castle at Himeji (fig. 42). Northern Noh Stage erected at Nishi Honganji (fig. 41).	Holland declares independence from Spain.
1582	Nobunaga subdues the Takeda, extending his realm into the Kantō region, marking his last military victory (April); the imperial court offers him an appointment as shogun (May). Nobunaga dies at the Honnōji, Kyoto. Hideyoshi makes peace with the Mōri clan and defeats Akechi Mitsuhide at the battle of Yamazaki; Hideyoshi succeeds Nobunaga.	Destruction of Azuchi Castle.	Jesuit mission in China founded.
1583	Battle of Shizugatake; Hideyoshi destroys Shibata Katsuie.	Hideyoshi begins construction of Osaka Castle; commissions screen paintings from Eitoku. Father Giovanni Nicolao arrives in Japan and soon after founds the Academy of St Luke, where he instructs native artists in Western-style painting and engraving. Founding of Sōken'in to commemorate Nobunaga's death; *Portrait of Oda Nobunaga* (cat. no. 1).	
1584	Spanish galleon reaches Hirado, Kyushu. Hideyoshi and Ieyasu confront each other in the inconclusive Komaki Campaign.	Eitoku and his atelier continue work at Osaka Castle. The Yamazato teahouse at Osaka Castle is first used by Hideyoshi, with Sen no Rikyū in attendance. Hideyoshi approves the rebuilding of Enryakuji on Mount Hiei. Prince Sonchō's transcription of poems by Fujiwara no Teika (cat. no. 68)	Mary Queen of Scots beheaded.
1585	Hideyoshi appointed *kampaku* (regent) on 6 August; Tenshō 13/7/11. Hideyoshi assumes the family name Toyotomi (October).	Hideyoshi sponsors a program of Noh plays at the imperial palace in celebration of his appointment to *kampaku*. Assisted by Sen no Rikyū, he entertains Emperor Ōgimachi at a tea ceremony in the imperial palace (October). Hosokawa Yūsai presents folding screens with depictions of Mount Fuji and Amanohashidate to the court. Nambanji (Catholic church) in Kyoto destroyed.	
1586	Emperor Go-Yōzei ascends throne (r. 1586–1611).	Plans laid for construction of Hōkōji in Kyoto (fig. 1). Hideyoshi visits the imperial palace and displays his portable golden tearoom to the emperor (fig. 18); he entertains Ōtomo Sōrin in the same tearoom at Osaka Castle. Eitoku and his atelier paint screens for Emperor Ōgimachi's retirement palace (In no Gosho).	
1587	Hideyoshi bans Christianity, although the ban is not enforced. Hideyoshi appointed *daijō daijin* (great minister of state) (27 January; Tenshō 14/12/19). Hideyoshi conquers Kyushu. Hideyoshi has *Tenshō tsūhō* coins minted.	Hideyoshi's grand tea ceremony at Kitano Shrine. Hideyoshi's Jurakutei mansion in Kyoto is completed (cat. no. 25); Kanō artists are commissioned to create paintings for its chambers. Approximate date of *Mythological Chinese Lions* (cat. no. 46).	England defeats the Spanish Armada.
1588	Hideyoshi orders the "sword hunt." Ashikaga Yoshiaki renounces the shogunate; official end of the Muromachi *bakufu*.	Emperor and his retinue are invited for a five-day visit at Hideyoshi's Jurakutei (cat. no. 25). Unkoku Tōgan paints the sliding screens for Ōbaiin, Daitokuji; *Plum Trees and Crows*, perhaps created for Najima Castle in Kyushu also usually dated to around this time (cat. no. 58). Foundation laid for the Great Buddha Hall of the Hōkōji. The *machishū* of Kyoto perform a *furyū* dance extravaganza at the ceremony.	
1589	Hideyoshi issues a list of prohibitions for the protection of Mishima Shrine (cat. no. 66)	Hideyoshi dedicates Great Buddha Hall of Hōkōji (fig. 1). Installation of a portrait statue of Sen no Rikyū in the upper story of Daitokuji's entry gate. Hasegawa Tōhaku	Cupola of St Peter's Basilica in the Vatican is finished by Fontana.

1590	Hideyoshi defeats the Hōjō of Odawara, achieving hegemony over Japan; he transfers Ieyasu from his old domains to the Kantō, with Edo becoming Ieyasu's castle town. Hideyoshi issues a list of ordinances for the protection of Mishima Shrine (cat. no. 67).	paints ceiling and pillar compositions on the Sammon Gate of Daitokuji. *Portrait of Oichi no Kata* (cat. no. 2). *Portrait of Inaba Ittetsu* (cat. no. 4). Osaka castle completed. Hideyoshi rebuilds the Imperial Palace. Eitoku dies, age forty-eight, while working on paintings for the new buildings. Printing presses exported to Japan.	Emperor of Morocco annexes Timbuctoo and Upper Niger.
1591	Hideyoshi overcomes enemy forces in northern Honshū, allowing the entire country to be reunified under the warlord's hegemony. Hideyoshi's edict prohibits the change of social status from samurai to farmer or merchant, or from farmer to merchant.	Sen no Rikyū ordered to commit suicide by Hideyoshi. First Christian books printed in Japan. Honganji moved to Kyoto, rebuilt at Rokujō-Horikawa.	
1592	Hideyoshi's first invasion of Korea. Death of Hideyoshi's mother (cat. no. 8). Hideyoshi resigns as *kampaku* in favor of his adopted son Hidetsugu (11 February 19/12/28); Hideyoshi becomes *taikō*. The Jurakutei becomes Hidetsugu's official residence; he is visited there by Emperor Go-Yōzei.	Kanō Mitsunobu and members of Hasegawa Tōhaku's atelier travel to Hizen in Kyushu to paint screens for Nagoya Castle, Hideyoshi's headquarters for the Korean invasion. Work begins on Fushimi Castle. Death of Kano Shōei (b. 1519). Construction of the Shōunji, the mortuary temple for Hideyoshi's infant son Sutemaru (cat. nos 139-40, figs 20, 49). Tōhaku commissioned to create paintings of flowering trees for the Shōunji.	
1593	Hideyoshi's son, Toyotomi Hideyori, is born. End of hostilities in Korea. The arrival of Franciscan missionaries.	Hideyoshi begins performing publicly in Noh plays. Death of Hasegawa Kyūzō. Hasegawa Tōhaku and members of his school do sliding-screen paintings for the Shōunji, now in the Chishakuin, including *Maple Tree and Autumn Plants* (cat. no. 54).	El Greco paints *The Crucifixion* and *The Resurrection*.
1594		Hideyoshi's cherry blossom viewing party at Yoshino, accompanied by a large entourage, which includes the noted poet Satomura Jōha (see fig. 22). Ōmura Yūko writes a Noh play, *Yoshino mōde* (Pilgrimage to Yoshino), to commemorate the event. Hideyoshi performs Nō plays for Emperor Go-Yōzei at the Imperial Palace. Fushimi Castle completed; Kanō Mitsunobu and Kanō Sanraku are commissioned to paint screens.	English break Portuguese monopoly in India.
1595	Hidetsugu commits suicide by order of Hideyoshi. The Jurakutei is dismantled.	Satomura Jōha is exiled from Kyoto for his association with Hidetsugu. *Portrait of Sen no Rikyū* (cat. no. 5). "Chinese Lion" Incense Burner by Tanaka Sōkei (cat. no. 82).	Henry IV declares war on Spain.
1596	Hideyori becomes *kampaku* at age three. Hideyoshi receives ambassadors from Ming China in Osaka; negotiations fail, and the Korean armistice collapses. Persecution of Christians begins.	Miniature lacquer shrines built by Kōami craftsmen for Hideyoshi and Kita no Mandokoro (now at Kōdaiji figs 29-31).	Shakespeare writes *Macbeth*
1597	Hideyoshi's second invasion of Korea. Hideyoshi orders the execution of twenty-six Christians in Nagasaki (5 February; Keichō 1/12/19); representing the first bloody persecution of Christianity.	Matsumoto Castle in Nagano completed (fig. 2).	
1598	Death of Hideyoshi, age 63 (Keichō 3/8/18). Japanese armies withdraw from Korea. Council of Regency is established under Ieyasu.	Hōkōji rebuilt. Sambōin buildings and garden finished at Daigoji (figs 23-24). Hideyoshi's cherry blossom viewing party at Daigoji (fig. 25). Long sword by Umetada Myōju (cat. no. 130).	Philip II of Spain dies and is succeeded by Philip III (–1621).
1599	Death of Maeda Toshiie. Ishida Mitsunari attempts to assassinate Ieyasu. Kita no Mandokoro moves from Osaka castle to Kyoto. Toyotomi Hideyori moves from Fushimi castle to Osaka castle.	Kaihō Yūshō's *Plum Tree; Pine Tree with Mynah Birds* (cat. nos 59-60). Hōkoku Shrine dedicated to Hideyoshi built in Kyoto; Kanō Sōshū paints panels of the Thirty-Six Poets for the Hōkoku Shrine dedicated to the deified Hideyoshi.	England establishes East India Company.
1600	Battle of Sekigahara allows Ieyasu to extend control over Japan. First Dutch ship (Liefde) lands in Kyushu. Englishman William Adams arrives.	Kangakuin subtemple established at Onjōji, Shiga, probably with a building from the Imperial Palace; Kanō Mitsunobu commissioned to create screen-paintings. Portraits of Hideyoshi (cat. nos 6-7). Helmet worn by Kuroda Nagamasa at the Battle of Sekigahara (cat. no. 138).	Jesuit missionary Mateo Ricci received by the emperor in Peking.
1601		Death of Kanō Sōshū (cat. no. 42).	Holland establishes Dutch East India Company.
1602		Kaihō Yūshō paints *Eight Immortals of the Wine Cup* screens (Kyoto National Museum). Death of the *renga* poet Satomura Jōha. Tsukubusuma shrine buildings reconstructed on Chikubushima (figs 38, 51). *Dōbuku* (campaign jacket) presented by Ieyasu to Yoshioka Hayato (cat. no. 142).	
1603	Ieyasu establishes *bakufu* (military government) in Edo; assumes title of shogun. Kita no Mandokoro receives name Kōdaiin and becomes a Buddhist nun (fig. 30). Beginning of Suminokura Vermilion Seal trade (cat. no. 19a).	Okuni, formerly a shrine dancer from Izumo, stages Kabuki dance at Kitano Shrine, Kyoto; later sets up a stage at Shijō-kawara. Ieyasu builds Nijō Castle in Kyoto. *Dōbuku* (campaign jacket) presented by Ieyasu to Yasuhara Dembei (cat. no. 143).	
1604	Hōkoku Shrine Festival, an extravagant celebration commemorating the seventh anniversary of Hideyoshi's death.	Kanō Naizen's screens depicting Hōkoku festival (fig. 26).	French East India Company established.

			
1605	Ieyasu's son Hidetada becomes second Tokugawa shogun.	Kōdaiji built for Hideyoshi's wife, Kita-no-Mandokoro (figs 29-31). Kanō Mitsunobu paints a great coiled dragon on the ceiling of Main Worship Hall (Hondō) of the Shōkokuji.	Cervantes, *Don Quixote*, part 1.
1606		Hikone Castle built by Ii family (fig. 3).	
1607		KitanoShrine rebuilt.	
1608		Ikeda Terumasa rebuilds Himeji Castle on large scale (fig. 42). Death of Kanō Mitsunobu. Sagabon edition of *Tales of Ise* (cat. no. 76).	Henry Hudson discovers the island of Manhattan.
1609	1609 First Dutch trading ship arrives in Hirado.	Date Masamune has Zuiganji built at Matsushima	
1610	Ieyasu sends Kyoto merchants to Mexico; first Japanese to cross the Pacific. Death of Honda Tadakatsu, one of Ieyasu's generals (cat. no. 15).	Death of Hasegawa Tōhaku, age seventy-two. Work on Nagoya Castle begun for Ieyasu. Hōkōji rebuilt again. Death of Hosokawa Yūsai (cat. no. 17). *Portrait of Tōsenin* (cat. no. 9).	Publication of the King James version of the Bible.
1611	Emperor Go-Mizunoo ascends the throne. Death of Katō Kiyomasa (cat. no. 10).	Ieyasu rebuilds the Imperial Palace. Zuisenji established by Suminokura Ryōi (cat. no. 19). Death of Shun'oku Sōen, Zen master of Rikyū (cat. no. 5). Death of Hasegawa Sōtaku (cat. no. 55).	
1612	Hidetada bans Christianity and orders destruction of Christian church in Kyoto. Chinese merchant ships are allowed to do commerce in Nagasaki.	Kanō Tan'yū moves to Edo. *Portrait of Hosokawa Yūsai* (cat. no. 17).	Rubens, *Descent from the Cross*.
1613	English traders arrive at Hirado. Delegation to Spain led by Hasekura Tsunenaga.	Death of Tosa Mitsuyoshi.	Galileo faces the Inquisition.
1614	Ieyasu issues order suppressing Christianity; persecution of Christians intensifies. Osaka Winter Campaign (November–January 1615).	Kanō Sanraku paints *ema* (votive paintings) of horses (cat. no. 36a). Death of Konoe Nobutada.	
1615	Osaka Summer Campaign (cat. no. 22); destruction of Osaka Castle. Death of Toyotomi Hideyori and his mother, Yodogimi.	Ieyasu grants Hon'ami Kōetsu land at Takagamine for an artist's colony. Death of Kaihō Yūshō, age eighty-three. Kanō Mitsunobu and his studio commissioned by the Tokugawa family to paint screens for Nagoya Castle. Sanraku takes refuge with Shōkadō Shōjō after defeat of Toyotomi clan (returns to Kyoto in 1619). Death of tea master Furuta Oribe.	Tartars of Manchu invade China.
1616	Death of Ieyasu. Government restricts foreign trade to the ports of Nagasaki and Hirado.		
1617		Ieyasu's shrine, Tōshōgū, built at Kunōzan in Shizuoka. Death of Kanō Naizen (cat. no. 47; fig. 26). *Portrait of Suminokura Ryōi* (cat. no. 19). *Portrait of Emperor Go-Yōzei* (cat. no. 18).	
1618		Unkoku Tōgan dies, age seventy-two (cat. nos 56–8); Tōeki inherits leadership of Unkoku school. Kanō Sanraku's *Red Plum Blossoms*; *Peonies* (cat. nos 50–1).	The Mayflower lands at Plymouth Rock in Massachusetts.
1619	Tokugawa Iemitsu becomes shogun. About sixty Christians burned at the stake in Kyoto. Marriage of Ieyasu's granddaughter Kazuko to Emperor Go-Mizunoo.		
1620		Prince Toshihito begins construction of Katsura Imperial Villa southwest of Kyoto.	
1622	Persecution of Christians intensified, signaling the end of Christian movement in Japan.		
1623	Hidetada's son Iemitsu becomes third Tokugawa shogun. Fifty Christians executed in Edo.	Death of Kanō Sadanobu. *Portrait of Kuroda Nagamasa* (cat. no. 16).	
1624	Relations with Spain are terminated by Hidetada. Death of Kōdaiin (Kita no Mandokoro).	Kan'eiji temple erected by Tokugawa Hidetada in Edo.	England declares war on France.
1625		Kanō Sanraku's *ema* (votive paintings) of horses (cat. no. 36). Approximate date of the portrait of Seitokuin, Ieyasu's eldest daughter (cat. no. 13).	
1629	Abdication of Emperor Go-Mizunoo.	The shogunate bans women's Kabuki.	English settlements in Massachusetts.
1630	Empress Meishō, daughter of Go-Mizunoo and granddaughter of the Tokugawa shogun, ascends throne.	Sōtatsu paints a copy of *Saigyō monogatari emaki* (Picture Scroll of the Life of Saigyō); Karasumaru Mitsuhiro transcribes the text.	Construction of the Taj Mahal.
1631		Kanō Sanraku or Sansetsu paints *Plum Tree and Pheasant* for the Tenkyūin, Myōshinji.	Harvard College in Cambridge Massachusetts founded.
1635	Edict prohibiting foreign travel.	Kanō Sanraku dies, age seventy-seven.	
1636		Nikkō Tōshōgū begun. Eulogy for Empress Chūkamon'in presented by Emperor Go-Mizunoo (cat. no. 72). Hon'ami Kōetsu dies, age eighty.	
1637	Shimabara rebellion in Hizen Province, spearheaded by persecuted Christians.		New Haven, Connecticut, founded.
1638		Death of Karasumaru Mitsuhiro (fig. 64).	
1639	All westerners living in Japan are expelled and intercourse with foreign nations restricted to Dutch and Chinese.	Shōkadō Shōjō dies, age fifty-six (cat. nos 77, 78).	

Bibliography

AICHI-KEN BIJUTSUKAN 1979 *Momoyama no byōbu-e ten* (Screens of the Momoyama period). Nagoya: Aichi-ken Bijutsukan, 1979.

AICHI-KEN TŌJI SHIRYŌKAN 1995 Aichi-ken Tōji Shiryōkan and Gotō Bijutsukan, eds. *Chanoyu no bi* (Tea-ceremony aesthetics). Seto City: Aichi-ken Tōji Shiryōkan, 1995.

AKIYAMA 1967-80 Akiyama Terukazu, et al. *Genshoku Nihon no bijutsu* (Full-color reproductions of Japanese art). Tokyo: Shogakukan, 1967-80.

ANDERSON 1991 Anderson, Jennifer L. *An Introduction to Japanese Tea Ritual*. Albany, N.Y.: State University of New York Press, 1991.

ARAKAWA 1992 Arakawa Masaaki. "Kan'ei barokku to Kokutani ishō" (Kan'ei baroque and Kokutani design). *Kobijutsu rokushō*, no. 6 (1992).

BECKER 1986 Becker, Johanna. *Karatsu Ware: A Tradition of Diversity*. New York: Kodansha International, 1986.

BERRY 1982 Berry, Mary Elizabeth. *Hideyoshi*. Cambridge, Mass.: Harvard University Press, 1982.

BERRY 1983 Berry, Mary Elizabeth. "Restoring the Past: The Documents of Hideyoshi's Magistrate in Kyoto." *Harvard Journal of Asiatic Studies 43*, no. 1 (1983): 57-95.

BERRY 1994 Berry, Mary Elizabeth. *The Culture of Civil War in Kyoto*. Berkeley: University of California Press, 1994.

BODART 1977 Bodart, Beatrice M. "Tea and Counsel: The Political Role of Sen Rikyū." *Monumenta Nipponica* 32 (Spring 1977): 49-74.

BOSCARO 1973 Boscaro, Adriana. *Sixteenth Century European Printed Works on the First Japanese Mission to Europe: A Descriptive Bibliography*. Leiden: E. J. Brill, 1973.

BOSCARO 1975 Boscaro, Adriana, trans. *101 Letters of Hideyoshi: The Private Correspondence of Toyotomi Hideyoshi*. Tokyo: Sophia University, 1975.

BOTTOMLEY and HOPSON 1988 Bottomley, Ian and Anthony Hopson. *Arms and Armour of the Samurai: The History of Weaponry in Ancient Japan*. Greenwich: Bison Books, 1988.

BOXER 1963 Boxer, C.R. *The Great Ship from Amacon: Annals of Macao and the Old Japan Trade, 1555-1640*. Lisbon: Centrode Estudos Historicos ultramarinos, 1963.

BOXER 1967 Boxer, C.R. *The Christian Century in Japan 1549-1650*. Berkeley: University of California Press, 1967.

BROWN 1947 Brown, Delmer M. "The Importation of Gold into Japan by the Portuguese during the Sixteenth Century." *Pacific Historical Review* 16, no. 2 (May 1947): 125-33.

BROWN 1948 Brown, Delmer M. "The Impact of Firearms on Japanese Warfare, 1543-98." *Far Eastern Quarterly* 7, no. 3 (May 1948); 236-53.

BROWN 1951 Brown, Delmer M. *Money Economy in Medieval Japan: A Study in the Use of Coins*. New Haven: Institute of Far Eastern Languages, Yale University, 1951.

BROWN 1987 Brown, Kendall H. "Shokado Shojo as 'Tea Painter.'" *Chanoyu Quarterly* 49 (1987):7-40.

CASTILE 1971 Castile, Rand. *The Way of Tea*. New York and Tokyo: Weatherhill, 1971.

CHADŌ SHIRYŌKAN 1994 Chadō Shiryōkan and Fukken-shō Hakubutsukan. *Karamono temmoku: Fukken-shō Ken'yō shutsudō temmoku to Nihon densei no temmoku* (Chinese Temmoku: Temmoku wares recovered from the Chien kilns in Fukien Province and Temmoku wares preserved as heirloom pieces in Japan). Kyoto: Chadō Shiryōkan, 1994.

COOPER 1965 Cooper, Michael, ed. *They Came to Japan: An Anthology of European Reports on Japan, 1543-1640*. London: Thames and Hudson, 1965.

COOPER 1971 Cooper, Michael, ed. *The Southern Barbarians: The First Europeans in Japan*. Tokyo: Kodansha, 1971.

CORT 1979 Cort, Louise Allison. *Shigaraki, Potters' Valley*. New York: Kodansha International, 1979.

CORT 1990 Cort, Louise Allison. "Japanese Ceramics and Cuisine." *Asian Art* 3: no. 1 (1990): 9-36.

CORT 1992 Cort, Louise Allison. *Seto and Mino Ceramics*. Washington, D.C.: Freer Gallery of Art, 1992.

COVELL and YAMADA 1974 Covell, Jon and Yamada Sobin. *Zen at Daitoku-ji*. Tokyo: Kodansha International, 1974.

CUNNINGHAM 1991 Cunningham, Michael H., ed. *The Triumph of Japanese Style: 16th Century Art in Japan*. Cleveland: The Cleveland Museum of Art, 1991.

DAY 1990 Day, Judith. "Interplay of Word and Image: *The Deer Scroll* of Koetsu and Sotatsu." Unpublished manuscript of a seminar paper presented at Columbia University, 1990.

DOI 1967 Doi Tsugiyoshi, et al. *Daikakuji*. Vol. 3 of *Shōhekiga zenshū* (Sliding-screen paintings). Tokyo: Bijutsu Shuppansha, 1967.

DOI 1970 Doi Tsugiyoshi. *Kinsei Nihon kaiga no kenkyū* (Research on Japanese painting of the Early Modern period). Tokyo: Bijutsu Shuppansha, 1970.

DOI 1973 Doi Tsugiyoshi. *Hasegawa Tōhaku*. No. 87 of *Nihon no bijutsu* (Arts of Japan). Tokyo: Shibundō, 1973.

DOI 1976 Doi Tsugiyoshi. *Kanō Sanraku, Sansetsu*. Vol. 12 of *Nihon bijutsu kaiga zenshū* (Japanese paintings). Tokyo: Shūeisha, 1976.

DOI 1977 Doi, Tsugiyoshi. *Momoyama Decorative Painting*. Trans. Edna B. Crawford. New York: Weatherhill, 1977.

DOI 1978a Doi Tsugiyoshi. *Kanō Eitoku, Mitsunobu*. Vol. 9 of *Nihon Bijutsu kaiga*

zenshū (Japanese paintings). Tokyo: Shūeisha 1978.

Doi 1978b Doi Tsugiyoshi. *Kanō Masanobu, Motonobu.* Vol. 7 of *Nihon bijutsu kaiga zenshū* (Japanese paintings). Tokyo: Shūeisha.

Doi 1980 Doi Tsugiyoshi. *Sanraku to Sansetsu.* No. 172 of *Nihon no bijutsu* (Arts of Japan). Tokyo: Shibundō, 1980.

Elison 1973 Elison, George. *Deus Destroyed: The Image of Christianity in Early Modern Japan.* Cambridge: Harvard University Press, 1973.

Elison 1981 Elison, George. "Hideyoshi, the Bountiful Minister," in *Warlords, Artists, and Commoners: Japan in the Sixteenth Century,* ed. George Elison and Bardwell L. Smith. Honolulu: University of Hawaii Press, 1981.

Elison and Smith 1981 Elison, George and Bardwell L. Smith, eds. *Warlords, Artists, and Commoners: Japan in the Sixteenth Century.* Honolulu: University of Hawaii Press, 1981.

Faulkner and Impey 1981 Faulkner, R.F.J. and O.R. Impey. *Shino and Oribe Kiln Sites.* Oxford: Robert G. Sawers/Ashmolean Museum, 1981.

Foulke and Sharf 1993/4 Foulke, T. Griffith and Robert H. Sharf. "On the Ritual Use of Ch'an Portraiture in Medieval China." *Cahiers d'Extreme Asie,* vol. 7 (1993/4).

Fujiki and Elison 1981 Fujiki, Hisashi with George Elison. "The Political Posture of Oda Nobunaga," in *Japan Before Tokugawa,* ed. John Whitney Hall, Nagahara Keiji and Kozo Yamamura. Princeton: Princeton University Press, 1981.

Fujioka 1973 Fujioka, Ryōichi, et al. *Tea Ceremony Utensils.* Trans. Louise Allison Cort. New York: Weatherhill, 1973.

Fujioka 1977 Fujioka, Ryoichi. *Shino and Oribe Ceramics.* Trans. Samuel C. Morse. Vol. 1 of *Japanese Arts Library.* New York: Kodansha International, 1977.

Fukuoka 1992 Fukuoka-shi Bijutsukan, ed. *Collection Catalogue of the Fukuoka Art Museum: Pre-Modern Art.* Fukuoka City: Fukuoka-shi Bijutsukan, 1992.

Furukawa 1983 Furukawa, Shōsaku. *Kiseto and Setoguro.* Trans. Robert N. Huey. Vol. 10 of *Famous Ceramics of Japan.* New York: Kodansha International, 1983.

Gluckman and Takeda 1992 Gluckman, Dale Carolyn and Sharon Sadako Takeda, eds. *When Art Became Fashion: Kosode in Edo Period Japan.* Los Angeles: Los Angeles County Museum, 1992.

Gotoh Museum 1987 *Teika yō* (Teika-style calligraphy). Tokyo: Gotoh Museum, 1987.

Grilli 1971 Grilli, Elise. *The Art of the Japanese Screen.* New York and Tokyo: Weatherhill, 1971.

Haga 1993 Haga Noboru, comp. *Nihon josei jimmei jiten* (Handbook of names of famous Japanese women). Tokyo: Nihon Tosho Senta, 1993.

Hall and Jansen 1968 Hall, John Whitney and Marius B. Jansen. *Studies in the Institutional History of Early Modern Japan.* Princeton: Princeton University Press, 1968.

Hamamoto 1988 Hamamoto, Sōshun. "The Master's Taste: Tea Utensils," in *Chanoyu: The Urasenke Tradition of Tea,* ed. Sōshitsu Sen; trans. Alfred Birnbaum. Tokyo: Weatherhill, 1988.

Hare 1986 Hare, Thomas Blenman. *Zeami's Style: The Noh Plays of Zeami Motokiyo.* Stanford: Stanford University Press, 1986.

Haruna 1971 Haruna Yoshishige. *Kan'ei no sampitsu* (Three brushes of Sampitsu). Kyoto: Tankōsha, 1971.

Hashimoto 1981 Hashimoto, Fumio. *Architecture in the Shoin Style; Japanese Feudal Residences.* Trans. H. Mack Horton. Tokyo: Kodansha and Shibundo, 1981.

Hayashibara 1989 Hayashibara Bijutsukan, ed. *Hayashibara Bijutsukan meihin sen* (A selection of masterworks from the Hayashibara Museum). Okayama City: Hayashibara Bijutsukan, 1989.

Hayashiya 1974 Hayashiya, Tatsusaburō, et al. *Japanese Arts and the Tea Ceremony.* Trans. Joseph P. Macadam. New York: Weatherhill, 1974.

Hayashiya 1977 Hayashiya Seizō, ed. *Iga* (Iga ware). Vol. 13 of *Nihon tōji zenshū.* Tokyo: Chūo Kōronsha, 1977.

Hayashiya 1979 Hayashiya, Seizo, ed. *Chanoyu: Japanese Tea Ceremony.* New York: Japan Society, 1979.

Hayashiya 1988 Hayashiya, Seizo. "Teabowls," Part II. *Chanoyu Quarterly,* no. 56 (1988).

Hayashiya 1989 Hayashiya Seizō. *Karatsu* (Karatsu ware). Vol. 5 of *Nihon no tōji.* Tokyo: Chūo Kōronsha, 1989.

Hayashiya 1990 Hayashiya Tatsusaburō. *Kadokawa sadō daijiten* (Encyclopedia of Japanese tea ceremony). Tokyo: Kadokawa Shoten, 1990.

Herbert 1967 Herbert, Jean. *Shintō: At the Fountain-head of Japan.* New York: Stein and Day, 1967.

Hickman and Satō Hickman, Money L. and Yasuhiro Satō. *The Paintings of Jakuchū.* New York: The Asia Society Galleries, 1989.

Iijima 1975 Iijima Shunkei. *Shodō jiten* (Encyclopedia of calligraphy). Tokyo: Tōkyōdō Shuppan, 1975.

Ikeda 1988 Ikeda, Hyoa. "Appreciating Teascoops," *Chanoyu Quarterly,* no. 54 (1988).

Inoura and Kawatake 1981 Inoura, Yoshinobu and Kawatake Toshio. *The Traditional Theater of Japan.* New York: Weatherhill, 1981.

Ishikawa 1987 Ishikawa Prefectural Museum of Art and The Kyushu Ceramic Museum, eds. *Imari Kokutani meihinten* (Exhibition of Imari and Kokutani ware). Kanazawa and Arita: Ishikawa Prefectural Museum of Art and the Kyushu Ceramic Museum, 1987.

Itō 1985 Itō, Toshiko. *Tsujigahana: The Flower of Japanese Textile Art.* Trans. Monica Bethe. New York: Kodansha, 1981

Itō 1994 Itō Yoshiaki. "Wamono temmoku" (Japanese Temmoku), in *Karamono Temmoku: Fukken Sho Ken'yō shutsudo temmoku to Nihon densei no temmoku: Tokubetsuten* (Chinese Temmoku: Temmoku wares recovered from the Chien Kilns in Fukien Province and Temmoku wares preserved as heirloom pieces in Japan: A special exhibition), ed. Chadō Shiryōkan and Fukken-shō Hakubutsukan. Kyoto: Chadō Shiryōkan, 1994.

Iwai 1974 Iwai Hiromi. *Ema* (Votive paintings). Tokyo: Hōsei Daigaku Shuppankyoku, 1974.

Iwao 1976 Iwao, Seiichi. "Japanese Foreign Trade in the 16th and 17th Centuries." *Acta Asiatica* 30 (February, 1976).

Iwasaki 1985 Iwasaki Haruko. *Nihon no ishō jiten* (Dictionary of Japanese design). Tokyo: Iwasaki Bijutsusha, 1985.

Japan Society 1985 *Spectacular Helmets of Japan, 16th–19th Century.* Japan Society, 1985.

Japan Textile Color Design Centre 1980 Japan Textile Color Design Centre, comp. *Textile Designs of Japan.* 3 vols. Tokyo: Kodansha International, 1980.

Jennes 1973 Jennes, Josef. *A History of the Catholic Church in Japan: From its Beginnings to the Early Meiji Era.* Tokyo: Oriens Institute for Religious Research, 1973.

Jūyō bunkazai 1976 Mombushō, Bunkachō, eds. *Kōgeihin II* (Applied arts). Vol. 25 of *Jūyō bunkazai* (Important Cultural Properties). Tokyo: Mainichi Shimbunsha 1976.

Kabuki zukan 1964 *Kabuki zukan: Uneme kabuki zōshi* (Kabuki Scroll: Illustrated tale of Uneme kabuki). Tokyo: Tokyo Chūnichi Shimbun Shuppankyoku, 1964.

Kageyama 1973 Kageyama, Haruki. *The Arts of Shinto.* Trans. Christine Guth. Vol. 4 of *Arts of Japan.* Tokyo: Weatherhill, 1973.

Kageyama and Guth Kanda 1976 Kageyama, Haruki and Christine Guth Kanda, *Shinto Arts: Nature, Gods, and Man in Japan.* New York: Japan Society, 1976.

Kano 1991 Kano Hiroyuki. *Kinsei fūzokuga* (Genre painting of the Early Modern period). Kyoto: Tankōsha, 1991.

Kashiwahara and Sonoda 1994 Kashiwahara, Yusen and Koyu Sonoda. Trans. Gaynor

Sekimori. *Shapers of Japanese Buddhism.* Tokyo: Kōsei Publishing, 1994.

KATŌ 1993 Katō Hideyuki. "Buke shōzōga no shin no shōshu kakutei e no sho mondai" (Various issues surrounding the identification of the subjects of portrait paintings of samurai). *Bijutsu kenkyū* 345, 346 (1993)

KAWADA 1974 Kawada Sadamu. *Ema* (Votive paintings). No. 92 of *Nihon no bijutsu* (Arts of Japan). Tokyo: Shibundō, 1974.

KAWAHARA 1977 Kawahara Masahiko. *Shigaraki.* Vol. 12 of *Nihon tōji zenshū* (Japanese ceramics). Tokyo: Chūo Kōronsha, 1977.

KAWAHARA 1986 Kawahara, Masahiko. "Iga Tea Ware." *Chanoyu Quarterly*, no. 47 (1986).

KAWAI 1978 Kawai Masatomo. *Yūshō, Tōgan.* Vol. 11 of *Nihon bijutsu kaiga zenshū* (Japanese paintings). Tokyo: Shūeisha, 1978.

KEENE 1955 Keene, Donald, ed. *Anthology of Japanese Literature: From the Earliest Era to the Mid-Nineteenth Century.* New York: Grove Press, 1955.

KEENE 1967 Keene, Donald, trans. *Essays in Idleness: The Tsurezuregusa of Kenkō.* Columbia University Press, 1967.

KEENE 1976 Keene, Donald. "Japanese Books and their Illustrations." *Storia dell'arte* 27 (1976).

KEENE 1983 Keene, Donald. *Some Japanese Portraits.* Tokyo: Kōdansha, 1983.

KEENE 1993 Keene, Donald. *Seeds in the Heart: Japanese Literature from Earliest Times to the Late Sixteenth Century.* New York: Henry Holt, 1993.

KENNEDY 1990 Kennedy, Alan. *Japanese Costume: History and Tradition.* New York: Rizzoli, 1990.

KESEL [n.d.] Kesel, Wilfried de. *Japanese Export Lacquers (16th–17th Century) from the Castle of Beloeil.* Drongen: Rectavit, [n.d.,1994?].

KIRBY 1962 Kirby, John B. *From Castle to Teahouse: Japanese Architecture of the Momoyama Period.* Rutland, Vt./Tokyo: Charles E. Tuttle, 1962.

KIRIHATA 1988 Kirihata Ken. *Senshoku: Kinsei hen* (Dyed and woven textiles: Modern Era). No. 265 of *Nihon no Bijutsu* (Arts of Japan). Tokyo: Shibundō, 1988.

KLEIN 1984 Klein, Bettina. *Japanese Kinbyobu: The Gold-leafed Folding Screens of the Muromachi Period (1333-1573).* Adapted and expanded by Carolyn Wheelwright. Ascona: Artibus Asiae, 1984.

KNAUTH 1970 Knauth, Lothar. "Pacific Confrontation: Japan Encounters the Spanish Overseas Empire 1542-1639." Harvard University: Ph.D. dissertation, 1970.

KOBE CITY MUSEUM 1968 Kobe Bijutsukan, comp. *Kobe Shiritsu Namban Bijutsukan zuroku* (Pictorial record of Kobe City Museum of Namban Art). Kobe: Kobe Shiritsu Namban Bijutsukan, 1968.

KODAMA 1956-58 Kodama Kōta, comp. *Azuchi-Momoyama jidai* (Azuchi-Momoyama period). Vol. 8 of *Zusetsu Nihon bunkashi taikei* (Illustrated Japanese history). Tokyo: Shogakukan, 1956-8.

KOMATSU 1982 Komatsu Shigemi, ed. *Shinkan* (Imperial letters). Vol. 8 of *Nihon no sho* (Japanese calligraphy). Tokyo: Chūo Kōronsha, 1982.

KONDO 1961 Kondo, Ichitaro. *Japanese Genre Painting: The Lively Art of Renaissance Japan.* Trans. Roy Andrew Miller. Rutland, Vermont: Charles E. Tuttle, 1961.

KORESAWA 1978 Koresawa Kyōzō, ed. *Tennō, kuge* (Emperors and aristocracy). Vol. 1 of *Sho to jimbutsu* (Calligraphy and historical personages). Tokyo: Mainichi Shimbunsha, 1978.

KOZURU 1981 Kozuru, Gen. *Agano and Takatori.* New York: Kodansha International, 1981.

KUMAKURA 1989a Kumakura, Isao. "Sen no Rikyū: Inquiries into his Life and Tea," in *Tea in Japan: Essays on the History of Chanoyu* edited by Paul Varley and Kumakura Isao. Honolulu: University of Hawaii Press, 1989.

KUMAKURA 1989b Kumakura, Isao. "Kan'ei Culture and *Chanoyu*," in *Tea in Japan: Essays on the History of Chanoyu,* ed. Paul Varley and Kumakura Isao. Honolulu: University of Hawaii Press, 1989.

KURODA 1984 Kuroda, Ryoji. *Shino.* Trans. Robert N. Huey. Vol. 12 of *Famous Ceramics of Japan.* New York: Kodansha International, 1984.

KURODA 1995 Kuroda, Taizō. "Figurative Screen Painting in the Late Momoyama and Edo Period: Introducing a Recently Discovered Work of the Kano School," in *Worlds Seen and Imagined: Japanese Screens from the Idemitsu Museum of Arts* by Taizō Kuroda, Melinda Takeuchi, and Yūzō Yamane. New York: Asia Society Galleries, 1995.

KYOTO 1977 *Momoyama jidai no kōgei: Handicrafts of the Momoyama Period.* Kyoto: Kyoto National Museum, 1977.

KYOTO 1990 *Masterpieces of the Kyoto National Museum.* Kyoto: Kyoto Kokuritsu Hakubutsukan, 1990.

KYOTO 1992 *Saga goshō Daikakuji no meihō: Art Treasures of Daikakuji Temple.* Kyoto: Kyoto Kokuritsu Hakubutsukan, 1992.

KYŌTO NO SHŌZŌ CHŌKOKU 1978 *Kyōto no shōzō chōkoku* (Portrait sculpture of Kyoto). Kyoto: Kyoto-fu bunkazai hogo kikin, 1978.

KYUSHU 1991 *Hizen no iro-e: Sono hajimari to hensen ten* (Polychrome porcelain in Hizen: Its beginnings and change of styles). Arita: The Kyushu Ceramic Museum, 1991.

KYUSHU 1992 *Fukuoka-ken no yakimono* (Ceramics of Fukuoka Prefecture). Arita: The Kyushu Ceramic Museum, 1992.

LEE 1983 Lee, Sherman, ed., *Reflections of Reality in Japanese Art.* Cleveland: Cleveland Museum of Art, 1983.

LUBARSKY 1992 Lubarsky, Jared. *Noble Heritage: Five Centuries of Portraits from the Hosokawa Family.* Washington: Smithsonian Institution, 1992.

MALM 1981 Malm, William P. "Music Cultures of Momoyama Japan," in *Warlords, Artists and Commoners: Japan in the Sixteenth Century,* ed. George Elison and Bardwell L. Smith. Honolulu: University of Hawaii Press, 1981.

MARUYAMA 1988 Maruyama, Nobuhiko. "Kosode of the Premodern Age," in the North Carolina Museum of Art, *Robes of Elegance: Japanese Kimonos of the 16th–20th Centuries.* Raleigh: North Carolina Museum of Art, 1988.

MARUYAMA 1994 Maruyama Nobuhiko. *Buke no isshoku* (Samurai clothing). No. 340 of *Nihon no bijutsu* (Arts of Japan). Tokyo: Shibundō, 1994

MASAKI 1993 Masaki Akira. "Seikūkan no shizen (II); Mikkyō sekai (1)–tsuki ya wa mono omowasuru" (Nature in sacred space, II: The world of esoteric Buddhism–The moon and its religious meaning beyond this world). *Nihon kenkyū* 8 (March 1993).

MASON 1993 Mason, Penelope. *History of Japanese Art.* New York: Harry N. Abrams, 1993.

MCCULLOUGH 1968 McCullough, Helen Craig, trans. *Tales of Ise: Lyrical Episodes from Tenth-Century Japan.* Stanford: Stanford University Press, 1968.

METROPOLITAN 1975 *Momoyama: Japanese Art in the Age of Grandeur.* New York: The Metropolitan Museum of Art, New York, 1975.

MINAMOTO 1976 Minamoto, Toyomune. *Sōtatsu.* Vol. 14 of *Nihon bijutsu kaiga zenshū.* Tokyo: Shōeisha, 1976.

MIYA 1982 Miya, Tsugiyo. *Myōshinji.* Vol. 24 of *Nihon koji bijutsu zenshū* (Art of ancient Japanese temples). Tokyo: Shūeisha, 1982.

MIYAGAMI 1977 Miyagami Shigetaka. "Azuchi-jō no fukugen to sono shiryō ni tsuite: Naitō Akira-shi 'Azuchi-jō no kenkyū' ni taisuru gimon" (The reconstruction of Azuchi Castle and documentary sources: Doubts concerning Naitō Akira's research on Azuchi Castle). *Kokka* 998-9 (Feb./Mar.,1977).

MIZUO 1972a. Mizuo Hiroshi. *Daigoji, Sambōin.* *Shōhekiga zenshū* (Sliding-screen paintings). Tokyo: Bijutsu shuppansha, 1972.

MIZUO 1972b Mizuo Hiroshi. *Edo Painting: Sōtatsu and Kōrin.* Trans. John Shields. New York, Weatherhill, 1972.

MIZUO 1983 Mizuo, Hiroshi. "A Portrait of Hon'ami Kōetsu," *Chanoyu Quarterly*, no. 34 (1983).

MONTREAL 1989 *The Japan of the Shoguns: The Tokugawa Collection*. Montreal: The Montreal Museum of Fine Arts, 1989.

MORRIS 1981 Morris, V. Dixon. "The City of Sakai and Urban Autonomy" in *Warlords, Artists, and Commoners, Japan in the Sixteenth Century*, ed. George Elison and Bardwell L. Smith. Honolulu: University of Hawaii Press, 1981.

MORSE 1989 Morse, Anne Nishimura. "Textiles and the Nō Theatre: Private Language, Public Statement," in *The Japan of the Shoguns*. Montreal: Montreal Museum of Fine Arts, 1989.

MURAKAMI 1943 Murakami, Naojiro. "The Jesuit Seminary of Azuchi." *Monumenta Nipponica* 6 (1943), 375-90.

MURASE 1973 Murase, Miyeko. "Fan Paintings Attributed to Sōtatsu: Their Themes and Prototypes." *Ars Orientalis* 9 (1973): 51-77.

MURASE 1975 Murase, Miyeko. *Japanese Art: Selections from the Mary and Jackson Burke Collection*. New York: The Metropolitan Museum of Art, 1975.

MURASE 1990 Murase, Miyeko. *Masterpieces of Japanese Screen Painting: The American Collections*. New York: George Braziller, 1990.

MUSÉE CERNUSCHI 1995 *Japon, Saveurs et Sérénité: La Cérémonie du Thé dans les collections du Musée des Arts Idemitsu*. Paris: Musée Cernuschi, 1995.

NAITŌ 1976 Naitō Akira. "Azuchijō no kenkyū" (Research on Azuchi Castle). *Kokka* 987-8 (1976).

NAKAI 1988 Nakai, Kate Wildman. *Shogunal Politics: Arai Hakuseki and the Premises of Tokugawa Rule*. Cambridge: Harvard University Press, 1988.

NAKAJIMA 1979 Nakajima Junji. *Hasegawa Tōhaku*. Vol. 10 of *Nihon bijutsu kaiga zenshū* (Japanese paintings). Tokyo: Shūeisha, 1979.

NAKAMURA 1971 Nakamura, Yasuo. *Noh: The Classical Theater*. Trans. Don Kenny. New York: Walker/Weatherhill, 1971.

NAKANO 1933 Nakano Sōkei, ed. *Shōzō* (Sculpture). Vol. 8 of *Kyōto bijutsu taikan* (Arts of Kyoto). Tokyo: Tōhō shoin, 1933.

NAKAYAMA 1994 Nakayama Kiichirō, ed. *Iki to fūryū: Edo no bi* (Art of the Edo period in the Idemitsu Collection). Fukuoka: Fukuoka City Museum, 1994.

NAKAZATO 1983 Nakazato Taroemon. *Karatsu*. New York: Kodansha International, 1983.

NARASAKI 1976 Narasaki Shōichi. *Seto Mino* (Seto and Mino ware). Vol. 9 of *Nihon tōji zenshū*. Tokyo: Chūō Kōronsha, 1976.

NEZU 1972 *Kōro* (Incense burners). Tokyo: Nezu Bijutsukan, 1972.

NEZU 1984 *Catalogue of Selected Masterpieces Vol. II*. Tokyo: Nezu Institute of Fine Arts, 1984.

NISHIDA and ŌHASHI 1988 Nishida Hiroko and Ōhashi Kōji, eds. *Koimari* (Koimari ware). *Bessatsu Taiyō*, no. 63 (1988).

NISHIDA and OZAKI 1992 Nishida Hiroko and Ozaki Naoto. *Chikuzen-Takatori Ware*. Fukuoka City: Cultural Association for Western Japan, 1992.

NOMA 1955 Noma Seiroku. *Kaka yuraku zu* (Merrymaking under the cherry blossoms). *Nihon no koten: kaiga* (Japanese classics: paintings). Tokyo: Bijutsu Shuppansha, 1955.

NOMA 1974 Noma, Seiroku. *Japanese Costume and Textile Arts*. Trans. Armins Nikovskis. The Heibonsha Survey of Japanese Art, vol. 16. New York: Weatherhill, 1974.

NORTH CAROLINA 1988 *Robes of Elegance: Japanese Kimonos of the 16th-20th Centuries*. Raleigh: North Carolina Museum of Art, 1988.

ŌHASHI 1989 Ōhashi Kōji. *Hizen tōji* (Hizen ceramics). Tokyo: Nyuu Saiensusha, 1989.

OHNUKI-TIERNEY 1987 Ohnuki-Tierney, Emiko. *The Monkey as Mirror: Symbolic Transformations in Japanese History and Ritual*. Princeton: Princeton University Press, 1987.

OKADA 1978 Okada, Jō. *Genre Screens from the Suntory Museum of Art*. Trans. Emily Sano. New York: Japan Society, 1978.

OKAMOTO 1972 Okamoto Yoshitomo. *The Namban Art of Japan*. Trans. Ronald K. Jones. Vol. 19 of *The Heibonsha Survey of Japanese Art*. New York: Weatherhill, 1972.

OKAMOTO and TAKAMIZAWA 1970 Okamoto Yoshitomi and Takamizawa Tadao. *Namban byōbu*. Tokyo: Kajima Kenkyūjo Shuppankai, 1970.

OKAYAMA 1981 *Shino, Kiseto, Oribe*. Okayama: Okayama Bijutsukan, 1981.

OKAYAMA 1991 *Kanzō yūhin zuroku* (Catalogue of selected works from the museum collection). Okayama: Okayama Kenritsu Hakubutsukan, 1991.

OKUDAIRA 1991 Okudaira Shunroku. *Rakuchū rakugai-zu to Namban byōbu* (Scenes in and around the capital and "Southern Barbarian" paintings). Vol. 25 of *Meihō Nihon no bijutsu* (Masterpieces of Japanese art). Tokyo: Shogakukan, 1991.

ONISHI 1993 Onishi, Hiroshi, et al. *Immortals and Sages: Paintings from Ryōanji Temple*. New York: Metropolitan Museum of Art, 1993.

OOMS 1985 Ooms, Herman. *Tokugawa Ideology: Early Constructs, 1570-1680*. Princeton: Princeton University Press, 1985.

ORTOLANI 1962 Ortolani, Benito. "Okuni-Kabuki und Onna-Kabuki." *Monumenta Nipponica* 17 (1962): 161-213.

ORTOLANI 1990 Ortolani, Benito. *The Japanese Theatre: From Shamanistic Ritual to Contemporary Pluralism*. Leiden: Brill, 1990.

OSAKA 1979 *Sengoku kassenzu byōbu* (Screen paintings of battles in the age of civil wars). Osaka: Osaka Castle Museum, 1979.

ŌSHITSU NO MITERA SENNYŪJI TEN 1990 *Ōshitsu no mitera Sennyūji ten* (Exhibition of the imperial mortuary temple, Sennyūji). Tokyo: Asahi Shimbunsha, 1990.

PALACIO DE VELÁZQUEZ 1994 *Momoyama: La Edad de Oro del Arte Japonés 1573-1615*. Madrid: Palacio de Velázquez 1994.

PEKARIK 1980 Pekarik, Andrew J. *Japanese Lacquer, 1600-1900: Selections from the Charles A. Greenfield Collection*. New York: The Metropolitan Museum of Art, 1980.

PERRIN 1979 Perrin, Noel. *Giving up the Gun: Japan's Reversion to the Sword, 1543-1879*. Boston: David R. Godine, 1979.

PHILLIPS 1994 Phillips, Quitman E. "Honchō gashi and the Kano Myth." *Archives of Asian Art* 47 (1994).

ROSENFIELD and CRANSTON 1973 Rosenfield, John M., Fumiko E. and Edwin A. Cranston. *The Courtly Tradition in Japanese Art and Literature: Selections from the Hofer and Hyde Collections*. Cambridge, Mass.: 1973.

ROSENFIELD and SHIMADA 1970 Rosenfield, John M. and Shūjirō Shimada. *Traditions of Japanese Art: Selections from the Kimiko and John Powers Collection*. Cambridge, Mass.: Fogg Art Museum, Harvard University, 1970.

SADLER 1937 Sadler, A.L. "The Naval Campaigns in the Korean War of Hideyoshi (1592-1598)." *Transactions of the Asiatic Society of Japan* 14 (June 1937): 179-208.

SAKAI 1993 *Hakata to Sakai* (Hakata and Sakai). Osaka: Sakai-shi Hakubutsukan, 1993.

SAKAKIBARA 1963 Sakakibara Kōzan. *The Manufacture of Armour and Helmets in Sixteenth Century Japan (Chūkokatchū, seisakuben)*. Trans. T. Wakameda, revised by A.J. Koop and Hogitarō Inada 1912; revised and edited by H. Russell Robinson, 1962. Rutland, Vermont: Charles E. Tuttle, 1963.

SAKAKIBARA 1976 Sakakibara Satoru. "Kyō meisho zu byōbu" (Screens of Famous Places in Kyoto). *Kobijutsu* 50 (Feb. 1976).

SAKAMOTO 1970 Sakamoto Mitsuru, Sugase Tadashi, and Naruse Fujio. *Namban bijutsu to yōfūga* (Namban arts and Western-style painting). Vol. 25 of *Genshoku Nihon no bijutsu* (Full-color reproductions of Japanese art). Tokyo: Shōgakukan, 1970.

SAKAMOTO 1977 Sakamoto Mitsuru. *Namban byōbu* ("Southern Barbarian" screens). *Nihon no bijutsu*, no. 135. Tokyo: Shibundō, 1977.

SAKAMOTO 1979 Sakamoto Mitsuru, ed. *Fūzokuga: Namban fūzoku* (Genre painting: "Southern Barbarian" paintings). Vol. 15 of *Nihon byōbu-e shūsei* (Japanese screen

paintings). Tokyo: Kōdansha, 1979

SAKAMOTO 1993 Sakamoto Mitsuru. "Namban – Its Richness and Ambiguity," in the *Via Orientalis* (1993).

SANSOM 1943 Sansom, George B. *A Short Cultural History*. New York: Appleton–Century Crofts, New York, 1943.

SANSOM 1950 Sansom, George B. *The Western World and Japan: A Study in the Interaction of European and Asiatic Cultures*. New York: Knopf, 1950.

SANSOM 1961 Sansom, George B. *A History of Japan 1334–1615*. Stanford: Stanford University Press, 1961.

SATO 1983 Sato, Kanzan. *The Japanese Sword*. Trans. Joe Earle. Tokyo: Kodansha International, 1983.

SEATTLE 1987 *A Thousand Cranes: Treasures of Japanese Art*. Seattle: Seattle Art Museum, 1987.

SHIMIZU 1988 Shimizu Yoshiaki, ed. *Japan: The Shaping of Daimyo Culture*. Washington: Washington, D.C.: National Gallery of Art, 1988.

SHIMIZU and ROSENFIELD 1984 Shimizu, Yoshiaki and John M. Rosenfield. *Masters of Japanese Calligraphy*. New York: Asia House Galleries/Japan House Gallery, 1984.

SHIMIZU and WHEELWRIGHT 1976 Shimizu, Yoshiaki and Carolyn Wheelwright, eds. *Japanese Ink Paintings from American Collections*. Princeton: Princeton University Press, 1976.

SHIN SHITEI JŪYŌ BUNKAZAI 1982 *Shin shitei jūyō bunkazai* (Newly registered Important Cultural Properties). 13 vols. Tokyo: Mainichi Shimbunsha, 1980-82.

SHIVELY, DONALD H. 1964/5 Shively, Donald H., "Sumptuary Regulation and Status in Early Tokugawa Japan." *Harvard Journal of Asiatic Studies* 25 (1964/5): 123–64.

SMITH 1981 Smith, Bardwell L. "Japanese Society and Culture in the Momoyama Era: A Bibliographic Essay." in *Warlords, Artists, & Commoners*, edited by George Elison and Bardwell L. Smith. Honolulu: University of Hawaii Press, 1981.

STINCHECUM 1984 Stinchecum, Amanda Mayer, et. al., *Kosode: 16th–19th Century Textiles from the Nomura Collection*. New York: Japan Society/Kodansha International, 1984.

SUGIYAMA 1990 Sugiyama Hiroshi, ed. *Toyotomi Hideyoshi jiten* (Toyotomi Hideyoshi handbook). Tokyo: Shin Jimbutsu Ōraisha, 1990.

SUNTORY 1982 *Myōshinji Rinkain ten: Hasegawa Tōhaku to fusuma-e* (Myōshinji Rinkain exhibition: Hasegawa Tōhaku and sliding-screen paintings). Tokyo: Suntory Art Museum, 1982.

SUNTORY 1989 Santori bijutsukan, comp.

Momoyama no hana: byōbu-e fusuma-e (Flowers of the Momoyama period: folding-screen and sliding-screen paintings). Tokyo: Santori bijutsukan 1989.

SUZUKI 1981 Suzuki, Tomoya. "*Chanoyu-gama*: Iron Kettles for Chanoyu." *Chanoyu Quarterly*, no. 27 (1981).

SUZUKI 1994 Suzuki Hiroyuki. *Kanō Hideyori hitsu Takao kanfūzu byōbu – kioku no katachi* (Cultural memory in arts Kanō Hideyori's screen painting *Maple Viewing at Mount Takao*). Vol. 8 of *E wa kataru*. Tokyo: Heibonsha, 1994.

TAKAMITSU and OKAMOTO 1970 Takamitsu Tadao and Okamoto, R. *Namban byōbu*. Tokyo: Kajima shuppankai, 1970.

TAKASE 1976 Takase Kōichirō. "Unauthorized Commercial Activities by Jesuit Missionaries in Japan." *Acta Asiatica* 30 (Feb.1976).

TAKAYANAGI 1977 Takayanagi, Shun'ichi. "The Glory that Was Azuchi." *Monumenta Nipponica* 32, no. 4 (Winter 1977).

TAKEDA 1976 Takeda Tsuneo. "Tosa Mitsuyoshi to saiga: Kyōto Kokuritsu Hakubutsukan Genji monogatari zujō o megutte" (Tosa Mitsuyoshi: Album paintings of the *Tale of Genji* at the Kyoto National Museum). *Kokka* 996 (Dec. 1976).

TAKEDA 1977a Takeda, Tsuneo. *Kanō Eitoku*. Trans. H. Mack Horton and Catherine Kaputa. New York: Kodansha International, 1977.

TAKEDA 1977b Takeda Tsuneo. *Tōhaku, Yūshō*. Vol. 9 of *Suiboku bijutsu taikei* (Ink paintings). Tokyo: Kodansha, 1977.

TAKEDA 1977c Takeda Tsuneo, ed. *Fūzokuga: Yūraku/tagasode* (Genre Painting: Pleasurable pastimes and "Whose Sleeves?" screens). Vol. 14 of *Nihon byōbu-e shūsei* (Japanese folding-screen paintings). Tokyo: Kōdansha, 1977.

TAKEDA 1978a Takeda Tsuneo, ed. *Fūzokuga: Rakuchū rakugai-zu* (Genre paintings: Scenes in and around the capital) . Vol. 11 of *Nihon byōbu-e shūsei* (Japanese folding-screen paintings). Tokyo: Kōdansha 1978.

TAKEDA 1978b Takeda Tsuneo, ed. *Fūzokuga: Sairei, Kabuki* (Genre painting: Festivals and Kabuki). Vol. 13 of *Nihon byōbu-e shūsei* (Japanese folding-screen paintings). Tokyo: Kōdansha, 1978.

TAKEDA 1979 Takeda Tsuneo. *Kyoto no ema* (Votive paintings of Kyoto). Kyoto: Kyōto-shi Bunkakan Kōkyoku Bunkazai Hogoka, 1979.

TAKEDA 1982 Takeda Tsuneo. *Kenran taru taiga I: Momoyama zenki no kachō* (Large-format paintings: Early Momoyama bird-and-flower painting). Vol. 3 of *Kachōga no sekai* (World of bird-and-flower painting). Tokyo: Gakken 1982.

TAKEDA 1992 Takeda Tsuneo, ed. *Momoyama no bijutsu* (Arts of Momoyama). Tokyo: Iwanami Shoten 1992.

TAKEDA 1993 Takeda Tsuneo. *Kaihō Yūshō*. No. 324 of *Nihon no bijutsu* (Arts of Japan). Tokyo: Shibundō 1993.

TAKEUCHI 1976 Takeuchi Jun'ichi. "Mino yaki no aya" (Mino ware designs), in Vol. 5 of *Sekai tōji zenshū* (Ceramics of the world). Tokyo: Shogakukan, 1976.

TAKEUCHI 1995a Takeuchi, Melinda. "The Golden Link: Place, Poetry, and Paradise in a Medieval Japanese Design," in Taizō Kuroda, Melinda Takeuchi, and Yūzō Yamane, *Worlds Seen and Imagined: Japanese Screens from the Idemitsu Museum of Arts*. New York: The Asia Society Galleries, 1995.

TAKEUCHI 1995b Takeuchi, Misako. "The Meaning of Pattern in Rimpa School Painting: *Mitate* and Visual Imagery." *Apollo* (Feb.1995): 3-10.

TANABE 1988 Tanabe, Willa J. *Paintings of the Lotus Sutra*. New York: Weatherhill, 1988.

TANI 1937 Tani Shin'ichi. "Muromachi jidai ni okeru shōzōga no seisaku katei" (Portraiture of the Momoyama period), part I. *Kokka* 558 (May 1937).

TANI 1939 Tani Shin'ichi. "Hō Taikō gazō-ron" (Portraits of Hideyoshi). *Bijutsu kenkyū* 92 (1939).

TANI 1973 Tani, Shin'ichi. *Namban Art: A Loan Exhibition from Japanese Collections*. International Exhibition Foundations, 1973.

TAZAWA 1981 Tazawa, Yutaka, ed. *Biographical Dictionary of Japanese Art*. Tokyo: Kodansha International/International Society for Educational Information, 1981.

TOKUGAWA 1983 *The Shogun Age Exhibition: From the Tokugawa Art Museum*. Tokyo: The Shogun Age Exhibition Executive Committee, 1983.

TOKYO 1980 *Cha no bijutsu: tokubetsu ten* (Art of the tea ceremony: Special exhibition) Tokyo: Tokyo Kokuritsu Hakubutsukan, 1980.

TOKYO 1989 *Muromachi jidai no byōbu-e* (Screen paintings of the Muromachi period). Tokyo: Tokyo Kokuritsu Hakubutsukan, 1989.

TOTMAN 1967 Totman, Conrad D. *Politics in the Tokugawa Bakufu 1600-1843*. Cambridge: Harvard University Press, 1967.

TRUBNER and MIKAMI 1981 Trubner, Henry and Mikami Tsugio, eds. *Treasures of Asian Art from the Idemitsu Collection*. Seattle: Seattle Art Museum, 1981.

TSUJI 1976a Tsuji Nobuo. "Kanō Hideyori kō" (Study of Kanō Hideyori). *Kokka* 986 (1976).

TSUJI 1976b Tsuji Nobuo. *Rakuchū rakugai-zu* (Scenes in and around the capital). *Nihon no bijutsu* (Arts of Japan), no. 121. Tokyo: Shibundō, 1976.

TSUJI 1978 Tsuji Nobuo. *Kachōga: kaki; kachō* (Bird-and-flower paintings). Vol. 6 of *Nihon byōbu-e shūsei* (Japanese folding-screen paintings). Tokyo: Kodansha 1978.

TSUJI 1991 Tsuji Nobuo, et al. *Eitoku to shōhekiga* (Eitoku and screen paintings). Vol. 15 of *Nihon bijutsu zenshū* (Complete arts of Japan). Tokyo: Kōdansha 1991.

TSUNODA 1958 Tsunoda, Ryūsaku, Wm. Theodore de Bary, and Donald Keene. *Sources of Japanese Tradition.* New York: Columbia University Press, 1958.

TURNBULL 1977 Turnbull, Stephen R. *The Samurai: A Military History.* London: Osprey Publishing, 1977.

TYLER 1992 Tyler, Royall, trans. *Japanese Nō Dramas.* London: Penguin Books, 1992.

UENISHI 1984 Uenishi Setsuo. "Bizen-ware ceramics." *Chanoyu Quarterly,* no. 38, 1984.

VARLEY 1970 Varley, H. Paul with Ivan and Nobuko Morris. *Samurai.* New York: Dell Publishing, 1970.

VARLEY and KUMAKURA 1989 Varley, H. Paul and Isao Kumakura, eds. *Tea in Japan: Essays on the History of Chanoyu.* Honolulu: University of Hawaii Press, 1989.

VLAM 1976 Vlam, Grace Alida Hermine. "Western Style Secular Painting in Momoyama Japan." University of Michigan: Ph.D. dissertation, 1976.

VLAM 1977 Vlam, Grace A.H. "Kings and Heroes: Western-style Painting in Momoyama Japan." *Artibus Asiae* 39 (1977).

WADA, RICE, and BARTON 1983 Wada, Yoshiko, Mary Kellogg Rice, and Jane Barton. *Shibori: The Inventive Art of Japanese Shaped Resist Dyeing.* Tokyo: Kodansha, 1983.

WAKIZAKA 1978 Wakizaka Atsushi. "Hasegawa Tōhaku to sono ichimon," in *Momoyama shōhekiga: Eitoku, Tōhaku, Yūshō* (Momoyama sliding-screen paintings: Eitoku, Tōhaku, Yūshō) ed. Takeda Tsuneo. Vol. 17 of *Nihon bijutsu zenshū* (Complete arts of Japan). Tokyo: Gakken, 1978.

WAKIZAKA 1980 Wakizaka Atsushi. "Soga ha no shōhekiga" (Soga School sliding screen paintings), in *Kōyasan shōheiga* (Sliding-screen paintings of Mount Kōya). Kyoto: Binobi, 1980.

WAKIZAKA 1982 Wakizaka Atsushi and Tanaka Toshio, eds. *Kenran taru taiga II: Momoyama kōki no kachō* (Large-format paintings: Late Momoyama bird-and-flower paintings). Vol. 4 of *Kachōga no sekai.* Tokyo: Gakken 1982.

WALEY 1949 Waley, Arthur. *The Pillow-Book of Sei Shōnagon.* London: George Allen Unwin, 1949 (1st ed., 1928).

WATSON 1981 Watson, William, ed. *The Great Japan Exhibition: Art of the Edo Period 1600-1868.* London: Royal Academy of Arts, 1981.

WATT and FORD 1991 Watt, James C.Y. and Barbara Brennan Ford. *East Asian Lacquer: Selections from the Florence and Herbert Irving Collection.* New York: The Metropolitan Museum of Art, 1991.

WEBB 1970 Webb, Glenn T. "Japanese Scholarship behind Momoyama Painting circa 1500-1700 as Seen in the Light of a Stylistic Reexamination of the Nature of Chinese Influence on Kano Painters and Some of their Contemporaries." University of Chicago: Ph.D. dissertation, 1970.

WHEELWRIGHT 1981a Wheelwright, Carolyn. "Kano Painters of the Sixteenth Century AD: The Development of Motonobu's Daisen-in Style," *Archives of Asian Art* XXXIV/1981.

WHEELWRIGHT 1981b Wheelwright, Carolyn. "Kano Shōei." Princeton University: Ph.D. dissertation, 1981.

WHEELWRIGHT 1981c Wheelwright, Carolyn. "A Visualization of Eitoku's Lost Paintings at Azuchi Castle," in *Warlords, Artists, and Commoners: Japan in the Sixteenth Century,* ed. by George Elison and Bardwell L. Smith. Honolulu: University of Hawaii Press, 1981.

WHEELWRIGHT 1989 Wheelwright, Carolyn, ed. *Word in Flower: The Visualization of Classical Literature in Seventeenth Century Japan.* New Haven: Yale University Art Gallery, 1989.

WILSON 1982 Wilson, William Scott. *Ideals of the Samurai: Writings of Japanese Warriors.* Burbank, Calif: Ohara Publications, 1982.

WILSON 1995 Wilson, Richard L. *Inside Japanese Ceramics: A Primer of Materials, Techniques, and Traditions.* New York: Weatherhill, 1995.

YAMAMOTO 1979 Yamamoto, Tsunetomo. *The Book of the Samurai: Hagakure.* Trans. William Scott Wilson.

YAMAMOTO 1993 Yamamoto Hideo. *Unkoku Tōgan to sono ippa* (Unkoku Tōgan and his lineage). No. 323 of *Nihon no bijutsu* (Arts of Japan). Tokyo: Shibundō, April 1993.

YAMANE 1962 Yamane Yūzō. *Sōtatsu.* Tokyo: Nihon Keizai Shimbun, 1962.

YAMANE 1966 Yamane Yūzō, ed. *Momoyama.* Vol. 8 of *Sekai bijutsu zenshū* (Arts of the world). Tokyo: Kadokawa Shoten, 1966.

YAMANE 1973 Yamane Yūzō. *Momoyama Genre Painting.* Trans. John M. Shields. Vol. 17 of Heibonsha Survey of Japanese Art. New York: Weatherhill, 1973.

YAMANE 1977 Yamane Yūzō, ed. *Sōatsu ha I* (Sōtatsu school). Vol. 1 of *Rimpa kaiga zenshū* (Rimpa paintings). Tokyo: Nihon Keizai Shimbunsha, 1977.

YAMANE 1978 Yamane Yūzō. *Kōetsu sho Sōtatsu kingindei-e* (Gold and silver paintings by Sōtatsu with Kōetsu calligraphy). Tokyo: Asahi Shimbunsha, 1978.

YAMANE 1979 Yamane Yūzō. *Yamato-e keibutsu* (Landscapes in the Yamato-e style). Vol. 5 of *Nihon byōbu-e shūsei* (Japanese folding-screen paintings). Tokyo: Kōdansha 1979.

YAMAOKA 1978 Yamaoka Taizō. *Kano Masanobu, Motonobu.* Vol. 7 of *Nihon bijutsu kaiga zenshū* (Japanese paintings). Tokyo: Shūeisha, 1978.

YAMASAKI 1981 Yamasaki, Shigehisa, ed. *Chronological Table of Japanese Art.* Tokyo: Geishinsha, 1981.

YAMATO BUNKA 1972 *Josei shōzōga tokushū* (Special issue on female portraiture). *Yamato bunka,* no. 56 (September 1972).

YAMATO BUNKA-KAN 1993 *Tokubetsu ten: Shōkadō Shōjō – Chanoyu no kokoro to hitsuboku* (Special exhibition: Shōkadō Shōjō – Tea ceremony and calligraphy). Nara: Yamato Bunka-kan, 1993.

YASUDA 1985 Yasuda Motohisa, ed. *Kamakura Muromachi jimmei jiten* (Kamakura-Muromachi name dictionary). Tokyo: Shin Jimbutsu ōraisha, 1985.

Index

PHOTOGRAPHIC ACKNOWLEDGEMENTS

The organizers are grateful to the Agency for Cultural Affairs, Shogakukan, Tokyo, and the authors for their assistance with the illustrations

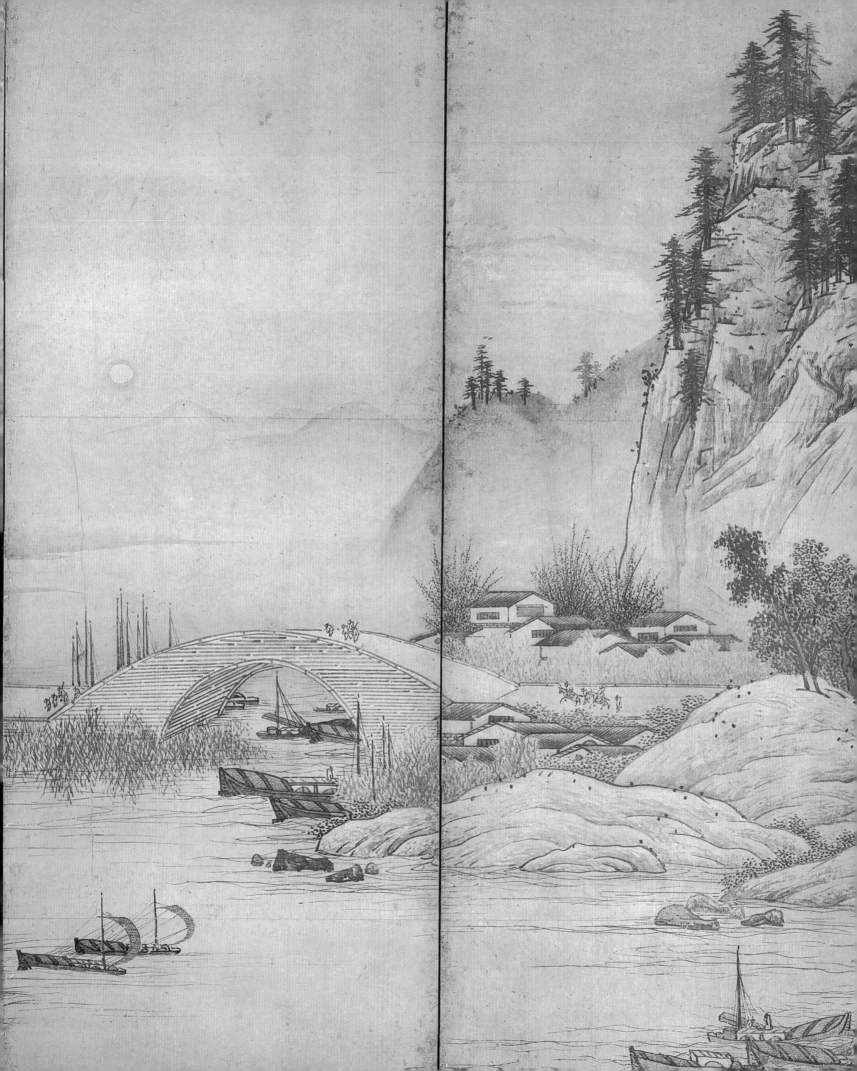